A Companion to
Museum Studies

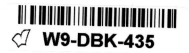

BLACKWELL COMPANIONS IN CULTURAL STUDIES

Advisory editor: David Theo Goldberg, University of California, Irvine

This series provides theoretically ambitious but accessible volumes devoted to the major fields and subfields within cultural studies, whether as single disciplines (film studies) inspired and reconfigured by interventionist cultural studies approaches, or from broad interdisciplinary and multidisciplinary perspectives (gender studies, race and ethnic studies, postcolonial studies). Each volume sets out to ground and orientate the student through a broad range of specially commissioned articles and also to provide the more experienced scholar and teacher with a convenient and comprehensive overview of the latest trends and critical directions. An overarching *Companion to Cultural Studies* will map the territory as a whole.

A Companion to
Museum Studies

Edited by
Sharon Macdonald

WILEY-BLACKWELL

A John Wiley & Sons, Inc., Publication

Library of Congress Cataloging-in-Publication Data

A companion to museum studies / edited by Sharon Macdonald.
p. cm.—(Blackwell companions in cultural studies ; 12)
Includes bibliographical references and index.
ISBN 978-1-4051-0839-3 (hardcover : alk. paper) ISBN 978-1-4443-3405-0 (paperback : alk. paper)
1. Museums—Philosophy. 2. Museums—Social aspects. 3. Museum techniques.
I. Macdonald, Sharon. II. Series.
AM7.C59 2006
069—dc22 2005033629

A catalogue record for this title is available from the British Library.

Set in 10.5/12.5pt Ehrhardt by Toppan Best-set Premedia Limited
Printed in Singapore

02 2011

Contents

Contents

Contents

Illustrations

List of Illustrations

Notes on Contributors

Jeffrey Abt is Associate Professor in the Department of Art and Art History, Wayne State University. His most recent book is *A Museum on the Verge*: *A Socioeconomic History of the Detroit Institute of Arts, 1882–2000* (2001). His next book, tentatively titled *A Scholar for our Time*: *James H. Breasted and Academic Entrepreneurship in Early Twentieth-century America and the Near East*, is an intellectual biography of America's first formally trained Egyptologist and one of the most celebrated scholars and institution builders of his time.

Marianna Adams works at the Institute for Learning Innovation, Annapolis, Maryland. Her research priorities include evaluation as an agent of organizational change, professional development and participatory evaluation, the impact of multi-visit museum programs on student learning, and the use of drawings as an evaluation methodology for children.

Mieke Bal, a well-known cultural critic and theorist, holds the position of Royal Dutch Academy of Sciences Professor (KNAW). She is also Professor of the Theory of Literature in the Faculty of Humanities at the University of Amsterdam. Her many books include *Quoting Caravaggio: Contemporary Art, Preposterous History* (1999), *Looking In: The Art of Viewing* (2001), *Louise Bourgeois' Spider: The Architecture of Art-writing* (2001), and *Travelling Concepts in the Humanities*: *A Rough Guide* (2002). *A Mieke Bal Reader* is forthcoming. Her areas of interest include literary theory, semiotics, visual art, cultural studies, postcolonial theory, feminist theory, French, the Hebrew Bible, the seventeenth century, and contemporary culture. She is also a video artist.

Rosmarie Beier-de Haan is Head of Collection and Exhibition Curator at the Berlin Historical Museum, Berlin, and Honorary Professor of Modern History at the Institute of History and Art History at the Technical University, Berlin. She is a board member of ICOM, the International Association of History Museums, of ICOM Germany, and the Network of European Museums. Her main areas of research interest are reflected in her exhibitions on the history of cultures and mentalities, and in her publications, including *Geschichtskultur in der Zweiten*

Moderne (ed., 2000) and *Erinnerte Geschichte – Inszenierte Geschichte*: *Museen und Ausstellungen in der Zweiten Moderne* (2005).

Tony Bennett is Professor of Sociology at the Open University and a Director of the ESRC Centre for Research on Socio-Cultural Change, jointly managed between the Open University and the University of Manchester. His current interests focus on the sociology of culture, with special reference to questions of culture and governance, culture and social change, the history and theory of museums, and the role of culture in the ordering of social differences. His publications include *The Birth of the Museum*: *History, Theory, Politics* (1995), *Culture*: *A Reformer's Science* (1998), *Culture in Australia*: *Policies, Publics, Programs* (co-edited with David Carter, 2001), *Pasts beyond Memory*: *Evolution, Museums, Colonialism* (2004), and (co-edited with Larry Grossberg and Meaghan Morris) *New Keywords: A Revised Vocabulary of Culture and Society* (2005). He was elected to membership of the Australian Academy of the Humanities in 1998.

Tristram Besterman, Director of the Manchester Museum, has worked in museums in both the UK and Australia, and has extensive experience of leading, managing, and developing museum services in both the local authority and university sectors. He is a Fellow of the Geological Society, a Fellow of the UK Museums Association, and a Fellow of the Royal Society of Arts. For over two decades, he has been influential in the development of museum ethics in the UK and internationally, having served as Convener of the Museums Association Ethics Committee until 2001 and as a member of the Ministerial Working Group on Human Remains from 2001 to 2004.

Patrick J. Boylan is Professor Emeritus of Heritage Policy and Management at City University, London, where, from 1990, he was Professor and Head of the Department of Arts Policy and Management. Prior to that, he spent almost thirty years in senior positions in museums and museum organizations, including Director of the Leicestershire County Museums, Arts and Records Service. He has served as the Centenary President of the UK's Museums Association, and from 1977 has held a wide range of offices in the UNESCO-linked International Council of Museums (ICOM), including service as a Member of the Executive Council (1989–98), Vice-President (1992–8), President of the ICOM International Committee for the Training of Personnel (1983–9 and 1998–2004), and of ICOM UK (1985–91). He has advised UNESCO, the Council of Europe, the World Bank, the British Council, and many governments and other agencies on issues relating to arts and heritage policy and management, and in 2004 was elected an Honorary Member of ICOM.

Steven Conn is the author of *Museums and American Intellectual Life, 1876–1926* (1998) and *History's Shadow: Native Americans and Historical Consciousness in the Nineteenth Century* (2004). He is currently working on a book on twentieth-century American museums.

Notes on Contributors

Susan A. Crane is Associate Professor of Modern European History at the University of Arizona. Her recent publications include *Collecting and Historical Consciousness in Early Nineteenth Century Germany* (2000) and *Museums and Memory* (2000). She is currently working on projects about subjectivity in contemporary history writing, and the history of southern German religious migration to Russia in the 1820s.

Elizabeth Crooke is Senior Lecturer in Museum and Heritage Studies at the Academy for Irish Cultural Heritages of Ulster, University of Ulster and Course Director of the PgDip/MA in Cultural Heritage and Museum Studies. Her research interests consider the social, cultural, and political roles of museums and heritage. She is the author of *Politics, Archaeology and the Creation of a National Museum of Ireland* (2000) and is currently writing a book on museums and community.

Lynn D. Dierking is Associate Director of the Institute for Learning Innovation, Annapolis, Maryland, and an internationally recognized authority on the behavior and learning of children, families, and adults in free-choice learning settings. Her publications include four books co-authored with John H. Falk, *The Museum Experience* (1992), *Collaboration*: *Critical Criteria for Success* (1997), *Learning from Museums*: *Visitor Experiences and the Making of Meaning* (2000), and *Lessons without Limit*: *How Free-choice Learning is Transforming Education* (2002); and one book co-authored with Wendy Pollack, *Questioning Assumptions*: *An Introduction to Front-end Studies in Museums* (1998). She also co-edited a volume with John H. Falk, *Public Institutions for Personal Learning*: *Establishing a Research Agenda* (1995). She serves on the editorial boards of *Science Education* and the *Journal of Museum Management and Curatorship*.

Steven C. Dubin is Professor of Arts Administration at Columbia University. He is author of *Bureaucratizing the Muse*: *Public Funds and the Cultural Worker* (1987), *Arresting Images*: *Impolitic Art and Uncivil Actions* (1992), *Displays of Power*: *Controversy in the American Museum from Enola Gay to Sensation* (2000), and *Mounting Queen Victoria*: *Transforming Museums in a Democratic South Africa* (2006); and has written and lectured widely on censorship, controversial art and museum exhibitions, government funding of the arts, popular culture, and mass media. The recipient of a Fulbright-Hays Faculty Research Abroad Fellowship to South Africa in 2003, he is writing a book about the post-apartheid transformation of museum exhibition and collection policies, staffs, and audiences.

John H. Falk is Director of the Institute for Learning Innovation, Annapolis, Maryland. He worked at the Smithsonian Institution for fourteen years where he held a number of senior positions including Director of the Smithsonian Office of Educational Research. He is the author of over ninety articles and essays in the areas of biology, psychology, and education, co-author with Lynn D. Dierking of *The Museum Experience* (1992), *Collaboration*: *Critical Criteria for Success* (1997), *Learning from Museums*: *Visitor Experiences and the Making of Meaning* (2000), and *Lessons without Limit*: *How Free-choice Learning is Transforming Education* (2002), and

editor of *Free-choice Science Education: How We Learn Science Outside of School* (2001).

Bruno S. Frey is Professor of Economics at the University of Zurich and Research Director of CREMA – Center for Research in Economics, Management and the Arts. He has been awarded an honorary doctorate in economics from the University of St Gallen and the University of Göteborg. He is the author of numerous articles and books, including *Not Just for the Money* (1997), *Economics as a Science of Human Behaviour* (1999), *The New Democratic Federalism for Europe* (1999), *Arts and Economics* (2000), *Inspiring Economics* (2001), *Successful Management by Motivation* (2001), *Happiness and Economics* (2002), and *Dealing with Terrorism: Stick or Carrot?* (2004).

Gordon Fyfe is a Fellow of Keele University where he was, until recently, Senior Lecturer in Sociology. He has published essays on the historical sociology of art and art museums with particular reference to the nineteenth and early twentieth centuries. He is co-editor, with Sharon Macdonald, of *Theorizing Museums* (1996) and author of *Art, Power and Modernity* (2000), which explores the development of Victorian art institutions and assesses their role in social reproduction. He is also a co-editor of the journal *Museum and Society*.

Patty Gerstenblith has been Professor of Law at DePaul University College of Law since 1984. She received a BA from Bryn Mawr College, a PhD in Art History and Anthropology from Harvard University, and a JD from Northwestern University School of Law. Before joining the DePaul faculty, she clerked for the Honorable Richard D. Cudahy of the US Court of Appeals for the Seventh Circuit. She served as editor-in-chief of the *International Journal of Cultural Property* from 1995 to 2002 and as a public representative on the President's Cultural Property Advisory Committee from 2000 to 2003. She currently serves as President of the Lawyers' Committee for Cultural Heritage Preservation and co-chair of the American Bar Association's International Cultural Property Committee. Her book, *Art, Cultural Heritage and the Law*, was published in 2004.

Michaela Giebelhausen is Lecturer in Art History and Theory at the University of Essex, and Co-director of the MA in Gallery Studies. She has published widely on the development of prison architecture, museum architecture, and on Pre-Raphaelite painting. She is editor of *The Architecture of the Museum: Symbolic Structures, Urban Contexts* (2003) and author of *Painting the Bible: Representation and Belief in Mid-Victorian Britain* (2006). She is currently working on her next book, *The City in Ruins*.

George E. Hein, Professor Emeritus at Lesley University, is active in visitor studies and museum education as a researcher and teacher. He was a Fulbright Research Fellow at King's College London, visiting faculty member at the University of Leicester Museum Studies Program, Visiting Scholar at the California Institute of Technology, Osher Fellow at the Exploratorium in San Francisco, and Visiting

Professor at the University of Technology, Sydney. He also served as president of ICOM/CECA. He is the author of *Learning in the Museum* (1998) and, with Mary Alexander, *Museums: Places of Learning* (1998). His primary current interest is the significance of John Dewey's work for museums.

Michelle Henning is Senior Lecturer in Cultural and Media Studies at the University of the West of England, Bristol. She has worked as an installation artist and published essays on photography and new media. She is the author of *Museums, Media and Cultural Theory* (2006).

Bill Hillier is Professor of Architecture and Urban Morphology and Director of the Space Syntax Laboratory at University College London, where he pioneered the methods of analysis known as "space syntax." He is author of *The Social Logic of Space* (1984), *Space is the Machine* (1996), and a large number of essays and articles concerned with space in buildings and cities.

Steven Hoelscher is a cultural geographer with research interests in the connections between identity, place, and heritage. His books include *Heritage on Stage* (1998) and *Textures of Place* (co-edited, 2001). He lives in Austin, Texas, where he is Associate Professor of American Studies and Geography at the University of Texas.

Eilean Hooper-Greenhill is Professor of Museum Studies and Director of the Research Centre for Museums and Galleries (RCMG) at the University of Leicester. Her research interests focus on the relationships between museums and their audiences. She is the author of *Museums and the Shaping of Knowledge* (1992), *Museums and their Visitors* (1994), and *Museums and the Interpretation of Visual Culture* (2000), and editor of *The Educational Role of the Museum* (2nd edn, 1999). She is currently working on *Museums and Learning: New Dimensions*.

Flora *Edouwaye* S. Kaplan is an anthropologist, and Professor Emerita, Faculty of Arts and Science, at New York University, where she also founded and directed the postgraduate Museum Studies Program. She has carried out fieldwork in Nigeria (where she has held a Fulbright Professorship at the University of Benin), Mexico, and the United States; has been a museum curator (in the Department of Primitive Art and New World Cultures, The Brooklyn Museum); and has served on the National Committee of the American Association/International Council of Museums and on the executive committee of the International Committee for Museology. She has published widely on Benin religion, art, and gender, as well as museology. Her publications include *Queens, Queen Mothers, Priestesses, and Power: Case-studies in African Gender* (1997), *Museums and the Making of "Ourselves": The Role of Objects in National Identity* (ed. 1994), and *Benin Art and Culture* (2006). In 1990, His Royal Highness, Oba *Erediauwa* of Benin, named her *Edouwaye*, meaning, "You have come home to Benin," making her a "Benin woman of honor," equivalent to a male chieftaincy title, and the first scholar to be so recognized.

Christina Kreps is Associate Professor of Anthropology and Director of Museum Studies and the Museum of Anthropology at the University of Denver. Her research interests include critical and comparative museology, art and cultural expression, international cultural policy, and culture and development. Her recent publications include *Liberating Culture*: *Cross-cultural Perspectives on Museums, Curation, and Heritage Preservation* (2003) and "Curatorship as Social Practice" in *Curator* 46 (3), 2003.

Sharon Macdonald is Professor of Cultural Anthropology at the University of Sheffield. Her books include *Theorizing Museums* (1996, co-edited with Gordon Fyfe), *Reimagining Culture* (1997), *The Politics of Display* (ed., 1998), *Behind the Scenes at the Science Museum* (2002), and *Exhibition Experiments* (2006, co-edited with Paul Basu). Her current primary research is an historical and ethnographic study of representations of the Nazi past in Germany.

Vittorio Magnago Lampugnani is Professor of the History of Urban Design and Head of Network City and Landscape at the Swiss Federal Institute of Technology (ETH) in Zurich, and director of an architectural practice in Milan. He has also held positions at academic institutions in Stuttgart, Berlin, Frankfurt, Milan, and Pamplona, as well as at the universities of Columbia and Harvard. He has curated exhibitions about architecture that have been shown in Germany, France, Italy, and the US; and between 1990 and 1995 was Director of the German Architecture Museum in Frankfurt. From 1986 to 1990 he was deputy editor and from 1990 to 1995 editor of *Domus*. Many of his numerous publications have been translated into English, including *Museum Architecture in Frankfurt 1980–1990* (1990) and *Museums for a New Millennium*: *Concepts, Projects, Buildings* (with Angeli Sachs, 1999).

Rhiannon Mason lectures in museum, gallery, and heritage studies at the International Centre for Cultural and Heritage Studies, University of Newcastle. Her research interests include critical and cultural theory, museum histories, new museology, and museum representations of cultural identities. She is currently working on a book about the construction and representation of national identities in the National Museums and Galleries of Wales.

Stephan Meier is a Fellow at the Kennedy School of Government at Harvard University. He studied history, economics, and political science at the universities of Zurich and Barcelona. He received his PhD in economics from the University of Zurich. His forthcoming book entitled *An Economic Analysis of Pro-social Behavior* (2006) analyzes empirically the conditions for contributions to public goods.

Donald Preziosi is the author of eleven books on art, architecture, archaeology, and museology, the most recent being *Brain of the Earth's Body*: *Art, Museums, and the Phantasms of Modernity* (2003), *Grasping the World*: *The Idea of the Museum* (co-edited with Clare Farago, 2004), and a collection of his essays entitled *In the Aftermath of Art*: *Ethics, Aesthetics, and Politics* (2005). In 2001 he delivered the Slade

Notes on Contributors

Lectures in the Fine Arts at Oxford University. He has taught at various universities in the US, including Yale, MIT, and UCLA, where he is now also Emeritus Professor of Art History.

Nick Prior is Senior Lecturer in Sociology at the University of Edinburgh. His research interests are in the sociology of art, urban sociology, and cultural theory. He is author of *Museums and Modernity* (2002) and a number of essays exploring the fate of modern art museums in contemporary culture.

Mark W. Rectanus is Professor of German Studies, Iowa State University. He has published on print culture, media, and the publishing industry in Germany and the US; cultural politics and corporate sponsorships; museums studies; conceptual art and performance studies. His most recent book is *Culture Incorporated: Museums, Artists, and Corporate Sponsorships* (2002).

Robert W. Rydell is Professor of History and Chair of the Department of History and Philosophy at Montana State University, Bozeman. He has published many books and articles about world fairs. His most recent book is *Buffalo Bill in Bologna: The Americanization of the World, 1869–1922* (with Rob Kroes, 2005).

Charles Saumarez Smith has been Director of the National Gallery, London since 2002. He was Director of the National Portrait Gallery from 1994 to 2002, and in 2001 was Slade Professor at the University of Oxford.

Anthony Alan Shelton is Professor of Anthropology and Adjunct Professor of Art History, Visual Culture, and Theory, and Director of the Museum of Anthropology at the University of British Columbia. He is author of numerous papers on critical museology, and editor of *Museums and Changing Perspectives of Culture* (1995), *Collectors: Expressions of Self and Other* (2001), and *Collectors: Individuals and Institutions* (2001).

Kali Tzortzi is an archaeologist-museologist and a doctorate candidate at the Bartlett School of Graduate Studies, University College London. She has worked as a Project Consultant for Space Syntax Ltd, London, and her recent work is concerned with issues of museum space and its relation to patterns of use.

Andrea Witcomb is Senior Lecturer, Cultural Heritage Program, Faculty of Built Environment, Art and Design, Curtin University of Technology, Perth, Western Australia. She is the author of *Re-imagining the Museum: Beyond the Mausoleum* (2003) and editor of *The Open Museum Journal*, an electronic, peer-reviewed journal found on the Australian Museums Online website. Her interest in interactivity in museums is an outcome of her wider interest in the ways in which contemporary multimedia practices connect with the politics of representation in museum exhibitions. Before entering academia, she worked as a curator in Australian Museums.

Acknowledgments

The first acknowledgment in a volume like this must go to the contributors on whom it all rests. Especial thanks go to those who also helped me out with queries, suggestions, reading, and pictures in relation to chapters other than their own; and to those anonymous others who acted as readers. Jane Fargnoli and Ken Provencher at Blackwell were enthusiastic and supportive when it mattered. You really should write that survival guide, Ken. Thanks too to Mike, Tara, Thomas and Harriet Beaney, true companions throughout.

Bibliographical Note

Items marked with an asterisk in the bibliographies are especially recommended for further reading.

Expanding Museum Studies: An Introduction

Sharon Macdonald

Museum studies has come of age. Over the past decade in particular, the number of books, journals, courses, and events dedicated to museum studies has grown enormously. It has moved from being an unusual and minority subject into the mainstream. Disciplines which previously paid relatively little attention to museums have come to see the museum as a site at which some of the most interesting and significant of their debates and questions can be explored in novel, and often excitingly applicable, ways. They have also come to recognize that understanding the museum requires moving beyond intra-disciplinary concerns to greater dialogue with others, and to adopting and adapting questions, techniques, and approaches derived from other areas of disciplinary expertise. All of this has contributed to museum studies becoming one of the most genuinely multi- and increasingly inter-disciplinary areas of the academy today.

This *Companion to Museum Studies* is intended to act as a guide through the thronging multi-disciplinary landscape; and to contribute to and develop cross-disciplinary dialogue about museums. By bringing together museum scholars from different disciplines and backgrounds, it presents a broad range of perspectives and identifies the most vital contemporary questions and concerns in museums, and in museum studies. Authors discuss what they regard as particularly important and interesting within their own fields of expertise in relation to key topics in museum studies, and they present original perspectives and arguments that constitute significant autonomous contributions to their specific areas as well as to museum studies more generally. The chapters have been specially commissioned for this volume, though in two cases they are expanded from earlier, shorter papers (chapters 15 and 33). Contributors to this *Companion* are museum scholars versed in relevant academic debates and many also have direct professional experience of working in or with museums, in a closer and more vibrant relationship between the museum and the academy – and practice and theory – that is a hallmark of expanding museum studies today.

The museum studies represented by this volume has its roots in, and takes up the challenge set by, developments often described as "the new museology" (see below). However, it also goes beyond some of what might be called the "first wave" of new museological work by broadening its scope, expanding its methodological

approaches, and deepening its empirical base. It also asks questions of some of the new orthodoxies – including the supremacy of the visitor – that have found their way into contemporary museum practice; and it suggests possible new avenues for future museum work and study. This expanded and expanding museum studies does not, however, have a single "line," and it is significant that a collective plural noun is replacing a singular one. Perhaps more than anything, museum studies today recognize (to use the plural now) the multiplicity and complexity of museums, and call for a correspondingly rich and multi-faceted range of perspectives and approaches to comprehend and provoke museums themselves.

The New Museology

In his introduction to *The New Museology*, an edited collection published in 1989, Peter Vergo expressed well the change from what he called "the old museology" to the new. The old, he wrote, was "too much about museum *methods*, and too little about the purposes of museums" (Vergo 1989: 3). The old was predominantly concerned with "how to" matters of, say, administration, education, or conservation; rather than seeking to explore the conceptual foundations and assumptions that established such matters as significant in the first place or that shaped the way in which they were addressed. By contrast, the "new museology" was more theoretical and humanistic. Although Vergo's volume was only one of a number of interventions made under the rubric of "the new museology" (see chapters 2 and 10 of this volume), it is worth looking at its content and coverage (despite its own acknowledgment that these are not intended to be comprehensive) in order to identify some of the main points of departure from "the old museology." Three seem to me to be particularly indicative.

The first is a call to understand the meanings of museum objects as situated and contextual rather than inherent. Vergo's own chapter, with its elegant concept of "the reticent object," makes this argument, as do various others, including that of Charles Saumarez Smith (1989), whose story of the way in which a seventeenth-century doorway became the logo of V&A Enterprises, the Victoria and Albert Museum's new commercial company, has become a classic example of shifting object meanings.

The doorway example also illustrates the second area to which the new museology drew attention: namely, matters that might earlier have been seen as outside the remit of museology proper, such as commercialism and entertainment. Chapters on great exhibitions and theme parks, as well as Stephen Bann's reflections on what he calls "fragmentary or incomplete expressions of the museological function" (Bann 1989: 100) – for example, individual quests to assemble histories – highlight continuities between museums and other spaces and practices, thus throwing into question the "set apartness" of the museum or the idea that it is "above" mundane or market concerns.

Linked with both the first and second is the third: how the museum and its exhibitions may be variously perceived, especially by those who visit. This is speculated upon in many of the chapters, and some valuable empirical evidence is provided in that of Nick Merriman (1989; see also chapter 22 of this volume). Collectively, then,

these three areas of emphasis demonstrate a shift to seeing the museum and the meaning of its contents not as fixed and bounded, but as contextual and contingent.

Representational Critique

The shift in perspective evident in *The New Museology* was part of a broader development in many cultural and social disciplines that gathered pace during the 1980s. It entailed particular attention to questions of representation – that is, to how meanings come to be inscribed and by whom, and how some come to be regarded as "right" or taken as given. Academic disciplines and the knowledge they produced were also subject to this "representational critique." Rather than seeing them as engaged in a value-free discovery of ever-better knowledge, there was a move toward regarding knowledge, and its pursuit, realization, and deployment, as inherently political. What was researched, how and why, and, just as significantly, what was ignored or taken for granted and not questioned, came to be seen as matters to be interrogated and answered with reference not only to justifications internal to disciplines but also to wider social and political concerns. In particular, the ways in which differences, and especially inequalities, of ethnicity, gender, sexuality, and class, could be reproduced by disciplines – perhaps through exclusions from "the canon," "the norm," "the objective," or "the notable" – came under the spotlight. This mattered, it was argued, not least because such representations fed back into the world beyond the academy, supporting particular regimes of power, most usually the status quo.

In response to such critiques, greater "reflexivity" – in the form of greater attention to the processes by which knowledge is produced and disseminated, and to the partial (in both senses of the word) and positioned nature of knowledge itself – was called for. This led to a flourishing of work that sought to "deconstruct" cultural products, such as texts or exhibitions, in order to highlight their politics and the strategies by which they were positioned as "objective" or "true," and to probe the historical, social, and political contexts in which certain kinds of knowledge reigned and others were marginalized or ignored.

The critique of representation at the level of cultural products and disciplines was itself part of a broader critique of the way in which the "voices" of certain groups were excluded from, or marginalized within, the public sphere. The challenge came especially from postcolonial and feminist activists and scholars who argued that existing, broadly liberal democratic, political models were inadequate to tackling the fundamental representational inequities involved. What was needed was a politics of recognition, specifically addressing not just whether people had the right to vote and otherwise participate as citizens but potentially more fundamental matters, such as whether the concerns of marginalized groups even made it onto the agenda. In the increasingly multicultural cities of North America and Europe in particular, political positions and claims came with increasing frequency to be articulated in terms of the needs and rights of "under-" or "mis-recognized" identities.

Sharon Macdonald

Identity Politics

It was in this context of "identity politics" that museums were subject to new critical attention. In many ways, the museum is an institution of recognition and identity *par excellence*. It selects certain cultural products for official safe-keeping, for posterity and public display – a process which recognizes and affirms some identities, and omits to recognize and affirm others. This is typically presented in a language – spoken through architecture, spatial arrangements, and forms of display as well as in discursive commentary – of fact, objectivity, superior taste, and authoritative knowledge.

The challenge to museum representation came, then, not only from theory and the academy. As is discussed especially in Part VI of this *Companion*, there have been a number of high-profile controversies about exhibitions, especially since the 1980s, which have collectively raised questions about how decisions are made about what should end up on public display, and who should be involved in making them. Various groups have protested about the ways in which they were represented in exhibitions, or excluded from museum attention altogether; and there have been demands for the return of objects to indigenous peoples (see, for example, chapters 5, 26, and 27 of this volume).

At the same time, others spoke out against what they saw as an unnecessary political correctness and postmodernist relativity leading museums away from their proper mandate to represent the majority high culture and truth and act as repositories of the collective treasure for the future. Museums found themselves at the center of the wider "culture wars" over whether it was or was not possible or permissible to see some cultural products and forms of knowledge as in any sense more valuable or valid than others (see chapters 29 and 30 of this volume). Museums became, in short, sites at which some of the most contested and thorny cultural and epistemological questions of the late twentieth century were fought out.

The Museum Phenomenon

These were not the only reasons why museums began to excite new levels of interest among cultural commentators, policy-makers, and scholars in many disciplines. The empirical fact that intrigued many was what Gordon Fyfe (chapter 3) calls "the museum phenomenon": namely, the extraordinary growth in the number of museums throughout the world in the second half of the twentieth century, especially since the 1970s. Ninety-five per cent of existing museums are said to have been founded since World War II (see chapter 13). This "phenomenon" showed not only that the museum could not just be understood as an "old" institution or relic of a previous age, but also that the critiques of representation had not undermined confidence in the museum as a cultural form. Indeed, as chapters 10, 11, and 29 demonstrate, the museum came to be embraced precisely by some of those who had reason to be critical of aspects of its earlier identity-work.

The museum phenomenon cannot be accounted for wholly by a proliferation of museums to represent previously marginalized groups, however. Indeed, just as sig-

nificant as the expansion in the number of museums was a stretching of their range and variability, including a blurring into other kinds of institution and event. So, while at one end of the scale there was a proliferation of small, low-budget, neighborhood museums, often concentrating on the culture of everyday life or local heritage; at the other, corporate museums, the development of museum "franchises," "blockbuster" shows, iconic "landmark" architecture (chapters 14 and 15), "superstar" museums (chapter 24) and "meta-museums" (chapter 23) also flourished. Certainly, these could be bound up with the representation of identity too – especially with cities promoting their distinctiveness in the global competition for prestige and a share of the cultural tourism market, and with corporations deploying the museum as part of their own image-marketing. But understanding them needed also to consider questions of spectacle, "promotional culture," the global traffic in symbols, and flows of capital (see, especially, chapters 23, 24, and 31).

The museum phenomenon is best seen as a product of the coming together of a heady mix of partially connected motivations and concerns. These include, *inter alia*, anxieties about "social amnesia" – forgetting the past (chapter 7); quests for authenticity, "the real thing," and "antidotes" to the throwaway consumer society (chapters 3, 6, and 33); attempts to deal with the fragmentation of identity and individualization (chapter 12); and desires for life-long and experiential learning (chapters 19 and 20). Indeed, although discussion of the changes in museums in the late twentieth century and into the twenty-first was not a specific remit for most contributors to this book, almost all comment upon it, so providing a wide-ranging, multi-disciplinary reflection on its nature, significance, and implications.

One of the key questions arising from the proliferation of museums is whether it will be possible to sustain. Will the public be afflicted with collective "museum fatigue" in the face of too much of a similar thing, however good (however defined)? The evidence at present is inconclusive: new museums continue to open, though there have also been closures and (some high profile) plans shelved. The question is also complicated by the fact that it is not always clear what should "count" as a museum. The development of "museums" that do not possess permanent collections or only "token" ones, including some corporate museums and most science centers, and the emergence of the virtual museum (chapter 18), also contribute to a definitional quagmire and to the continuing soul-searching about what is a museum – and also to what it might or should be. Contributors here offer their own, various, answers. Rather than seeing these developments and difficulties as threatening the validity of the museum as a focus of study, however, the new museum studies embrace these as part of a continuing and expanding fascination with museums.

Expanding Museum Studies

The expanded and pluralized museum studies build on insights of the new museology and representational critique to further develop areas to which these drew attention but also to extend the scope of study. In addition to this broadening of scope, there is also a growing recognition of the complexity – and often ambivalent

nature – of museums, which calls for greater theoretical and methodological sophistication. What we see in museum studies as represented here is a broader range of methods brought to bear and the development of approaches specifically honed to trying to understand the museum. Also characteristic is a renewed commitment to trying to bring together the insights from academic studies with the practical work of museums – to return to some of the "how to" concerns of the "old museology" from a new, more theoretically and empirically informed, basis.

This *Companion to Museum Studies* as a whole speaks to and illustrates the new museum studies more eloquently than can a brief introduction and overview. It is, however, worth noting some of the ways in which the new museum studies have built on and developed the three areas outlined above as particularly indicative of the new museology. First, the new museological idea that object meanings may change in different contexts has been fleshed out through a range of work that addresses the ways in which objects may take on particular meanings and values. For example, there is research that has involved developing techniques to try to elucidate a language or grammar of exhibitions (chapters 17 and 32); or to distinguish different kinds of visual – or multi-sensorial – regimes (chapters 16, 21, and 31). Some of the newer work has also tried to move beyond predominantly text-based models in order to understand the significance of the materiality of objects and, indeed, of forms of exhibiting themselves (chapters 2, 13, and 18); and to explore how this interacts with notions such as "heritage," "authenticity," "narrative," and "memory" (chapters 3, 7, and 13). Further study has considered how these may play out in different cultural or political contexts (chapters 10 and 28) and has addressed questions of the legal status and ethical implications of how objects are treated (chapters 26 and 27). There has also been a move toward looking at the meanings of museum objects not only as a reflection of changing contexts or the perceptions of different groups, but as themselves helping to shape how various other kinds of objects – and, indeed, a complex of related notions, including subjectivity, knowledge, and art – are apprehended and valued (chapters 4, 6, and 16).

Expansion and Specificity

The new museological broadening of remit, and in particular its attention to matters of commerce, market, and entertainment, has also continued and become further developed in the expanded museum studies. Some such work follows from the recognition that "museological" practices (for example, collecting, assembling heritage, performing identity via material culture) are not necessarily confined to the museum, and that the museum may shape ways of seeing beyond its walls. This has also seen further scholarly attention given to some of the historical ideas about what constitutes a museum (chapter 8) and its links with other institutions, such as world fairs (chapter 9).

At the same time, there has been empirical and theoretical work dedicated to trying to understand the (sometimes subtle) implications for museums of the various and changing financial and governmental contexts in which they operate. As chapters here variously document, these include such matters as the effort put into

attracting commercial sponsorship or maximizing visitor numbers, the relative amount of space allocated to the display of objects or to the museum shop, the numbers of staff working on different museum tasks and their expected levels of expertise (chapter 25), the ways in which the museum audience is conceptualized (for example, as child or adult, as customer or citizen), the kinds of looking or learning that are encouraged, and how challenging or controversial exhibitions are likely to be. By providing a greater range of studies of what is going on in museums in various places, the new museum studies are also able to highlight some of the alternatives available. For example, Bruno S. Frey and Stephan Meier's discussion of museum economics in chapter 24 shows various possible options and gives attention to the agency of museum directorates – agency that sometimes may feel rather depleted when certain ways forward come to be taken for granted rather than critically interrogated (chapter 33).

What also emerges – perhaps initially apparently paradoxically – from this broadening of scope and the recognition of overlap between the museum and other institutions is an acknowledgment of the relative specificity or distinctiveness of museums. As with the move beyond approaches that look at museums as texts, there is greater recognition in the expanding museum studies of the necessity to extend, reconfigure, or even move beyond, approaches that have been developed primarily for the study of other institutions or practices, and to find ways of recognizing aspects of museums that might otherwise be overlooked. To take the case of museum economics as the example again, Frey and Meier argue that while many conventional economic concepts can be used to provide insights into the economic situation of museums, the "cultural value" of museums – typically ignored – should also be included in the analysis.

Similar arguments are also evident in a range of other areas in the *Companion*, such as education, the profession, and technology. In making these, contributors are not seeking to essentialize the museum or identify the *only* aspects that are really important but to put these together with other features in order to better understand the complex and often diverse nature of museums themselves. Museums, whatever family resemblances they have with other institutions or practices, are also a particular kind of mix, drawn from a partially shared repertoire of ambitions, histories, structures, dilemmas, and practices. It is for this reason that museum studies cannot just be dissolved into, say, media studies or cultural studies, however much museum studies may profit from plundering those areas for insights.

A note here is perhaps necessary on the use of the singular and plural forms "museum" and "museums." It has become a rather standardized and sometimes hackneyed move in cultural studies to reject the use of singular terms and to use plurals. In choosing to talk of "museum studies" rather than "museology," I have also given preference to a plural term – which seemed appropriate in this context and given the argument made. As Mieke Bal (chapter 32) argues in relation to the term "the public," however, a singular term does not necessarily have to indicate an entity understood as undifferentiated. Moreover, it can be helpful to use the singular, especially to indicate where an abstract idea (which may be variously realized) rather than specific instances are intended. For this reason, the term "the museum" is used in the *Companion* – as well as, where appropriate, "museums."

The Plural Public

The third of my suggested indicative areas of the new museology was that of the museum audience/public/visitors. As Eilean Hooper-Greenhill's contribution (chapter 22) here shows especially, the amount of work dedicated to trying to understand how museums and exhibitions may be perceived or otherwise related to by those who go to them – and also, though this remains under-addressed, by those who do not – has expanded greatly since *The New Museology* was published. Not only has there been an expansion of the quantity of visitor research, but a greater range of methodological approaches – particularly qualitative – has also been brought to bear.

Some of the predominant methodological developments are bound up too with changes in the way that "the audience" or "the public" is understood – both by those conducting the research and by museums themselves. As is argued in many chapters in this *Companion*, there has been a shift, underway for quite some time now though still only patchily achieved, toward understanding the public as diverse, plural, and active, rather than as a relatively homogeneous and rather passive mass (see, for example, chapters 2, 8, and 19). This is evident not only in styles of research, which have increasingly involved methods that allow variations and ways of seeing beyond pre-defined research frames to come to light, but also in the approaches of some museums themselves (for example, chapters 16 and 20).

What is also evident, however, is a more critical take on some of the ways in which aspects of the new orthodoxy of visitor sovereignty – and various linked ideas, such as "accessibility," "diversity," "community," "interactivity," "visitor involvement" – have been understood or put into practice. There is plenty of evidence of this more critical approach throughout this volume. It is important to note, however, that for the most part the aim of those producing such critical analyses is to contribute to, rather than to abandon, the original ambition to find better ways of helping museums to relate to diverse audiences. Take, for example, Andrea Witcomb's (chapter 21) dissection of "interactivity" in museums – something that too often is reduced to a rather mechanistic approach; or Mieke Bal's (chapter 32) analysis of a range of exhibitionary attempts to alter the relationship between the museum and the public. In both cases, as in many others discussed in this *Companion*, they are also concerned to identify more promising strategies and to suggest possible ways forward.

Policy, Practice, and Provocation

All of the developments in museum studies outlined here have significant implications for museum policy and practice. They provide not only more nuanced theoretical tools but also methodological techniques and a growing and more robust empirical base of research and critical accounts of existing museum practice. What this adds up to, I suggest, is a reconnecting of the critical study of the museum with some of those "how to" concerns that the "new museology" saw itself as having superseded.

This reconnection is not only evident on paper: it is also underway in many museums, though to varying extents in different places and in different types of museum. What it involves is a greater openness on the part of museums and museum staff to engage with those who study museums but who do not necessarily work in them. Pioneering directors and curators want to know what some of the exciting critical disciplinary and trans-disciplinary ideas can say to help them create innovative exhibitions. My own sense is that this is coming to supplant the idea, common over the past decade (though more so in some countries and types of museum than in others), that market research on visitors is the panacea for the museum's ills. While understanding what might be wanted by visitors – and those who do not visit – is crucial to the successful museum enterprise, simply playing back what visitors might think that they already wish to see, tends to produce uninspired and quickly dated exhibitions.

Thought-provoking, moving, unsettling, uplifting, challenging, or memorable exhibitions, by contrast, are more likely to be informed by extensive knowledge of diverse examples, questions of representation, perception, museological syntax, and the findings from nuanced and probing visitor research. Those who work on museums – practitioners of museum studies – are coming to a new extent to be in demand to provide the wider perspectives and knowledge that are, increasingly, required. The fact that Mieke Bal – one of the most significant but perhaps also one of the most "difficult" theorists of museums – has been involved in exhibition-making (as she describes in chapter 32) is an indication not only of this development but also of what it can contribute to both museums themselves and to the understanding of them.

The Encyclopedic Struggle

In compiling this volume, I have sometimes found myself thinking about Gustave Flaubert's story of Bouvard and Pécuchet, a pair of autodidacts who seek numerous means – including creating a museum – to try to grasp and catalogue all knowledge. What they find, however, is that the world and things resist their schemes, and that their ordering attempts fall apart. Flaubert's story speaks eloquently to museums today, many of which have questioned their own earlier attempts at encyclopedism and have embraced other approaches to collecting and exhibiting, as various chapters here show.

In shaping this *Companion to Museum Studies*, however, I undoubtedly felt an encyclopedic urge even though I knew that as soon as I had completed one list of "definitive topics" others would rapidly emerge. Nevertheless, rather like Bouvard and Pécuchet, I persevered, for there was also something tantalizingly attractive about at least trying to approach some kind of provisional comprehensiveness. Unlike Bouvard and Pécuchet, however, my recognition of the inevitability of provisionality and incompleteness meant that I did not come to abandon the task altogether.

Moreover, having spent several years as an ethnographer watching museum staff struggle to create exhibitions (Macdonald 2002), I also knew that even with the most meticulously laid plans and precisely defined rules of selection, the process of cre-

ation often takes unexpected turns – and that these could even turn out to be the most interesting. Just like the curators whom I observed shifting their plans because they had fallen in love with a particular object that they had happened upon in the museum's store-rooms, I sometimes found my intentions to include a chapter on a particular topic swayed when the potential contributor whom I approached suggested something slightly different which he or she most wanted to write. Recognizing, too, that this was a better way to ensure lively, engaged chapters, I either acquiesced or, as I also witnessed in my study of exhibition-making, agreed to settlements that were usually far superior to – if harder to classify than – my original conceptions.

The Compass of the *Companion*

Despite the negotiated nature of the production of this *Companion to Museum Studies*, the volume does cover the topics which seem to me to be central to an expanding and vibrant museum studies. Many of these are signaled explicitly in the titles of the chapters, though others, such as "objects," are so fundamental that they run through many chapters or throughout. Some of these links are indicated in the short introductions to each of the Parts of the *Companion*. Each chapter also contains its own bibliography of selected works in its area and indicates (with an asterisk) a number that are particularly recommended for initial further reading.

What I have not tried to do in the *Companion* is to catalogue different kinds of museum, though there are some chapters, such as Anthony Shelton's on anthropology (chapter 5), that do in effect provide excellent overviews of particular types of museum; and in the volume as a whole, under many different titles and themes, a wide range of types of museum are discussed. Many of the discussions and questions covered in the various chapters are, of course, common to many different kinds of museum, though there is recognition throughout that differences matter and that variations such as museum genre, subject matter, scale, size, funding arrangements, location, national or political context, and so forth are all relevant. What this *Companion* seeks to do is to open up this awareness rather than attempt to chart it.

This opening up of possible directions and routes is in the nature of a Companion and is part of what distinguishes it from an encyclopedia. So, too, is the fact that it is a collection of distinct, individual voices rather than a shared authorial declaration. There are differences of language, approach, and opinion here; and, in effect, the reader is presented with a set of (carefully chosen) companions, rather than a single guide, on their journey into museum studies. In this respect, too, the *Companion* bears similarities with the post-encyclopedic museum developments toward polyphony.

There are other ways, of course, in which this volume might have been organized. Chapters often speak to concerns in other sections. For this reason, the introduction to each Part also identifies at least some of the other chapters which bear upon the themes of those included in that particular Part. Readers may wish to begin at the beginning and work through the volume; and chapters have been organized such that some of the earlier ones provide a useful basis for understanding some of those that

follow. Chapters have also been grouped in order to bring particular themes together and to enable readers to follow a relatively ordered course through particular territories. The independent traveler may, of course, wish to simply wander or to follow his or her own itinerary, perhaps assisted by the index, that venerable if flawed convention that also has its origins in the taxonomic urge.

The *Companion* is divided into six parts. Part I: *Perspectives, Disciplines, Concepts* has a double remit to present some of the disciplinary perspectives that have been pre-eminent in reshaping the new museum studies and to explore key museum concepts and practices. The chapters highlight some of the main elements of the critical discourse that has emerged to interrogate the museum and its role; and they show how good the museum is for thinking through key and timely concerns in a wide range of disciplines. These chapters introduce the volume by exploring some of the fundamental aspects of museums and highlighting the reasons why museums matter.

Part II: *Histories, Heritage, Identities* follows up and extends some of the concerns introduced in Part I through a focus on a range of aspects of museum history, including both histories *of* the museum and ways in which museums have, variously, represented and been the cultural repositories of history and heritage. This Part also looks further into one of the central dimensions of museums, raised in Part I, that of identities, especially – though not exclusively – in relation to national identities.

Some of the chapters in Part III: *Architecture, Space, Media* might equally have been placed in a section on histories. Brought together here, however, they are intended to draw attention to the ways in which the museum is physically or materially encountered. Museum buildings, the organization of space and exhibits, and their forms matter. All of these incorporate particular assumptions about the nature of the museum – its role in relation to both its collections and to the public. And all of them have implications for the visitor's encounter with the museum and its collections.

Part IV: *Visitors, Learning, Interacting* takes up questions of the visitor's encounter in relation to debates about education and learning. Chapters here explain different models of education, of visitor study, and of museological approach that have predominated at certain points in time. All show, in various ways, a move toward what could be called a more "interactive" approach – often literally so in the case of modes of exhibit, though all also, again in various ways, question quite what this might mean; and they provide provocative suggestions for future possibilities.

Part V: *Globalization, Profession, Practice* looks at some of the most pressing aspects of the museum context today, including changes that are often described as "globalization," and some of the practical dilemmas currently facing museum professionals. This section includes discussion of the changing economic context, something partly shaped by a growing corporatization and privatization in many countries. Dealing with increasingly complex economics – such as the need to garner income from a range of public and private sources – is one of the factors involved in moves toward a greater professionalization and complexity of the museum workforce. So, too, are the legal and ethical dilemmas facing museums, which are also often bound with both globalization and the identity politics and shifts to a greater voice for minorities discussed above and in the following Part.

Sharon Macdonald

The final Part of the *Companion* – Part VI: *Culture Wars, Transformations, Futures* – directly takes up the debate from the previous Part, and continues questions raised throughout the volume in its focus on some of the controversies – often dubbed "culture wars" – that museums have faced in recent years. These return us to some of the fundamental and awkward aspects of museums: questions of "truth," of whom they speak on behalf of and to, of the role of objects, and of possibly changing sensibilities. This final section both discusses some of the changes underway and makes provocative suggestions about where they – and museums – might, or should, go in the future.

Bibliography

Bann, S. (1989) On living in a new country. In P. Vergo (ed.), *The New Museology*, pp. 99–118. London: Reaktion Books.

Flaubert, G. (1976) *Bouvard and Pécuchet with the Dictionary of Received Ideas*, trans. A. Krailsheimer. Harmondsworth: Penguin.

Macdonald, S. (2002) *Behind the Scenes at the Science Museum*. Oxford: Berg.

Merriman, N. (1989) Museum visiting as a cultural phenomenon. In P. Vergo (ed.), *The New Museology*, pp. 149–71. London: Reaktion Books.

Saumarez Smith, C. (1989) Museums, artefacts, and meanings. In P. Vergo (ed.), *The New Museology*, pp. 6–21. London: Reaktion Books.

Vergo, P. (ed.) (1989) *The New Museology*. London: Reaktion Books.

Perspectives, Disciplines, Concepts

Introduction

Many disciplines have important perspectives to bring to bear on the museum. Those represented in Part I are not intended to constitute an exclusive set. Elsewhere in this *Companion*, further disciplinary perspectives are specifically addressed: in particular, that of education in Part IV and that of cultural economics in Part V. Moreover, chapters dealing with particular topics or aspects of museums also draw on disciplines, such as law and psychology, additional to those included in Part I; and many chapters employ a wide range of analytical perspectives that originally derive from various disciplinary homes.

There are, however, two characteristics that, variously, set apart the disciplines discussed in Part I. The first is that their own existence is deeply entangled with that of the museum. This is most evidently so for art history – the museum being the primary institutional locus where "art worth" is proclaimed and the history of art materialized into public view. History more generally, as well as anthropology and, to a lesser extent, sociology, are, however, also disciplines whose character can be said to be infused with the logic of the museum. Collecting, classifying, and presenting ordered – especially sequential and evolutionary – accounts are fundamental to nineteenth-century history and anthropology in particular (though also to various other disciplines, such as natural history, as noted in chapter 6), as well as to the modern Western museum project. Such accounts underpin and justify the formation and expansion of the nation-state as a widely accepted way of ordering the world, and also colonial hierarchies of peoples and cultures (see also chapters in Part II). Museums and their relatives (such as the world fairs discussed in chapter 9) are among the most publicly visible performances of the classifications produced.

The second characteristic of the disciplines and bodies of theory discussed in Part I is that they have been particularly influential in driving change in museum studies and in museums. This is especially the case for the set of critical perspectives that can collectively be called "cultural theory" which Rhiannon Mason outlines in chapter 2. As she acknowledges, there are other rich areas of cultural theory that have not yet received quite so much attention in museum studies, including the work of theorists such as Bakhtin, Benjamin, Butler, Debord, and Virilio (see especially chapters 16, 31, and 32), and media theory (chapter 18), and that are likely to be drawn on increasingly in future. The bodies of theory discussed by Mason are

also at least partially shared by the other disciplines represented in Part I – sociology, art history, anthropology, and history – though these disciplines have also added further perspectives and concepts. These include looking at the museum as an agent of social differentiation and distinction (chapter 3), as a "screen for the dramaturgy of the self" (chapter 4), as an identity narrator (chapter 5), as a definer of object-value (chapter 6), and as an externalized form of collective memory (chapter 7).

None of the chapters, however, is simply concerned to show how theoretical ideas can be applied to the museum and enhance our understandings of it. Rather, all also consider the traffic of ideas between the academy and the museum as two-way. The museum, and the changes in museums, provoke, as well as being subject to, theoretical reflection. As Mason states, museum studies is not just a recipient of cultural theory but an active contributor in reshaping it; or, in the words of Donald Preziosi (chapter 4), the relationship is "anamorphic" – mutually defining – rather than merely "transitive."

The chapters in Part I are not only about disciplines and disciplinary perspectives. Their collective aim is also to raise questions about the nature of the museum and some of its key concepts and practices. Mason (in chapter 2) introduces debates about museum meanings: how do museums work culturally? In particular, she addresses questions of identity and difference, matters vital to museums and to many other chapters in this *Companion*. Gordon Fyfe (chapter 3) extends this further into the social work of museums. His careful theorizing of the museum in terms of a set of cultures of space – calculated, conflicted, and collective – provides a compelling original matrix for museum analysis, and also opens up a discussion of other concepts key to understanding the museum, including "power," "commodification," and "authenticity."

Questions of identity, difference, space, and power are also central to Anthony Shelton's discussion of anthropology and ethnographic museums (chapter 5). As well as showing the interplay between the academy and the museum, and the ways in which this has been variously played out at different times, Shelton highlights, among other things, what can be at issue in definitions of value or deployment of "art" as a classification. The latter is also a focus for Donald Preziosi in chapter 4, which explores the relationship between art history and museology. Preziosi's writing is sometimes cryptic and even poetic. It bears careful reading, for he is probing the roles and assumptions of disciplines and museums themselves, and addressing deep-seated and wide-ranging matters of how we understand the nature of things, of persons, and of key modern concepts and institutions such as "nation-state," "history," and "citizen." He addresses some of the most intransigent of museological questions, including "What is the nature of the museum object?" On this, he argues – in a manner analogous to some of his other arguments – that museum objects are never *just* things, but are also bound up with the understanding of objects outside the museum and of the nature of the subject and subjectivity. Museums inform not just how we see what is in them, but also how we see what is outside, and how we see ourselves.

This is also a part of the argument of my own discussion (chapter 6) on collecting – a practice that can be seen as central to the museum, though which also extends beyond it, the museological model of collecting never being entirely absent. It can

also be seen as part of Susan Crane's discussion of collective memory (chapter 7), another practice which is far from exclusive to the museum but in which the museum nevertheless not only plays an important role but also constitutes part of the way in which we think about the "memorable" and about temporality more generally.

The chapters in Part I also contain arguments about the nature of change within the museum world. Mason and Fyfe present some of the theoretical and contextual background to a move in the late twentieth century toward trying to incorporate audience desires and greater reflexivity. Fyfe's discussion of the "museum phenomenon" (see also chapter 1) takes us into discussion of heritage (see also chapter 13) and of "globalization" and "commodification" (see also chapter 23). The lucid account of changes in modes of displaying ethnographic materials, presented by Anthony Alan Shelton (chapter 5), includes an insightful outline of a range of what he calls "post-narrative" responses (including reflexive exhibitions) to the difficulties inherent in the display of such materials.

Many of the temporal moves and strategies that Shelton presents can also be seen in relation to other types of museum (see also chapter 12 on history museums). In chapter 6, I discuss the increased tendency to display popular culture and to allow "ordinary" collectors into the museum, as well as returns to the curiosity cabinet (see also chapters 16 and 18), of which the recently refurnished Sir John Soane Museum, analyzed in fascinating detail by Preziosi (chapter 4), might be seen as an instance. The final chapter in Part I, by Susan Crane, highlights the increase in contest over the nature of museum display, a topic that recurs throughout the *Companion* and is a main focus of Part VI. This chapter also leads directly into Part II, where questions of history are the subject of further examination.

Cultural Theory and Museum Studies

Rhiannon Mason

Like many recent developments in the academy, cultural theory is characterized by its interdisciplinary nature and its disregard for traditional academic boundaries. Ideas linked to the term "cultural theory" are as likely to be found in geography or music seminars as in those of history, philosophy, literature, film, art, gallery, and museum studies. There is no one single definition of cultural theory and its application varies according to intellectual context. There are, however, a number of key concepts and issues which fall under its name. This chapter examines these to see how they have informed and contributed to the field of museum studies, looking, in particular, at the increasingly explicit use of cultural theory within museum studies. In turn, it also explores how ideas in cultural theory are themselves being adapted and refashioned by museological research and practice.

What is "Cultural Theory?"

Milner and Browitt (2002) date the ascendance of cultural theory within the academy to the 1970s and 1980s, although they trace the genesis of many of its central debates to the work of nineteenth-century thinkers such as Matthew Arnold. Put simply, contemporary cultural theory involves the analysis of culture in its broadest sense: from culture as a way of life to culture as the result of aesthetic practices (i.e. paintings or music). It takes as its central premise the idea that culture is a signifying practice which is bound up with value judgments (Hall 1997). This last way of conceptualizing culture is central to contemporary cultural theory, but is only the latest development in the usage of that term (Jordan and Weedon 1995).

Contemporary cultural theory is all-encompassing in its choice of subject matter: from literature, art, and cinema to soap operas, comics, and hairstyles. In this respect, cultural theory, like much of contemporary art and cinema, has moved beyond the hierarchical distinction between high and low culture which characterized earlier literary and artistic modernism. This same rejection of the traditional division between elite and popular culture is also apparent in many contemporary museums, particularly in social history and contemporary collecting projects. The Twentieth-century Gallery in the Museum of Scotland, for example, displays the popular Scottish fizzy

drink "Irn Bru" alongside a ballot box from the 1997 referendum on political devolution for Scotland and treats both as equally significant to the story of Scottish culture at the end of the twentieth century (Watban 2000: 57).

Influenced by the politics of difference and postmodern relativism, contemporary cultural theory tends to approach culture from a pluralist perspective. This means that cultural theorists talk of cultures rather than Culture and cultural analyses often focus on cultural differences. It should come as little surprise, then, that the museum – an institution that actively seeks to display multiple cultures and to mark out cultural differences – should have become a site of prime interest for those interested in cultural theory.

Contemporary cultural theory argues that we inhabit culture in the sense that we share a certain amount of knowledge and understanding about our environment with others. We share "cultural maps," as Stuart Hall puts it, although membership of groups and communities is in itself a complex issue (Hall 1997: 18). The existence of shared cultural maps involves making judgments about cultural practices or products and their value, status, and legitimacy. By implication, this confers or denies value and status to their producers, owners, and consumers. Again, this process can be seen at work within museums and galleries where the act of display is always simultaneously one of definition and attribution of value; it says "this is art" or "this is culture." The controversies that sometimes arise over such acts of value-definition are discussed in this volume by Steven C. Dubin (chapter 29) and Steven Conn (chapter 30) among others. As their examples demonstrate, museums are public spaces in which definitions of cultures and their values may be actively contested and debated. Museums materialize values and throw the processes of meaning-making into sharp relief, and it is for this reason that they are of such interest to cultural theoreticians and museum studies researchers alike.

Theorizing Meaning: Semiotics and Structuralism

British cultural studies and cultural theory mostly take as their starting-point semiotics, post-Saussurean linguistic theory and, in particular, poststructuralism. Semiotics is the term now given to the study of signs pioneered by Swiss linguist Ferdinand de Saussure at the beginning of the twentieth century (Saussure 1974). Saussure set out to theorize how people communicate and proposed that we employ a signifying system based on signs which comprise of signifiers (phonic, written, or visual indicators) and signifieds (the concept or meaning). He argued that signification relies on comparison and differentiation between signifiers and that we learn to differentiate as we acquire language. In this respect, meaning depends on a shared understanding of a given signifying system which is socially constructed.

For Saussure, the relationship between signifiers and signifieds is arbitrary. This is to say that those who share the same signifying system agree upon a given signifier to indicate a signified, but there is no inherent reason why one signifier should be attached to one signified as opposed to another. Moreover, signifieds themselves are constructs. Language is thus not simply an objective description of an external reality, but a social construction which we learn, which is negotiated, and which con-

ditions the way in which we view reality. Saussure also considered the use of language at the levels of the social and the individual and made a distinction between *langage*, "the universal human phenomenon of language," *langue* "a particular language system, for example, English," and *parole*, "language in use, specific speech acts" (Lodge 1988: 1).

Saussure's and other related theories of language and meaning – for example, those developed by the Russian Formalists – were extremely influential throughout the twentieth century, particularly with the emergence of structuralism in the late 1950s and early 1960s (Milner and Browitt 2002: 96). Structuralism, like semiotics, sought to identify underlying structures in the organization of societies and proposed that these differences were often marked through binary oppositions, for example, hot/cold, woman/man, nature/culture. French intellectual, Roland Barthes, for example, pursued the ideas of semiotics and structuralism in his study of popular culture, advertising, and myth, *Mythologies* (1957), while structural anthropologist, Claude Lévi-Strauss, developed schematic analyses of cultural practices such as kinship and marriage (see, for example, Lévi-Strauss 1963).

Structuralism and semiotics have made their presence felt in museum studies and material culture studies. In *Museums, Objects, and Collections* (1992), for example, Susan Pearce uses Saussure's and Barthes' discussions of *langue* and *parole*, and the structuralist interest in binary oppositions, to carry out schematic analyses of museum collections, although she also recognizes some of the limitations of this kind of museum analysis (1992: 166–91). The term "semiotic" is often used more loosely and has been applied to a whole range of museum critics (for example, Haraway 1989; Bal 1992; Duncan 1995), who take a less tightly structured approach to their exploration of how museums function as systems of signification and can be read as texts (see below.)

Rethinking Saussure: Poststructuralism

While many of Saussure's ideas continue to inform theoretical thinking, certain aspects and, in particular, their structuralist derivation, have themselves been challenged and revised within the field of cultural theory. These revisions have come to be known as *poststructuralist* or *post-Saussurean* theory, although "poststructuralism" serves as an umbrella term for many different theorists rather than indicating a single, definitive theory (Weedon 1987: 19).

Poststructuralism continues from Saussure's central premise that "language, far from reflecting an already given social reality, constitutes social reality for us" (Weedon 1987: 22). However, it departs from Saussure in its emphasis on the plurality and change of meanings over time and the nature of the relationship between the signified and the signifier. To take the first point, Saussure and later structuralists focused on language and culture synchronically rather than diachronically. Poststructuralists argue that this approach does not pay sufficient attention to change in meanings over time and within different contexts. Conversely, poststructuralist theory emphasizes change over time. This is particularly true of those branches interested in the cultural politics of difference and identity – for example, those

working on feminism, queer theory, race, and class – because it enables them to draw attention to the power struggles involved in the attribution of meanings and the value systems attached to those meanings.

Museums are especially valuable in this respect because they materialize cultural and historical differences. An example can be found in Henrietta Lidchi's (1997) discussion of Elizabeth Lawrence's (1991) case of the stuffed horse, Comanche, which was involved in the famous American battle, Custer's last stand at Little Bighorn. The horse was an exhibit at the University of Kansas from 1893 to the 1970s when it became the subject of considerable controversy due to the perceived bias in the interpretation attached to it: it was initially labeled as the "sole survivor" of Custer's last stand. This labeling was rejected in the 1970s by American Indian university students as being historically misleading and written from a white settler perspective. In response, the curator worked with Native Americans to rewrite the labels in a way that took account of the different perspectives on this historical event.

Lawrence's example illustrates the polysemic quality of museum objects. This one exhibit simultaneously held opposing meanings for Native Americans, white American students, and for museum curators. It also makes apparent how meanings considered appropriate at one point can be read another way in a later context. In this case, as is often the way, the cultural artifact became emblematic of a much wider political debate about whose version of history is recorded as the official one and whose is marginalized (Hutcheon 1994; Riegel 1996; Luke 2002; see also chapters 7 and 12 of this volume).

Lidchi (1997) also provides a useful definition of two other key museum studies terms: "poetics" and "politics" (Silverstone 1989; Karp and Lavine 1991). "Poetics" refers to "the practice of producing meaning through the internal ordering and conjugation of the separate but related components of an exhibition" (Lidchi 1997: 168). It includes how museums employ certain representational strategies to claim authenticity and mimic reality. The linked term "politics" refers to "the role of exhibitions/museums in the production of social knowledge" (1997: 185).

The distinction between poetics and politics is valuable because it offers a way of subdividing museum analysis into manageable components while stressing their interconnectedness. This is crucial because the more practically oriented literature on museum and exhibition design often treats display as though it is an ideologically neutral and unproblematic act. By contrast, the extent to which the poetics of display is always already political is made abundantly clear in accounts which demonstrate how different cultures make different judgments about appropriate methods of display and interpretation (Clifford 1997; Appadurai and Breckenridge 1999; Thomas 2001; Witcomb 2003; chapter 28 of this volume).

The politics of display is demonstrated by Helen Coxall's (1996) work on the assumptions contained within the language and grammatical constructions used in museum labeling. In one example, she examines labels presented at the National Railway Museum, England, on the subject of the employment of women during World War II. She argues that the language used implicitly constructs women as passive, while men are discussed in the active tense. The result is that women's work is cast as a necessary expediency rather than in terms of empowerment and progress

toward women's equality. Coxall's work highlights the possibility of multiple readings and the existence of alternative meanings present in museum displays. It also demonstrates how the acts of display, documentation, and labeling in museums make apparent poststructuralist arguments about the ways in which societies construct meanings. This issue of multiple meanings returns us to the second point on which poststructuralism parts company from structuralism and Saussure: the relationship between the signifier and the signified and the ensuing nature of the sign.

Deconstructing Saussure: Derrida

Saussure argued that the linguistic sign comprised a signifier and a signified and that their relationship was arbitrary. However, he claimed that the combination of signifier and signified produced a single, fixed sign: "Although both the signified and the signifier are purely differential and negative when considered separately, their combination is a positive fact" (Saussure 1974: 120). Poststructuralists, in particular the French philosopher Jacques Derrida, have revisited this point and rejected this idea of fixity in favor of what Derrida calls "deferral" and "*différance*." Weedon (1987: 25) explains:

> For Derrida there can be no fixed signifieds (concepts), and signifiers (sound or written images), which have identity only in their difference from one another, are subject to an endless process of deferral. The effect of representation, in which meaning is apparently fixed, is but a temporary retrospective fixing. Signifiers are always located in a discursive context and the temporary fixing of meaning in a specific reading depends on this discursive context.

The idea that any act of signification will always involve competing meanings, and that the interpretation and recognition of those meanings is dependent on the context, has proved valuable for museum studies. It has provided a way of theorizing, first, how meanings of particular objects arise out of their relationships to other objects within a given display or collection; secondly, how those meanings change either when their place is revised or through the passage of time; and, thirdly, how visitors themselves will understand those objects in different ways. Charles Saumarez Smith demonstrates this by showing how a wooden doorway held at the Victoria and Albert Museum in London, the Mark Lane Archway, has moved from being an exhibit within the Furniture and Woodwork Study Collection through marketing icon to useful decoration within the shop (Saumarez Smith 1989: 14). Its resignification occurred because of reorganization of the collections and also as part of the rebranding of the V&A during the 1980s in line with a more consumerist ethic. This example reiterates the point that every arrangement is an interpretive and representational decision that will produce different effects. However, some arrangements will be considered more timely and appropriate than others at a given moment.

It is important to note that taken to its logical conclusion, poststructuralist theory does not automatically imply that the material world ceases to exist, although this is sometimes how it is understood. Pearce (1992), for example, condemns

poststructuralism as damagingly relativistic with negative connotations for museums and curators. However, Pearce conflates a host of different theorists (Foucault, Derrida, Lacan, Baudrillard, and Barthes) and omits the related theoretical debates within cultural and media studies which do have something constructive to offer museum studies (see below). A more positive understanding of poststructuralism is to accept that the real world exists but to acknowledge that it will always be mediated by the signifying systems we inhabit.

Similarly, for poststructuralist-inspired museologists to argue that the meanings of objects are inseparable from the context of their display and interpretation is not the same as saying that they are meaningless. Nor does this theoretical direction necessarily lead to a rejection of history. On the contrary, it emphasizes the importance of historical context while drawing attention to the constructed and plural nature of "histories." Museums contribute to our understanding of these theoretical points by enabling us to see the processes in practice. Indeed, museums are ideal places in which to explore the issues raised within cultural theory *precisely* because they are in the business of identification, differentiation, and classification. An example of how classificatory systems may shape our understanding of objects and cultures can be found in Annie Coombes's (1994) discussion of the Benin Bronzes (and see chapter 10 of this volume). Gaby Porter's (1990) work on the gender bias inherent in the categories used for social history documentation and classification provides another excellent way of understanding how cultural theory might be applied to the functions of museums.

Cultural Politics of Difference and Identity

Many of the examples mentioned so far raise questions of identity and difference, both key to contemporary museums and cultural theory alike. The theory of difference is central to Derridean and poststructuralist theory, but it is equally central to cultural theory as a whole because it coincides with the theoretical and political concerns of various social movements which have marked the second half of the twentieth century: feminism, multiculturalism, lesbian and gay rights, disability issues, and civil rights (Milner and Browitt 2002: 128). Academic interest in cultural theory stems partly from the fact that its emphasis on the constructedness of norms and values resonates with the political and ethical concerns of these social movements. At the same time, these theories also articulate many of the practical issues and concerns currently facing museums around the world, a situation which is a legacy of the historical context – that of colonialism and modernity – within which the concept of the public Western museum was developed.

The politicization of museums and the reorientation of their function, as the title of Stephen Weil's (1999) article puts it, "From Being *about* Something to Being *for* Somebody: The Ongoing Transformation of the American Museum," form arguably the key paradigm shift of recent years. In the literature of museum studies this shift is often discussed in terms of "new museology," and this term is usually attributed in Anglophone circles to British art historian Peter Vergo's (1989) T*he New Museology*. For Vergo, new museology meant a "state of widespread dissatisfaction with

the 'old' museology, both within and outside the museum profession . . . what is wrong with the 'old' museology is that it is too much about museum methods, and too little about the purposes of museums . . ." (1989: 3; and see the Introduction to this volume).

As with all such theoretical movements, "new museology" has itself been inter-preted differently. Dutch scholar Peter Van Mensch argues that there have been three different applications of the term: in the US (1950s), the UK (late 1980s), and France (1980) (cited in Davis 1999: 54). Peter Davis also points to the links between "new museology," ecomuseology, and community museology, and stresses the international aspect of the movement developed within the International Council of Museums (ICOM) during the late 1970s and early 1980s (1999: 56). Irrespective of these dif-fering time-scales, Davis suggests that: "[n]ew museology could be seen as shorthand for the radical reassessment of the roles of museums in society . . ." (1999: 55). I would suggest that "new museology" can be understood as a name for the branch of museum studies concerned with those ideas central to cultural theory.

The embracing of the issues and ideas developed within cultural theory/new museology and the ensuing acknowledgment of the political nature of museums have led to increased attention to questions about the relationship between government, museums, and cultural policy. Such attention has been particularly influenced by the work of French philosopher and historian, Michel Foucault.

The "Foucault Effect" in Museum Studies

Foucault's ideas have been particularly influential in museum studies since the end of the 1980s. His work is extensive and defies easy classification. Among other things, his studies encompass a rethinking of the relationship between power and knowl-edge, the status of truth, the politics of sexuality and subjectivity, and the way that histories are written (1973, 1974, 1990, 1991). He argues against a traditional notion of linear, progressive, and teleological history and in favor of what he calls "effective history," which draws attention to discontinuities, breaks, ruptures, and non-linearity (1974: 4). His concepts of *epistemes* and *discursive formations* explain how certain meanings and ways of thinking gain credence at particular times. Dis-courses – another key Foucauldian term – are "systematic conceptual frameworks that define their own truth criteria, according to which particular knowledge prob-lems are to be resolved, and that are embedded in and imply particular institutional arrangements" (Milner and Browitt 2002: 110).

An explicit example of the use of Foucault's ideas in museum studies is Eilean Hooper-Greenhill's *Museums and the Shaping of Knowledge* (1992), which maps Foucault's concepts of the Renaissance, the Classical, and the Modern *epistemes* onto specific shifts in conceptions of knowledge and the changes these shifts engendered within museum collecting. For example, Hooper-Greenhill argues that sixteenth-century collections – so-called "cabinets of curiosity" – were structured around the principles of rarity and novelty, whereas the seventeenth century witnessed moves toward organizing collections along more taxonomic lines. Her third epistemic shift relates to the emergence of the disciplinary museum during the late eighteenth and

nineteenth centuries and the ways in which states began to deploy public museums as a means of "civilizing" their populations (1992: 168).

The concept of the disciplinary museum (Hooper-Greenhill, 1989, 1992) is developed in Tony Bennett's "The Exhibitionary Complex" (1988) and *The Birth of the Museum: History, Theory, Politics* (1995), the latter title echoing Foucault's *Discipline and Punish: The Birth of the Prison* (1975). Bennett applies Foucault's ideas about disciplinary power, panopticism, and governmentality to the development of the public museum in the nineteenth century. He argues that at this time the museum should be understood as an institution that was designed not only to "improve" the populace as a whole but to encourage citizens to regulate and police themselves (1995: 59–88). This is understood as part of a broader shift toward "governmentality," defined by Stuart Hall as "how the state indirectly and at a distance induces and solicits appropriate attitudes and forms of conduct from its citizens" (1999: 14).

In "The Exhibitionary Complex," Bennett draws on Foucault's discussion of the panopticon – a model for a self-regulating prison – developed by the English Enlightenment philosopher, Jeremy Bentham. Self-regulation would be achieved because inmates would always be visible to the guards but would be unable to tell whether they were being observed at a particular moment. Bennett suggests that visitors to nineteenth-century public museums would be similarly encouraged to accept and internalize such visual "lessons in civics" because the arrangement of space in such institutions created public spaces in which the public itself was put on display and held in perpetual tension between observing and being observed (Bennett 1995: 67–9; chapter 16 this volume).

Bennett's account is significant for its pairing of Foucault's discussions of knowledge, power, and spatial relations with Italian revolutionary, Antonio Gramsci's interest in the "ethical and educative function of the modern state" (Bennett 1995: 63). Bennett introduces a similar bifocal perspective on the question of museums and hegemony. He argues that a synthesis between Foucault and Gramsci is necessary because a purely Gramscian approach to museums is inattentive to its institutional specifics. Bennett argues that a Gramscian focus on the museum as purely an "instrument of ruling–class hegemony" leads to the idealistic notion that the museum could be simply turned on its head as a counter–hegemonic tool (1995: 91). In other words, that the museum could be purged of its elitist function and turned toward empowerment of the hitherto excluded, an argument often made for community museums or community participation within museums. Bennett questions this, as Pierre Bourdieu has in relation to art galleries and the politics of taste, by pointing out that the situation is complicated by the ways in which culture has long been used to differentiate people into social groupings and to accord status to those various strata (Bourdieu and Darbel 1991; Bourdieu 1993, 1994; Bennett 1995: 105).

Museum Studies Speaks Back to Cultural Theory

The introduction of Foucault, and to a lesser extent Gramsci, to museum studies has brought museums to the attention of a much wider cultural studies audience. At the same time, there have been a number of rejoinders to the kind of Foucauldian

analyses practiced by Bennett. Clive Barnett (1999), for example, points to the fact that Bennett's approach has a specific institutional and cultural context originating out of a body of work developed within the Institute for Cultural Policy Studies at Griffith University, Australia. For Barnett, the reading of Foucault's concept of disciplinary power within such cultural-policy literature neglects Foucault's own emphasis on the ways in which subjects of government continue to have agency and to be active participants within the operations of power (Barnett 1999: 374). It also "fails to attend in detail to the contradictions that beset practices of government" (1999: 374). Colin Trodd (2003) similarly questions the Foucauldian-inspired position as insufficiently attentive to the conflicting forces existing within individual museum contexts; in his case, the art museum. Trodd is also critical of what he perceives to be an oversimplification of the various relationships between state and museum: "the state becomes a thing rather than an antagonistic complex of differentiated forces, powers, and interests" (2003: 19).

An alternative model of how museums function within society can be found in James Clifford's idea of the museum as "contact zone" (1997: 188–219). Clifford borrows the term from Mary Louise Pratt (1992) to emphasize the interactive nature of the relationships between various communities, stakeholders, and museums. As "contact zone," the museum functions more as a permeable space of transcultural encounter than as a tightly bounded institution disseminating knowledge to its visitors. Clifford recasts the museum as a space where different cultures and communities intersect, interact, and are mutually influenced by the encounter. Moreover, as Andrea Witcomb notes, Clifford recognizes that the museum itself is a community with its own conventions and cultural values (Witcomb 2003: 79–101). The real advantage of Clifford's conception of the museum is that it accounts for the diversity of museums by stressing how they are changing continually in response to their own changing contexts – colonial, postcolonial, modern, postmodern, public, commercial, and so on. He writes: "[a] contact perspective views all culture-collecting strategies as responses to particular histories of dominance, hierarchy, resistance, and mobilization" (1997: 213). Viewed in this light, the term "museum" is understood as a much more flexible and expansive way of describing a whole range of relations and activities which surround the valuation, collection, and display of cultures and histories.

Clifford's foregrounding of the extent to which the world outside the museum – in the form of various communities or audiences – exerts its own forces upon the museum raises the other major criticism leveled at the governmental model of the museum: namely, that it places too much emphasis on the production side of museums at the expense of the consumption side of the process. As a result, visitors are often overlooked or their responses oversimplified. Yet, as is increasingly acknowledged (see chapter 22 of this volume), visitors do not come to museums wholly passive or as blank slates.

To be fair, Bennett himself explicitly anticipates and answers many of these criticisms, but while he is more circumspect about the limitations of his approach than his critics perhaps allow (1998: 61, 12–13; chapter 16 of this volume), cultural theory has sometimes been guilty of underestimating the subjects of its analysis. The tendency of cultural theory-inspired museum critiques to ignore audiences or,

alternatively, to imagine them as uncritical consumers reproduces some of the attitudes toward audiences of mass culture found in the early work of the Frankfurt School. The Frankfurt School, or the Institute of Social Research at the University of Frankfurt, was founded in 1923 and included many of the twentieth century's most pre-eminent cultural critics such as Theodor Adorno (1903–69), Max Horkheimer (1892–1940), Walter Benjamin (1892–1940), and Herbert Marcuse (1898–1979). It was members of the Frankfurt School who coined the term "critical theory" to "distinguish their own kind of 'critical sociology' from what they saw as the 'traditional theory' of mainstream social science" (Milner and Browitt 2002: 57).

This idea of the cultural consumer as passive and uncritical dupe continued late into the twentieth century, particularly in analyses of television, film, and the heritage industry. However, in the same way that television and film studies have now revised and refined their conceptualization of audiences, consumption, and the nature of cultural texts, so museum studies too is increasingly recognizing and researching the complexity of people's responses to these multi-faceted cultural phenomena (see chapter 22).

Reading Museums as Texts: Cultural Theory and Textuality

In addition to the Foucauldian/power model of museums, the other, most influential, cultural studies/museum studies approach of recent years is the *textual approach*. This involves reading the object of analysis like a text for its narrative structures and strategies. In museums, the textual approach can involve analysis of the spatial narratives set up by the relationship of one gallery or object to another, or it might consider the narrative strategies and voices implicit in labeling, lighting, or sound. Mieke Bal (1992), for example, has written about the museum-as-text using concepts of narratology and the "voice" adopted by exhibitions. She also posits an extremely useful distinction between textual and spatial narratives and the ways in which they might conflict, thus producing dislocation within the overall text of the exhibition or museum.

Roger Silverstone has similarly applied the idea of narrative to museums: "The study of the narrativity of the museum or the heritage display involves a study of an exhibition's capacity to define a route (material, pedagogic, aesthetic) for the visitor, and to define thereby a particular logic of representation, a particular legitimate and plausible coherence for itself" (1989: 143–4). Like Lidchi (1997), Silverstone invokes the concept of poetics but uses it specifically to refer to "the particularities of the museum as medium: with its role as story-teller, as myth maker, as imitator of reality" (1989: 143). He proposes that a study of poetics should have to consider the "conflicting pressures on museum curators of the mythic and mimetic" and the strategies that museums deploy to construct a sense of reality in their displays (1989: 143). Silverstone also briefly introduces the idea of genre, which has been extremely influential in media and film studies but has not yet been explored to its full potential in museum studies.

Barbara Kirshenblatt-Gimblett (1997, 1998) adds another dimension to the textual approach by drawing attention to the degree of performance involved in the narration of spatialized stories within museums. For her, it is the immersive quality of the museum visit that differentiates it as a cultural practice. It is "the movement of spectators through space that distinguishes museums (and many tourist attractions) from theatre" (1997: 8). This emphasis on the specific nature and range of media at work in museums is another way that museum studies researchers are customizing concepts developed elsewhere within the literary theory or media studies branches of cultural theory.

The advantage of understanding museums in terms of texts and narratives is that it moves away from privileging or compartmentalizing a particular aspect of the museum; for example, its building, collections, individual staff, or organizational status. All these components remain crucial, but a textual approach argues that they must be viewed in concert to understand the possible meanings of the museum. Another useful aspect of the idea of textuality is that it raises the question of unintentional meanings, omissions, or contradictions present within displays. A common analytical strategy within cultural and literary studies has been the practice of reading texts "against the grain" for their internal inconsistencies (Turner 2003: 71–108). Reading texts for their contradictions or subversive potential draws on the idea within poststructuralism and deconstruction that meaning is a messy, complex, and multidirectional process and that all texts will contain a plurality of possible meanings. On a practical level, this point is borne out by any account of the complexity and multifaceted nature of the process of exhibition creation (Macdonald 2002).

Another benefit of the textual analogy is that it can shift emphasis away from the curator-as-author and his/her intentions toward the visitor-as-reader and his/her responses. The visitor is therefore understood to be a crucial participant in the process of meaning-making. These ideas correlate with the introduction of constructivist communication theory within museum studies (Hooper-Greenhill 1999), visitor and non-visitor studies (EVR SIG 2004), cultural diversity (Hooper-Greenhill 1997; Desai and Thomas 1998), work on the role of cultural capital in shaping visitor responses (Bourdieu and Darbel 1991), and research into the visitor experience (Falk and Dierking 1992).

Irrespective of the distinctions between these audience-oriented approaches, they all problematize the concept of authorship and question the museum professional's ability to control meanings. Instead, they promote the idea that visitors will construct multiple and differentiated readings perhaps in conflict with those intended by museum professionals. Again, cultural theory and poststructuralism have contributed to this debate. Barthes and Foucault both examined authorship respectively in "Death of the Author" (Barthes 1968) and "What is an Author?" (Foucault 1969), and both rejected the idea that the author controls the meanings of texts, moving instead toward a notion of the text as product and producer of its own social, cultural, and historical discourses. Barthes famously concluded his polemic with: "the birth of the reader must be at the cost of the death of the Author" (Lodge 1988: 166). Recent sociological work on how visitors construct their own narratives in response to museum displays has added considerably to our understanding of this

process, as has visitor studies literature which investigates the physical use of museum spaces by visitors (see chapters 3 and 22).

The "death of the author/curator" and the "birth of the reader/visitor" strand of cultural theory has not necessarily been welcomed in all circles. As Ghislaine Lawrence notes, if taken too literally the concept can appear disempowering and threatening for curators who have been traditionally trained to think in terms of educating and "delivering" messages to visitors: "[i]n the face of the death of the author, how relevant is it to speak of the effectiveness of museum communication?" (1991: 25).

Although unsettling to curators, these theoretical concerns do again link very closely to the practical issues with which museums are concerned in terms of improving communication with visitors and overcoming barriers to access. Indeed, it could be argued that critical and cultural theory has helped to foreground the complexity of possible responses to museums because of its emphasis on the multiple and negotiated nature of meanings and texts.

The museum-as-text approach is not without its weaknesses. Sharon Macdonald, for example, has cautioned that in some applications:

> The model does not allow for the investigation of whether indeed there is such a neat fit between production, text and consumption. It supposes both too clear-cut a conscious manipulation by those involved in creating exhibitions and too passive and unitary a public; and it ignores the often competing agendas involved in exhibition-making, the "messiness" of the process itself, and interpretative agency of visitors. (1996: 5)

As Macdonald rightly points out, an analysis that is directed purely at the *finished text* does not necessarily exhaust all possible accounts of production. For example, shortcomings within displays may be linked to lack of funding and time, or to practical constraints regarding access, health and safety, and conservation. It is worth remembering that the process of developing a new gallery from conception to completion can be very protracted, during which time ideas, demands, policies, resources, and possibilities will often shift repeatedly so that the end result will be a palimpsest of the whole process. At the same time, discussions with staff can be revealing as museum professionals are themselves immersed in their own professional and subject-based discourses and will be operating with certain assumptions. To recognize this is not to negate the value of textual critiques, but to omit these other considerations is to tell only part of the story of how museum representations come to fruition.

What is needed is a way of combining the textual approach with other elements and methods of cultural analysis in order to capture the multifaceted nature of museums and to be fully "textual" in the broadest sense. Silverstone (1989) makes a similar point when he advocates the textual approach but proposes that it be combined with what he terms an "ethnographic" approach which takes proper account of the social and historical context within which museums are embedded. Bal goes one step further by arguing that museums would do well to foreground their own histories and contexts within the space of their displays. This "metamuseal func-

tion," she argues, would help to situate the knowledge that museums present and to alert their audiences to the reasons for the anachronistic vagaries of museum collections (Bal 1992: 579; and see chapter 32 of this volume).

From a cultural studies perspective, to advocate this kind of holistic approach is not new. In 1997, du Gay et al. proposed the "circuit of culture" as a model of cultural analysis to look at five interconnected stages of "representation," "identity," "production," "regulation," and "consumption." Du Gay et al. applied the circuit to the Sony Walkman as cultural artifact, but the same principle can be extended to museums as Fiona McLean has suggested (1998). The reason why this kind of approach is not as widely practiced as it might be speaks to a wider problem within museum studies: namely, the gap between museums and universities, and practitioners and critics. This is partly a practical issue about conducting research. Academics are rarely able to be immersed within museums and, as such, often find it difficult to access the kind of behind-the-scenes information necessary to reflect on the processes of production and regulation. Conversely, practitioners are often enmeshed in the day-to-day practical issues and may not be inclined to take the longer, historical view preferred by academics. The problem may relate equally to the nature of museums as institutions with their own reputations and public profiles to protect. As with any such organization, there will be political sensitivities and personal investments in museum work which may make it difficult to open the museum up to critical investigation.

Developing a "Theoretical Museology"

Despite these practical restrictions, an approach is needed that can combine the useful analytical approaches of cultural theory but is simultaneously sensitive to the unique differences of museums as objects of cultural enquiry. There are those who are already doing such work. Clifford (1997), Dicks (2000a, b), Cooke and McLean (2002), Macdonald (2002), and Witcomb (2003), for example, have all carried out studies which combine an analysis of textual representation, institutional conditions of production, and a discussion of audiences and consumption. This kind of research, which seeks to locate itself at the *intersection* of theory and practice, as opposed to a mode of critique which stands outside looking inward, is, in my view, best suited to capture the complexity of museums as cultural phenomena. This returns me to the proposition with which this chapter began: namely, that museum studies is exerting, and should continue to exert, a reciprocal influence on cultural theory by adapting and refashioning it into a form appropriate to museological research and practice.

Postscript

In a chapter of this length and scope it has been necessary to select certain aspects of cultural theory while omitting others. (Some are also covered elsewhere in this

volume.) The decision about what to include and exclude has been made according to my primary aim to examine the interrelationship between cultural theory and museum studies and the problematics which their encounter has generated. To this end, I have focused on semiotics, poststructuralism, Foucault, ideology, meaning, textuality, and power because these seem to me to be the main trends in the cultural theory-influenced literature of museum studies to date. The reason why these particular aspects of cultural theory have been selected as opposed to possible others is, I believe, because they best articulate the practical, legal, and ethical debates occurring in Western museums as a result of the multicultural and postcolonial nature of the societies they now find themselves within. If my analysis is correct, then theory and practice are shown to be anything but separate spheres. On the contrary, they are mutually informing and intimately connected. Recognition of the importance of research to practice and vice versa will only enrich both academics' and practitioners' understanding of museums.

Bibliography

Appadurai, A. and Breckenridge, C. (1999) Museums are good to think: heritage on view in India. In D. Boswell and J. Evans (eds), *Representing the Nation: A Reader: Histories, Heritage and Museums*, pp. 404–20. London: Routledge.

Bagnall, G. (2003) Performance and performativity at heritage sites. *Museum and Society*, 1 (2): 87–103.

Bal, M. (1992) Telling, showing, showing off. *Critical Inquiry*, 18 (Spring): 556–94.

Barnett, C. (1999) Culture, government and spatiality: reassessing the "Foucault effect" in cultural-policy studies. *International Journal of Cultural Studies*, 2 (3): 369–97.

Barthes, R. (1957) *Mythologies*, trans. A. Lavers. London: Vintage, 1993.

— (1968) Death of the author. In D. Lodge (ed.), *Modern Criticism and Theory: A Reader*, pp. 167–72. London: Longman, 1988.

Bennett, T. (1988) The exhibitionary complex. *New Formations*, 4 (Spring): n. p.

— (1995) *The Birth of the Museum: History, Theory, Politics*. London: Routledge.

— (1998) *Culture: A Reformer's Science*. London: Sage.

Bourdieu, P. (1993) *The Field of Cultural Production: Essays on Art and Literature*, ed. R. Johnson. Cambridge: Polity Press.

— (1994) Distinction and the aristocracy of culture. In J. Storey (ed.), *Cultural Theory and Popular Culture: A Reader*, pp. 444–54. Hemel Hempstead: Harvester Wheatsheaf.

— and Darbel, A. (1991) *The Love of Art: European Art Museums and their Public*. Cambridge: Polity Press.

Clifford, J. (1997) *Routes: Travel and Translation in the Late Twentieth Century*. Cambridge, MA: Harvard University Press.

Cooke, S. and McLean, F. (2002) Our common inheritance? Narratives of self and other in the Museum of Scotland. In D. C. Harvey, R. Jones, N. McInroy, and C. Milligan (eds), *Celtic Geographies: Old Culture, New Times*, pp. 109–22. London: Routledge.

Coombes, A. E. (1994) *Reinventing Africa: Museums, Material Culture and Popular Imagination in Late Victorian and Edwardian England*. New Haven, CT: Yale University Press.

Coxall, H. (1996) Resistant readings: it is what you say and the way you say it. *Journal of the Social History Curators' Group*, 22: 5–9.

Davis, P. (1999) *Ecomuseums: A Sense of Place*. Leicester: Leicester University Press.

Desai, P. and Thomas, A. (1998) *Cultural Diversity: Attitudes of Ethnic Minority Populations towards Museums and Galleries*. Report prepared for the Museums and Galleries Commission by BRMB International.

Dicks, B. (2000a) Encoding and decoding the people: circuits of communication at a local heritage museum. *European Journal of Communication*, 15 (1): 61–78.

— (2000b) *Heritage, Place, and Community*. Cardiff: University of Wales Press.

Duncan, C. (1995) *Civilising Rituals: Inside Public Art Museums*. London: Routledge.

EVR SIG (Evaluation and Visitor Research in Museums Special Interest Group) (2004) http://amol.org.au/evrsig/ (accessed March 20, 2004).

Falk, J. and Dierking, L. (1992) *The Museum Experience*. Washington, DC: Whalesback Books.

Foucault, M. (1969) What is an author? In D. Lodge (ed.), *Modern Criticism and Theory: A Reader*, pp. 197–228. London: Longman, 1988.

— (1973) *The Order of Things*. New York: Vintage Books.

— (1974) *The Archaeology of Knowledge*. London: Tavistock.

— (1990) *The History of Sexuality*, vol. 1: *An Introduction*, trans. R. Hurley (first published 1976). London: Penguin.

— (1991) *Discipline and Punish: The Birth of the Prison*, trans. A. Sheridan (first published 1975). London: Penguin.

du Gay, P., Hall, S., Janes, L., et al. (eds) (1997) *Doing Cultural Studies: The Story of the Sony Walkman*. London: Sage/Open University.

Hall, S. (ed.) (1997) *Representation: Cultural Representations and Signifying Practices*. London: Sage/Open University.

— (1999) Un-settling "the heritage": re-imagining the post-nation. In *Whose Heritage? The Impact of Cultural Diversity on Britain's Living Heritage*, pp. 13–22. Keynote Address to the National Conference, Manchester, November 1–3. London: Arts Council of England.

Haraway, D. (1989) Teddy bear patriarchy: taxidermy in the Garden of Eden. In *Primate Visions: Gender, Race and Nature in the World of Modern Science*, pp. 26–58. London: Routledge.

Hooper-Greenhill, E. (1989) The museum in the disciplinary society. In S. Pearce (ed.), *Museum Studies in Material Culture*, pp. 61–72. Leicester: Leicester University Press.

— (1992) *Museums and the Shaping of Knowledge*. London: Routledge.

— (ed.) (1997) *Cultural Diversity: Developing Museum Audiences in Britain*. Leicester: Leicester University Press.

— (ed.) (1999) *The Educational Role of the Museum*, 2nd edn. London: Routledge.

Hutcheon, L. (1994) The post always rings twice: the postmodern and the postcolonial. *Textual Practice*, 8: 205–38.

Jordan, G. and Weedon, C. (1995) *Cultural Politics: Class, Gender, Race and the Postmodern World*. Oxford: Blackwell.

*Karp, I. and Lavine, S. (eds) (1991) *Exhibiting Cultures: The Poetics and Politics of Museum Display*. Washington: Smithsonian Institution Press.

Kirshenblatt-Gimblett, B. (1997) Afterlives. *Performance Research*, 2 (2): 1–10.

— (1998) *Destination Culture: Tourism, Museums, and Heritage*. Berkeley, CA: University of California Press.

Lawrence, E. A. (1991) His very silence speaks: the horse who survived Custer's last stand. In R. B. Browne and P. Browne (eds), *Digging into Popular Culture: Theories and Methodologies in Archaeology, Anthropology, and Other Fields* (n. p). Ohio: Bowling Green State University Popular Press.

Lawrence, G. (1991) Rats, street gangs and culture: evaluation in museums. In G. Kavanagh (ed.), *Museum Languages: Objects and Texts*, pp. 9–32. Leicester: Leicester University Press.

Lévi-Strauss, C. (1963) *Structural Anthropology*, vol. 1, trans. C. Jacobson and B. G. Schoepf. New York: Basic Books.

*Lidchi, H. (1997) The poetics and politics of exhibiting other cultures. In S. Hall (ed.), *Representation: Cultural Representations and Signifying Practices*, pp. 151–222. London: Sage/Open University.

Lodge, D. (ed.) (1988) *Modern Criticism and Theory: A Reader*. London: Longman.

*Luke, T. W. (2002) *Museum Politics: Power Plays at the Exhibition*. Minneapolis, MN: University of Minnesota Press.

Macdonald, S. (1996) Introduction. In S. Macdonald and G. Fyfe (eds), *Theorizing Museums: Representing Identity and Diversity in a Changing World*, pp. 1–18. Oxford: Blackwell.

*— (2002) *Behind the Scenes at the Science Museum*. Oxford: Berg.

*— and Fyfe, G. (eds) (1996) *Theorizing Museums: Representing Identity and Diversity in a Changing World*. Oxford: Blackwell.

McLean, F. (1998) Museums and the construction of national identity: a review. *International Journal of Heritage Studies*, 3 (4): 244–52.

Milner, A. and Browitt, J. (2002) *Contemporary Cultural Theory: An Introduction*. London: Routledge.

Pearce, S. (1992) *Museums, Objects, and Collections: A Cultural Study*. Leicester: Leicester University Press.

Porter, G. (1990) Gender bias: representations of work in history museums. *Continuum: The Australian Journal of Media and Culture*, 3 (1): 1–10.

Pratt, M. L. (1992) *Imperial Eyes: Travel Writing and Transculturation*. London: Routledge.

Riegel, H. (1996) Into the heart of irony: ethnographic exhibitions and the politics of difference. In S. Macdonald and G. Fyfe (eds), *Theorizing Museums: Representing Identity and Diversity in a Changing World*, pp. 83–104. Oxford: Blackwell.

Saumarez Smith, C. (1989) Museums, artefacts, and meanings. In P. Vergo (ed.), *The New Museology*, pp. 6–21. London: Reaktion Books.

Saussure, F. de (1974) *Course in General Linguistics*, trans. Wade Baskins. London: Fontana.

Silverstone, R. (1989) Heritage as media: some implications for research. In D. Uzzell (ed.), *Heritage Interpretation*, vol. 2: *The Visitor Experience*, pp. 138–48. London: Frances Pinter.

Thomas, N. (2001) Indigenous presences and national narratives in Australasian museums. In T. Bennett and D. Carter (eds), *Culture in Australia*, pp. 299–312. Cambridge: Cambridge University Press.

Trodd, C. (2003) The discipline of pleasure; or, how art history looks at the art museum. *Museum and Society*, 1: 17–29.

Turner, G. (2003) *British Cultural Studies: An Introduction*. London: Routledge.

*Vergo, P. (ed.) (1989) *The New Museology*. London: Reaktion Books.

Watban, R. (2000) Public perception of history: the twentieth century gallery. In J. M. Fladmark (ed.), *Heritage and Museums: Shaping National Identity*, pp. 53–60. Oxford: Alden Press.

Weedon, C. (1987) *Feminist Practice and Poststructuralist Theory*. Oxford: Blackwell.

Weil, S. (1999) From being *about* something to being *for* somebody: the ongoing transformation of the American museum. *Daedalus*, 128 (3): 229–58.

*Witcomb, A. (2003) *Re-imagining the Museum: Beyond the Mausoleum*. London: Routledge.

Sociology and the Social Aspects of Museums

Gordon Fyfe

Until recently, the museum was rarely mentioned by sociologists. It was absent from investigations that might arguably have had a museum dimension, such as the sociologies of education, knowledge, community, class, occupation, leisure, civil religion, and nation-states; and, unlike, say, churches, schools, or sport, the museum did not present itself as a sociological topic. Moreover, its relevance for mid-twentieth-century debates about core values, consensus, and conflict was not spotted. The exception to this roll call of omission was the sociology of art and art institutions where the consecrating function of the museum was self-evident.

Whilst the museum has yet to establish itself in sociology textbooks as a fully fledged undergraduate topic, things have changed: the significance of the museum is now apparent in the study of inequality, tourism, popular culture, and visual depiction. Sociologists have begun to register an interest in how culture is exhibited, in what is shown, in who displays things, and in who consumes museum meanings. The subject is debated at national and international conferences of sociology, and funded by research councils and government agencies. Museum sociology has burst into life.

This tardy recognition of the museum's sociological salience marks a contemporary convergence between social science and museum practice. Thus, museum practitioners have acquired a sociological imagination; social research services both the global expansion in professional training and the demand by public and private agencies for audited knowledge about museums. Marxism, structuralism, poststructuralism, cultural studies, feminism, social class theory, concepts such as cultural capital and systematic methods of research are amongst the broadly social perspectives and practices which have been admitted to the museum. Metaphorically and literally, the museum seminar room has become an interdisciplinary place for exchanges of ideas about the social world.

Disciplinary Origins and Institutional Affinities

Sociology and museums are quintessentially modern institutions. They share an historical relationship to industrialization, to political revolution, and to the formation of nation-states. Both emerged as Enlightenment projects which were committed to

reason and rationality and both were concerned with understanding and ordering a world that was thought to be disordered by industrial and political revolutions. Both were responses to the uncertainties that attended the decline of patrimonial power, bourgeois empowerment, and modernization's disruption of traditional modes of control.

In the eighteenth and early nineteenth centuries, collections acquired their modern functions as public goods that were enshrined in museums. Whilst the origins of museums are conventionally traced to the medieval *Schatz*, to the *Kunst-kammer* and *studioli* of the Renaissance, and to the collections of absolutist monarchs and princes, the museum was no mere opening up of these spaces to publics (see chapter 8). There is a body of writing (for example, Pomian 1990; Hooper-Greenhill 1992; Pearce 1992; Bennett 1995; Hetherington 1999), much of it influenced by the early writings of Michel Foucault, in which it is argued that the transition from cabinet to museum was an epistemic shift, a mutation in the space of representation which transformed Western structures of knowing (see chapter 6).

Sociology crystallized in the late nineteenth century and reached its contemporary form in the early twentieth century when it was institutionalized in university departments and research institutes in Europe and North America. Conceived as a science of social change, sociology investigated the problems of transition from agrarian societies of estates to urban societies of markets and classes which gave the appearance of being nothing more than aggregates of individuals. Its deliberations were part of wider speculations about the decline of community, about the fate of the individual, and about whether the market might provide a basis for social order.

Investigation of the impact of change on identities, for example of migration, social mobility, bureaucratization, the formation of nation-states, and globalization, was the hallmark of the discipline. Twentieth-century sociologists studied the conversion of warriors into courtiers, of European peasants into American citizens, of independent American farmers into corporate employees, and the formation of elites. They studied the making of the housewife, the embourgeoisement of the British working class, the winding down of the inner-directed Puritan, the constitution of the outer-directed consumer, and the conversion of the unemployed into the marginal poor.

Sociologists take Karl Marx (1818–83), Max Weber (1864–1920), Georg Simmel (1858–1918), and Emile Durkheim (1858–1920) to be amongst the founders of their discipline. For these writers there was an evident contradiction at the heart of the new social order: on the one hand, it had given birth to the modern individual, whilst, on the other, it threatened to exchange freedom for economic compulsion and bureaucratic control. This was the context in which concepts, such as anomie, alienation, and rationalization, were appropriated by sociologists from other intellectual traditions and reformulated as critical tools for diagnosing the problems of freedom and constraint in human affairs.

The tension between freedom and constraint was manifest in twentieth-century sociology's tendency to veer between methodological individualism and holism and in the great debate about structure and action. The problem of structure and action was one of overcoming common-sense representations of social relations as antinomies of individuals and societies and of curbing the Western conceit that knowledge

was accumulated by means of the isolated intellectual reflections of sovereign individuals.

Cultures of Space

How a contemplative theory of knowledge was written into the fabric of Western institutions is in part the story of the emergence of a culture of space that was peculiar to modernity (Foucault 1970; Panofsky 1991; Hetherington 1999). Pre-modern space was a hierarchy of aggregated spaces; this was displaced by modernity's notion of a continuous and systematic time–space that might be represented by visual depiction or by the microcosm of the museum. The museum's space possessed distinctive characteristics: (a) it was, *pace* Foucault, a *heterotopic* space in that it was a place, outside of all other places, and within which other places and times were "represented, contested and reversed" (Foucault 1994: 178); (b) it was also a characteristically Western, universalizing, heterotopia in that it aspired to contain all times, ages, forms, and tastes in one space (Duncan and Wallach 1980; Foucault 1994: 182).

Nineteenth-century exhibitionary spaces were novel places of public social intercourse. The public exhibition was a space of crowds who were invited to think of themselves as spectacle to each other and as self-regulating civilized individuals for whose benefit the museum's exposition was presented. The researches of Bennett, of Duncan, and others have enhanced our understanding of the development of the modern self as a bounded interior world of restrained affects and disciplined knowledge; they show how the museum constituted individuals as subjects who experienced themselves as separate from, and as opposed to, the exhibited nature and culture that they observed.

Recent scholarship, arguing that museums are as *cultural* as the things they contain, has been concerned with the discursive weight of galleries, installations, and exhibitions, which are, as it were, spatial arguments about the world that they denote and which construct a point of view from which it is addressed by subjects. Three perspectives are discernible, each of which has its roots in the sociological tradition and all of which are realized, with different emphases and combinations, in the work of contemporary researchers into the socio-genesis of museums.

Calculated space

In a tradition of enquiry that descends from Weber to Norbert Elias and Foucault, some researchers have focused on how the museum made the world calculable and on how the heterogeneity of experience was, by means of the pure space of the museum's array of objects, interiorized as the disciplined taste of the connoisseur (Hetherington 1999), as the ethnographic knowledge of colonial domination (Coombes 1991), and as the expertise that serviced the panoptic state (Bennett 1995). The thesis that the museum brought the artifacts of non-European peoples under the calculating gaze of Europeans who read them metonymically as signs of styles, cultures, and inferior civilizations is well established (Coombes 1991; Riegel 1996; see chapter 5 of this volume). Thus, it has been argued that the projection of a

Euclidean museum space enlisted Western populations on the side of an apparently superior rationality; in the nineteenth and twentieth centuries Western peoples found their intrinsic differences from "primitive" colonial peoples ratified by the museum and calibrated within the deep time of civilization.

Conflicted space

In the tradition of conflict sociology that is descended from Weber and Marx, Duncan and Wallach (1980), Wolff and Seed (1988), Fyfe (2000), and Prior (2002) are amongst those who argue that the genesis of a Kantian space was interwoven with social class and state formation. Dimaggio (1982) traces the elitism of late nineteenth-century Eastern Seaboard art institutions to the conflicted situation of Boston Brahmins whose cultural aspirations emerged from the compulsions of their interdependence with European elites and the migrant masses of late nineteenth-century America. Nineteenth-century museums were sites of conflict between established and outsider groups (for example, between aristocratic and bourgeois status groups); they were also enmeshed in developing global patterns of interdependence between people who might never encounter each other but who were connected via the trade routes of collecting and expropriation.

Collective space

Durkheimian theories concerning the collective character of rites and representations (with its powerful insight that people put things into categories because they live in groups) are discernible in work on the museum's role in transfiguring societies as communities and nations. Duncan and Wallach (1980), describing the museum visit as a rite of citizenship, provide an implicitly Althusserian and Durkheimian argument about the social constitution of individuals as subjects. They show how modern populations, despite divisions of class, gender, and ethnicity, come to think of their commonality; they show how "imagined communities" were conjured out of the complexity, impersonality, and opacity of modern social life.

Materializing and Visualizing Knowledge

The nineteenth-century museum materialized knowledge across a range of disciplines; it brought populations under the surveillance of liberal states and identified the "primitive within" as a subject for eugenics. In the early 1900s, British sociology and the museum had convergent interests in evolution and urban society that were exemplified in the work of Patrick Geddes and that of his associates at the Sociological Society (by 1930 the Society had become the Institute of Sociology; Bennett 2004). However, as sociology began to eschew its classical concerns with evolution and change, the museum lost its salience. By the mid-twentieth century, as A. L. Kroeber observed, sociology lacked the museum affiliations characteristic of other university disciplines (Kroeber 1954: 764). Moreover, sociology, unlike anthropology, displayed little interest in visual depiction except as the sociology of art. For

the most part, sociology exhibited people through the abstractions of interview and survey rather than through methods of visualization, depiction, and installation.

Museums and sociology were both shaped by the contradictory classical and romantic impulses that constituted the deep structure of social thought. In the case of sociology, the structural emphasis of an *industrial-societies* paradigm meant that sociologists approached institutions as configurations that were more or less adapted to the technical requirements of an industrial capitalism; schooling, for example, was theorized as a functional process of social selection. If the industrial-societies perspective was classical in its emphasis on order and structure, then a second, romantic, impulse was associated with the Chicago School and its legacy. Here, sociology focused on the outsider's point of view, on the marginal world of the street corner with its gangs, its drugs, and on the outsider-artist who suffered the neglect of academies and museums. This perspective, concerned with the "authenticity of the disreputable" (Gouldner 1973), had priorities other than the museum; the museum was perhaps a metaphor for the established world against which the subjects of romantic sociology were defined. Where the museum entered the sociological lexicon it denoted the pernicious positivism of modern forms of regulation, the prison and the asylum, which exhibited deviations from the normal.

A correlate of their discipline's paradigmatic heterogeneity is that sociologists have been sharply divided on matters of research methods. The 1960s' debate about the ontological status of official statistics and other large data-sets is a celebrated example of this, and there are signs that it may yet irrupt into museum studies (Schuster 2002; Selwood 2002; and see Hooper-Greenhill's discussion of visitor figures in chapter 22). There are internal links between theory, research design, and methods so that researchers who draw on sociology need to evaluate this relationship for themselves (Lawrence 1993). In the matter of visitor studies, there is the contrast between data that are derived from visitors' retrospective responses to questionnaires (Bourdieu and Darbel 1991; Merriman 1991) and data derived from field observations of what visitors do and say in the course of their visits (Lehn and Heath n.d.; Macdonald 2002). Some museum sociologists focus on how visitors construct and negotiate the meaning of their visit in the course of face-to-face interactions with things and with people (installations, other visitors, museum personnel) and negotiate the meanings of an installation. Others theorize the visit as a script which is external to individuals, as a Durkheimian social fact which encodes a set of prior expectations about what a visit is and how it should be conducted.

Institutional Critiques

One of the defining features of twentieth-century intellectual life was the conviction that the Enlightenment had failed to deliver on its promise of human emancipation, that rationality had been unhitched from reason and harnessed to reification, alienation, and repression. The museum has long been a *sine qua non* for alienation and the dead hand of tradition. Thus, Theodor Adorno argued that the museum, in mediating our relationship to art, neutralized culture, substituted market value, and amputated art from the living "pleasure of looking" (Adorno 1967: 175). For

avant-garde artists, the museum was seen as a place where artifacts were cut off from the springs of creation, and the notion that museums, particularly art museums and ethnographic collections, are like prisons continues to animate the museum literature.

Sociological investigation entails a critical shift away from philosophical explanations of alienation to empirical assessments of the social contexts in which people are estranged from their fellow beings. It is, for example, less concerned with archetypal conflict between artists and museums than with specifying the conditions which generate alienation. Thus, museums, galleries, and their personnel have been studied as contested terrains: in the early twentieth century, artists were separated from the means of determining art history and excluded as museum decision-makers (Fyfe 2000). Museum people have been studied as they are perceived by artists (Rosenberg and Fliegel 1970), as "gate-keepers" (Becker 1982; Crane 1987; Greenfeld 1989). Sociologists have studied both gate-keepers and the socio-genesis of "cultural gates"; they have explored the art museum's role in cultural stratification, in articulating the distinction between high culture and low culture (Dimaggio 1982; Prior 2002).

In the USA, Grana (1971), conscious that he was dealing with a new mass phenomenon, was one of the first to note that if the museum was enmeshed in the competing claims of democracy and elitism, then this warranted sociological investigation. Here, we find the now familiar argument that the museum may ratify feelings of inclusion and exclusion. Museum critiques have been given a materialist twist by sociologists who argue that the alienating effects of the museum are refracted through the class structures of capitalist societies. This approach, dubbed the *institutional critique*, is sometimes associated with Bourdieu and Darbel (1991), who reported a statistical association between museum visiting and class, and argued, on the basis of survey evidence, that working-class visitors experienced museums as sites of symbolic violence (i.e. as exclusive places which confirmed their inner sense that they were out of place and inferior).

The institutional critique is more familiar to sociologists as the *dominant ideology* approach to state-sponsored cultural institutions. Museums may be seen to function as a dominant ideology insofar as they contribute to the cohesion and reproduction of capitalist society. Thus, museum classifications are taken to be rituals of state power; studied as civic ritual, museum visiting provides clues as to how structural inequalities are internalized by subordinate classes as inferiority (Duncan and Wallach 1980; Meltzer 1981; Bourdieu 1984). Accordingly, the museum is seen as an agency of conservation for objects and as conduit for a dominant ideology whose function is to conserve the social order; its narrative of civilization is interwoven with the divisions of nation-building, imperialism, corporate power, elitism, and plunder.

Three problems are associated with this perspective. First, there are theoretical and empirical reasons for doubting the veracity of the dominant ideology thesis as a complete account of the function of cultural institutions in advanced capitalist societies (Abercrombie et al. 1980). In respect of museums, its veracity has been questioned by Merriman (1991), Samuel (1994), and Huyssen (1995). Secondly, there is the matter of museum expansion since the 1960s and whether or not contemporary visitor profiles retain the class characteristics identified by Bourdieu. Bourdieu's findings, showing that museum visiting was predominantly the preserve of higher

and aspirant classes, based on European data-sets from the 1960s, are broadly confirmed in other national settings: see, for example, on the USA, Dimaggio and Useem (1978b), Blau et al. (1985), and Merriman (1991) on heritage museums in Britain. More recently (and there are parallels with sociological research into schooling and higher education), it has become evident that the expansion of art museums is commensurate with the reproduction of social-class differences in visiting (Zolberg 1994; Selwood 2002).

Thirdly, there are variations between types of museum which suggest a need to bring the museum itself into the analytical frame. Industrial and working-class heritage, for example, is significant because, until recently, our understanding of the museum–society relationship was refracted through research into art museums (Merriman 1991). The subject of heritage more broadly invites neglected questions about how the structuration of classes is interwoven with museum change and demonstrates the poverty of research which merely correlates visiting habits with the supposed attributes of individuals in social classes (Fyfe and Ross 1996). For example, contemporary marketization may have the effect of depriving the middle class of a distinctive museum identity, whilst there is the puzzle of new patterns of omnivorous middle-class consumption that breach the boundary between high and low.

The museum is sociologically relevant partly because it is a place in which received notions of oppression, identity, and citizenship have been challenged since the 1960s. The politics of identity associated with new social movements means that, whereas museums once submerged difference in the bounded selves of universal citizenship, they are today called to recognize the plurality and flux of identities. For sociology, there is the need to provide a theory of the fragmentation of identity in the modern world. At the museum, there is the implication that mere access may exact a price from the socially excluded who must give up part of themselves: they will not find their culture and identity represented (Sandell 2002). Thus, some researchers have focused not just on visitors but also on the social character of the museum: they have tilted the lens of research toward the social backgrounds and identities of museum personnel and concerned themselves with the ways in which social power and privilege penetrate the form and content of the museum (Dimaggio and Useem 1978b; Zolberg 1981; Ross 2004).

Museums as Social Facts

Amongst the most significant of global social facts in the late twentieth century was the growth of museum activity, with perhaps 90 percent of the world's museums established after World War II (Boylan 1995). More than three-quarters of English museums were established after 1970, and the majority of new museums opened since 1960 have been independents (Davies and Selwood 1998: 71–2). A correlate of this has been the expansion of museum labor forces whose character and relationship to the culture industry has received little sociological attention (see chapter 25). Visitor numbers have grown and their analysis forms the subject of an emerging literature (see chapter 22). However, it is not merely a matter of expansion but also of

diversification; for example, heritage museums in Britain and eco-museums in France (Poulot 1994) are signs that new things and new forms of authority have been validated by the museum.

The museum phenomenon is linked to processes that have been characterized variously as post-industrial, post-capitalist, high-modern, or postmodern. These processes include shifts in the sectoral balance of capitalist societies toward the service industries, "de-industrialization," transformations of regional economies, the structuration of comparatively large middle classes, the development of a consumer society, and the breaching of established and modernist boundaries between high and low culture. The contemporary museum operates in a mediated world of digital networking, of rapid flows of images and artifacts, of marketization of culture, and of mass tourism where meanings patently escape the horizons of curatorial control. These developments are linked to wider changes in the relationship between professional power, culture, and audiences. For example, debates about the role of the museum in enhancing the public understanding of science are bound up with the transformation of the museum's authority. A study of the inner world of London's Science Museum shows how new kinds of installation go hand in hand with a new kind of curator, interpreters rather than legislators (Macdonald 2002).

"Blockbuster" shows have transformed some museums into commercial enterprises and endowed them with an "organizational" character (see chapters 23 and 31). Zolberg (1981) and Alexander (1996) have conducted case studies of museums as arenas of conflict, showing how their corporate identities are reflexively constructed and reconstructed. This work, influenced by the sociology of organizations, suggests that museums are shifting coalitions of actors with different stakes in the external worlds of cultural, economic, and political power.

Heritage and the heritage industry constituted a leading edge of twentieth-century museum development (see chapter 13). Some writers have argued that estrangement and loss is at the heart of expansion, that heritage museums articulate characteristically post-industrial and postmodern structures of feeling. The mediated, impersonal, and uncertain character of contemporary social life is said to drive the museum, which provides opportunities for narrating the past and imagining the face-to-face bonds of community (Merriman 1991; Walsh 1992).

One debate concerns heritage culture and whether it is inauthentically commercial and manipulative *or* authentically spontaneous and of the people. Against the charge that heritage is no more than reactionary nostalgia are the accounts of Merriman (1991), Samuel (1994), Huyssen (1995), Urry (1996), and Dicks (2004), which variously explore the connections between heritage, novel meanings, and twentieth-century social change (the waning of traditional class politics, the emergence of new social movements, the hybridization of social identities, the flow of things and people across social borders).

In Britain (but not only in Britain) change was associated with the emergence of post-industrial society that was also adjusting to its situation as a postcolonial society. Just as new museums were invented to recover the material culture of an old, industrial, working-class heritage, established museums have addressed issues of ownership in the material cultures of non-Western peoples and new kinds of museum

register challenges to the authority of Western cultural codes (Clifford 1988; Riegel 1996). There is a substantial literature about the museum's colonial legacy which points to the institution's significance as a locus of shifting balances of cultural power between established and outsider groups. Not only are received Western notions of ownership and control being challenged by the claims of indigenous peoples for the return of stolen artifacts and human remains (see chapters 26 and 27), but the very notion of the museum as a uniquely Western project is being questioned (see chapter 28). In other words, these are both moral and sociological questions concerning the dialogic character of the museum in its global context.

Whilst Dicks (2004) and others have rescued heritage from economism, the production of authenticity is, nonetheless, interwoven with the expansion of a service economy, with the development of culture industries, with the increasing weight of symbolic specialists within the social structures of advanced capitalist societies, and with the aestheticization of social life (Featherstone 1991; Selwood 2001). Amongst sociologists there are well-rehearsed debates about how economic and cultural processes may be distinctively interwoven in a postmodern society. One emphasis has been on the economic significance of cultural processes such as gentrification and on the commodification of authenticity as a moment in the formation of new circuits of cultural power; thus, for example, regeneration of manufacturing and old commercial districts creates new spaces of consumption (Zukin 1995).

Museums, People, and Cultures of Collecting

New directions in the study of collecting have been informed by broadly structuralist ideas descended from Durkheim's investigations into systems of classification: here the compulsion to collect things is traced to the collective character of social life, and accumulations of artifacts are theorized as realizations of implicit cultural rules of discrimination between things. A problem, which attends theories of the sociogenesis of taxonomies, is whether we should treat classificatory systems as providential expressions of a common culture or as the contested outcomes of cultural conflict between groups.

Some writers have focused on the processes by which singularity is conferred on objects, exploring the dynamics and semiotics of authenticity. See, for example, Baudrillard (1994) on collecting, Clifford (1988) on collecting and Western identity, and Kopytoff (1986) on singularization as a sacralizing process. Pomian (1990) argues that rituals of collecting and display are the means by which societies manage the relationship between the mundane world of everyday social intercourse and the invisible spiritual world. For example, a national collection of art mediates between the visible venality of competitive commercial activity and the invisible sanctity that is the nation. Yet, collecting practices may not be realizations of a unified collective conscience so much as they are precipitates of struggles over the definition of a public culture; they may arise from the contradictions of social relations (realized as strong cultural classifications which deepen an established group's sense of cultural dignity by discrediting the material culture of other groups). Hence, Dimaggio (1982) and Bourdieu (1984) have melded Durkheimian perspectives with Weberian

theories of status groups, emphasizing the contested character of classifications whose social character is rendered invisible by ritual practices.

It is characteristic of nation-states that collections of things, which are held in trust on behalf of the people, are taken to be a sign that a population is indeed a people and that its territorial space is a national space. Whilst national museums bear the imprint of a state monopoly, collecting is also associated with diverse institutions such as universities, military regiments, friendships, corporations, and families whose symbolic boundaries are signified in collecting practices. Curating may be a province of elite specialists, but it is also increasingly practiced by lay people in a variety of gendered social settings including households (Pearce 1998; Goode 2002). Belk (1995) and Pearce (1998) are amongst those who have conceptualized contemporary collecting as a form of consumption; they explore the impact of consumer culture on collecting practices in a world whose modernity is signified by the fact that households purchase more things than they inherit and dispose of more things in a week than most previous generations consumed in a life-time (see McCracken 1990: 44–53). Collecting has been transformed by the advent of a consumer culture which has spawned popular cultures and institutions of collecting which exploit established and new means of electronic communication. Whilst this, no doubt, leads to a democratizing of existing collecting, it also engenders practices which escape the hegemony of traditional modes of control and which may attract official opprobrium (Martin 1999).

The sociological relevance of this is that, in being collected, "ordinary things are made extraordinary" (Leach 2002: 153); social boundaries are materialized and the disenchanted modern world re-enchanted. Three themes may be noted. First, there is research on the spaces and processes of conversion, the ritual practices and alchemy that converts the detritus of an industrial civilization into objectified cultural capital (Thompson 1976; Clifford 1988). Secondly, there is work on the constitutive role of collecting in relation to everyday institutions, such as households, families, friendships, or even businesses (for example, Martorella 1990; Halle 1993; Pearce 1998; Goode 2002; Leach 2002). Finally, there is writing on how ideologies of state patronage, which may empower elites and elite collecting practices, have developed as components of liberal democracy (Dimaggio and Useem 1978a; Pearson 1982; Bourdieu and Haacke 1995; Wu 2002).

How new kinds of artifacts may become museum-worthy, how collections formed by private citizens acquire a significance that makes them into a public culture is a matter for investigation. The association between collecting and social elites is popularly filtered through anachronistic conceits about enlightened patrons, narratives of heritage and donors, and unexamined assumptions about the psychology of accumulation. Some sociologists have investigated the historical sociology of art collectors and collecting (for example, Montias 1982). However, modernity has transformed the relationship between elites and power: whereas cultural power was once concentrated in the hands of patriarchs, this is no longer typically so; elite collecting has long been refracted by networks, fields or figurations of cultural power and, with some exceptions, wealthy lifestyles have become less visible in capitalist societies. Moreover, as with economic property, so too with cultural property, elite prerogatives were both constrained and enabled by twentieth-century states (for

example, through taxation and export controls which regulate the conversion of cultural capital into economic capital).

Much remains to be done in this area, although the work of Dimaggio and Useem (1978a) and Martorella (1990) in the USA and scattered contributions in Britain (Hatton and Walker 2000; Wu 2002), point a way forward, as does the empiricist tradition of reporting who owns what that stretches back from Hobson (1999) to the New Doomsday Book of the 1870s via Anthony Sampson. Key questions concern the ways in which power and privilege may be reproduced through the medium of impersonal cultural possession and how, for example, contemporary corporate sponsorship and collecting may function as symbolic domination (Bourdieu and Haacke 1995).

Museums as Agencies of Social Research

Daniel Bell's (1973) thesis that knowledge is becoming the axial principle of society anticipated contemporary arguments that modern societies have become radically recursive (Giddens 1990; Lash and Urry 1994). What distinguishes modern society is not that people reflect on themselves and their courses of action ("I wish I had said that better"), but that critical reflection, which includes the social sciences, recursively transforms people and institutions. Modernity is deeply and intrinsically sociological in that the social sciences play a constitutive role in social life and continually "'circulate in and out' of what they are about" (Giddens 1990: 36–43).

The contemporary relationship between the museum and sociology expresses a new kind of social fact. Museums have, of course, long conducted social research, especially in the pragmatic mode of visitor studies. However, the new order of market and state requires a new professional habitus; museums operate in a world which is saturated by data derived from official and semi-official statistics and commercial research. Audience research is an obligation with which museums are charged; they are "to find out as much as possible about [their] visitors and potential visitors, including their learning needs" (Lang and Wilkinson 1999). The flow of social science to the museum reflects new forms of power/knowledge; it is indicative of an institution that must constantly adjust to change and that is required continuously to reflect on the outcomes of its actions. The museum has internalized social research.

The "new museology" (Vergo 1989), which addresses the history and purpose of museums through a reflexive and critical practice, has set a research agenda which is receptive to the social sciences. It has developed an epistemological dimension to museum writing which is sociologically informed about the nature of knowing. The work of contemporary social theorists such as Baudrillard, Foucault, Giddens, and Lyotard informs the shift in emphasis from the isolated curatorial object toward the cultural and social contexts within which the meanings of objects are generated (see chapter 2).

The reflexive character of modern social life is illustrated by four developments in museum research. One is the growing interest in ethnographic and phenomenological visitor research of the kind called for by Zavala (1993), which focuses less on

the attributes of visitors than on the ways in which they interact with exhibits and negotiate meaning. Secondly, museum research such as that of Bagnall (2003) and Dicks (2004) corrects the cognitive bias of some theorists by emphasizing the embodied aesthetics of reflexivity. Thirdly, there is the proliferation of cultural statistics under the aegis of government departments, professional bodies, research institutes, and organizations such as the International Council of Museums. Here we are beginning to see, for example with Schuster (2002) and Selwood (2002), a critical and evaluative literature on the subject of cultural statistics. Lastly, the transformation of the museum expressed in the heritage industry, eco-museums, and community museums exemplifies the radical reflexivity of social life that interests postmodern theorists.

Disciplinary Change and Museum Studies

The incorporation of a new topic by a discipline is a selective process that is determined in relation to a topic's intellectual status, the state of the discipline, and the moral and political pressures of the wider society (Bernstein 1974). Fifty years ago, British sociologists would have seen museum research as a minor adjunct to the sociology of education whose key problems were informed by an industrial-societies perspective on social selection, stratification, and social mobility. By the late 1960s, the sociology of education was animated by its new interest in educational meanings and the sociology of knowledge. Here were some of the first indications of sociology's cultural turn away from a one-sided emphasis on the imperatives of social systems and social structures, and which was to become the hallmark of Birmingham cultural studies. From the 1980s, production-oriented ways of mapping identities in terms of class and occupation were responding, amongst other things, to feminism and to the recognition that consumption was a site of social differentiation.

Sociology's contemporary interest in museums reflects disciplinary changes that have made relevant other new topics such as the body, the emotions, the senses, memory, time, tourism, shopping, lifestyle, and consumption. These newcomers are, however, not merely additions to textbooks; their insertion reflects deeper developments in both museum practice and sociology. The cultural turn has established the museum's significance for sociology; sociologists have returned, via the museum, to neglected questions about the socio-genesis of the fundamental categories of knowledge, such as time and space: Haraway (1989) on nature and culture, Urry (1990) on travel and tourism, Crang (1994) on time, Barry (1998) on interactivity, Hetherington (1999) on space. It is perhaps in the study of visual culture and of visual methods of analysis that a distinctively sociological imagination can be noticed as engaging with the museum (Emmison and Smith 2000; Rose 2001).

More than this, museum research is sociologically significant because it resonates with debates about the theoretical core of sociology and the concept of society. One aspect concerns the normative tendency of twentieth-century sociologists to conflate their object of study – society – with the nation-state. It is arguably the case that in the past century both the sociological and museum imaginations were nationalized, limited by nation-centred perspectives that had abandoned nineteenth-century preoccupations with change and process at regional and global levels (Elias 1978:

235–45; Urry 2000). Prösler (1996), Kreps (2003), and Morishita (2003) are amongst writers who have broken out of "the nation-equals-society" formula to challenge Eurocentric perspectives on the museum.

That museums and sociology have begun to challenge their shared implicit assumptions about the social world suggests that there are affinities in their responses to social change. Within sociology, theorists have recognized the museum's ontological significance and its distinctive role in the making of Western modes of culture and identity. Bruno Latour, for example, asks in relation to eighteenth-century voyages of scientific exploration: how was the divide between the universal knowledge of Europeans and the local knowledge of non-Europeans produced? He argues that the making of modern science presupposed a networking of power which allowed things to flow to a center of calculation, such as a natural history museum, where flora and fauna could be classified and calibrated. The contrast between local and universal taxonomies was produced through "networks of accumulation" which delivered things into drawers and cases. The technologies of the museum, in enhancing "the mobility, stability and combinability of collected items" made collections into centers of calculation and permitted people to see new things (Latour 1987: 225).

It is, therefore, the agency of collection and display that warrants attention (Kirshenblatt-Gimblett 1998). The museum is studied as a modality of showing, of telling, and of mediating that is critically interwoven with divisions of modernity, with generation, class, ethnicity, and gender, and with the formation of global patterns of interdependence and consciousness. Prösler's (1996) argument that the world order was, as it were, realized by means of the ordering of things is an illustration of the museum's discursive weight.

Sociology is distinguished by its focus on patterns of association between people. Its starting-point is that the relationships between people are just as real as people themselves. One influential formulation is that of C. Wright Mills (1959), who invited his contemporaries to consider how the personal and the public spheres were interwoven. How, he asked, were the personal troubles of people and their milieux related to the public issues of changing social structures; how were structure, biography, and history related? Sociological neologisms such as symbolic violence, structuration, habitus, figuration, and cultural code are means of connecting inner experience and the symbolic order, of connecting personal experiences at the museum and the impersonal structure of cultural power in which the museum is enmeshed. The sociological imagination that Mills so famously celebrated was the nimble one that moved easily between inner meanings and the outer patterns of human association.

Contemporary museum practitioners may find themselves charged with the obligation to imagine not only the consciousness of their visitors but also that of visitors who have yet to come and who may never materialize. The job of the sociologist is perhaps slightly different. It is to show how the inner worlds of visitors, non-visitors, and curators are constituted out of their mutual and dialogic dependence on the museum. The claims of new visitors, of non-visitors, and of indigenous peoples are indications that the museum as a relationship of cultural classification is a process and that museum meanings are continuously constituted out of the flux

45

that is the shifting interdependencies between groups. The idea that it is possible to fix a new community of museum meanings is no more tenable than the idea that contemporary museums can continue with their classical ways. However, just as it is important to avoid reification of museum culture, so too is it important to avoid reifying museum visitors as though they were monads who arrive without any socially constructed compulsions to see or to know the world in their own manner and for their own reasons and purposes.

Bibliography

Abercrombie, N., Hill, S., and Turner B. S. (1980) *The Dominant Ideology Thesis*. London: George Allen and Unwin.

Adorno, T. W. (1967) Valery Proust museum. In *Prisms: Cultural Criticism and Society*. London: Neville Spearman.

Alexander, V. (1996) *Museums and Money: The Impact of Funding on Exhibitions, Scholarship, and Management*. Bloomington, IN: Indiana University Press.

Bagnall, G. (2003) Performance and performativity at heritage sites. *Museum and Society*, 1 (2): 87–103 (www.le.ac.uk/museumstudies/m&s/m&sframeset.html; accessed March 14, 2004).

Barry, A. (1998) On interactivity: consumers, citizens and culture. In S. Macdonald (ed.), *The Politics of Display*. London: Routledge.

Baudrillard, J. (1994) The system of collecting. In J. Elsner and R. Cardinal (eds), *The Cultures of Collecting*, pp. 7–24. London: Reaktion Books.

Becker, H. (1982) *Art Worlds*. Berkeley, CA: University of California Press.

Belk, R. W. (1995) *Collecting in a Consumer Society*. London: Routledge.

Bell, D. (1973) *The Coming of Post-industrial Society*. New York: Basic Books.

*Bennett, T. (1995) *The Birth of the Museum*. London: Routledge.

— (2004) *Pasts beyond Memory: Evolution, Museums, Colonialism*. London: Routledge.

Bernstein, B. (1974) Sociology and the sociology of education: a brief account. In J. Rex (ed.), *Approaches to Sociology*, pp. 144–59. London: Routledge.

Blau, J. R., Blau, P. M., and Golden, R. M. (1985) Social inequality and the arts. *American Journal of Sociology*, 91 (2): 309–31.

Bourdieu, P. (1984) *Distinction: A Social Critique of the Judgement of Taste*. London: Routledge.

*— and Darbel, A. (1991) *The Love of Art: European Art Museums and their Public*. Cambridge: Polity Press.

— and Haacke, H. (1995) *Free Exchange*. Cambridge: Polity Press.

Boylan, P. J. (1995) Heritage and cultural policy: the role of museums (www.city.ac.uk/artspol/world-comm.html; accessed March 14, 2004).

Clifford, J. (1988) *The Predicament of Culture*. Cambridge, MA: Harvard University Press.

Coombes, A. E. (1991) Ethnography and the formation of national identities. In S. Hiller (ed.), *The Myth of Primitivism*, pp. 189–214. London: Routledge.

Crane, D. (1987) *The Transformation of the Avant-garde*. Chicago: University of Chicago Press.

Crang, M. (1994) Spacing times, telling times and narrating the past. *Time and Society*, 3 (1): 29–45.

Davies, S. and Selwood, S. (1998) English cultural services: government policy and local strategies. *Cultural Trends*, 30: 69–110.

Dicks, B. (2004) *Culture on Display: The Production of Contemporary Visitability*. Milton Keynes: Open University Press.

Dimaggio, P. (1982) Cultural entrepreneurship in nineteenth-century Boston. *Media Culture and Society*, 4 (1): 33–50, and 4 (4): 303–22.

— and Useem, P. (1978a) Cultural policy and public policy. *Social Research*, 45 (2): 356–89.

— and — (1978b) Social class and arts consumption. *Theory and Society*, 5: 141–61.

*Duncan, C. and Wallach, A. (1980) The universal survey museum. *Art History*, 3 (4): 448–69.

Elias, N. (1978) *The History of Manners: The Civilizing Process*, vol. 1. Oxford: Blackwell.

Emmison, M. and Smith, P. (2000) *Researching the Visual: Images, Objects, Contexts and Interactions in Social and Cultural Inquiry*. London: Sage.

Featherstone, M. (1991) *Consumer Culture and Postmodernism*. London: Sage.

Foucault, M. (1970) *The Order of Things*. London: Tavistock.

— (1994) Different spaces. In James Faubion (ed.), *Michel Foucault: The Essential Works*, vol. 2: *Aesthetics, Method and Epistemology*, pp. 175–85. London: Allen Lane.

Fyfe, G. (2000) *Art, Power, and Modernity: English Art Institutions, 1750–1950*. Leicester: Leicester University Press.

— and Ross, M. (1996) Decoding the visitors' gaze. In S. Macdonald and G. Fyfe (eds), *Theorizing Museums: Representing Identity and Diversity in a Changing World*, pp. 83–104. Oxford: Blackwell.

Giddens, A. (1990) *The Consequences of Modernity*. Cambridge: Polity Press.

Goode, J. (2002) Collecting time: the social organization of collecting. In G. Crow and S. Heath (eds), *Social Conceptions of Time Structure and Process in Work and Everyday Life*, pp. 230–51. London: Palgrave.

Gouldner, A. (1973) *For Sociology*. Harmondsworth, Penguin.

Grana, C. (1971) *Fact and Symbol*. New York: Oxford University Press.

Greenfeld, L. (1989) *Different Worlds*. Cambridge: Cambridge University Press.

Halle, D. (1993) *Inside Culture: Art and Class in the American Home*. Chicago: Chicago University Press.

Haraway, D. (1989) *Primate Visions: Gender, Race and Nature in the World of Modern Science*. London: Routledge.

Hatton, R. and Walker, J. (2000) *Supercollector: A Critique of Charles Saatchi*. London: Ellipsis.

Hetherington, K. (1999) From blindness to blindness: museums, heterogeneity and the subject. In J. Law and J. Hassard (eds), *Actor Network Theory and After*, pp. 51–73. Oxford: Blackwell.

Hobson, D. (1999) *The National Wealth*. London: Harper Collins.

Hooper-Greenhill, E. (1992) *Museums and the Shaping of Knowledge*. London: Routledge.

Huyssen, A. (1995) *Twilight Memories*. London: Routledge.

Karp, I. (1991) Other cultures in museum perspective. In I. Karp and S. D. Lavine (eds), *Exhibiting Cultures: The Poetics and Politics of Museum Display*, pp. 373–85. Washington: Smithsonian Museum.

Kirshenblatt-Gimblett, B. (1998) *Destination Culture: Tourism, Museums, and Heritage*. Berkeley, CA: University of California Press.

Kopytoff, I. (1986) The cultural biography of things: commoditization as process. In A. Appadurai (ed.), *The Social Life of Things*, pp. 64–91.Cambridge: Cambridge University Press.

Kreps, C. F. (2003) *Liberating Culture*. London: Routledge.

Kroeber. A. L. (1954) The place of anthropology in universities. *American Anthropologist*, 56: 764–7.

Lang, C. and Wilkinson, S. (1999) *Social Inclusion: Fact Sheet*. London: Museum and Galleries Commission.

Lash, S. and Urry, J. (1994) *Economies of Signs and Space*. London: Sage.

Latour, B. (1987) *Science in Action*. Milton Keynes: Open University Press.

Lawrence, G. (1993) Remembering rats, considering culture: perspectives on museum evaluation. In S. Bicknell and G. Farmelo (eds), *Museum Visitor Studies in the 90s*, pp. 117–24. London: Science Museum.

Leach, R. (2002) What happened at home with the art: tracing the experience of consumers. In C. Painter (ed.), *Contemporary Art and the Home*, pp. 153–80. Oxford: Berg.

vom Lehn, D. and Heath, C. (n.d.) Studying "visitor behaviour" in museums and galleries (www-sv.cict.fr/cotcos/pjs/FieldStudies/PublSpandLeisure/PSLpapervomLehn.htm; accessed March 14, 2004).

McCracken, G. (1990) *Culture and Consumption*. Indianapolis, IN: Indiana University Press.

Macdonald, S. (2002) *Behind the Scenes at the Science Museum*. Oxford: Berg.

*— and Fyfe, G. (eds) (1996) *Theorizing Museums: Representing Identity and Diversity in a Changing World*. Oxford: Blackwell.

Martin, P. (1999) *Popular Collecting and the Everyday Self*. London: Leicester University Press.

Martorella, R. (1990) *Corporate Art*. New York: Rutgers University Press.

Meltzer, D. J. (1981) Ideology and material culture. In R. J. Gould and M. B. Schiffer (eds), *Modern Material Culture: The Archaeology of Us*, pp. 113–25. New York: Academic Press.

*Merriman, N. (1991) *Beyond the Glass Case*. Leicester: Leicester University Press.

Mills, C. W. (1959) *The Sociological Imagination*. Harmondsworth: Penguin.

Montias, J. M. (1982) *Artists and Artisans in Delft*. Princeton, NJ: Princeton University Press.

Morishita, M. (2003) Empty museums: transculturation and the development of public art museums in Japan. Unpublished PhD thesis, Open University.

Panofsky, E. (1991) *Perspective as Symbolic Form*, trans. C. S. Wood. Cambridge, MA: MIT Press.

Pearce, S. (1992) *Museums, Objects, and Collections: A Cultural Study*. Leicester: Leicester University Press.

— (1998) *Collecting in Contemporary Practice*. London: Sage.

Pearson, N. (1982) *The State and the Visual Arts*. Milton Keynes: Open University Press.

Pomian, K. (1990) *Collectors and Curiosities: Paris and Venice, 1500–1800*. Cambridge: Polity Press.

Poulot, D. (1994) Identity as self discovery: the ecomuseum in France. In D. J. Sherman and I. Rogoff (eds), *Museum Culture: Histories, Discourse, Spectacles*, pp. 66–84. London: Routledge.

Prior, N. (2002) *Museums and Modernity*. Oxford: Berg.

Prösler, M. (1996) Museums and globalization. In S. Macdonald and G. Fyfe (eds), *Theorizing Museums: Representing Identity and Diversity in a Changing World*, pp. 21–44. Oxford: Blackwell.

Riegel, H. (1996) Into the heart of irony. In S. Macdonald and G. Fyfe (eds), *Theorizing Museums: Representing Identity and Diversity in a Changing World*, pp. 83–104. Oxford: Blackwell.

Rose, G. (2001) *Visual Methodologies*. London: Sage.

Rosenberg, R. and Fliegel, N. (1970) Dealers and museums. In M. C. Albrecht, J. H. Barnett, and M. Griff (eds), *The Sociology of Art and Literature: A Reader*, pp. 469–82. London: Duckworth.

Ross, M. (2004) Interpreting the new museology. *Museum and Society*, 2 (2): 84–103 (www.le.ac.uk/ms/m&s/m&sframeset.html; accessed March 1, 2005).

Samuel, R. (1994) *Theatres of Memory*. Verso: London.

Sandell, R. (ed.) (2002) *Museums, Society, Inequality*. London: Routledge.

Schuster, J. M. (2002) Informing cultural policy: data statistics and meaning. In *Informing Cultural Policy*. International Symposium on Cultural Statistics (www.colloque2002symposium.gouv.qc.ca/PDF/Schuster_paper_Symposium.pdf; accessed March 14, 2004).

Selwood, S. (ed.) (2001) *The UK Cultural Sector*. London: Policy Studies Institute.

— (2002) Measuring culture. *Spiked*, September 30 (www.spiked-online.com/Articles/00000006DBAF.htm; accessed March 14, 2004).

Thompson, D. (1976) *Rubbish Theory*. Oxford: Oxford University Press.

Urry, J. (1990) *The Tourist Gaze*. London: Sage.

— (1996) How societies remember the past. In S. Macdonald and G. Fyfe (eds), *Theorizing Museums: Representing Identity and Diversity in a Changing World*, pp. 45–65. Oxford: Blackwell.

— (2000) *Sociology beyond Societies*. London: Routledge.

Vergo, P. (ed) (1989) *The New Museology*. London: Reaktion Books.

Walsh, K. (1992) *The Representation of the Past: Museums and Heritage in the Post-modern World*. London: Routledge.

Wolff, J. and Seed, J. (eds) (1988) *The Culture of Capital: Art, Power and the Nineteenth-century Middle Class*. Manchester: Manchester University Press.

Wu, Chin-tao (2002) *Privatising Culture: Corporate Art Intervention since the 1980s*. London: Verso.

Zavala, L. (1993) Towards a theory of museum reception. In S. Bicknell and G. Farmelo (eds), *Museum Visitor Studies in the 90s*, pp. 82–5. London: Science Museum.

Zolberg, V. (1981) Conflicting visions in American art museums. *Theory and Society*, 10: 81–102.

— (1992) Art museums and living artists: contentious communities. In I. Karp, C. M. Kreamer, and S. D. Lavine (eds), *Museums and Communities*, pp. 104–36. Washington: Smithsonian Institution.

— (1994) "An elite experience for everyone": art museums, the public and cultural literacy. In D. J. Sherman and I. Rogoff (eds), *Museum Culture: Histories, Discourse, Spectacles*, pp. 49–65. London: Routledge.

Zukin, S. (1995) *The Cultures of Cities*. Oxford: Blackwell.

Art History and Museology: Rendering the Visible Legible

Donald Preziosi

The sheer uncanniness of museums as indispensable institutions in many modern and modernizing societies is a function of their enduring power to define, stage, circumscribe, and haunt our individual and collective lives and dreams. It is as difficult today to imagine a world without museums as it is easy to feel that we have never fully left the first museum we ever visited.

Walking (through) a museum appears to resemble walking through history: we move in and among a succession of objects, pantomiming not only the passage of time but also appearing to exemplify evolutionary changes or even the progressive developments in form, style, invention, value, or mentality. This extraordinary interactive machinery is designed to engage and be operated by its users, who literally (re)enact history and chronology *choreographically*.

The museum and the nation-state and the modern notion of culture arose together. The museum's function was to provide a space within that of the nation or community whose unity and autonomy both prefigured and was paradigmatic of the projected unity of the nation. At the same time, in juxtaposing subjects vis-à-vis artifacts, the museum provided its citizen-subjects with *exemplary* objects, "object-lessons" of aesthetic, ethical, political, and historical worth: no museum object is mute, but is already entailed with a legend and an address in cultural and historical space–time. Museums render what is visible legible.

Objects in museums bear very complex relationships to similar or identical objects outside museums and collections, as well as to themselves prior to collection. The act of collecting and exhibiting artifacts, of passing them across an exhibitionary threshold, is much more than an act of removal from some prior place, context, or condition. The object is not simply transported but *transformed*. This raises the question of what, then, is the nature of the museum object?

An uneasily interwoven and dynamically changing network of fields, professions, and institutions has arisen over the past several centuries with the aim of attending to the questions and problems just rapidly sketched, albeit with disparate and often contrary and apparently irreconcilable motivations. This chapter is devoted to these issues in the light of the complex and fraught relations between the academic and professional fields of art history and museology. Never entirely distinct institutionally, professionally, or personally, their similarities and differences are not easily artic-

ulated: art history is not satisfactorily reduced to being the "theory" to the museum's "practice," nor the ghost in the museum's machinery. Nor is the museum simply – if at all – the exemplification or application of art history, or merely the staging or stagecraft of the dramaturgies of art historical analysis and synthesis. If anything, their relations are anamorphic – each transforming the other – rather than direct or transitive.

The chapter will explore some of the complexities of the interactions of art, art history, and museology at the very locus of their *convergence*: the uncanny semiotic nature of the (art) object, and the psycho-dramaturgy of "subjects" (in their various incarnations as viewers, visitors, or citizens) interacting with "objects" in museo-logical and art historical (not to speak of more generally social and civic) space–time. Museology is considered in relation to a network of practices and professions – art history, art criticism, art theory, aesthetic philosophy, social history, and connois-seurship – which are here collectively termed *museography*.

Art History and Museology

For some time we have come up against the limits of our historiographies of the humanities and social sciences which articulated disciplinary histories as narratives imposing sequential order on otherwise chaotic, contingent, and apparently irrecon-cilable occurrences of practice. Such narratives commonly assumed the continuity and essentialist nature of (what were thereby constituted retrospectively as) distinct disciplines or fields of knowledge production, such as "art," "art history," or "muse-ology." Commonly, tales of disciplinary and institutional origins have relied explic-itly or implicitly upon a fantasized image of a certain wholeness in pre-modernity which has been shattered, fragmented, or erased in various ways – by (to take one familiar example) the irruption of capital through industrialization, mechanization, and mass production, which is held responsible for "segregating" fields such as art and craft, or history, theory, and criticism.

But the qualities said to belong to "traditional society" often only come into exis-tence with the emergence of our modernities themselves; they are in fact their con-stitutive underside. The task confronting disciplinary knowledge today is no longer simply that of gluing back together the fragments and shards of disciplinary prac-tices so as to reconstitute by hindsight a fantasized unity. Such a pursuit would serve mostly to perpetuate the ideology of identity formation, dislocation, and transfor-mation underpinning the psychodrama of modern nation-state formation itself as living in a present anchored in a projection into the future of the fulfillment of a lost or stolen wholeness or original purity, living out the putative dreams of lost but unforgotten ancestors. The future anterior of what one (a citizen, a state, or a disci-pline) shall have been for what one (or it) is in the process of becoming.

The social, cultural, and political circumstances of the present time require at the least a fundamental reconfiguration of the epistemological assumptions sustaining such phantasmatic identities and essences. In acknowledging the more than acci-dental connections between our period's murderous realities and the playing out of such desires on individual and collective scales, those concerned with the state and

fate of museums and museology, no less than of art and its history, theory, and criticism, may be in a unique and potentially powerful position to contribute substantively to affecting the hegemonic structures of the status quo.

The reason for this may lie in the unique nature of what is at the core of all these practices and institutions; namely, the concern with the art object, with artifacts as such, and with the roles objects are understood to play in the social, political, and psychic life of individuals and nations. Understanding the extraordinarily uncanny psycho-semiotic nature of the "museum object" (whether staged as "art" or not), in relation to and in concert with the museum or disciplinary "subject," may provide us with a way through to rearticulating the liberatory potential of art no less than of museums. Museum objects in general *are* astonishing phenomena, whatever their origins, and "art" objects in museums (as well as outside museums, if there can justifiably be made a case that in modernity, artworks actually have any extra-museological existence) are phenomena that "astonish" even more: more on this below.

One important facet of the "liberatory potential" of the art object is related to the destabilizing and relativizing potentials of art recognized by Plato as inimical to his vision of civic order in an ideal republic: the "divine terror" (*theios phobos*) evoked by the arts. In a congruent fashion, the complex and unpredictable dynamics of museum use in relation to prescriptive museological stagecraft and dramaturgy may arguably be related to the liberatory potentials of "reading against the grain" and the unpredictable or uncontrollable opening up of alternative readings and interpretations. Articulating the dynamics of both of these cases, as argued below, demands close attention to the inherently complex nature of artifice itself, with respect to the semiotic and epistemological status of art object and of the (art or not) museum object, with respect to the relationships of both objects to makers and users.

The Art Museum Object

Museums are not simply utopian but rather heterotopic sites within social space that provide subjects with some of the means and methods to simulate mastery of their lives whilst compensating for the contradictions and confusions of daily life. What this entailed in the course of the nineteenth-century evolution of academic and professional fields was nothing less than the disciplining of whole populations through a desire-driven interaction with objects that were object-lessons in at least two principal ways: (a) as documentary indices of a (narrative) history of the world and its people, construed as teleological dramaturgy ("evolution"), a "story" having a direction and point and leading up to the spectator in the present, at the apex of this development; and (b) as simulacra of a rich cornucopia of subject-positions (multiple ways of "being"-in-the-world) which might be admired, desired, abhorred, mirrored, emulated, or rejected. These "object-lessons" one might take to heart, take under advisement, or not take or take to at all. Early museums, such as the Parisian Musée des Monuments Français or the Louvre (Lenoir 1800–21; Bann 1984; Deotte 1993) or Schinkel's Altes Museum in Berlin (Crimp 1993), or the British Museum

(Crook 1972; Miller 1973; Caygill 1981), provided evolutionary paradigms for the history of art and the development of the modern nation-state.

Just as the museum object came to serve as a window or perspective on the complex historical evolution of attitudes, values, styles, or peoples, so also did the new modern social subject itself come to be constituted as an anamorphosis of the bits and pieces of its own life and experience: a place from which to view those bits in such a way as to realign them in a (previously hidden or invisible) order, a "story" that makes a certain sense. The art museum object is a screen for the dramaturgy of the desiring self, a demonstration or ostensification of someone's seeing – a someone whom one may learn to wish to coincide with or to emulate; a someone whom one might recognize as one's "self" (see Bal 1994).

What the museum subject "sees" in this remarkable institutional space is a series of "mirrors"– possible ways in which it can construct or compose its life as one or another kind of centered unity or consistency which draws together in a decorous and telling order its sundry devices and desires. Museums put us in the picture, by teaching us how to appear picture-perfect. Ethics and aesthetics, in this virtual reality, are portions of the same museological Moebius strip; discursive spaces which only at first glance appear unconnected and discontinuous (as with any "contiguous" or "related" field). They are allomorphs, so to speak – variant formations stemming from a common core concern. The semiotic operations of this disciplinary technology are stunningly simple, even if their effects are enormously complex and subtle.

The museum (art) object has, in fact, a distinctly hybrid status, staged – as it has been since the late eighteenth century – in a spatiotemporal framework of oscillating determinacy and causality. *On the one hand*, the object's meaning or significance is perpetually deferred across a network of associations defined by formal or thematic relationships. Staged as a specimen of a class of like objects (which may or may not be physically present in the same space – every museum, after all, is a fragment of some vaster ideal totality of instances), each of which seems to provide "evidence" for the progressive "solution" to similar problems of depiction or representation, the object's meaning is literally "elsewhere" (in museographical, archival, or art historical space).

On the other hand, it is invariably foregrounded as unique and irreplaceable, as singular and non-reproducible, its significance or meaning rooted in its emblematic and expressive properties relative to (emblematic or "representative" of) its maker or source. In this respect, the very *form* of the work is always read in some manner as the *figure* of its truth – a truth seemingly connected directly and transitively to the vision, mission, intentions, mentality, or character of the maker or source (a person or people, an ethnicity, class, gender, or race, and so on).

As deployed in museographical (art historical, critical, or theoretical) exegesis and museological stagecraft, the museum object is thus *simultaneously* referential and differential in character. This is akin to the simultaneity of an optical illusion, wherein there is an oscillating determinacy (akin to that of the famous Necker cube or the rabbit/duck illusion), where either one or the other facet is foregrounded at any one time, only to be subject to a perpetual slippage or alternation with its other. This precisely constitutes the semiotic and epistemological status of the art museum

object, if the term status is at all meaningful in this highly complex, dynamic, and co-constructive system of relationships, suggesting as it does a certain stasis. But any stasis here is momentary, always subject to change and reversal or transformation.

In brief, referentiality is paradoxically both the foreground and background to differentiality, and vice versa, in an oscillation or slippage which can never finally be fixed in place, and which itself mirrors the paradoxical and ambivalent psychic status of ourselves as subjects. We are both instances and unique. Of course, historically, it has been this very oscillation or "incompleteness" of any one mode of (for example) art historical "explanation" that has literally kept disciplinary discourse in play for so long, by the continual fielding of art historicist "theories" and "methodological" paradigms. Rather like an alternating current, this oscillating determinacy is virtually invisible in "ordinary" (that is, exegetical or analytical) light, and is palpable primarily anamorphically, by reading or seeing "against the grain." Since its historical foundations, the academic discipline of art history has been (and remains) deeply rooted in this perennially inescapable paradox – a situation echoed in sociology in the perennial structure/agency debates.

All this is, in fact, epistemologically similar to the object/instrument character of art itself on another level, wherein museological stagecraft – and museographical argument – generate a paradoxical, enigmatic, and indeterminate field of legibility. In attending to the artifice of museological stagecraft (and that of museographical demonstration and proof), the ambivalent semiotic character of this extraordinary object may be made more palpable. The aim of art historical exegesis in the twenty-first no less than in the nineteenth and twentieth centuries is, of course, to *render legible what is visible* – and this has always included those forms of reading where illegibility and enigma were articulated as versions of the legible.

The Object in Space and Time

In that regard, museum objects are literally both "there" and "not-there," present and absent, and in fact in two distinct ways.

In the first place, (a) the object is quite obviously materially part of its position (situation) in the historiographic theater of the museum. (It is in fact physically present.). Yet at the same time, (b) it is unnaturally abstracted there from some "original" situation: its present situation is in one sense fraudulent (this museum is not "its" place, even where the object's authenticity-value supports its exhibition-value). This complexity is further compounded in the case of objects ostensibly (or not) "made for" museological or museographic reasons, which problematize (or not) the belonging-ness of other (or any) museum objects, or objects of museographic (art historical or critical) attention.

In the second place, the object's significance, how it may be construed or constructed or behaviorally deployed is both present and absent, in the manner described above: its semiotic status is both referential and differential; it is both directly and indirectly meaningful. Or, to speak more technically, it exhibits *sense-determinative* and *sense-discriminative* semiotic properties.

54

The situation may be further elucidated by focusing on the hybrid nature and functioning of the *commodity* during and since the nineteenth century. Commodities seem like unified objects, but their unities mask an often very great disjunction between the processes of labor which engender the commodity and the object's (aesthetic or monetary) exchange-value. In a literal sense, it is the familiar erasure of all but highly aestheticized or romanticized traces of work and labor which thereby stages and circulates the object *as* a commodity as such, and as an object of (varying forms of fetishistic) desire.

Formalism and contextualism – which situate meaningfulness either in the object itself or in the object's historical contexts or circumstances of production and reception – are prefabricated positions in the same ideological system of representation; co-determining and coordinated facets not only of art history, but also of the sociopolitical (and semiological) enterprise of modernity itself. It may be time to rethink certain other conventional and static oppositions such as the distinction between "monuments" imagined to be mute and "documents" imagined to be vocal. Each of these is in fact already a semiologically hybrid category: within a singular continuum of artifice, it would be more accurate to speak in terms of the relative dominance of one semiotic relationship over a subordinate, but nonetheless co-present, relationship among object, maker, and user. Another term for such a tri-partite relationship is *decorum*.

Semiotic processes are at base coevally multi-functional and multi-modal. Simply put, (a) social and cultural behaviors and signifying activities are at base multiply meaningful, and (b) social and cultural behaviors are predominantly carried forth using a variety of signaling means or modalities, typically simultaneously or in tandem. In the latter case, for example, this means that we invariably speak *in concert with* other signifying or semiotic behaviors (body-language, spatial behaviors, costuming, and so on) so that the communicative process goes forward using a variety of signaling systems, whether one or another may be dominant and inflected by another or others.

Suffice it to say here that *metonymy* – the sequential, juxtapositional, and part–whole relations between events or things – and *metaphor* – relationships of similarity between events or objects – are invariably co-present and interactive at multiple levels of making meaning. Rather than continuing to run around in circles trying to fix in place once and for all the singular, pure, or "true" meaning of an object or objects, we might more productively attend to the manner in which referentiality and differentiality operate in differing degrees in specific historical contexts. At the same time it is necessary to articulate just who or what benefits by keeping such "running in circles" in play.

We have far to go to adequately understand the implications of seeing "history" as the museological unconscious, for the semiotic status of the museum's objects implicates subjects whose own unconscious is trans-individual. Moreover, we are just beginning to appreciate some of the central semiological and psychological mechanisms upon which the objects of museological stagecraft and museographical (i.e., art historical, critical, and theoretical) discourse are dependent, and with which being a "subject" in a museum (and consequently in that thoroughly museologized world whose name is modernity) is staged, framed, and played out. It may

become clearer just what these modernist "subjects" and "objects" are doing in the first place.

In this regard, museology and museography are inseparable from and continuous with other epistemological technologies for the fabrication and maintenance of the modern nation-state and of the kind of subjects it requires to function effectively. Both practices might arguably be seen as *allomorphic* to other professional practices later in the nineteenth century – the distinct and opposed discursive sites of history-writing (historiography) and psychoanalysis.

The Subject in the Museum

In the end, our attempts to articulate the nature of the museum object slide imperceptibly, as along the surface of a Moebius strip, into an engagement with the museum subject. The veritable *summa* of opticality – and an invention as profound in its consequences as that of one-point perspective construction a couple of centuries earlier – the museum exposes the user's identity to an "otherness" whose own identity is *both* present and absent. The object can only confront the subject from a place where the subject is not. It is in this fascination with modernity's paradigmatic object – with "art" as such in museological and discursive space – that the subject or spectator is "bound over" to it, laying down his or her gaze in favor of this quite remarkable object. And it is in this fascination that we find ourselves, as subjects, *re*-membered (repairing our dis-memberment). Museums dis-arm us so as to make us remember ourselves in new ways. Or, to put it another way, museums help us to forget that we have forgotten who we are. Our need (or desire) to reckon with the institution of the museum is a perpetuation of the Imaginary order in the daily life of the systems of the Symbolic; the fascination of the child – its being drawn to and tied to its mirror image(s), its "imaginary" or image-laden sense of wholeness, which coincides with its (and our) recognition of lack.

As optical instruments, then, museums in this sense serve a decidedly *autoscopic* function, providing "external" (organs for the) perception of the individual subject and its agency. However, the museum object (rather like an ego) does not strictly coincide with the subject, but is rather an unstable site where the distinction between inside and outside, and between subject and object, is continually and unendingly negotiated in individual confrontations. The museum is in fact a theater for the coordination of an I/eye confronting the world-as-object, with an I/eye confronting itself as an object among objects in that world: an adequation that is never quite complete and that remains endlessly pursued. The museum and art have been so successful precisely because these adequations, these circuits of desire, must be continually (re)adjusted. There is always more than meets the I.

What we recognize in modernity as art came to be a universal method of (re)narrativizing and (re)centering history itself by establishing a standard or canon (medium or frame) in or against which all peoples of all times and places might be seen together in the same epistemological space. All could be plotted on the same graph of aesthetic progress and (thus) ethical and cognitive advancement; all could

be accorded historiographic anteriority or posteriority. Once this remarkable invention came to be deployed (museologically and museographically), it proceeded, inevitably, to "find itself" everywhere, in all human productivity. Works of art were constru(ct)ed as the most paradigmatic and exemplary of human activities, more fully revelatory and evidentiary than anything else (apart from subjects themselves) in the world. All the world's things and all commodities are thus galvanized into greater or lesser approximations of this ideal.

To each people belongs its proper and unique art, and to each art its proper position as a station on the historiographic grand tour leading up to the modernity and presentness, the always-alreadyness, of Europe (or "the West"). Against this, all that which was not (of) Europe was "objectified" – or put-back-behind as anterior. To leave Europe (that brain of the earth's body) was to enter the past, the realm of all that might be framed as prologue. This constituted an alterity in the process of being transformed into the future anterior of political, economic, and social colonization and domination, into the field of play of entrepreneurial opportunism.

Museology and art history came to modern maturity in the age of the European Enlightenment, a period not so coincidentally a time of the blossoming of (among a series of related creeds) the secular religiosity of Freemasonry, whose central tenets were that transformations of character could be effected by transformations in the material environment. The idea that character and spirit could be molded (for good or ill) by molding space and material circumstance is at the core of the modern idea of the museum, and indeed of art as such. The modern history of the civic museum begins in attempts in various parts of Europe and America to embody that creed (Preziosi 2003).

Molding Material: The Masonic Idea of the Museum

It may be useful to recall here something that has become largely invisible today in the modern discourse on museology and art history: that the rise of the modern museum as an instrument of individual and social transformation during the Enlightenment was a specifically *Masonic* idea. It is not simply the case that virtually every single founder and director of the new museums in Europe and America in the late eighteenth and early nineteenth centuries was a Freemason; the idea of shaping spatial experience as a key agent in the shaping of character was central to the Enlightenment mission of Freemasonry from the beginning (Lenoir 1814). The civic museum institutions founded in the late eighteenth and early nineteenth centuries in Europe and America were Masonic realizations of a new form of fraternization not dependent upon political, religious, or kinship alliances, and tied to the social revolutions on both sides of the Atlantic – that is, citizenship. As with the most influential of these institutions, the Louvre Museum (which was very explicitly organized for the political task of creating republican citizens out of former monarchical subjects), they provided subjects with the means for recognizing and realizing themselves as citizens of communities and nations (a fuller account of this and what follows may be found in Preziosi 2003).

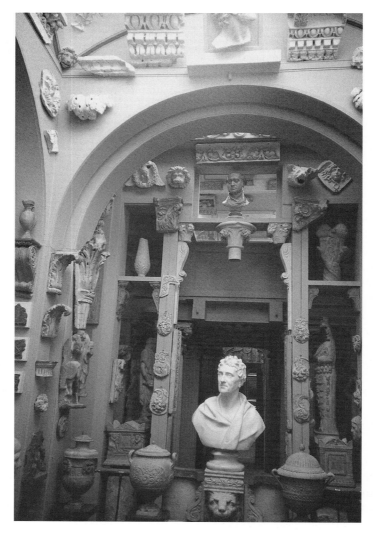

Figure 4.1 Sir John Soane's Museum: interior of the Dome area. Photograph by Donald Preziosi. Reproduced courtesy of the Trustees of Sir John Soane's Museum.

Sir John Soane's Museum in London (figs 4.1–4.3) is, in fact, unique today because, in its actual physical preservation, it has retained a palpable flavor of the articulation of the Masonic program that Soane shared with contemporaries such as Alexandre Lenoir, founder of the Museum of French Monuments in the former Convent of the Lesser Augustines (Lenoir 1800–21, 1814; Bann 1984; McClellan 1994), the original Ashmolean, arguably the first public museum in Europe (1683), founded by one of the first known British masons, Elias Ashmole (Josten 1966; Simcock 1983), and, in part, the British Museum during its Montague House period, the antecedent of the present classicist confection of 1847–51 (Crook 1972; Miller

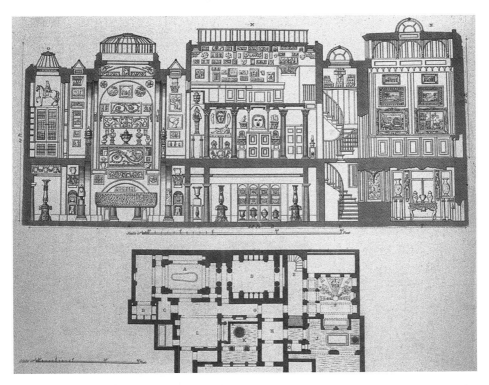

Figure 4.2 Plan and section of Sir John Soane's Museum from John Britten, *The Union of Architecture, Sculpture and Painting* (London, 1827). Reproduced courtesy of the Trustees of Sir John Soane's Museum.

1973; Caygill 1981). In Berlin, Karl Friedrich Schinkel's Altes Museum exemplified similar organizational principles (Crimp 1993). Of all these Masonic foundations, only Soane's retains the character that all these others (where they still exist) have lost. The earliest American museum, Peale's Museum in Philadelphia, occupying the upper floor of the newly inaugurated American government, no longer exists. Soane's collection of Masonic books also included those of Lenoir, and he was well acquainted with Ledoux's 1804 volume *L'Architecture considerée sous la rapport de l'art, les moeurs, et de la législation* (Ernst 1993; Watkin 1995).

"Free" or "speculative" Masonry, which was set in opposition to practical masonry as "theory" to "practice," was founded upon a desire to reconstitute in modern times *simulacra* of the ancient Temple of Solomon, said to have been designed by the Palestinian (Philistine) architect Hiram of the old coastal city of Tyre for the Jews of the inland kingdom of Israel – a building which, in its every, tiniest detail, was believed to encapsulate all knowledge.

Soane's Museum, insofar as the archival records examined to date indicate, was not used as a Masonic lodge or temple. Yet there is a passage through these complex spaces that uncannily replicates the stages illustrated in the Masonic "tracing board" presentations of the three stages or "degrees" of initiation – that is, the three stages

Figure 4.3 Bust of Sir John Soane from behind. Photograph by Donald Preziosi. Reproduced courtesy of the Trustees of Sir John Soane's Museum.

of enlightenment the individual is exhorted to follow. Where this route may have been is given by a single, remaining clue: the name Soane gave to a small space in the basement on the south side of the lower floor, namely "The Anteroom"; this is a room a visitor would pass by on the way to the public restrooms, but in Soane's day it could be directly entered from the outside of the building. This constituted the "other" or lower ground floor level access into the building. If you were to begin your visit to the museum in this "anteroom" or vestibular space, you would then proceed into and through this dark and sepulchral basement, with its reminders of death and mortality – the (no longer extant cul-de-sac of) the "Egyptian tomb" ahead of you and into the realm of the fictitious medieval monk Padre Giovanni – his parlor, cell, and tomb-yard to the east.

This would then lead you to the stairwell to the first floor, with its classical decoration, and you would pass through the Corinthian order colonnade toward the back of the bust of Soane confronting the Apollo Belvedere across the open space. From behind, as you approach the back of Soane's bust, Soane and Apollo are superimposed, Soane's head in fact hiding the (now fig-leafed) god's genitalia (see fig. 4.3). The position of Soane's bust on the Dome's balustrade was the place where the fragments of the collection fell into their proper perspective, and where, standing with Soane, the veritable *genius loci* or "spirit" of the place, you would see laid out verti-

cally before you the progression from the sarcophagus in the basement to Apollo to the brilliant light of the Dome skylight above. This vertical tableau corresponds, in Masonic lore, to a passage from the death of the old self, to rebirth and enlightenment. The sarcophagus on these tracing boards symbolically holds the dead body of the artist or architect before rebirth and enlightenment.

You have, in other words, a series of progressions mapped out throughout the museum's spaces: from death to life to enlightenment; from lower to higher; from dark to light; from multiple colors to their resolution as brilliant white light; from a realm where there is no reflection (basement level) to one where everything is multiply reflected and refracted (the many mirrored spaces of the first-floor level). Soane stands at the pivotal point of all of this, and moreover *ostensifies* his role as a Master Mason devoted to community outreach, charity, and education, by (if you stand across the Dome by Apollo; see fig. 4.1) appearing to carry on his shoulders the future generation of student apprentices who study and work in their office above and behind his bust. In Masonic tracing boards, the Master Mason is frequently depicted as carrying a child on his shoulders.

Soane – who as a Master Mason (and as Grand Superintendent of Works within the upper echelons of British Freemasonry) was obliged to dedicate his life to communal or public service, and who created this as a kind of secular Masonic institution – here provided his visitors with a set of techniques, derived from Masonic practice, for creatively and concretely imagining a humane modern world, a world that reintegrated the lost social and artistic ideals being rent asunder by the early Industrial Revolution; that is, by capitalism. It did *not* portray or "illustrate" a "history" of art or architecture, and in this respect, Soane's Museum was a *critical* rather than representational artifact. At the same time, Soane ostensified, revealing by his pose and position, the taking up of a point of view – literally, a *telling perspective* – which provided keys to the narrative sense and compositional order and syntax of the fragments in the museum (on collecting as narration, see Ernst 1993; Bal 1994). In seeing Soane seeing, the visitor could learn to envision a new world out of the detritus of the old.

Soane's Museum was thus neither an "historical" museum, nor a "private collection" in their more familiar recent senses. It was among other things an instrument of social change and transformation. To visit it was not to enter a warehouse but a kaleidoscopic machinery designed to proactively engage the imagination. It was a *collection* in the root meaning of the term: an assemblage of objects given to be "read together," in which the process of "reading" – the visitor's active use of the spaces over time – was dynamically and metamorphically productive of sense.

Whatever art historical values we may attribute to the objects we see today in Soane's Museum, they did not, in Soane's time, have primarily autonomous meanings that were fixed or final; they were, to use a linguistic or semiotic analogy, more phonemic than morphemic, being indirectly or differentially meaningful rather than directly significative. Their significance lay in their potential to be recombined and recollected by the visitor to form directly meaningful units – what Soane himself referred to as the "union of all the arts." They are thus not strictly "objects" at all in the common (modern art historical or museological) sense of the term; and still less are they "historical" in any historicist sense.

Donald Preziosi

John Soane's Museum ostensified a mode of perception understood as proactive and constructive, rather than passive and consumptive. Emblematic of Soane's practice as an architect and designer, it existed to enlighten and to project a vision of a humane modern environment in response to the massively disruptive forces of early nineteenth-century industrialization. That world came to be apotheosized a decade and a half after Soane's death in the Great Exhibition of the Arts and Manufactures of All Nations at the Crystal Palace of 1851 (Preziosi 1999). The latter's many progeny – and not Soane's more radical (Masonic) Enlightenment visions – constitute the museological and art historical institutions and their associated professional practices so familiar to us now as to seem natural or inevitable (Preziosi 2003; Preziosi and Farago 2004).

Conclusion

We have yet to exit that space haunting all subsequent museums, or to cease our fascinations with being haunted by what we find there, or the selves that appear to be elicited in what we find.

Bibliography

Bal, M. (1994) Telling objects: a narrative perspective on collecting. In J. Elsner and R. Cardinal (eds), *The Cultures of Collecting*, pp. 97–115. London: Reaktion Books.

*Bann, S. (1984) *The Clothing of Clio: A Study of the Representation of History in Nineteenth-century Britain and France*. Cambridge: Cambridge University Press.

Caygill, M. (1981) *The Story of the British Museum*. London: British Museum.

Crimp, D. (1993) *On the Museum's Ruins*. Cambridge, MA: MIT Press.

Crook. J. M. (1972) *The British Museum: A Case-study in Architectural Politics*. London: Allen Lane.

Curl, J. S. (1993) *The Art and Architecture of Freemasonry*. Woodstock, NY: Overlook Press.

Deotte, J-L. (1993) *Le Musée, l'origine de l'esthétique*. Paris: Harmattan.

Elsner, J. (1994) A collector's model of desire: the house and museum of Sir John Soane. In J. Elsner and R. Cardinal (eds), *The Cultures of Collecting*, pp. 155–76. London: Reaktion Books.

Ernst, W. (1993) Frames at work: museological imagination and historical discourse in neoclassical Britain. *The Art Bulletin*, 75 (3): 481–98.

Josten, C. H. (1966) *Elias Ashmole (1617–1692): His Autobiographical and Historical Notes, his Correspondence, and other Contemporary Sources relating to his Life and Work*, 5 vols. Oxford: Clarendon Press.

Lenoir, A. (1800–21) *Musée des monuments Français*, 8 vols. Paris: Imprimerie de Guilleminet.

—— (1814) *La franche-maçonnerie rendre à sa veritable origines, ou, l'antiquité de la franche-maçonnerie*. Paris: Fournier.

McClellan, A. (1994) *Inventing the Louvre: Art, Politics, and the Origins of the Modern Museum in Eighteenth-century Paris*. Cambridge: Cambridge University Press.

Miller, E. (1973) *That Noble Cabinet: A History of the British Museum*. London: Deutsch.

Preziosi, D. (ed.) (1998) *The Art of Art History*. Oxford: Oxford University Press.

— (1999) The crystalline veil and the phallomorphic imaginary. In A. Coles (ed.), *The Optic of Walter Benjamin: De-, Dis-, Ex-*, vol. 3, pp. 120–36. London: Black Dog.

*— (2003) *Brain of the Earth's Body: Art, Museums, and the Phantasms of Modernity*. Minneapolis, MN: University of Minnesota Press.

*— and Farago, C. (eds) (2004) *Grasping the World: The Idea of the Museum*. London: Ashgate Press.

Simcock, A. V. (ed.) (1983) *Robert T. Gunther and the Old Ashmolean*, part II: *A Dodo in the Ark*, pp. 43–92. Oxford: Museum of the History of Science.

Watkin, D. (1995) Freemasonry and John Soane. *Journal of the Society of Architectural Historians*, 54 (4): 402–16.

Museums and Anthropologies: Practices and Narratives

Anthony Alan Shelton

The development of anthropology has been strongly influenced by its pre-institutional intellectual presuppositions and its subsequent early and varied institutionalization in learned societies, museums, and universities. At least three distinct modes of the discipline's institutionalization can be discerned. In Britain, Germany, and Denmark, anthropology's newly emerging mainstream paradigms were nurtured in museums; while in the United States, Mexico, and Japan, although some areas of the subject were, and are, closely connected to museums, it was not exclusively associated with them. Elsewhere, in France, anthropology, closely associated with sociology in the Durkheimian tradition, underwent separate academic institutionalization. Not until the former Musée d'Ethnographie du Trocadéro underwent disciplinary reform, consummated in its name change in 1937 to the Musée de l'Homme, did a significant current of museum anthropology come to maturity. Different national traditions cannot therefore be reduced to a single or general developmental model. Furthermore, given that curators work in medium-term cycles divided between "housekeeping," exhibitions, and scholarly research, chronologies, such as those devised by Sturtevant (1969), based primarily on the output of museum and material culture related articles in selected journals, must be regarded as imprecise indications of the vitality or otherwise of ethnographic museums generally. Only in a few, mainly northern European, cases can museums be regarded as what Lurie has called the "institutional homeland of anthropology" (1981: 184).

Origins and Foundation Narratives, 1836–1931

In Europe and the Americas, museums created to house "ethnographic" collections were constructed in two waves: the first dating between 1849 and 1884; the second, following shortly after, from 1890 to 1931. With the exception of two early precursors – the museum of the Academy of Sciences of St Petersburg, founded in 1836 and Ph. F. von Siebold's Japan Museum, which after opening in 1837 later became

Leiden's Rijksmuseum voor Volkenkunde – most of the two continents' great ethnographic museums were established in a brief period of thirty-five years during the first of these two waves. The inauguration of the Royal Ethnographic Museum of Copenhagen (1849) was followed by a long line of eminent institutions: the Göteborg Museum (1861); the Museu Paraense Emílio Goeldi, Belém (1866); the Peabody Museum of Archaeology and Anthropology at Harvard (1866); Leipzig's Grassi Museum (1868); the Munich Museum für Völkerkunde (1868); the American Museum of Natural History in New York (1869); the Berlin Museum für Völkerkunde (1873); the Museo Nacional de Etnologia, Madrid (1875); the Ethnographische Museum, Dresden (1875); the Pigorini Museum, Rome (1876); the Musée d'Ethnographie du Trocadéro, Paris (1878); the Pitt Rivers Museum, Oxford (1883); the Museum voor Land-en Volkenkunde, Rotterdam (1883); and the Cambridge Museum of Archaeology and Anthropology (1884).

Significantly, all these museums predated the 1884–5 Conference of Berlin which marked the start of Europe's systematic and concerted colonization of Africa, while the second wave, instigated with the establishment of the Museum für Natur-, Völker- und Handelskunde, Bremen (1890), followed by the Imperial Institute, London (1893), the Musée Royal de l'Afrique Centrale, near Brussels (1898), the Koloniaal, later Tropenmuseum, Amsterdam (established 1910, but opened 1926), and the Musée des Colonies, Paris (1931, after 1960, the Musée des Arts d'Afrique et d'Océanie), corresponded to the heyday of European colonization. This latter wave of museums was dedicated to the collection, research, and exhibition of exotic products and was everywhere strongly inflected by colonial ideologies, policies, and aspirations. Each wave of museum construction, despite occurring in close succession, corresponded to distinct social and political conditions within European metropolitan cultures, which culminated with the rise of competitive nationalisms whose aggressive postures were fortified by a closer identification between individual wellbeing and that of nation-states (Schildkrout and Keim 1998: 10). When examining differences in the early presuppositions behind exhibitions, it is worth remembering that most German museums originated well within the national culture of the first of these waves, while British museums and collections corresponded to a transitional period, more closely associated with the second.

The institutionalization of non-Western objects was, of course, neither restricted to ethnographic and colonial museums, nor the interpretative strategies they espoused. Frese (1960: 15) distinguished eight types of institutions housing ethnographic collections, including encyclopedic, natural history, mankind, art, and missionary museums, to draw attention to the different significations that institutional narratives ascribe. More recently, Clifford (1997: 110) has described and portrayed in more detail the entangled, subtle, and complex relations between museum narratives and material interpretations in four Canadian Pacific Coast museums. Narratives are also affected by external contingencies, sometimes reflected in a museum's name change, which might, over time, even redefine institutional objectives (Shelton 2000: 155). Bremen's Museum für Natur-, Völker- und Handelskunde, for example, was founded in 1890. Under the Nazis, it was renamed the Deutsches Kolonial- und Übersee-Museum, reflecting imperial sentiment; then, in 1945, its colonial appellation was withdrawn, leaving it as the Übersee-Museum which, in the 1970s, changed

its orientation again to adopt new sociological perspectives. Other institutions have changed their objectives without any corresponding name change. The Imperial Institute shifted its collection and exhibition policy several times, effectively transforming itself, first in 1926, from an index collection of the British Empire's natural, industrial, and commercial resources, into a narrative-centered "empire story-land" in which dioramas, models, photographs, and maps illustrated notable events, economic activities, and geographical regions. In 1952, it moved its emphasis a third time: from commodity- to people-centered exhibits (Crinson 1999: 109–13).

A large part of the nineteenth-century museological infrastructure – collections, systems of classification, and institutional imaginaries – predated museums themselves. Two early systems of classification and display were developed in the 1830s and 1840s by the French geographer Edmé François Jomard and the Prussian physician Ph. F. von Siebold. Jomard's comparative approach to the presentation of objects according to their function was challenged by von Siebold, who argued that objects should first be classified and presented according to geographical origin, and only secondarily by function. Jomard was unequivocal in his materialism and rejection of aesthetic approaches: "there is no question of beauty in these arts . . . but only of objects considered in relation to practical and social utility" (quoted in Williams 1985: 147). Over and above their differences, Jomard and von Siebold attempted to impose systematic scientific principles of classification as a means of relating collecting and presentation to illustration in place of the caprice of their former curiosity values and, consequently, are often acknowledged as the forefathers of "scientific" museum ethnography.

Frese (1960: 39) saw Jomard and von Siebold as precursors to evolutionary and geographical-cultural approaches to ethnographic classification and the various attempts at their reconciliation which they repeatedly elicited. In one early synthesis, Christian Jürgensen Thomsen advocated that material culture should be divided geographically and then subdivided according to Jomard's detailed functional classification. He then imposed two further tripartite classifications of his own, creating additional subdivisions based on the climatic conditions under which peoples lived (hot, temperate, and cold climates), and their stage of cultural development (societies with writing and knowledge of metallurgy, societies without writing, but with knowledge of metallurgy, and societies that lacked both). Even the typological evolutionist Augustus Pitt Rivers tried to reconcile his approach with a geographical perspective by suggesting that, in an ideal museum, collections would be arranged around successive concentric galleries, each containing objects attributed to a specific period (see fig. 5.1 for an example of typological display in the Pitt Rivers Museum). The inner to outermost galleries would be divided into distinct slices within which objects from specific geographical areas would be assembled in close proximity (Chapman 1985: 40–1). The idea for such an apparently novel architectural space was perhaps taken from Le Play's design for a concentric exhibition building for the 1867 Paris international exhibition which also attempted to reconcile evolutionary and geographical classification of exhibits in an encyclopedic-type presentation.

Not only classificatory schemes, but collections too predated the establishment of the first ethnographic museums. European museums, like Berlin, Copenhagen,

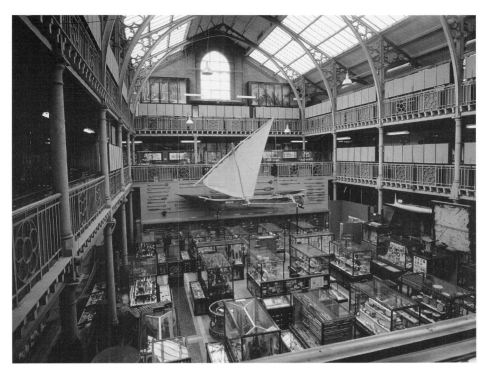

Figure 5.1 View of Pitt Rivers Museum from east side of lower gallery looking over the court exhibition area where the artifacts are displayed according to type and function (c. 1975). Reproduced courtesy of the University of Oxford, Pitt Rivers Museum, 1998.267.281.1.

Munich, Leiden, and St Petersburg, were from the beginning heavily indebted to former royal cabinets. Others incorporated ecclesiastical collections, like the Pigorini in Rome, which inherited the holdings of the former Museo Kircheriano. More commonly, collections were acquired from defunct scientific or philosophical societies, or from the activities of amateur scientists and collectors, like Augustus Pitt Rivers for Oxford, von Siebold for Leiden, Godeffroy for Leipzig, or Maudslay, Gordon, and von Hügel for Cambridge. Many museums benefited from collections acquired from international exhibitions: the Trocadéro from the 1878 Exposition Universelle; the Musée Coloniale from the 1931 Exposition Coloniale; the Imperial Institute from the 1886 British Colonial Exhibition; the Museum für Natur-, Völker- und Handelskunde from the 1890 Handels- und Kolonial Ausstellung; and the Chicago Columbian Field Museum from the 1893 World's Columbian Exhibition.

By the late nineteenth century, German museums had moved away from acquiring collections solely through donations and purchase to sponsoring their own scientific expeditions. The model for these was provided by Adrian Jacobsen's 1881 expedition for the Berlin Museum to the Northwest Coast and Alaska and his subsequent expeditions to Siberia (1884–5) and Indonesia (1887–8). Between 1887 and 1915, the Berlin Museum sent six expeditions to Mexico, and at least another six to

Oceania, without counting those it dispatched elsewhere in the world or joint expeditions organized with other institutions. In Britain, Alfred Cort Haddon led an expedition to the Torres Strait Islands in 1898, but his venture failed to attract the same support as those in Germany, and was not quickly emulated. Expeditionary collecting allowed for more controlled and better-documented acquisitions, a requirement that provided criteria for distinguishing the emerging subject position of scientific specialists from amateur collectors. Objects collected during expeditions to little-known regions were valued as pristine cultural representations and clearly distinguished from later, post-contact material. This allowed museums to compete in establishing monopolies over possession of material culture from specific regions. Expeditionary culture also redefined and shifted the value of ethnographic material away from it being intrinsic to the objects themselves to a measure of their referential or documentary significance for non-material culture.

Though this pattern of collecting developed late in France, the Trocadéro's Dakar–Djibouti expedition, undertaken between 1931 and 1933 still managed to acquire 3,500 ethnographic objects, including an important collection of Abyssinian paintings and murals from a church in Gondor, 300 Ethiopian manuscripts and amulets, and 6,000 photographs, to say nothing of botanical and zoological collections. These highly organized, comprehensive, systematic, and concerted collecting expeditions deeply affected the societies they afflicted. Complaints against Leo Frobenius, who led no less than six major expeditions to Africa between 1904 and 1914 for various German museums, were legion; while the reputation of the Dakar–Djibouti expedition for looting and desecration preceded it, leaving expectant villages terrified and panic stricken. So effective was this form of accumulation world-wide that Sturtevant estimated that, by the mid-1960s, there were more than 1,500,000 ethnographic items in US museums alone, and 4,500,000 in the world as a whole (1969: 640).

Collections were constantly enlarged to achieve increasing comprehensiveness or to reflect new scientific interests, while classifications were adopted and modified for storage, display, and publication. Museum objectives were seldom static and were frequently revised, transforming the character of the institutions themselves (Shelton 2000: 155). German museums, by placing stress on the accumulation of objects over their classification and exhibition, and despite demanding, and often securing, ever-larger buildings to house them, suffered such re-occurring shortages of space that displays were constantly being added to and changed, though not necessarily according to any easily recognizable classificatory logic (Penny 2002: 182). Although displays began to look increasingly like the overstuffed cabinets of curiosities that their curators had most wanted to distance themselves from, the dynamics and motivations behind their growth caution against too readily accepting the popular image of museums as simply being dusty and neglected storehouses of the world's cultures.

German museums justified their unbridled growth by arguing that "primitive" cultures faced extinction due to Western encroachment. Felix von Luschan, one-time director of the Berlin Museum, was adamant that "ethnographic collections and observations can either be made now, in the twelfth hour, or not at all," while his counterpart in Hamburg, Karl Hagen opined: "each day not taken advantage of by a Völkerkunde museum can be counted . . . as a day lost to it" (Penny 2002: 32–3). British observers, while sharing similar fears themselves, were startled by the growth

of their German counterparts. O. M. Dalton, a curator at the British Museum, estimated that, in 1898, the collections of the Berlin Museum alone were "six or seven times as extensive" as those in London, while his contemporary, Northcote Thomas, claimed that in the previous twenty-five years Berlin's ethnographic collections had increased tenfold over those of the British Museum (Penny 2002: 1).

The spectre of cultural extinction, so it was believed, endangered the Enlightenment enterprise of constructing universal history. Adolph Bastian, the first director of Berlin's ethnographic museum, hoped that his exhaustive collections would enable him to devise a comprehensive account of the effects of historical contingency and climatic and geographical variability on material culture from around the world. For Bastian, material culture represented embodied ideas: "material items are forms which are imbued with ideas. To this extent we can call them 'animated' as is any item upon which man has left the imprint of his thinking" (quoted in Koepping 1979: 5). Given that humanity possessed a fundamental psychic unity, similar geographical conditions and shared historical experiences were thought to give rise to closely similar societies sharing related systems of material culture, while divergences were attributed to different historical contacts and dissimilar environmental situations. Once defined, the resulting culture areas provided the organizing criteria for German exhibitions.

Outside Germany, Thomsen's successful tripartite classification of European prehistory based on the use of stone, iron, and bronze, along with the simple chronologies worked out by C. L. Steinhauer and John Lubbock, encouraged British curators to adopt their method to order ethnographic collections (Chapman 1985: 26–7; Shelton 2001: 223). Augustus Pitt Rivers devised an order of weapons using the criteria of "connection of form," tracing their development through the morphological changes that they underwent from the simple to the more complex. After adding a further classification by functional affinity to explain the purpose underlying the developmental linkages within classes, he used the resulting sequences to deduct the evolution of the thought that had produced them (Chapman 1985: 33).

It was not the qualities and propensities common to humanity that subsisted under variations in physical material expressions, endemic to Bastian's universalism, but morphological differences that motivated British and American approaches to universal history. In the latter part of the nineteenth and early twentieth centuries, German intellectual traditions embraced an idealistic, universal conception of humanity that eschewed hierarchical classification and refused to privilege any one society over another (Penny 2002: 23). According to Penny, it was provincial pride, internationalist outlook, and the civic acclamation of the rapidly growing cities that led to sponsorship of the great ethnographic museums of Berlin, Munich, Leipzig, and Hamburg. In contrast, in Britain and the United States, cultural evolution, once adopted by museums, provided an illustrative method by which external and internal colonial ideologies based on notions of tutelage over so-called inferior races could be legitimated. In Britain, such views also enabled class differences, and their wide economic and cultural discrepancies, to be minimized by emphasizing the shared racial unity of the nation against that of others. The ethnocide inflicted on externally or internally colonized cultures, although tainted by nostalgic laments in early exhibits, was nevertheless regarded as inevitable and even justifiable in the wake of

the advancement and provision of more "progressive" forms of technology, beliefs, and economic and organizational models.

Nowhere did the German and British perspectives on universal history come into more sharp contrast than in the United States, where Franz Boas, himself a former member of the Berlin Museum and strongly influenced by Bastian, criticized the evolutionary schemes devised by Otis Mason and John Wesley Powell at the US National Museum (later Smithsonian Institution) for sacrificing the cultural uniqueness of societies for generalized, abstract, and unconfirmable conjectural histories. Even though his culture-area approach temporarily succumbed to that of his evolutionary rivals at the American Museum of Natural History, in the longer term, Boas succeeded in shifting enquiry away from form and function, to meaning, both in material culture studies and later in museum displays (Jacknis 1985: 79).

In Asia, the development of museums promoted by the European powers began in 1778 with the collections assembled by the Dutch in the Bataviaasch Genootschap van Kunsten en Wetenschappen. Other Asian museums incorporating archaeological and ethnographic collections were subsequently established by the British in Calcutta (1796), Madras (1851), Lucknow (1863), Lahore (1864), Bangalore (1865), Mathura (1874), and Colombo (1877). In those parts of Asia that escaped Western colonization, ethnographic collections were established later. In Japan, a nation with an empire of its own, the Tokyo National Museum, which opened in 1872, contained minor ethnographic holdings, though no systematic collecting comparable to that undertaken in Europe and America was instigated until the institutionalization of academic anthropology in Tokyo University twenty years later. Japanese collecting coincided with the second wave of European ethnographic museums, and, like its counterparts, was focused on areas of entrenched colonial interests: Taiwan, Korea, China, Mongolia, Siberia Sakhalin, and the Kuriles (Yoshida 2001: 89). Japan also adopted European anthropological paradigms to structure its exhibitions. In the Fifth Domestic Exhibition for the Promotion of Industry, Tokyo, a "Great Map of the Human Races" was displayed alongside collections focused on the "customs, implements and patterns of daily life" of those races living near the country's borders. By 1904, the paradigm had changed from a universal, comparative approach to one firmly based on hierarchical classifications in which collections were used to illustrate evolutionary sequences which equated ancient Japan with the contemporary ethnic groups living around its borders (Yoshida 2001).

By the late nineteenth and early twentieth centuries, European and Asian museums tended to reflect, either in their collections or in their interpretations, and often in both, the colonial interests of the metropolis. Although often fiercely competitive, many museums were part of larger networks which, regardless of scholarly orientation, encouraged the sharing of knowledge and the exchange of "duplicate" or "superfluous" objects. Museums sometimes adopted similar stratified organizational models as the political regimes in which they operated, with a national metropolitan museum at the head, followed by the large, then smaller, provincial museums and overseas colonial museums. By the influence they exerted in directing collecting, and in organizing, interpreting, and disseminating the data obtained, such arrangements assisted metropolitan institutions in shaping knowledge in accordance with national interests.

Divergences, Eclipses, and Renewals, 1932–1994

While in France the Année Sociologique encouraged a redirection in the research and exhibits of the Musée de l'Homme, in Britain, museum anthropology became increasingly marginalized as a result of Radcliffe-Brown's reorientation of ethnographic method and subject. Mauss's 1926–39 Paris lectures, published in 1947 in his *Manuel d'ethnographie*, unequivocally claimed museography to be a branch of ethnography; the ethnographic museum was the material archive of the people that it studied, and the interpretation and presentation of material and non-material culture was, he argued, inseparably linked (1947: 11–13). In Mauss's view, museum exhibits should be divided between *synthèse* and *analyse*: the first was constituted by comparative summaries of a region's material culture, equivalent to the *morphologie sociale* or survey which he advocated as a prerequisite to detailed ethnographic work, while additional displays, corresponding to his *analyse*, would provide specific functionally related aspects of material and non-material cultures derived from particular sub-areas or related societies. Exhibits were intended to address both the manufacture and use of the materials displayed.

Such a view directly contested the evolutionary museology of Ernest-Théodore Hamy, the founder of the Trocadéro, who, while acknowledging art to be an expression of the religious, cultural, and intellectual conditions of its makers, also saw it as a sign of their position within an evolutionary continuum stretching from the barbarous or grotesque to the European realist ideal. Nevertheless, with his museum understaffed and underfunded, and compounded by his and his successor, René Verneau's, own preferences for speculative research over exhibit design, these prejudices were not reproduced in the displays themselves. For a brief period in the early 1930s, Georges-Henri Rivière organized a number of art exhibitions in the museum, but Paul Rivet's plans for a new institution which would bring teaching, research, and museum activities closely together, brought radically different influences to bear on it (Clifford 1988: 139). Until the 1930s, it was acknowledged that the museum's collections were "arrayed in a haphazard arrangement determined only by storage and display facilities" that "caused pain and embarrassment to ethnographers" (quoted in Williams 1985: 158–63). Nevertheless, despite the surrealist celebration of the Trocadéro as "a jumble of exotica" (Clifford 1988: 135–6) and its brief flirtation with art, an aesthetic revaluation of *arts primitifs* was resisted as Rivière and Rivet showed their closer affinities to Mauss's more scholarly approach. Together with its growing research program, which had already had a spectacular impact on the public imagination with the Dakar–Djibouti expedition, the newly named Musée de l'Homme provided a new institutional setting for anthropology that escaped the crises that afflicted British, German, and American museums.

In Britain, a change in the focus of anthropology away from universal history to the study of the social structure of specific, small-scale societies, coupled with new funding sources and its re-institutionalization in university departments, led to the rejection of the evolutionary paradigm, and with it a decline in the significance and interest in ethnographic collections. The decisive break between museums and anthropology can be traced to the publication in 1922 of Radcliffe-Brown's *Andaman*

Islanders. Here, a functionalist anthropology of art, articulated in the chapter on the social significance of tattoos, complemented his overall interpretation of Andaman society, while material culture was consigned to a long descriptive appendix completely divorced from the text's main interpretative body. Museums were abandoned to material culture studies, most of which amounted to little more than descriptive accounts of technical processes or compendia of material systems, while the eclipse of interpretative or critical research permitted long-outdated evolutionary exhibitions to dominate provincial displays until the middle of the century.

It was not until around the 1950s and early 1960s in Britain that Manchester and Glasgow museums rearranged evolutionary displays and adopted what might be termed a broad functionalist perspective. They were followed in the early 1970s by Brighton, Exeter, and Leeds. On account of the size of their collections, these attempts at monographic displays, although usually fragmentary, were either geographically or thematically focused. Material culture was of secondary importance, serving only as an illustration of general ahistorical, functionalist edicts: masks as agents of social control; the adaptation of tools, clothing, shelters, and containers with their environment; or the integrative function of exchange goods. Nowhere was the intellectual bankruptcy of museum ethnography more evident than in the long periods of time it took for academic narratives to percolate down to inform museum display practices. By the time functionalism finally displaced evolutionary exhibitions, it too was vociferously being rejected by its former academic practitioners.

Until the 1980s, field collecting suffered similar neglect, as the presuppositions and values behind salvage ethnography lingered as its sole justification. Lévi-Strauss echoed fears over the irrevocable disappearance of "traditional" material culture everywhere: "Formerly, anthropological museums sent men travelling in one direction to obtain objects that seemed to be drifting in the opposite direction. Today, however, men travel in all directions; and . . . this increase in contacts leads to the 'homogenization' of material culture (which for primitive societies usually means extinction)" (1968: 377). Nevertheless, although Brian Cranstone, a curator at the British Museum, lamented in 1958 that it was seldom possible for museums in Britain to undertake field collecting, two decades later the situation unexpectedly changed. In 1987, Malcolm McLeod suggested that material culture was not becoming homogenized but hybridized. Arguing that the necessity to collect older material systems of objects and newly hybridized ones presented novel opportunities for ethnographic museums, he succeeded in reversing the British Museum's former inactivity in the field. In just ten years he added nearly 23,000 items to the museum's collections (Houtman 1987: 4).

The period 1920–69 coincided in the United States with what Sturtevant (1969) also found to be a time of sharp decline and intellectual barrenness, marked by the diminishing prestige of museum jobs, a shift in employment and research opportunities to the university, and static policies toward collecting. Research during the period, according to Sturtevant, was negligible, leaving up to 90 percent of US collections never having been investigated (1969: 632). Despite such bleak conditions, the following decade saw a surprising resurgence in material culture studies and the beginning of anthropological museology (Kaplan 1994).

The loss of direction, resulting from the academic isolation felt in museums in Britain and America also affected Germany. Despite a threefold expansion of its museum sector as a whole between 1969 and 1988, ethnographic museums benefited from just four redevelopment projects (Harms 1997: 22). In northern Europe, a number of institutions, including some former colonial museums, reacted to the loss of anthropological direction by adopting sociological perspectives to focus on the global context of other cultures. Some museums even assumed advocacy roles. For example, *Töpferei in Spanien; Ende einer Tradition?* (Museum für Völkerkunde, Hamburg, 1972) criticized Spain's tourist policy under Franco and *Toys for the Souls* (Delft Nusantara Museum, 1979) examined cultural disruption caused by deforestation and forced resettlement in Indonesia. Between 1971 and 1979, Rotterdam curated a series of exhibitions on the lives of Moroccans, Surinamers, and Turkish children living in The Netherlands, while Bremen (1974) and Hamburg (1977) sponsored similar exhibitions on German-based Turkish minorities. Despite having a social relevance that more conventional ethnographic exhibitions had long since lost, a study of visitors to the Tropenmuseum and the Übersee-Museum found the public reluctant to be confronted with the same issues presented in newspapers, news magazines, and television programs, and audiences continued to decline (Harms 1997: 23–4).

After decolonization, former colonial museums continued to function as narrowly applied institutions, much like the Commonwealth Institution, the heir to the collections of the former Imperial Institute. By the end of the twentieth century, despite numerous reforms, refurbishments, and changes in management structure, its endemic failure to reverse public disinterest finally caused its closure. Because such museums often continued to be funded by foreign relations rather than educational ministries, and were hampered by collections narrowly drawn from their former colonies, their fortunes continued to be closely tied to the vicissitudes of colonial and postcolonial history. Changes in government and administration impacted directly on more ideologically constructed displays which could quickly be made redundant or irrelevant. Far from providing the state with a sustained, coherent, and consolidated legitimating narrative for its colonial or neo-colonial adventures, colonial museums mirrored their historical shifts replete with their uncertainties, bad faith, and contradictions well into the postcolonial period. By 1987, commenting on the wider panoply, Kenneth Hudson glumly opined that "it is quite possible that the day of the ethnographic museum has already gone" (Harms 1997: 24).

However, ethnographic museums did not disappear. In Britain, for example, museums such as the Marischal Museum, Aberdeen (see fig. 6.1), the Brighton Museum, and especially the Museum of Mankind (the Ethnography Department of the British Museum), made significant contributions to maintaining and reinvigorating ethnographic displays and museum-based anthropology. At the Museum of Mankind, a lively temporary exhibition policy between 1970 and 1997 defied any single paradigmatic classification. During the early period, contextual exhibitions – what Sturtevant (1969: 644) called the "Milwaukee style" after the museum which, between 1963 and 1971, pioneered them – were common. These used elaborate scenographies to recreate the physical context in which objects from the collection

Anthony Alan Shelton

had once been used; examples included *Yoruba Religious Cults* (1974) and *Asante: Kingdom of Gold* (1976).

Other exhibitions, such as *The Hidden World of the Amazon* (1985) and *Paradise: The Wahgi People of the New Guinea Highlands* (1992), used part reconstructions of original physical spaces in mixed-genre exhibitions. Aesthetic genres were, with the exception of two permanent exhibitions, rarely used. More orthodox monographic exhibitions were employed for historical and technology-centered galleries, such as *A Victorian Earl in the Arctic: The Travels and Collections of the Fifth Earl of Lonsdale* (1989). Craftsmen were brought to the museum to demonstrate the processes through which often impressive constructions were created, *Toraja: Creating an Indonesian Rice Bar* (1988) being of special note. Close participation with originating communities, made possible through fieldwork and collaboration with local anthropologists, characterized many exhibitions, such as *Paradise*. Others, like those curated by Paolozzi (1985) and Sokari Douglas Camp (1995), breached and questioned conventional distinctions between ethnographic and contemporary art and contributed significantly to rethinking museum displays more generally.

Post-narrative Museology, 1994–2005

Beginning in the 1980s, conferences and edited volumes aimed at examining the museum's endemic crises proliferated (for example, Karp and Lavine 1991), and this became part of an impetus for anthropologists to turn their attention to the museum once again. At the same time, ethnographic museums themselves experienced even greater diversification and narrative fragmentation. Strategies to deal with the critique included shifting their focus to collectors and their cultural milieu (for example, in Brighton Museum's 1995 *Collectors Gallery*) or to the general collection's history (for example, *The World Mirrored: Ethnographic Collections over the Last 150 Years*, Nationalmuseet, Copenhagen, 2000).

A different response to the milieu of intellectual uncertainty has been the increasing adoption of aestheticized or "art-type" displays. Some museums, like the Paris-based Musée Dapper, opened with an explicit commitment to aesthetic exhibitions; others, like the Museum für Völkerkunde, Berlin, and the National Museum of Ethnology, Osaka, while having consciously employed aesthetic effect, have structured their displays using anthropological categories; while a further group of museums, including the Tropenmuseum, Amsterdam, sometimes eschew aesthetic effect altogether in favor of documentary realism.

Anthropological debate on the merit of aesthetic approaches to ethnographic exhibitions has recently been revived by major museum developments in Paris and London. The exhibition of selected "masterpieces" or "*arts premiers*," held in the Louvre's Pavillon des Sessions in 2000, coupled with a government proposal to incorporate the collections of the Musée de l'Homme, as well as those of the Musée des Arts d'Afrique et d'Océanie into a newly constructed museum at the Quai Branly, provoked strong resistance from anthropologists. Subsequently, a purely aesthetic approach, promoted by the late art dealer Jacques Kerchache, was tempered, with the appointment of the Marxist anthropologist Maurice Godelier, by a

renewed commitment to ethnographic and historical contextualization. While an aesthetic approach was agreed to be necessary to affirm the universality of artistic creation, geographical and comparative criteria were introduced to structure the organization of collections in the new galleries (Dias 2001: 90–93).

Despite thirty years of anthropological debate, which the curators of the Museum of Mankind did much to foster, the Museum of Mankind was closed in 1994 and its collections reincorporated into the British Museum. The new galleries are examples of the subordination of interpretation to aesthetic presentation. In the case of the Mexican gallery, funded by the Mexican government and part of the country's business community, a display which combined ethnographic and archaeological collections was rejected in favor of a pre-Hispanic "treasures" type exhibition designed by Teodoro Gonzalez de Léon (1994). The adoption of "white cube" designs for the commercially sponsored African galleries clearly confirms a distinct shift in exhibition strategies away from the use of the heterogeneous and more intellectually articulated genres which the museum had pioneered to more circumspect ocular experiences. The support of these and other galleries by foreign national and corporate organizations attests to the growing importance of transnational capital over formerly state-provided funds for national institutions, and coincides with object-makers wanting to identify their works and themselves less with ethnographic and more with aesthetic and universal genres of display. Both of these point to new directions and uses to which museums and collections are being put in some of the world's core cities.

A final type of re-institutionalization and representation of collections to be mentioned here are the newly emerging world cultures, world arts, or international museums, like Rotterdam, Hamburg, and the Swedish consortium based in Stockholm and Göteborg. In 1999, the Museum of Ethnography, Göteborg was amalgamated with the Stockholm-based National Ethnographic Museum, the Museum of Mediterranean and Near Eastern Antiquities, and the Museum of Far Eastern Antiquities to form the National Museum of World Culture. The move was intended to rationalize part of the country's national and municipal collections, promote access, stimulate people-centered, interdisciplinary, and innovative genres of exhibition, and express the global context of many of the world's cultures, including that of Sweden itself. The new museum is intended to instigate a new pedagogy, to close the space between the everyday lived world and museum activities, to conflate academic learning with popular expression, and empower communities to be part of new dialogical relationships, which would acknowledge both scientific and subjective facets of culture. Its new building is due to include temporary exhibitions on African refugees, a global perspective on AIDS, and an installation work by Fred Wilson, thereby incorporating many of the most progressive developments found within museums in the past thirty years, and re-engaging the institution with some of the contemporary issues to which anthropology has itself turned. Furthermore, the Göteborg consortium has been a leading supporter of ASEMUS (The Asia–Europe Museum Network), a proactive body of organizations which include a significant number of ethnographic museums, which has begun to establish joint projects between the two continents designed to create more equitable relations in the sharing of tangible and intangible cultural properties.

What the French and Swedish museums have in common is the erasure of previously consecrated subject boundaries and the desire to revise working relationships with originating communities. What separates them might be the Quai Branley's refusal of any ethnographic deconstruction and decolonization to acknowledge the a priori sanctity of the category "art" in either Western or non-Western societies, and Göteborg's refusal to privilege categories like "art" and "creativity." Quai Branley cannot, therefore, be postcolonial for many anthropologists, in the same way that the Museum of World Culture might not, perhaps, be considered postcolonial by many artists.

Behind what might be seen as many museums' retreat from anthropology, and the fragmentation of any singular or dominant academic paradigm for ethnographic displays, lies a significant organizational shift that has displaced power and influence away from a curatorial coterie into the hands of professional managers and administrators. The rise of managerial dominance in museums in many countries, especially Britain, is part of an "audit culture" which has seen the implementation of policies designed to introduce greater accountability and supposed transparency into institutions, while making them more responsive to the majority population that funds them. Although these structures should theoretically be helpful in narrowing the gap between museum activities and the wider society, in practice such controls have resulted in greater centralization, the redirection and concentration of power into a professional non-curatorial managerial class, and the subordination of museum policies to external institutional objectives. The repercussions of such far-ranging and barely acknowledged changes within museums rank among the most important issues that now need to be addressed. Museums, consequently, are no longer motivated primarily by either established or experimental academic programming, but by the delivery of external institutional objectives broadly related to social-engineering policies and subordinated to supposed market forces. Formerly accepted universal truths have lost the legitimacy they once possessed, and with them, the intellectual legitimation behind narratives has been displaced to the institution's performance in relation to externally imposed objectives.

Ethnographic museums in Canada and the United States, despite also having adopted managerial models, seem at least in part to have avoided anthropology's partial failures in Europe. This may be attributed to wider variations in management models, greater diversity of funding sources, and the effects of particular national political agendas. The more successful museums, acknowledging their position in multi-ethnic nation-states, were quick to reformulate their relations to the originating communities from which parts of their collections came. The Museum of Anthropology at the University of British Columbia (fig. 5.2) has pioneered participatory action research programs with First Nation peoples, and seldom curates exhibitions without the participation of relevant indigenous communities. The National Museum of the American Indian in Washington goes even further by acknowledging the importance of cultural over object preservation, the right of native communities to use museum objects, and the authority of Native American philosophies on the understanding and care of collections, clearly aligning itself with indigenous interests (Clavir 2002: 77).

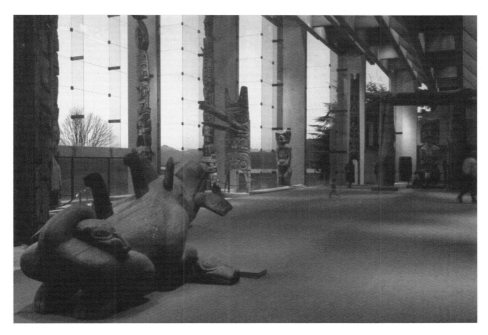

Figure 5.2 "Modernist"-type display in the Great Hall, Museum of Anthropology, University of British Columbia (opened 1976). Photograph courtesy of the Museum of Anthropology, University of British Columbia.

Museums in the Americas, as well as other settler nations, can no longer rely on their traditional monopoly over technologies of representation, but must embrace new ethical values to replace those which were sometimes harmed by former collection and exhibition policies (for example, Phillips 2003). This involves widening intercultural relationships from those established solely around collecting and display to include related issues of restitution, cultural management, and the museum's wider political integrations. As Clavir (2002: 76) astutely notes with reference to Canadian First Nation peoples: "Having control over the tangible objects in museums plays a role in having control over the intangibles" and becomes an important step toward the reclamation of cultural heritage.

Despite, or perhaps because of, such changes, some museums have developed and sharpened innovative interpretative strategies by curating temporary exhibitions. It is here that the past thirty years of critical scholarship have had their greatest impact. Even a superficial review of temporary exhibitions curated by ethnography museums or by anthropologists during the past few decades shows an impressive array of approaches.

1 Comparative thematic approaches are particularly evident in the programs of the Musée d'Ethnographie, Neuchatel (*Collections passion*, 1982; *Objets prétextes, objets manipululés*, 1984; *Temps perdu, temps retrouvé*, 1985; *Le mal et la douleur*, 1986; *Des animaux et des hommes*, 1987; *Les femmes*, 1992; *Marx 2000*, 1994).

2 The reflexive turn in anthropology has also had an important impact on ethnographic exhibitions (*Melanesian Objects, Objets Melanesians*, Museu de Etnologia, Lisbon, 1988; *Man Ape, Ape Man*, Nationaal Natuurhistorisch Museum, Leiden, 1993; *Bringing It All Back Home*, Etnografiske Museum, Oslo, 1996; *Inventing the Southwest: The Fred Harvey Company and Native American Art*, Heard Museum, Phoenix, 1996).

3 Related to this de-cloaking of the conditions under which collections have been made, exhibitions have also employed deconstruction to focus on the interpretation and production of museological effects (*Art/Artefact*, Center for African Art, New York, 1988; *Fetishism*, Brighton Museum, 1995; *Angola a preto e branco*, Museu de Antropologia, Coimbra, 1999; *ExitCongo Museum*, Royal Museum of Central Africa, Teurveran, 2000; and *Le musée cannibale*, Musée d'Ethnographie, Neuchatel, 2002).

4 Dialectical approaches examining the mutual relations and reciprocal interpretative strategies through which different nation-states have represented others are strongly illustrated by *Images of Other Cultures*, curated by the National Museum of Ethnology, Osaka, 1997.

5 Artist interventions in ethnographic museums to expose their paradoxes, contradictions, and parodies have, with Fred Wilson, Jimmie Durham, Lothar Baumgarten, and Susan Hiller, become almost commonplace (see Putnam 2001).

6 Multiple or plural interpretations, returning to the basic focus of all ethnography on the speaking, interpreting subject, are not only in evidence in new permanent displays, such as the African galleries at the Horniman Museum and the Smithsonian Institution, but in temporary exhibitions too (*All Roads are Good: Native Voices on Life and Culture*, 1994–2000; *The Path We Travel: Celebrations of Contemporary American Creativity*, 1994–5, both at the George Gustav Heye Center, Museum of the American Indian, New York).

7 Finally, some museums have refused to shy away from political subjects, even when these involved their own funding bodies. At the Rautenstrauch-Joest-Museum, Cologne, after a long unsuccessful attempt to get the city to modernize storage facilities, Gisela Völger sponsored Peter Pick to make an installation (*Objekte schlagen zurüch*, 1994) using the poorly preserved African collection, while at the Musée du Ville de Neuchatel, Jacques Hainard and Roland Kaehr responded to budget cuts with the exhibition, *A chacun sa croix* (1991).

Unlike the grand narratives described earlier, these exhibitions have, without exception, developed independently of any national intellectual traditions at a time of postmodern incredulity, accelerated globalization, and rising Fourth World consciousness. These positions, developing with the end of grand narratives and the erosion of the universal truths on which they were based, far from undermining the relevance of anthropology, contribute to reaffirming its basic tenets and revitalizing its radical potential to be, as Malcolm McLeod attempted at the Museum of Mankind: "a place where the visitor's imagination is stimulated, where he or she is made to see things in a new light, where some sort of stretching – conscious or unconscious – occurs in the way they see the world" (Houtman 1987: 7).

Museums are a microcosm of the wider society in which inter-ethnic relations are played out through a struggle over interpretation and control of cultural resources. In a recent article, Ruth Phillips has argued that the new democratic, collaborative, and non-essentializing policies of some museums are diagnostic of the beginning of a second museum age (Phillips 2005). Furthermore, it is argued that the expanded space of interpretation, the conflation of subject and object, the appreciation of the fugitive nature of meaning, and the expanded field of contestation, brought about by increasing globalization and urban multi-ethnicity, mark new and reinvigorated departures for material culture studies. It is this new, revitalized sub-discipline of anthropology that, through its dialectical engagement and transformation of its subject, has done much, and can be expected to do much more, in charting new courses not only for ethnographic but for other museum presentations too. Whereas forty years ago, William Sturtevant raised the question of whether anthropology still needed museums, we can add to his positive, if somewhat apprehensive affirmation, that museums also need anthropology.

Bibliography

*Ames, M. (1992) *Cannibal Tours and Glass Boxes: The Anthropology of Museums*. Vancouver: University of British Columbia Press.

Chapman, W. R. (1985) Arranging ethnology: A. H. L. F. Pitt Rivers and the typological tradition. In G. Stocking, Jr (ed.), *Objects and Others: Essays on Museums and Material Culture*, pp. 15–48. Madison: University of Wisconsin Press.

Clavir, M. (2002) *Preserving What is Valued: Museums, Conservation, and First Nations*. Vancouver: University of British Columbia Press.

Clifford, J. (1988) *The Predicament of Culture*. Cambridge, MA: Harvard University Press.

— (1997) *Routes: Travel and Translation in the Late Twentieth Century*. Cambridge, MA: Harvard University Press.

Crinson, M. (1999) Imperial story-lands: architecture and display at the Imperial and Commonwealth Institutes. *Art History* 22 (1): 99–123.

Dias, N. (2001) Esquisse ethnographique d'un projet le Musée du Quai Branley. *French Politics, Culture and Society*, 19, no. 281-101.

*Frese, H. (1960) *Anthropology and the Public: The Role of Museums*. Leiden: E. J. Brill.

Harms, V. (1997) The future of the museum of ethnology in Germany. *Antropologia Portuguesa*, 14: 21–36.

Houtman, G. (1987) Interview with Malcolm McLeod. *Anthropology Today*, 13 (3): 4–8.

Jacknis, I. (1985) Franz Boas and exhibits: on the limitations of the museum method of anthropology. In G. Stocking, Jr (ed.), *Objects and Others: Essays on Museums and Material Culture*, pp. 75–111. Madison: University of Wisconsin Press.

Kaplan, F. (1994) Introduction. In F. Kaplan (ed.), *Museums and the Making of "Ourselves": The Role of Objects in National Identity*, pp. 1–15. London: Leicester University Press.

Karp, I. and Lavine, S. (1991) *Exhibiting Cultures: The Poetics and Politics of Museum Display*. Washington, DC: Smithsonian Institution Press.

Koepping, K-P. (1979) *Artefacts and Theory Building in Anthropology*. Occasional Papers in Anthropology, 9: 1–8. St Lucia: Museum of Anthropology, University of Queensland.

Lévi-Strauss, C. (1968) *Structural Anthropology*. London: Allen Lane.

Lurie, N. (1981) Museums revisited. *Human Organization*, 40: 180–87.

Mauss, M. (1947) *Manuel d'ethnographie*. Paris: Payot.

*Penny, H. G. (2002) *Objects of Culture: Ethnology and Ethnographic Museums in Imperial Germany*. Chapel Hill, NC: University of North Carolina Press.

Phillips, R. B. (2003) Introduction. In L. Peers and A. Brown (eds), *Museums and Source Communities: A Reader*, pp. 155–70. London: Routledge.

— (2005) Re-placing objects: historical practices for the second museum age. *Canadian Historical Review*, 86 (1): 83–110.

Putnam, J. (2001) *Art and Artefact: The Museum as Medium*. London: Thames and Hudson.

Sandahl, J. (2002) Fluid boundaries and false dichotomies: scholarship, partnership and representation in museums. Keynote paper presented at the INTERCOM Conference "Leadership in Museums: Are our Core Values Shifting?" Dublin, October 19.

Schildkrout, E. and Keim, C. (eds) (1998) *The Scramble for Art in Central Africa*. Cambridge: Cambridge University Press.

Shelton, A. A. (2000) Museum ethnography: an imperial science. In E. Hallam and B. Street (eds), *Cultural Encounters: Representing "Otherness"*, pp. 155–93. London: Routledge.

— (2001) Museums in an age of cultural hybridity. *Folk*, 43: 221–49.

*Stocking, Jr, G. (ed.) (1985) *Objects and Others: Essays on Museums and Material Culture*. Madison: University of Wisconsin Press.

Sturtevant, W. (1969) Does anthropology need museums? *Proceedings of the Biological Society of Washington*, 82: 619–50.

Williams, E. (1985) Art and artefact at the Trocadéro: *Ars Americana* and the primitivist revolution. In G. Stocking, Jr (ed.), *Objects and Others: Essays on Museums and Material Culture*, pp. 146–66. Madison: University of Wisconsin Press.

Yoshida, K. (2001) "Tohaku" and "minpaku" within the history of modern Japanese civilization: museum collections in modern Japan. In T. Umesao, A. Lockyer, and K. Yoshida (eds), *Japanese Civilization in the Modern World: Collection and Representation*. Osaka: National Museum of Ethnology.

Collecting Practices

Sharon Macdonald

Collecting – including the assembly, preservation, and display of collections – is fundamental to the idea of the museum, even if not all "museums" directly engage in it. Equally, I suggest, the idea of the museum has become fundamental to collecting practices beyond the museum. Furthermore, collecting is variously entangled with other ways of relating to objects and according them meaning and value – that is, to wider epistemologies and moral economies of objects.

There is now an enormous literature on collecting, encompassing the history of collecting, including biographies of individual collectors and tomes on specific collections, as well as on the anthropology, psychology, and sociology of both museum and popular collecting. Rather than submit to a collector's urge to try to gather and order all of this (and risk the failure inherent in such an ambition), my aim here is to highlight some of the main – and changing – epistemological and moral economies in which museum collecting has been implicated. I do this primarily via a schematic account of the history of collecting, from the curiosity cabinet, via discussion of research on popular collecting, to debates and innovations in museum collecting today. First, however, I address the fraught question of what is meant by collecting.

What is Collecting?

Collecting is sometimes seen as a basic urge or instinct, and as a fundamental and universal human (and, indeed, sometimes also animal) activity. This, however, does not explain very much and it ignores important differences in the nature of, and motives for, different kinds of gathering or accumulation of material things. Moreover, it naturalizes the museum, casting it as an inevitable expression of the collecting urge rather than seeking to understand its various manifestations and flourishing in specific historical and cultural contexts. Museums and related forms of collecting practices need to be interrogated in the same way as do practices that initially seem less obvious to Western observers, such as the famous *potlatch* ceremonies recorded in the early twentieth century in North-West America, which involved first accumulating and then giving away or even destroying vast quantities of objects, in rituals that culminated in a kind of obverse of collecting: a conspicuous dispersal. Just as

such practices raise questions about the specificity of cultural and historical contexts, motives, and implications, as well as about possible similarities with other practices, so too does museum collecting and its relatives (cf. Clifford 1988).

There have been useful attempts to distinguish collecting from related practices, such as gathering or accumulating. In archaeology, for example, there have been debates over the status of objects amassed in grave sites, and it has been argued that these should properly be regarded as "hoards" or "accumulations" rather than "collections" on account of the fact that these are probably artifacts gathered for their individual significance and perceived function in the afterlife rather than to form a set of related objects in itself (Bradley 1990). Collecting, according to this perspective, should be seen as a practice in which the intention is to create a collection; and a collection in turn is a set of objects that forms some kind of meaningful though not necessarily (yet) complete "whole." Although delimiting "collecting" to activities intended to form "a collection" might at first seem tautologous, it serves to identify a distinctive type of object-oriented activity in which items are selected in order to become part of what is seen as a specific series of things, rather than for their particular use-values or individualized symbolic purposes. While in everyday language we might use the terms "collecting" and "collection" loosely to cover a wide range of practices (for example, collecting tax), it is analytically useful to distinguish "collecting" as a self-aware process of creating a set of objects conceived to be meaningful as a group. Exactly how "groupness" is perceived is not the defining matter: collecting is as much about creating a rationale as filling it.

Museums play an important role in institutionalizing this conception of a "collection" as more than – and different from – the sum of its parts. In forming collections, museums *recontextualize* objects: they remove them from their original contexts and place them in the new context of "the collection." This recontextualization of objects primarily in terms of other objects with which they are considered to be related, is a fundamental aspect of the kind of collecting legitimized by the museum. In a collection, objects take on additional significance specifically by dint of being part of the collection; and, in most cases, the life of objects once in a collection is notably different from their pre-collection existence. In particular, objects in collections are less likely to be available for use or purchase than they were previously: they enter into a new stage in their biographies (Kopytoff 1986). Their separation from other objects and their status as a collection are generally culturally marked by distinctive forms and levels of attention, including particular technologies of storage, cataloguing, and display. Moreover, collections are typically formed with the ambition of being kept long term or even in perpetuity, so simultaneously establishing a likely terminal phase in objects' biographies and attempting to give them a more lasting life and significance.

Collecting and Differentiation

This is not to say that collecting should be seen as a homogeneous practice. Indeed, as described below, there are variations in the principles involved, and collecting may blur into other practices. Much collecting research has included identifying types of

collecting and highlighting different impetuses that may be concerned; and mapping collecting types onto social differences (for example, of gender or class) is prevalent in academic approaches and collectors' own discourses. Many distinctions have been produced. For example: between the taxonomic and the aesthetic, the clinical and the passionate, the systematic and the eclectic, the authentic and the inauthentic, the planned and the impulsive, the institutional and the individual, the connoisseurial and the fetishistic, the high and popular cultural, the dealer and the true collector (see, for example, Danet and Katriel 1989; Pearce 1995). Such attempts to make distinctions between types of collecting, and to prize "real" or "proper" collecting from its perceived counterfeits, are often infused with implicit or explicit moral judgments in which some types of collecting are valued as relatively worthy and others dismissed or seen as signs of pathology.

In literary accounts, particularly since the nineteenth century, the figure of the collector may act as a trope for certain, generally negative, character traits. In John Fowles's *The Collector* (1964), for example, collecting is contrasted with a genuine love of life and things, and cast as a reprehensible "deadening" activity in which mastery through possession dominates any kind of real sensibility to that which is collected. The museum, too, has sometimes been characterized in this way, particularly in the analogy with the mausoleum.

That collecting attracts such moral judgments should not, however, be regarded as evidence of its actual moral status but instead of the fact that it is a culturally significant and morally charged activity which is about more than the mere gathering together of things. Collecting is the performance of a certain form of human–object relations: a particular approach to the material and social world. For this reason, it needs to be understood also in relation to other kinds of human–object relations; and, as we will see below, its development and moral evaluations of it are intertwined with other modes of relating to both things and people.

Renaissance and Early Modern Collecting

Histories of collecting have identified various periods and places in which forms of collecting can be found (Rigby and Rigby 1944; Impey and MacGregor 1985; Clunas 1991; Pearce 1995; Bounia 2004). These include Ancient Greece and Rome, medieval Europe and the Edo and Ming periods (beginning about the mid-sixteenth century) in China and Japan. I begin my account, however, with the flourishing of collecting in Renaissance and early modern Europe because this is widely seen as a precursor to modern museum collecting, though also as distinct from it in interesting ways (see chapter 8), and because, as I discuss in the final part of this chapter, there have been some recent arguments that we are today seeing a return to some aspects of this form of collecting.

During the Renaissance, a new passion for collecting developed among a learned elite, and this extended the sites of collections away from the specifically royal (the regal treasure) or religious (for example, the collection of saints' relics), and saw the formation of dedicated spaces for collection and display – specialized cabinets and rooms. By the early modern period, new collecting technologies, such as the

inventory and catalogue, had been devised. Spurring on the new collecting was "the empirical explosion of materials that wider dissemination of ancient texts, increased travel, voyages of discovery, and more systematic forms of communication and exchange had produced" (Findlen 1994: 3). Collecting was a means of bringing together and reveling in the newly discovered, and also of trying to make some sense of it.

To the modern eye, the collections of objects produced sometimes seem eclectic and even haphazard, mixing together, perhaps, items such as corals, statuary, books, animal skeletons and – a favoured item – the horn of a unicorn. Yet these were not merely randomly accumulated things (Hooper-Greenhill 1992). While the specific organizing principles by which objects were brought together might vary, these were themselves governed by ideas of objects as having intrinsic meanings that had been laid down during the Creation, and of the collection as ideally constituting a "microcosm" or "mirror of nature" that would aid in the interpretation of the divine text. As Foucault (1970) pointed out, various notions of "resemblance" now unfamiliar to us were central to sixteenth-century epistemology; and collections of objects into cabinets and the like allowed for the bringing together of things that could be arranged according to notions of meaningful proximity, juxtaposition, or alignment that might indicate underlying symbolic resemblance. Curiosities, which became a special target of collectors' attention in this period (Pomian 1990), were those things "new, unknown or unseen, that needed to be integrated into the existing perception of the world" (Prösler 1996: 28). They were also seen as evidence of God's "power to alter the course of nature" (Shelton 1994: 184–5), and thus as potentially particularly telling signs of divine logic.

Taxonomy and System

During the seventeenth century, new ideas about how to organize and order objects into meaningful collections began to supersede some of those that had informed earlier practices. In particular, the idea that there were multiple forms of resemblances, connected by complex and cryptic linkages, came to be replaced largely by the idea that evident physical similarities or dissimilarities between things could themselves point directly to the natural scheme (see fig. 8.1). The systematic observation and comparison of objects became a key feature of natural science; and the cabinet and museum maintained and even strengthened their role as principal means of bringing together and organizing objects in order to attempt to map the world's patterns. The curiosity ceased to be such a focus in these newer epistemologies, and notions of typological mapping, or what Foucault refers to as "tabulation" (1970), and "coverage" gained ground. Taxonomies flourished, and some categories of choice for collecting waxed and waned with fashion. For example, in The Netherlands in the early seventeenth century, there was a craze for collecting tulip bulbs (Schama 1987), and in early eighteenth-century France, ancient medals came to be a particular focus among some groups of collectors (Pomian 1990). It should also be noted that the collecting of the curious and the eclectic did not disappear entirely, and that non-systematic collecting also persisted, different principles existing alongside one another.

Evident in all of these collecting practices are the notions that objects are meaningful and that collecting and organizing them can be a means of making sense and gaining knowledge of the world. Removing objects from their pre-existing worlds of use and arranging them in a designated space allowed meaning and order to be discerned in the unruly and teeming world of things. But, as with later collecting practices, these early forms were not only about gaining knowledge of divinely inspired nature and of the new worlds that were being opened up through increased travel. Collecting was also partly a celebration of objects both in themselves and as evidence of divine skill, and this could disrupt classificatory schemes.

Moreover, collecting worlds were also social worlds. Collecting produced not just new knowledge but also new kinds of social practices (for example, of trade in exotic artifacts, and of gentlemanly visiting of noted collections) and social relationships (for example, between collectors and their patrons). Possessing a collection became a mark of status, injecting a new dynamic possibility into existing social hierarchies; and the relative qualities of collections themselves became a basis for identifying and expressing social distinctions. Collecting was a means of fashioning and performing the self via material things; and the new social figure of the collector became the epitome of the then relatively novel idea that personal identities could be made rather than being definitively ascribed at birth (Findlen 1994: 294).

Modern Collecting and the Museum

Much of the early modern European complex of notions and practices concerning collecting has persisted into the present, but it has also been extended and changed both over time and as it has spread across the globe and beyond its elite origins. Particularly important in the systematization and diffusion of collecting practices was the development of the modern, and especially the national, museum in the late eighteenth and nineteenth centuries.

National museums acted as symbols of the existence of the newly forming nation-states (see chapter 10); and although many were based on existing collections that had been created by individual collectors, they helped to materialize the new political-cultural forms into being. They did so in part by positioning the new nation-states as "collectors," signaling their identity and indeed very existence by their ownership of collections. As in relation to individual collectors, the collections of nations were simultaneously expressions of belonging to a worthy and educated club and of being individually distinctive. Collections allowed nation-states to show their possession and mastery of the world – something that colonial powers were especially well able to demonstrate through the accumulation of material culture from the countries that they colonized (see, for example, Coombes 1997; Barringer and Flynn 1998; Gosden and Knowles 2001). They also gave them the opportunity to amass and present evidence of their own pasts, so turning their histories into "objective" fact and legitimizing their right to exist. This same complex of ideas was extended to other entities, especially the city, and the nineteenth century saw a massive explosion of new museums, both national and civic, across Europe and beyond.

Sharon Macdonald

Collecting and the public

Although earlier proto-museums had been available to some visitors, a hallmark of the modern museum was that it was open to the public. Indeed, the modern museum can be seen as one of the technologies through which "the public" as an aggregation of self-directed citizens was imagined into being (see chapters 8 and 16). The museum was able to perform this task in part by positioning members of the public as collectors. They were collectors insofar as it was in their name that the museum project was conducted: they were the "owners" of the collections. Furthermore, museums encouraged members of the public to conceive of themselves as autodidactic collectors of knowledge, and the museum made visible suitable classifications and taxonomies into which that knowledge could be organized.

The museum also played a role in encouraging the public literally to become collectors of things. The collections of the new museums were created not only from the collections of wealthy aristocrats but also by the collecting activities of the newly educated middle classes, especially by literary and philosophical societies. As Didier Maleuvre has observed, this was a period in which collecting was democratized and the "museum penetrated the cultural consciousness . . . The nineteenth-century mania for collecting was not merely a public concern: domestic collections flourished, and remodelled interior spaces into esthetic and historic museums of themselves" (1999: 4). Special items of furniture, such as the "Empire cabinet" and "whatnot," were produced for citizens to display their own collections in their own homes (1999: 180), thus showing off their good taste, education, and social status.

Creating a collection required the ability to make careful selections from the profusion of objects that had become more widely available during the eighteenth century and especially into the nineteenth. Not only were there still enormous quantities of exotica and novel things to cope with, there were also new, mass-produced goods. New things became more easily available to a wider range of people than ever before, especially in the department stores that sprung up alongside museums in the expanding cities. Museums and department stores sometimes borrowed design features from one another; and both put objects on display through the tantalizing technology of the vitrine or glass case, in which things could be seen and admired but not touched, the possessive appetite thus being whetted but not immediately satisfied. The shop, though, made possession a real possibility; and the new production of "collectibles" – items designed specifically to be collected – tapped into this possibility and market. The perceived danger, however, was that people would be so dazzled by the new acquisitive possibilities that they would not know when to stop or how to select responsibly. This was articulated especially clearly in the disease of "kleptomania," which first came to be identified at the time, and which was a particular affliction of middle-class ladies in department stores (Abelson 1989).

Museums had an ambivalent position in relation to bourgeois acquisitiveness. On the one hand, they encouraged a collecting urge, supporting the idea of amassing aggregations of objects that might never be used. On the other, they could act as a kind of moral antidote to unfettered consumption by illustrating careful and meaningful object selection. Moreover, in a world in which novelty and cycles of fashion

acted as motors for yet more production and consumption, museums could stand for a different kind of relationship to objects: one that was both more lasting and more meaningful. As Walter Benjamin puts it: "To [the collector] falls the Sisyphean task of divesting things of their commodity character by taking possession of them" (2002: 19).

Disciplining collecting

The museum faced its own problems of selection: of how to identify the significant and meaningful amidst the excess of both things and information. Collecting needed to be carried out with care, sifting the meaningful from the dross, on the one hand, and seeking to be properly comprehensive, on the other. Certain categories, such as "Etruscan" and "Old Masters," emerged, which were to be found in most self-respecting generalist museums, and which were used not only to organize existing material but as a spur to the museum's active collecting. The idea of collections as potentially complete series became widespread alongside evolutionism in the nineteenth century, some museums choosing to fill in the gaps in series of sculptures or of skeletons with plaster casts or other replicas, though in others the idea of the "real thing" was a primary filter. In art museums, the new discipline of art history informed a novel means of organizing galleries from the late eighteenth century, the works typically being presented as exemplifications of particular styles, themselves classified by both "period" and "civilization" or "nationality," and this being spatially organized such that visitors could take an educational tour through the progress of art over time, crossing continents, and experiencing characteristic differences, as they did so. Museums of anthropology, ethnology, natural history, and science and industry also frequently employed forms of classification based on evolutionary chronology and territory-based difference (Bennett 2004; see also chapter 5), thus also helping to naturalize these as ways of apprehending the world in all its manifestations, and to create rationales for selection.

The growth of academic disciplines and sub-disciplines, such as art history or palaeontology, and of particular figures such as the art critic, helped produce principles and practices for selecting and organizing what was worthy of keeping, though it remained a struggle (Siegel 2000). Moreover, as museums and universities drew further apart toward the end of the nineteenth century, and as the idea of objects as a privileged route to knowing the world went into decline, collecting began to lose its status as a worthy intellectual pursuit, especially in the sciences. The really interesting and important aspects of science were increasingly those invisible to the naked eye, and the classification of things collected no longer promised to produce cutting-edge knowledge (Conn 1998). The term "butterfly collecting" could come to be used with the adjective "mere" to indicate a pursuit of secondary academic status.

Collecting did not fall out of favor in the same way in all disciplines and areas. In art, it continued to play a vital function in art markets, collectors being central to the definition of the significant through their purchases. Individual collectors remained important here, reinforcing notions of individuality with which collecting was also, and perhaps increasingly, associated. The collecting of "old things" also remained respectable and even took on new resonance in the nineteenth century. Although

earlier museums had often contained old or ancient items, the notion of museums as a kind of haven for things of the past – and of the aged as especially worth collecting – became much stronger. In part, this was informed by a new historicism – the sense of the past as a "foreign country" to which we could never return (Lowenthal 1985), as well as by the organizing principle of the temporal series. The turn to the past and to things of the past was part of a rescue attempt: to save what might otherwise vanish in what was now increasingly perceived as swiftly coursing, transient time. And as perceptions spread of time as non-reversible and of change as ever-more insistent, "the past" came to be conceived of as increasingly recent. New things, correspondingly, came to be seen more quickly as "old."

Collecting Dilemmas

During the twentieth century, especially its later decades, questions about the legitimacy of existing classificatory categories for organizing collecting and about the pedagogical role of collections were raised increasingly in museums. Challenges to the notion of "the canon" and the sense of an overwhelming "information glut" contributed to the unease. At an international conference aimed at addressing the dilemmas facing museums as they moved into the new millennium, one museum director suggested that the problem of what to collect had become so fraught – and decisions so hard to make – that a possible solution might be to try to collect an example of everything produced, pack it into a big warehouse, and leave the selecting for curators a hundred years or so into the future (Cossons 1992).

For others, the fact that more and more collections were confined to storage, rather than being on show, was itself a dilemma. In many museums, a gap had opened up between collecting and exhibition. A growing lack of confidence in the pedagogic potency of objects – both in themselves and as part of collections – led to increasing use of exhibitions based on "stories" or "narratives" rather than collections, and these used dioramas or text panels as the main structuring device, with objects only as illustration. This undermined the rationale of collecting in many different kinds of museum, especially those which gave priority to their educational role. Toward the end of the twentieth century, questions not only about what to collect but about the very purpose of collections came to be asked with increasing frequency and urgency (for example, Knell 2004).

While many established museums began such questioning, however, numerous new, generally fairly small, local, collection-based museums were being established. These were typically run independently or by local branches of the state (for example, local authorities in the UK). Rather than exhibiting collections of the rare and exotic, such museums mostly collected and displayed the material culture of the everyday and more recent past, especially that of working-class and minority communities. This proliferation was testament to the continuing salience of the idea of collecting and displaying material culture as a means of reinforcing and giving legitimacy to group and place-based identities. It was also a function of an escalating sense of "the past" arriving ever more quickly, provoking fear of cultural amnesia (Huyssen 1995). Gathering up the material fragments before they were forgotten was

a means of holding onto pasts, values, and cultural forms whose future felt uncertain (Macdonald 2002).

Individual and Popular Collecting

Individual collecting, especially of the recent past, everyday and mass-produced, also escalated in the same period (Martin 1999: 14), and, indeed, some of the new museums, as had been the case for earlier museums, were effectively based on the collections of single individuals. Many of the same themes – a new valuation of "ordinary" culture, saving the past, materializing distinctive identity – seem likely to apply at individual level too, and to be sustained by the broader museological discourse. The study of individual collecting practices, however, also addresses variations among individuals, including the question of why some people become collectors at all.

Individual collecting

One of the most common attempts to account for differences between individuals is a loosely psychoanalytic perspective that understands collecting as a result of childhood experience, especially sexual experience or its repression, and thus as an expression of either sublimated need or pathology. There are variations in the kinds of account offered and their degrees of subtlety, and some should be regarded more as part of the moral evaluation of collecting discussed above than as the results of research. Baudrillard, for example, notes that collecting often occurs more intensely during life phases in which sexual activity is less, and as such can be seen as "a regression to the anal stage, manifested in such behaviour patterns as accumulation, ordering, aggressive retention and so forth" (1994: 9). Such a regression can take a pathological turn when it exhibits a compulsive or fetishistic overwhelming attachment to collected objects. Freud himself offered only a few comments on collecting, suggesting that it was a substitute for erotic activity; though he was himself a collector – of (following the death of his father) ancient Egyptian, Roman, and Greek figurines and other antiquities, as well as of non-material items such as jokes or slips of the tongue (Forrester 1994; Barker 1996).

In his sensitive analysis of Freud's own collecting, John Forrester offers a more wide-ranging account, exploring the differentiations between Freud's collecting of the material and the non-material and that which he made public and kept private, and covering various psychological motivations and cultural conditions, some of which derive from a wider museological discourse, including a response to loss, collecting as a subscription to Enlightenment ideals, and objects acting as both sites of memories and as means of "effacing the past [by] building a new timeless world of the collection" (Forrester 1994: 244). This is a multi-faceted account that avoids reducing collecting to a single motive or cause, though much of what Forrester discusses could loosely be described as relating collecting to identity.

The idea that collecting can be seen as an expression of individual identity is one of the most widespread, and above we have touched on some of the historical and

Sharon Macdonald

museologically entangled background to the emergence of this notion. Narrowly understood, this perspective casts the urge to collect as a function of a drive to express individual distinctiveness (analogous to the impetus for nations to express their collective distinctiveness), and thus argues that a collection can be seen as a set of clues about an individual personality. Baudrillard expresses both of these ideas concisely when he writes: "It is inevitably *oneself* that one collects" (1994: 12).

Like Forrester's account of Freud's collecting, the best of the studies of individual collectors, including Susan Stewart's (1994) account of Charles Willson Peale and Stephen Bann's (1994) of John Bargrave (and see also contributions to Shelton 2001a, b), take a broader approach, providing sensitive discussion of historical context as well as of the individual life, and of the specific lived realization of collective identity categories (for example, of gender or class), thus throwing light on more general aspects of collecting, while illustrating the rich mix of factors at work in the activities of any one collector.

"Ordinary" collecting

In addition to these studies of single individuals, a small number of studies has begun to address collecting by looking at a wider population. Surveys led by Russell Belk in the US and Susan Pearce in the UK, conducted in the 1980s and 1990s respectively, show that collecting is far from being the preserve of rare personalities (Belk 1995/2001; Pearce 1998). On the contrary, it is widespread, with around one-third of the adult population regarding themselves as engaged in it (Pearce 1998: 1). Moreover, rather than being an expression of the relatively unusual or esoteric, both Belk and Pearce show that collecting is linked to other, ordinary and everyday, practices and experiences: for example, of shopping or home-making, of being a member of a club or a circle of friends or a member of a family, and of particular life-stages. Both do so not only via their own original empirical material but also via wide-ranging discussions of other literature (see also Pearce 1995). In both cases, their analyses are multi-faceted, drawing on a range of theorizing, primarily sociological, though also some psychological, and seeking to show the mix of factors that may be involved in any particular case.

Belk, however, conceptualizes collecting particularly as a form of consumption and argues that collecting gives legitimacy to the emphasis placed upon consuming and upon material things in contemporary society. Moreover, he argues, the motives, skills, and experiences involved in collecting are in many ways those of other forms of "consumption writ large. It is a perpetual pursuit of inessential luxury goods. It is a continuing quest for self completion in the marketplace. And it is a sustained faith that happiness lies only an acquisition away" (Belk 2001: 1). This leads him to highlight a range of notions bound up with collecting as a form of consumption, including possession as an index of success, the honing of skills of discrimination, the thrill of the hunt, and emotional complexes of pleasure and guilt involved in material acquisition. He also acknowledges, however, that collecting can sometimes act, as I have suggested above, as a kind of challenge to consumerism and materialism (2001: ix); and, as such, his account seems to support a characterization of collecting as a multivalent set of meaning and value-imbued object practices. This is a

perspective shared by Pearce, who regards collecting as a kind of language through which a whole range of meanings may be articulated.

Both Belk and Pearce discuss the expansion of popular collecting in the late twentieth century, but this is most extensively explored by one of Pearce's students, Paul Martin (1999), whose work included in-depth interviewing as well as participant-observation in popular collecting worlds – the collectors' clubs, societies, and fairs that mushroomed in the late twentieth century. On the basis of this, and drawing on Guy Debord's *Society of the Spectacle* (1967), Martin argues that collecting is a type of "masquerade" (1999: 23), a form of denial, providing solace in a time of increased anxiety. The rise in popular collecting in the late twentieth century is, he says, a reflection of social fragmentation; and he finds that collecting is particularly prevalent among those "who have traditionally felt themselves to be an integral part of society, but who have been increasingly disenfranchised or alienated from it" (1999: 9). Narratives by such collectors seem to suggest attempts to connect with past happier times in order to cope with the "uncertainties of the future" (1999: 9).

Martin's use of collectors' narratives – looking at the ways in which they talk about collecting and the things that they choose to relate it to – also represents a partial analytic shift from Pearce's main conceptualization of collecting as a linguistic system to be decoded through structural techniques (see especially Pearce 1995; and see chapter 2). A narrative approach to collecting, as argued for particularly by Mieke Bal (1994), puts its emphasis, by contrast, on process and the indeterminacy of meaning. This serves to unsettle some of the existing framings of collecting analyses (and, indeed, some of the problems of survey-based approaches). In particular, it highlights the fuzziness of the distinction between "when collecting begins to be collecting . . . [and] say, buying a thing or two" (Bal 1994: 100), as well as the elusiveness of motive, which may change according to its place in the narrative being told, and which needs itself to be understood as part of the telling rather than as an "objective" fact to be unearthed. A narrative approach also opens up the possibility of further exploring the kinds of stories that people may tell through and about objects, and how meanings, morals, and museums, as exemplars of a certain object–value–meaning complex, are implicated in them. These are areas to which future work in this field may be dedicated.

Reconfiguring Museum Collecting

All of the studies of popular collecting discussed in the previous section observe that during the late twentieth century "ordinary" collectors became involved in museums to a new extent, in particular by opportunities to have their possessions put on public display. A well-documented example is that of the "People's Shows" held in many museums in the UK between 1992 and 1996 (Pearce 1995, 1998). These entailed the temporary display of the collections of non-elite collectors, such collections typically being of mass-produced items – for example, beer-mats or sweet-wrappers – or in non-museological categories, such as "Do not disturb" signs, or items in the shape of frogs or tortoises (Lovatt 1997). There were similar shows elsewhere in Europe, North America, and beyond (Belk 2001). At the same time, established

Sharon Macdonald

museums themselves began to collect more mass-produced and everyday items, the Smithsonian, for example, acquiring a collection of airline sick-bags (Belk 2001: 147); and more museums opened based on non-elite collections, often of relatively everyday items, such as lawnmowers, pencils, or packaging.

Such developments are linked in part to the challenge to the idea of a canon discussed above, and in turn to both changing epistemologies and socio-economic restructurings, sometimes described as postmodern (see chapter 31). They are part of an increased claiming of the museum form, and existing museum space, by different groups; and of a changing museum–society relationship in which museums have come to be seen less as offering up preferred or superior culture and more as responsible for representing society in its diversity. Including the material culture of diverse groups and of everyday life is seen as a means of democratizing the museum, of showing its responsiveness to, and inclusion of, various possible constituencies. However, it only adds to the dilemmas discussed above of how to establish limits to potentially limitless collecting.

Some of these dilemmas have begun to be addressed through practical measures, such as the greater use of recording, especially 3-D imaging, and coordinating collecting across museums, producing greater specialization and less encyclopedism. They have also been addressed by other strategies, including reflecting on the process of collecting itself.

Reflecting on Collecting and Re-centering Objects

Exhibitions that specifically address the question of collecting, highlighting it as located cultural activity rather than assuming its inherent legitimacy, have been gathering pace since the 1970s (see also chapter 5). Such exhibitions may focus on the activities – and individual proclivities, as well as social backgrounds – of particular collectors, or make experimental interventions that raise questions about the status or categories of collecting (see Putnam 2001). They include the work of Fred Wilson, whose installations, as in his exhibit for the British Museum multi-sited exhibition *Collected* (1997), for example, raise questions about the impartiality and objectivity of collecting and display (Putnam 2001: 102); or the intervention of Mary Beard and John Henderson in Oxford's Ashmolean Museum, in which they questioned the legitimacy of the museum contents, and how authenticity and value are bestowed, by such interventions as placing plastic Venuses bought from a store alongside the existing statuary and putting price tags onto the classical vases (Beard and Henderson 1994). In one gallery at the Marischal Museum in Aberdeen, the arbitrary nature of classification is highlighted by displaying objects alphabetically (fig. 6.1).

Alphabetical display also effectively puts more emphasis on the objects themselves rather than on the meaningfulness of their mode of ordering. This "re-centering" of the object is a paradoxical consequence of questioning the legitimacy of collecting rationales. Stephen Bann has suggested that of the many various new approaches evident in museums at the end of the twentieth century and into the twenty-first, a new emphasis on "curiosity" is particularly indicative of challenges to earlier museum orthodoxy, and especially to historicism. He writes: "Curiosity has the

92

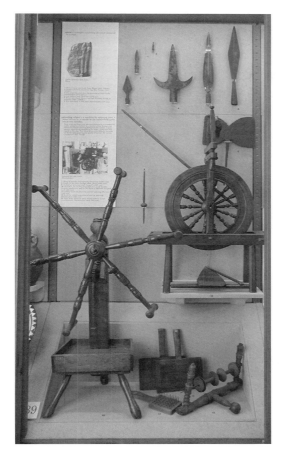

Figure 6.1 Case "Sp" in the alphabetical display of the North Gallery of Scottish Ethnography in the Marischal Museum, Aberdeen. The exhibition was devised by Charles Hunt and opened in 1990. For further details of the exhibition, see www.addn.ac.uk/virtualmuseum. Reproduced courtesy of the University of Aberdeen.

valuable role of signalling to us that the object on display is invariably a nexus of interrelated meanings – which may be quite discordant – rather than a staging post on a well trodden route through history" (Bann 2003: 120). Objects understood as curiosity, rather than as exemplars of an underlying system, exhibit what Bann calls "typological exuberance" (2003: 125), and draw attention to questions of their selection (by making this unclear or indeterminate) and to their possible multiple meanings and associations. By undercutting the rationale of the chronology or taxonomy, objects themselves come to the fore. *They* are the "nexus of meaning" rather than its illustration. As such, they can become the beginning point for analyses that trace links and cross boundaries in ways that defy more conventional approaches, as has been argued for the new material culture studies (Thomas 1991; Miller 1998) and illustrated particularly well in relation to memory (Kwint et al. 1999; Crane 2000).

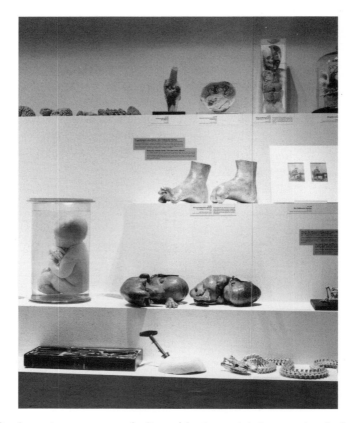

Figure 6.2 A contemporary curiosity cabinet, containing anatomical specimens, models in plaster and wax, and a selection of fetuses, body parts, and bones, from the collections of the Humboldt University of Berlin; part of an exhibition entitled *Theater der Natur und Kunst: Wunderkammer des Wissens* (2000–2001). For further details of the exhibition see www2.rz.hu-berlin.de/kulturtechnik. Photograph by Thomas Bruns.

Moreover, as curiosities, objects become more open to both apprehension through, and analysis in terms of, the sensory or existential (Bann 2003). In exhibitions of objects as curiosity in the late twentieth and early twenty-first centuries, including those in which actual or surmised cabinets of curiosity and early museums are recreated, as well as those deploying curiosity as an organizing motif (fig. 6.2; see also chapters 16 and 18), there is a glorying in individual objects – even those not produced to be unique – and in the ultimate eclecticism of collecting.

Conclusion

Collecting is a set of distinctive – though also variable and changing – practices that not only produces knowledge about objects but also configures particular ways of

knowing and perceiving. It is a culturally recognized way of "doing" – or rehearsing – certain relations between things and people. Moreover, collecting produces and affirms identities and acts as morally charged commentary on other ways of dealing with both objects and persons.

This chapter has sought to highlight various kinds of museological collecting practices in order to illuminate some of the ways in which collecting may be implicated in according meaning and value to objects, not only in the museum but also beyond it (for example, in commodity consumption). Museum and individual collecting have been argued to be mutually entangled, not only literally, with individual collections sometimes entering or even forming the basis of museums, but also in more subtle and ramifying ways. Museums have promoted and legitimized individual collecting practices and have provided exemplars for them. Moreover, they have helped to define the potential value of objects and their salience for identity work, and have established a cultural model in which collected material performs individual distinctiveness.

Over the past two decades, there has been a considerable expansion of research on collecting, which has included many disciplines and approaches, and has been evident in developments such as the *Journal of the History of Collecting* (founded in 1989), as well as in works cited in this chapter and the works to which those in turn also refer. In recognition of this, it has been suggested that we are seeing the emergence of "a new field of enquiry, Collecting Studies" (Pearce 1998: 10). My argument here, however, is that collecting is fundamentally museological, whether the museum is directly involved or not. This is not to say that there was no collecting before the birth of museums, but that the museum inevitably infuses collecting thereafter. For this reason, rather than fragmenting into a separate area of collecting studies, it seems to me that the study of collecting – whether undertaken by a museum or not – is best carried out under the rubric of museum studies.

Studying collecting, however, also means expanding museum studies. The new forms of collecting and exhibiting discussed here – including focusing on the object and tracing its multifarious links, engaging in critical and reflexive questioning, and boundary-crossing – also seem to offer models for a museum studies that moves beyond the museum as a physical site and traces its entanglements, and its significance, across space and into other practices.

Bibliography

Abelson, E. (1989) *When Ladies Go A-thieving: Middle-class Shoplifters in the Victorian Department Store*. New York: Oxford University Press.

Bal, M. (1994) Telling objects: a narrative perspective on collecting. In J. Elsner and R. Cardinal (eds), *The Cultures of Collecting*, pp. 97–115. London: Reaktion Books.

Bann, S. (1994) *Under the Sign: John Bargrave as Collector, Traveller and Witness*. Ann Arbor: University of Michigan Press.

— (2003) The return to curiosity: shifting paradigms in contemporary museum display. In A. McClellan (ed.), *Art and its Publics: Museum Studies at the Millennium*, pp. 117–30. Oxford: Blackwell.

Barker, S. (1996) *Excavations and their Objects: Freud's Collection of Antiquity*. Albany, NY: State University of New York Press.

Barringer, T. and Flynn, T. (eds) (1998) *Colonialism and the Object: Empire, Material Culture and the Museum*. London: Routledge.

Baudrillard, J. (1994 [1968]) The system of collecting, trans. R. Cardinal. In J. Elsner and R. Cardinal (eds), *The Cultures of Collecting*, pp. 7–24. London: Reaktion Books.

Beard, M. and Henderson, J. (1994) "Please don't touch the ceiling": the culture of appropriation. In S. Pearce (ed.), *Museums and the Appropriation of Culture*, pp. 5–42. London: Athlone.

*Belk, R. (2001) *Collecting in Consumer Society*, 2nd edn (first edition 1995). London: Routledge.

*Benjamin, W. (2002 [1982]) *The Arcades Project*, trans. H. Eiland and K. McLaughlin. Cambridge, MA: The Belknap Press of Harvard University Press.

Bennett, T. (2004) *Pasts beyond Memory: Evolution, Museums, Colonialism*. London: Routledge.

Bounia, A. (2004) *Collecting in the Classical World: Collectors and Collections 100 BC to AD 100*. Aldershot: Ashgate.

Bradley, R. (1990) *The Passage of Arms: An Archaeological Analysis of Prehistoric Hoards and Votive Deposits*. Cambridge: Cambridge University Press.

Clifford, J. (1988) *The Predicament of Culture*. Cambridge, MA: Harvard University Press.

Clunas, C. (1991) *Superfluous Things: Material Culture and Social Status in Early Modern China*. Urbana, IL: University of Illinois Press.

Conn, S. (1998) *Museums and American Intellectual Life, 1876–1926*. Chicago: Chicago University Press.

Coombes, A. E. (1997) *Reinventing Africa: Museums, Material Culture and Popular Imagination*. New Haven, CT: Yale University Press.

Cossons, N. (1992) Rambling reflections of a museum man. In P. Boylan (ed.), *Museums 2000: Politics, People, Professionals and Profit*, pp. 123–33. London: Routledge.

Crane, S. (ed.) (2000) *Museums and Memory*. Stanford: Stanford University Press.

Danet, B. and Katriel, T. (1989) No two are alike: the aesthetics of collecting. *Play and Culture*, 2 (3): 253–77.

Debord, G. (1967) *La Société du spectacle*. Paris: Buchet Chastel. English translation: *The Society of the Spectacle*, trans. D. Nicholson-Smith. New York: Zone, 1995.

*Elsner, J. and Cardinal, R. (eds) (1994) *The Cultures of Collecting*. London: Reaktion Books.

*Findlen, P. (1994) *Possessing Nature: Museums, Collecting, and Scientific Culture in Early Modern Italy*. Berkeley, CA: University of California Press.

Forrester, J. (1994) "Mille e tre": Freud and collecting. In J. Elsner and R. Cardinal (eds), *The Cultures of Collecting*, pp. 224–51. London: Reaktion Books.

Foucault, M. (1970 [1960]) *The Order of Things*. London: Tavistock.

Gosden, C. and Knowles, C. (2001) *Collecting Colonialism: Material Culture and Colonial Change*. Oxford: Berg.

Hooper-Greenhill, E. (1992) *Museums and the Shaping of Knowledge*. London: Routledge.

Huyssen, A. (1995) *Twilight Memories: Marking Time in a Culture of Amnesia*. New York: Routledge.

Impey, O. and MacGregor, A. (eds) (1985) *The Origins of Museums*. Oxford: Oxford University Press.

Knell, S. J. (2004) *Museums and the Future of Collecting*. Aldershot: Ashgate.

Kopytoff, I. (1986) The cultural biography of things: commoditization as process. In A. Appadurai (ed.), *The Social Life of Things: Commodities in Cultural Perspective*. Cambridge: Cambridge University Press.

Kwint, M., Breward, C., and Aynsley, J. (eds) (1999) *Material Memories: Design and Evocations*. Oxford: Berg.

Lovatt, J. R. (1997) The People's Show Festival 1994: a survey. In S. Pearce (ed.), *Experiencing Material Culture in the Western World*, pp. 196–254. London: Leicester University Press.

Lowenthal, D. (1985) *The Past is a Foreign Country*. Cambridge: Cambridge University Press.

Macdonald, S. (2002) On "old things": the fetishization of past everyday life. In N. Rapport (ed.), *British Subjects: An Anthropology of Britain*, pp. 89–106. Oxford: Berg.

Maleuvre, D. (1999) *Museum Memories: History, Technology, Art*. Stanford: Stanford University Press.

Martin, P. (1999) *Popular Collecting and the Everyday Self: The Reinvention of Museums?* London: Leicester University Press.

Miller, D. (ed.) (1998) *Material Cultures: Why Some Things Matter*. Chicago: University of Chicago Press.

*Pearce, S. M. (1995) *On Collecting: An Investigation into the European Tradition*. London: Routledge.

— (1998) *Collecting in Contemporary Practice*. London: Sage.

Pomian, K. (1990 [1987]) *Collectors and Curiosities: Paris and Venice, 1500–1800*, trans. E. Wiles-Porter. Cambridge: Polity Press.

Prösler, M. (1996) Museums and globalization. In S. Macdonald and G. Fyfe (eds), *Theorizing Museums*, pp. 21–44. Oxford: Blackwell.

Putnam, J. (2001) *Art and Artifact: The Museum as Medium*. London: Thames and Hudson.

Rigby, D. and Rigby, E. (1944) *Lock, Stock and Barrel: The Story of Collecting*. Philadelphia: J. B. Lippincott.

Schama, S. (1987) *The Embarrassment of Riches: An Interpretation of Dutch Culture in the Golden Age*. New York: Alfred Knopf.

Shelton, A. A. (1994) Cabinets of transgression: Renaissance collections and the incorporation of the New World. In J. Elsner and R. Cardinal (eds), *The Cultures of Collecting*, pp. 177–203. London: Reaktion Books.

— (ed.) (2001a) *Collectors: Expressions of Self and Other*. London and Coimbra: The Horniman Museum and the Museu Antropológica da Universidade de Coimbra.

— (ed.) (2001b) *Collectors: Individuals and Institutions*. London and Coimbra: The Horniman Museum and the Museu Antropológica da Universidade de Coimbra.

Siegel, J. (2000) *Desire and Excess: The Nineteenth-century Culture of Art*. Princeton, NJ: Princeton University Press.

Stewart, S. (1994) Death and life in that order, in the works of Charles Willson Peale. In J. Elsner and R. Cardinal (eds), *The Cultures of Collecting*, pp. 204–23. London: Reaktion Books.

Thomas, N. (1991) *Entangled Objects: Exchange, Material Culture and Colonisation in the Pacific*. Cambridge, MA: Harvard University Press.

The Conundrum of Ephemerality: Time, Memory, and Museums

Susan A. Crane

The history of museums is the history of a conundrum: how is what is always the same also always different? A modern museum's mandate is to collect, preserve, and present objects for the public to appreciate. But preservation and conservation never completely "fix" the contents of the collections and or their presentation for all time. Constantly changing needs and interests – economic and political, as well as scholarly – shape the museum and its contents. For all the solidity of a museum's magnificent façades or secured basements, it is a malleable and ever-changing institution. But in the most ordinary or common-sense way, members of the public generally feel that they know what a museum is, and that it is in fact solid (not to say stolid) and permanent. For many, museums perform the externalized function of their own brains: it remembers, for them, what is most valuable and essential in culture and science. And yet generations of curators and visitors have inhabited the institution, actively shaping (and necessarily changing) those memories over time. In addition, scholars of museums regard the institutions, collections, curators, and visitors with the eyes of distanced but interested observers. With all these simultaneous layers of temporal experience shaping the museum, we need some tools to help us understand how experience over time creates an institution at once essentially familiar and yet capable of challenging and changing both memory and expectations.

This chapter will provide an overview of how interested observers of museums have responded to its conundrum of "fixed ephemerality" in two key conceptual formations: the narrative role of "timelessness" and "progress," and the nature of collective memory as it shapes historical consciousness. Any discussion of time and memory in a museum must acknowledge that no single account can "cover" intensively or extensively the infinite variety of even apparently similar experiences. What wealth of subjective impressions, past and present experiences formed through memories, does any individual bring to the organized efforts of scholars or curators who present an exhibition – at any point in time? How does the memory of previous museum experiences, and the knowledge of what the museum as institution represents, affect understandings of the museum and its purpose? And how, above all,

is this infinite mass of impressions to be understood by those who care about the museum as an institution, and who will shape its status and future?

Collective memory theory, first developed by Maurice Halbwachs in the early twentieth century and expanded upon considerably since the 1970s, offers insight into how subjectivities align along common experiences, such as museum visits, or encounters with particular objects, to create expressions of collective meaning – familial, communal, national, and more (Halbwachs 1980). Numerous examples of the application of collective memory theory to historical museum experiences can be drawn from the 1990s, when many exhibitions commemorating World War II and the Holocaust occurred around the world. This chapter will present these international case studies in the context of the questions raised above. Individual and public memories of World War II, memories of museums, and public interaction with scholarly interpretations of the history of the war will be addressed as interwoven aspects of controversial exhibits.

Progress and Timelessness

For much of the modern era, societies have labored within a consciousness of progress that makes us highly sensitive to the phenomenon of change. The value of change is under constant revision, and the topic itself remains vital to societies' self-understanding. Change happens over time, within the duration of time, as the *fin-de-siècle* philosopher Henri Bergson insisted; and museum publics exist within the flow of transition. Bergson wrote in the era that responded most sensitively to the throes of modernity, when progress was perceived as a violent and destructive force whose speed and volatility were never predicted by the more optimistic Enlightenment thinkers. The *philosophes* believed progress to be beneficial and essential. The first European museums were built in the Enlightenment mode, drawing on Renaissance curiosity about the inexhaustible variety of nature and man's divinely directed talents. Early modern museums, creating a tradition that reached well into the nineteenth century, represented the breadth of scientific knowledge, an accumulation of as many original and facsimile historical objects as possible, and the finest art that could be commissioned. The world of the early modern museum was plentiful and potentially boundless; only the physical confines of the museum itself construed the limits to natural plenitude and its visible diversity. Museums came to represent a stable reference point of cultural heritage and a measure of man's wisdom. But museums also became, ironically, the institutions most clearly committed to representing the mechanisms of change.

The irony lies in the fact that preservation is the antithesis of progress. Change occurs as a phenomenal aspect of the immutability of time, within which progress occurs. But collected or conserved objects are frozen in the moment of their most emblematic value – of singularity, of implementation, or representativeness – and denied their natural, or intended, decadent lifespan. In museum collecting, active selection intervenes in passive eternity ("the passing of time"). As Octavio Paz pointed out long ago, this often means that objects that were never intended to last very long have their life trajectories interrupted. The natural decay of natural

historical objects is likewise prevented by their preservation, whereas other objects, such as industrial or toxic waste, remain despite anyone's desire to keep them. Paz wrote: "The obscene indestructibility of trash is no less pathetic than the false eternity of the museum" (Paz 1974: 24). Time is frozen in museums to the extent that its objects are preserved, their natural decay intentionally prevented.

While much has been written about how museums came into historical being, I want to emphasize how museums have been created to capture a moment of creativity or cultural significance. This may seem a rather limited notion of the museum's purpose, but it is a useful way to think about how a fundamental conundrum has been established. Much has been written about forgetting, about the loss of social memory that is the catastrophic result of violence and the decline of civilizations, which museums are supposed to counteract. But we might suggest as well that forgetting is a naturally occurring process which museums disturb. We would then need to write a history of interventions against the flow of time.

Preservation deliberately interrupts time's natural order. Within the scope of modernity, both evolutionary theory and Enlightenment conceptions of progress developed similarly as attempts to account for perfectability over time: improvement was a sign of nature's or God's will expressed in concrete terms. Accordingly, change was not only good, it was *supposed* to happen. Western thinkers from the Greeks to the moderns articulated a sense of time's inevitable movement, but modernity excelled in expressing that movement as positive and forward–inclined. To interrupt the natural order of things, including time, was to deny the benevolence of progress, and its duration. Decay and extinction, as Charles Darwin among others pointed out, occurred naturally and necessarily, as part of this process. Darwin framed his evolutionary thought in terms of competitive survival. The contents of museums, one might suggest, represent the traces of evolutionary stages, examples of what did not survive but yet, paradoxically, transcended into the present. It is no accident that fossils, those material traces of previous evolutionary stages, are to be found in natural history museums: in the natural order of things, the existence of the living came to an end; while the remains – the traces, the randomly fossilized artifacts which transgress time by becoming mired in the primordial muck – transcended their previous form to acquire new significance as relics. Preservation intervened twice: once in nature, once in the museum. For me, this brings back fond memories of childhood visits to the La Brea Tar Pits, now part of a museum in Los Angeles, where the primordial muck still bubbles.

As Michel Foucault influentially suggested, the natural historians of early modernity redefined time:

> The ever more complete preservation of what was written, the establishment of archives, then of filing systems for them, the reorganization of libraries, the drawing up of catalogues, indexes and inventories, all these things represent, at the end of the Classical age, not so much a new sensitivity to time, to its past, to the density of history, as a way of introducing into the language already imprinted on things, and into the traces it has left, an order of the same type as that which was being established between living creatures. And it is in this classified time, in this squared and spatialized development, that the historians of the nineteenth century were to undertake the creation of a history that could at last be "true" – in other words, liberated from Classical ratio-

nality, from its ordering and theodicy: a history restored to the irruptive violence of time. (Foucault 1973: 132)

History exists within "the irruptive violence of time" and its epochs and eras are merely markers. Classification manages time. This fundamental shift in attitudes toward time occurred during what Reinhart Koselleck refers to as the *Sattelzeit* or "saddle period" between the *ancien régime* and modernity (Koselleck 2002). The nineteenth century's contribution to reorganizing time was its creation of the modern disciplines of history, and anthropology, and of museums. This "saddle period" endured revolution and, in its Romantic rhetoric, perceived a rupture between old orders and new chaos, which was visualized in the form of ruins. The Romantic fascination with ruins is a corollary of the new historical consciousness that became a hallmark of modernity. Ruins were both longstanding architectural features of the landscape and newly created reminders of war and secularization. In the nineteenth-century fervor for preservation, all ruins were seen as objects in need of defense, conservation, and preservation. Not only portable artifacts, but ruins in general became collectible objects within the realm of newly historicized preservation. According to Romantics then and now, posterity demands preservation against the ravages of time.

Once "time" became manageable and the posterity of the archive or collection was (presumed to be) assured, its representation in the museum became linked to objects. But the meaning of "the past" was to be distinguished from the meaning of the object itself. The ruin or relic does not define its own fixed or guaranteed place within the collection. It can be put to many purposes that are stringently and multiply constrained by historical context. For instance, Susanne Koestering and Donna Haraway have vividly demonstrated how apparently "natural" groupings of flora and fauna in late nineteenth-century German and American natural history museums were shaped by provincial or national identities and bourgeois morality rather than by any "timeless" naturalness of nature (Haraway 2004; Koestering 2005). In her influential essay, "Objects of Ethnography," Barbara Kirshenblatt-Gimblett discussed how one era's curiosities were another's scientific or ethnographic relics, many of which were simply translated from the earlier era's cabinets to the later era's museums (Kirshenblatt-Gimblett 1998).

Nineteenth-century museums contemporaneously exhibited natural history and history – separately. Museums of ethnography depicted "primitive" (although contemporary) cultures as timeless entities, while museums of history established trajectories of modernization and industrialization that depicted the inevitable progress of Western civilization (Karp and Lavine 1991). The Smithsonian's original museum complex included a museum of history and technology and a separate museum for natural history. The distinction between "peoples with histories" and "peoples without" separated Native Americans from Europeans, as early anthropology and ethnography developed the idea of "primitive" peoples, those whose lifeways had altered only through contact with modernizing Westerners. Timeless, essentialized "primitives" and natives were classified within the natural history of man's development, rather than within the civilizing order of history. At the end of the twentieth century, a new Museum of Native American Indians re-visioned the place of those peoples within history, insisting on their place in the irruptive violence that

had removed their traditions and artifacts from an historical existence. Objects removed from a natural history to a new historical museum altered in their temporal significance.

Timelessness is rendered visible in another way at heritage and "living history" museums. Visitors hope to feel as if they have "stepped back in time," attempting the experience of living in the past. We know that this is impossible, but our encounters with period-costumed, arcanely voiced guides and re-enactors provide a *frisson* of verisimilitude that we find compelling. Such encounters appeal to the imagination and draw on memories of school lessons and history museums, public television specials, and period films. We have a range of sources to draw upon, as do the re-enactors. Barbara Kirshenblatt-Gimblett (1998) notes that we all watch to see whether the Pilgrims, or Vikings, or whomever we are "visiting," will be able to stay in character. Our awareness of the discrepancy between the past and the present never entirely disappears, but we enjoy the illusion of timelessness – the ability to share the past as if it had never passed – even as we are drawn to that past because of its differences from our present.

Preservation is predicated on posterity sharing the desires of the present, although, as we have seen, those desires can never be taken for granted and do in fact change with time. Museum collections are built so that future generations will have the benefit of the knowledge and meanings accumulated in the museum – on the implicit assumption that progress has been made, and that future generations will value the results and continue to do so. In speaking of the museum as an agent, and assigning motivational interest to an impersonal future collectivity, I am highlighting the way in which museums themselves are regarded – are seen, experienced, described, written about – as manipulable, so that the temporality of their mission is seamlessly projected from the present to the future. The future *must* care, else the project is doomed. The goal of all preservation is to intervene in the natural history of destruction (with apologies to W. G. Sebald, who contemplated writing such a history and whose essay on the subject appeared in a posthumously published volume entitled *The Natural History of Destruction* [2003]).

Remembering and Forgetting: World War II and Collective Memory in Museums

Museums organize the significance of what we already knew – the archives we carry in our minds, the ineffable as well as the rigorously conscious memories that comprise our knowledge. In the course of time, memories shift from front to back in our minds, sometimes resonant, other times filed away in addresses which, like semi-conducted codes no longer in use, we can no longer access. Externalizing the mental function of remembering, museums of history, natural history, and culture select some memories to retain in the perpetual present. Preserved and conserved objects are organized in a meaningful narrative that is offered continuously and accessibly. With these foregrounded significances embedded in art, historical objects, or exempla of natural phenomena, we are reassured that meaning will not be lost in the synapses of our brains but collectively represented in the tableaux of exhibitions.

These representations, foregrounded and (it is hoped) permanently shelved (fixed or presented) in an easily accessible location (even if you do not go, you know it is there; it is reassuring), form the basis of our cultural identities. Memory ensures meaning and reassures or reaffirms identities repeatedly, despite the fact that the remembering never recurs in exactly the same way. As Daniel Dennett and others have shown, individuals never re-experience memory as pure, perfect repetition of the past. Each act of remembering is discrete, and although connected to past memories, is not a duplication of them (Westbury and Dennett 2000). Museums are no different; contact with their contents renews remembered connections. Each time we visit a museum (for the first time, on a repeat visit, alone, with others), we experience the preserved perpetual present anew. We bring to the exhibitions those accumulated life experiences and maturity, those constantly changing iterations of the personal which construct our daily identities. We possess knowledge, which we deploy in the midst of the museum, equally as much as we gain knowledge and experience from the information and objects presented. Even total ignorance of a museum's contents or mission does not preclude visitors from bringing expectations (Crane 1997).

Imagine, then, the consternation of an American World War II veteran who learns that the famous National Air and Space Museum (NASM) in Washington, DC intends to exhibit the *Enola Gay*, the B-29 which dropped the world's first atomic bomb on Hiroshima. The museum is the most popular of Washington's many public museums, and its location on the Mall, adjacent to the halls of government, reinforces public perception of its mission: to honor technological progress, and America's role in supporting its development. From the Wright Brothers' plane to a NASA space capsule, NASM's collections illustrate a celebratory narrative of technological achievement. The *Enola Gay* could have been displayed as an exemplar of advances made in air power during the 1940s, and the veteran could have visited the museum happily, assured that his understanding of the war and this object's place in it would reaffirm his expectations.

Controversy erupted over the proposed exhibition in 1994, as the nation approached the fiftieth anniversary of both the bomb and the end of the war. For veterans, the bomb's role was incontestable: it had brought a swift end to a bloody conflict and saved at least a million American lives, serving as appropriate retribution for the devastating and shocking attack on Pearl Harbor and the brutality of the ensuing war in the Pacific. However, NASM's curators, in consultation with veterans' groups, American military representatives, and historians, created an exhibit which focused not on the B-29 as such, but on the *Enola Gay* and its mission: as bearer of the bomb, destroyer of innocent lives, initiator of the Cold War and the atomic age of fear (fig. 7.1). As NASM's exhibit plans became public, reactions were immediate and hostile. Most people who had lived through the war did not want to challenge their lived experience and memories of how the war ended, which had served as a stable point of reference (Crane 1997; Hein and Selden 1997; chapter 30 of this volume).

Collective memory theory helps us to understand why some perceptions or beliefs remain intransigent, while others are more flexible. It is not simply a matter of "time passing." The most influential theorist of collective memory, Maurice Halbwachs,

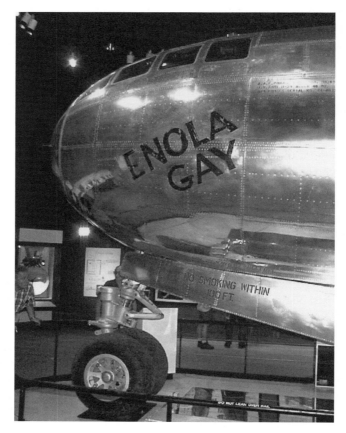

Figure 7.1 The revised *Enola Gay* exhibit featured the plane's fuselage but very little about its non-aeronautic historic significance. National Air and Space Museum, Washington, DC. Photograph by Bill Bezzant, Saipan.

discussed how memories form among people who share a common experience, belief, or idea (Halbwachs 1980). Halbwachs argued that individuals experience time not only as duration but also as multiplicity. So long as there are others for whom memories lie in common, an individual can recall experiences as shared. Each recall reshapes that memory for the individual and in turn affects the memories of others. Over time, some memories are retained because they continue to be shared; other memories fade away or find another repository, such as a museum. Modern memory theory relies on the notion that memories are never entirely subjective, or relying completely on a single person's solitary brain. Collective memory, then, is the basis for all memories, and each individual participates in many collectives that vary over time, waxing and waning in significance, or, to borrow the computer analogy again, sometimes the memory addresses are on the screen, and sometimes they are buried in the hardware. Collectives may be as large as a nation or humanity, or as small as

the two people who shared an experience, and all individuals participate in a changing plurality of collectives throughout their sentient lives.

As the study of collective memory intensified in the 1980s–1990s, scholars and critics emphasized different aspects of its influence and developed a larger critical vocabulary. Some, such as Mieke Bal, use the term "cultural memory" to refer to "memory that can be understood as a cultural phenomenon as well as an individual or social one" (Bal et al. 1999: vii). "Social memory" tends to be preferred among anthropologists, "cultural memory" within cultural studies, and "collective memory" by historians. Arguably, the terminological differences are primarily semantic, signaling disciplinary boundaries, but they signify a range of scholarly viewpoints on the ways to understand memories that appear to belong to more than one individual. Marita Sturken suggests that "memory that is shared outside the avenues of formal historical discourse yet is entangled with cultural products and imbued with cultural meaning" marks the subject of cultural memory studies (Sturken 1997: 3). History and memory appear to be at odds (although not entirely separated) in this rendering, much as Pierre Nora influentially argued. Nora, directing a collaborative project on French collective memory, urged attention to the "sites of memory" around which collective memories aggregated (Nora 1996). "Sites of memory" persist even when direct connection to the past appears to have been lost, and allow for the recovery of memories without necessarily involving traditional historical study. Collective memory thus compensates for loss.

Viewed from a different slant, loss of memory can be recognized at times to have been willfully achieved, as James Young (1993) noted in his perceptive account of Holocaust memorials. Young drew attention to the "counter-memories" that contest official or national narratives of the past and challenge society to recall what they have not wished to pay attention to, such as participation in the Holocaust. "Counter-memorials" thus defy conventional expectations of celebratory monuments to past glories, by insisting on representing loss, trauma, and failure to come to terms with the past.

When war is the basis of collective memories, their multiplicity renders difficult any attempt to educate a public, recall a particular version of the past, or create a new narrative of its meaning. This phenomenon is not limited to Western museums' attempts to remember World War II. The year 1995 was a watershed for memorial and commemoration of the war, and not only because the fiftieth anniversary was particularly significant. Ten years after the war (and, not coincidentally, shortly after the withdrawal of American occupation), Japan's first museums of atomic power opened: the Hiroshima Peace Museum and the Nagasaki Atomic Bomb Museum. They emphasized local experience, as the true "ground zero" of a new and terrible era. Honoring the dead, and decrying the use of atomic weapons ever again, these museums served a powerful moral and didactic purpose. As museums of the war, however, they represented only its end. The Greater East Asian Co-prosperity Sphere, the emperor's role in supporting militarism and imperialism, the subjugation of conquered Asian peoples – all were missing from the museums dedicated to peace. Japan's role in the war was marginalized, even though attention to its recent past and acceptance of its memory could have contributed to the message of peace.

Local experiences, so horribly and uniquely traumatic, dominated the institutions created in their memory.

The Japanese public was largely kept in ignorance of its wartime history. American occupation forces and the new Japanese government colluded in looking forward, rather than back, in order to stabilize the fledgling democracy. As a result, most Japanese learned nothing about Japan's wartime atrocities. Their collective memories were forged around a national identity based on victimhood. This identity was challenged in the late 1980s and 1990s, as the other victims began to speak out after a long silence – of wartime biological experiments in China, of sexual slavery as so-called "comfort women" from Korea in particular. Collective memory among comfort women first found its voice only after Korean feminists encouraged these "grandmas" to come forward and demand recognition. The Japanese public and its government responded with incredulity, based on their own lack of collective memory of the comfort women's exploitation. Veterans and former patrons of the comfort stations had been encouraged to see it as a legal system of prostitution. Cultural mores and shame had kept the Korean victims silent but the memories alive. No museums had included these memories or any other that challenged the official national narrative of victimhood and peace advocacy. Time had been allowed to follow its natural, destructive flow.

The uncanny ability of photography to render the past visible has made this medium one of the most attractive for museums wishing to narrate modernity. Photographs and film of World War II provide us with ample evidence of atrocity and barbarity, but they also offer us insight into how we experience time, memory, and the past in museums. In the 1990s, a controversial exhibit of Holocaust atrocity images called *Crimes of the Wehrmacht* toured Germany and Austria. The Nazified German army was indicted through the exhibit's documentation of active participation in the mass shootings of Jews on the Eastern Front. Although some photographs were mislabeled and misidentified, the bulk of the exhibition's accuracy caused painful self-reflection and denial among its German viewers. Postwar German speakers had largely accepted the Wehrmacht as a Nazi army, but believed that individual soldiers were not culpable for the crimes of the regime. Viewers were forced to reconsider their own relatives' potential involvement in genocide. As Ruth Beckerman demonstrates in her 1996 documentary of the exhibit in Vienna, *East of War*, veterans disagreed with each other in front of the very photographs that documented the crimes; children of soldiers refused to believe that their beloved parents had been involved in genocide; and still others voiced sentiments eerily reminiscent of their 1930s' life experiences. Photographs may "freeze" their subjects, but they do not freeze time.

In Japan, the mid-1990s brought photography exhibits about World War II to its art museums. The exhibit location implicitly raises controversy about the photograph as document: is it an historical artifact or "merely a picture?" Julia Thomas (1998) explored these ambiguities at the Yokohama Museum of Art's *Photography in the 1940s* exhibit in 1995. Japanese military involvement in the war was invisible. Instead, Japanese auteurs' renderings of patriotic homefront women and children were presented alongside contemporary photographs by famous American and other photographers. An essential, national timelessness was suggested in the Japanese

photographs, which evaded the historical specificity of their composition. Thomas suggests that photographs can operate in multiple time-frames simultaneously. Just as collectives form independent *and* inter-related memories, so too photographs can depict many separate notions of time. For instance: the time of a nation coming into being or the span of a war; the lifetime of a veteran or survivor or their children; the past during which the photograph was composed; the present of the viewer. The photograph can also appear in a strictly formal sense as a work of art, itself the reason for its being and its meaning, regardless of context. Ironically, photographs epitomize the ways in which artifacts fit into non-simultaneous chronologies simultaneously. Museums' representations of the past through photography will always be freighted with these multiple temporal frames.

A Natural History of Preservation and Destruction

Michel Foucault understood that most modern inquiry into memory and historical consciousness emphasized a search for origins. But, he wrote, such inquiries are doomed to frustration: "there is nothing one can do about it: several eternities succeeding one another, a play of fixed images disappearing in turn, do not constitute either movement, time or history" (Foucault 1972: 166). A narrative of progress may be imposed on a chronology, but that imposition will never be able to efface itself or make those meanings "natural." The meanings that we attempt to attach to objects are dependent on historical context and the multiple collective memories that shape their reception. We can know an object's provenance, but does that really tell us the "origin" of its significance? Meanings, embedded in narrative, rely on repetition, context, and memory for their posterity. Time endures, but meanings only endure with continual effort. Forgetting attempts what natural time cannot: to remove "the traces of conflict, failure and disaster [which] are never erasable in time" (Sennett 1998: 11). Silencing and forgetting go hand in hand when speech is prevented, but as we have seen with the "comfort women," silence also shelters memory. For survivors of trauma, what forgetting they are able to achieve against all odds, may count as grace. Though there may be political or moral reasons why we condemn silence or generate narratives of recovery, forgetting is not necessarily anathema.

When meanings are forgotten, it is usually because other meanings have been generated in their place, even using the same objects of reference. A hundred or five hundred years from now, the *Enola Gay* may well be just another B-29. The Smithsonian has chosen to present the plane in a commemorative hangar at Dulles International Airport outside Washington, DC, along with other planes. By removing the *Enola Gay* from NASM's premier venue on the Washington, DC Mall, its curators have attempted to reduce the scope of the plane's significance. No exhibit which would remind viewers of its mission accompanies the *Enola Gay* to its new home; no images of children's lunch boxes or stopped watches will remind the viewer of the plane's unique mission. It is a plane among planes in an historical narrative of technological progress. But it is also possible that, one hundred or five hundred years from now, the *Enola Gay* will figure as the primary commemorative tool in a history of peace, as the plane which sparked the atomic age and Japan's pacifist response,

whose significance would only be realized after the twentieth century's violent legacy was understood in a larger context. I offer this scenario as an imaginary optimistic prognosis, but "what if" history never satisfies anyone completely, and should not. The meanings of this plane, indeed of any preserved object, are not limited to the single instance of their display.

The past, like museum and archive collections, is always the lodestone of meaning and understanding. Our knowledge of it is never complete. We rely on preservation to secure the referents of the past, and we attempt to delay or interrupt the natural history of destruction in order to underpin our own fragile memories. Why has this desire become tantamount to modernity? Why are we unwilling to let the past go? The lessons are still there, in other forms; one could argue, for instance, that the original Declaration of Independence, so fragile that curators fear for its life, is itself re-written in the institutions of democratic society. We can also make copies. Other objects, less unique and less central to the notion of "freedom," may have fewer reasons for continuing to exist. But we preserve, protect, and defend the objects we choose to represent our pasts and our cultures because that choice, that representation, is itself valuable to us. So long as that value remains intact, we will have collections, museums, and the narratives of their meaning. The narratives, however, will change, and that too is a part of the natural history of preservation and destruction. To understand the ramifications of time and memory in the museum, historical consciousness demands accountability. But at the same time, we recognize that "what has been" is the starting-point of meaning, and only that.

Bibliography

Bal, M., Crewe, J., and Spitzer, L. (eds) (1999) *Acts of Memory: Cultural Recall in the Present*. Hanover: New England University Press.

Crane, S. A. (1997) Memory, distortion and history in the museum. *History and Theory*, 36: 44–63.

— (2000a) *Collecting and Historical Consciousness in Early Nineteenth-century Germany*. Ithaca, NY: Cornell University Press.

*— (ed.) (2000b) *Museums and Memory*. Palo Alto: Stanford University Press.

Foucault, M. (1972) *The Archaeology of Knowledge* (originally published 1969). New York: Pantheon.

— (1973) *The Order of Things* (originally published 1966). New York: Vintage.

*Halbwachs, M. (1980) *The Collective Memory*. New York: Harper and Row.

Haraway, D. (2004) Teddy bear patriarchy: taxidermy in the Garden of Eden, New York City, 1908–1936. In *The Haraway Reader*, pp. 151–98. London: Routledge.

*Hein, L. and Selden, M. (eds) (1997) *Living with the Bomb: American and Japanese Cultural Conflicts in the Nuclear Age*. New York: M. E. Sharpe.

Hughes, D. O. and Trautman, T. R. (eds) (1995) *Time: Histories and Ethnologies*. Ann Arbor: University of Michigan Press.

Karp, I. and Lavine, S. (1991) *Exhibiting Cultures: The Poetics and Politics of Museum Display*. Washington: Smithsonian Institution Press.

Kirshenblatt-Gimblett, B. (1998) *Destination Culture*. Berkeley, CA: University of California Press.

Koestering, S. (2005) Biology, *Heimat*, family: nature and gender in German natural history museums around 1900. In T. Lekan and T. Zeller (eds), *Germany's Nature: Cultural Landscapes and Environmental History*. Ann Arbor: University of Michigan Press.

Koselleck, R. (2002) *The Practice of Conceptual History: Timing History, Spacing Concepts*. Palo Alto: Stanford University Press.

*Nora, P. (1996) *Realms of Memory: Rethinking the French Past*. New York: Columbia University Press.

Paz, O. (1974) *In Praise of Hands*. Toronto: McClelland and Stewart.

Sebald, W. G. (2003) *The Natural History of Destruction*, trans. A. Bell. New York: Random House.

Sennett, R. (1998) Disturbing memories. In P. Fara and K. Patterson (eds), *Memory*, pp. 10–26. Cambridge: Cambridge University Press.

Sturken, M. (1997) *Tangled Memories: The Vietnam War, the AIDS Epidemic, and the Politics of Remembering*. Berkeley, CA: University of California Press.

Thomas, J. A. (1998) Photography, national identity and the "cataract of times." *American Historical Review*, 103 (5): 1475–501.

Westbury, C. and Dennett, D. (2000) Mining the past to construct the future: memory and belief as forms of knowledge. In D. L. Schacter and E. Scarry (eds), *Memory, Brain, and Belief*, pp. 11–34. Cambridge, MA: Harvard University Press.

*Young, J. (1993) *The Texture of Memory*. New Haven, CT: Yale University Press.

Histories, Heritage, Identities

Introduction

Part II of the *Companion* presents some of the history of museums, while also reflecting on museums as makers of histories and identities. Looking at these together is in many ways inevitable as they are so intimately entangled. Museums are bound up with collectivities of various kinds – "the public," "the nation," "the community" – and these are usually realized at least in part via projections into the past.

The first chapter in Part II, by Jeffrey Abt (chapter 8), provides a history of museums that stretches back to classical antiquity. Providing a long account is not, however, part of a move to legitimize the museum by driving the story of its origins deep into the past, but is, rather, in order to challenge what has sometimes become an easy acceptance of the idea that the *public* museum began in the eighteenth century. Abt's careful scholarship explores what is meant by "public," and indeed also by "museum," in order to produce a more nuanced account of museum history. His argument is not one of straightforward continuity, however. There are changes over time but these are rarely moments of sudden rupture, drawing instead on earlier notions and practices. The museum does not "go public" by just opening its doors and letting the people in (though individual museums may do so, as Abt discusses in relation to the iconic example of the Louvre). Rather, there are degrees of going public. Museums become "more wholly public," as he puts it, in a process that involves not just access but also changing notions of ownership and the taking on of a more actively constitutive social role by the museum in relation to "the public," something that also entails the increasing professionalization of museum work (see also chapter 25). This more constitutive role, as also suggested by some of the chapters in Part I, is shown in relation to national identities by Flora Kaplan in chapter 10 and further explored by Tony Bennett in chapter 16. However, it does not work in the same way everywhere, as Abt shows well through his discussion of the differences between Europe and the US.

By extending his discussion into the past, and into institutions that might or might not usually be dubbed "museums," Abt usefully highlights the potential fluidity of the notion of "museum" as well as the ways in which it can be demarcated from other similar agencies. This is also discussed to some extent by Shelton in relation to curiosity cabinets in chapter 5, and in Christina Kreps's examination of practices and institutions in a range of non-Western institutions that variously share museum

features (chapter 28). Robert Rydell's discussion of world fairs (chapter 9) provides a further instance, in this case of an institution that, while it may often be thought to be rather different from the museum, shares a good deal in terms of its representational activities and social and cultural roles. In particular, world fairs, which can reasonably be said to have begun in the nineteenth century (1851 to be precise), were bound up with the making of national identities. As also discussed by Flora Kaplan and Elizabeth Crooke (in chapters 10 and 11), this entailed constructing progressive narratives in which non-national and especially colonized subjects were cast in the role of the not-yet-progressed (see also chapters 5 and 7 in Part I).

Like Abt's and other chapters in the *Companion* (for example, Preziosi's discussion of Soane in chapter 4), Rydell's chapter is illuminating in showing not only the generalities of the processes involved, but also some of the key individuals and the way in which their decisions and actions helped shape events and practice. As he shows, through the person of G. Brown Goode, there were thoroughgoing literal links between the museum and the world fair, highlighting the traffic between them, even while the former often sought to define itself as unlike its noisier and more ephemeral counterpart. Rydell provides an individualized example not only of one of the architects of world fairs and modern museology, but also of some of those who were displayed at the fairs. While those displayed were clearly relatively powerless, he shows some of the ways in which they could be said to retain agency, and his approach of providing more detailed cases could itself be said to entail a degree of return of agency to them.

Chapter 10 by Flora Kaplan and chapter 11 by Elizabeth Crooke both include discussion of the ways in which groups – some of which would previously have found themselves the subject of museum display by others – have come to appropriate the museum model in order to proclaim their own identities. Kaplan looks at national identities, especially in postcolonial and post-socialist contexts, and indicates that the national model still has considerable global purchase and that museums continue to be a significant means of proclaiming national identities. The context in, and means by, which they do so, however, has changed, as Kaplan's discussion of contest and the role of national, and especially international, museum organizations and museum studies reveals. This is clear too in Crooke's discussion of "community" – a term that has been widely and often politically deployed in relation to national as well as more localized identities. She looks especially at what might be called "bottom-up" examples in which museums are deployed for community development, with case studies of District Six Museum in South Africa (see also chapter 29), community museum networks in Mexico, and community museums in Northern Ireland. These show well how important museums can be in the affirmation of local identity and pride; though, as she also notes, there can be dangers in the politicized use of "community," and "social inclusion" can also entail its own "exclusions."

Alternative museological approaches to the representation of identity and history are also the subject of chapter 12 by Rosmarie Beier-de Haan. She looks, in particular, at attempts to move beyond conventional bounded models of identity and to deal with cultural diversity. As she argues in relation to a judicious selection of recent examples, this does not necessarily mean that national identity is no longer a focus: rather, it may be performed in a range of ways, some of which are very different

from earlier models, reflecting changing contexts and sensibilities, and also changing historiographies. The move from "grand histories" to social history in the 1970s is evident in many museums. This is now giving way, she argues, to newer approaches which reflect a fragmentation of identity and greater individualization. Novel forms of exhibition do not seek to represent and address the individual "as a representative of a collective identity (for example, of gender or class)" but "re-stage" history in ways which leave open alternative interpretations and create the possibility for individualized perceptions.

Alongside these novel approaches, however, a discourse of "heritage" continues to gain ground. This is a key concept in museum studies, and Steven Hoelscher (chapter 13) analyzes its modes of operation, so illustrating how it works in relation to other key concepts of display, place, time, politics, authenticity, popular appeal, and development strategies. His timely examples, beginning with the looting of the Baghdad Museum during the Iraq War, and including case studies of struggles over the representation of the past in the US South and in Guatemala, show how crucially important are the issues at stake. Heritage, as he states, "is not merely a way of looking at the past, but a force of the present that affects the future."

The Origins of the Public Museum

Jeffrey Abt

The beginnings of the public museum are commonly traced to either the founding of the Ashmolean Museum in 1683 or the opening of the Louvre Palace's Grand Gallery in 1793. The Ashmolean is singled out for being the earliest museum whose creation stipulated accessibility for public viewing. The Louvre is noted because its opening to public access, achieved during the French revolution, symbolized the French people's claims to political sovereignty and the national patrimony. It would be a mistake, however, to assume that the modalities represented by "public" and "museum" were new to the seventeenth and eighteenth centuries. To the contrary, the Ashmolean and Louvre mark only a couple of points in nearly two millennia of intersections among the uses of objects, the spaces of display, learning practices, and communities. Before addressing these terms and the understandings they represent, however, I want to consider their conflation in modern museology.

"Public museum" must be one of the most commonly used and least-questioned expressions in contemporary museological discourse. The reduction of "public" to an adjective modifying "museum" suggests that the meaning of "museum" precedes the qualification of "public" as though, for example, the "public" museum came into being with the Ashmolean. However, the nomenclature and meaning of "public" in relation to the practitioners, places, and audiences of collecting and display has been, like that of "museum," in use and evolving over two thousand years. For this reason, I explore the nascence of the public museum by investigating the individual trajectories of "public" and "museum" as they began to intertwine during classical antiquity and the Renaissance. I then return to the Enlightenment and the Ashmolean and Louvre before briefly considering their successor institutions in nineteenth-century Europe and America.

Classical Antiquity and *Res Publica*

Most accounts of museum history begin with either the etymological origins of "museum" in the ancient Greek word for cult sites devoted to the muses (*mouseion*) or the legendary Museum of Alexandria's founding c.280 BCE. However, the association of "museum" with the systematic collection and study of evidence began some-

where in between – probably with Aristotle's travels to the island of Lesbos in the mid-340s BCE. It was there that Aristotle, in the company of his student Theophrastus, began collecting, studying, and classifying botanical specimens; and in so doing formulated an empirical methodology requiring social and physical structures to bring into contiguity learned inquiry and the evidence necessary to pursue it.

Aristotle's methodology found expression in the formation of his Lyceum, a community of scholars and students organized to systematically study biology and history, among other subjects. The Lyceum contained a *mouseion*, and it is probably during this period that the term came to be associated with scholarly investigations. According to some, when Ptolemy I Soter began building Alexandria in c.331 BCE, he invited Theophrastus to join his court and advise the monarch on creating this new capital of his empire. Theophrastus declined and Ptolemy Soter turned to Demetrius Phalereus, a former governor of Athens who was familiar with Theophrastus's Lyceum. Demetrius Phalereus apparently inspired the monarch to establish the Mouseion of Alexandria in c.280 BCE. It seems that, in creating Alexandria, Ptolemy Soter was striving to become heir to the glory of Alexander the Great's rule, an effort that included establishing something akin to the Lyceum of Alexander's famous teacher, Aristotle (El-Abbadi 1990).

The Mouseion of Alexandria is one of the most renowned institutions of classical antiquity and the one whose accomplishments resonated most strongly with scholars of subsequent eras. Yet cultural memory of the Mouseion tends to conflate two distinct aspects: a community of resident scholars and the cult-center where their activities were housed (the Mouseion); and a collection of texts, the acquisition, editing, cataloguing and – in some instances – translation into Greek of which formed a share of the scholars' work (the Library). While many details regarding the Mouseion and Library remain in dispute to this day, there is a consensus about some aspects of the Mouseion. Some of the ancient world's greatest minds participated in the work of the Mouseion, the text editing and cataloguing practices established there transformed the nature of Western scholarship, and the Library's collections – reputed to have numbered more than half a million works at their greatest point – formed the basis for much of the classical literature that survived the dissolution of Hellenic civilization. Equally important, in establishing the Mouseion, Ptolemy Soter, and his successors who continued to support it, redefined kingly patronage (Fraser 1972). Because the monarch's possessions, powers, and interests constituted the state, Ptolemy Soter's founding of the Mouseion of Alexandria linked the institution of learning and its materials to the purposes of the state in a manner that enhanced the sovereign's prestige and extended his reach to include the less tangible but no less significant realm of knowledge. There was "something imperialist in the [Mouseion's] treatment of the books themselves – organizing them, cataloguing them, and editing them" (Erskine 1995: 45). The Mouseion's establishment appeared to have been, like Ptolemy Soter's processions and similar symbolic acts, a means of declaring his sovereignty over Ptolemaic Egypt, and ultimately over all of Hellenic civilization.

Although some believe that objects other than texts, including botanical and zoological specimens, were eventually added to the Mouseion of Alexandria's resources, the evidence is scanty and unreliable. Things were different in Pergamon, however,

a contemporary city with a library and scholarly community striving to rival Alexandria's. Pergamon and its institutions came to prominence under the leadership of Attalus I Soter, the first king in the Attalid dynasty and an aggressive collector of statuary and paintings from lands he controlled or conquered. Some of these works were installed throughout the outdoor spaces of Pergamon during the Attalids' ambitious building program, while others appear to have been reserved, perhaps in gallery-like settings, for local artisans to imitate (Hansen 1971). Despite the fragmentary evidence for these practices, they suggest an intriguing shift in the use of such objects during the transition from Greek power and influence to that of Rome – a shift from serving as objects of religious veneration to trophies of conquest and cultural veneration. With the advent of Roman expansionism between 211 and the early 60s BCE, and the arrival of looted statuary and paintings from conquered lands coinciding with the inauguration of a massive building program, Greek statuary was used to ornament the exteriors of new buildings and monuments throughout ancient Rome. In the words of Jerome Pollitt (1978: 157): "Rome became a museum of Greek art."

While Pollitt's use of "museum" may be overly broad by today's standards, it calls attention to the several ways by which Romans institutionalized the assimilation of Greek statuary and other precious objects into the visual culture and daily life of Rome. One was through stewardship, particularly the state's administration of statuary and other valued objects on or in state buildings, including temples and shrines. Existing administrative offices were enlarged to set and enforce standards for the care of public statuary, usually through the purviews of *aediles*, censors, and later *curatores* (Strong 1994: 16ff). Another was through ownership, expressed in a contest of attitudes about the use of Greek statuary in public (meaning outdoor) settings. It was ultimately a debate over the use of Greek statues by strongmen displaying their power and wealth to challenge that of the central authorities. Augustus resolved the debate by "let[ting] it be known that Greek art should henceforth be considered *public property* and that it should [only] be *used in the service of the state*" (Pollitt 1978: 165, emphasis in original). The symbolic potency of statuary in Rome's visual culture reveals a general sensitivity to the spaces as well as ownership rights of *res publica*. "Public" in this context thus defined the spaces of the *civitates* (community of citizens) bound together by Roman law – an arena delimited by an opposing "private," or settings where something could be seen by the many as opposed to settings where visibility was confined to a relative few. Here a brief digression on the nature and interpenetrations of "public" and "private" spaces in ancient Rome is necessary.

Vitruvius wrote his famous *De architectura libri decem* (Ten Books on Architecture) in c.30–20 BCE, when Rome was in the youth of its ascendancy, to prescribe architectural standards in anticipation of the city's expansion. In laying out his vision, Vitruvius distinguished between "Public Buildings" (in Book 5) and "Private Buildings" (in Book 6). He prepared the way in Book 1, on city planning, by characterizing public spaces as open areas to be allocated for siting temples, forums, theaters, and other structures requiring considerations of physical accessibility and convenience. As Vitruvius suggests in Book 5, "Public Buildings" also include basilicas, porticoes, baths, and ports. It is important to note, however, that "public" and "private" could overlap, as in the case of libraries:

> Private libraries were normally available to [patricians'] clients and would probably have been the primary means of access to books by those who were not wealthy until the first "public" libraries opened in Rome about the time Vitruvius was writing . . . These public libraries were essentially private libraries writ large and made only slightly more available to the public than a "private" library would be . . . Their purpose was to serve the personal political advertisement of the patrons in the environment of competitive patronage of the 30s and 20s BC. A "public" library in effect asserted the right . . . to the clientage of the entire public. (Howe and Rowland 1999: 2 and n.10)

When, in Book 6, Vitruvius addresses "Private Buildings," by which he means everything from the various structures in villa compounds (including farming-related buildings) to the somewhat more modest *domus*, he reveals the house was yet another boundary area where "public" and "private" overlap. This was because many Roman patricians conducted business in the *domus*, and thus Vitruvius had to distinguish between "Personal areas . . . those into which there is no possibility of entrance except by invitation . . . [and] Public areas . . . those into which even uninvited members of the public may also come by right" (Vitruvius 1999: 80). As John Clarke (2003: 221) put it, "Ancient Romans never understood the home as a private refuge . . . cut off from the invasions of commerce and the intrusions of strangers . . . [T]he house was the primary place of business. Daily visits of the paterfamilias's clients required the house to be open to everyone." The shading of "public" space within the *domus* becomes particularly clear when discussing the display of paintings.

During this period there was a proliferation of *pinacothecae* (picture galleries) in Roman domiciles. Derived from the Greek word *pinakes* for (painted) tablets, the *pinacotheca* was a room containing movable paintings and/or frescos depicting scenes in panel-like frames or *trompe l'oeil* images of paintings hanging on or installed in walls (van Buren 1938). Like Roman libraries, *pinacothecae* were socially ambiguous spaces because, although situated inside houses, most social conventions dictated that they ought to be accessible to the many:

> For . . . those who should carry out their duties to the citizenry by holding honorific titles and magistracies . . . there should be libraries, picture galleries, and basilicas, outfitted in a manner not dissimilar to the magnificence of public works, for in the homes of these people, often enough, both public deliberations and private judgments and arbitrations are carried out. (Vitruvius 1999: 81)

Yet the entire house was not readily accessible either. Rather, it functioned "as a place where zones of increasing intimacy opened to the visitor, depending on the closeness of his relation with the *familia*." This "gradient of intimacy," ranging from conventional clients, to special clients and peers, to close friends and relations, determined how far a visitor could penetrate into the variously arranged succession of spaces in the Roman house (Clarke 2003: 222).

One last point about Rome's function as a "museum": as spoils of war and conquest, the Greek statuary displayed in Rome's public arenas communicated the state's power and reach, not only to *res publica*, but to foreign emissaries and traders passing through this center of imperial might. Yet the widespread veneration of Hellenic

culture, which led the Romans to ornament their capital with Greek statuary in the first place, would later be complicated by the advent of Christianity. When Constantine and his successors sought to establish a "New Rome" in Byzantium by replicating Rome's architectural grandeur, the display of Greek pagan deity sculptures in the public spaces of the Byzantine empire's now Christian capital city seemingly contradicted the anti-paganism of the state religion. However, the installation of the Lausos Collection of several famous sculptures of Hellenistic antiquity, including pagan deity figures, along a major thoroughfare in fifth-century Constantinople, indicates that this kind of display was permitted. Surely Lausos, a high-ranking figure in the court of Theodosios II, would not have been able to display the statues in such a prominent location if their presentation did not accord with the monarch's imperial and Christian policies.

Sarah Bassett (2000) argues that the prominent display of these celebrated works of Hellenic culture signified the Byzantines' veneration of and triumph over their powerful predecessors. Moreover, with regard to the sculptures' pagan content, Bassett cites an edict concerning public access to pagan images in a temple now under Byzantine rule: "We decree that the temple . . . is for the common use of the people, and in which images [there] . . . must be measured by the value of their art rather than by their divinity . . . In order that this temple may be seen by the assemblages of the city and by frequent crowds . . . you shall permit the temple to be open" (quoted in Bassett 2000: 18–19). The display of the Lausos Collection in Constantinople thus served as a "visual corollary" to the imperial policy of mediating between a continuing admiration for its Greco-Roman past and Christianity's anti-pagan doctrine. "Emphasis on the aesthetic appeal of cult images neutralized their sacred qualities and in so doing made them legitimate objects of profane aesthetic contemplation of the Christian viewer," thus allowing their display to convey both Byzantium's dominance, as well as Lausos' personal prestige and loyalty to the sovereign (Bassett 2000: 19). The public display of symbolic or precious objects, whether for reasons of state policy or personal prestige, was acquiring a significant rhetorical power in its own right.

Renaissance and the Reformation of Civil Space

The retrieval of classical learning that shaped so much of Renaissance culture rekindled interest in Aristotle's writings and methods. What began in the 1400s as a widespread effort to translate Aristotelian texts directly from the Greek and disseminate them through the new medium of printing, evolved by the 1500s into ambitious enactments of his empirical methodology. Among these was the study and classification of specimens from nature, often with reference to Aristotle's writings in order to verify or gloss his teachings. And what began as studies of materials from local sources soon broadened as objects and specimens were brought to Europe by explorers to the New World and traders returning from distant lands. By the late 1500s, the assimilation of this evidence included its more or less systematic arrangement in tidy cabinets, cases, drawers, and other specialized furnishings, often in specially designated rooms in the homes and workplaces of amateurs and scholars. It also found

expression in an outpouring of books that catalogued, classified, and illustrated the findings.

A variety of words was employed to characterize these collections, their settings, the encyclopedic ambitions of their creators, and the kinds of objects collected: *pandechion, studiolo, gabinetto,* or *Wunderkammer, galleria, Kunstkammer,* or *Kunstschrank.* However "*musaeum*" soon became the most widely accepted and broadly applied term for characterizing the physical manifestations of this activity, whether spaces filled with objects or books filled with descriptions. As Paula Findlen (1989: 59) observed:

> Mediating between private and public space, between the monastic notion of study as a contemplative activity, the humanistic notion of collecting as a textual strategy and the social demands of prestige and display fulfilled by a collection, *musaeum* was an epistemological structure which encompassed a variety of ideas, images and institutions that were central to late Renaissance culture.

Yet, the emergence of *musaeum* as the preferred nomenclature was no accident. The recovery of classical learning included a fascination with Alexandria's ancient institutions as well, albeit in sadness over what had been lost and a longing to recreate them (Heller-Roazen 2002). For Renaissance scholars, then, "The trail of words leading from the Greek ideal of the home of the muses and μουσεíον, the famous library of Alexandria, marked the transformation of the museum from a poetic construct into a conceptual system through which collectors interpreted and explored their world" (Findlen 1994: 49).

The joining of objects and inquiry in architectural and textual spaces would be replicated with growing frequency and ever more encyclopedic breadth throughout Europe over the course of the sixteenth and seventeenth centuries. However, the acquisition of objects from explorers and traders was expensive and a number of scholar/collectors drew on a widening interest in collections to seek the patronage of royalty and church leaders. A noteworthy rhetorical strategy for pursuing patronage cited the precedent of Alexander's sponsorship of Aristotle and the enduring role of the latter's work in preserving the memory of the former – coyly implying that a Renaissance prince, aspiring to the eternal fame and prestige of Alexander, had much to gain by sponsoring the Aristotle of his own time. The formation of this patronage system not only enabled the creation and maintenance of collections, it also brought them – and the scholar/collectors who created them – into the ambit of European courtly society to inspire and entertain. According to travelers' accounts and collectors' visitor books, a relatively large audience of clerics, scholars, and others – some traveling long distances – began to see the collections as well (fig. 8.1). Naturalist and professor at the University of Bologna, Ulisse Aldrovandi, recorded the names and occupations of nearly 1,600 visitors between about 1566 and 1605, though there were certainly many more because he listed only those whose nobility or reputation warranted documentation (Findlen 1994: 352ff, 137ff).

While Renaissance collections tended to mingle specimens from nature (*naturalia*) with human-made objects (*artificialia*), their varying emphases nonetheless indicated differing purposes. Collections of *naturalia* were formed to support the investigative

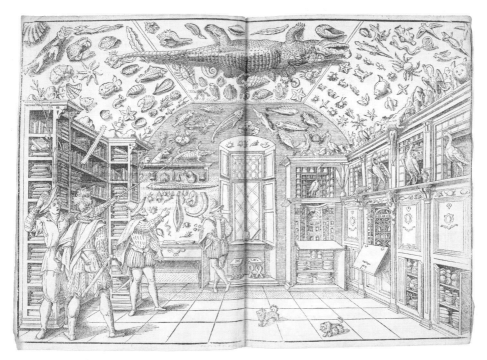

Figure 8.1 Frontispiece from Ferrante Imperato, *Dell'historia naturale . . .* (Naples: C. Vitale, 1599). This woodcut shows visitors being shown through Imperato's museum by, in all likelihood, his son Francesco on the far left. Reproduced courtesy of the Smithsonian Institution.

interests of scholars adumbrating what would be called "natural sciences" in later centuries; collections of *artificialia*, especially ancient coins, medals, and fragments of epigraphy facilitated antiquarian studies. Collections of painting and statuary, however, constituted a distinctive sub-group that addressed a variety of other needs depending on the nature of the works collected. These ranged from conveying the wealth, refinement, and power of their owners, such as the Medicis' holdings, to serving particular intellectual interests such as Paolo Giovio's portrait collection. Although the settings of painting and statuary collections, especially those in Italy, were frequently called *galleria*, here too "museum" was often the more general term of choice for collections whose contents were delimited in terms of thematic or investigatory purpose. For example, Giovio's collection, which facilitated his later books of elegies, was installed in a specially constructed space he called a *museo*. Both the *museo* and his *Elogia* were models for contemporary and later generations of collectors and elegists (Klinger 1991).

Whereas statuary and painting were displayed in outdoor or readily accessible settings during the Roman and Byzantine eras, during the Renaissance the presentation of such works moved indoors or to less approachable locations. Accordingly, the

potential for large sections of the populace to see collections was severely limited. Nonetheless, as during classical antiquity, the spaces of public and private access overlapped *within* the confines of palaces, church-related institutions, universities, and the homes of scholars and merchants. When Aldrovandi's collection of *naturalia* became a widely known destination for visitors from Italy and across Europe, it evolved from a private project into a semi-public gathering place for the learned, curious, and famous of the day. The earliest documentation of Aldrovandi's museum situates it in a room adjacent to his *studio* or study. The Renaissance study, however, was typically located in the innermost spaces of the home, often adjacent to the owner's bedroom. When, as often happened, the *studio* was transformed into a collection space or an adjacent room was adapted for this purpose, the acceptance of visitors into it – and the conversation it thus engendered – transformed the collection into a *mouseion* in the classical sense, a setting for learned discourse in the presence of its objects. Because this conversation was so important to the formation of Renaissance civil society, collections were increasingly viewed as quasi-public forums. The Senate of Bologna accordingly understood the communal value of, and accepted "with great affection," Aldrovandi's 1603 donation of his collection for installation in Bologna's seat of government (Findlen 1994: 24).

The association of collections with affairs of state became manifest in new ways during the Renaissance or perhaps in ways not apparent during classical antiquity. Francesco I de' Medici's *studiolo* was situated in the Palazzo Vecchio, the seat of Florentine government and Medici domicile, adjacent to the *sala grande* where he received state visitors. The *studiolo* contained both *naturalia* and *artificialia* installed in an elaborate scheme of cabinets and iconographically related wall paintings and ornamentation commissioned for the setting. Though it was created primarily for private contemplation, it is conjectured to have been "an attempt to reappropriate and reassemble all reality in miniature, to constitute a place from . . . which the prince could symbolically reclaim dominion over the entire natural and artificial world" (Olmi 1985: 5). Perhaps the rewards of having the *studiolo* in this boundary zone between private interests and public responsibilities led Francesco I to transform the loggia above the Uffizi (then literally the administrative "offices" of the Duchy of Tuscany) into a suite of galleries. There gleanings from the Medicis' collections of painting, statuary, and related kinds of precious objects and scientific instruments – including the *studiolo* – were gathered and displayed to Florence's elite and foreign dignitaries (Barocchi and Ragionieri 1983). According to Olmi, this vast reorganization of the Medici collections may have been related to the dynamics of Tuscan politics:

> The need to legitimize the Grand Duke and his dynasty meant that the glorification of the prince, the celebration of his deeds and the power of his family had constantly to be exposed to the eyes of all and to be strongly impressed on the mind of every subject.
>
> This transition from private to public . . . entailed a new arrangement of the collections . . . [in which works] of art and antiquities gradually came to be seen as status symbols and instruments of propaganda . . . (Olmi 1985: 10; see also Findlen 1994: 113–14)

Other collections of the era functioned in similar ways, especially with regard to the projection of regal power. The diplomatic uses of Emperor Rudolf II's collection toward the end of the sixteenth and early seventeenth centuries are particularly well documented. The collection, which contained *naturalia* and *artificialia*, including a number of paintings, statuary, and other works created by court artists and artisans, was one of the largest and most celebrated of the era and occupied an entire wing of the Habsburg monarch's palace in Prague. Rudolf II used it as a setting for private audiences with visiting monarchs, receiving foreign ambassadors, tours for other dignitaries, and viewings for his own ambassadors before being dispatched to foreign courts. And although the collection was not ordinarily accessible to the less highly placed, several did see it.

In considering Rudolf II's uses of the collection in conjunction with its placement, organization, contents, and iconographic program, Kaufmann (1978) found that the monarch's collection "like much of the art and public ceremony of his reign, was a form of *representatio*, of imperial self-representation." Rudolf II not only spoke in but "through" the collection as a medium of diplomacy; and one of its primary messages was "Rudolf's possession of the world in microcosm . . . an expression of his symbolic mastery of the greater world" (Kaufmann 1978: 22, 27). Comparable uses of collections are also found in early- to late-seventeenth-century Rome. As Patricia Waddy notes, "Collections of paintings and sculptures were not only for the private delectation of their owners; they were also part of their public reputations." Significantly, as in Rudolf II's palace, a purpose-specific architecture of separate "apartments" and galleries "so located within the palace that visitors could enter them without passing through other rooms of the palace" began to arise, spaces that would thus be "increasingly accessible to artists, travelers, and other interested persons" (Waddy 1990: 58–9).

Enlightenment and Assertions of the Museum's Public

Realization of the museum as a more wholly public institution, whether defined by accessibility or ownership, was born of the "crisis of authority" and efflorescence of social idealism that began in mid-seventeenth-century England (Cochrane et al. 1987: 1). The increasingly combustible swirl of grievances that sparked the English revolution, and resonated in the American and French revolutions, are best understood in the context of developing visions of the public good, economic opportunity, and political sovereignty that juxtaposed unbearable actualities with nearly utopian ideals. Throughout this sequence of revolutions, regressions, and eventual successes, practical concerns and idealistic visions clashed and battled for supremacy.

Not surprisingly, these debates widened to include the ownership and uses of cultural patrimony, notions which informed the divergent aims of individuals throughout Europe and England concerned with the transmission of collections to subsequent generations and the opportunities afforded by such acts. When Ulisse Aldrovandi donated his collection to Bologna, it was not only to assure that it remained "for the utility of every scholar in all of Christendom," but to guarantee

publication support for his remaining works (Findlen 1994: 24, 109). This transaction modeled exchanges whereby the donation of collections to institutions was reciprocated with certain benefits; here continuing access to the collection for future generations of scholars and publications funding, secured by the presumed durability and fiscal well-being of the Bolognese government. The uses and disposition of John Tradescant's collection reflects this model, albeit colored by the shifting political and economic circumstances of England in the years following the English revolution.

A British naturalist and gardener to Charles I, Tradescant ("the Younger") inherited his father's position, interests, and collection of *naturalia* and *artificialia*. He added to the collection, which was based primarily on materials acquired from Algiers and Virginia, such that it came to be regarded as one of the best gatherings of its size and quality in early modern England. Celebrated as the "ark of Lambeth," a reference to Noah's Ark and its aggregation of diverse species, the collection was located near London and attracted visitors from the continent as well as throughout the British Isles. Tradescant, like Aldrovandi, led visitors through the collection and apparently welcomed anyone wishing to see its contents, including children, beginning as early as 1649 and continuing until his death in 1662. He charged an admission fee of six pence, beginning about 1649, which coincides with Charles I's execution and, no doubt, Tradescant's unemployment (MacGregor 1983: 22–3). Among the visitors was Elias Ashmole, who befriended Tradescant and assisted him in compiling a collection catalogue (Tradescant 1656). Tradescant bequeathed the collection to Ashmole, a man of modest origins who rose to a high level of British society, power, and wealth as a solicitor, treasury official, and adviser to the king. Also an antiquarian, astrologer, and founding member of the Royal Society of London – a group with shared interests in the natural sciences – Ashmole had formed his own collection and published a number of books on history, alchemy, and related subjects. In 1675 Ashmole expressed interest in donating his collection, including the Tradescant holdings, to his Alma Mater, Oxford University. In 1677, the university proposed erecting a building with a "laboratory" to house it; the cornerstone was laid in 1679, and it opened in 1683 (Josten 1966: vol. 1: 205, 218). The Ashmolean Museum, which contained ten rooms to house collections and three larger rooms designated for "public" uses, was "designed for the study of natural philosophy, with a laboratory superbly equipped for experimental research, with a magnificent lecture hall, and with a museum of objects close at hand to aid and illuminate these studies" (Ovenell 1986: 22ff). The original structure still stands in Oxford though the collections were moved to newer quarters in 1845.

Ashmole's 1682 memorandum of gift and his 1686 set of "Statutes, Orders and Rules" specify the museum's governance, operations, and income sources. Though owned by Oxford University and supervised by a university board of visitors, the Ashmolean was intended to be fully accessible to the public from the outset and its operating funds, including a two-thirds salary for a keeper (who taught at Oxford for his remaining income) and pay for two half-time assistants, were to be drawn entirely from admission fees. The museum was to be open throughout the year except for Sundays and holidays ("unless there be an especiall occasion"), from eight to eleven in the morning and from two to five in the afternoon during the "Sommer halfe

yeare," and from two to four in the "Winter [half]." Visitors were to be shown through the collections by the keeper or an assistant, one at a time (Ovenell 1986: 26ff, 50ff). The admission fees were variable, and between 1683 and 1697 most paid one shilling, some as little as six pence, and "an outlandish Lord" and other notables as much as five or even ten shillings. A year-by-year accounting between 1683 and 1687 showed the annual income falling steadily so that the staff's income must also have been reduced (Josten 1966: vol. 1: 278). The extent of the museum's public access and popularity in 1710 was attested, if in a somewhat back-handed fashion, by visiting German scholar Zacharias Conrad von Uffenbach. When he first entered the museum the rooms containing the collections were so crowded with country folk ("*Manns- und Weibsleute vom Lande*") that he put off the visit. On his next visit he observed: "it is surprising that things can be preserved even as well as they are, since the people impetuously handle everything in the usual English fashion and . . . even the women are allowed up here for sixpence; they run here and there, grabbing at everything and taking no rebuff from the [attendant]." As Martin Welch (1983: 62–3) conjectured, perhaps the one-at-a-time visitor rule was ignored to increase the income from admission fees.

Ashmole's goal in donating his collection to Oxford University was to ensure its continuation in perpetuity. In a 1674 letter regarding a medal he received from the King of Denmark, Ashmole wrote "when I dye, [I shall] bequeath it to a publique Musaeum; that Posterity may take notice . . ." Josten believes that because there was no "publique" museum in England at the time – about a year before the donation – Ashmole must already have been thinking about founding one to preserve his collections for "posterity" (Josten 1966: vol. 4: 1395). The museum thus provided an institutional form that enabled the donor to perpetuate his legacy and the university to add a facility which, like the *mouseion* of antiquity, integrated inquiry and its objects. Further, by structuring a method of self-financing based on admission fees, Ashmole used his knowledge of finance to sustain this new institution without imposing a burden on the university. One wonders, however, why Ashmole did not donate his collection to the nation as would another similarly well-connected collector, Hans Sloane, about sixty years later. After all, Ashmole was a former government official and one-time adviser to the king. Perhaps the difference is due to the political environment of the time and Ashmole's particular place in it. He allied himself with the "royalists" during the English civil war and revolution in support of Charles I and preservation of the institution of monarchy in opposition to the "parliamentarians" who sought to permanently remove both. Even though Charles I's execution and the unrest that followed had passed, and the monarchy's restoration was underway in the 1670s, parliament retained its relative independence. Many members who had opposed the royalists retained their seats and they certainly would have fought expenditures for a museum housing a royalist's collections. Parliament's treatment of Hans Sloane's collections a generation later is instructive in this regard.

Sloane was a physician, naturalist, and collector who became a "fashionable" doctor in London with a practice that served members of the royal family and the aristocracy. Sloane's collection began with *naturalia* which he personally gathered in Jamaica which were then augmented with purchases, including entire collections acquired from three other naturalists. By the end of his life, Sloane's collection

had grown to include thousands of coins, medals, antiquities from throughout the Mediterranean and the Near East, old master drawings, and books and manuscripts related to medicine and natural history. When Sloane decided to leave his collection for posterity, he specified the creation of a board of trustees to oversee the process, indicating his first choice was the nation of England, provided that the government pay Sloane's heirs £20,000 and assure the collection's proper housing and maintenance.

Despite Sloane's popularity and the renown of his collection, when – after his death in 1753 – the estate's trustees approached the king and then parliament about the bequest, they were gently but firmly rebuffed, all citing the government's limited finances. The plan only went through when Sloane's offer was linked with remedying the poor conditions of the Cottonian Library, for which parliament had accepted responsibility in the early 1700s, and the availability of the Harleian collection of over 20,000 manuscripts. By act of parliament, the British Museum was established in 1753 to function as a public repository of objects *and* texts that would be maintained in perpetuity by the English government and overseen by a government-appointed board of trustees (Miller 1974: 28–63). It would continue to serve as both England's national museum and library until 1973 when the institution's books and manuscripts were put under the separate administration of the newly formed British Library (and moved to another location in 1997–8). The natural history collections were gleaned out and moved to a separate Natural History Museum in 1881. While the British Museum's collections grew to include works of art, particularly antiquities from around the world, such as the celebrated Elgin Marbles, its scope was limited by the founding of the National Gallery in 1824, also by parliamentary purchase of an individual's collection, which concentrated the acquisition of paintings and the graphic arts there.

Acquisition of Sloane's collection, and a mansion large and safe enough to house it along with the book and manuscript collections, was financed by lottery – one of parliament's more reliable if easily corruptible financing tools. The museum's annual operating funds were drawn from the interest yielded by the unused balance of lottery income, a very modest sum that began to be supplemented by parliament in 1762. Although there was some debate among the trustees about how broadly to interpret the "public" to be admitted, it was finally agreed that the museum: "tho' chiefly designed for the use of learned and studious men, both natives and foreigners, in their researches into the several parts of knowledge, yet being a national establishment . . . it may be judged reasonable, that the advantages accruing from it should be rendered as general as possible" (from *Statutes and Rules Relating to . . . British Museum*, 1759, quoted in Miller 1974: 61).

The museum was initially open every day except Saturdays and Sundays, Christmas day, the week after Easter, Whitsunday, Good Friday, "and all days . . . specifically appointed for Thanksgivings or Feasts." The hours were nine in the morning to three in the afternoon, and during the summer the museum was open on some days from four until eight. Despite the trustees' best intentions, however, entry was controlled by a ticket application process that could drag on for two or three days, and they were capped at ten per each hour of admission. Groups wishing to visit were limited to five per tour led by a staff member. Despite the restrictions, by 1762

the museum was serving as many as 10,000 visitors a year with ticket-applicant waiting lists lengthening to 300 per week. It seems the trustees' hesitation over truly throwing open the museum's doors to the public found partial expression in the staff's admission procedures. Yet, it also appears that the museum supported the research interests of a growing number of scholars – an audience whose needs surfaced repeatedly in the trustees' appeals to parliament for additional support (Miller 1974: 62–3, 66–71). The discourse surrounding the founding and maintenance of both the Ashmolean and the British Museum reflects subtle but important changes in the institutionalization of collecting and display. While the "museum" remained closely associated with scholarship, access to the learning it offered was slowly being widened. Whether this access was for largely pecuniary reasons, as with the Ashmolean, or out of a sense of governmental obligations to its citizens, as with the British Museum, the museum in England was becoming a social as well as physical space in order to accommodate larger numbers of visitors of varying backgrounds and classes.

The period of these developments was marked by a gradual opening of royal collections throughout Europe. Some, like that of Landgrave Frederick II, resembled the British Museum in combining a heterogeneous array of natural history specimens and statuary with a library. The Museum Fridericianum in Kassel, which opened in 1779, was available to visitors four days a week, for an hour in mid-morning and one in mid-afternoon (Sheehan 2000: 36–9). Far more common, however, were the princely collections of painting and statuary being made available such as the Medici's in the Uffizi on a limited basis in 1743 and more widely in 1769. This incremental widening of access, particularly to painting collections, took place against a background of social and cultural changes across the face of Europe and the British Isles. Chief among these were a growing interpenetration of court and public, facilitated in part by a specializing architecture of palace galleries, proliferating spaces for musical and theatrical performances (Sheehan 2000: 14–26), the demands of art academies seeking works to emulate, and a broadening of visual culture venues and markets. In particular, painting competitions, such as the salons in Paris beginning in 1737 and the Royal Academy exhibitions beginning in 1768, were widely attended and reported – later with illustrations – in contemporary print media (McClellan 2003: 4). As observed by Sheehan and McClellan, the constituents of the "public" finding its way to monarchs' galleries, museums, or to exhibitions, remain unclear. In general, however, access to the most significant collections on the continent remained at the discretion of the monarchs who possessed them. When access was allowed, whether for art students, foreign dignitaries, and the elite, or a larger segment of the populace, it was nearly always for a purpose that redounded to the monarchy's interests: demonstrating beneficence toward the kingdom's subjects, conveying moral authority by association with the works displayed, cultivating the arts on the populace's behalf. Although absolutism was beginning to wane by the mid-eighteenth century, pressures for economic and political reform were building throughout continental Europe.

The effort to create a national art museum for France originated with a display of paintings selected from King Louis XV's collections in a suite of rooms in the Luxembourg Palace. Mounted partly to assist the training of French artists and

partly to demonstrate the monarch's benevolence and effective handling of the collections, the Luxembourg Gallery was opened in 1750 for two days a week. When the gallery was closed in 1779 to provide quarters for members of the royal family, plans were already underway to establish a larger and more extensive display in the Grand Gallery of the Louvre Palace. For two centuries the site most conspicuously associated with the French monarchy, until Louis XIV moved his court to Versailles, the Louvre was also home to the Royal Academy of Painting and Sculpture. Though the planning was supported by Louis XVI, it became mired in a number of disputes concerning lighting and best use of the gallery, as well as the contents and organization of the display. The disputes, which in some respects mirrored the dithering nature of the monarchy, continued until 1792, three years after the French revolution began, when the king's palaces were overrun and he was taken prisoner. The museum initiative then fell to appointees of the revolutionary National Assembly. Parenthetically, in 1789 the revolutionaries appropriated church property and subsequently that of the monarchy, émigrés, and the royal academies, including their collections of painting and statuary. Together, these actions transferred sovereignty from the monarchy to the people and, in the name of the people, created a national patrimony out of the seized collections. The potential symbolism of these acts was realized in August 1793 when a selection of the appropriated treasures was displayed for all to see in the Grand Gallery of the Louvre Palace, newly renamed the *Muséum Français*. The opening was timed to coincide with the Festival of National Unity, a triumphal celebration of the first anniversary of the fall of the monarchy and the successes of the revolutionaries.

The transformation of the formerly restricted Louvre into a truly public space, one in which the treasures of the people's adversaries were now rendered accessible, reified the revolution's accomplishments in a manner that few other acts could. In the gallery, as Andrew McClellan put it, "Elegant men and women of the world rubbed shoulders with artists and simple countryfolk, some proud to be there, others hoping to learn, and some content to be seen" (1994: 12; see fig. 8.2). Yet the selection of works to be shown was not without controversy. One of the concerns, as with the Lausos Collection nearly a thousand years earlier, was the religious content of some of the works. In this instance, however, instead of enforcing the teachings of Christianity, the new government sought to quash religious fervor in favor of the "cult of reason." And rather than relying on aesthetic qualities alone to override the troubling content of religious works, the museum's organizers hoped that a rigorously chronological display subdivided by national school – the articulation of a visual history of art – would do the job. Ideally, the "power of the museum to elide original meanings and to substitute for them new aesthetic and art historical significances" would result in a fresh role for the paintings in France's republican future (McClellan 1994: 14, 108–14).

The disposition of art in the Louvre was further complicated by the influx of works appropriated within France and later those confiscated by Napoleon as he conquered land after land across the face of Europe. This growing bounty offered the possibility of making the Louvre Europe's artistic crown and added to its symbolism that of France's cultural and military supremacy. Yet it also rendered superfluous many lesser works for which there was no longer room in the museum. The

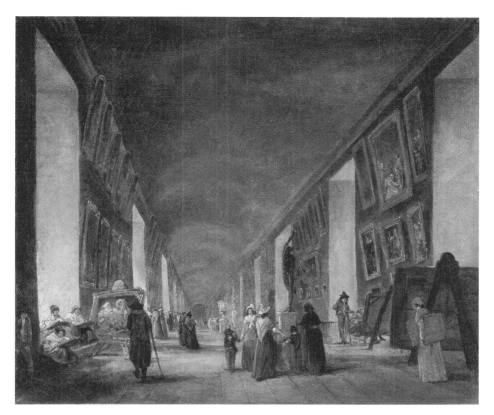

Figure 8.2 Hubert Robert, *La Grande Galerie [of the Louvre]*, oil on linen, c.1795. Painted after the Louvre palace's Grand Gallery was opened to the public in 1793, this view shows a broad cross-section of visitors, including art students on the far left and women with children admiring the bronze Mercury by Jean de Bologne in the center-right foreground. Reproduced courtesy of the Réunion des Musées Nationaux/Art Resource, New York.

government responded in 1801 by establishing fifteen other public museums among its *départements* to receive the surplus art. The museums of Bordeaux and Marseille (1804), Lyon (1806), and Rouen and Caen (1809) soon followed, most originally housed in existing buildings which were later replaced with purpose-built museums (Sherman 1989). The French authorities' appetite for centralized administration, along with the confiscation of church, royal, and noble property in conquered lands, enabled the establishment of central museums modeled after the Louvre in regions occupied by Napoleon: the Galleria dell'Accademia (1807), Venice; the Pinacoteca di Brera (1809), Milan; the Rijksmuseum's predecessor (1808), Amsterdam; and the Museo del Prado (1809), Madrid. While the French were eventually forced to retreat, they left behind a durable model for the public museum in Europe which, despite the political vicissitudes of many countries, continue today as symbols of, and containers for, national patrimonies, such as the Rijksmuseum for The Netherlands and the Prado for Spain.

Jeffrey Abt

The Privatization of Public in Nineteenth-century America

The history of museums took a decidedly different turn after "the curio cabinet [was] transplanted to the New World" toward the end of the eighteenth century (Orosz 1990: 11ff). Over the course of the nineteenth century there were experiments with museum-like proprietary enterprises designed to entertain and amuse, including "dime museums" and P. T. Barnum's American Museum (Dennett 1997), teaching collections formed to support an indigenous object-based educational movement, and institutions similar to European precedents like the Brooklyn Museum (New York, 1823) and the Wadsworth Atheneum (Hartford, Connecticut, 1842). But the nature of American democracy in general, and its legal and economic system in particular, turned upside down the relationship of collecting and the public sphere established in Europe.

Collections were rarely of interest to federal, state, or municipal officials. An exception which proves the rule on the federal level is the Smithsonian Institution in Washington, DC. The United States of America only inadvertently accepted collecting and display as a federal responsibility in the course of implementing the 1835 bequest of French-born Englishman and scientist, James Smithson "to found in Washington, under the name of the Smithsonian Institution, an Establishment for the increase and diffusion of knowledge" (Oehser 1983: 15). Formally authorized twelve years later as primarily a research center, augmented – almost as an afterthought – by a repository of natural history specimens gathering in various Washington offices, the Smithsonian gradually expanded its collecting and display interests to include ethnology, archaeology, the history of science and technology, as well as art.

Aside from isolated instances like the Smithsonian, however, the creation and governance of museums in America were led by private citizens pursuing commonly shared goals in concert. As Alexis de Tocqueville observed in *Democracy in America* (1835–40), "Americans of all ages, all conditions, and all dispositions constantly form associations." Nowhere is this more evident than in the formation of museums. During the late nineteenth century in particular, westward expansion, mineral exploitation, and industrial growth seeded unparalleled opportunities for the accumulation of wealth among a rising number of mercantilists, industrialists, and financiers in the country's urban centers. Many devoted fortunes to acquiring all kinds of specimens and objects with a special appetite for works of art, other precious objects, and rare books and manuscripts. Those who possessed the wealth to acquire great collections also possessed the civic influence and social connections with other like-minded leaders to found cultural institutions modeled on those of Europe.

A disproportionate emphasis on creating art museums as opposed to other types has been attributed to the concerns of opinion leaders about the youth and inferiority of American culture. Many institutions were thus created in a burst of activity beginning in the 1870s: the Museum of Fine Arts, Boston (1870) and Metropolitan Museum of Art, New York (1870, fig. 8.3), the predecessor to the

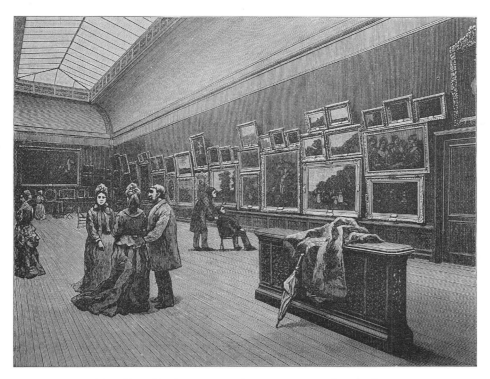

Figure 8.3 "Art Gallery [in the Metropolitan Museum of Art]" from *Harper's New Monthly Magazine*, vol. 60, no. 360 (May 1880). The engraving shows the interior of the first of the museum's buildings to be erected at its permanent location shortly after completion in 1880.

Philadelphia Museum of Art (1876), the Art Institute of Chicago (1879), and the Detroit Institute of Arts (1885) (Burt 1977). Each was created as a non-governmental, non-profit institution overseen by a self-perpetuating board of trustees composed of business, civic, educational, and cultural leaders. Sometimes individual states assisted these efforts by enacting statutes legalizing these voluntary associations as "non-profit" corporations so they could pool resources to acquire land, erect buildings, and establish endowments that could continue in perpetuity; and, further, do so without being required to pay taxes like ordinary corporations of individual investors. Sometimes museums received state, or more often, municipal assistance in the form of land grants or annual funding. But such assistance rarely amounted to more than a fraction of the institutions' needs, and it was seldom available for acquiring objects. Accordingly, the vast majority of American museums are privately governed and funded. The American museum's attention to local constituencies derives from the legal stipulations accompanying its formulation as a "public trust," as well as the interests of its creators enshrined in founding articles of incorporation.

Of nineteenth- and twentieth-century museums, Andrew McClellan has observed: "the question of the public became not so much who was admitted, for in

131

time virtually all were welcome, but how museums would be called upon to shape the public in keeping with perceived political and social needs" (McClellan 2003: 7). Without exception, American museums reflected this shift in founding documents which identified them with civic virtues of public service, education, and social stability. In particular, they focused on providing public instruction for a variety of purposes, including the training of craftsmen to improve manufacturing design, the orientation of recent immigrant populations to a unifying culture, and the elevation of manners and morals. A dominant concern was the fortification of the spiritual life of ordinary citizens, and museums were envisaged as potential surrogate religious institutions, calculated to help preserve family and social values (Fox 1995). This conviction held that social improvement could be obtained through exposure to the past and eternal, especially religious, verities in museums where great works were marshaled into visual narratives of the saga of human development.

Conclusion

The origins of the public museum derived from many sources over the course of more than two millennia, its evolution as an institutional form resulting from chance confluences of individuals' interests and ever-widening social demands. The nature of that development accelerated, however, with the professionalization of museum work toward the end of the nineteenth century (Lewis 1989; Spiess et al. 1996; see also chapter 25 of this volume). When the museum became the province of professional associations replete with the organizational accoutrements of journals, annual conferences, and accreditation criteria, the "public museum" acquired a kind of Platonic image – an idealized standard against which individual institutions would be measured.

Soon a literature that probed and sought to close the gaps between ideals and actualities flowered. The best of these studies constituted the beginning of an emerging new conception of the public museum in the twentieth century. It was one based increasingly on "performance"-related measures, including virtually everything from attendance (in comparison with local demographics; Rea 1932) to efficiency (based on comparisons of museums according to various operational criteria; Coleman 1939). To read these studies today is to appreciate the relentless dynamism of social change and its effects on the collecting and display of objects and, further, how the pace of change has been telegraphed by the professionalization of museum work. Despite the great antiquity of its origins, the public museum remains a steadily evolving institutional form, one that continues to be shaped by the demands of preserving objects to address societal needs.

Bibliography

Barocchi, P. and Ragionieri, G. (eds) (1983) *Gli Uffizi: Quattro secoli di una galleria*, 2 vols. Florence: Olschki.

Bassett, S. G. (2000) "Excellent offerings": The Lausos Collection in Constantinople. *Art Bulletin*, 82 (1): 6–25.

van Buren, A. W. (1938) *Pinacothecae*, with especial reference to Pompeii. *Memoirs of the American Academy in Rome*, 15: 70–85.

*Burt, N. (1977) *Palaces for the People: A Social History of the American Art Museum*. Boston: Little, Brown and Co.

Clarke, J. R. (2003) *Art in the Lives of Ordinary Romans: Visual Representation and Non-elite Viewers in Italy, 100 BC – AD 315*. Berkeley, CA: University of California Press.

Cochrane, E., Gray, C. M., and Kishlansky, M. A. (eds) (1987) General introduction. In *University of Chicago Readings in Western Civilization*, vol. 6: *Early Modern Europe: Crisis of Authority*, pp. 1–8. Chicago: University of Chicago Press.

Coleman, L. V. (1939) *The Museum in America: A Critical Study*, 3 vols. Washington, DC: American Association of Museums.

Dennett, A. S. (1997) *Weird and Wonderful: The Dime Museum in America*. New York: New York University Press.

El-Abbadi, M. (1990) *The Life and Fate of the Ancient Library of Alexandria*. Paris: United Nations Educational, Scientific and Cultural Organization.

Erskine, A. (1995) Culture and power in Ptolemaic Egypt: The Museum and Library of Alexandria. *Greece and Rome*, 42 (1): 38–48.

Findlen, P. (1989) The museum: its classical etymology and Renaissance genealogy. *Journal of the History of Collections*, 1 (1): 59–78.

*— (1994) *Possessing Nature: Museums, Collecting, and Scientific Culture in Early Modern Italy*. Berkeley, CA: University of California Press.

Fox, D. M. (1995) *Engines of Culture: Philanthropy and Art Museums*. New Brunswick, NJ: Transaction.

Fraser, P. M. (1972) Ptolemaic patronage: the Mouseion and Library. In *Ptolemaic Alexandria*, pp. 305–35. Oxford: Clarendon Press.

Hansen, E. V. (1971) *The Attalids of Pergamon*, 2nd edn. Ithaca, NY: Cornell University Press.

Heller-Roazen, D. (2002) Tradition's destruction: on the Library of Alexandria. *October*, 100: 133–53.

Howe, T. N. and Rowland, I. D. (1999) Introduction. In Vitruvius, *Ten Books on Architecture*, trans. I. D. Rowland. Cambridge: Cambridge University Press.

Josten, C. H. (1966) *Elias Ashmole (1617–1692)*, 5 vols. Oxford: Clarendon Press.

Kaufmann, T. D. (1978) Remarks on the collections of Rudolf II: The *Kunstkammer* as a form of *representatio*. *Art Journal*, 38 (1): 22–8.

Klinger, L. S. (1991) The portrait collection of Paolo Giovio. Unpublished doctoral dissertation, Princeton University.

Lewis, G. (1989) *For Instruction and Recreation: A Centenary History of the Museums Association*. London: Quiller Press.

*McClellan, A. (1994) *Inventing the Louvre: Art, Politics, and the Origins of the Modern Museum in Eighteenth-century Paris*. Cambridge: Cambridge University Press.

*— (2003) A brief history of the art museum public. In A. McClellan (ed.), *Art and its Publics: Museum Studies at the Millennium*, pp. 1–49. Oxford: Blackwell.

MacGregor, A. (1983) The Tradescants as collectors of rarities. In A. MacGregor (ed.), *Tradescant's Rarities: Essays on the Foundation of the Ashmolean Museum, 1683*, pp. 17–23. Oxford: Clarendon Press.

Miller, E. (1974) *That Noble Cabinet: A History of the British Museum*. Athens, OH: Ohio University Press.

Oehser, P. H. (1983) *The Smithsonian Institution*, 2nd edn. Boulder, CO: Westview Press.

Olmi, G. (1985) Science–honour–metaphor: Italian cabinets of the sixteenth and seventeenth centuries. In O. Impey and A. MacGregor (eds), *The Origins of Museums: The Cabinet of Curiosities in Sixteenth- and Seventeenth-century Europe*, pp. 5–16. Oxford: Clarendon Press.

133

Orosz, J. J. (1990) *Curators and Culture: The Museum Movement in America, 1740–1870.* Tuscaloosa: University of Alabama Press.

Ovenell, R. F. (1986) *The Ashmolean Museum, 1683–1894.* Oxford: Clarendon Press.

Pollitt, J. J. (1978) The impact of Greek art on Rome. *Transactions of the American Philological Association*, 108: 155–74.

Rea, P. M. (1932) *The Museum and the Community: A Study of Social Laws and Consequences.* Lancaster, PA: The Science Press.

Sheehan, J. J. (2000) *Museums in the German Art World: From the End of the Old Regime to the Rise of Modernism.* Oxford: Oxford University Press.

*Sherman, D. J. (1989) *Worthy Monuments: Art Museums and the Politics of Culture in Nineteenth-century France.* Cambridge, MA: Harvard University Press.

Spiess II, P. D., Zeller, T., and Washburn, W. E. (1996) 75th anniversary issue. *Museum News*, 75 (2): 38–63.

Strong, D. (1994) Roman museums. In D. Strong (ed.), *Roman Museums: Selected Papers on Roman Art and Architecture*, pp. 13–30. London: Pindar Press.

Tradescant, J. (1656) *Musaeum Tradescantianum: Or, a Collection of Rarities, Preserved at South-Lambeth neer London.* [London: John Tradescant.]

Vitruvius (1999) *Ten Books on Architecture*, trans. I. D. Rowland. Cambridge: Cambridge University Press.

Waddy, P. (1990) *Seventeenth-century Roman Palaces: Use and Art of the Plan.* Cambridge, MA: MIT Press.

Welch, M. (1983) The Ashmolean as described by its earliest visitors. In A. MacGregor (ed.), *Tradescant's Rarities: Essays on the Foundation of the Ashmolean Museum, 1683*, pp. 59–69. Oxford: Clarendon Press.

World Fairs and Museums

Robert W. Rydell

Unless one is already knowledgeable about these subjects, any connection between world fairs and museums may seem forced. World fairs, after all, seem like "totally yesterday," to borrow the recent insight of one of my first-year university students. Most people have no idea that world fairs, sometimes called expositions or international exhibitions, still exist (indeed, they are surprised to learn that a major world fair occurred in Nagoya City, Japan in 2005 and that a universal-class exposition is planned for Shanghai in 2010). Museums, on the other hand, while they may seem dated, have the decided advantage of being immediately recognizable as cultural institutions with histories deeply rooted in communities, regions, and nation-states. World fairs seem like ephemeral theme parks from another time; museums seem like pillars of both community and nation.

It would, in short, be unwise to presume a general understanding of the hand-in-glove relationship that existed historically between world fairs and museums. Hence, before tackling a review of the scholarly literature on international exhibitions, this chapter begins with a brief overview of the fairs themselves and then examines the career of G. Brown Goode, the Assistant Secretary of the Smithsonian Institution and one of the key individuals who forged the chain that linked world fairs and museums in the latter third of the nineteenth century.

World Fairs

World fairs originated with the 1851 London Great Exhibition of the Works of Industry of all Nations, better known as the Crystal Palace Exhibition. Its success launched a world fair movement that, by 1900, ringed much of the globe. Major European metropoles, including Vienna, Paris, Amsterdam, and Brussels hosted major fairs, as did cities on the periphery viewed by Europeans as hubs of their empires. Colonial fairs mushroomed across southern Asia, Australia, and northern Africa as exercises in European power and "uplift." At the same time, world fairs took hold in the United States, playing a crucial role in the cultural reconstruction of the United States after the Civil War. The spectacles of "civilization" and "progress" attracted tens of millions of people to their architectural, industrial,

agricultural, and anthropological exhibits. One world fair alone, the 1900 Paris Universal Exposition, saw more than 50 million people pass through its portals during its six-month run. By World War I, few would have doubted the claim that world fairs had shaped both the form and substance of the modern world.

After World War I, with the rise of electronically mediated forms of entertainment, especially the movies, interest in world fairs temporarily waned. But to rebuild public faith in their own legitimacy and in the legitimacy of their colonial enterprises, the French, British, and Belgian governments jump-started the exposition medium. Then, in the late 1920s and early 1930s, when the bottom fell out of capitalist economies globally, the United States government, with the support of major corporations, reignited the American exposition tradition with a series of spectacular Depression-era fairs that culminated in the 1939–40 New York World's Fair.

As many scholars have attested, these fairs were remarkably complex events that served multiple functions as architectural laboratories, anthropological field research stations, proto-theme parks, engines of consumerism, exercises in nationalism, and sites for constructing seemingly utopian and imperial dream cities of tomorrow. World fairs also drew upon and contributed to the development of museums. London's Victoria and Albert Museum as well as London's Science Museum, Paris's Musée National des Arts Africaines et Océaniens, and Chicago's Museum of Science and Industry owed their origins respectively to the 1851 Crystal Palace Exhibition, the 1931 Paris Colonial Exposition, and the 1933–4 Chicago Century of Progress Exposition. Countless other museums, including the Smithsonian Institution, augmented their collections with exhibit materials first organized for world fairs and later sent to museums to save shipping costs on returning objects to their home countries. It would be easy to naturalize the relationship between fairs and museums, but the connections between these institutions were hammered out in the white heat of nation-building by a handful of individuals who took to heart the importance of building the cultural infrastructure of emerging nation-states during the Victorian era. One of these individuals was G. Brown Goode.

Exhibitionary Complexes and G. Brown Goode

When he died in 1896 at the age of forty-five, tributes to G. Brown Goode poured in from around the world. So profound was their sense of loss, that his friends and colleagues organized a memorial meeting that resulted in a 515-page Festschrift. There were multiple reasons why so many people mourned Goode's death. He was a superb naturalist who had studied under Louis Agassiz at Harvard. He had an international reputation as an ichthyologist and a growing reputation as America's first historian of science. He had more than a passing knowledge of anthropology and was active in a variety of professional societies in Washington, DC, including the local chapter of the American Association of Architects (see Alexander 1983; Kohlstedt 1991). But the passion of Goode's life was his devotion to what cultural sociologist Tony Bennett has aptly termed the "exhibitionary complex," the emerging network of world fairs and museums that provided the cultural underpinnings

for the development of the modern nation-state. As Bennett explains it, the essence of the exhibitionary complex, was to persuade the public:

> [t]o identify with power, to see it as, if not directly theirs, then indirectly so, a force regulated and channeled by society's ruling groups but for the good of all: this was the rhetoric of power embodied in the exhibitionary complex – a power made manifest not in its ability to inflict pain but by its ability to organize and co-ordinate an order of things and to produce a place for the people in relation to that order. (Bennett 1995: 67)

In ways Foucault would later elaborate upon, Goode understood the relationship between knowledge and power and the ability of cultural institutions to deploy science in the service of reconstructing American political culture in the aftermath of the Civil War. Born in the year of London's fabled 1851 Crystal Palace Exhibition, Goode came of age with the modern exhibitionary movement and did more than any other individual of his generation to hasten its development in the United States.

For Goode, unlike some of his contemporaries who sought to sacralize high cultural institutions, there was never any question about letting the masses into museums and international exhibitions. The museum "is more closely in touch with the masses than the University or the Learned Society, and quite as much so as the Public Library," he declared in his paper "Museums and Good Citizenship" (Goode 1894: 8). The issue was not whether to let the public in, but how to use exhibitionary sites effectively to "minister to the mental and moral welfare" of the masses and to turn them into good citizens of the newly rebuilt national state (Goode 1901c: 466). Finding means to reach those ends became the driving ambition of Goode's life and propelled him to forge America's first exhibitionary network with the Smithsonian Institution as its hub.

From the vantage point of Smithsonian Institution officials, the Philadelphia Centennial Exhibition could not have come at a more propitious time (fig. 9.1). Rightly perceiving the fair as the cultural concomitant to the Republican Party's national reconstruction policy, Smithsonian officials seized the occasion of the Centennial to transform the Smithsonian from a research-centered institute into a national museum. To accomplish this end, the Smithsonian needed more objects for display, new exhibition space, and a larger staff than the thirteen men who often lived and worked in the Castle on the Mall. For them, the Centennial was a golden opportunity for institutional development and one not to be missed. Goode, working as an assistant at the Smithsonian at the time, was entrusted with much of the planning and installation of exhibits. This firmly established his reputation as America's leading exhibition specialist.

It also transformed the Smithsonian Institution into the US government's exhibitionary agency – a role it would continue to play until after World War I. Indeed, it is no exaggeration to say that the Smithsonian Institution and world fairs, while not exactly joined at birth, developed a symbiotic relationship over the years. Between 1876 and World War I, the Smithsonian Institution participated in dozens of national, industrial, and international exhibitions. In exchange for staff time and

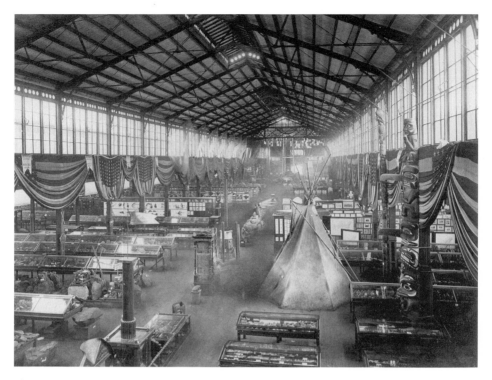

Figure 9.1 Interior, US Government Exhibit, Philadelphia Centennial Exhibition, 1876. This exhibit was organized by G. Brown Goode. Reproduced courtesy of the Smithsonian Institution Archives.

exhibition material from the Smithsonian, world fair managers sent surplus displays to the Smithsonian that helped Smithsonian officials make the argument to Congress that more museum space had to be provided – and it was. As a result of its involvement in international expositions, the Smithsonian built not one, but two new museums (Arts and Industries in 1881, and the US Natural History Museum in 1911) – both modeled after US government buildings designed for world fairs – and its staff expanded from thirteen to more than 200 and its collections increased from 200,000 objects to more than three million.

In the course of this work, Goode developed his own exhibitionary theory, rooted in his passion for the classification and ordering of things. This led him to publish *Classification of the Collections to Illustrate the Animal Resources of the United States*, a taxonomy of exhibits devoted to demonstrating the utility of animal resources to human progress. In the early 1880s, he assumed primary responsibility for constructing the classification for US government displays at the International Fisheries Exhibition in Berlin. Then, because of his international reputation as a titan of taxonomy, the directors of the 1893 Chicago World's Columbian Exposition invited him to prepare a classification system for the millions of objects expected to be placed on display at their fair.

As significant as it was, Goode's involvement with international exhibitions was not only that of a master taxonomist. He also regarded world fairs as laboratories for developing new techniques in installation and labeling. For instance, at the Centennial, he pioneered the development of prefabricated exhibition cases and platforms that could be assembled from crating materials. For that exhibition, as well, he experimented with printed labeling techniques and color-coding labels – techniques that utterly transformed museums around the country by the turn of the century and followed directly from his central theoretical contribution to the emerging exhibitionary complex, a contribution that took form in a theory of "visualization" (Langley 1901: 53–4; Corbey 1993).

Goode articulated the essence of his exhibitionary theory in "The Museums of the Future," a paper he delivered in 1889 at the Brooklyn Institute. "There is an Oriental saying that the distance between ear and eye is small, but the difference between hearing and seeing very great," Goode began. "More terse and not less forcible," he continued, "is our own proverb, 'To see is to know,' which expresses a growing tendency in the human mind." What evidence was there for this tendency? Goode thought he had plenty:

> In this busy, critical, and skeptical age each man is seeking to know all things, and life is too short for many words. The eye is used more and more, the ear less and less, and in the use of the eye, descriptive writing is set aside for pictures, and pictures in their turn are replaced by actual objects. In the schoolroom the diagram, the blackboard, and the object lesson, unknown thirty years ago, are universally employed. The public lecturer uses the stereopticon to reenforce his words, the editor illustrates his journals and magazines with engravings a hundredfold more numerous and elaborate than his predecessor thought needful, and the merchant and manufacturer recommend their wares by means of vivid pictographs. The local fair of old has grown into the great exposition, often international and always under some governmental patronage, and thousands of such have taken place within forty years, from Japan to Tasmania, and from Norway to Brazil. (Goode 1901a: 243)

The implications for museums were clear. "The museum of the past must be set aside, reconstructed, transformed from a cemetery of bric-a-brac into a nursery of living thoughts" (1901a: 243). "The museums of the future in this democratic land," he added, "should be adapted to the needs of the mechanic, the factory operator, the day laborer, the salesman, and the clerk, as much as those of the professional man and the man of leisure" (1901a: 248). The museum, in other words, should appeal to the same social classes as world fairs, but with this difference. Where fairs devoted considerable energy to attracting people of all ages, museums, Goode believed, should be vehicles for adult education, and, like libraries, become "passionless reformers" dedicated to "the continuance of modern civilization" (Goode 1901b: 239). Because it was their duty to let the masses in and remind people of the value of civilization, "[t]he people's museum" – this was a phrase Goode borrowed from Ruskin – "should be much more than a house full of specimens in glass cases. It should be a house full of ideas, arranged with the strictest attention to system" (Goode 1901a: 249).

What exactly did Goode have in mind when he suggested that a museum for the masses should be "a house full of ideas" systematically arranged? One has only to look as far as his work at world fairs to discover an answer. As his conceptual models and display installations for every fair beginning with the Centennial made clear, Goode's general outlook on the world rested on the assumption that a hierarchical continuum existed between something called "savagery" and something else called "civilization." The distance between the two, he was convinced, could be measured in terms of progress and classified by science. It followed from these convictions that the museum's highest duty was to arrange the lessons about civilization and progress so that they could be learned by the masses, rendering them good citizens of the modern nation-state. This, at least, was the upshot of his 1894 essay, "Museums and Good Citizenship." "It will be a happy day for our country," he wrote, "when every town and village has its public library and museum in a commodious little building which shall contain also a reading room and assembly rooms and lecture halls for the use of the local culture-clubs and societies. Could anything be more conducive to good citizenship?" (1894: 8).

Achieving these goals, Goode argued, would not only require "intelligent, progressive, well-trained curators," but a radical revisioning of exhibitionary techniques. Most fundamentally, he insisted, "[t]he ideas which a museum is intended to teach can only be conveyed by means of labels" (Goode 1894: 8; 1901b: 220). This insight, in turn, led Goode to another epigrammatic assertion: "An efficient educational museum may be described as a collection of instructive labels, each illustrated by a well-selected specimen." As he explained his thinking: "labels describing the specimens in a collection are intended to take the place of the curator of the collection when it is impossible for him personally to exhibit the objects and explain their meaning" (Goode 1901b: 220, 230). Previously, in the era when cabinets of curiosities reigned, visitors had to rely on lecturers for information about displays. Not only did the lecturer give visitors no chance to select what they would see, lecturers often used unfamiliar words that were rarely remembered. The result, according to Goode, was that "examining a collection was looked upon rather in the light of amusement than study, and what might have been possible in the way of instruction was rarely attempted." Modern museums, with larger collections and larger audiences, demanded a new system – one that could instruct as well as control the behavior of the multitudes. Labels, Goode argued, were the linchpins of this system because they would be prepared by specialists and "could be read over and over again" and because they would often "be copied into the visitor's notebook" (Goode 1901b: 230). Reading labels, copying, and remembering label descriptions, Goode believed, would discipline museum-goers and, at the same time, give them a sense of being panoptic, leaving them with a feeling of omniscience.

In the struggle that characterized the political culture of late nineteenth-century America, such a mindset would prove invaluable in the effort of the national government to craft model citizens, to win their consent to the existing political order, and to the essential rightness of the government's growing interest in overseas imperialism (Hoffenberg 2001). To state that world fairs and museums were organized to accomplish all of these goals is only to restate what scholars who have studied the exhibitionary complex have been saying over the past two decades (Greenhalgh 1988;

Hinsley 1991; Coombes 1994). What makes the focus on Goode so important is that an examination of his life-work makes it possible to show just how this exhibitionary network came into being. It did not just happen; the exhibitionary network, which Goode broadened to include zoos, aquariums, public monuments, botanical gardens, and a range of other institutions, was the result of the labors of individuals, Goode pre-eminent among them (Alexander 1983: 296). Examination of such individuals, should help us in our efforts to understand the complex motivations that contributed to "letting the masses in" through the portals of fairs and museums.

Complicating the Story of Exhibitionary Complexes

G. Brown Goode believed that cultural institutions like museums and fairs could educate and mold the citizens of nation-states. But, in the course of taking in exhibitions, was the public taken in? Over the past twenty-five years, with the rediscovery of world fairs by historians and anthropologists, and the emergence of new scholarly disciplines such as museum studies and cultural studies, Goode's assumptions – and those of historians like me who have been inclined, within a Gramscian framework, to argue that Goode and his allies succeeded in providing, with world fairs, a cultural safety net that prevented the free-fall of capitalism (a process that began in the United States in the 1870s and gained momentum through the 1930s) – have found themselves challenged by analyses that insist on more complex ways of understanding these cultural spectacles.

To be sure, not everyone has abandoned the Gramscian and Foucauldian paradigms that have guided Tony Bennett's work and my own. Anthropologist Raymond Corbey, for instance, has zeroed in on the central axiom in G. Brown Goode's exhibitionary theory, "to see is to know," and reminded us: "The eye is not innocent. The motto succinctly expresses an underlying ideology that is at work in a range of seemingly disparate practices in colonial times: photography, colonialist discourse, missionary discourse, anthropometry, collecting and exhibiting, and so on." What people saw, in other words, was not "reality as it was," but a highly mediated and constructed version of reality intended to make exhibition-goers self-regulating and to outfit them with "an encyclopedic urge" to possess the world through knowledge of its component parts (Corbey 1993: 360–2). Paul Greenhalgh underscores this argument in "Education, Entertainment and Politics: Lessons from the Great International Exhibitions" and notes that exhibitions were anything but neutral, having instead "a definite social intrusiveness" that "bristled with a sense of purpose, with a knowledge as to why they had been created" (Greenhalgh 1989: 94, 96).What Mitchell adds to this analysis is an insistence that exhibitions were not merely "re-presentations of the world, but the world itself being ordered up as an endless exhibition." Exhibitionary representations, in other words, are "part of a method of order and truth essential to the peculiar nature of the modern world" that gives them primary importance in defining modernity (Mitchell 1992: 290, 314).

In most respects, these arguments dovetail with my own assessment that exhibitions were ideologically conceptualized and driven, especially with respect to taxonomies of racial and cultural progress put on display through ethnographical

exhibits drawn from the colonies of the Western powers. It was hardly accidental, for instance, that the Midway Plaisance at the 1893 fair was hinged to the White City, the main exposition grounds, at precisely the point where exposition organizers located Woman's Building, thus representing middle-class women as the gatekeepers and arbiters of "civilization." No less important, I have argued that it is hardly accidental that the Pledge of Allegiance to the American flag was introduced to a mass audience on the occasion of the 1893 Dedication Day ceremonies for the World's Columbian Exposition. As its author, Francis J. Bellamy (cousin of Edward Bellamy, author of *Looking Backward*) described how the salute should be performed:

> At a signal from the Principal the pupils, in ordered ranks, hands to the side, face the Flag. Another signal is given; every pupil gives the Flag the military salute – right hand lifted, palm downward, to a line with the forehead and close to it. Standing thus, all repeat together, slowly: "I pledge allegiance to my Flag and the Republic for which it stands: one Nation, indivisible, with Liberty and Justice for all." At the words, "to my Flag," the right hand is extended gracefully, palm upward, toward the Flag, and remains in this gesture till the end of the affirmation, whereupon all hands immediately drop to the side. (National School Celebration 1892; Rydell 1993a)

Disciplining bodies and minds through ritualistic performances of nationalism was clearly an aim and – as the recitation and performance of the pledge of allegiance in American classrooms today attests – a long-term result of the exhibitionary complexes that gave meaning to emerging nation-states in the Victorian era.

There can be little doubt, in short, that fairs sought to discipline bodies – and body politics – in industrializing nation-states. The same line of reasoning can be made about fairs in our own, postmodern era. In *Hybrids of Modernity: Anthropology, the Nation State and the Universal Exhibition* (1996), Penelope Harvey examines Seville's 1992 fair and concludes that exhibitions in our own age offer an "informatics of domination" that recapitulates the myth of "human liberation through technology." The same, of course, could be said of nineteenth- and early twentieth-century exhibitions. But where nineteenth-century exhibitions were harnessed to a variety of nation-building projects, she suggests that postmodern world fairs illustrate the "harnessing of national identities to corporate ends" (1996: 126, 103). The cultural function of exhibitions, in other words, has evolved to reflect changes in the post-Cold War political economy. Fairs continue to be disciplinary institutions, but multinational corporations have displaced nation-states as their primary movers. However plausible (though one should not be too hasty to proclaim the death of the modern nation-state), this argument begs an important question. Have the disciplinary effects of exhibitionary complexes really been as complete as some scholars have suggested? Like the entrances into Paris from the Peripherique, there are multiple ports of entry into this maze.

One cohort of scholars calls into question the structural coherence of exhibitions themselves. Meg Armstrong, for instance, in her "'A Jumble of Foreignness': The Sublime Musayums of Nineteenth-century Fairs and Expositions" (1992–3), notes the "cultural bricolage" and a degree of "hysteria" in representations of different cultures. Far from the ordered hierarchies that I argued exist along midways (central

avenues) and in colonial sections of fairs, Armstrong finds a chaotic, fluid mix that, when contrasted with the ordered world of official exposition palaces, reinforced dominant ideas about "civilization" and "savagery." Furthermore, she raises the issue of agency with respect to fair-goers and attributes to them the capacity to constitute meaning for themselves from the fragments that they see around them (1992–3: 209). Historian Keith Walden, drawing on Peter Stallybrass and Allon White's work on the importance of cultural transgression at Toronto's industrial fairs, stresses the importance of thinking of exhibitions as being in motion and filled with enormous potential for the subversion of dominant beliefs and values. Fair-goers, Walden writes, were:

> lured by the erotic, exotic and absurd – by young women fluttering diaphanous petti-coats over strawberry tights, by Native peoples in feathered head-dresses shouting war-whoops, by men with blackened faces wearing animal hides and bones in their hair. They were drawn by the barkers themselves: sunburned, sweating, hoarse yet eloquent, inventive, spontaneous, audacious. These were all marginal people – wanderers and mountebanks whose normal stock in trade was deformity, perversion, and sexual titillation. (1997: 291)

As Walden points out, the cultural authorities who ran the fairs had to make concessions to central areas in response to the restive voices and demands of the broader popular culture that existed just off the exposition grounds. It would be fascinating to determine the degree to which museums followed a similar course.

Showcases of Science and Technology

World fairs, of course, were showcases of scientific and technological innovation. From air conditioning through escalators to x-rays, world fairs introduced mass publics to the building blocks of modern civilization. But more than this, exposition authorities sought to use the power of display to convince the public of the necessary connection between scientific and technological innovation and national progress. Not surprisingly, given the transitory nature of expositions, not a few builders of world fairs sought to sustain the educational – and ideological – value of their work by housing world fair exhibits in museums. Goode's work on the 1876 Centennial Exhibition, as we have seen, contributed materially to the creation of the Smithsonian Institution's Arts and Industries Building, a building dedicated to illustrating the twin cornerstones of "civilization." But Goode was not alone. Indeed, he drew inspiration from Henry Cole's successful efforts to translate the success of the Crystal Palace Exhibition into a permanent museum, the Victoria and Albert Museum, which in turn helped inspire the creation of London's Science Museum. No less important was Chicago's Museum of Science and Industry, the direct outgrowth of the 1933–4 Century of Progress Exposition.

There is surprisingly little scholarship on the connections between world fairs and the creation of museums of science and industry. Eugene S. Ferguson's older, but insightful "Technical Museums and International Exhibitions" (1965) outlines the relationships between these institutions with a view to criticizing the transfer of

technological enthusiasm from fairs to museums. Likening them to "a technical Coney Island," Ferguson concludes that these museums' "uncritical emphasis upon the superficial and spectacular and their failure even to suggest the unsolved problems posed by the 'progress' to which the whole show is dedicated can only add strength to the accelerating movement toward undiscriminating mechanization of man's environment" (Ferguson 1965: 30–46).

More recent scholarship has focused less on the mechanization of the environment than on the way in which museums, like the fairs that gave birth to them, have served to perpetuate existing power relations and underscored the importance of "[r]epresentation as central to the work of science." The best example of scholarly work in this vein is the product of the Whipple Museum's project on "Innovation in Britain and Germany, 1870–1920: Science, Technology, Society." In their several volumes dedicated to examining the representational base of science in the world of late nineteenth-century international exhibitions, Jim Bennett, Robert Brain, Simon Schaffer, Heinze Otton Sibum, and Richard Staley make explicit the crossovers between representations of science at world fairs and at science museums and emphasize how "people in the nineteenth century, and historians following them, could gain a long-range view of the interrelations between science, commerce and culture in a changing world" (Staley 1994: 13).

No less valuable is Steven Conn's (1998) examination of the Philadelphia Commercial Museum (fig. 9.2), a museum generally leap-frogged in the scholarly record. First proposed in the aftermath of the 1893 Chicago fair by University of Pennsylvania botanist William P. Wilson to house artifacts from the World's Columbian Exposition, the Commercial Museum became a science-based clearinghouse of information for American business and agricultural interests seeking information about how best to penetrate foreign markets. The museum faded from glory with the creation of the US Department of Commerce, but for twenty years it served as a museum center for globalizing American commercial interests.

In retrospect, it is easy, almost too easy, to see the close connections between world fairs and museums of science and industry. But, as Mari Williams (1993) points out in "Science, Education and Museums in Britain, 1870–1914," debates within the British government over the exact content and function of the Science Museum were protracted. This is not surprising for, as Sharon Macdonald reminds us, "[m]useums of science can be regarded as cultural technologies which define both certain kinds of 'knowledge' (and certain knowledges as 'Knowledge' or 'science') and certain kinds of publics" (Macdonald 1998: 5). Just as G. Brown Goode struggled with classifying and displaying knowledge about the known world at the 1893 fair, so museum and state authorities sought to arrange knowledge systems that would build public confidence in equating scientific knowledge and industrial growth with the meaning of progress.

Visitors and Performers

What about fair-goers, the millions, indeed tens of millions of people who visited world fairs? Not much has been written about this subject, but some day, an enter-

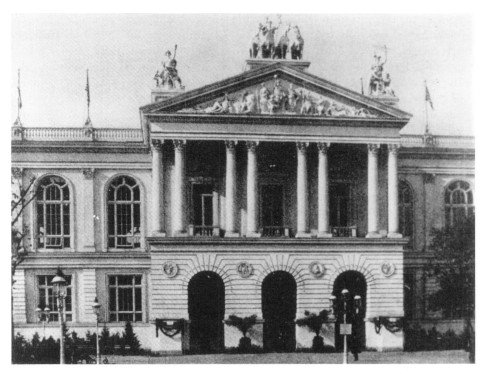

Figure 9.2 Exterior, Philadelphia Commercial Museum. This museum was inspired by the 1893 Chicago World's Columbian Exposition. Reproduced courtesy of the National Museum of American History, Larry Zim Collection.

prising scholar will have a field day with the marketing surveys of visitors to the 1939 New York World's Fair which show the degree to which this fair was intended to shore up support for the corporate-run American state among the middle classes (Rydell 1993b: 155–6). For earlier fairs, we can learn a great deal from Manon Niquette and William J. Buxton's "'Meet Me at the Fair': Sociability and Reflexivity in Nineteenth-century World Expositions" (1997). On the basis of their analysis of world fair cartoons that stereotyped different groups of people, they hypothesize that, because middle-class visitors were constantly subject to the surveillance of the crowds drawn from all social classes and ethnic groups, they found themselves "in a situation of high vulnerability." "Anxious about being associated with outcasts," they argue, "the white, middle-class visitors processed the information they received from these exhibits so they could set themselves apart." Racist, sexist, rural stereotypes embedded in humor magazines produced for the fairs provided cultural armor for the bourgeoisie. Niquette and Buxton's arguments make clear that, for all of the arguments that Goode and others made about letting the masses into exhibitionary spaces, the effect of these spaces was to help visitors draw distinctions in their own minds about who belonged in particular public spheres and who did not. Their research, Niquette and Buxton conclude, "provides us with good clues about why

145

the museum today is largely a middle-class institution" and "sheds light on the present lack of interest by the popular classes in museum visits" (1997: 108). Theirs is not the last word on the subject, but it is certainly one of the most original efforts to come to terms with the complex issues surrounding audience responses to exhibitionary spaces in the Victorian era.

In addition to trying to understand the response of exposition visitors who paid to attend these spectacles, scholars have also examined another category of "visitors," the indigenous people from areas of the world who were put on display at the fair as objects of ethnological curiosity and/or as performers. Exhibits of "exotic" people, of course, had a long tradition in the popular culture that characterized preindustrial Europe. What gave them added importance in the early nineteenth century, with the exhibition of Sarah Bartmann, the so-called "Hottentot Venus," was the way in which anthropologists used them to illustrate and popularize theories of racial hierarchy (Strother 1999). By the 1870s, such shows had become mainstays at the Jardin des Plantes in Paris; by 1904 in St Louis, they constituted sites for field trips for college students who received college credit for studying the people put on exhibit in these "authentic" settings (Schneider 1982: 125–51; Rydell 1984: 166). But who were these objects of study, these subjects of empire-builders? Why were they at the fairs? How did they respond when they were alternately gazed upon, poked and prodded, and alternately ridiculed and sometimes envied for being unburdened with the over-civilized refinements of modern life?

Some of the most fruitful answers to these questions have come from anthropologists and from scholars working in the area of performance studies and from performing artists themselves. Anthropologists Kevin Smith and Michelle Smith, in a recent exhibit organized at the Buffalo Museum of Science, explored the life and career of John Tevi, an African who helped organize shows variously called the *Dahomey Village* at the 1893 Chicago fair and *Darkest Africa* at the 1901 fair (Smith and Smith 2001). As many authorities have noted, the Africans put on display at the fair were exploited (it is unclear whether they actually received their minimal wages or whether these were kept by the concessionaire), subjected to brutal racist stereotyping, and generally regarded as anthropological specimens, not as human beings in their own right (Rydell 1984). But as the Smiths have made clear, the Africans brought to the fair as specimens thought of themselves in other terms. Tevi and his cohorts saw themselves as performers and artisans, interested in learning about the West and in negotiating the complex shoals of colonialism. They hoped for respect and sought to inform fair-goers about their cultures. More than this, they seized the occasion of the fairs to resist the colonizing situation in which they were placed.

Art historian Fatimah Tobing Rony explains how this process of resistance might have worked. Imagine, she says, that "[y]ou are a Wolof woman from Senegal. You have come to Paris in 1895 with your husband as a performer . . . because of the promise of good pay. You have been positioned in front of the camera, and you are thinking about how cold it is; you can't believe that you have to live here in this reconstruction of a West African village, crowded with these other West African people, some of whom don't even speak Wolof. Every day the white people come to

stare at you as you do your pottery. You make fun of some of them out loud in Wolof, which they don't understand" (Rony 1992: 263).

Equally compelling is this incident recited by Gertrude Scott in her analysis of villages at the 1893 fair. Every day, the villagers were organized into a grand parade of "ethnological types" from around the world. The colors and sounds dazzled fair-goers and the multiplicity of languages made the Midway seem like a veritable Babel. But one man who claimed he understood West African languages had this to say about the parade: "A good many people imagine, I suppose [that the African women] are sounding the praises of the Exposition or at least voicing their wonder at the marvels they have seen since coming to this country. But the fact is that if the words of their chants were translated into English they would read something like this: 'We have come from a far country to a land where all men are white. If you will come to our country we will take pleasure in cutting your white throats'" (Scott 1990: 312–29).

An updated version of this theme comes from the contemporary film, *The Couple in a Cage*, featuring performing artists Coco Fusco and Guillermo Gómez-Peña, who put themselves on exhibit in contemporary museums to demonstrate the legacy of colonial exhibitions in museum spaces and to demonstrate how those put on display can return the imperial gaze and turn audiences to their own purposes (Fusco 1993). What their presentation so effectively demonstrates is that the intentions of exposition organizers, however powerful, to represent the Third World as savage and docile were imperfectly realized.

A postcolonialist argument along the same lines, advanced by Anne Maxwell, calls attention to how some photographs of indigenous people at world fairs reveal a "looking relation that disrupts the semiotics of the one-way imperial gaze." The motif of individuals looking back into the camera, she suggests, reveals "an oppositional gaze that confronts and interrogates the viewer." "The effect," she writes, "is to undo what the western gaze had achieved – the creation of a hegemonic power relation" (Maxwell 1999: 197). Where Goode insisted that "to see is to know," Maxwell argues that the political optics of sight involve possibilities of returning the gaze. Or, as Barbara Kirshenblatt-Gimblett insists, it is important to understand "when people are themselves the medium of ethnographic representation, when they perform themselves – when they become living signs of themselves" (Kirshenblatt-Gimblett 1998: 18). Essential to these arguments is the idea that exhibitions, far from being "total institutions," embodied what Saloni Mathur, in her examination of ethnological exhibitions at the 1886 London and Colonial Exhibition, terms "incomplete processes of representation" (Mathur 2001: 516). The bars in the iron cages of race constructed for exhibiting so-called primitive people were never so closely spaced as to wholly contain the performers who lived within them. The complex story of Ota Benga, the African exhibited as part of the Department of Anthropology's exhibits at the 1904 St Louis fair, is a case in point.

There is no easy way to summarize Ota Benga's complex life, but Philipps Verner Bradford and Harvey Blume's *Ota Benga: The Pygmy in the Zoo* is a suggestive starting-point. Bradford's grandfather, Samuel Phillips Verner, was a missionary/imperialist who brought Ota, and a company of twenty pygmies, to the United States to

be part of the landscape of living ethnological villages at the St Louis exposition. After the fair concluded, Ota became a featured exhibit at the American Museum of Natural History and the Bronx Zoo. In one dramatic moment, at a fund-raising dinner at the American Museum, Ota had enough of being treated as an object of curiosity and heaved a chair in the direction of socialite Florence Guggenheim, narrowly missing her head. This was human agency with a vengeance, and would seem to be one of the best illustrations of exactly what recent scholars have suggested about the ability of people on exhibit at fairs and museums to maintain their self-esteem and even resist the oppressive conditions in which they found themselves. There is, however, a risk in pushing this line of argumentation too far, as the rest of Ota Benga's story suggests.

After the chair-throwing episode, Ota Benga was turned over to New York's Howard Colored Orphan Asylum. Because the asylum's director deemed him to be a bad influence on the other children, he sent him to a seminary in Lynchburg, Virginia. For the last six years of his life, he studied at the seminary and escaped, when he could, into the forests of Virginia where he tried to reconnect to the way of life he had left behind in Africa. One day, he carried a revolver with him, aimed it at his heart, and pulled the trigger. Is this an example of the powers of human agency? Of the ability of "performers" to script their own lines and final acts? Or does Ota Benga's tragic ending speak to the broader horrors of the representational conditions that imposed limits on his existence?

Make no mistake about it. The representational space in which ethnological villagers could perform was pretty hideous. Outbreaks of disease were commonplace; so much so, in fact, that exposition authorities in St Louis anticipated that, of the 1,200 Filipinos transported to that fair, at least forty would die. Thinking ahead, exposition officials arranged for forty burial sites. And what happened to those "performers" who died? In the case of two Filipinos, they received something less than a standing ovation. Ales Hrdlicka, one of the world's premier physical anthropologists, severed their heads, removed their brains, and sent them to the Smithsonian Institution for preservation and study (Rydell 1984: 165).

I relate these incidents not to suggest that performers were incapable of independent consciousness or of creating performative spaces for resistance. Indeed, it appears quite likely that one of the unintended consequences of the imperial brokers who organized African colonial villages at French fairs was to promote pan-African consciousness among the people put on display! But, the journey from world fair performance to pan-Africanism was hardly seamless; it could be interrupted at any moment, leaving actors and artisans alike finding themselves being treated as specimens.

Conclusion

The work of Michaela di Leonardo can help us to understand the complexity of Ota Benga's story. Culture, she writes, "is never separate from, and cannot be understood apart from, politics and economy" (di Leonardo 1998: 77). World fairs, especially their "human zoo" components, need to be understood in exactly this light.

International exhibitions mushroomed across the landscape of the industrializing and modernizing world as agents of imperial state formations. That is precisely why they were taken so seriously by African Americans, among others, who argued, sometimes bitterly, about how best to engage these spectacles of power and statecraft. Anti-lynching crusader Ida Wells and former abolitionist Frederick Douglass understood the World's Columbian City for what it was: a "White City" in name and fact that had to be contested precisely because of its power to determine American racial politics and economic relations far into their future. It is precisely their struggle that di Leonardo brings to the fore when she admonishes scholars: "Only forthrightly investigating the hideous sea-crab of hegemony gives us the tools to prevent its reproduction in a world without end" (di Leonardo 1998: 21).

That is why I began this chapter with my cultural biography of G. Brown Goode. We need more studies of his contemporaries, especially of his British and French counterparts, Henry Cole (one of the prime movers behind the Crystal Palace Exhibition) and Frederic Le Play (one of the shapers of the French exhibition tradition). We need to understand how these individuals collaborated with political and business authorities to construct the exhibitionary complexes that spanned the globe after 1851. It is not enough to rest content with structural analyses of exhibitions and museums or to think wishfully about how subaltern groups "made do" with the representational space they struggled to obtain and control. We need to begin with the recognition that exhibitions were embedded in particular national and globalizing political economies. We know that exhibitionary spaces have always been sites of contestation – and not just between those with power and those without. Exhibition authorities disagreed among themselves. For example, Goode's extensive taxonomy for the 1893 fair was reformulated by Chicago's exposition bosses; and subaltern groups who were displayed at or performed at fairs disagreed about how best to articulate responses to the "white cities" that enveloped them.

We can acknowledge these disagreements without losing sight of the broader political function and legacy of the exhibitionary complex which was to weave and extend a cultural safety net across the widening fault-lines of class and racial conflict that perpetually threatened the existence in chronological order, first, of the emerging nation-state, and, second, of the emerging multinational hegemons that are plundering the world's human and natural resources in the present. In light of recent perceived failures of so many postmodernist world fairs, I am often asked about the future of world fairs and whether they have become cultural dinosaurs. I do not have a crystal ball, but when I gaze into the Crystal Palace – and, just as important, gaze through it into the broader political and economic conditions that led particular individuals to build it – it is only the rash prophet who thinks world fairs have lost their influence.

World fairs arose in response to the "crisis of confidence" that swept the Victorian world and, because I doubt our post-9/11 world is any less anxious about the future, I suspect that world fairs, like museums, will continue to serve as life-buoys for postmodern forms of "civilization." Whether these institutions can help us envision a better future for humanity, one predicated on shared responsibility for the planet and our fellow beings, remains – in a phrase G. Brown Goode might appreciate – to be seen.

Robert W. Rydell

Bibliography

Alexander, E. P. (1983) George Brown Goode and the Smithsonian Museum: a national museum of cultural history. In *Museum Masters: Their Museums and their Influence*, pp. 278–309. Nashville: American Association for State and Local History.

Ames, M. (1992) *Cannibal Tours and Glass Boxes: The Anthropology of Museums*. Vancouver: University of British Columbia Press.

Armstrong, M. (1992–3) "A jumble of foreignness": the sublime Musayums of nineteenth-century fairs and expositions, *Cultural Critique*, 21–3: 199–254.

*Bennett, T. (1995) *The Birth of the Museum: History, Theory, Politics*. New York: Routledge.

*Conn, S. (1998) *Museums and American Intellectual Life, 1876–1926*. Chicago: University of Chicago Press.

Coombes, A. E. (1994) *Reinventing Africa: Museums, Material Culture and Popular Imagination*. New Haven, CT: Yale University Press.

Corbey, R. (1993) Ethnographic showcases, 1870–1930, *Cultural Anthropology*, 8 (3): 338–69.

Davison, G. (1983) Exhibitions. *Australian Cultural History*, 2.

Ferguson, E. S. (1965) Technical museums and international exhibitions. *Technology and Culture*, 6: 30–46.

Fusco, C. (1993) *The Couple in a Cage: A Guatinaui Odyssey*. New York: Authentic Documentary Productions.

Goode, G. B. (1894) Museums and good citizenship, *Public Opinion*, 17, no. 31.

— (1901a) The museums of the future. In *A Memorial of George Brown Goode, Together with a Selection of his Papers on Museums and on the History of Science in America*. Washington, DC: Government Printing Office.

— (1901b) The principles of museum administration. In *A Memorial of George Brown Goode, Together with a Selection of his Papers on Museums and on the History of Science in America*. Washington, DC: Government Printing Office.

— (1901c) The beginnings of American science: the third century. In *A Memorial of George Brown Goode, Together with a Selection of his Papers on Museums and on the History of Science in America*. Washington, DC: Government Printing Office.

Greenhalgh, P. (1988) *Ephemeral Vistas: The Expositions Universelles, Great Exhibitions and World's Fairs, 1851–1939*. Manchester: Manchester University Press.

— (1989) Education, entertainment and politics: lessons from the great international exhibitions. In P. Vergo (ed.), *The New Museology*, pp. 74–98. London: Reaktion Books.

*Harris, N. (1990) *Cultural Exchanges: Marketing Appetites and Cultural Tastes in Modern America*. Chicago: University of Chicago Press.

Harvey, P. (1996) *Hybrids of Modernity: Anthropology, the Nation State and the Universal Exhibition*. London: Routledge.

Hinsley, C. (1991) The world as marketplace: commodities of the exotic at the World's Columbian Exposition, Chicago, 1893. In I. Karp and S. Lavine (eds), *Exhibiting Cultures: The Poetics and Politics of Museum Display*, pp. 344–65. Washington, DC: Smithsonian Institution Press.

Hoffenberg, P. (2001). *An Empire on Display: English, Indian, and Australian Exhibitions from the Crystal Palace to the Great War*. Berkeley, CA: University of California Press.

Kirshenblatt-Gimblett, B. (1998) *Destination Culture: Tourism, Museums, and Heritage*. Berkeley, CA: University of California Press.

*Kohlstedt, S. G. (1991) *Science in America: The Essays of G. Brown Goode*. Washington, DC: Smithsonian Institution Press.

Langley, S. P. (1901) Memoir of George Brown Goode, 1851–1896. In *A Memorial of George Brown Goode, Together with a Selection of his Papers on Museums and on the History of Science in America*. Washington, DC: Government Printing Office.

di Leonardo, M. (1998) *Exotics at Home*. Chicago: University of Chicago Press.

Macdonald, S. (1998) Exhibitions of power and powers of exhibition: an introduction to the politics of display. In S. Macdonald (ed.), *The Politics of Display: Museums, Science, Culture*, pp. 1–24. London: Routledge.

Mathur, S. (2001) Living ethnological exhibits: the case of 1886. *Cultural Anthropology*, 15: 492–524.

Maxwell, A. (1999) *Colonial Photography and Exhibitions: Representing "Native" People and the Making of European Identities*. London: Leicester University Press.

Mitchell, T. (1992) Orientalism and the exhibitionary order. In N. B. Dirks (ed.), *Colonialism and Culture*, 289–318. Ann Arbor: University of Michigan Press.

National School Celebration of Columbus Day (1892) The official program. *The Youth's Companion* 65, September 8.

Niquette, M. and Buxton, W. J. (1997) "Meet me at the fair": sociability and reflexivity in nineteenth-century world expositions. *Canadian Journal of Communication*, 22: 81–113.

Rony, F. (1992) Those who squat and those who sit: the iconography of race in the 1895 films of Felix-Louis Regnault. *Camera Obscura*, 28 (January): 263–89.

*Rydell, R. (1984) *All the World's a Fair: Visions of Empire at America's International Expositions, 1876–1916*. Chicago: University of Chicago Press.

— (1993a) A cultural Frankenstein? In N. Harris et al. (eds), *Grand Illusions: Chicago's World's Fair of 1893*, pp. 143–70. Chicago: Chicago Historical Society.

— (1993b) *World of Fairs: The Century of Progress Expositions*. Chicago: University of Chicago Press.

Schneider, W. (1982) *An Empire for the Masses: The French Popular Image of Africa, 1870–1900*. Westport, CT: Greenwood Press.

Scott, G. (1990) Village performance: villages of the Chicago World's Columbian Exposition of 1893. Unpublished PhD thesis, New York University.

Smith, K. and Smith, M. (2001) Through a clouded mirror: Africa at the Pan-American Exposition, Buffalo 1901. Buffalo Museum of Science (www.sciencebuff.org/africa_at_the_pan_am_introduction.php).

Staley, R. (ed.) (1994) *The Physics of Empire*. Cambridge: Whipple Museum of Science.

Strother, Z. S. (1999) Display of the body Hottentot. In B. Lindfors (ed.), *Africans on Stage: Studies in Ethnological Show Business*, pp. 1–61. Bloomington, IN: Indiana University Press.

Walden, K. (1997) *Becoming Modern in Toronto: The Industrial Exhibition and the Shaping of a Late Victorian Culture*. Toronto: University of Toronto Press.

Williams, M. (1993) Science, education and museums in Britain, 1870–1914. In Brigitte Schroeder-Gudehus (ed.), *Industrial Society and its Museums*, pp. 5–12. Paris: Harwood Academic.

Making and Remaking National Identities

Flora *Edouwaye* S. Kaplan

If nations and museums were the florescence of the late nineteenth and twentieth centuries, the twenty-first century promises to challenge the identities that came to be assigned and defined by them as ideas and places, both imagined and experienced physically. Nations and museums germinated in the early mix of medieval mercantile capitalism and fifteenth-century European global expansion. National museums in the West (as we now know them) are rooted in the humanism of the Italian Renaissance, and flourished in the light of eighteenth-century scientific experiment and rationalism. Colonialism, which spread with nineteenth-century industrial capitalism to distant continents, generated new wealth and expressions of pride at home that quickened world fairs and the growth of museums.

But colonial encounters were often violent, and generated sparks of resistance that would later ignite movements for independence that were played out in the post-World War II era in particular historical, global contexts (Kaplan 1994: 1–15). In the waning years of the twentieth century, rising tides of ethnicity in nations old and new, brought contention as well as appropriation and innovation to nations and museums. Deliberate destruction of historic sites, theft of artifacts, specimens, and museum collections that were formerly spoils of war and prerogatives of aggressors, were now seen as unacceptable violations and loss of the world's cultural heritage. Together with issues of ownership and "voice," they are among the wrenching issues facing museums in the twenty-first century in the wake of erupting ethnic and religious conflicts and the break-up of former nations.

Nation, Nationalism, and National Identity

"Nation" is defined here as a state, a centralized authority, and political entity that governs within a named physical space; it is glossed with a declared identity, and attached to diverse groups living within the borders maintained and defended by the state. The identity of a nation is closely bound up with an ideology and worldview, purveyed and associated with the named space it occupies. It is assumed the diverse groups residing within a nation's borders identify with and owe allegiance to the governing center – be it in the form of a ruler, a spiritual leader, a chosen secular rep-

resentative and/or a type of government. National identity is effectively imposed by authority of the state; and it is accepted with a greater or lesser degree of enthusiasm by those groups and individuals who are the presumed recipients of benefits and subject to the sanctions of the state.

National identity at times may be expressed as "patriotism," a love of country; and at times it may take the form of "nationalism" when expressed as domestic and foreign, economic, social, and political policy. Where national identity and the enthusiasm associated with the state are high among individuals and diverse groups, patriotism and nationalism are likely to be supported and deeply felt. Where identity is imposed (or withheld) and/or enthusiasm is low, patriotism and nationalism may instead generate feelings of alienation and resistance. Propositions and definitions of ideas as complex as those presented here are inevitably subject to the hazards of universal applications. But they are both necessary and useful to any discussion of issues affecting museums, especially against the contemporary and changing backdrop of nation, nationalism, and national identity. Individuals and groups who diverge from a nation's prevailing ideology and worldview may then seek other ideas on which to base their identity, and utilize those available to them. Ethnicity is one of the ideas most often used in this way.

Ethnicity as Identity

In the twenty-first century, ethnicity has come to occupy the widening space between nations and the diverse groups they govern. This trend emerged in the twentieth century with declarations of independence by many new nations. These nations were themselves the products of earlier arbitrary boundaries established in previous decades by foreign colonial administrations that aimed to divide and rule. Some new nations were the products of competing foreign powers. These polities imposed by force, by foreign colonial administrations, papered over the longstanding tensions, conflicts, and enmity that existed among formerly independent and neighboring ethnic groups.

Ethnicity as a concept is complex. It does not easily lend itself to a clear-cut, cross-cultural definition. At times, it intersects with related ideas of class and interest groups (Blu 1980: 218–19). The distinguishing feature of ethnicity, however, is the accessibility and ready acceptance of the idea by diverse groups of *self-definition* usually associated with cultural behaviors, for example, language, custom, belief, history, dress, and material culture. This feature has had and continues to have implications for museums.

Cultural features associated with ethnicity and identity may be perceived or retrieved as "traditional" and even ancient, but they are frequently recent as well, wholly invented, and/or re-invented (Cohn 1980; Anderson 1983; Hobsbawm and Ranger 1983). Foremost among the achievements of ethnic groups is the sense of unity it creates in striving for political power and change. Material representations of traditionality and age help to legitimate an ethnic group's claims to a unique identity and political power and to their attempts to create a sense of unity among themselves. This is a major reason why the creation of a museum is often seen as vital to

those groups seeking wider visibility in order to be granted greater political rights, autonomy, or "national" status.

"Native Americans" in the United States of America and "First Peoples" in Canada, for example, are regarded today as sovereign nations within larger nation-states, based on treaties and legislation. The Iroquois nation is a confederacy of six related tribal groups located in upper New York State and Canada. Their perception of themselves and their position as a nation was vested in part in a particular group of objects, namely, eleven nineteenth-century Canadian Iroquois cut and polished clamshell belts, called *wampum*. These wampum belts were seen by them as markers of sovereignty: as documents that recorded earlier Iroquois alliances, treaties, and historic events, and as mnemonic devices to be "read" on important occasions by tribal elders. For decades, these *wampum* belts reposed in the collections of the Museum of the American Indian (MAI), a private institution in New York City. Persistent efforts, beginning in 1977, by the Iroquois nation to retrieve the belts, eventually resulted in their return from the MAI to the Six Nations Confederacy in Ontario, Canada, in 1988 (Abrams 1994).

In 1989, by agreement, the former MAI and its collections became the property of the newly re-incorporated National Museum of the American Indian (NMAI) and part of the United States Smithsonian Institution, Washington, DC. Soon after, in 1994, the NMAI George Gustav Heye Center for exhibitions was opened in the Alexander Hamilton United States Customs House, at One Bowling Green, New York City. A series of three thematic, inaugural exhibitions was launched, using the Indian cultural metaphor of "the journey" (West 2004). Beginning in 1994, in keeping with that metaphor, the three exhibitions made use of a wide range of ethnic art and artifacts at the Heye Exhibition Center. *This Path We Travel* (August 1, 1994– August 1, 1995) brought together the work of fifteen living Native American artists, sculptors, musicians, dancers, and writers. *Creation's Journey*, subtitled, *Masterworks of Native American Identity and Belief* (August 1, 1994–June 1, 1996), showed works from "200 tribal groups" in the Americas, "dating from 3200 BC to the twentieth century." The third and longest running exhibition, *All Roads Are Good* (August 1, 1994–August 1, 2000), actively engaged twenty-three Native Americans to act as curators and choose a total of three hundred objects "that would illustrate the diversity and continuity of Native cultures." The latter aimed to present the worldviews of indigenous cultures now part of other nations in the Western hemisphere. Each culture saw itself as a separate group and/or as a sovereign nation. In these exhibitions, however, they were joined together in a pan-American Indian identity.

Public interpreters of the three NMAI inaugural exhibitions actively promoted the idea of a new, over-arching Indian identity that encompassed Native Americans in the Americas north, south, and in between (fig. 10.1). Historically, many of these ethnic groups actually differed in economic and political organization, language, custom, worldview, and religion. Some of them had been long-time enemies, others friendly, and still others competitive and aggressive against their neighbors, raiding and/or subjugating them from time to time over the centuries. The NMAI pan-Indian approach to museum interpretation had its roots in the curatorial perception of shared cultural qualities in being "Indian" and displaying "Indian-ness." This perception also had its roots in post-contact history: most Indians were initially dec-

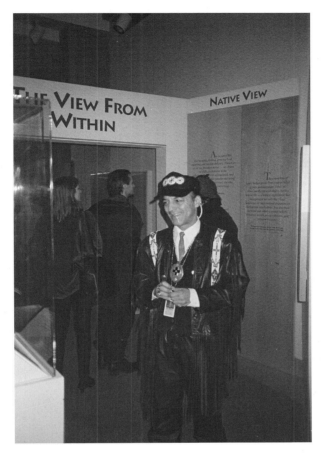

Figure 10.1 Native American education interpreter. The interpreter provides commentary for visitors to the inaugural show, *All Roads are Good*. He answers questions, wearing items of dress that identify him as an indigenous person, and conveys a view from "within." The George Gustav Heye Exhibition Center, National Museum of the American Indian, Smithsonian Institution, New York. Photograph 1994 by Flora *Edouwaye* S. Kaplan.

imated by disease in large numbers and exploited as labor by colonists and the church fathers. Virtually all Indian groups experienced widespread displacement, deception, and force deployed against them by European explorers, traders, and immigrants to the Americas.

It is no small irony that the location of the NMAI George Gustav Heye Exhibition Center in lower Manhattan, at the foot of Broadway, is in a magnificent Beaux Arts building that is a paean to nineteenth to early twentieth-century industrial capitalism (fig. 10.2). Broadway, formerly the British "King's Highway," was originally an old Indian trade route before the seventeenth-century Dutch settlement of Manhattan. The building designed by the architect Cass Gilbert, was graced, on completion in 1907, with monumental figural sculptures of the four continents. From

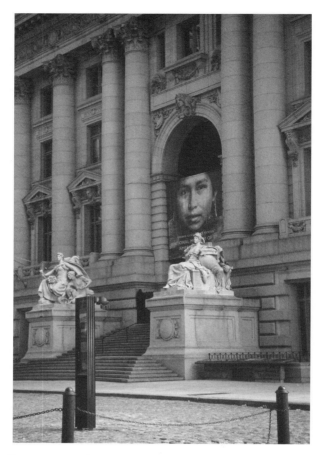

Figure 10.2 Entrance to the George Gustav Heye Exhibition Center, Bowling Green, New York. This view shows two of the four monumental sculptures flanking the present museum entrance. The Beaux Arts building was designed as the United States Customs House by Cass Gilbert and completed in 1907. On the left is a figural tableau, *America*, and to the right is *Europe*, created by the sculptor Daniel Chester French (1907). An inaugural exhibition banner, emblazoned with the face of an American Indian, announces the new museum and hangs prominently above the main entrance. The US Alexander Hamilton Customs House, George Gustav Heye Exhibition Center, National Museum of the American Indian, Smithsonian Institution. Photograph 1995 by Flora *Edouwaye* S. Kaplan.

left to right, the carved stone groups by Daniel Chester French represent Asia, America, Europe, and Africa. They reflect then prevailing stereotypical views of the Old and New Worlds.

Asia is impassive with eyes cast downward, her people bent in bondage, kneeling, and giving obeisance (fig. 10.3); *America* is the most active of the four figures, and appears ready to rise from her seat (fig. 10.4). She is shown as a classical female figure with sheaves of corn, symbols of plenty, on her lap, and Labor at her side. A Native

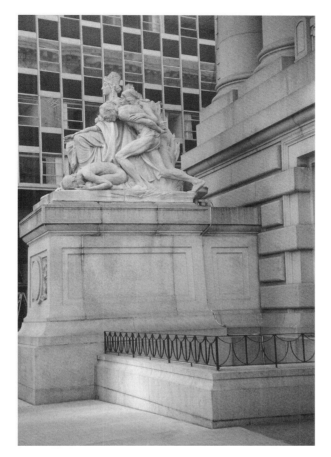

Figure 10.3 *Asia*, figural sculpture by Daniel Chester French (1907). This classic and remote allegorical figure, eyes gazing downward, sits calmly amidst struggling and worshipful figures and symbols of domination. The figure references the ancient and despotic past of the continent (as then perceived). The US Alexander Hamilton Customs House, George Gustav Heye Exhibition Center, National Museum of the American Indian, Smithsonian Institution. Photograph 1994 by Flora *Edouwaye* S. Kaplan.

American is just behind her and, like her, looks ahead into the future. *Europe* wears a crown and sits unperturbed, clothed in robes of regal status quo, holding in her hands symbols of office. Ancient history is by her side, along with symbols of power past and present. *Africa*, barely robed, her eyes closed, still sleeps next to the Sphinx.

Religion as Identity

Religion may be defined as a belief system in one god or many, based on faith, and about the way in which the world is ordered and functions. It has influenced and

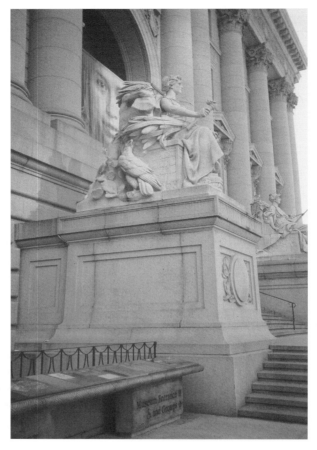

Figure 10.4 *America*, figural sculpture by Daniel Chester French (1907). One of four continents created for the front of the US Alexander Hamilton Customs House, Bowling Green, New York, *America* is the only central allegorical figure shown as active, about to rise. She holds a symbol of plenty in her lap represented by sheaves of corn, and the man at her side symbolizes labor. An American Indian looks into the future from over her shoulder. The US Alexander Hamilton Customs House, George Gustav Heye Exhibition Center, National Museum of the American Indian, Smithsonian Institution. Photograph 1996 by Flora *Edouwaye* S. Kaplan.

guided human actions over millennia. Religion is both a cultural feature of ethnicity, and a feature of identity apart from ethnicity. Like class, a hierarchical economic system with distinguishing social features that it resembles, religion, at times, is related to ethnicity, as well as class and/or interest groups. Ideologically based governments were sometimes supportive of organized religion (fascist states); others discouraged or marginalized its practice, as part of its own ideological explanation (socialist/communist states).

Religion re-emerged in the 1970s as a global focal point of identity and a rallying cry for disaffected groups within nation-states across the Middle East, Africa,

Europe, and the Americas. World religions in particular, such as Islam, Christianity, Buddhism and others proselytizing in the twenty-first century, have entered the dialogue among nations. Where they have taken on roles of civil governance, some theocratic states have re-appeared. Iran and Afghanistan are but two examples of several that can be cited; and elsewhere religious groups currently vie for control in other nations. In the 1970s the Shah of Iran was deposed and replaced by an Ayatollah and rule by clerics who became the final arbiters of civil society, morality, and secular behavior. Museums were affected as well: modern Western art was not shown for more than two decades at the Tehran Museum of Contemporary Art, following the 1979 Islamic revolution. The morality of modern Iranian artists was suspect and their work was scrutinized for exhibition by a government agency. Latitude to show and travel was feared as corrupting to the public and empowering for artists and the art world (Fathi 2004). In the 1990s, the Taliban imposed an extreme version of Islamic governance in Afghanistan. In both states, ethnicity and national identity were either usurped or submerged by religion.

Nations whose dominant religion(s) actively proselytize, seeking converts in various parts of the world, have at times opposed, undermined, abused, and sometimes coexisted with indigenous religions that formerly served independent and culturally homogeneous, small-scale societies. Formerly independent, small-scale societies are now considered ethnic groups, to be willingly and unwillingly subsumed under the centralized political authority of heterogeneous nation-states. For example, various indigenous peoples in Brazil, Mexico, and other parts of the Americas are cases in point. They are frequently found in contention with the central governments of nation-states, reported by the world news media. In secular states, citizenship confers national identity by known and established means on those who are born or living within a nation's borders and subject to its sanctions. In secular states, religion is rarely a criterion for citizenship. In theocratic states, the rights and conditions accorded to "others" may be quite different, and even absent.

The passion that religion inspires among "true believers" often conspires not only to attack or reject "non-believers" and their belief systems, but to denigrate them and even obliterate evidence of their cultural identity. The passion of believers is inflamed by a sense of righteousness and fed by the praise heaped upon them by those who are like-minded, of which many examples are found throughout human history. Spanish Catholic religious zeal in the early sixteenth century led to the burning of books and texts written by ancient Maya and Aztec priests in Mexico and Central America. Recently, a religious and politically motivated act of willful destruction of cultural heritage was met with dismay and a vocal outcry from world organizations.

In March 2001, the Taliban demolished the monumental Buddhas, dating from the fifth to the seventh century AD, carved into the rock cliffs at Bamiyan in Afghanistan. This irrevocable act by the ruling Islamist Afghan government was widely condemned by international museums, organizations, committees, and governments in the West and East. Offers were made beforehand to preserve or otherwise remove to safety elsewhere the offending figural sculptures of the Bamiyan Buddhas. All offers were rejected by the Taliban. It was noted that Islam actually allowed less-destructive methods of disabling images: the faces of the statues could

have been obliterated, or the Buddhas could have been decapitated instead (Flood 2002). The impulse to alter, deny, or destroy the "other," however, not only takes lives and wounds many more, it often seeks cultural annihilation as well. It is hardly a new impulse historically. Apart from accidents, many heads, noses, and penises of classical Greek and Roman statues of heroes and deities were lost in ancient conflicts. Later, fig leaves were sometimes added to cover the male sexual organs on classical pagan statues that offended Christian sensibilities in the Victorian era. All such acts are condemned by the global museum community for attacking the integrity of the object; and for impoverishing world knowledge, diversity, scholarship, and culture history.

Ideology as Identity

At times, nationalist ideology and policies pose a threat within the nation and the wider international arena. The fascists in Italy did just that; and so did those in Germany who came to power in the 1930s proclaiming Aryan racial superiority, and embarking on conquests to restore national pride, which eventually triggered World War II. Following the end of that global conflict, nationalism, once again, this time packaged as economic ideology, set in motion the game–set–match that was played for many decades between the socialist/communist governments of Eastern Europe, China, and Russia, and the Western capitalist democracies. Cultural heritage provided a bridge to diplomacy in easing the threat-and-response between major players. Communist China, after its 1949 takeover, signaled a new diplomacy with America to its threatening neighbors, beginning with tours of lightning-speed games of "ping-pong" in 1971. A quarter-century after World War II ended and the Cold War began, President Richard Nixon's visit famously "opened" American diplomatic relations with China in 1972.

In 1974, China sent the first of many exhibitions of national treasures to solidify its new diplomacy with America and to encourage positive public opinion during the Cold War matches. *The Chinese Exhibition: The Exhibition of Archaeological Finds of the People's Republic of China* traveled to the East Coast in December 1974, to the National Gallery of Art, Washington, DC; then to middle America, at the Nelson Gallery-Atkins Museum, Kansas City, Missouri; and ended its tour, in August 1975, at the Asian Art Museum of San Francisco, on the West Coast of California (personal communication, Barry Till 2004). A rare archaeological find, which the press called the "Jade Lady," excited much admiration. Her mortuary suit from the second century BC was made of more than two thousand pieces of jade. It was sewn with gold thread by Western Han Dynasty master craftsmen for Princess Dou Wan. It was widely published and illustrated, an indication of the "Jade Lady's" success in capturing the public's imagination across America.

Russia, too, embarked on cultural exchange with Western democracies in 1974. They sent a highly praised exhibition, *Treasures from the Kremlin*, to the Metropolitan Museum of Art in New York (1979); and then on to the Grand Palais in Paris (1980). In his "Foreword" to the *Kremlin*'s catalogue, the Director of the Kremlin's State Museums in Moscow, Mikhail P. Tsukanov, took the opportunity to state:

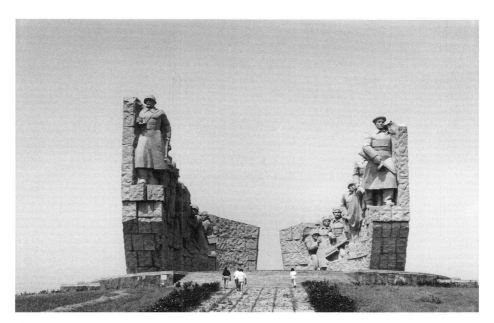

Figure 10.5 Memorial to the defenders of the city of Leningrad (St Petersburg), Russia. This monumental memorial was created to remember the heroic defense of the city of Stalingrad by soldiers, workers, women, and children. Hundreds of thousands died and suffered starvation during the siege resisting the invading German army in World War II. The imagery of this memorial conveys the socialist ideology of the nation and glorifies the bravery and endurance of ordinary Russian people. Photograph 1993 by Flora *Edouwaye* S. Kaplan.

"After the great Socialist October Revolution of 1917 the Revolutionary Government decreed that the historic and artistic treasures of the Kremlin were to be nationalized and brought together in a single museum complex – the State Museums of the Moscow Kremlin" (1979: 7). Tsukanov outlined the socialist government's continuing efforts to record, restore, and renovate historic and artistic monuments (fig. 10. 5). The government's official policy on heritage, he pointed out, was first set by Lenin in 1918; it is codified today and part of the USSR constitution. In his text, Tsukanov clearly stated the government's desired goal, saying, "The extensive cultural exchanges between our two nations doubtless serve the cause of universal peace and understanding" (1979: 8). Under socialist rule, the czarist riches were realigned as the people's national treasures.

The director of the Metropolitan Museum of Art, Philippe de Montebello, eschewed political comments in his "Foreword" to the same catalogue, *Treasures from the Kremlin* (1979). He confined himself to simply stating that the *Kremlin* show was the fourth in a continuing cultural exchange with Russia, begun in 1974. De Montebello opted instead to expand on the quality, variety, and content of the art treasures in the exhibition; and he extended acknowledgments and suitable thanks to all those involved in bringing the show to fruition. During the Cold War and since,

cultural exchange and museum exhibitions have been used to defuse tensions between ideologically opposed nations.

The case of Romania, an East European state, was both like and unlike Russia with regard to cultural heritage. Like virtually all socialist states of the Cold War era, the ideology of identity was based on a theory of economic and emergent social and political relations, commonly called socialist, communist, "Marxist" (or Maoist) governments, and coupled in referrals as national-socialist states (Godelier 1977: 29–32, 169–82). Such states, imposed and/or established in the Cold War era, espoused the ideology advanced by its principal founders and secular leaders: Marx and Engels, Lenin and Stalin; and they were reinterpreted and expounded by other counterparts, prominent among them Zhou Enlai and Mao Zedong in China, and elsewhere.

Romania, like Russia at the end of World War II, set out to restore and protect its damaged architectural cultural heritage. By the 1970s, however, postwar industrialization and population growth in Romania created an urgent need for urban housing and planning. Eventually, those needs collided with existing cultural heritage policy that called for protection of a rich inventory of churches and buildings, from the tenth century to the present, in Romanian communities. In response to those needs, the national-socialist government of Romania changed course in the early 1980s, and adopted a new and radical policy toward architectural heritage, designed to meet the urgent needs of a rapidly growing population, industrialization, and urbanization.

The aim of Romania's socialist government's new policy was consistent with its ideology: to eliminate the differences found in rural and urban living standards. The methods to be employed were to demolish single family and private houses in villages, towns, and urban areas. The goal was to resettle entire rural populations of Romanians, as well as ethnic Hungarians, Germans, and Serbians in urban areas and multiple dwelling housing. The city of Bucharest, for example, was slated to have centuries of architecture deliberately destroyed – ranging in style and period from Byzantine, classical Renaissance, and the Belle Epoque, to the international and local ethnic styles. This policy was seen by Romanian historians, architects, and museum professionals as "an attempt to homogenize the national cultural experience and to eliminate the history of the country" (Giurescu 1989). Resettled families would instead become state tenants in apartment buildings. That rural, "ethnic," architecture was deemed "backward" by the government, encouraged the planned "systematization" of living conditions.

These actions by Romania's socialist government advanced an internal ideological agenda. They also stirred restive groups within the country, including museum professionals, architects, historians, and other academics in various fields. The large-scale proposed destruction of architectural heritage (later carried out) generated considerable opposition to the new heritage policy. Groups coalesced in order to have a "voice" in decision-making, and to influence the outcome in relevant public arenas. These groups found themselves visible and vocal nationally, but without internal power to effect change in state policy.

Romania's new policy on architectural heritage was met with intense external protests. The Seventh ICOMOS General Assembly, on May 12–18, 1984, met in

Rostock and Dresden in the German Democratic Republic (GDR). At the behest of internal opponents of Romania's new policy, who turned to this international committee for outside support, ICOMOS considered the housing plan. The GDR assemblage was the International Committee of the International Council of Museums (ICOM) (the world organization of museums), and its focus was monuments and sites (ICOMOS). This committee announced that they found the peacetime "government-sanctioned assault on the architectural heritage of Romania and the citizens of Romania" simply "not negotiable" (Giurescu 1989).

The Romanian government ideologically construed the planned destruction of 7,000–8,000 villages, and the "reconstruction" of another 5,000–6,000 as "improving" peasant life. Those opposed to the plan (rural farmers, artisans, shopkeepers, architects, historians, art historians, and curators) saw the forced transformation of people and place as a loss of cultural identity among all Romanians and the country's minority peasant communities. Museum professionals and academic scholars had inventoried preservation plans under the old policy before the 1980s. When the new policy was implemented, a comparable group of professionals compiled data on the scope of architectural destruction that was visited on cities and villages in Romania. Despite internal and external opposition, Romanian state policy prevailed. National-socialist ideology replaced vigorous efforts to retain ethnic and national cultural identity in architecture. Giurescu, the distinguished Romanian historian and author of *The Razing of Romania's Past: An International Preservation Report* (1989), found it necessary to flee the country with his family before publication. The policy remained unchanged until Romania's socialist government under President Nicolae Ceauşescu was overthrown in 1989.

The Museum and the Nation in the Twenty-first Century

Achieving a balance nowadays between national interests and preservation, and between those in and those out of power, increasingly falls to international museum organizations, professionals, and academics. These groups often cooperate in international arenas; and in recent and egregious cases, such as the destruction of the Bamiyan Buddhas, and of Romania's architectural heritage, they act together across national boundaries. In some cases, international condemnation of a nation's policy or practice may cause serious problems for museum professionals and academic scholars who are civil servants in government-sponsored systems. Romania is a case in point: the career and safety of scholars and preservationists opposed to a new domestic heritage policy were threatened. Russia, however, continued to support preservation of cultural patrimony throughout the postwar period. Both nations today are among 140 member countries belonging to the International Council of Museums (ICOM), founded in 1946.

A major force and leading organization in the international museum world, ICOM is a non-governmental organization having formal relations with the United Nations Economic, Social and Cultural Organization and enjoying consultative status. It is dedicated to conserving, continuing, and communicating the value of the world's natural and cultural heritage. It sets standards for personal and professional

exchange, ethical behavior, illicit traffic, and preservation (ICOM 1946–98; *Museum* 1980). It is concerned with the tangible remains of human and natural origins, and intangibles as well: oral tradition, performance of all kinds, and living collections that include persons and ephemera.

ICOM's triennial conference in 2004, in Seoul, Korea, chose a theme central to ethnic and national identity: "Museums and Intangible Heritage." It brought much-needed attention to traditions many consider to be endangered by globalization, rapid change, and ease of manipulation in a digital era of worldwide media. Collecting, preserving, exhibiting, and reproducing intangible heritage may be claimed and disputed within and between nations – by competing ethnic groups. Privacy issues, such as those of ownership, are difficult to monitor and maintain, and pose special risks for national and private museums. Virtual museums, which are themselves intangible, without a space and place beyond websites, promise to raise other issues (see chapter 18). ICOM is beginning to address all of these matters (for example, ICOM 2002, 2003, 2004; *Museum International* 2002). Museums can, however, look to the realm of legal precedent developed in intellectual property cases that indeed span beyond national borders (see chapter 27).

ICOM works with national committees, such as the American Association of Museums (AAM/ICOM), to try to attain "the highest standard of legal and ethical collections stewardship practices" (AAM 1999: 2). Issues of the repatriation and return of works bought, stolen, or acquired in time of conflict and conquest, foreign or colonial rule, and in periods of intolerance and persecution, will continue in the twenty-first century, with those, or their descendants, who were powerless to protect or keep their property, trying to reclaim it. Cultural exchange, international exhibitions, loans, and displays in museums have thrust many of these issues before the public. So ownership of the Elgin Marbles, those iconic works removed from the Parthenon in Athens and now in the British Museum, is a matter of continuing dispute between Britain and Greece. Expatriate Benin chiefs living in London in the 1990s began to lobby for the return of cast bronze and brass statues, plaques, and heads that were part of their cultural identity. These famed works were looted from the Oba's Palace in Benin City, Nigeria during the British military assault in 1897 that established colonial rule which lasted until 1960.

During the Nazi persecution of Jewish citizens in Germany and various parts of Europe (1933–45), paintings and sculptures were seized from their owners under various pretexts, threats, and outright thefts. Those survivors, or more often some of their descendants, identified and attempted to reclaim missing works of art as they began to appear, decades later, in museum catalogues and art exhibitions in the United States and Europe. Several important court cases and rulings in the 1980s involved exhibition loans, sales, and gifts to American museums. This led to key reviews of complex issues that originated in Europe, but were being adjudicated in the US. The Working Group of the AAM/ICOM Board and the AAM Board developed criteria and a website to disseminate information. In 1999, they published their results for use by the nation's museums: *Guidelines Concerning the Unlawful Appropriation of Objects during the Nazi Era* (see chapter 27).

Like the privately funded International Foundation for Art Recovery (IFAR), which published its first *Index of Stolen Objects* (1978), the goals of AAM and

AAM/ICOM were to facilitate recovery of cultural property, interrupt illicit traffic, and restore works otherwise removed from their places of origin and ownership. Internet sites dedicated to these tasks continue to enhance recovery, providing immediacy, images, information, and access worldwide. The Metropolitan Museum of Art (MMA) set a high bar for art museums now maintaining websites by posting a separate list of "suspect" works belonging to the Nazi era. It is expected that other museums will follow suit.

With Western art essentially international, especially modern art, many problems of theft and repatriation have become multinational. The exceptions are propaganda art employed in the service of the state. These works are often confined to storage in basements as second- and third-rate art and are rarely exhibited in museums or public places with the passing of former authoritarian regimes. I saw many busts and sculptures of Stalin in museums' dead storage in 1993 in Russia after *glasnost*. Perhaps, when memories dim, the best of these works will have a place in history museums; perhaps not. Outside, beneath a Kremlin wall, a neat row of stones marks the graves of lesser Russian revolutionary leaders, barely noticed by visitors walking along the path. They once were the faces of the nation. All are now strangely absent from the national museums. Earlier despots, kings, clerics, and merchant princes apparently chose better artists and sculptors to memorialize them. A nation's identity now rests on more mundane civic images (photographs, stamps, signature buildings, and the ubiquitous national flag).

Museums and their Study

Museums are more than the sum of their parts. They played and continue to play important roles in creating national identity (Kaplan 1981). Although museums arise in particular historical contexts, everywhere they involve the selection and display of made objects and those of the natural world (Kaplan 1994: 1–15). In the nineteenth and twentieth centuries, the formation of museums and nation-states multiplied rapidly with the spread of industrial capitalism, the sciences, and the downward spread of knowledge in more open, changing, and democratic societies. They are now widely understood as secular sites of contestation and representation, and as places where groups vied with each other to define and redefine "themselves" as nations. Successful players on the international stage proudly displayed the spoils of their colonial control of distant trade and markets; and their museums claimed pride of place among other nations.

The critical study of museums as social institutions began to develop in the 1970s, initially most strongly in Europe and later spreading to North America and other parts of the globe. It was mostly Europeans working in museums, scholars and museologists, along with some in the United States of America and Canada, who first directed attention to the critical study of museums as social institutions. It met with success as a new field at the University of Leicester, which initially qualified applicants to work in the United Kingdom's museums, and awarded graduate degrees. The latter eventually included a doctorate in museum studies, the highest academic research degree.

Anthropology, a discipline with a long association with museums, however, lagged behind in the study of museums in the United States. A start was made in the mid-1970s in the AAM, when the Council for Museum Anthropology (CMA) was started by a group of anthropologists and archaeologists working in museums. They began a dialogue together, and in the process pioneered what became "museum anthropology." They also published a journal. In 1990, the CMA voted to affiliate with the American Anthropological Association (AAA). The AAA was rethinking museums in response to growing public interest and the visibility museums offered, along with job opportunities. Disciplines such as anthropology came to play an important role (see chapter 5), with journals such as *Museum Anthropology* and the *American Anthropologist* carrying reviews of museum exhibitions and related topics. Fields such as the anthropology of museums (Jones 1993), museum anthropology, and museum studies developed (Kaplan 1996), and provided critical analyses of political roles, policies, and the politics of museums informed by theory; and addressed controversial issues of representation, control, power, and gender.

In an invigorated search by scholars for museum theory, ideas borrowed from French scholars of knowledge bestowed intellectual respectability and legitimated the study of museums, especially in older disciplines (see Part I). By the end of the twentieth century, issues of national identity and museums had come to occupy many serious scholars across a wide spectrum of disciplines (anthropology, history, sociology, political science, and philosophy). In academia, scholars found that curating and/or reviewing and writing about exhibitions and museums offered new opportunities to engage with key questions of power and identity politics in contemporary society. The keen public interest in museums allowed many scholars to have a "voice" and take an active role in issues of the day (for example, Kaplan 1981, 1995; Stocking 1985; Appadurai 1986; Clifford and Marcus 1986; Bennett 1988; Pearce 1989; Vergo 1989; Williams 1990; Karp and Lavine 1991; Macdonald and Fyfe 1996). Museums also garnered a bad press for their past sins of omission and commission in the days of colonialism. But museums and the identities they created were recognized in the literature, despite criticism, as important nexuses of politics and culture in the study of contemporary society and its discontents.

Into the Future

After two decades of much "museum bashing" in print as colonialist, racist, maleficent, misogynist, and even irrelevant institutions, there is a new emphasis and search to redefine the museum in the twenty-first century. Whereas interactive media and virtual museums are seen by some as redemptive alternatives, others are not quite ready to abandon museums as we know them (see Haas 1996). It cannot be claimed, however, that social issues are new concerns of museums (Alexander 1983). John Cotton Dana (founder of the Newark Museum and Library) is easily read as both a pioneer and a "modern" in that regard. He was deeply interested in how museums have an impact upon craft, industrialization, the working class, and the underrepresented. Stocking traces the ethnology (albeit) of "Man" at the Royal Anthropological Institute (RAI), founded in 1871, as having its antecedents in the defense

of "uncivilized tribes" forty years earlier, by the "Aborigines Protection Society" (Stocking 1971: 1, 3). He reminds readers that some of the debates of the late nineteenth century are echoed in late twentieth-century criticism of natural history museums that represent non-Western peoples in nature and natural habitats, and Europeans, when shown, in built environments of home and castle.

Nonetheless, Native Americans themselves, on opening their new ethnic museum (NMAI) on the Mall in Washington, DC, September 2004, declared their conscious decision to incorporate what they see as their unique spiritual and physical connection with the natural landscape and environment from Alaska to the tip of South America. They see themselves *in*, not apart, from the natural world, and draw attention to this connection in the architecture, grounds, interior spaces, and exhibits of the new NMAI (Maxwell 2004). "In Native culture, the animals, plants, and rocks are people"; the forty granite boulders that greet visitors to the grounds are "called 'Grandfather Rocks.'" They "show that all parts of the natural world are our relatives" says Donna House (Navajo). Their respect for the land is demonstrated by creating "a stable ecosystem" as landscape for the museum, Donna House continues. It is "in balance," "attracting birds, insects, and animals that haven't been here for a long, long time" (Maxwell 2004: 19). Donna House was a member of the five-strong NMAI design team; and is a botanist/ethno-botanist. Native Americans embrace and identify themselves in the natural world. Their view is unlikely to be challenged.

Elsewhere there have been many instances of challenge (see chapters 29 and 30). Some contemporary exhibitions have been scarred by controversy, as were the curators and scholars associated with them. *Into the Heart of Africa* (Royal Ontario Museum) was as much a victim of local activism and a political agenda as the failure of its ironic commentary (see chapter 2). Likewise, the *Enola Gay* exhibition (National Air and Space Museum, Smithsonian Institution) collided with World War II veterans over the curatorial voice that interpreted the use of the atomic bomb to end World War II (Macdonald 1998; see also chapters 7 and 30 of this volume). It was as much a reflection of generational difference and revisionist history as it was a casualty of "political correctness" and the "culture wars."

In the twenty-first century, more, rather than less, controversy can be expected in museums, with the fracturing of national identities and contention within nations. Some factors in these conflicts are old: religious extremism, intolerance, fundamentalist ideologies, economic deprivation, and ethnic conflicts. Other factors are old in new ways and degree: exponential population growth, environmental degradation, increasingly mobile populations (legal and illegal, and asylum seekers), instant and untrammeled worldwide communication, and a widening gulf in educational and economic opportunity, especially for women after decades of progress in many nations. And there is always the usual suspect, "globalization," frequently blamed for all of the above.

It is promising, therefore, that some museums in the developing world have pioneered exhibitions of public health issues, child care, and disease prevention, albeit while other issues are avoided; for example, female circumcision, domestic abuse, AIDS, women's economic roles and importance, civic and voter education. However, developed countries equally avoid many of the same issues, and museums that attend to them do so sporadically, usually in specialized museums of science, medicine, war,

women, work, film and television, and so on. Cultural differences and multiple identities further complicate the choice of subject matter, content, and interpretation in museums, beyond the eternal question of "who is the audience?" Applied to the global community and virtual museums, the answers may yet raise more questions, and offer greater opportunity for appropriation and manipulation of objects and images for betterment or worsening of human relations around the world.

Whatever the answers and the questions asked, it is clear that the storyline of national identity is being rewritten. What is the future role of museums? Is it to be purveyors of knowledge, unifiers of nations, of ideas and place, marketers of ideology, myth, arts and science? Will museums continue to define national identity, or will they represent a collectivity or a multiplicity of competing ethnic, religious, and/or ideological groups in a physical space? Will there be other collectivities, creating shifting communities linked by inclination and common interests; and will they appear in outer space across former boundaries spanned by the Internet, ground lines, and wireless systems? Will national identity survive or only museums and identity, redefined? For now, identity, like the ideas of nation and museum, remains a viable, if mutable concept, having heuristic value in social and political analysis in complex societies. Identity (variously defined and hyphenated) serves, increasingly, as a fulcrum for group relations in existing nation-states and the more so today across national boundaries.

Bibliography

AAM (American Association of Museums) (1999) *Guidelines Concerning the Unlawful Appropriation of Objects during the Nazi Era*. Washington, DC: AAM.

Abrams, G. H. J. (1994) The case for wampum: repatriation from the Museum of the American Indian to the Six Nations Confederacy, Branford, Ontario, Canada. In F. E. S. Kaplan (ed.), *Museums and the Making of "Ourselves": The Role of Objects in National Identity*, pp. 351–84. London: Leicester University Press.

Alexander, E. P. (1983) *Museum Masters: Their Museums and their Influence*. Nashville: American Association for State and Local History.

*Anderson, B. (1983) *Imagined Communities: Reflections on the Origin and Spread of Nationalism*. London: Verso Press.

Appadurai, A. (ed.) (1986) *The Social Life of Things: Commodities in Cultural Perspective*. Cambridge: Cambridge University Press.

Bennett, T. (1988) Museums and "the people." In R. Lumley (ed.), *The Museum Time Machine: Putting Cultures on Display*, pp. 63–85. London: Routledge.

Blu, K. (1980) *The Lumbee Problem: The Making of an American Indian People*. Lincoln: Nebraska University Press.

Clifford, J. and Marcus, G. (1986) *Writing Culture: The Poetics and Politics of Ethnography*. Berkeley, CA: University of California Press.

Cohn, B. S. (1980) History and anthropology: the state of play. *Comparative Studies in Society and History*, 22 (1): 198–221.

Fathi, N. (2004) In Tehran, the Mullahs learn art is long, censorship brief. *The New York Times*, April 25.

Flood, F. B. (2002) Between cult and culture: Bamiyan, Islamic iconoclasm, and the museum. *The Art Bulletin*, 84 (4): 641–59.

Giurescu, D. C. (1989) *The Razing of Romania's Past*. Baltimore, MD: World Monuments Fund.

Godelier, M. (1977) *Perspectives in Marxist Anthropology*. Cambridge: Cambridge University Press.

Haas, J. (1996) Power, objects, and a voice for anthropology. *Current Anthropology*, 37: S1–S21.

Hobsbawm, E. J. and Ranger, T. (1983) *The Invention of Tradition*. Cambridge: Cambridge University Press.

ICOFOM (International Committee for Museology) *Working Papers, 1981 – Present*. Paris: UNESCO.

ICOM (1946–98) *Administrative Reports*. Paris: UNESCO.

— (2002) *ICOM News*, 55 (1).

— (2003) *ICOM News*, 56 (4).

— (2004) *ICOM News*, 57 (2–4).

IFAR (International Foundation for Art Recovery) (1978) *Index of Stolen Objects*.

Jones, A.L. (1993) Exploding the canons: the anthropology of museums. *Annual Review of Anthropology*, 22: 201–20.

Kaplan, F. E. S. (1981) Interdisciplinarity in museology. *Museological Working Papers*, 1/1981. Paris and Stockholm: UNESCO.

*— (ed.) (1994) *Museums and the Making of "Ourselves": The Role of Objects in National Identity*. London: Leicester University Press.

— (1995) Exhibitions as communicative media. In Eilean Hooper-Greenhill (ed.), *Museum, Media, Message*, pp. 37–58. London: Routledge.

*— (1996) Museum anthropology. In D. Levinson and M. Ember (eds), *Encyclopedia of Cultural Anthropology*, vol. 3, pp. 813–17. New York: Henry Holt.

Karp, I. and Lavine, S. D. (eds) (1991) *Exhibiting Cultures: The Poetics and Politics of Museum Display*. Washington, DC: Smithsonian Institution Press.

Macdonald, S. (1998) Exhibitions of power and powers of exhibition: an introduction to the politics of display. In S. Macdonald (ed.), *The Politics of Display: Museums, Science, Culture*, pp. 1–24. London: Routledge.

*— and Fyfe, G. (eds) (1996) *Theorizing Museums: Representing Identity and Diversity in a Changing World*. Oxford: Blackwell.

Maxwell, S. (2004) A creation story. *National Museum of the American Indian: Commemorative Issue*, pp. 18–19. Washington, DC: Smithsonian Institution Press.

Museum (1980) 32, no.3.

Museum International (2001) no. 212 (vol. 53, no. 4). Paris: UNESCO.

— (2002) no. 215 (vol. 54, no. 3). Paris: UNESCO.

*Pearce, S. M. (ed.) (1989) *Museum Studies in Material Culture*. Leicester: Leicester University Press.

Stocking, G. W., Jr (1971) What's in a name? The origins of the Royal Anthropological Institute. *Man*, 6 (3): 369–90.

*— (1985) *Objects and Others: Essays on Museums and Material Culture*. Madison: University of Wisconsin Press.

Tsukanov, M. P. (1979) Foreword to the *Treasures of the Kremlin* exhibition catalogue. New York: Metropolitan Museum of Art.

Vergo, P. (ed.) (1989) *The New Museology*. London: Reaktion Books.

West, W. R., Jr (2004) A vision come to pass. *National Museum of the American Indian: Commemorative Issue*, p. 11. Washington, DC: Smithsonian Institution Press.

Williams, B. F. (1990) Nationalism, traditionalism, and the problem of cultural inauthenticity. In R. G. Fox (ed.), *Nationalist Ideologies and the Production of National Cultures*. Washington, DC: American Anthropological Association.

Museums and Community

Elizabeth Crooke

"Community" and creating an "inclusive community" have become buzzwords in the arts and museum sectors. The past five years have seen an immense increase in the literature and debate that have attempted to address museums and their roles and aspirations in relation to "community" and "communities." In this literature, the word "community" seems to have replaced "audience," "public," and "visitor"; the new term seems to reflect the more comprehensive, welcoming, and relevant service that museums are aspiring to create. The concern to make museums relevant to the "community" has swiftly moved to combining museums with some of the key social policy issues, such as tackling exclusion, building cohesive communities, and contributing to community regeneration. Furthermore, away from museum debate and government policy, rural and urban groups are coming together to explore their history and heritage and forming their own exhibitions and collections. The relationship that is developing between the community and the museum, either by museums attempting to engage better with their communities or by community groups becoming more actively interested in heritage activity, encourages us to investigate the meaning and consequences of this relationship and what it may inform us about the role of museums today.

Drawing on examples of community projects around the world, this chapter considers the links that have been established between community groups and museum practice, be it through activity within the established museum sector or examples of separate community initiatives that have drawn on the techniques and methods of museums. The first section looks at the links between community studies and museum studies, considering key issues that are of relevance to both: the challenges of representation; understanding people and how they interact; and the idea of social responsibility. The second section asks what might be meant by the term "community": the difficulties inherent in defining the term; the many myths associated with the concept; the potential negative associations with community; and, despite the many challenges to the significance of the community in modern life, the continuing relevance of the concept. The third and fourth sections draw on two key areas where community and museum studies come together: the role of museums in the representation of community identity and the role of museums in community development. The consideration of how museums represent community identity looks at

the way in which heritage symbolizes community and the role of museums in building communities. The evaluation of museums and community development provides an understanding of the purpose of community in public policy and how the arts and museum sectors are now playing an active role in achieving these aims. The final section considers the consequences of community interaction for the way in which museums are understood, and argues that the very idea of the museum is being challenged through community involvement.

The Links between Community Studies and Museum Studies

Key areas of concern for museum studies and the museum sector – identity, representation, people, and the social responsibility of museums – link directly to the themes investigated within community studies. The literature on "community," which comes mostly from the areas of social and cultural anthropology, sociology, cultural studies, development studies, and public policy, can, for the purposes of this chapter, be broadly separated into two areas. First, is the area of community studies, which considers mainly how understanding the dynamics of community will bring a greater appreciation of the formation of identity, the creation of relationships, and definitions of belonging. The themes that dominate such work include how "community" is symbolized, the role of imagination in expressing community, and the frequently invented nature of communities. This area of community studies clearly links to writings in museum studies that have explored the meaning of objects in museums and the use of display as a means to express identity, represent culture, and define nations (see especially chapter 10).

A second area of community studies, which is of relevance to this work, is the use of community in public policy. This area focuses on how public policy has integrated the notion of "community" as a tool of local and national government. Within the local and national government museum services, the creation of community collections, exhibitions, museums, outreach officers, and education officers can be associated with this movement. In many of these cases it is important to create a public museum service that is meaningful for a broader range of people. It is about moving away from the grand narrative, traditionally told in the national museums, and giving greater recognition to local and community histories.

However, the ease with which the word "community" has been slipped into current policy and practice, in a whole range of sectors, has come under scrutiny. Allan Cochrane, for instance, argues that the term "community" has often been used as an aerosol can "to be sprayed on to any social programme, giving it more progressive and sympathetic cachet; thus we have community policing, community care, community relations, community development, community architecture and the community programme among others" (Cochrane 1986: 51). Although it is unlikely to be true of every case, Cochrane's concern is that the term is simply added on to policy, rather than integrated into the complete approach. Rather than being used as a label, Cochrane advocates that community becomes a means for political change and the development of more democratic processes. This latter approach links to

activity that is considered to belong to the "unofficial heritage sector." This will include the work of community groups which have used heritage and museum activity as a vehicle for protest and as integral to their social and political campaigns. Involvement of community in this context is about the creation of new "circuits of power" and sustainable community networks that promote access and inclusion and are accountable to diverse communities. These are the same principles that underpin the debates in museum studies concerning social responsibility, equality, and democracy.

The insights that the methods, concerns, and literature of community studies can provide those working in the museum sector are invaluable. In the first place, we need to investigate the meaning and consequence of this idea of community, which is used with such frequency in the museum and heritage sectors. This will lead to a better understanding of why group identities are formed and how they are constructed, symbolized, and ritualized. Secondly, consideration of the characteristics and rise of community development policy will inform our interrogation of what the arts, museums, and heritage can contribute to this area.

Understanding Community

The concept of community is prevalent in museum policy and planning. In this context, the word "community" is used almost indiscriminately; there is rarely qualification of what the term means and how community is identified. The range of meanings associated with the word "community" is the first challenge for those embarking on community studies. The American sociologist G. A. Hillery is often quoted as having identified fifty-five definitions of community used in the sociological literature of the 1950s. Rather than attempting to reduce this diversity to a single definition, it is more useful to consider the multitude of characteristics associated with community. Gerard Delanty opens his book *Community* by emphasizing the range:

> Communities have been based on ethnicity, religion, class or politics; they may be large or small; "thin" or "thick" attachments may underlie them; they may be locally based and globally organized; affirmative or subversive in their relation to the established order; they may be traditional, modern and even postmodern; reactionary and progressive. (Delanty 2003: 2)

Delanty's description of community is useful because it helps to dispel some of the many myths associated with the term, namely, that community necessarily: has long established roots; is based on traditional modes of behavior; that characteristics are easily recognizable and that they are often associated with a fixed place. Instead, Delanty emphasizes the range of experiences of community: that community is not only about the past or nurturing communal living, which some consider as having been lost and in need of rebuilding. Community is not necessarily tied to a single place; it is not always about association with a certain village or landscape; it can be geographically spread but linked by an agreed interest. The idea of community can

be nurtured between people by a whole range of characteristics; hence the notion of a "thick" basis to that community. Alternatively, community may be recognized on the basis of only a few shared characteristics; in other words, a "thin" community. Furthermore, community is not principally about premodern, village, or rural-based societies; instead, for many today community is about developing new power relationships and sustainability. This range suggests that community is a word that alters in different contexts in an almost chameleon-like fashion. For some, this point would be grounds to dismiss the idea of community as outdated, vague, and of little use. However, no matter how forcefully an argument of redundancy may be presented, one cannot dismiss the frequency of the use of the word and therefore its importance.

Rather than attempting to define the word, understanding how the term "community" is used is likely to prove more productive. The essays in the edited collection *Realizing Community* (Amit 2002) provide examples of how groups across the United Kingdom, Norway, Canada, and Central Europe have used and drawn on the concept of community. What is common to many of these examples is the importance of developing a sense of place, building social networks, and both recognizing and acknowledging shared characteristics, such as a common history, religion, sport, or employment. The discussions consider the role of sentiment, emotion, and nostalgia in the formation of group identities. Shared features become cherished marks of community identity and a conscious decision is made to use these experiences to create unity. Frequently, any variation in experience is ironed out in order to develop a sense of sameness. In examples of community where a sense of place is central, the disruption of place becomes a key threat and people will then pull together to construct a narrative of belonging to counteract this. The examples brought together in *Realizing Community* demonstrate the importance of the intangible character of community construction. Although we may think we recognize community by tangible attributes, such as location or shared characteristics, the creation of community is bound up in the meanings associated with these symbolic markers. It is not enough to have the characteristics of community; rather, it is essential to have the motivation to bring these into a self-forming unit.

The interrogation of the idea of community also raises warnings. Many express the idea of community action and forging new relationships with communities in positive language. Others, however, are more wary of the seemingly nostalgic, over-simplified, and exclusionary nature of community. Hand in hand with growing recognition of the cultural symbolism of community is an increasing awareness of the need to establish a sense of similarity within the group at the expense of any differences. As communities are established, so too is the recognition of boundaries and an awareness of belonging. Emerging apparently effortlessly from shared characteristics, community is, in fact, constructed in a deliberate fashion, bringing security to its makers and uncertainty to those who feel they do not belong. Critical to the success of cultural codes, rituals, and symbols of belonging is their selectivity and ability to be recognized by those who are not part of that community. This is important for the survival of community: it needs to be easily identified by both its members and its non-members. If community is about coming together and unity, it is equally about division and exclusion. Worldwide, there are many examples of

the use of the preservation of community identity, heritage, and culture to justify racism and genocide, perhaps the most tragic being the consequence of the use of "community" as justification for fascism in Nazi Germany.

Museums and the Construction of Community Identity

Community can be constructed at local, national, and global levels. The formation of nation-states, for instance, is based on the idea that humanity is naturally divided into national communities, each of which has its own character. The characterization of the nation as an "imagined community" (Anderson 1991) has been invoked to express the idea that, although all of the members of the nation will not meet, they are aware of each other's existence and that they all belong to a common entity. The national community is naturalized through a shared history represented in the grand narrative of the nation, and in turn depicted in museums, history books, and by other forms of cultural symbolism, such as memorials. The history of European museum development in the nineteenth century links directly to the rise of the nations and the need for those places to claim and present a national past.

The national case shows that "community" depends on the development of an awareness of common characteristics, which can draw from a whole range of possibilities. Although community may be politically manipulated, for example for nationalist ends, community should not be thought of as purely instrumental but acknowledged as part of the inevitable human processes of creating collective identities and generating senses of belonging. What this means in relation to the use of the concept by museums is that we should not be uncritical, but that we should be prepared to explore how museums and heritage have been used to express community and to look at the role of objects in symbolizing community and expressing senses of belonging. It also reminds us of the social and political values placed on museum collections and of the potential of museums to engage in community construction and consolidation. All of these points are evident in the three examples that follow.

The District Six Museum, Cape Town

The development of the District Six Museum in Cape Town, South Africa is an example of community capacity building in a place torn apart by the separatist politics of apartheid (see also chapter 29). District Six is an area of Cape Town that was defined as white only under the Group Areas Act of 1966. As a result of this Act, 60,000 people were forcibly removed from the area and their homes were demolished. With this move, people were distanced from their friends, family, jobs, schools, and churches, and the community they had developed was broken. For many, this was deeply traumatic. In the 1980s a campaign, "Hands-off District Six," which aimed to protect the land from unsympathetic redevelopment, raised the idea of the creation of a museum as part of this process and in 1994 the District Six Museum emerged.

The museum was, and is, very much considered as an engagement with contemporary issues; it is a mode of expression and has an active part in the re-use of District Six. The development of a museum was an opportunity to recapture the community spirit of the area and generate support for the campaign to return the families who had been removed. Since its opening, former residents of District Six have seen the museum as: "a place to memorialise the history of the struggle" against apartheid, "a living museum," and a space "where stories can be told, where the layers of memories can be uncovered in an ensemble of hope" (Abrahams 2001: 4). The museum was to "engineer a collective spirit and a camaraderie" (Le Grange 2001: 7), and it was to be "a community museum, an open museum, the people's museum" (Fredericks 2001: 14).

It is not simply the fact that a museum of District Six opened that is relevant; what is far more interesting is *why* a museum should have emerged. The museum has become a space where people who formerly lived in District Six can come together and share past experiences. The museum provides an opportunity for people to "recall community." This community capacity building is based upon shared history and a clear sense of place. The museum exhibition draws on nostalgia for past lives and harnesses this sentiment as a vehicle for political change. In this example, the community has used the museum idea, but revisited it and presented it anew. In the Cape Town museum landscape, which traditionally reflects the European approach to museum building and display, the District Six Museum stands out as being very different. In the District Six Museum, the building and space is modest; there are no glass cases; the curator has not taken authority; and the exhibition text is not fixed: former residents may add to the panels while they visit the exhibition. The example of the District Six Museum conveys very well the values associated with museums and, in turn, their power. The public and shared recollection of events in a museum space empowers and changes how that past is understood. What caused people to feel shame now evokes pride; closed memories have now become open and shared; and a fragile people are becoming a stronger community. The District Six Museum is also an example of a community taking control of the presentation of its own history and this brings with it numerous consequences. Those involved have recognized the sense of pride associated with displaying one's own story in a public space, the value of nourishing group identities and establishing group bonds. The museum, and the activities it encourages, provides opportunities for community empowerment.

Community museum networks, Mexico

In the State of Oaxaca, south-east Mexico, a community-based cooperative has developed a network of local museums as part of a range of projects with the aim of contributing to the social and economic improvement of the area. Inspired by the importance of the cultural heritage of the region, and encouraged by the interest of anthropologists working in the area, as well as the financial support of development agencies, the idea of the *museo comunitario* network was born. Described as "a bottom up community museum networking process," the opening of the first museum in the

mid-1980s has lead to the creation of ninety-four community museums in seventeen Mexican states. The network is seen as an example of how development can have a positive impact on the mobilization of social capital, empowerment of the rural poor, enhancement of local government, the creation of durable partnerships between the state and civil society, and the creation of local defenses against the homogenizing forces of cultural globalization (Healy 2003).

The so-called "bottom-up" approach to this museum network is regarded as having been essential to its success; this project is seen as a positive alternative to other "misdirected" community museum programs in which "a top-down leadership and management style have left community members on the outside looking in rather than vice versa" (Healy 2003: 17). Community members describe *museo comunitario* as a means of developing a greater sense of collective ownership and raising self-esteem. One member stated how, before his involvement with *museo comunitario*, he had a "vague notion" of his cultural roots and "felt ashamed," but "now my knowledge and pride in my cultural origins have given me an empowering sense of cultural identity" (Healy 2003: 20).

Community exhibitions in Northern Ireland

In Northern Ireland, the development of the idea of group heritage is a means to create community identity through interpretations of history, memory, and place. An addition to the exhibition landscape in the region has been the development of often short-lived local history exhibitions curated by community organizations (figs 11.1–11.3). These exhibitions are only ever open to the public for a few weeks, are often quite amateur, are hosted in local community venues, and are usually underpinned by a particular developmental or cultural agenda.

Examples of such exhibitions include that supported by the Ulster People's College in Belfast through their People's History Initiative. This initiative has been running since 2001 and has resulted in approximately fifteen groups developing exhibitions based on the history of their community (Crooke 2005). In each of the cases, the exhibitions were an exercise in community autobiography: the community selected its own stories, chose the objects and images to place on display, and provided its own interpretation of past events and experiences. For the groups, success has been based on the contribution of the collective exercise to community identity formation, cohesion, and empowerment. Each stage is of value and part of a process and the group gains from researching potential themes, collecting stories and display material, and finally mounting the exhibition and sharing it with others. The fact that the exhibitions lack permanence, and the use of established experts, does not detract from their impact. Instead, the exhibition is valued as part of a process; it is not an end in itself, but a means to an end, the development of shared community identity.

The examples of the District Six Museum in Cape Town, the *museo comunitario* network in Mexico, and the initiatives in Northern Ireland demonstrate the value of these new forms of museum and museum practice within their various communities. All have been described as empowering institutions that have provided the people of the area with a renewed and positive sense of identity and improved self-

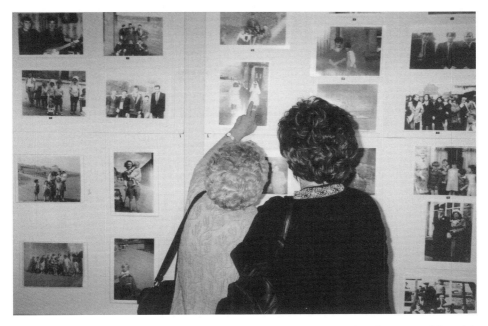

Figure 11.1 Community exhibition, Newry, Northern Ireland, July 2003. This exhibition was developed by the heritage committee of a community development organization. Photograph by E. M. Crooke.

esteem. The success of the projects has often been based on their bottom–up approach, on the fact that the projects began with a community which then decided to embrace the museum process. Central to this shift into the museum is the community need or desire that drives the process.

The strengths of these projects lie in the fact that they are genuinely community based; however, as established in the previous section, the idea of "community" needs to be approached with some caution. While "community" may be constructed in a multitude of ways and take a variety of forms, it can set up mythological ideals that are hard to realize or, by making community appear static, make change harder to achieve. By grounding a community in a particular history or experience, those who do not share that history are at risk of being excluded, past lives may be idealized, and events misrepresented. When any group begins to publicly construct and broadcast its history, it is essential to investigate the motivating factors and impact of the messages conveyed. In Cape Town, the District Six Museum is intertwined with the land use campaign, which aims to bring the families forced from their homes back to the area. The approach to telling history and representing it in a museum reflects that agenda. The examples from Mexico and Northern Ireland both use the empowering capacity of exhibitions as identity projects: the Oaxaca project aims to forge community by improving the economic potential of the area and the People's History Initiative uses education to achieve a similar goal. In both cases, these

Figure 11.2 Community exhibition, Lisburn, Northern Ireland, July 2003. This exhibition was developed to mark "Orange Culture Week." Photograph by E. M. Crooke.

agendas will shape how the project emerges and the impact it will have on the community it claims to represent. Although the strength of all the projects lies in the fact that they are led by community members, only external assessment will reveal whether or not the presentations are risking nostalgia, becoming over-simplified, or potentially exclusionary.

Museums and Community Development

It is through this potential contribution of museum and heritage activity to the realization of community empowerment that the cultural sectors have been brought into

Figure 11.3 Community exhibition, Lisburn, Northern Ireland, July 2003. Photograph by E. M. Crooke.

the community development field. Gathering pace over the past decade, museums have now become a means to reach some of the goals of community development, such as encouraging participation of the marginalized and excluded, promotion of opportunities for self-help, and a means to bring about changes that can lead to greater social equality. The reasons why such connections should have arisen are complex and draw on a number of areas, such as how community development is

understood; the changing implementation of community development ideals since the popularization of the idea in the mid-twentieth century; and the more recent approaches to community development. Consideration of this history is a means to explaining the many connections made between museum projects and community issues, which have become such a key area of concern for museums in the past decades. Engagement with this history also emphasizes the importance of continual critique of the community development process and the involvement of the museum and heritage sector within it.

Community has been a central theme in public policy since the promotion of community development ideas in the 1950s and 1960s. At this time, focusing on community development was seen as an opportunity for the state to involve itself with civil society. This approach went on to have an impact on policy development locally, nationally, and internationally. Looking first at global movements, government and non-governmental agencies, both national and international, continue to engage in modernization movements in regions of the world considered less developed and in need of international aid. Since the 1950s, the focus has moved from charity linked to modernization, such as the provision of financial aid, and toward development and reform; for example, supporting the creation of education and health facilities. In comparison, community development taking place within the US, Canada, and many European countries had different priorities, but within these places community development initiatives followed similar trends. Often having its roots in cooperative movements of the early twentieth century, community development in the Western world, by way of societal guidance and social reform, became an essential tool of the welfare state as it emerged in the mid-twentieth century.

In the 1980s, one of the aims of the politics of the "new right," evident in both the US and the UK, was to reduce the role of the state in the marketplace and increase the primacy of the individual through a shift from "state care" to "community care," and to move from a tax system concerned with welfare to one that favored the business sector. The shift to state care involved the dismantling and privatization of the welfare state with greater emphasis on self-help, the voluntary sector, and the community. Increasing community self-help and voluntarism was seen as a means to introduce cost savings to the public sector and to provide community development projects with greater relevancy and sustainability (Campfens 1997). In the 1990s, and more recently, community development has been regarded as a means to address the problems associated with economic and social exclusion. Central to this approach is belief in the role of participation; it is argued that greater involvement of the marginalized and excluded in solving community problems will bring about more effective solutions.

This approach is found expressed in many government policy documents that relate to community development. Policy guidance in both the UK and the US asks museums to foster "social capital." The American Association of Museums (AAM) appealed for museums to "explore an expanded civic role for museums in building social capital and contributing to community life" through community dialogue. In the UK, culture has been referred to as a means to "build social capital." The idea of social capital has come from economic, political, and social science, and its value

is based on the perceived advantage of networks and association within a community and between the community and local and national government. The approach taken by Robert Putnam in *Bowling Alone* (2000), his vastly popular study of the loss of community in America, has been summarized as:

> The social or community cohesion resulting from the existence of local horizontal community networks in the voluntary, state and personal spheres, and the density of networking between these spheres; high levels of civic engagement/participation in these local networks; a positive local identity and a sense of solidarity and equality with other community members; and norms of trust and reciprocal help, support and co-operation. (Campbell 2000: 183)

The museum and heritage sectors have been directly linked in this movement as a means to address the problems linked with social exclusion and other forms of community breakdown. In 2002, the UK Ministerial Report *Building Cohesive Communities* established the UK government's commitment to civil renewal as a response to "deep fracturing of communities on racial, generational and religious lines." To reverse this trend, it advocated "uniting people around a common sense of belonging." In this report, the UK government proposed a multi-layered approach that would involve the improvement of housing, the development of employment opportunities, the enhancement of the role of education, the strengthening of community leadership, a better response to the needs of young people, and a harnessing of the potential of sport and culture as a means of "re-engaging disaffected sections of the community, building shared social capital and grass roots leadership." The report specifically referred to the learning potential of museums as places where cross-cultural themes can be explored.

Such governmental embracing of arts, culture, and heritage as a means of tackling community breakdown has led to direct recognition by museum policy-makers of the sector's potential contribution to community development. The UK Council for Museums, Archives and Libraries (MLA, formerly Resource), for instance, regards museums as a means to enhance community participation. The 2001 strategic plan *Using Museums, Archives and Libraries to Develop a Learning Community* presents museums as places to inspire creativity, stimulate learning, and encourage active participation. Central to this approach is the promotion of learning, rather than education, arguing that the former embraces the broader and more informal approach appropriate to museums. The Council proposes to provide museums with the support that will enable them to develop links with communities in order to empower users, celebrate and reflect diversity, forge new partnerships, and maximize the learning potential of their collections (Resource 2001).

Examples of museums working directly with communities provide evidence of the positive impacts that can be generated by the association. In Scotland, the Methil Heritage Centre was established with the main aim of contributing to the regeneration of the area chiefly through the involvement of the local community in planning and decision-making, in partnerships for creative projects, and by placing exhibitions in community centers (Samuel and Brown 2001). In 1997, Plymouth City

Museum in the south-west of England established links with community groups in order to improve the accountability and accessibility of their work and make a positive contribution to local regeneration initiatives. The creation of a community history group, and the participation of local people as "community curators," has raised participants' awareness of their own skills and potential. The benefits to the museum include a better appreciation of the diversity of the museum audience, greater trust amongst those previously skeptical of the value of museums, and recognition by city managers that museums have a role within the community (Loosemore and Moyle 2001). The examples of the potential relationship between museums and community from the UK discussed here have taken a very deliberate community development approach. Steered by a clear social-policy agenda, generated from central government, the museum sector is falling into line with a movement that is not just having an impact on the arts. Issues of social inclusion, marginalization, and neighborhood renewal are also causing new approaches to be taken in the health, education, and planning sectors.

The AAM has also fostered links between museums and communities according to a similar social agenda. This is demonstrated by the goals of the "Museums in the Life of a City" initiative, which involved museums and community groups in Philadelphia working together so that the museum sector would get a better awareness of its social and educational potential. The goals of this scheme were to improve communications between the museums and the different communities in Philadelphia; to demonstrate that museums can serve diverse and culturally under-represented citizens; to forge new partnerships between museums and communities; and to empower communities and museums to deal with contemporary problems through cooperative strategies (AAM 1995). The Philadelphia scheme was followed in 1998 by the "Museums and Community Initiative," which was regarded as a way of strengthening the relationship between museums and their communities across the US. The initiative was based on the development of community dialogues, which provided an opportunity to re-evaluate the role of museums, establish a means to foster greater community awareness, embracing new values that are more relevant, and forming sustainable collaborative relationships between museums and their communities (AAM 2002).

The examples of how museums have been linked with community in both the UK and American museum sectors contain two strands: one which is asking museums to recognize the diversity of the communities that they must serve, and the second which is attempting to establish museums as social agents that can contribute to the alleviation of social problems. The first strand is concerned with building bridges to new audiences by having more representative collections, practices, and histories within the museum. The second strand is related to a movement that is outside the museum, one that is linked to the priorities of social and public life. Both strands are concerned with the survival of the museum, with a re-evaluation of the purpose of museums and with establishing their relevance.

Conclusion: Revisiting the Museum Idea through Community

Addressing community issues has had an important and valuable impact on the work of museums and on museum studies. Community collaboration has been a means to reach new audiences, build trust, and re-establish the role of museums in contemporary society. The idea of community and community engagement is drawn into the museum sector both through projects that assert local identities and others that foster a social and developmental role. Community involvement with museum services has been promoted as a means to reverse the "once grand and imposing structure" that is the traditional museum. Furthermore, the interest that community groups have shown in developing their own independent museums and exhibitions is an illustration of the importance of self-representation of one's own history as a form of group capacity building and empowerment. Community history, exhibitions, and museums are advocated as a means to move away from the grand narratives of the history of the nation and the state and an opportunity to give voice and authority to those who were formerly excluded.

Engagement with the concept of "community" is prompting the museum sector to revisit the museum space and question its identity, role, and social worth. Encouraging community participation in museum activity is often linked to the idea of democratizing history and the museum space. It is linked with bringing in new voices, new histories, and new people – an approach that is challenging the established authority of the curatorial and research expertise of museum staff. The success of community projects reported in the literature of museum studies is very convincing on the benefits of new participatory relationships. The community participant is bringing new, and often welcome, challenges to the museum sector: through their engagement, museum services have reported becoming more welcome, valued, and relevant.

The value of a thorough investigation of the idea of community is that the process demonstrates that the notion cannot be accepted uncritically. For some, community has not been a positive experience and the emphasis on cherishing, fostering, or recalling it is misplaced. We must investigate the choices that are being made as community is being recalled. As the idea of community development through museums is nurtured, and the links to fostering "social capital" are explored, it is important not to forge a community that bonds itself tightly against those who are perceived as non-members. The complexity of past experiences must be acknowledged, as must the diversity that exists amongst people and within places. If heritage and museums are legitimized as a means to identify and build community, it is essential to ask what sort of community is being forged. Perhaps the history being presented is intimidating to people who think they are part of the community that the initiative claims to represent: they may feel excluded by this new representation or non-members may feel a greater isolation.

A tension exists in the relationship between the museum sector and the level and nature of community involvement. The representation of community histories, just like the creation of any history, must be measured, as new voices will often be just

as partial as the old. Therefore, despite the fact that one of the goals of community involvement is to reverse the hierarchy built into the interpretation and representation of history and identity, it would seem that some form of external intervention or review might still be valid. In addition, as museum professionals begin to engage in forms of community development activity, they have to ask themselves whether the community they are engaging with is representative, whether the community leaders are accepted by the members, and how the balance of authority between the community and museum expert is best struck. Rather than cause us to shy away, the challenges set by such tensions should draw us further into the museum and community debate.

Bibliography

*AAM (American Association of Museums) (1995) *Museums in the Life of a City: Strategies for Community Partnerships*. Washington: American Association of Museums.

— (2002) *Mastering Civic Engagement: A Challenge to Museums*. Washington: American Association of Museums.

Abrahams, S. (2001) A place of sanctuary. In C. Rassool and S. Prosalendis (eds) (2001) *Recalling Community in Cape Town: Creating and Curating the District Six Museum*, pp. 3–4. Cape Town: District Six Museum.

Amit, V. (ed.) (2002) *Realizing Community: Concepts, Social Relationships and Sentiments*. London: Routledge.

Anderson, B. (1991) *Imagined Communities: Reflections on the Origin and Spread of Nationalism*. London: Verso.

Campbell, C. (2000) Social capital and health: contextualizing health promotion within local community networks. In S. Baron, J. Field, and T. Schuller (eds), *Social Capital: Critical Perspectives*, pp. 182–96. Oxford: Oxford University Press.

Campfens, H. (1997) International review of community development. In H. Campfens (ed.), *Community Development around the World: Practice, Theory, Research, Training*, pp. 13–46. London: University of Toronto Press.

Cochrane, A. (1986) Community politics and democracy. In D. Held and C. Pollitt (eds), *New Forms of Democracy*, pp. 51–75. London Sage.

Crooke, E. (2005) The construction of community through heritage in Northern Ireland. In M McCarthy (ed.), *Ireland's Heritages: Critical Perspective on Memory and Identity*, pp. 223–34. Aldershot: Ashgate.

*Delanty, G. (2003) *Community*. London, Routledge.

Dodd, J. and Sandell, R. (2001) *Including Museums: Perspectives on Museums, Galleries and Social Inclusion*. Leicester: Research Centre for Museums and Galleries.

Fredericks, T. (2001) Creating the District Six Museum. In C. Rassool and S. Prosalendis (eds), *Recalling Community in Cape Town: Creating and Curating the District Six Museum*, pp. 13–14. Cape Town: District Six Museum.

Healy, K. (2003) Mobilizing community museum networks in Mexico and beyond. *Grassroots Development: Journal of the Inter-American Foundation*, 24 (1): 15–24.

Le Grange, L. (2001) The collective spirit of the museum. In C. Rassool and S. Prosalendis (eds), *Recalling Community in Cape Town: Creating and Curating the District Six Museum*, pp. 7–8. Cape Town: District Six Museum.

Loosemore, J. and Moyle, N. (2001) Regenerating Plymouth. In J. Dodd and R. Sandell (eds), *Including Museums: Perspectives on Museums, Galleries and Social Inclusion*, pp. 42–5. Leicester: Research Centre for Museums and Galleries.

*Peers, L. and Brown, A. K. (eds) (2003) *Museums and Source Communities*. London: Routledge.

Putnam, R. D. (2000) *Bowling Alone: The Collapse and Revival of American Community*. New York: Simon Schuster.

Rassool, C. and Prosalendis, S. (eds) (2001) *Recalling Community in Cape Town: Creating and Curating the District Six Museum*. Cape Town: District Six Museum.

Resource (2001) *Using Museums, Archives and Libraries to Develop a Learning Community: A Strategic Plan for Action*. London: Resource.

Samuel E. and Brown, K. (2001) Regenerating communities. In J. Dodd and R. Sandell (eds), *Including Museums: Perspectives on Museums, Galleries and Social Inclusion*, pp. 42–4. Leicester: Research Centre for Museums and Galleries.

Re-staging Histories and Identities

Rosmarie Beier-de Haan

In recent decades there has been an international boom in new museums and memorials, many of which are concerned with history and the past, and many of which have been initiated by national or regional governments. There has also been growth in the number of people visiting historical museums and places of remembrance. This turn to the past, or emergence of an "historical culture," is itself related to social change in general and to changing museological paradigms. Museums and history, and especially history museums and historical culture, are intimately intertwined.

In this chapter, I offer a structural explanation for the creation of new history museums and exhibitions, the expansion of visitor interest in the presentation of history, and associated changes in exhibitionary design. Internationally, we can see changes in the ways in which history is staged, and in how societies (nations or smaller collectivities) remember the past. As history always represents both past and present, such changes must be understood as being about the present, and as embedded in continuing cultural practice, as much as about the past (cf. Beier 2000).

Changing Histories, Changing Exhibitions

A history museum today is totally different from a history museum of the nineteenth century or even of the 1950s and 1960s, even though an institution may have retained the same name throughout the period. The changes that history museums have faced, and are still facing, can be best described by looking at changes in the discipline of history itself since the two are mutually dependent. Historiographic developments are reflected in history museums – at least, in the innovative ones.

From the late nineteenth century until the 1970s, international history writing was pervaded by a central conflict. On the one side stood the (conservative) assumption that history is "past politics" – that is, that it deals with kings, ministers, battles, and treaties, with nation-states and their mutual relations. On the other side was a more modern, broader, understanding of history which gave priority to social structure and change, and dealt with social class and stratification. The focus was economic and social history. Over the past thirty years or so, there has been a new shift

toward cultural and micro-history, in which the emphasis is less on facts and more on the description of contexts and emotions, and in which the scientific analysis of sources is accompanied by inspiration, empathy, and understanding. The history workshop movement of the 1970s is one manifestation of this development, as is oral history, which emerged at the same time.

All of these changes are part of a wider crumbling of clear-cut givens. Even the main interpretative categories of the 1970s and 1980s, such as "class," "gender," and "social history," have gradually faded away. In their stead is a patchwork of inter-pretations, points of view, and diversely attributed meanings. This has also led to those who work for and with museums giving more critical consideration to their own constructions of history than they have ever done before. Their questions are: Who owns the past? What gives me authority to speak for others? Who do I include and who do I exclude? Whose memories are privileged, whose fall by the wayside? How can I generalize without ignoring? And how can I mediate between individual memory and the general interpretation of histories?

A set of new critical approaches has emerged in which memory has taken on new significance and there is increased attention to the individual. While these began with the oral history tradition in the 1970s, the individual today is less likely to be taken as a representative of a collective identity (for example, of gender or class). Instead, as sociological theories of individualization suggest (for example, Beck et al. 1994; Beck and Beck-Gernsheim 2002), individuals are understood as having their own distinctive and self-styled perceptions of history. Freed from given definitions and interpretational frameworks, individual subjects seek to assert their right to see things and history in their own way.

In history museums, these changes are reflected in a shift from displaying grand histories of nation-states to focusing on everyday themes, experiences, and memo-ries. Topics covered have ranged from working-class life to women's recollections of war, flight, or expulsion, to the history of the human body, health and hygiene, and death. Forty years ago, none of these would have been seen as properly part of "history." The same is the case for the focus on individual life experiences and per-sonal memories. Autobiographical documents and personal testimonies (for example, on video) have become a staple of modern exhibitions, and are also an important part of allowing for multiple interpretations rather than a single authoritative account of the past. Accompanying these changes in forms of display has also been a move toward using visitor questionnaires and surveys to harness individual opinions and to evaluate exhibitions from the perspective of their audiences (see chapter 22).

Beyond National Histories

While, in the early modern period, history was typically understood as universal, from the late eighteenth century, alongside the formation of the nation-state, this conception came to be increasingly replaced by an understanding of history as national history. Thus a secular *Heilsgeschichte*, or salvation history, replaced a uni-versal story of apocalypse and non-secular expectations of salvation. While this national-secular salvation history also contained a future-oriented vision, this was

not universally shared but was tied to the nation-state, the experiential venue (the nation-state), and the expectational space (progress) being conceptualized as identical.

Over the past thirty years or so, however, this acceptance of the nation-state as a key locus of experience and expectation has been dissolving. Globalization has rendered national futures uncertain, so weakening the connection between national pasts and the future. It can neither be assumed that past and present will merely be reproduced in the future, nor that the nation-state will continue to provide the framework for social relations. If the future will be structured less and less according to the present model of the past, then the seamlessness of past and future will be lost. If the boundaries of the nation-state can no longer be asserted as a firmly established unit of meaning for a territory, a people, or economic and political action, then spatial continuity will disappear with respect to both populace and the formation of identity.

According to German sociologist Ulrich Beck (1997), what we see emerging is a "world society," characterized by everything that distinguishes people – religious, cultural, and political differences – being present in a single location, a single city, and, increasingly, even within a single family or life story. The "ubiquity of world differences and world problems," according to Beck, is the exact opposite of the "convergence myth," according to which all cultures are becoming more and more the same. "World society" is shorthand for a multiple-world society – a multiplicity without unity. According to such a view, globalization causes not the leveling out of differences but an accumulation of diverse perspectives. The local persists in a complex interaction with the global (as also theorized in Robertson's notion of "glocalization" [1992]).

If it is true that nation-states lose significance in a globalized world, then this should be reflected in how history museums view themselves, and should be especially evident in newly established museums. What is shown by the following examples of state-of-the-art museum projects in New Zealand, Germany, and South Africa is a tendency to present polyvalent or non-national identities (though not ones entirely free of cultural origins). What is also shown is that all three share the goal of intensifying acceptance of the diversity of cultures and identities, and of reinforcing weaker identities.

Te Papa, New Zealand

The Te Papa Tongarewa National Museum of New Zealand, which evolved out of a nineteenth-century colonial museum, reopened in 1998 in Wellington, the capital of New Zealand. The spectacular new exhibition building demonstrates not just the totally redesigned museum, but also a change in how it sees its role and place in present-day New Zealand society. With its state-of-the-art technology and didactics (*Time Warp Blastback and Future Rush*), the museum aims to make it possible to experience the heritage of New Zealand's cultures as the diversified cultural past and present of the country. There are long-term exhibitions devoted to indigenous culture, such as *Made in New Zealand: Art and Identity* and *Mana Whenua*, which is "an exploration and celebration of Maori as the *tengata whenua* [people of the

land] of Aoteaora New Zealand." The *Passports* exhibition is about "journeys and arrivals": "A thousand years of people leaving home to come here. Now, concentrating on the nineteenth century and onwards, you can meet the immigrants. Who were they? What did they bring? What did they leave behind? How would you fare?"

Te Papa does not view itself as an institution standing above history, the present, and the people, according to one of its founders, Ken Gorbey (2001). The museum does not want to prescribe a standpoint; instead, it aims to bring out the heterogeneity of perspectives; it seeks not to judge and direct, but to identify and allow "bipolarity." This is based on a view of cultures that sees them as influencing and enriching one another without judging and offsetting each other. It dismantles the ethnographic view of what is considered foreign and underscores the absorption of the achievements of indigenous cultures in the present.

Glocalization is taken as given in the conception of Te Papa's exhibitions as reflecting the fact that New Zealand is based on the many different immigrant and indigenous cultures. The histories of immigrants and indigenes are mixed together; and "national consciousness" is understood as the accumulation of these. The museum thus "becomes a model for experiencing life outside its walls" (Kirshenblatt-Gimblett 1991: 410) – a world whose identity is no longer based on an exclusive nationalism, but is characterized by the fundamental idea of unity through multiplicity.

Te Papa and other museums established in similar contexts (the National Museum of Australia in Canberra, for example) are instances of a type of museum that has rejected colonial nationalism. They replace the idea of the nation-state with an emphasis on the formation of a national consciousness, and can be seen as exemplars of national glocalization rather than as general manifestations of globalization. They bring together different ethnicities and cultural traditions, and demand cultural polyvalence and transculturalism. Nationalisms are, therefore, still given significance as forces of integration and reconciliation.

The German Historical Museum

The German Historical Museum in Berlin was founded in West Germany in 1987 with the goal of presenting German history within European and international contexts (cf. Stölzl 1988). It was to be neither a "holy place" nor an "identification factory," aiming instead to foster education and understanding in the treatment of shared history. Not only do transnational references allow different perspectives to exist, they virtually require them in order to achieve proper understanding. The exhibitions thus aim to promote understanding of disparate positions of consciousness and cultural limits. To this end, the museum's numerous special exhibitions since German reunification in 1990 have attempted to highlight both global connections and differences. For example, *Myths of the Nations* (1998) explored the fact that, since the fall of the Iron Curtain and the collapse of the postwar order, people have increasingly questioned what their own country actually represents within the European context. The question of the constituent elements of the nation touches not only on politics and economy, but also, and above all, on history.

Rosmarie Beier-de Haan

The German Historical Museum is the museum of a country that can look back on an extremely varied national history at the center of European cultural tradition and the development of fundamental science, technology, and economy. The decades in which there were two Germanys caused a profound break in this nation's national, political, and cultural history. The way in which this is treated in the new German Historical Museum supports the notion of the dwindling significance of the nation-state. It sees the disintegration of the nation-state not as having taken place only in recent decades, but presents the boundaries as disintegrating over a far longer period of time. It also aims to show that the process of European unification has already been underway for a long time in cultural as well as legal and economic areas. By highlighting the mobility of people in Europe, which developed centuries ago, as well as common traditions, the museum also serves an identity-forming function.

The German Historical Museum seeks to assist people in their search for an historically informed identity by providing objects, interpretations, and orientation. While interpretations of (national) identity are understood as diverse, this diversity is not understood so much as global as transnational or European. To that extent, it can be said that the German Historical Museum attempts to view the nation-state as a system that has always been watered-down by transnational references and influences. References to other (European) countries are interrelated and structured variously, depending on the subject area, be it art, the economy, law, philosophy, or the history of migration. This is not about the idea of a "melting pot" and the integration of many different ethnic groups, as at Te Papa, but is about a search for the roots of relationships. The presentation of the historical evolution of transnational relations is intended to support an understanding of community above and beyond persisting national borders.

Robben Island Museum, South Africa

My third example is from South Africa, a country that is in the process of constituting itself as a nation based on equality (see chapter 29). Since the end of apartheid, South Africa's political focus has been on the formation of a strong national identity and the creation of a consciousness of being a united nation that has freed itself from repression, oppression, and inequality. According to Metz (1996: 131), institutional changes have been imperative in order to build a foundation for democracy and achieve lasting peace and social and economic stability. This also applies to museums: "museums are there for the people, and their principal mission is to aid in the protection and sustainable utilisation of our country's natural and cultural heritage" (Küsel et al. 1994: 1).

In particular, the new Robben Island Museum, the "hell-hole" (Diamini 1984) of oppression during the apartheid regime, has taken on an important role in acting as "a landmark . . . in our ever unfolding history" (Metz 1996: 135). The Robben Island Museum received its millionth visitor in 2001, the same year that it inaugurated a new museum building, the Nelson Mandela Gateway, in the port of Capetown. The visitor center is housed in the former x-ray room at the small harbor, where metal detectors scanned newcomers for weapons and explosive materials. A number of different tours are offered on the island, including the "Mandela Footsteps Tour,"

"Living Legacy Experience," "Cell Stories Exhibition," and "Smuggled Cameras Exhibitions." These are supplemented by reports by former inmates. By taking such a tour, visitors may directly experience Robben Island's narrative of "the triumph of the human spirit over enormous hardship and adversity" and its symbolic message that in "a world still troubled by division, social injustice and intolerance, [there is] hope for the future" (Robben Island Museum 2000: 5).

The conceptions of South African museums are different from Te Papa's proclamation of the importance of the interaction and equal rights of the many cultures in the country. Even more so than in New Zealand, equal status in South Africa is not yet a fact but the ultimate goal. The end of apartheid is still too recent for individuals to embark on a search for identity on their own. While the new museums of the Pacific can be relatively relaxed regarding the constitution of national unity, and can just present a desire for further communication, South Africa favors the promotion of a strong, uniform national consciousness. This is constituted through the story of liberation, the creation of a national constitution, and remembrance of the resistance. It is also performed with urgency as part of South Africa's search for an identity.

At the same time, however, the new museums in South Africa have a clear goal of reaching out internationally, not just to celebrate South Africa as a new nation, but to highlight its exemplary path from apartheid to democracy. South African museums, such as the Robben Island Museum, display attempts to gain liberation from political repression and oppression. By telling their own story, these museums aspire to become an international model.

These three examples show differences as well as common ground. There are clear differences in their level of focus. The Te Papa museum is focused on the national level while redefining the notion of nation. The German Historical Museum is attempting to shift the national idea into a transnational context, but without placing it in a global context. Museums in South Africa are seeking a context for their influence on both national and global levels. All three share a framework of national change and search for new transpersonal identities above and beyond those of ethnicity. Despite their different focuses, and the different paths that they have taken, they share a common desire to promote unity.

History and the Staging of History

Whereas the study of history is dominated by written materials, that is, by textuality, museums are shaped by a fundamentally different presentational mode. Daniel J. Sherman (1995) has shown that the "founding fiction" of the institution of museums is based on an "archeological epistemology." An extant artifact is both an original and a fragment, and the combination of fragments in an exhibition or a room in a museum is based on the premise that these fragments or remnants do not stand only for themselves, but are historically significant in the sense that they can create a coherent representational universe. The museum requires the artifacts it displays at once to be original and collectively to explain the meaning of a larger history. In traditional exhibitions, it is the texts that then create connections between the rudi-

mentary objects. They create the contexts, allowing something to appear as a whole even if only fragmented objects from the past are known. Such a procedure can be successful only if the objects are showcased, as it were, along the linear patterns of a text, appearing one after another like an illustrated commentary on the text.

The practice of displaying objects in showcases along with written information ceased to be the almost ubiquitous means of presentation about thirty years ago. This is connected with the fact that scholars no longer have a monopoly on determining how something is to be interpreted, and with increased acceptance of experience-based interpretations and the idea that views of reality are individual and context-dependent. In any case, historical presentations everywhere run into difficulties if they assume that they are merely presenting facts and doing nothing more than simply displaying objects. In the days when objects were deemed to speak for themselves, it might have sufficed to place them in a showcase or hang them on the wall to be seen by the viewers. If ways of understanding the world are subjective and means of processing experience are varied, however, then this approach is inadequate.

To make an exhibition attractive to museum-goers, it is as insufficient to just open up objects to different perceptions and try to evoke different ways of looking at them as it is to contextualize them exclusively through comments made by historians. Sherman (1995) interprets the interrelations of objects and sustaining fictions as possibilities for a different, more interrogative, approach, thereby suggesting that the dialogics and interrelations are not given but in flux. Even so, this still does not sufficiently explain the meaning of the new forms of staged presentation of objects of the past two decades or so.

The significance of such new, and often elaborate, forms of presentation only becomes fully evident when one views not the individual exhibition objects but the ensemble of exhibited objects as a whole. Even traditional museums attempted to convey meanings through their spatial organization and arrangements of objects:

> many nineteenth-century museums . . . had central atria, surrounded by viewing galleries, and the galleries themselves tended to be designed so as to provide a long, clear, well-ordered vista. Such a "world as exhibition" gaze, as exhibitions exemplified and offered up . . . was crucial to modern Western notions of objectivity and reality – notions which meant being able to think of properly informed looking as a "separation from an external object-world . . . mediated by a non-material plan or structure" ([Mitchell,] 1988, p. 21) . . . Particularly important among the "ways of seeing" suggested by the museum is what Timothy Mitchell (borrowing from Heidegger) calls the "world as picture" or "world as exhibition." This "way of seeing" crystallised in the nineteenth century (Mitchell, 1988, pp. 18–23). It entailed a detachment of the viewer – thinking of themselves as outside or above that which was represented. This was coupled with the idea that there was an "'imaginary structure' that exists before and apart from something called 'external reality'" (Mitchell, 1988, p. 21) and that it was possible to find external viewing positions from which the world would appear as ordered and complete. (Macdonald 2003: 3–4)

It is precisely this positioning of the viewer as a detached observer that has been abandoned in the new ways of staging exhibitions. Viewers are now drawn into the

ensemble of exhibited objects, no longer able to assume the position of detached museum-goers hovering above or outside the exhibition. The viewers and their potential perceptions are now taken into account; they become part of the ensemble and are challenged to express their own perceptions, judgments, and emotions.

This can be best illustrated by exhibitions that seek merely to *stage* a theme – without authentic objects and without extensive written panels. This can be exemplified by the exhibition *Prometheus: Humans – Images – Visions* (1988–9).

The *Prometheus* exhibition was European in scope but had even further ramifications. In 1998 it was shown in Saarland (Germany), the tri-country corner of Germany, France, and Luxembourg, where almost 200,000 viewers attended over the course of only a few months. A year later it traveled to Tel Aviv. The exhibition title was to be understood programmatically. Prometheus, according to mythology, bestowed the gift of fire upon humans, and taught them art and science. Humanity itself has since become Prometheus, according to the exhibition. Humanity creates itself in its own image. Of and by themselves, people keep creating new ideas of beauty and grace, of what comprises a good person, of heroes and bravery, of community and equality. The *Prometheus* exhibition focused on the changes – as well as the constancy – in humanity's major self-images and ideals. It dealt with a broad spectrum of subjects, starting with questions about the nature of beauty, how one becomes a good Christian, what a hero is, and ideal images of love and happiness, and also considering attempts to outwit death and create an "artificial person" (cf. Beier 1998; Schaal 1999).

The exhibition was held at the Völklingen steelworks near Saarbrücken (UNESCO World Cultural Heritage Site) in the nineteenth-century blast furnace building which covers almost 65,000 sq. ft. The building, with its enormous dimensions and huge flywheels, was an ideal venue for the *Prometheus* exhibition, since it was itself a Promethean site in that traces of the domination of nature, converting natural resources into iron and steel, could still be felt. Large reproductions and multimedia installations were displayed, offering an appropriate and vivid visualization of the exhibition subject. By going beyond traditional, art history scales, people's visions of themselves were afforded more space and given form through blow-ups, photographs, computer-generated images, slides, films, and reproductions.

The exhibition was intended to offer an *open* vision of the many Promethean images and opinions that people need, desire, or confront. Its focus was on the human body as the site at which such visions and ideals often consolidate. Sometimes the body was considered literally, sometimes more metaphorically. *Prometheus* was thus not a socio-historical exhibition that compared images and reality; instead, it was an attempt to gain anthropological insight into social and iconographic processes that the human body has been through over the past five hundred years. The exhibition's complex cosmos of pictures informed visitors of the historicity of human self-images as well as how they could be changed and formed. Gender was presented as a concept and the body as culturally constructed. These ideas of construction and change were also supported by the mix of media and lack of originals.

The *Prometheus* exhibition sought to involve visitors by prompting them to ask themselves about their own perspectives. For example, in a section on "heroes" (called the "Hero Construction Site" and replete with scaffolding and other build-

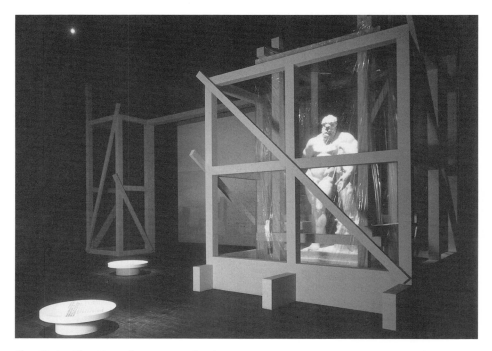

Fig. 12.1 The Hercules Farnese in the "Hero Construction Site" section of the exhibition *Prometheus: Humans – Images – Visions*, held at the Völklingen steelworks near Saarbrücken, 1988–9. Photograph by Reinhard Görner, Berlin.

ing materials representing human "construction"), the Hercules Farnese filled the center of the room (fig. 12.1). This 3-m high copy of the colossal Roman statue was one of the few borrowed objects in the exhibition. Hercules, a demi-god symbolizing power and strength, stood, surrounded by scaffolding and partly concealed by a plastic drop cloth. This was an image saying that heroes today are not what they once were. But who is a hero? What is a hero? Do we even need heroes? These and other questions were written on white sitting-stones arranged around the Hercules figure. If an exhibition is "a suggested way of seeing the world" (Macdonald 1996: 14), the *Prometheus* exhibition made its suggestions through large-scale materials, objects, and examples of how the human body has been variously understood over several centuries. Viewers were offered pictures and scenes that they could add to their own pictures and memories. Moreover, the exhibition acted as a theater in which the visitors were invited to participate in the performance. They wandered over bridges between the objects, they immersed themselves in media of the present or recent past, and, in effect, they "staged" themselves. This had the effect of prompting the visitors to locate themselves and their identities in relation to that displayed, and to see themselves as part of the performance, without denying their subjectivity.

As all of these examples illustrate, since the 1980s there have been changes in exhibition culture such that exhibitions can no longer be understood merely as the

rational scientific presentation of a single worldview. The new forms of display are more open and ambiguous. Abandoning the monopoly of a structure based on a traditional scholarly discourse, exhibitions such as these allow new possibilities through the way in which they are staged. Objects and documents are arranged and mounted in such a way that multiple references between the displayed objects – and thus many histories – become possible. The forms of presentation – and the strong emphasis on presentation itself – add metaphorical layers of meaning. Pictures and other media are not to be understood as ornamental accessories but as prompts to try out unexpected new ways of seeing and to imagine a topic without necessitating a discursive account.

Conclusions

My opening thesis assumed a contradiction between accelerated social change and growing insecurity regarding the future in a globalized world, on the one hand, and a growing interest in history museums and historical exhibitions, on the other. What conclusions can now be drawn?

The idea mentioned at the outset, that the significance of nation-states diminishes with globalization and that this has repercussions on the national character of museums, can be confirmed only to a limited degree, as illustrated by the cases discussed here and numerous other prominent history museums (cf. Beier 2005), as well as examples elsewhere in this volume. Of course, not all commentators agree that the nation-state is dwindling in significance. While the view that the nation-state is disappearing is very popular and even promoted by some European museums, it is not often so by museums in newer nation-states (see chapter 10). The presentation of recent history is not so much characterized by "glocalization" as by the much more prevalent notion that mixing histories is an appropriate presentation principle. Moreover, with respect to the (self-)placement of individuals within their history, there is no uniform picture. While some museums tend to support a postmodern formation of identity, in which a national ethos is no longer propagated, others are inspired by the idea of creating a uniform ethos.

It nevertheless appears to be the case that innovative museums today are thinking about nations in a new way – no longer as a category of national law and an interplay of self-sufficient nation-states, but as spheres of communication, of coexistence, of multivalence. It would, therefore, be inappropriate to claim that museums have left the notion of the nation behind. Multiple connections and overlappings of nation, identity, and museum continue to exist.

Historical museums and modern historical exhibitions hardly view their subjects and themselves within the scope of a globalized world. They tend instead to give meaning within "glocal" contexts, without being nationalist. The task of historical museums and exhibitions to "make meaningful" – *Sinnstiften* – has taken on added significance in a world of accelerated change and uncertainty about the future, as philosopher Hermann Lübbe (1992) recognized some time ago. He argued that accelerated social change means that individuals experience the present as of a shorter duration, and that this is necessarily connected with a growing interest in the past.

Knowing (one's own) history – confirming one's own "roots" – helps absorb uncertainty, and it makes the negative sides of individualization (that is, a lack of ties, loss of home and shared experience, and so on) more tolerable. While new, innovative exhibitions can be said to confront individualization, they do not eschew a common memory culture. On the contrary, exhibitions act as events that create common ground in an individualized world. This takes Hermann Lübbe's ideas a step further. Historical exhibitions are not only compelling because they compensate for uncertainty, they serve at the same time to restore shared memory. At least, they may do so if, as is presently the case, they take potential visitors and their possible views of the subject matter and of history into account when preparing and implementing themes and when presenting exhibition objects. In this way, exhibitions create common ground in a world filled with insecurity, uncertainty, and "patchwork" identities (cf. Keupp et al. 1999).

This creation of commonality is not, however, achieved normatively. This is not possible in modern exhibitions because they deploy the subjective – the emotions and wonder of the visitor. They do so, however, without necessarily eschewing the idea of knowledge altogether. At the same time, they cease to be aimed exclusively at educating the audience. Part of the leisure industry, their aim is to provide an "experience" as much as an opportunity to learn.

To be sure, exhibitions today do not abandon all sense of ordering, or all ordering narratives, even if they allow for diverse forms of narratives. It is precisely the presentation of some kind of ordering, which requires contemplation, that accounts for the power and compelling nature of modern exhibitions. It follows that they do not just offer up a range of entirely re-combinable elements of identity, even if they demand that the individual finally takes on much of the work of sorting through them and making sense. Strongly staged exhibitions, such as those discussed here, involve intensive work to stabilize or modify identities, and to even create them anew – but they do not destroy identities or do away with them altogether.

Translated by Allison Brown

Bibliography

*Beck, U. (ed.) (1997) *Perspektiven der Weltgesellschaft* [Perspectives on Global Society]. Frankfurt am Main: Suhrkamp.

— and Beck-Gernsheim, E. (2002) *Individualization: Institutionalized Individualism and its Social and Political Consequences*. London: Sage.

—, Giddens, A., and Lash, S. (1994) *Reflexive Modernization: Politics, Tradition and Aesthetics in the Modern Social Order*. Cambridge: Polity Press.

Beier (–de Haan), R. (ed.) (1998) *Prometheus: Menschen – Bilder – Visionen: Ausstellungskatalog* [Prometheus: Humans – Images – Visions: Exhibition Catalogue]. Berlin: Deutsches Historisches Museum.

*— (ed.) (2000) *Geschichtskultur in der Zweiten Moderne* [Historical Culture/Culture of History in the Second Modern Age]. Frankfurt am Main: Campus.

— (2005) *Erinnerte Geschichte – Inszenierte Geschichte: Museen und Ausstellungen in der Zweiten Moderne* [Remembering History – Displaying History: Museums and Exhibitions in the Second Modern Age]. Frankfurt am Main: Suhrkamp (Edition Zweite Moderne).

Boswell, D. and Evans, J. (1999) *Representing the Nation: Histories, Heritage and Museums.* London: Routledge.

Burke, P. (2000) *Kultureller Austausch* [Cultural Exchange]. Frankfurt am.Main: Suhrkamp.

Cheah, P. and Robbins, B. (eds) (1998) *Cosmopolitics: Thinking and Feeling beyond the Nation.* Minneapolis, MN: University of Minnesota Press.

Diamini, M. (1984) *Hell-hole Robben Island.* Trenton: Africa World Press.

Gorbey, K. C. (2001) Development, premises and mission [*Entstehung, Selbstverständnis und Ziele*] of Te Papa Tongarewa National Museum of New Zealand. Unpublished presentation given at the Deutsches Historisches Museum, Berlin, January 22.

Keupp, H., Ahbe, T., and Gmür, W. (1999) *Identitätskonstruktionen: Das Patchwork der Identitäten in der Spätmoderne* [Constructions of Identity: The Patchwork of Identities in Late Modern Times]. Reinbek: Rowohlt.

Kirshenblatt-Gimblett, B. (1991) Objects of ethnography. In I. Karp and S. D. Lavine (eds), *Exhibiting Cultures: The Poetics and Politics of Museum Display*, pp. 386–443. Washington, DC: Smithsonian Institution Press.

Küsel, Udo S., et al. (1994) Revitalising the nation's heritage: a discussion document on the involvement of South African museums in the reconstruction and development programme (RDP). Unpublished paper presented at the South African Museums Association Conference, Willem Prinsloo Agricultural Museum.

*Lübbe, H. (1992) *Im Zug der Zeit: Verkürzter Aufenthalt in der Gegenwart* [In Time's Way: A Brief Stay in the Present]. Berlin: Springer.

*Macdonald, S. J. (1996) Theorizing Museums: an introduction. In S. J. Macdonald and G. Fyfe (eds), *Theorizing Museums: Representing Identity and Diversity in a Changing World*, pp. 1–18. Oxford: Blackwell.

— (2003) Museums, national, postnational and transcultural identities. *Museum and Society*, 1: 1–16.

*McIntyre, D. and Wehner, K. (eds) (2001) *National Museums: Negotiating Histories.* Canberra: National Museum of Australia.

Metz, G. (1996) Museums after the end of the Cold War: South Africa and the new frontier. In H-M. Hinz (ed.), *Museen nach dem Ende des Kalten Krieges*, pp. 130–36. Berlin: Deutsches Historisches Museum.

Mitchell, T. (1988) *Colonizing Egypt.* Cambridge: Cambridge University Press.

Museum of New Zealand Te Papa Tongarewa (ed.) (1998) *Te Papa: Statement of Intent.* Wellington: Museum of New Zealand Te Papa Tongarewa.

Robben Island Museum (2000) *Visitor Information.* Cape Town: Robben Island Museum.

Robertson, R. (1992) *Globalization: Social Theory and Global Culture.* London: Sage.

Schaal, H. D. (1999) *In-between: Exhibition Architecture.* Stuttgart: Edition Axel Menges.

Sherman, D. J. (1995) Objects of memory: history and narrative in French war museums. *French Historical Studies*, 19: 49–74.

Stölzl, C. (ed.) (1988) *Deutsches Historisches Museum: Ideen – Kontroversen – Perspektiven* [The German Historical Museum. Ideas – Controversies – Perspectives]. Berlin: Propyläen.

Web sources

www.dhm.de (accessed July 27, 2004).

www.robben–island.org.za (accessed July 27, 2004).

www.tepapa.govt.nz (accessed July 27, 2004).

Heritage

Steven Hoelscher

Among the innumerable tragedies of the 2003 United States-led coalition invasion of Iraq, the widespread destruction and looting of the country's antiquities took many by surprise. Certainly, the US armed personnel stationed in Baghdad seemed to have been caught off guard: on April 10, one day after Saddam Hussein's regime collapsed and Baghdad found itself in the hands of US military forces, Iraq's National Museum of Antiquities was ransacked. In just a few hours, hundreds of Iraqis – some of whom were later determined to be working for art dealers outside the country – streamed into the museum that for years had been closed to the public. Two days of looting left thousands of the museum's estimated 170,000 artifacts either damaged or stolen, *The New York Times* reported on April 13, 2003. Statues were beheaded to make them easier to carry away. Ancient vases were shattered. Irreplaceable items – Sumerian clay pots, Assyrian marble carvings, Babylonian statues, clay tablets with cuneiform writing – disappeared under the eye of the military (fig. 13.1). "Our heritage is finished," mourned Nabhal Amin, a former museum curator, as she surveyed the destruction. "It feels like all my family had died."

Nabhal Amin was not alone in her despair; within days of the looting, citizens from around the world voiced outrage at what came to be seen as a preventable calamity. Scholars in a variety of fields and across the globe delivered petitions to the United Nations requesting that the US-Allied military command protect Iraq's museums and cultural monuments. The United Nations Educational, Scientific, and Cultural Organization (UNESCO) responded quickly with emergency meetings to prepare preliminary evaluations of the country's museums, archives, and libraries, and to make recommendations to "safeguard Iraq's cultural heritage." And in the United States, representatives of sixteen heritage organizations hastily called special meetings of an expanded Heritage Emergency National Task Force "to discuss what united actions the American heritage community should take." Specific concerns varied from the role that such artifacts could play in the return of tourism and the building of a viable economic future in Iraq to the fear that allowing such destruction might further inflame resentment and anger throughout the world, particularly in the Middle East. Some anxiety was backward looking, to the five thousand years represented by the stolen or damaged artifacts, while others specifically lamented the loss to future generations. For some commentators, the destruc-

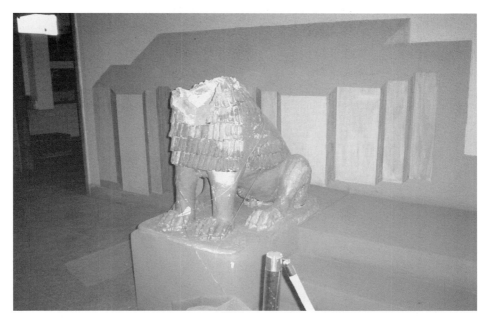

Figure 13.1 Baghdad Museum, May 2003. Photograph by Corine Wegener.

tion was to no less than "human civilization," but for others, the loss was national in scope.

For its part, the Bush administration dismissed such worries as overwrought. "Freedom's untidy," observed US Defense Secretary Donald H. Rumsfeld in the immediate wake of the museum's ransacking. "And free people are free to make mistakes and commit crimes." Such comments, and the more general failure of American troops to prevent the destruction, served to breed anger and frustration among Iraqis already deeply suspicious of US motives for occupying their country. "A country's identity, its value and civilization, resides in its heritage," countered Raid Abjul Ridhar Muhammad, an Iraqi archaeologist, one day after Rumsfeld's casual statement. "If a country's civilization is looted, as ours has been here, its history ends. Please tell this to President Bush. Please remind him that he promises to liberate the Iraqi people, but that this is not liberation, this is a humiliation" (*The New York Times*, April 12 and 13, 2003).

The comments of Nabhal Amin, Donald Rumsfeld, and Raid Abjul Ridhar Muhammad each point, in very different ways, toward an unmistakable fact: for some, the destroyed items were of far less importance than Iraq's oil reserves, but for those who cherished them, the broken pottery shards and stolen tablets from Iraq's National Museum represented more than just dusty objects from a forgotten past. They were alive with emotion, tension, and profound feelings. They were at once local and global in nature. They were family and nation. They offered a connection to ancestors and an avenue to the future. For those who cared for them and who knew their secrets, they were the most precious things in the world, while for

others they were expendable casualties – the collateral damage – of a larger cause. They were, in short, the stuff of heritage.

One of the defining elements of the contemporary world, heritage is a mode of understanding and utilizing the past that is, at its very core, deeply partisan and intensely felt. It is the source of vital economic revenue, and a foundation of personal and collective identity. Heritage plays a role in justifications of national and ethnic conflicts, in debates over genetic engineering, and in the creation of historic districts. And it is everywhere, not just in national history museums, but also along city streets, inside nature preserves, on genealogy charts, and at festivals. Over the past three decades, such domestications of the past have expanded from the pastime of a small elite concerned with inheritance to a major international phenomenon. With its ascendancy, "the heritage industry" enjoys both proponents and detractors. To its critics, heritage represents not only "bad history" but also the basis of ethnic turmoil from Northern Ireland to Israel, while advocates see it as the root and substance of long-neglected identities. The past might be a foreign country, an alien and exotic realm where people lived differently, but, as David Lowenthal (1998: xv) has argued, "probably most people, most of the time, view the past not as a foreign but a deeply domestic realm."

In this deeply domestic realm reside the concerns of heritage, concerns that are central to the constitution of the museum, but that inevitably spill beyond its confines. Providing an outline of some of those concerns is the primary aim of this chapter and I do this in several ways. First, I describe the growth of heritage in recent decades, and suggest a number of reasons for its striking popularity. I then assess seven key features and premises of contemporary heritage. I conclude the discussion by looking at two examples in more detail which, when taken together, suggest something of the scope, utility, and importance of this heavily freighted concept.

The Rise of Heritage as a Global and Local Phenomenon

Heritage, despite its appearance of age, is actually something quite new. Barbara Kirshenblatt-Gimblett (1998: 7) describes heritage as "a mode of cultural production in the present that has recourse to the past," as a specific way of interpreting and utilizing bygone times that links individuals with a larger collective. Certainly, heritage as a form of inheritance – as property bequeathed from an heir – has a much longer lineage. Prehistoric peoples bestowed possessions on their offspring, and like-terms such as patrimony, birthright, and inheritance evoke the idea of heritage as legacy: "something transmitted by or acquired from a predecessor," as Merriam-Webster puts it. However, what we today call "heritage" is something rather different, and more a product of a self-conscious kindling and celebration of the past than a genetic bequeathal.

If, a half-century ago, heritage connoted heredity and the transferal of possessions, today it includes roots, identity, and sense of place and belonging. In the United Kingdom, Raphael Samuel (1994) identifies the 1960s with the "historicist turn in national life," as the beginning of this shift. It was then that the "museums movement got underway, and that projects for 'folk' museums, or 'industrial parks,'

were widely adopted by county and municipal authorities." Institutionalization soon followed in the next decades, often with attendant privatization of the heritage/museum industry.

This general periodization holds true for most industrial countries, although the specifics may vary. In Quebec, for example, the Cultural Properties Act of 1972 had the effect of institutionalizing heritage preservation. In the United States, the National Historic Preservation Act of 1966 created the National Register of Historic Places as that country's official list of cultural resources worthy of preservation (Handler 1988: 184; Wallace 1996: 190). In the United Kingdom, the National Heritage Acts of the 1980s consolidated several decades of conservation efforts. To be sure, the heritage impulse long predates these years. With the creation of Yellowstone National Park in 1872, and Sequoia, King's Canyon, and Yosemite Parks two decades later in the United States, and the National Trust at roughly the same time in Britain, precedents were set for the preservation of natural landscapes and historic buildings as national heritage. Still, the phenomenal growth in the number of museums, historic properties, and conservation zones during the past four decades far outpaces anything before it.

Everyone and every place, it is well agreed, has a heritage worth preserving, and preserve it we do. In Germany alone, there are over 6,000 museums, the vast majority of which are of recent origin (Auswärtiges Amt Deutschland 2004), while in the United States, the number of properties on the National Register rose from 1,200 in 1968 to 37,000 in 1985 and to 77,000 in 2004 (Frieden and Sagalyn 1989: 201; National Park Service 2004). During the 1970s and 1980s, the number of authorized genealogists in France grew from 300 to 20,000, and, worldwide, 95 percent of existing museums postdate World War II (Lowenthal 1998: 3, 16).

But it is not just sheer numbers that characterizes the ascendancy of heritage. The scope of what is deemed worth preserving has also expanded dramatically, extending now to environments, artifacts, and activities that, in the past, would have been considered beyond the scope of historical attention. Samuel (1994: 160) goes on to explain that the version of the past that today is seen as "heritage" is "inconceivably more democratic than early ones, offering more points of access to 'ordinary people,' and a wider form of belonging." Examples of heritage's inflation abound. In celebration of their city's bicentennial in 1989, residents of Cincinnati, Ohio, chose to nurture their industrial past with the construction of four winged pigs atop a suspension bridge, giving concrete testimony to its once scorned nickname, Porkopolis. The Auschwitz-Birkenau State Museum, once the most deadly of all Nazi death camps, is today Poland's most popular tourist attraction, attracting nearly 250,000 visitors every year. Irish genealogists visit Salt Lake City's Family History Research Center, Ellis Island Museum in New York Harbor, and Genealogy.com in search of ancestral roots. And from the cultural landscape of Afghanistan's Bamiyan Valley to Zimbabwe's Khami Ruins, countries everywhere are working with UNESCO to designate and protect specific properties as World Heritage Sites.

Now an indisputably global phenomenon – a majority of the twenty-five sites added to UNESCO's World Heritage List in 2003 came from regions outside North America and Europe – heritage nonetheless might best be seen as Western in character. Certainly, the language that suffuses heritage bears the traces of its origins in

industrial society. Identifying, conserving, and protecting "the world's superb natural and scenic areas and historic properties for the present and the future of the entire world citizenry" forms the core of the World Heritage Convention and dates to a 1965 White House Conference in Washington, DC, that called for a World Heritage Trust (UNESCO 2004). Beyond the official realm of the United Nations, multinational corporations based in New York, London, and Cologne, finance and guide restoration projects giving heritage sites the world over a similar feel, and bearing the stamp of their Western origins.

That is not to say that nurturing a shared past means the same thing everywhere, as even translations of "heritage" carry significant nuances. In French, the word *patrimoine* means something more personal than the English *heritage*, while in German, *Erbe* connotes a meaning more patriotic than the Italian *iàscito*. Moreover, as David Lowenthal (1998: 4–6) notes, the specific reasons frequently given for the rise of heritage vary geographically: "Heritage in Britain is said to reflect nostalgia for imperial self esteem and other bygone benisons, in America to requite economic and social angst and lost community, in France to redress wartime disgrace, in Australia to replace the curse of recency to forge indigenous pride." Nonetheless, the concerns of heritage are so global in scope that no explanations specific to one group can adequately account for so infectious a trend. At root, Lowenthal (1998: 16) argues, the bewildering speed and scale of change in every aspect of life during the mid- to late-twentieth century produced the seeds of contemporary heritage: "beleaguered by loss and change, we keep our bearings only by clinging to remnants of stability."

The stability that heritage seems to offer, though global in scope, is experienced and most often expressed at the local level. By "local," I mean a range of spatial possibilities, extending from a region within a nation-state (such as Dalarna in central Sweden or the US South) to an exact location of an historical event commemorated by a monument or memorial. The Jewish Holocaust may have been a continent-wide, even global, atrocity, but its heritage is preserved in discretely local settings: Holocaust museums in Berlin, Washington, DC, and Jerusalem; death camps in Poland; and the Anne Frank House museum and memorial in Amsterdam (fig. 13.2). "Even when heritage is created and maintained largely as a matter of national objectives the execution of such policy will of necessity be local" (Graham et al. 2000: 201). Just as other aspects of national policy are localized – education and health care, for instance, are delivered through local schools and hospitals – heritage is structured through the locality-based museums, monuments, and street names that differing levels of governance sponsor or endorse.

Premises of Contemporary Heritage

Despite the tremendous variety of heritage experiences, certain generalizations might be made about how it operates in the contemporary world. At its most fundamental level, "heritage" refers to present-day uses of the past for a wide array of strategic goals, some economic and some more a matter of identity. Seven premises follow from this basic observation, each of which articulates different levels of political, cultural, and social organization around the act of using the past. In sum, I

Figure 13.2 Anne Frank House Museum and memorial, Amsterdam. Photograph by Steven Hoelscher.

hope to hint at the range of heritage practices, rather than provide anything like a comprehensive overview.

Display

Heritage is produced through objects, images, events, and representations; these are the displays of heritage. Since the original experiences of the past are irretrievable, we can only grasp them through their remains. Moreover, those displays – most notably museums, but also monuments, public art, memorials, television images, photographs, landmark districts, and pageants – are not passive containers, but are active vehicles in producing, sharing, and giving meaning to popular understandings of the past. Barbara Kirshenblatt-Gimblett (1998: 6–7) has written that display, or exhibition, is "an interface and thereby transforms what is shown into heritage."

This is an especially useful way to think about how heritage is created; it also helps explain why heritage, as a mode of understanding the past, is inseparable from the displays that represent it. Put somewhat differently, a heritage display or representation is "intentionally, a cultural explicating device" (Macdonald 1997: 156).

It is precisely such intentionality, or "making explicit," that sets heritage apart from other modes of apprehending the past, that makes it so powerful, and that has attracted academic scorn. Heritage displays rely on artifacts, including buildings and landscapes, costumes and cuisine, to impart its messages of the past. Open-air museums, historical re-enactments, theme parks, and conservation districts emphasize the visual, rather than the purely textual, making it difficult to present contradictory and ambiguous material. John Urry (1990: 112) goes even further and claims that the reliance of heritage display on visualization makes it inevitably distorting. Heritage, he argues, is a kind of "artefactual history," in which "social experiences are necessarily ignored or trivialized, such as war, exploitation, hunger, [and] disease." Celeste Ray (2001: xii) puts it somewhat more positively, emphasizing the "creative side" to heritage, as it always balances historical "truths" with "idealized simulacra." Rather than passing judgment on the inventiveness of the process – which, after all, is what makes heritage interesting, adaptable, and meaningful to its constituents – Ray prefers to "examine the selection and variable expression" of heritage.

Place

Regardless of whether we see the variable and self-conscious expressions of heritage as "distorting" or "creative," there is little doubt that they are nearly always grounded in place. Displays of heritage – artifacts in a museum, public squares, war memorials, even texts – bear a definitive relationship to space. And this occurs at all scales, from the body to a building to a street to a neighborhood to a city to a region to a nation to the globe. Among current scholars, the work of French historian Pierre Nora (1989) has been especially influential in establishing the connection between heritage and place.[1] His notion of "sites of memory" – or *lieux de mémoire* – gives prominent attention to the various ways in which heritage is spatially constituted. For Nora, heritage is attached to "sites" that are concrete and physical – the burial places, cathedrals, battlefields, prisons that embody tangible notions of the past – as well as to "sites" that are non-material – the celebrations, spectacles, and rituals that provide an aura of the past.

Cultural and governing elites who most frequently served as the guardians of heritage have long recognized this fundamental aspect of commemorating the past. Powerful interests, to be sure, are careful to locate monuments and to construct museums in strategic places with the intention of communicating desired ideologies, but so too have their critics. Indeed, the politics of heritage has become an integral component of human rights movements across the globe; most of those movements have sought to commemorate the victims of past injustices with a variety of heritage displays, or *lieux de mémoire*, that are firmly rooted in place. Robben Island, located just off the Cape Town coast, is now home to a National Museum and UNESCO World Heritage Site, commemorating the struggle for justice in apartheid-era South

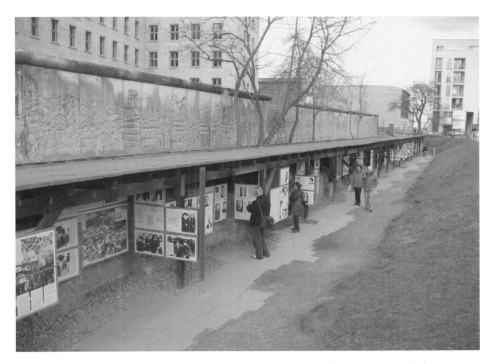

Figure 13.3 Topography of Terror, Berlin. Photograph by Steven Hoelscher.

Africa. Native American groups have pressured the National Park Service into redefining the memorialization of the Custer Battlefield, or Little Bighorn, in the rolling prairies of eastern Montana. The *Madres* (Mothers) of the Plaza de Mayo, in Argentina, one of the most effective and enduring networks of human rights activists in Latin America, have sought to remember their country's 30,000 "disappeared" people by setting up temporary exhibitions of photographs in city parks and other public places during weekends (Linenthal 1989; Deacon 1998; Gordon 2000).

In these and in countless other cases, political and community activists have drawn on the unique connection between heritage and place for their commemorative work. They have recognized, with the philosopher Edward Casey (1987: 186), that "it is the stabilizing presence of place as a container of experiences that contributes so powerfully to its intrinsic memorability." Such recognition is beginning to affect the creation of museums, which, by their very nature, usually break the link between object and site. When an artifact is removed from its surroundings and placed within a new taxonomic arrangement with other artifacts, it acquires a different set of meanings, however well intentioned curators may be. A museum like the Topography of Terror in Berlin works against this inherent problematic as it directly encourages visitors to contemplate the connection between the heritage of National Socialist tyranny and place (fig. 13.3). As a *Gedenkstätte*, or memorial museum, the remains of the central institutions responsible for that regime's repressive and criminal policies have been excavated and preserved, and put in context by detailed exhibition displays (Rürup 2003).

Steven Hoelscher

Time

One of the most intriguing elements of heritage has to do with its relation to time. Two issues are of especial relevance here. First, heritage might look old – after all, the language of heritage focuses on preservation, revitalization, and restoration – but closer inspection usually reveals contemporary concerns. Lurking just below the surface of the reclamation of a heritage are the needs, the interests, and affairs of a present generation (Glassberg 2001). Second, and just as revealing, is the processual nature of heritage, a social process that is continually unfolding, changing, and trans-forming. Commemorative activities, especially those involving the establishment of historic museums or monuments, attempt to stabilize and clarify the past that remains elusive. History, as it has been traditionally written, might follow chronology, but time's passage is never so neatly defined in heritage, where time is the target of strategic rearrangement.

A striking example of the processual nature of heritage is also found in Berlin, along its historic boulevard, Unter den Linden. The Neue Wache (or "New Guard-house"), originally built for the Prussian king's palace guard in 1816–18, was redesigned one hundred years later as a war memorial during the Weimar Republic. The Nazi regime altered it soon thereafter, adding new structural elements and mean-ings to the "place of remembrance." After World War II, the Neue Wache then served as the East German site to commemorate a heritage of fascists' victims, but with German unification in 1990, governmental and cultural authorities transformed the Neue Wache yet again, this time with a five-times-enlarged copy of Käthe Kollwitz's 1937 *Mourning Mother and Dead Son*. The exterior of the structure (fig. 13.4) bears striking similarity to Karl Friedrich Schinkel's original neoclassical design and, as such, would seem to anchor the past in a shared landscape form. However, its resculpted interior space (fig. 13.5) and newly written inscriptions conjure a complex heritage of victims, perpetrators, totalitarianism, tyranny, and genocide, a heritage that would have been entirely unimaginable when first built (Till 1999).

Politics

Such profound changes in heritage at the Neue Wache did not go unnoticed. On the contrary, the most recent permutation generated considerable and often contentious arguments over the form, value, and purpose of a national heritage fraught with con-tradiction. As Karen Till (1999) has shown, the Neue Wache became one display – albeit a strategically important one – in a larger field of heritage politics. In Germany, such debates center on the role and meaning of the National Socialist past within con-temporary German social relations. Although Germany's heritage politics, or, *Erin-nerungspolitik*, might be especially explosive, that country's conflict-ridden experience with its past is hardly singular. Rather, questions of politics lie at the core of heritage.

Such could hardly be otherwise, for debates about the past always occur within a larger socio-cultural framework, leading discussions of heritage eventually to a con-sideration of power. What Paul Connerton (1989: 1) has written about collective memory applies equally to its close relative, heritage: "control of a society's memory largely conditions the hierarchy of power." Since political identities are frequently

Figure 13.4 Exterior of the Neue Wache, Berlin. Photograph by Steven Hoelscher.

validated through some sense of an enduring past, governing elites in many societies vigorously create heritage displays to maintain social stability, existing power relations, and institutional continuity. Certainly, during times of political transition and turmoil, officials have frequently built large-scale heritage displays like museums, monuments, and memorials to naturalize their own position atop their society's hierarchy of power (Hobsbawm and Ranger 1983; Anderson 1991; Levinson 1998).

If heritage is, at some level, inevitably political, it is also true that conservative interests have typically dominated heritage politics. As John Urry (1996: 57) has noted, the "'heritage' that mostly gets remembered is that of elites or ruling classes. It is their homes and estates that have been 'saved for the nation' by the [British] National Trust and other preservation organizations." This, he concludes, "produces a one-sided history which under represents the poor," and many other non-elite groups, and it "conceals the social relationships of domination by which that ruling class exerted power." Robert Hewison (1987: 47) put it even more bluntly when he declared: "nostalgia is profoundly conservative. Conservativism, with its emphasis on order and tradition, relies heavily on appeals to the authority of the past."

Authenticity

Robert Hewison may have been the most outspoken critic of the politics of the British "heritage industry," but his was not the only voice. Together with Patrick

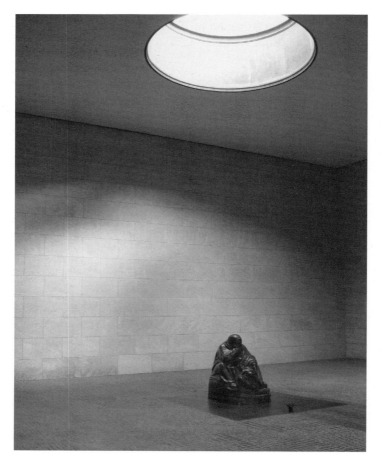

Figure 13.5 Interior of the Neue Wache, Berlin. Photograph by Steven Hoelscher.

Wright's *On Living in an Old Country* (1985), Hewison's *The Heritage Industry* (1987) launched a strident attack on the national cultural priorities of the Thatcher administration, priorities that successfully utilized British heritage to bolster support for deeply controversial political and economic restructuring. Even worse, but certainly related for Hewison, are the patently false notions of the past being promulgated by heritage displays. For such critics, heritage is best summarized as "bogus history" which commodifies the past, distorts the "real history" that is more accurately presented in written form, and shamelessly caters to the whims of tourists.

Observers of American heritage sites have been equally severe. Jean Baudrillard (1988) writes that Americans construct imitations of themselves that eventually become "more real" than the original, while Umberto Eco (1986: 6) contends that in the United States "the past must be preserved and celebrated in full-scale authentic copy," and "where the American imagination demands the real thing, and, to attain it, must fabricate the absolute fake." Such proclamations, though cloaked in

the contemporary language of postmodernism, merely echo complaints by earlier critics who lamented the vulgarization of mass society. Most notable, perhaps, was the American historian, Daniel Boorstin, who in his 1961 book, *The Image*, claimed that postwar Americans were living in an "age of contrivance," in which illusions and fabrications had become the dominant force in society. Public life, he said, was filled with "pseudo events" – staged and scripted events that were a kind of counterfeit version of actual happenings and places. Like Eco and Baudrillard, Boorstin reserved special derision for tourists, who, apparently, not only lacked the critical skills to distinguish "real history" from "fake heritage," but who seemed to prefer the latter.

While there is something of value to these comments, the limitations of this perspective can be seen in the battle over a failed heritage theme park, near Haymarket, Virginia, proposed by the Walt Disney Company in 1994. When the company withdrew its plans for Disney's America, it responded to a public furor that Walt himself would have found strange. Disney's enormously popular theme parks in California and Florida, and in France and Japan, though derided by modern academics as quintessentially "inauthentic," appear harmless, if shallow. This was not so with the proposed Disney's America, a theme park deliberately constructed "to bring our country's vast tapestry of culture and heritage to life." Opposition to the 3,000-acre site near Washington, DC, drew fire from all quarters, from professional historians and environmentalists to members of the National Trust for Historic Preservation; a grassroots coalition of local farmers, civic activists, preservation lawyers, and Civil War re-enactors collected eighty thousand signatures opposing the project. The prominent historian and television host, David McCullough, argued that its virtual-reality battles and Lewis and Clark raft ride would destroy important Civil War sites, while another opposition group, Protect Historic America, believed that the heritage theme park would trivialize and sanitize American history beyond recognition (fig. 13.6). Far from being beguiled dupes who accept whatever the entertainment industry tells them about their past, the American heritage enthusiasts, who told Disney CEO, Michael Eisner to "take your fantasy elsewhere and leave our national past alone," cared passionately about the authenticity of their past's display (Wallace 1996: 166).

Popular appeal

By failing to make distinctions between scholarly museums and heritage sites, on the one hand, and amusement parks that utilize historic motifs, on the other – a distinction clear to the opponents of Disney's America – critics like Robert Hewison and Daniel Boorstin simplify matters dramatically. This is related to another premise of heritage: professional historians might have led the campaign against Disney, but they would not have succeeded without considerable local and popular support. More than its critics generally recognize, the activities of documenting and preserving the past enjoy enormously important popular bases that reach across lines of class, race, and gender. With more than three million members, the National Trust is one of the largest mass organizations in Britain, and in the United States participation in historical activities is, for the most part, not wedded to one particular

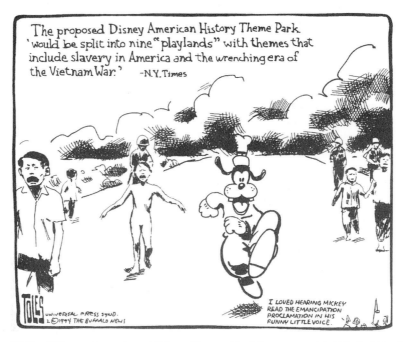

Figure 13.6 "Disney American History Theme Park" cartoon. TOLES © 1994 by *The Washington Post*.

social group or background. Indeed, as the historians Roy Rosenzweig and David Thelen (1998: 28) found in an exhaustive survey of Americans' use of the past, there is "little support for the claim that an interest in the past or formal history is the property of 'elites.'"

A remarkable portion of Americans they interviewed – 91 percent – had engaged in some form of "popular history making" over the past year, from looking at old photographs to watching history-related television shows to reading books about the past. Among the heritage-related activities that made their respondents "feel extremely connected to the past," visits to museums and historic sites held especially large importance. Such heritage displays might be "entertaining," but also, and no less important, "Americans believe they recover 'real' or 'true' history at museums and historic sites" (Rosenzweig and Thelen 1998: 32).

Development strategies

The mass appeal of heritage has not been overlooked by commercial interests, which have often worked closely with government agencies to promote the conservation of landscapes and places deemed historic. Formerly dying economies and lifeless localities are given a new lease on life as representations of themselves. Monterey, California, may well be more profitable as a display of John Steinbeck's *Cannery Row* than it ever was as a fishing center (Walton 2003). "Most livable city" polls, long

popular in the United States, consistently rate older cities with historic associations, such as San Francisco, Boston, or Seattle, as top scorers. And restored waterfronts in New York, San Antonio, and Baltimore are heralded as preservation successes, spawning similar developments elsewhere.

Of especial interest are places promoting an industrial heritage past. No clearer example of the democratization of heritage can be found than in places like Wigan Pier Heritage Centre in Lancashire, UK, the cities of Duisburg and Dortmund in Germany's Ruhrgebiet, and Lowell, Massachusetts, in the US – industrial districts, once thought to be the antithesis of heritage conservation effort, are now suddenly at its center. The Rivers of Steel National Heritage Area in Southwestern Pennsylvania is one such example. For nearly a century, the region served as a powerful hub of industrial development, producing the steel used to build some of the greatest icons of the modern age such as the Brooklyn Bridge, the Panama Canal locks, and the Empire State Building. After reaching its peak during World War II, when government leaders spoke of the region as "America's Arsenal of Democracy," Southwestern Pennsylvania began its long slide into economic stagnation. Pittsburgh's "rebirth" as a high-technology, education, and finance center in the 1970s and 1980s included a much-touted emphasis on leisure, historic preservation, and waterfront development. Today, the city is the center of a National Heritage area, one of twenty-four such areas sponsored by the National Park service, but run by a private corporation. Its stated mission – to "conserve, interpret, promote, and manage the historic, cultural, natural, and recreational resources of steel and related industries . . . and to develop uses for these resources so that they may contribute to the economic revitalization of the region" – seamlessly blends economic development with identity construction (Steel Industry Heritage Corporation 2004). Exhibitions, driving tours, and websites interpret the heritages of America's corporate giants, some of its most bitter labor struggles, and the often difficult histories of the region's diverse immigrant communities.

Two Examples

In order to provide firmer grounding for this discussion of heritage, I now turn to two examples in more detail. Each, in different ways, provides evidence for the claim that heritage is not merely a way of looking at the past, but also a force of the present that affects the future.

"Heritage, not Hate" in the American South

The American South, long a crucial site of memory within the United States, is engaged in a bitter struggle over the proper display and meaning of heritage. In a continuous arc from North Carolina to Texas, cars with bumper stickers proclaiming "Heritage, not Hate," sit uncomfortably next to those carrying protesters of "Southern Heritage." In courtrooms and in shopping malls, Civil War re-enactors clash with civil rights advocates over renaming downtown streets after Martin Luther King, Jr. State governments in South Carolina, Georgia, Mississippi, and Texas have

become increasingly embroiled in controversies over public displays of the Confederate battle flag. In one case, tensions became violent, resulting in the 1995 shooting dead of a white teenager who had provocatively waved the flag from a pickup truck in a predominately black Tennessee town (Horwitz 1996). William Faulkner's famous observation, that in the South "the past is never dead; it's not even past," would seem to be more true today than ever before.

Among the episodes most suggestive of the contemporary relevance of heritage, the recent Confederate flag controversy in South Carolina, where the divisive symbol had flown over the seat of the state government since 1962, stands out. The decision to resurrect it at that time was a gesture of hostility and resistance by the all-white legislature during the struggle for civil rights. By 2000, South Carolina was the only state that still flew the Confederate battle emblem above its state capitol building. Although there have been episodic calls for its removal, on the first day of the new millennium the boycott of South Carolina's tourism industry, organized by the National Association for the Advancement of Colored People (NAACP), brought immediate attention to the issue. Seventeen days later – on Martin Luther King, Jr Day – nearly 50,000 people rallied against the flying of the Confederate flag over the statehouse, chanting, "Your heritage is my slavery" (*The New York Times*, January 20, 2000).

The protesters' chants were well phrased: as the historian Eric Foner wrote in *The Nation* (February 14, 2000), among its defenders, "the Confederate flag represents not slavery but local identity, a way of life and respect for 'heritage.'" In this context, regional "heritage" had become a racially charged code word for a white, conservative backlash against perceived threats to its own hegemony. Underscoring this point, one week before the King Day rally, the right-wing South Carolina Southern Heritage Coalition organized an event designed to "begin the reversal of the ethnic cleansing process being waged against our proud heritage by the forces of political correctness." The pro-flag rally, dubbed "Heritage Celebration 2000," featured period-costumed men, women, and children re-enacting various roles of the Civil War past. Not surprisingly, the national media caught on to the Confederate flag spectacle, drawing in the major presidential contenders, from Republican candidates George W. Bush and John McCain to Democrat Al Gore. Political cartoonists from the nation's leading newspapers had a field day lampooning the idea of southern regional heritage (fig. 13.7).

In the wake of the hullabaloo, and in response to the economic pressure that cost the state an estimated $100 million in tourist revenues, the South Carolina General Assembly voted to take down the Confederate flag from the capitol dome. At noon on July 1, 2000, South Carolina became the last state to remove the controversial symbol of regional heritage from its seat of government. "Today, we bring this debate to an honorable end. Today, the descendants of slaves and the descendants of Confederate soldiers join together in the spirit of mutual respect," Governor Jim Hodges said just before he signed the bill into law. "Today, the debate over the Confederate flag above the Capitol passes into South Carolina history" (*Washington Post*, May 24, 2000).

Unfortunately, the concerns of heritage are not so easily quelled, nor so easily dismissed to the realm of history, especially when its symbol is an element of the land-

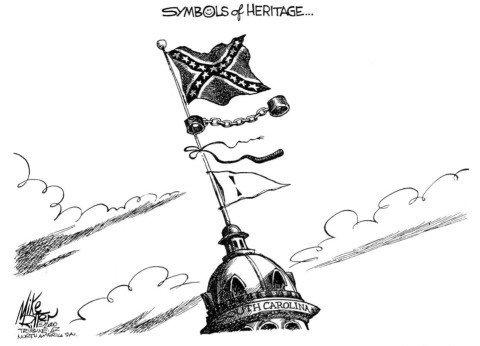

Figure 13.7 "Symbols of Heritage" cartoon. Reproduced courtesy of Mike Ritter; reprinted with special permission of King Features Syndicate.

scape, in view for all to see. In order to placate the flag's backers, the so-called Heritage Bill called for it to be flown atop a 30-ft pole in *front* of the capitol, beside an even taller monument to the "Lost Cause" of the Confederacy. Even supporters of the regional "heritage" movement to protect the flag recognized that this solution would not appease its opponents. As Republican Senator David Thomas noted, the "compromise" location is arguably a more prominent spot than atop the dome: "if you're going to achieve some balance with this thing, you've got to get it out of people's faces" (*Atlanta Journal and Constitution*, May 25, 2000). The NAACP, insulted by the South Carolina decision, determined to expand its boycott of the state, calling on the motion picture industry, professional athletes, and labor organizations to join in until the flag is permanently removed from the Statehouse grounds.

The South Carolina controversy is an especially relevant example because it calls direct attention to several important facets of heritage: the strategic use of the selective memory and tradition for social and political purposes; the multiple and conflictual definitions of what constitutes a heritage; and the role of exhibition and display in helping construct a meaningful (if contested) interpretation of a region's heritage. As a visible and prominent element of the public landscape, the Confederate flag crystallizes – in black and white – the conflicting sentiments on what heritage means to diverse Americans today.

Steven Hoelscher

Heritage displays of atrocity in Guatemala

Far removed from the statehouse in South Carolina, but joined in the bitter heritage of war, a small flame burned on the edge of Guatemala City's spacious central plaza. Etched in the modest stone base supporting the Bunsen burner-sized flame were the words, *A los héroes anónimos de la paz* ("To the anonymous heroes of the peace") and the date December 29, 1996, when the Guatemalan government and its opponents signed accords ending more than three decades of violent civil war. As a state-sponsored heritage display, the memorial was entirely unsatisfactory and recently became even more so. Its diminutive size, lack of custodial care, and vagueness – which heroes? whose peace? – point more toward amnesia than to remembrance. Added to this, government authorities, in 2004, removed the small memorial to the interior of the National Palace of Culture; there, disconnected from the messy unpredictability of the public square and safely tucked away in the safe confines of a vast bureaucratic museum and now cleansed of any remaining graffiti, the memorial attracts little, if any, attention. Such invisibility might seem strange given the magnitude of the events it purports to commemorate. But then again, oblivion always accompanies memory, since forgetting is as strategic and central a practice as remembering itself. Fledgling democratic governments across Latin America have been frequently disinclined to commemorate the painful experiences of authoritarian repression and have often sought to implement policies of oblivion, usually through recourse to "anonymous heroes" (Smith 2001).

Try as it might to remove the heritage of war atrocity from sight, the Guatemalan government has not been able to prevent unofficial, or non-state sanctioned heritage displays from appearing across the country. One of the most striking takes the form of an angel who appears suddenly and without warning in the most public and symbolically resonant spaces in the capital city. Since 1999, the photographer Daniel Hernández-Salazar, with the assistance of an extensive network of fellow artists, has pasted large-scale posters – a photomontage popularly known as the *Angel Series* or *Esclarecimiento* (Clarification) – throughout Guatemala City. The *Angel Series* adorned the cover of the Recovery of Historical Memory (REHMI) Project – the four-volume study that detailed 55,000 human rights violations, nearly half of which resulted in death, largely at the hands of the state security forces – and has since become a chief symbol of Guatemalan remembrance (Hoelscher forthcoming).

Every year on April 26 – the anniversary of the murder of the human rights activist and Catholic Bishop Juan Gerardi, the man most responsible for the REHMI report – Guatemala City residents awaken to find the key sites of Guatemala's heritage of atrocity made into miniature museums for the dead. These include such places as the façade of the slain bishop's church; on the west wall of the military barracks; at the United Nations verification mission headquarters; on a wall across the street from the county's military intelligence facilities; and above the city's central post office (fig. 13.8).

Reactions to the installations were discordant. The Banco Industrial immediately tore down the angel that graced its bomb-proof perimeter walls as the poster was seen to violate the sanctity of what it deemed private space. For its part, the Guatemalan military apparently did not understand the critical statement on its

214

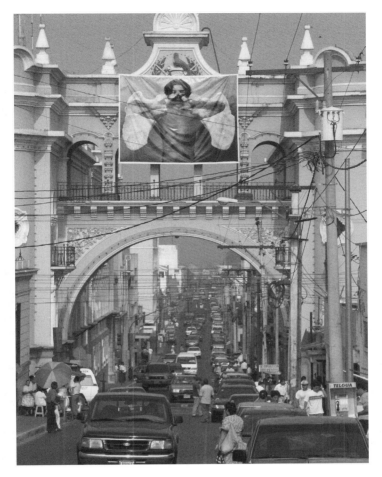

Figure 13.8 Recovery of Historical Memory Project, Guatemala City. "Angelarco" © 2003 by Daniel Hernández-Salazar.

walls, leaving the angels alone for the better part of a week, before systematically tearing them down. Hernández-Salazar notes, with no small degree of irony, that many of the heritage displays were made to disappear in the same way as thousands of Guatemalans were "disappeared" by death squads. Others, however, were actively nurtured and lasted for months; some pieces of the original angels can be seen today, five years after the original installation.

Like heritage itself, the angels became fragmented and worn with time, blending into the familiar landscapes of everyday life; also, like heritage, they would suddenly reappear and once again claim attention. Thus, what would appear to be a weakness of the *lieux de mémoire* – their ephemerality – was in fact one of their greatest strengths. Unlike traditional monuments, which often become rapidly stale and forgettable – Robert Musil famously declared that "there is nothing in this world as invisible as a monument" – this heritage display never ossified, but changed with

215

the weather, and with varying levels of care and neglect, of opposition and support.

The installation received further power from its incessant dedication to place. Unlike the famous public art of Christo, which, while visually stunning, frequently neglects any critical understanding of the complex historical circumstances of its location, Hernández-Salazar's angels are profoundly connected to geographic specificity.[2] The angels are like ghosts haunting graves of the murdered, fortresses of the powerful, bastions of the complicit. No less than the scapulae that comprise its wings – bones that came from a mass burial site – the place itself offers testimony to the past and recalls a heritage that weighs heavily upon its viewers.

Conclusion

From the conservative patriotism of the Confederate flag's defenders to the progressive memorials of Guatemala's "angels," heritage has become a fundamental means by which claims to the past infuse the politics of the present, inevitably affecting the future. That the name of heritage can fly under the banner of both nostalgia for a slave-holding society, in one case, and desire to remember atrocity so that its perpetrators face justice, in the other, speaks to the range of heritage possibilities. The everyday experiences and expressions of heritage that form the background to most of our lives might be less dramatic than these examples suggest, but the prospect of misunderstanding, if not outright conflict, is never far removed.

It could not be otherwise, for the concerns of heritage, by their very nature, are exclusive and exclusionary. Indeed, awarding possession to some, while excluding others, gives heritage its primary function. Heritage, therefore, is a faith, and like all faiths it originates in the deeply rooted human need to give meaning to temporary chaos, to secure group boundaries, and to provide a symbolic sense of continuity and certainty that is often lacking in everyday life. As a way of apprehending, ordering, and displaying the past, heritage's future looks bright.

Acknowledgments

The research and writing of this chapter were completed when I was a Fulbright scholar in the Nordamerikastudienprogramm at the University of Bonn. I would like to thank my hosts in Bonn, Sabine Sielke, Claus Daufenbach, and Hans-Dieter Laux, for their kind hospitality, and both the German-American Fulbright Commission in Berlin and the Faculty Development Program at the University of Texas for their support of my work.

Notes

1 Although Nora writes of "memory" and not "heritage," *per se*, I would argue that the two are indistinguishable in his discussion. The "museums, archives, cemeteries, festivals,

anniversaries, treaties, depositions, monuments, sanctuaries, fraternal orders" that he describes as *lieux de mémoire* are, essentially, what I am calling displays of heritage (Nora 1989: 12).

2 Erika Doss notes that Christo's 1991 outdoor sculpture project *The Umbrellas*, in California, took place on an historically significant site where California Indians were rounded up and imprisoned during the nineteenth century. "Millions of dollars were generated during the three weeks that *The Umbrellas* graced this terrain, as tens of thousands of tourists came to look at the temporary project, to buy T-shirts, postcards, videos, coffee cups, posters, and baseball hats emblazoned with umbrella symbols, and to think about what Christo and his crew had done to the landscape. But few moments were probably spent considering what had been done in that landscape, and to whom, one hundred years earlier" (Doss 1995: 222–3).

Bibliography

Anderson, B. (1991) *Imagined Communities: Reflections on the Origin and Spread of Nationalism*, 2nd edn. London: Verso.

Auswärtiges Amt Deutschland (2004) *Tatsachen über Deutschland* (www.tatsachen-ueber-deutschland.de/; last accessed April 19, 2004).

Baudrillard, J. (1988) *America*. London: Verso.

Boorstin, D. (1961) *The Image: A Guide to Pseudo-events in America*. New York: Atheneum.

Casey, E. S. (1987) *Remembering: A Phenomenological Study*. Bloomington, IN: Indiana University Press.

Charlesworth, A. (1994) Contesting places of memory: the case of Auschwitz. *Environment and Planning D: Society and Space*, 12: 579–93.

Connerton, P. (1989) *How Societies Remember*. Cambridge: Cambridge University Press.

Deacon, H. (1998) Remembering the tragedy, constructing modernity: Robben Island as a national monument. In S. Nuttall and C. Coetzee (eds), *Negotiating the Past: The Making of Memory in South Africa*, pp. 161–79. Cape Town: Oxford University Press.

Doss, E. (1995) *Spirit Poles and Flying Pigs: Public Art and Cultural Democracy in American Communities*. Washington, DC: Smithsonian Institution Press.

Eco, U. (1983) *Travels in Hyperreality*. New York: Harcourt, Brace, Jovanich.

Frieden, B. J. and Sagalyn, L. B. (1989) *Downtown, Inc.: How America Rebuilds Cities*. Cambridge, MA: MIT Press.

Glassberg, D. (2001) *Sense of History: The Place of the Past in American Life*. Amherst: University of Massachusetts Press.

Gordon, A. (2000) *Ghostly Matters*. Minneapolis, MN: University of Minnesota Press.

Graham, B., Ashworth, G. J., and Tunbridge, J. E. (2000) *A Geography of Heritage: Power, Culture, and Economy*. London: Arnold.

Handler, R. (1988) *Nationalism and the Politics of Culture in Quebec*. Madison: University of Wisconsin Press.

Hayden, D. (1995) *The Power of Place: Urban Landscapes as Public History*. Cambridge, MA: MIT Press.

Herbert, D. T. (ed.) (1995) *Heritage, Tourism, and Society*. London: Mansell.

*Hewison, R. (1987) *The Heritage Industry: Britain in a Climate of Decline*. London: Methuen.

Hobsbawm, E. and Ranger, T. (eds) (1983) *The Invention of Tradition*. Cambridge: Cambridge University Press.

Hoelscher, S. (1998) *Heritage on Stage: The Invention of Ethnic Place in America's Little Switzerland*. Madison: University of Wisconsin Press.

— (forthcoming) Photography, urban space, and the heritage of atrocity: Daniel Hernández-Salazar's angel series. In O. Moldonov (ed.), *The Photography and Art of Daniel Hernández-Salazar*. Austin: University of Texas Press.

Horwitz, T. (1996) *Confederates in the Attic: Dispatches from the Unfinished Civil War*. New York: Vintage.

*Kirshenblatt-Gimblett, B. (1998) *Destination Culture: Tourism, Museums, Heritage*. Berkeley, CA: University of California Press.

Levinson, S. (1998) *Written in Stone: Public Monuments in Changing Societies*. Durham, NC: Duke University Press.

Linenthal, E. T. (1989) *Sacred Ground: Americans and their Battlefields*. Urbana: University of Illinois Press.

*Lowenthal, D. (1998) *The Heritage Crusade and the Spoils of History*. Cambridge: Cambridge University Press.

Macdonald, S. (1997) A people's story: heritage, identity, and authenticity. In C. Rojek and J. Urry (eds), *Touring Cultures: Transformations of Travel and Theory*, pp. 155–75. London: Routledge.

National Park Service (2004) *National Register of Historic Places* (www.cr.nps.gov/nr/; last accessed May 15, 2004).

Nora, P. (1989) Between memory and history: *les lieux de memoire*. *Representations*, 26: 7–25.

Ray, C. (2001) *Highland Heritage: Scottish Americans in the American South*. Chapel Hill, NC: University of North Carolina Press.

*Rosenzweig, R. and Thelen, D. (1998) *The Presence of the Past: Popular Uses of History in American Life*. New York: Columbia University Press.

Rürup, R. (ed.) (2003) *Topography of Terror: Gestapo, SS, and Reichssicherheithauptamt on the "Prinz-Albrect-Terrain"*. Berlin: Verlag Willmuth Arehnövel.

*Samuel, R. (1994) *Theatres of Memory*, vol. 1: *Past and Present in Contemporary Culture*. London: Verso.

Smith, P. (2001) Memory without history: who owns Guatemala's past? *The Washington Quarterly*, 24: 59–72.

Steel Industry Heritage Corporation (2004) *Rivers of Steel National Heritage Area* (www.riversofsteel.com; last accessed May 1, 2004).

Sturken, M. (1997) *Tangled Memories: The Vietnam War, the AIDS Epidemic, and the Politics of Remembering*. Berkeley, CA: University of California Press.

Till, K. E. (1999) Staging the past: landscape designs, cultural identity, and *Erinnerungspolitik* at Berlin's *Neue Wache*. *Ecumene*, 6: 251–83.

Trouillot, M-R. (1995) *Silencing the Past: Power and the Production of History*. Boston: Beacon Press.

UNESCO (2004) *World Heritage Convention* (whc.unesco.org; last accessed April 4, 2004).

Urry, J. (1990) *The Tourist Gaze*. London: Sage.

— (1996) How societies remember the past. In S. Macdonald and G. Fyfe (eds), *Theorizing Museums: Representing Identity and Diversity in a Changing World*, pp. 45–65. Oxford: Blackwell.

Wallace, M. (1996) *Mickey Mouse History and Other Essays on American Memory*. Philadelphia: Temple University Press.

Walton, J. (2003) *Storied Land: Community and Memory in Monterey*. Berkeley, CA: University of California Press.

Wright, P. (1985) *On Living in an Old Country*. London: Verso.

Architecture, Space, Media

Introduction

To most people the word "museum" probably conjures up an image of a building. This might be a solid, neo-classical example with steps ascending to a large door under a pillared portico; it might be a late twentieth-century, iconic, innovative, architectural edifice, such as the Guggenheim Bilbao or the Berlin Jewish Museum; or it might be a less ostentatious but equally material, smaller-scale museum. "Museum" might also trigger visions of interior space, probably populated with objects, perhaps sculptures and paintings, glass cases of china or silverware, dioramas with stuffed animals, dinosaur skeletons, or even computer displays.

Part III of the *Companion* examines the physical, spatial, and visual nature and implications of the museum. It does so in recognition that there are today "virtual museums" on the worldwide Web, many of which are simplified representations of some of the contents of existing physical museums, though others exist in cyberspace alone. Consideration of these museums, together with a range of uses of new media *in* museums, is the focus of Michelle Henning's discussion (chapter 18). The fact that the museum was historically a physical space, and that this remains its most familiar form, is nevertheless crucial, as chapters here show. The architecture of the museum, its external form, and the internal layout of its galleries, together with exhibit design and display, shape the ways in which the museum and its contents are likely to be perceived.

Chapters 14 and 15, by Michaela Giebelhausen and Vittorio Magnago Lampugnani respectively, eloquently demonstrate that museum buildings are never "merely" containers. The fact that so much money and architectural ingenuity are typically lavished upon them is itself recognition of this, of course. What these chapters reveal, however, is the intricate dance between context, content, space, and visitors that is choreographed via architecture. Both illuminate how the relative significance of different partners in this dance, as well as the nature of their relations to one another, has changed over time. Giebelhausen takes a wide sweep of museum architectural history that traces the emergence of museums through to today. This includes the nineteenth-century conception of the museum as a monument, and the later development of the idea of museum buildings as "symbolic containers," illustrating and expressing the contents within. Something of both of these concepts persists, though they took on new forms in the later twentieth century, a period which

is sometimes said to be characterized by fragmentation, witnessed in increasing architectural diversity and the postmodern play with stylistic forms such as collage, pastiche, and reflection on ruin.

Changes in twentieth-century architecture, specifically centered on the art museum, the locus of so much architectural innovation, are the subject of Magnago Lampugnani's discussion. He argues that museums have become architectural playgrounds in which art is increasingly subsumed to architecture, to the extent that it risks – even in its ostensibly "quieter" forms – "drowning out the art that it is housing." This is compounded too by a greater emphasis, generally financially driven or at least accentuated, on museum visitors, which sees museum spaces and architecture being transformed to incorporate speedier temporalities, and functions such as shopping and eating (see also chapters 23 and 31). Far from acting in synchrony, Magnago Lampugnani shows us, museum containers and contents can, inadvertently, fall out of step with one another.

The following two chapters share similar concerns, though their focus is primarily on museum interiors. Tony Bennett (chapter 16) explores changes in the ways in which museums organize vision. He shows how the nineteenth-century art museum's forms of "eye management" sought to enlist visitors into particular practices of looking, or "civic seeing," a process that also entailed a differentiation of visitors, some of whom were considered less able to appreciate the museum's visual address than were others. Also involved was the museum seeking to distinguish the forms of visual attention appropriate to itself from those of other visual technologies, such as the curiosity cabinet and, later, film. In the late twentieth century, however, in tandem with the changes in museum architecture described in the previous two chapters, the museum was increasingly attempting to incorporate alternative visual technologies and practices of looking. This was part of a more pluralized form of address, related to a changing emphasis on the visitor in which the audience was conceptualized as more fragmented and multiple (see also chapters 12, 31, and 32). While Bennett focuses primarily on the visual in this chapter, he suggests that this may be giving way to a broader sensory address, incorporating – as seen, for example, in the rise of interactive exhibits (see chapters 18 and 21) or a return to curiosity (see chapters 6 and 18) – the tactile and auditory, and even the olfactory and gustatory, as well.

Whether the museum's intended address to visitors – the ways in which curators attempt to "speak to" an audience via exhibits – actually works is one of the central questions in museum studies. To try to tackle it, research on museum visiting has grown enormously over the past decade (see chapters 3 and 22). Much of this relies, however, on tapping the verbal responses of visitors. In chapter 17, Bill Hillier and Kali Tzortzi present a set of techniques for analyzing the ways in which visitors move through museum space. Their aim is to expose what they call "space syntax" – the grammar of the layout and design of exhibitions. What is clear from the case studies that they present – returning to an argument of Magnago Lampugnani – is that curatorial intentions are often not realized because of failures to envisage how an exhibition will work in practice. Matters such as the circulation routes through galleries, the juxtaposition of artifacts of different scale, and the relative placing of interactive exhibits, can have considerable, and often unforeseen,

consequences for the ways in which an exhibition is received (see also chapter 32).

The syntactic approach outlined in Hillier and Tzortzi's chapter has the potential to be expanded further to incorporate other exhibition features, including the different kinds of media employed. That different media (in which we can also include architecture) are not just more- or less-effective means of "packaging" content is a point that resounds through the chapters in Part III. Michelle Henning (chapter 18) expands the discussion to new media. By looking not only at recent uses of new media, including "virtual museums," but also older instances of the employment of digital technologies in museums, she provides an insightful account of the ways in which technologies may variously "organize and structure knowledge and visitor attention." Like Bennett, in particular, she is also concerned with how this may interact with political changes in museums, though she raises questions about whether interactivity is necessarily as inherently democratizing as is so often proclaimed (see also chapter 21). What is needed, she suggests, are ways of producing "deeper and more diverse engagement between visitors and the museum" – a theme that is central to the concerns of Part IV.

Museum Architecture: A Brief History

Michaela Giebelhausen

In his impressive survey, *A History of Building Types*, Sir Nikolaus Pevsner claimed that museum architecture had not developed any significant new types since World War II. "In fact," he wrote, "no new principles have turned up, except that the ideal of the museum as a monument in its own right has been replaced by the ideal of the museum as the perfect place to show, enjoy and study works of art (or of history or of science)" (Pevsner 1976: 136). In Pevsner's assessment, the exhibiting of objects was complemented by enjoyment and study; or, in contemporary parlance, education and entertainment. His statement also implied that art museums were central to the history of the building type. The display of objects pertaining to history or science was bracketed off as an aside. The museum's architectural articulation is here seen to oscillate between two paradigms: monument and instrument. These also define the complex relationship of content and container played out in the dialogue between functional and aesthetic considerations that is crucial to an understanding of museum architecture.

During the last quarter of the twentieth century, the museum became increasingly popular and diverse. Its architecture explored a range of stylistic modes and social roles, attracting the attention of urban planners and star architects alike, and spawning a gargantuan literature. Writing in the 1970s, Pevsner could, of course, not have foreseen the impact postmodernism was to have on museum architecture. But if he had, would his view have changed? This chapter refrains from indulging in futile speculation. Instead, it addresses four central issues: the emergence of the museum as an independent building type and its symbolic and architectural lineage; the museum as monument; the museum as instrument; and, finally, it considers some of the issues connected with the museum boom during the last quarter of the twentieth century.

Collecting/Displaying: The Birth of the Museum

The intricate relationship between content and container defines the architecture of the museum. The age-old activity of collecting predates the history of the museum and its architectural form. While collecting tends to presuppose display of some

kind, be it permanent or temporary, it does not necessarily require self-contained and independent structures. During antiquity, collections of precious objects were kept at sacred sites such as temples, sanctuaries, and tombs, or in the residence of a sovereign. In addition to serving religious purposes, collections also emphasized the worldly powers of sovereign, city, or state. The Renaissance witnessed a renewed interest in antiquity as well as vigorous collecting activities. The cabinet of curiosities, the *studiolo*, and the gallery provided different types of spaces in which collections were kept and displayed (see chapter 6). While prominent and important, these spaces formed part of domestic interiors, be they Italian palazzi or French chateaux.

The legacy of the princely palace was to accompany the formation of the museum. During the eighteenth century, royal collections were gradually being opened to a wider public. From 1750, a selection of works from the French royal collections was on public view in the Palais du Luxembourg in Paris. Parts of the Habsburg imperial collections went on display at the Upper Belvedere in Vienna; Christian von Mechel arranged them according to schools in 1779. One of the earliest independent museum buildings was the Museum Fridericianum in Kassel, begun in 1769 and designed to house the art collections and library of the Landgrave of Hesse-Kassel. A central portico with six Ionic columns separates the two Baroque wings which are accentuated with giant pilasters.

While princely, royal, and imperial collections were gradually being made accessible to a wider public, they were mostly installed in palaces. Very few were housed in purpose-built structures such as the Museum Fridericianum (1769–77), or the Prado (1784–1811) in Madrid, built to display natural history. In most cases, access depended on observing a certain dress code or even obtaining a permit. Visiting felt like a privilege rather than a civic right.

The display of the papal collections in the Vatican was architecturally among the most influential. Under popes Clement XIV and Pius VI, the Museo Pio-Clementino (1773–80) was being built as an extension to the Vatican palace (Springer 1987: 21–38). It was widely visited and formed a central highlight on any eighteenth-century tourist itinerary. The galleries were modeled on traditional display spaces for sculpture: Rome's antique baths. Two key architectural features – the grand staircase and domed rotunda – inspired museum architecture across Europe.

The most impressive late eighteenth-century museum was the Musée Français, installed in the Louvre. The former royal palace opened its doors to the public in August 1793, the first anniversary of the abolition of the monarchy (McClellan 1994: 91–123). In its display of works that had once been owned by crown, church, or aristocracy, the museum made a strong political statement. The traditional signs of privilege had become the property of the young French republic. The museum redefined the collections as national treasures and created the notion of a general public synonymous with the republic's citizenry, thus cultivating what Carol Duncan and Alan Wallach (1980) have termed the "civilising ritual." It also served a more traditional role as a study collection for artists.

Installed in a former palace, the Musée Français did not significantly contribute to the history of museum architecture, but it signaled the museum's enormous political potential as a governmental instrument. The Musée Français helped to legitimize the political claims of the new republic, combining the notion of progress with linear

art-historical narratives, and to visualize the abstract idea of a civic populus. Increasingly, it became a showcase for the republic's successful war efforts. The Italian campaign of 1797 and the surrender of the Vatican state initiated the plunder of Italy's cultural riches. As a result of Napoleon's extensive military campaigns, the Musée Français – renamed Musée Napoleon in 1804 – became the largest and most impressive collection of art objects ever amassed (McClellan 1994: 124–54). However, it did not survive the fall of Napoleon. Following the Vienna Congress of 1815, almost half the works were repatriated. The return of looted art works generated a museum-building boom across Europe. The political legacy of the Musée Français lived on in these new institutions. The returned treasures were no longer just royal or princely collections but were increasingly perceived as national assets to which the population was to have ready access.

While the trend to open collections to the public continued during the eighteenth century, the museum also began to figure as an exercise for students at art academies throughout Europe. For example, the annual competition for the Prix de Rome held by the French Academy for the Arts repeatedly set the task of designing an imaginary museum or picture gallery (Pérouse de Montclos 1984). By the early 1800s, the design for a museum had been standardized. Jean-Nicolas-Louis Durand's influential *Précis des leçons* (1802–5), which was based on his lectures held at the école Polytechnique in Paris, provided European architects with blueprints for a wide range of old and new building types. His design for a museum featured four wings arranged in a square into which a Greek cross and central rotunda were inscribed (fig. 14.1). Each of the wings had a separate entrance accentuated by a long portico with forty-six columns.

Durand's museum was intended to house painting, sculpture, and architecture as well as temporary exhibitions. It furthermore contained artists' studios. It thus echoed the primary functions identified by the Musée Français, which recognized practicing artists as one of its main user groups. Durand's logical and lucid design, together with the compelling example of the Musée Français, which crystallized the museum's political potential, established the ideological motivation and architectural framework for the creation of a wide range of museums across Europe.

The Museum as Monument

During the first half of the nineteenth century, the small German kingdom of Bavaria witnessed an impressive museum-building boom. Inspired by his visit to Rome, Bavaria's future king, Ludwig, decided Munich, too, needed a museum. In quick succession, in fact, three key museums were being planned: the Glyptothek (1815–30) for the display of sculpture; a picture gallery, Alte Pinakothek (1826–36); and a museum for contemporary art, Neue Pinakothek (1846–53).

The young architect Leo von Klenze won the competition for the Glyptothek held in 1814. His design showed a rectangular building with a central wing stretching out at the back. It reflected and modified designs such as L. C. Sturm's ideal museum (1704), George Dance's gallery design (1763), for which he won the gold medal of the Parma Academy, and the Museum Fridericianum (1769–77).

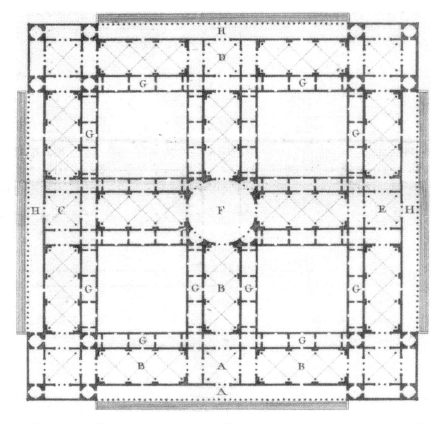

Figure 14.1 Jean-Nicolas-Louis Durand, "Ideal design for a museum: plan," from *Précis des leçons de l'architecture données à l'École royale polytechnique*, 2 vols (Paris, 1817–19).

The layout was firmly rooted in eighteenth-century tradition, but Klenze's conception of the façade was innovative. He offered a range of stylistic modes: Greek, Roman, Renaissance. For all three, he cited historical precedents. The Greek temple was both shrine to cult objects and ornamented with sculpture; the Roman baths had also served as public display spaces for sculpture; the Renaissance was the great age of collecting.

During the planning stages, the layout was significantly modified. It was replaced by a four-wing plan modeled on Durand's ideal design, albeit without the Greek cross and central domed rotunda. The chosen stylistic idiom was classical Greek, as it best promoted the collection's superb examples of genuine Greek sculpture (fig. 14.2). The central portico has eight Ionic columns and the pediment sculptures represent Greek artisans at work, showing the different production processes of sculpture in various materials.

The interior decoration scheme was hotly debated. While the architect favored contextual and richly ornamental display spaces, the scholarly advisor wanted to see the galleries modeled on the sparse interiors of academy or studio, which combined

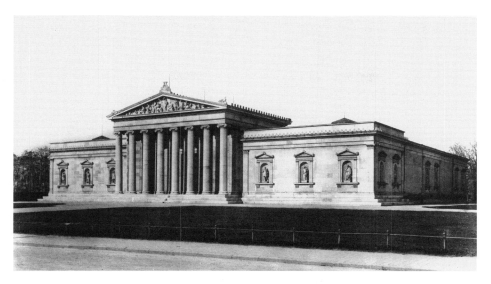

Figure 14.2 Leo von Klenze, Glyptothek, Munich (1815–30), main façade. Photograph: Zentralinstitut für Kunstgeschichte, Photothek.

light wall colors with even lighting (Gropplero di Troppenburg 1980). The architect's vision prevailed: the interiors showed a rich, dark decoration scheme. The walls of each gallery were painted a monochrome color, mostly red or green; ceilings and floors were heavily patterned. These ornaments were both decorative and didactic, intended to add period flavor and provide historical context for the works on display.

On entering the museum, visitors were greeted by a plaque reminding them that the collection and galleries had been funded by the generous benevolence of Ludwig I, king of Bavaria. The four wings provided a linear route through the collection which started in the entrance hall and moved clockwise, traversing the chronological sculpture displays. Galleries housing ancient Egyptian, Greek – subdivided chronologically and typologically – and Roman works were followed by a gallery for sculpture in colored stone and bronze. The final gallery contained works by contemporary artists such as Canova, Thorwaldsen, Shadow, and Rauch. At the far end of the building – directly opposite the main entrance – the sequence of galleries was interrupted by a second, smaller entrance and two adjoining banqueting rooms. The leading Nazarene artist, Peter Cornelius, was commissioned to fresco the ceilings with scenes from the Trojan War and Greek mythology.

Reserved for royal entertainment, these rooms served as a potent reminder of the museum's architectural lineage. The palace had traditionally provided spaces that combined the functions of display and entertainment in a gesture of political power. Although the museum promoted chronological and contextual displays which were cutting edge at the time that the collection was installed, it also remained indebted to earlier display modes, even if the royal privilege was rarely exercised.

The museum was located in a newly developed suburb. It stood at one side of Königsplatz, together with equally Greek-inspired structures: a building for tempo-

227

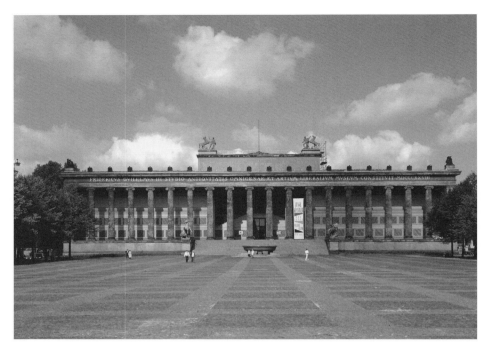

Figure 14.3 Karl Friedrich von Schinkel, Altes Museum, Berlin (1823–30), exterior view. Photograph: Staatliche Museen zu Berlin.

rary exhibitions and a symbolic gate, modeled on the Propylaea on the Athenian Acropolis, which marked the city's new entrance. At the center of the square, a monument commemorated the foundation of the Bavaria kingdom in 1806. The museum formed part of a new urban development and, together with the neighboring structures, invoked a classical, almost Arcadian past that helped to validate the recent political transformation of Bavaria. Furthermore, with its collection of classical and contemporary sculpture, the Glyptothek forged an active link between the achievements of classical civilization and contemporary art.

A similarly symbolic location was allotted to the Altes Museum (1823–30) in Berlin (fig. 14.3). The museum was situated on the north side of Schlossplatz, across the square from the royal palace, flanked by cathedral, arsenal, and university. Here the museum took its place alongside the markers of Prussia's societal powers: monarchy, church, military, and bourgeois intelligentsia. Karl Friedrich von Schinkel's design also represented a variation on Durand's blueprint. While the Glyptothek was a reduced version, Schinkel's reworking was more extensive. He retained the central rotunda, but halved the square outline to form a rectangular ground-floor plan and arranged the gallery spaces on two floors. The museum sits on a plinth-like podium which one ascends via wide stairs. The main entrance on the raised ground floor takes the visitor straight to the heart of the building: the rotunda which is two-stories high and domed. This central space has a complex architectural lineage, derived in equal measure from the galleries in the Vatican museum, the magnificent interior of

the Pantheon in Rome, and the rotunda at the center of Durand's influential museum design. As a transitional space, it also fulfills an important psychological function. In the rotunda, visitors are supposed to leave behind the everyday world and prepare themselves for the contemplation of art.

A monumental staircase provides access to the upper story. It is tucked in behind the giant Ionic columns that run the whole length of the main façade. Ascending the stairs, visitors catch glimpses of the royal palace and cathedral, and across the Kupfergraben they take in the arsenal and university. In this unusual access route to the first-floor galleries, which allows a range of vistas, the museum proclaimed and consolidated its position in the urban fabric of Prussia's capital.

The museum housed Greco-Roman sculpture on the raised ground floor and painting on the first. The collections followed an arrangement similar to that of the works displayed in the Glyptothek: a roughly chronological sequence was presented in the clockwise route through the galleries. As in Munich, debates ensued over the interior decoration. In Berlin, too, the architect's vision prevailed over a more modest setting modeled on academy and studio.

Although centrally located in the city, the museum also functioned as a piece of Arcadia. During the nineteenth century, a cultural complex developed behind the Altes Museum. It encompassed the Neues Museum (1841–59), National Gallery (1866–76), Kaiser Friedrich-Museum (now Bode-Museum, 1904), and Pergamon Museum (1930). A picturesque representation of the early 1840s shows the projected Museumsinsel (museum island), its outline invoking the Acropolis, the cultural and ritual precinct towering above classical Athens (Zentralinstitut für Kunstgeschichte München 1994: 59). As in Munich, Berlin's cultural institutions were massed together. They provided an almost Arcadian moment aimed at invoking the mythical virtues of classical antiquity – learning and civic values – in the modern metropolis.

After successfully working on the Glyptothek, Klenze was asked to design a gallery for the royal collection of paintings. In the Alte Pinakothek (1826–36) Klenze used a Renaissance idiom for the façade (fig. 14.4). The building is a structure of twenty-five bays with small corner pavilions at either end. The ground floor housed offices, reserve collections, and store rooms, the display galleries being located on the first floor. The entrance to the main collection was situated at the east end. Once the visitor had ascended the staircase, an uninterrupted set of large galleries unfolded in a linear sequence. These were flanked by small galleries on the north and a corridor on the south side. Klenze created large, top-lit rooms for the large-scale works and cabinet-sized, side-lit rooms for the small works. This distinction, together with the linear arrangement of galleries, became the blueprint for the nineteenth-century picture gallery. Similar museums include Gottfried Semper's Picture Gallery, Dresden (1847–55), Klenze's new wing for the Hermitage, St Petersburg (1842–51), August von Voit's Neue Pinakothek, Munich (1846–53, destroyed) and Oskar Sommer's Städelsches Kunstinstitut, Frankfurt (1878).

The building's Renaissance style was validated with a symbolic act: the foundation stone was laid on April 7, 1826, the birthday of Raphael, the most highly regarded painter of the Renaissance. While the collection was arranged broadly chronologically, the works by Raphael were displayed in a side room in the west pavil-

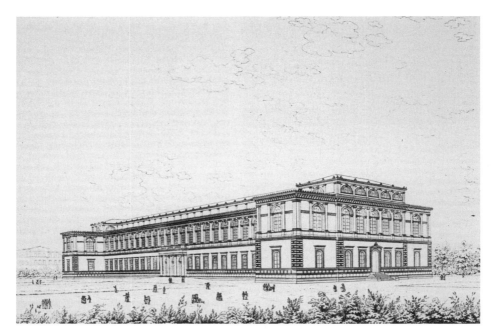

Figure 14.4 View of the Alte Pinakothek from the south-east, architectural sketches in the collection of Leo von Klenze. Photograph © Bayerische Staatsgemäldesammlungen, Munich.

ion. They were placed out of sequence and at the opposite end from the entrance: a timeless highlight awaiting the visitor at the end of the visit. The corridor was inspired by Raphael's *loggie* in the Vatican. It was decorated with frescos illustrating the history of art and thus complemented the actual displays. In the Alte Pinakothek, the history of art figured in two ways: an exemplary selection of works and a painted pantheon of canonical masters, both arranged according to national schools.

The museums in Berlin and Munich helped to codify the new building type. The Altes Museum and the Glyptothek both modified Durand's influential design for an ideal museum. They presented the display of art as a linear, progressive history which the visitor traversed and physically re-enacted. All three buildings discussed here constructed a close relationship between the content and the container. The symbolic language of their architecture was in tune with the collections. The display spaces were fixed: the history of art was not subjected to revisions and interpretations. Instead, it was presented as universal, chronological, and progressive. The architecture of the museum underscored the institution's function as a monument to culture.

Similar issues can be observed in museums dedicated to the display of natural history. Here, too, architecture often functioned as a symbolic container which both illustrated and embodied the displays. This is most clearly expressed in the Oxford University Museum (1855–60) (Yanni 1999: 62–90). The Gothic idiom allowed the integration of natural forms in elements such as capitals and window arches. The

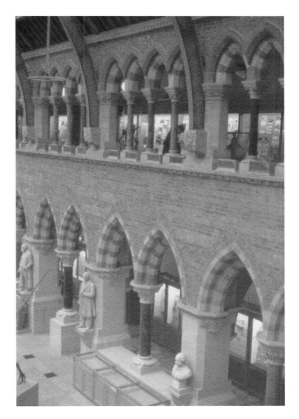

Figure 14.5 Thomas Dean and Benjamin Woodward, Oxford University Museum, Oxford (1855–60), view of courtyard arcades. Photograph by Michaela Giebelhausen.

arcades surrounding the central display atrium rest on columns which also serve as specimens (fig. 14.5). They are made from stones found in the British Isles. Here the container doubles up as the content: it both illustrates and forms part of the collection. London's Natural History Museum (1871–81), designed by Alfred Waterhouse, also registers a connection, albeit less strong, between the decoration scheme and the displays it houses. The museum as monument extended to encompass the display of both culture and nature.

The Museum as Instrument

The architecture of the nineteenth-century museum embodied permanence. It was designed to make a symbolic statement, at once civic and educational. Often the building and the collection evolved in tandem as in the case of the Glyptothek, or the building was designed to house an existing collection as in the case of the Alte

231

Pinakothek. Together, collection and building were conceived as a monument which allowed little scope for change or expansion.

This traditional approach to display changed dramatically with the Great Exhibition held in London's Hyde Park in 1851. The event inaugurated the age of world fairs; it was innovative and enormously ambitious both in its scale and international remit (Greenhalgh 1988). It also added two significant features to the architecture of display: impermanence and flexibility. The Crystal Palace, a vast glass and iron structure of prefabricated units that were easily assembled and dismantled, responded to the needs of this new exhibition format. As the exhibition closed, the Crystal Palace was re-erected, in a slightly modified form, in Sydenham where it continued to serve as a display space, until destroyed by fire in 1936.

The success of the Great Exhibition was manifested in the subsequent fashion for international exhibitions (for example, Paris 1855, 1867, 1878, 1889, and 1900, London 1862, Chicago 1893) and in the foundation of the South Kensington Museum (later renamed the Victoria and Albert Museum), which was set up as a visual archive to enhance the design and production of contemporary crafts and industrial goods (Physick 1982: 13–32). The foundation of the South Kensington Museum in 1852 spawned similar institutions across Europe, such as the applied arts museums in Vienna (founded 1863), Berlin (founded 1867), and Hamburg (founded 1877). The museum was extending its function as a repository of exemplars for study to include the applied arts.

The idea of the museum as instrument implied a degree of flexibility and adaptability. While the international exhibitions had introduced the demand for temporary display spaces, Le Corbusier extended the notion of the museum as time's arrow, an instrument designed to show the cumulative progress of humanity's achievements and nature's transmutations. In his design for a Museum of Unlimited Growth (1939), the galleries were arranged in a spiral which was square in shape. Thus the building could grow with the collections. Whenever more display space was required, one would simply add to the spiralling structure. The whole building rested on pilotis, Le Corbusier's hallmark supports. The main entrance was located at the center of the spiral, from where the gallery spaces unfolded with the potential for unlimited growth.

The notion of the museum as instrument also underlies the Museum of Modern Art, New York (Grunenberg 1994). It was founded in 1929 to focus on contemporary artistic production, including painting, sculpture, architecture, works on paper, photography, film, design. Its first director, Alfred H. Barr, compared the museum to a torpedo moving through time. In order to remain truly contemporary, works would be regularly reviewed and either transferred to the Metropolitan Museum's permanent collections or de-accessioned. MoMA's original policy to focus on the contemporary (a time span defined as fifty years) would ensure that it had a permanent collection but one whose content would constantly change. This radical approach to collecting was given up and MoMA has since become the definitive repository for twentieth-century art.

Philip L. Goodwin and Edward Durell Stone designed MoMA's permanent home in midtown Manhattan, which opened in 1939. At that time, MoMA was still following its radical convictions and needed flexible display spaces. The galleries were

232

arranged on several floors, each an open-plan space, interrupted only by the load-bearing pillars. They could be subdivided with the use of partitions to accommodate a wide range of works and display narratives.

MoMA aimed to create display spaces that were both flexible and "neutral." The aesthetic of the "white cube" originated here. Most previous forms of display had situated the work in precious interiors, be they princely palaces or the grand museums of the nineteenth century. Instead, the "white cube" interior sought to focus attention on the object: it aimed to provide a space that invited aesthetic contemplation and immersion without distraction. Works were hung on white walls, floors were monochrome, ceilings unadorned and functional, with unobtrusive tracking systems to provide flexible lighting conditions. Just as the traditional enfilade of galleries – derived from the palace – had constituted the norm for nineteenth-century museum spaces, the "white cube" became the modernist paradigm of display. It was to dominate museum and gallery interiors throughout the second half of the twentieth century (O'Doherty 1999).

MoMA had successfully extended the art museum's traditional remit to include a wide range of contemporary practices. In their design for the Centre George Pompidou (1977), Renzo Piano and Richard Rogers developed the all-encompassing embrace of the museum even further. The Centre Pompidou helped to redefine the traditional museum (Davis 1990: 38–59). It is a cultural center which accommodates a range of art forms. In addition to the Musée National d'Art Moderne and several spaces for temporary exhibitions, it also contains spaces for theater performances and concerts, a cinema, videotheque, library, bookshop, cafes and restaurants. Visits to the museum make up a fraction of the overall visitor numbers (see also chapter 31).

The Centre Pompidou promoted a democratization of culture. The architecture's bright color scheme suggests a playfulness at odds with the notion of the museum as monument. The building, with its external ducting and glass-covered escalators, is high-tech modern (see fig. 15.3). The entrance is at street level where a generous piazza invites impromptu performances. Here the boundaries between high and popular culture begin to blur, as do those of inside and outside. With a myriad of different activities taking place simultaneously, the Centre Pompidou embodies a notion of culture as participatory process. It represents a multivalent instrument, enabling at once the production, collection, dissemination, and consumption of culture.

Institutions such as MoMA (as originally conceived) and the Centre Pompidou helped to redefine the role of the art museum. Worthy monuments had become instruments that tried to accommodate ever-changing modes of contemporary artistic production. With the Centre Pompidou, the traditional museum was integrated in a portfolio of cultural practices and activities.

On the Museum's Ruins?

In 1980, Douglas Crimp meditated on the museum's ruins (Crimp 1993: 44–64). In the subsequent anthology of the same title, his explorations were characterized by attempts at defining ends or endings: the end of modernism, painting, sculpture.

Such multiple ends also seemed to spell the end of modernism's powerful instrument, the museum.

The art practices of the 1960s and 1970s reacted against the ubiquitous "white cube" that both guaranteed "neutral" – aestheticized and depoliticized – viewing and defined the meaning of art. Art increasingly aimed to assert itself outside the gallery space: gestural, political, non-commercial. In the wake of such redefinitions, alternative spaces for art emerged. Mostly, they were artist-run cooperatives which functioned as both studio and display spaces. One of the most enduring alternative spaces was PS1. In 1976, this derelict school in New York City's borough of Queens reopened to the public as a center for contemporary art. In deliberate rejection of the "white cube" aesthetic, the building retained its former character. The displays often seemed like unexpected discoveries. In the catalogue for the inaugural exhibition, *Rooms*, Alanna Heiss, PS1's founding director, outlined the fundamental differences between the traditional museum and alternative spaces.

> Most museums and galleries are designed to show masterpieces; objects made and planned elsewhere for exhibition in relatively neutral spaces. But many artists today do not make self-contained masterpieces; do not want to and do not try to. Nor, are they for the most part interested in neutral spaces. Rather, their work includes the space it's in; embraces it, uses it. Viewing space becomes not frame but material. (quoted in Reiss 1999: 126)

The museum after modernism has taken on a wide range of forms. In the modernist aesthetic, architecture played a subservient and allegedly "neutral" role. Intended to facilitate the pure contemplation of art, it continued to frame the exhibits but in a far less ornate, contextual, or didactic fashion than before. Although in many ways modernist, the Solomon R. Guggenheim Museum (1959) challenged this "white cube" aesthetic. Frank Lloyd Wright modulated museum architecture's signature centerpiece, the domed rotunda, into dynamic form (see fig. 15.2). The museum space is reconceptualized as sculpture. A sky-lit central atrium is surrounded by a spiralling ramp along which Solomon R. Guggenheim's collection – mostly abstract works by early twentieth-century European artists – was displayed in shallow bays. While the museum interior remains modernist white, the visitor route along the sloping ramp is linear and ceremonial, characteristics associated with the traditional layout of the museum as monument. The Guggenheim's monumental aspirations, however, differ from those of the nineteenth-century museum. Understood as sculptural form, the interior functions not simply as a didactic and decorative context that frames the displays, but it makes an almost emancipatory claim. The architecture provides a unique setting for the viewing of art, offering a spatial experience that is unlike anywhere else. Universality was replaced by individuality: the signature building increasingly became a trademark of museum architecture during the final decades of the twentieth century.

The postmodern museum also mused on the museum's ruins. James Stirling's extension to the Staatsgalerie in Stuttgart (1977–84) has widely been regarded as the paradigmatic postmodern articulation of museum architecture (see fig. 15.4). The building is a variation on the layout of Schinkel's Altes Museum: an enfilade of sky-

lit galleries encloses a central rotunda on three sides. At several crucial points, however, the blueprint was significantly remodeled.

The front lacks the monumentality and symmetry of the Altes Museum. It consists partly of an undulating glass front whose segments are framed in bright green and refract and fragment every reflection. A ramp with two slopes provides an almost processional approach to the museum. But the traditional configuration is skewed: on ascending the ramp one finds that the museum entrance is set at an angle. The rotunda at the center of Stirling's design is open to the elements and laced with ivy. Both sculpture court and ruin, it remains inaccessible from the display galleries which surround it. Here the center becomes a meditation on the history of the building type and one of its most significant architectural elements. This is ironically inflected by a detail in the museum's outer wall. Here a few blocks are chinked out and scattered on the ground: not a random act of vandalism but a witty denouement. The gap reveals both the thinness of the stone cladding and the mundane car park behind it. The museum's playfulness is also evident in the color scheme: the bright pink and blue oversized railings that accompany the ramp, the bright red doors, the grass-green window frames and floor in the central lobby, and the multi-colored elevator that takes visitors to the permanent galleries on the first floor. The extension to the Staatsgalerie inflected both the classic nineteenth-century museum layout in the tradition of Durand and the "white cube" aesthetic of the modernist museum. It combined the former's enfilade of sky-lit processional galleries with the neutral interiors of the latter. Minor touches, such as the wall-mounted lights in the form of architrave fragments, introduced a note of playfulness into the gallery spaces. In some ways, Stirling's design heralded both a return to, and a reflection on, the architectural history of the museum.

Self-conscious and playful meditation on the building type informed museum architecture during the 1980s. Aldo Rossi's design for the Museum of German History (Museum für Deutsche Geschichte, 1989, unexecuted) presented a reflection on the cultural institution and its often invoked metaphors. He proposed an ensemble of architectural quotations and fragments that referenced the columned portico and central rotunda of Durand and Schinkel, as well as a range of less clearly articulated metaphors used to describe the museum as cathedral or factory. According to Rossi, we live in a fragmented age and hence architecture needs to deliver multifaceted articulations of a building type such as the museum (Stölzl 1988: 691–3).

The notion of fragmentation was further explored in the Groninger Museum (1995) in The Netherlands. Alessandro Mendini led a team of architects and designers, among them the architectural practice Coop Himmelb(l)au and Philippe Starck (Martin et al. n.d.). They were invited to contribute pavilion-like structures to an overall ensemble designed to house the diverse collections of the Groninger Museum (fig. 14.6). The edgy tectonics of Coop Himmelb(l)au contrast with the colorful exuberance of Mendini's interiors and the cool signature chic of Starck's pavilion. Here, too, the museum was no longer conceived as a universal or unifying institution of culture but as a collage of different architectural expressions which highlight the diversity of the collections.

The museum has also played an important part in urban regeneration projects. At a moment when critics such as Jane Jacobs were charting the death and life of

Figure 14.6 Alessandro Mendini's team, Groninger Museum, Groningen (1995), exterior view. Photograph by Michaela Giebelhausen.

great American cities, the postmodern museum, which had emerged from the ruins of the modernist museum, forged strong links with the city (Jacobs 1961). From the late 1960s onward, attempts were being made to reconfigure the inner cities. This was particularly pronounced in Germany where the modernist agenda that had driven the large-scale postwar rebuilding was increasingly being regarded as obsolete. Generous provisions for motorized traffic were modified to accommodate pedestrians who shopped and strolled. While the first wave of urban revitalization rested mainly on the force of commerce, culture was also being mobilized. Increasingly, the strolling shopper was incarnated as the *flâneur* who took an active interest in historical urban traces.

A most impressive case of urban refashioning was the transformation of Frankfurt during the 1980s (Giebelhausen 2003: 75–107). As many German cities, Frankfurt had sustained heavy bomb damage during World War II. With the near total destruction of the medieval center, the city lost its distinct urban identity. The postwar decades saw a colossal rebuilding program with emphasis on modernization and motorization. By the 1960s, Frankfurt had emerged as the banking capital of West Germany. Nicknamed Bankfurt or Krankfurt (sick city), it had a reputation as pragmatic and tough. In lifestyle polls, Frankfurt lagged behind cities such as Munich, Hamburg, Düsseldorf, and Cologne.

The magistrate launched a campaign to enhance the city's tarnished image: culture was the key. Frankfurt's cultural landscape had not fully recovered from the ravages of World War II. Consequently, the city aimed to remedy the long neglect of its splendid collections and museums, most of which had suffered bomb damage. All in all, thirteen museums were housed or re-housed. Most of these were extensions to existing institutions, while others were new foundations.

On the south side of the river Main, amidst a range of nineteenth-century bourgeois villas and their ample garden settings, some of Frankfurt's most impressive museums are located. The purpose-built art gallery (*Städel*) sits alongside the Sculpture Museum (*Liebieghaus*) and the Museum of Applied Arts, both housed in former private residences. During the early 1970s, several of the remaining villas along the riverfront had been earmarked for redevelopment and threatened with demolition. The city magistrate stepped in to preserve this unique urban landscape. It seemed logical to extend and consolidate the sprinkling of museums along the Main and establish a veritable museum mile. In 1976 plans for the museum embankment (*Museumsufer*) were launched.

The concept was mainly driven by two concerns: preservation of historic urban fabric and refashioning of the city's image. The foundation of museums for film and architecture (the first of their kind in Germany) and the competition for the Museum of Applied Arts, which produced the first European commission for American star architect Richard Meyer, aimed to place Frankfurt on the cultural map, both nationally and internationally. A stellar cast of architects worked on Frankfurt's museums, among them Günther Behnisch, Hans Hollein, Josef Paul Kleihues, Gustav Peichl, Axel Schultes, and Oswald Mathias Ungers. Consequently, one critic termed the city the Eldorado of postmodernism.

The *Museumsufer* concept spilt over to the north side of the river. It encouraged a combination of re-use and context. The Museum of Pre- and Early History (Museum für Vor- und Frühgeschichte) was established in the former Carmelite monastery, its thirteenth-century church a burnt-out shell since World War II. While the museum gained a much-needed permanent home, the remnants of the church were integrated into a modern structure. The hybrid building – part church, part postmodern museum – speaks evocatively of the city's violent past (fig. 14.7). While it leaves visible some of the scars, the blank and almost windowless exterior retraces the outline of the monastery. Frankfurt's emerging museum landscape was dominated by contextuality. Often this approach created awkward and crammed museum interiors with gallery spaces that proved difficult for display.

The museum played several conflicting roles in the city's face-lift. Museum-use furnished a means to safeguard historic urban fabric. Well-publicised architectural competitions and their resultant signature buildings helped to attract international attention. The city also aimed to foster an international perspective through museum foundations that were unique in Germany's cultural landscape, such as the institutions dedicated to architecture and film. Furthermore, an ambitious exhibition program was established in most of the city's museums, including international blockbusters at the *Kunstschirn*, a major venue for temporary exhibitions which opened in 1985.

As the case of Frankfurt shows, the postmodern museum could be deployed to promote strategies of urban and cultural regeneration. It functioned as an instrument with a wider set of applications than those that preoccupied the modernist museum, no longer just – as Pevsner had put it – "the perfect place to show, enjoy and study." One high-profile example is Frank O. Gehry's Bilbao Guggenheim (1997). It played a crucial role in the city's ambitious building program which included an airport extension and a new metro system with stations designed by

237

Figure 14.7 Josef Paul Kleihues, Museum für Vor- und Frühgeschichte, Frankfurt am Main (1985–9), exterior view. Photograph by Michaela Giebelhausen.

Norman Foster. The sculptural museum became the emblem of the campaign (see fig. 15.5). Gehry's early design drawing, a signature squiggle, graces a wide range of merchandise for sale in the museum's several shops, including mugs, mouse mats, lighters, and erasers. While these function as souvenirs, the publicity that surrounded the museum also satisfied the armchair traveler. The building featured in every Sunday supplement and architectural magazine across the globe. Such publicity – including a brief appearance in a James Bond film – helped to put Bilbao on the cultural tourist's global itinerary.

London's Tate Modern (2000), designed by the Swiss practice Herzog and de Meuron, has also been billed as part of an urban regeneration project, targeting the rundown borough of Southwark. The museum gave a new lease of life to Giles Gilbert Scott's semi-defunct power station located on the south bank of the Thames (fig. 14.8). In order to fully function as a cultural landmark and tourist destination it needed to be integrated into the urban infrastructure. Access routes range from the traditionally processional approach via Norman Foster's pedestrian bridge, which links the museum to the City and St Paul's Cathedral, to the nearby underground stop on the Jubilee Line extension. In its first year, Tate Modern registered

Figure 14.8 Herzog and de Meuron, Tate Modern, London (2000), exterior view. Photograph by Michaela Giebelhausen.

an astounding 5.25 million visitors, making it the most visited museum of modern art worldwide, ahead of the Centre Pompidou, the New York Guggenheim, and MoMA.

In the case of Tate Modern, urban regeneration also meant the re-use of an existing architectural structure: a huge power station, gutted for its metamorphosis. The massive turbine hall with its constant engine hum gives the interior an industrial edge (fig. 14. 9). The actual gallery spaces are inspired by the building's industrial past and yet conscious of the "white cube" aesthetic. The raw oak floors, slightly soiled from use, and the heavy iron floor grilles, invest the otherwise pristine white interiors with the semblance of industrial roughness. Apart from obvious differences in size, the "feel" of the galleries is homogeneous and permanent. Partitions are conceived as movable walls rather than temporary structures. This gives every layout the appearance of permanence. Despite regular changes to the permanent displays and to the layouts of temporary exhibitions, the interiors of Tate Modern seem to configure the museum as monument.

In contrast, the Bilbao Guggenheim presents a very different form of urban intervention. Gehry's spectacular building provides a memorable landmark and anchors a range of cultural institutions lined up along the river front. While exhibition spaces at Tate Modern aim for a degree of uniformity, the Bilbao Guggenheim champions variety. The display spaces that radiate from the expressive central lobby vary considerably in size and ambience, ranging from large, cavernous galleries to a traditional enfilade of top-lit galleries. This diversity acknowledges the wide range of artistic production and refutes the modernist assumption of "neutral" space.

In 1999, MoMA and PS1 announced a merger (Baker 1999: 27). After more than twenty years of conceptual stand-off, the quintessential modernist museum and the

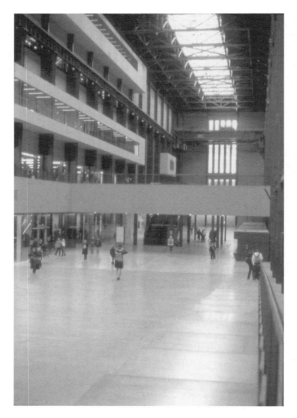

Figure 14.9 Turbine hall, Tate Modern. Photograph by Michaela Giebelhausen.

quintessential alternative space – type and anti-type – became part of the same organization: the postmodern museum, characterized by a desire for empire-building and franchising (Cembalest 1997; Wee 2004). The most prolific examples of this recent practice are the Guggenheim – with landmark buildings in New York, Venice, and Bilbao and a presence both in Berlin and Las Vegas – and the Tate, which has outposts in Liverpool and St Ives. This high-profile merger marked the end of an era. In some ways, it also validated the postmodern museum's diverse approach to gallery interiors.

In November 2004, MoMA reopened to the public after a two-and-a-half-year rebuilding program. The Japanese architect Yoshio Taniguchi was responsible for the museum's massive transformation. Having to negotiate a complex urban site with several layers of archaeology, Taniguchi opted for a restrained but monumental modernism. The "white cube" aesthetic lives on, but is mitigated by tantalizing glimpses of distant galleries and fellow visitors (fig. 14.10). Rosalind Krauss (1996) has considered such playfulness a hallmark of the postmodern museum visit. While some critics have applauded the architecture's refined modernism (Evans 2004; Mitchell 2005), others have deplored the fact that MoMA did not take the chance of fully reclaiming the territory of the contemporary (Fairs and Long 2005).

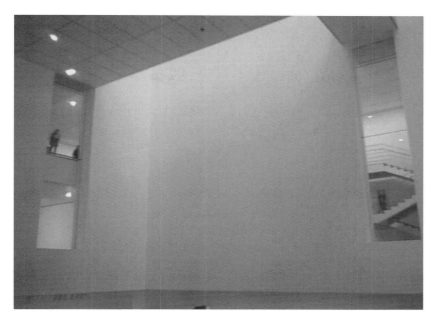

Figure 14.10 Yoshio Taniguchi, Museum of Modern Art, New York (2002–4), view of the interior. Photograph by Takaharu Saito.

Although the impressive ground-floor galleries are dedicated to the display of contemporary works, they read as modernist museum spaces. Alfred H. Barr acknowledged the complexities of modernity when conceptualizing the museum as a torpedo moving through time. MoMA has since increasingly pandered to the permanence traditionally associated with the museum. However, the building's ability to function as instrument is expressed in two frequently quoted claims. The architect asserted that "architecture should not compete with the work of art" but that it "should disappear" (Swanson 2004). This statement gains meaning when read in conjunction with the chief curator John Elderfield's remark that, during installation of the works, "the architecture suddenly composed itself around the painting" (Farr 2004). Consequently, critics who deplore the fact that Taniguchi's decidedly modernist architecture fails to fully reclaim MoMA's once instrumental mode refuse to acknowledge the obvious. While the museum's function as instrument has always been subtly articulated, it has irrevocably become the definitive monument to twentieth-century art.

Writing in the 1970s, Pevsner presented the history of museum architecture as a shift from monument to instrument. The rise of postmodernity has blurred the boundaries of these two distinct modalities. In recent years, the architecture of the museum has rejected the Miesean credo "less is more," showing little desire to "disappear." In fact, it has witnessed a return to the monument. Daniel Libeskind's museums – Felix Nussbaum Haus, Osnabrück (1998), the Jewish Museum, Berlin (2001), the Imperial War Museum of the North, Manchester (2002) – might serve to illustrate this trend. They are replete with symbolic and emotive resonances that

actively contribute to the visitor experience. The architecture interprets and frames the exhibition narratives, eliciting both intellectual and physical responses from the visitor.

Interactivity of a different kind is being demanded at Zaha Hadid's Phaeno Science Center, currently under construction in Wolfsburg, Germany (opened in 2005). In the tradition of the Exploratorium (founded 1969) – San Francisco's experimental "museum of science, art and human perception" as the web page's tagline has it (www.exploratorium.edu) – the center champions a hands-on approach to learning and provides interactive exhibits (Hein 1990: 23–43). Hadid's design for Phaeno offers an experimental landscape – complete with craters, plateaus, and caves – which the visitor is invited to explore, plotting their own route. The fluid and uninterrupted exhibition spaces are raised off the ground and supported by ten cones, inclined at different angles and housing a variety of traditional museum functions such as auditorium, shops, and cafes. The building's cavernous underbelly functions as public space. As inside and outside elude traditional definitions, the structure merges with its surroundings. While the project has been widely praised for its complex and daring use of concrete (Pearson 2004), critics have struggled to describe it in conventional architectural terms (www.phaeno.de). Comparisons have ranged from alien space ship to centipede, simultaneously capturing the architecture's high-tech and organic qualities.

Such far-flung and contradictory descriptions also signal the astounding diversity of museum architecture; a diversity, however, that continues to fall within the parameters of monument and instrument, identified by Pevsner. The spectrum between these contrary modalities has since been widely explored and has generated an exciting range of complex and contradictory structures. Rather than being either monument or instrument, the museum has taken up various positions in between, resulting in the classic postmodern "both–and" (Venturi 1966: 23–33). While museums as both instrumental monuments and monumental instruments continue to be built, the museum's instrumental applications have also proliferated, from a narrow focus on display to one that encompasses questions of urban re-imaging and regeneration and global tourism.

Bibliography

Baker, E. C. (1999) MoMA and PS1 reveal plans to merge. *Art in America*, 87: 3, 27.

Bennett, T. (1995) *The Birth of the Museum: History, Theory, Politics*. London: Routledge.

Cembalest, R. (1997) First we take Bilbao. *Artforum*, 31 (1): 63–4.

Crimp, D. (1993) *On the Museum's Ruins*. Cambridge, MA: MIT Press.

*Davis, D. (1990) *The Museum Transformed: Design and Culture in the Post-Pompidou Age*. New York: Abbeville Press.

Duncan, C. and Wallach, A. (1980) The universal survey museum. *Art History*, 3: 448–69.

Durand, J. N. L. (2000) *Précis of the Lectures on Architecture*, trans. D. Britt. Los Angeles: The Getty Research Institute (original work published 1802–5).

Evans, B. (2004) Art of restraint. *The Architects' Journal*, 220 (21): 22–33.

Fairs, M. and Long, K. (2005) Two art museums. *Icon*, 20: 62–72.

Farr, S. (2004) MoMA's $858 million transformation gives us a new view of the icons of modern art. *Seattle Times*, November 21 (seattletimes.nwsource.com; accessed December 14, 2004).

Giebelhausen, M. (2003) Symbolic capital: the Frankfurt museum boom of the 1980s. In M. Giebelhausen (ed.), *The Architecture of the Museum: Symbolic Structures, Urban Contexts*, pp. 75–107. Manchester: Manchester University Press.

Greenhalgh, P. (1988) *Ephemeral Vistas: The Expositions Universelles, Great Exhibitions and World's Fairs, 1851–1939*. Manchester: Manchester University Press.

Gropplero di Troppenburg, E. (1980) Die Innenausstattung der Glyptothek durch Leo von Klenze. In K. Vierneisel and G. Leinz (eds), *Glyptothek München 1830–1980* [Glyptothek Munich 1830–1980], pp. 190–213. Munich: Glyptothek München.

Grunenberg, C. (1994) The politics of presentation: the Museum of Modern Art, New York. In M. Pointon (ed.), *Art Apart: Art Institutions and Ideology across England and North America*, pp. 192–211. Manchester: Manchester University Press.

Hein, H. (1990) *Exploratorium: The Museum as Laboratory*. Washington, DC: Smithsonian Institute Press.

Jacobs, J. (1961) *The Death and Life of Great American Cities*. New York: Vintage.

Krauss, R. E. (1996) Postmodernism's museum without walls. In R. Greenberg, B. W. Ferguson, and S. Nearn (eds), *Thinking about Exhibitions*, pp. 341–8. London: Routledge.

Lorente, J. P. (1998) *Cathedrals of Urban Modernity: The First Museums of Contemporary Art*. Aldershot: Ashgate.

*McClellan, A. (1994) *Inventing the Louvre: Art, Politics and the Origins of the Modern Museum in Eighteenth-century Paris*. Cambridge: Cambridge University Press.

Martin, M., Wagenaar, C., and Welkamp, A. (eds) (n.d.) *Alessandro and Francesco Mendini, Philippe Starck, Michele de Lucchi, Coop Himmelb(l)au in Groningen*. Groningen: Groninger Museum.

Mitchell, B. (2005) Less is more is back. *RIBA Journal*, 112: 1, 14.

*Newhouse, V. (1998) *Towards a New Museum*. New York: Monacelli Press.

O'Doherty, B. (1999) *Inside the White Cube: The Ideology of the Gallery Space*, expanded edn. Berkeley, CA: University of California Press.

Pearson, A. (2004) The impossible achieved. *Building*, March 26: 66–72.

Pérouse de Montclos, J. M. (1984) *Les prix de Rome: concours de l'Académie royale d'architecture au XVIIIe siècle*. Paris: Bergert-Levrault.

*Pevsner, N. (1976) *A History of Building Types*. London: Thames and Hudson.

Physick, J. (1982) *The Victoria and Albert Museum: The History of its Building*. Oxford: Phaidon and Christies.

Plagemann, V. (1967) *Das deutsche Kunstmuseum, 1790–1870: Lage, Baukörper, Raumorganisation, Bildprogramm* [The German Art Museum, 1790–1870: Location, Building, Internal Structure, Decorative Scheme]. Munich: Prestel Verlag.

Reiss, J. H. (1999) *From Margin to Center: The Spaces of Installation Art*. Cambridge, MA: MIT Press.

Springer, C. (1987) *The Marble Wilderness: Ruins and Representation in Italian Romanticism, 1775–1850*. Cambridge: Cambridge University Press.

Stölzl, C. (ed.) (1988) *Deutsches Historisches Museum: Ideen, Kontroversen, Perspektiven* [German Historical Museum: Ideas, Controversies, Perspectives]. Frankfurt am Main: Propyläen Verlag.

Swanson, S. (2004) Museum of Modern Art gains new space, style. *Seattle Times*, November 16 (seattletimes.nwsource.com; accessed December 12, 2004).

Van Bruggen, C. (1997) *Frank O. Gehry: Guggenheim Museum Bilbao*. New York: The Solomon R. Guggenheim Foundation.

Michaela Giebelhausen

Venturi, R. (1966) *Complexity and Contradiction in Architecture*. New York: The Museum of Modern Art.

Wee, C. (2004) MoMA and PS1: a postmodern alliance (www.cavant-garde.com; accessed November 29, 2004).

*Yanni, C. (1999) *Nature's Museums: Victorian Science and the Architecture of Display*. Baltimore, MD: The Johns Hopkins University Press.

Zentralinstitut für Kunstgeschichte München (ed.) (1994) *Berlins Museen: Geschichte und Zukunft* [Berlin's Museums: History and Future]. Munich: Deutscher Kunstverlag.

Web sources:

www.exploratorium.edu (accessed February 1, 2005).

www.phaeno.de (accessed February 1, 2005).

www.tate.org.uk (accessed January 25, 2005).

Insight versus Entertainment: Untimely Meditations on the Architecture of Twentieth-century Art Museums

Vittorio Magnago Lampugnani

At the start of the century from which we have only recently taken our leave, Filippo Tommaso Marinetti – in the first of the many manifestos that he either wrote or intensively edited – announced that museums were nothing but public dormitories. In a world enriched with the new beauty of speed, they no longer served any purpose. Since a roaring automobile was a greater miracle than the Winged Victory of Samothrace, there was no longer any need for a place to protect the Winged Victory and make it accessible to the public. In the case of Italy, in particular, he not only wanted to liberate the country "from the cancer of professors, archaeologists, tourist guides and antiquarians" but also "from the countless museums that are covering it like innumerable graveyards" (Marinetti 1909).

Every prediction runs the risk of being disproved by subsequent events, but few can have proved more mistaken than this one. The twentieth century, in particular, which the Futurists thought would be the epoch that would bury everything old, turned out after a significant but relatively short avant-garde interlude to be a century well described by the adjective "passatistic" – a neologism coined by the Futurists and used as their favorite term of abuse. The shock of modernization and the horrors of two fully mechanized world wars were followed by an increasing withdrawal into a world of values from the past. Art museums were among the main channels that made this withdrawal possible and also came to symbolize it.

Architects rose to the challenge with growing enthusiasm. The task corresponded to a social need – thanks to which it also enjoyed a basis of political and economic support that inevitably benefited architectural work. And it offered scope (whether real or supposed – as we will discuss below) for architectural work that seemed to be capable of fulfilling even the most daring ambitions of the architects who were lining up to carry it out.

Vittorio Magnago Lampugnani

Modernism against the Museum

Initially, it seemed that the twentieth century might follow Marinetti's appeal to stop filling cities with obsolete "dormitories." During the first half of the century, the commissioning of art museums was indeed hardly at the focus of public attention. Although Rittmeyer and Furrer built the functional, elegant museum in Winterthur in 1912–16 and John Russell Hope started the classicist National Gallery in Washington, DC, in 1936, the modern movement – which did to some extent inherit ideas derived from Marinetti and his Futurist followers – was mainly concerned with creating buildings for people rather than for works of art. And this was no accident: the avant-garde was fundamentally questioning the justification for the museum as an institution, and the upturned urinal that Marcel Duchamp exhibited as a "fountain" at the Salon des Indépendants exhibition in New York in 1917 provided a radical example of the problematic relationship that existed between the work of art and the institution of the museum. As a "ready-made," it was raised to the status of an art object by the mere fact of having been selected by the artist. The Dadaists and Surrealists, in particular, made efforts to extend the territory of art well beyond the walls of the museum – which appeared to be losing its right to exist.

Architecture occasionally made efforts to fill the resulting gap, and itself began to take the place of the vanishing art works. The few museums that were built during the classic period of modern architecture thus became containers that presented themselves as art, while at the same time they remained (logically enough) empty. Examples include the German pavilion by Ludwig Mies van der Rohe at the World Exhibition in Barcelona in 1929, and the Danteum by Pietro Lingeri and Giuseppe Terragni, designed in 1938–40 for the Via dei Fori Imperiali in Rome (but never built). The elegant project for an art gallery for a small town that Mies van der Rohe designed in 1942 but was not initially able to build, represents an enigmatic compromise, with a small number of exhibits. The community museum built by Hendrik Petrus Berlage in the Hague (1919–20, 1928–35) and the Rijksmuseum Kroller-Müller erected in Otterlo by Henry van de Velde (1934–53) are thus genuine exceptions.

After the War: The Seduction of History

It was only after World War II that interest in new facilities for museums revived. It was not only the fact that numerous buildings housing art had been damaged or destroyed by bombing, postwar society itself was yearning both for self-renewal and for secure models on which such a self-renewal might be based. Art appeared to be capable of providing such models.

The museum facilities that were built in Italy in the 1950s had a mediating position that was peculiar but nevertheless consistent. In various ways, each in accordance with his own view of architecture, Franco Albini in the Museo di Palazzo Bianco in Genoa (1950–51) and in the Museo di Palazzo Rosso (1952–62), the BBPR Group (Ludovico Barbiano di Belgiojoso, Enrico Peressutti, Ernesto Nathan Rogers)

with the arrangement of the museum in the Castello Sforzesco in Milan (1954), Carlo Scarpa with the Galleria Nazionale della Sicilia in the Palazzo Abatellis in Palermo (1953–4), the extension of the Gipsoteca Canoviana in Possagno near Treviso (1956–7), and the Museo Civico di Castelvecchio in Verona (1958–64) were all playing out variations on the same theme: a revaluation and representation of older art using modern architectural means. The buildings impressively demonstrated an extended view of classic modernism that had certainly shown itself capable of incorporating history, tradition, and the urban context and assimilating them productively. Despite assertions to the contrary, this was not achieved without some elements of cultural violence. When Albini presents Giovanni Pisano's marble fragment of Margherita di Brabante in the Palazzo Bianco, he turns it into an almost metaphysical sculpture. This exploits Pisano for the purposes of a version of modernism that is and must be alien to him (although it is given a more ecumenical interpretation than the modernism of the 1920s and 1930s). In other words, even when the boundary between old and new is sharply emphasized and heavily underlined, a contemporary interpretation is taking place.

In its restraint, Ignazio Gardella's new building for the Galleria d'Arte Moderna (later Padiglione d'Arte Contemporanea) in Milan, built between 1947 and 1953, presents itself in a less problematic fashion. In place of the stables building of the Villa Belgiojoso (later Villa Reale) by Leopold Pollack, which had been destroyed in the war, Gardella created a light, delicate structure that has the same volume as the building it replaced and, with its large glass wall, elegantly links the art with the garden.

The same topic, although with more complex implications, is dealt with by the Louisiana Museum in Humlebaek near Copenhagen, a masterpiece of classically disciplined northern modernism built in 1958–9 (fig. 15.1). Jörgen Bo and Vilhelm Wohlert succeeded in creating a highly sophisticated spatial composition that combines calm introvertedness with precisely placed openings, quiet attention to art, and relaxed contemplation of nature in an astonishingly natural way. The architectural forms used in postwar modernism are here impressively placed at the service of a modesty and restraint of the type that had reached its climax in nineteenth-century museum architecture.

In Search of Distinctiveness

Another museum, which opened in the same year as the Louisiana, represents the complete opposite: the Solomon R. Guggenheim Museum, which Frank Lloyd Wright had been planning for New York since 1943. The monumental sculptural form, distantly hinting at Abstract Expressionism, presents itself as a deliberate contrast to Manhattan's uniform grid, and straightforwardly declares its desire for sensational self-dramatization (fig. 15.2). The interior invites the visitor to follow a spiral ramp, which (not without its own apodictic quality) sets a predetermined circuit from which there is no escape. The paintings hung on the interior surfaces of the building's external wall are difficult to see, and instead the gaze wanders easily into the large, round courtyard that receives light from above through a Plexiglas cupola. It

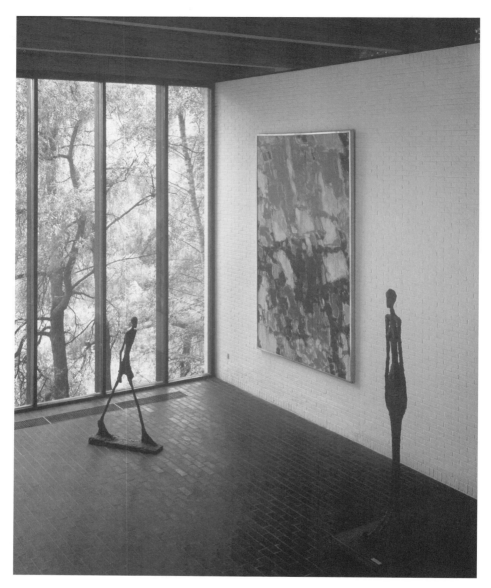

Figure 15.1 Louisiana Museum, Humlebaek, interior of the North Wing. The two-story gallery with sculptures by Alberto Giacometti and painting by Sam Francis. Photograph: Louis Schnakenburg; © Louisiana Museum of Modern Art, Humlebaek, Denmark.

is not the art, but the architecture that is the real attraction here. And the architecture is not behaving subserviently, but acting as the protagonist.

This arrogant attitude derived not only from modernism's claim that architecture itself is art. It was also a response to a new requirement in the construction program developed by Wright, the architect, and Guggenheim, the art collector, during the

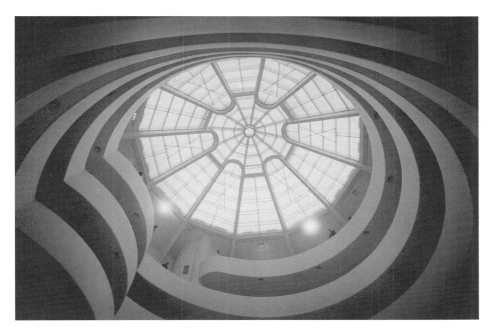

Figure 15.2 Solomon R. Guggenheim Museum, New York, Frank Lloyd Wright (1943–6, 1956–9), interior staircase. Photograph © www.schindelbeck.org.

discussions they conducted with tremendous intensity throughout the whole period in which the building was being designed and built (both Guggenheim and Wright died in 1959, the year in which the museum opened). It was the museum's duty not only to provide a home for art but also to give the collection an identity. Only an expressive, unmistakable building was capable of achieving this; and this type of building can in turn only be designed by an architect with a strong personal style. The museum as an institution thus challenges the architect to produce an advertisement for it using easily remembered images – even if these images compete with, or even contradict, those contained in the collection.

The Guggenheim sounded for the first time a theme that was to become the dominant one in twentieth-century museum architecture. Most of the new buildings followed this theme, although with varying degrees of virtuosity. Even the New National Gallery which Mies van der Rohe erected in Berlin in 1962–8, in which he realized his early dreams of creating a perfectly transparent museum, is primarily the materialization of an architectural vision, to which every consideration of practical usefulness has had to be ruthlessly subordinated. The large glass cube that is set underneath the boldly projecting coffered steel roof can only be used for exhibition purposes with difficulty, and the lower floor, where the actual exhibition rooms are located, looks like a concession that the artist has grudgingly made to the task he was commissioned with.

The Kimbell Art Museum built by Louis Kahn in Fort Worth, Texas, in 1967–72 is a different case altogether. Although Kahn had continued with a brutalist inter-

pretation of Mies van der Rohe's aesthetics in his extension for the Yale Art Gallery in New Haven, Connecticut (1951–3), in this case he continued the achievements and discoveries of the great museum buildings of the nineteenth century. The neutral design of the clearly arranged rooms and the perfect way in which natural light is filtered through skylights make the building an ideal example of modern museum architecture.

The Cultural Supermarket: Shopping and Entertainment as Ideology

However, Kahn's building also remained a special case. The Centre National d'Art et de Culture Georges Pompidou (fig. 15.3), designed by Renzo Piano and Richard Rogers in 1971–7 and erected on the Plateau Beaubourg in Paris, established a manifesto for a new attitude to architecture – in which the commission to build a museum served as a mere pretext. This is no longer organic architecture, as in the Guggenheim Museum, or constructive classicism as in the New National Gallery, but rather a form of technological expressionism. In addition to its structural functions, the steel framework that is left visible with uncompromising radicality, with the combination of supports, trussed girders, cantilevered corbels, and diagonal wind bracing, also has a symbolic function of the utmost importance. The aesthetic that the British utopian group Archigram had propagated in the 1960s, in sketches that were both virtuoso and entirely lacking in practical effect, was to be implanted here into the very heart of old Paris. The fact that this aesthetics was derived from that of Antonio Sant'Elia, whom Marinetti had recruited to his movement and had chosen as the Futurist architect par excellence, can be regarded from today's perspective almost as a case of history taking its revenge. Of all things, it was the new, impertinent language of architecture, intended to express the beauty of speed, that was being used seventy years later in the construction of a "public dormitory."

Admittedly, the underlying intention – to represent a new and dynamic form of culture – would not have been displeasing to the founder of the Futurist movement. Only a few years after the disturbances of May 1968, the conservative President Pompidou was attempting to capture the fundamental cultural change that the student revolt had initiated and express it in a museum structure that would fulfill its old task in a new way: to create identity and consensus. The anti-institutional element was to be captured and placated here in a (demagogically) open institution.

The complex and novel architectural program matched this intention. Later developments confirmed the largely ideological nature of both the intention and the program, as well as their architectural implementation. For example, the six exhibition halls stacked one on top of the other soon had to undergo alterations because they had been designed to render homage to the myth of total flexibility, but not to the art that they were intended to contain. The impressive, but definitely over-instrumentalized supporting construction had to undergo elaborate and complete renovation only twenty years after it had been completed.

In the Centre Pompidou – which was built with the claim that it would be merely a stimulating framework within which unprecedented processes of assimilation of

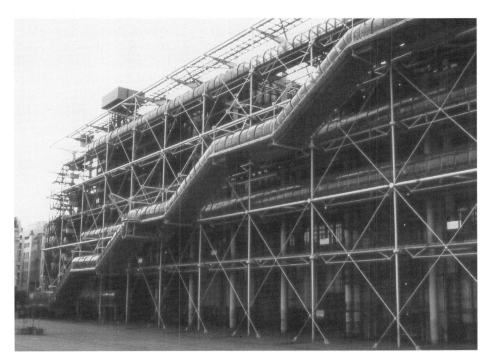

Figure 15.3 Centre National d'Art et de Culture Georges Pompidou, Paris, Renzo Piano and Richard Rogers (1971–7). Photograph © www.schindelbeck.org.

culture by the masses could take place – it is once again the building's architecture rather than art that is the real attraction. Only a fraction of the countless "visitors" who allow themselves to be conveyed upward by the Plexiglas-covered escalators enter the actual exhibition rooms. They pay homage to the monumental cultural machine and enjoy a breathtaking view of historic Paris from the top story.

The Centre Pompidou thus gives the impression of being a gigantic, high-technology stage production, symbolizing cultural work that it does not in fact perform. In these vast, noisy spaces, with crowds of people streaming through them, all contemplative analysis of art is nullified. As if they were in a supermarket, visitors are kept in constant motion and forced to consume as they do so. And the architecture matches this new function: escalators, previously used mainly in large department stores, suddenly make their first appearance in a museum. Soon they will also be making their entry into the Museum of Modern Art in New York and the Grand Louvre in Paris to channel the constant streams of visitors in and out more efficiently. And other architectural features previously only seen in railway stations, airports, and shopping malls were to follow, particularly the turnstiles through which one now has to enter more and more of the large museums. Museums are thus increasingly losing their own special physiognomy and turning into the non-places of global mass society.

But the superficial architectural innovations that started with the Centre Pompidou and soon spread to museums throughout the world also represent a more fundamental caesura. The museum appears to have lost its purpose as a public service. It is now no longer restricting itself to preserving and exhibiting art, but is also developing countless concomitant activities that will soon proceed to become its core business: guided tours, lectures, conferences, film projections, selling catalogues and books and marketing arts-and-crafts products ranging from reproductions of paintings to notepaper and T-shirts. Add to this banquets, parties, and soon fashion shows. This sort of frenetic activity is part of a program; the museum is now a place in which culture is exploited in order to create turnover. And architecture has become an instrument in this process – an iridescent, agreeable costume for a machine which, not unlike Jean Tinguely's fountain just next to the Centre Pompidou, cheerfully chops up culture (and not only bourgeois culture) into attractively presented, bite-sized pieces, providing an easy diet for the inattentive, pleasure-craving masses.

Art responded to this indifference and arrogance equally brusquely, by seeking out locations other than museums in which to present itself. Pop Art had already shown opposition to the museum as an institution; with the development of Land Art, Minimal Art, and Environmental Art, and all the more so with happenings and performances, a cultural system emerged that saw itself as an alternative to the network of museum institutions. It was a definite act of protest when Donald Judd opened a permanent installation of his works in Marfa, Texas, in 1986; along with the Chinatown Foundation, his main purpose was to denounce the inappropriate-ness of contemporary museums as locations for art. "Somewhere a portion of con-temporary art has to exist as an example of what art and its context were meant to be. Somewhere, just as the platinum–iridium meter guarantees the tape-measure, a strict measure must exist for the art of this time and place. Otherwise art is only show and monkey business" (Judd 1987: 111).

The operation carried out by the Foundation for the Arts in Manhattan was less polemical, but no less radical. Individual parts of cast-iron buildings in SoHo were converted into almost accidental-looking locations for art. Walter de Maria's *The New York Earth Room* (1977), for example, is an apartment that looks exactly the same as the ones immediately above it and below it, except for the fact that it is covered by a layer of black earth 56 cm thick and is therefore not only uninhabitable but also, in a poetic fashion, absurd. *The Broken Kilometer* (1979) also opens with apparent naturalness onto West Broadway, between a grocery store and a travel agency. These installations demonstrate, quite disrespectfully, that art is perfectly capable of man-aging for itself in the city even without museums. And, in fact, more: precisely because it is not housed in a museum, it causes greater disorientation and expresses a more intense poetry. The same is achieved by the Land Art installations created in the countryside by Robert Smithson, James Turrell, Christo, or, again, de Maria.

Postmodernism: Back to Venerability

The view of the museum as a playground for the artist–architect reached its climax in the late 1970s and 1980s. In contradiction to the working hypothesis that had led

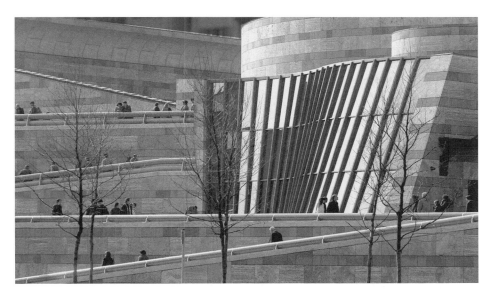

Figure 15.4 Extension of the Staatsgalerie, Stuttgart, James Stirling, Michael Wilford and Associates (1977–83). Photograph © www.schindelbeck.org.

to the program for the Centre Pompidou, society's demand that there should be clearly separate locations for art became stronger. The enclosed, unified quality of these locations was felt to be reassuring, and their explicitly institutional character was perceived as a confirmation of values that were threatening to dissolve in a fragmented, democratic, and media-dominated society. The return to history involved in postmodernism was another factor. The issue of the museum as an architectural task became a focus of public attention. Buoyed up by an unprecedented level of social demand, the museum became emblematic of a new form of community architecture; it was not by accident that the new museums were referred to as the "new cathedrals." Soon every city, and even every town, was demanding its own example of this type of "social condenser." Countless museums were built, and they were visited by countless people.

At the same time, postmodernism introduced a typology and iconography that corresponded to public recognition of the museum's old architectural task. The ritual of visiting a museum and enjoying art became thoroughly staged, and the implied cultural claims were given prestigious representation in monumental and dignified forms. Architecture was once again in demand – and plenty of it.

Emblematic of this new historical culture was Stuttgart's Neue Staatsgalerie and Kammertheater (studio theater), created by James Stirling in 1977–83 (fig. 15.4). Conceptually anticipated by the competition projects for the State Gallery in North Rhine–Westphalia in Düsseldorf and for the Wallraf-Richartz Museum in Cologne (both 1975), the building displays a sophisticated intellectual play with elementary volumes, surrealistic fusions, and openly displayed (and at the same time ironically undermined) historical references. While variously sized exhibition rooms at the

gallery level are grouped into a simple enfilade circuit, the ground floor contains a room for temporary exhibitions, a lecture hall, store-rooms and technical rooms, all arranged around a circular sculpture courtyard that is connected to a city passage-way. The foyer and café curve gently in front of this. Stirling thus created a build-ing which, thanks to its aesthetic program, not only became a place of pilgrimage for architects and architecture students from all over the world, but was also an urban element that solved a difficult town-planning problem with astonishingly unerring accuracy.

The Stuttgart museum thus became the starting-point for a new architectural genealogy that quickly spread all over Europe and to the United States of America and Japan as well. Its main characteristics included: complex programs for usage in which public facilities, such as restaurants and museum shops, played an increas-ingly important role; town-planning ambitions that made the new buildings into genuine catalysts of urban development; and ambitious aesthetic arrangements that allowed the authors in each case to provide a virtuoso display of their architectural skill (and their level of historical education). In many cases, all of this was to the detriment of what the buildings were originally conceived for: to present art in ideal conditions in terms of space, lighting, and atmosphere. At the opening of his Stuttgart masterpiece, Stirling himself is said to have remarked jokingly that the building would have turned out even better if it had not been for the annoying pictures that had had to be accommodated somehow.

This *bon mot* should not be overestimated. Nearly ten years after Stirling's mile-stone, Robert Venturi and Denise Scott Brown provided evidence in the Sainsbury Wing of London's National Gallery (1985–91) that ambitious architecture and advantageous presentation of art are not irreconcilable opposites. The collection rooms located in the upper story, arranged into three suites illuminated from the roof spaces above, are tailored to specific paintings in such a way that the pictures can be shown to their best advantage. The comparatively small extension placed in a restrained way next to the classicist main building of 1837 copies the latter's pro-portions, its façade arrangement, and even its materials, although the pilaster rhythm on the slightly vaulted front creates the effect of a meticulously elaborated screen. The play of imitation and interpretation reaches its culmination here. It serves not least to incorporate the building into its urban setting in a precise way, in which the massive staircase, with its spectacular view of Trafalgar Square, unequivocally emphasizes the building's role in the city's life.

Otherwise, a glimpse at the museum architecture of the 1980s shows that, apart from experiments in city planning, typology, and formal language, the production of exhibition spaces was often dealt with as if it were merely a troublesome duty. Archi-tects such as Aldo Rossi, Giorgio Grassi, Oswald Mathias Ungers, and Josef Paul Kleihues mainly carried out exemplary work in the urban field. Venturi and Scott-Brown, as well as Norman Foster, Jean Nouvel, Renzo Piano, and Rem Koolhaas dis-covered coherent and logical solutions for the museums' new programs of usage. With increasingly free recourse to the past, both to distant historical styles and to examples nearer at hand in classic modernism, Hans Hollein, Ieoh Ming Pei, Richard Meier, Jose Rafael Moneo, Alvaro Siza Viera, and Juan Navarro Baldeweg produced discerning formal solutions. In cities such as Frankfurt am Main, programmatically

and systematically planned museum buildings became veritable urban renewal measures that not only restored and added to the town, but also gave the entire city a new image and a new sense of life. However, the place in which the least innovation occurred was precisely in the exhibition rooms that had originally been the focus of the architectural task that museums represent. These were now a mere pretext for other strategies and experiments, which were also the main focus of interest for critics and public opinion.

Crisis and Distraction

Behind the heterogeneous and increasingly flamboyant architecture being produced, however, there was a deep and fundamental crisis approaching. Paradoxically, it was the immediate result of the art museums' unprecedented social, political, and, not least, economic success – with the financial aspect playing the decisive role. The growth that was induced by their success (and which was demanded by the various supervisory boards) also increasingly produced costs that the museums themselves had to bear. More and more special programs and special exhibitions were designed, and more and more restaurants, cafés, and shops were installed to attract more and more visitors. This activism went hand in hand, of course, with equally expanding financial requirements that had to be covered by even more frenetic activity to capture fresh markets. The resulting vicious circle meant that art came to be replaced as the museum's focus by the visitor – who was, however, not well served by this development because the museums started to adjust themselves to the visitor's taste, instead of taking the risk of extending its clientele's cultural horizons by presenting anything unusual.

The crisis, which threatened to fundamentally alter the essence of the art museum, continued in the 1990s. The architecture produced during this period is as difficult to sum up under a single stylistic denominator as that of the previous few decades. Increasingly, various attitudes coexisted (and still coexist) alongside each other. Contemporary museum buildings are mainly pure materializations of each of their author's architectural attitudes and thus serve as seismographs of the architectural culture to which they belong. The development of architecture, with its rapid succession of sometimes parallel and often opposing streams and tendencies, can be read from these buildings *in nuce*.

The Guggenheim Museum in Bilbao (fig. 15.5), built by Frank Gehry in 1993–7, is emblematic in several ways of the new situation represented by the museum as an architectural task – first and foremost because it is the product of an aggressive and expansionist international cultural policy initiated by the Guggenheim Museum in New York under the directorship of the agile culture-manager, Thomas Krens, in the second half of the 1980s. The commission went to Gehry because it was expected (correctly) that the innovative American architect would provide the strong architectural shape that a newly founded branch of the American institution in the Basque country appeared to require. Entirely in the neo-traditionalist spirit of cultivating cultural values, the program specified that the museum should serve as a treasure-house for art and a site with which people should be able to identify.

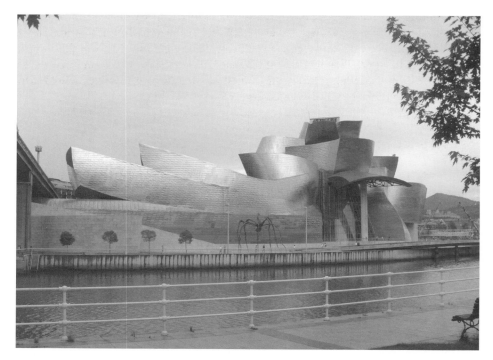

Figure 15.5 Guggenheim Museum, Bilbao, Frank O. Gehry (1993–7). Photograph by Sharon Macdonald.

Gehry implemented this program precisely, creatively, and brilliantly. With its extravagant shape, the gigantic stone and titanium structure set in the very heart of Bilbao openly asserts both its own exceptional functional status and the aesthetic universe of the contemporary world, while at the same time it makes a clear claim to its own artistic quality. It does not adapt itself to the structure of the city and radically ruptures its scale. Its sculpturally shaped volumes perturb its surroundings and create a disturbing relationship to the disparate aspects of its context – to the city's nineteenth-century districts, to the river with its industrial infrastructures, to the hills over the Nervión valley. In the interior, a complex of rooms creating an impression of magnificence opens up, which twines itself sleekly around the art works but treats them as if they were a precious decoration for itself. The collection is reduced to the status of being an ingredient, with the real attraction being the building itself. And it is thanks to the building, rather than to the collection, that Bilbao has become a landmark and a new site in Europe's tourist geography.

The fact that Gehry's work is affiliated to deconstructivism is less important here than its relationship to contemporary sculpture, particularly that of Claes Oldenburg, with whom Gehry has friendly links and has collaborated professionally on various occasions. It is not the style that is important, but the personal handwriting; and the most important element is the unequivocal assertion of his own affil-

iation to the world of art that the museum represents. The contrast with the Centre Pompidou could not possibly be sharper: the Guggenheim Bilbao is a completely un-ideological structure, an interchangeable piece of corporate identity for a multi-national organization. The fact that it has also contributed to the corporate identity of the city itself was a not entirely unplanned accident that has added a new dimension to architecture's function as a landmark.

Noisy Silence

The 1990s did not fundamentally change anything, but witnessed a decisive innovation. Alongside historicism and technological expressionism, alongside postmodernism and deconstructivism, a new current emerged in international architectural culture – minimalism. Like its predecessors, it did not displace the currents already present, but presented itself as a new, additional alternative. Twentieth-century pluralism, which was already widely diversified in any case, was enriched with yet another variant.

This new approach appears to be particularly significant for art museum architecture, since the restraint evident in minimalism at first sight corresponds to the restraint seen in the very best tradition of new museum buildings – the prime example being Leo von Klenze's Alte Pinakothek in Munich. Minimalism's restraint appears to suggest that the new generation of art museums will inevitably place themselves at the service of art – an attitude that is the greatest homage architecture is capable of showing to art.

This initial appearance is deceptive. A second look shows that even the magnificent work of architects such as David Chipperfield, Jacques Herzog and Pierre de Meuron, Annette Gigon and Mike Guyer, Alvaro Siza Vieira, Eduardo Souto de Moura, or Peter Zumthor, although rigorously restrained, consists of tremendously ambitious structures that are by no means as discreet as they pretend to be. The relentless aesthetic laws they set themselves always lead to peculiar and sometimes even quite unmanageable spatial constructs that occasionally brusquely contradict their real purpose. Minimalism is not *per se* identical with appropriateness or naturalness.

Emblematic of this is the Kunsthaus Bregenz, planned and executed by Peter Zumthor in 1990–97 (fig. 15.6). The program was not as grandiose as that of the Guggenheim Bilbao, but ambitious enough. The small town on Lake Constance was to be linked to the international cultural network and required both an appropriate space and also a symbolic architecture for the purpose. In addition, as in Bilbao, the aim was to provide the dilapidated city center with a new underpinning. Zumthor produced a brilliant solution to all three tasks. He separated the exhibition and administrative areas into two distinct buildings, which he incorporated into the structure of the town with an instinctive certainty of touch. The small black cube of the administrative area, with its indispensable café, and the large, glass-enclosed, slightly raised cube of the actual exhibition building combine to form a disturbing sculpture that exerts a subtle dominance over the town and was also publicized in

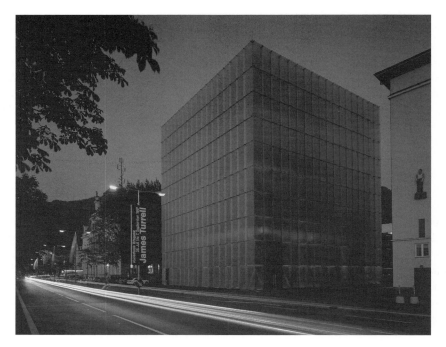

Figure 15.6 Kunsthaus Bregenz, Bregenz (1990–7), Peter Zumthor. Keith Sonnier, Millennium 2000 Installation. Photograph: Markus Tretter; © Kunsthaus Bregenz, Keith Sonnier.

all the media. The gallery rooms, stacked on top of each other, provide a generous and neutral framework for exhibitions that can be produced either by the Kunsthaus itself or by other international institutions.

Zumthor deliberately exploited various forms of refusal – refusal of the spectacular architectural gesture, refusal to create spaces that would arouse enthusiasm and affect the way in which visitors behave. From the outside, the enigmatic building scarcely reveals what it is used for, while inside it there is practically no relation to the exterior. Even the roof surface, which provides a breathtaking view of the city, Lake Constance, and the Alps, is withheld from the visitor and made inaccessible. The museum is a public cell, a *hortus conclusus*, which consciously seals itself off from the town and its bustle. The museum's function consists of providing visitors with an opportunity for concentrated contemplation of art – for which they require protection. Even the slightest glimpse of the external world would be a distraction that visitors are expected to abandon.

Zumthor's refusal is a radical, virtuoso one, but it represents an extremely subtle way of meeting the audience-oriented program he was presented with. His architecture is unsensational, but in the panorama of the constructed spectacle it attracts attention for that very reason. And the seclusion it offers corresponds precisely to the visitors' need to withdraw to a place where they are safe from noise and a flood of images.

Despite all their superficial dissimilarity, the Guggenheim Bilbao and the Kunsthaus Bregenz are thus related to each other and even represent two sides of the same coin. They are both inordinately large sculptures that have descended like envoys from a foreign and majestic culture onto dilapidated towns in order to ennoble them. They are both public spaces in which visitors can pay tribute to the ritual of assimilating art as if they were enclosed in a sacred space. They are both symbolic objects whose fullness of meaning and special use make them into landmarks. And they are both structures that attract identification and are made available to an educated cosmopolitan public that takes priority over the local citizens.

One reason for the astonishing, disorientating, and occasionally even devastating aesthetic dominance emanated by art museum buildings from the 1990s lies in the fact that they are not so much the legacy of nineteenth-century objective historicism as of the abstract modernism of the twentieth century. They are based on a passionate, sometimes doggedly determined and ruthless artistic will which no orthogonal spatial arrangement, no unbroken wall, no hidden detail of construction is capable of concealing. It is not the art that they serve to house and present that these buildings primarily care about, but their own. They are indisputably works of art that absorb other works of art. The conflict inevitably resulting is only very rarely resolved by the design. In most cases, it is the art that is receiving the architecture's hospitality that comes off second best.

Plea for Niches

In this way, the paradox arises that extreme reduction in museum architecture presents itself with exactly the same purpose as extreme expressiveness (as well as all the intermediate steps of architectural expression) – namely, to establish the primacy of architecture over art. Art museum architecture at the close of the twentieth century was still the architects' playground that it had been since at least the middle of the century. It serves primarily as a self-portrait of a new, different style. The same narcissism, the same importunacy, and, above all, the same indifference toward the deeper problems that the architectural task creates are merely clothed in a different costume.

This is not entirely the fault of the architect alone. The architect receives a program from clients, from the local community, patrons, supervisory boards, and curators. These in turn – as is their duty – discuss and agree views with the artists and above all with the public. Thus, if the program has been properly developed, it is a social program. The weaknesses of contemporary museum buildings, like their strengths, can be traced back to the society to which the new buildings are answerable.

The strengths of the buildings are undisputed. One of these lies precisely in the fact that the art museum as an architectural genre is exemplary for architecture *tout court*, as a location in which architectural ideas are implemented in practically their purest form and all important contemporary trends can be set alongside each other in their most extreme positions – their most original, most radical, and even most exalted versions. In the process, experiments in urban planning, typology, and not

least in formal language are carried out that fertilize and advance the discipline as a whole.

The buildings' principal weaknesses arise precisely out of these strengths. Architecture is drowning out the art that it is housing – and it is doing so both when it speaks loudly and when it speaks quietly. Ultimately, this can be traced back to a view of art as entertainment, which like any form of entertainment is best offered for sale in a container that attracts attention, in an unmistakable ambiance. This view is in contradiction to the view that art involves a spirit that seeks insight. The opposition between these two approaches is stark and insurmountable. Ultimately, it derives from the dilemma that museums have to reconcile their democratic tasks with the elitist claims of art. A contrast of this sort cannot possibly be overcome through compromise.

It could quite easily be overcome with alternative options, however. Even though contemporary society, and most of its artists with it, take the view that art is something stimulating – sometimes gripping, sometimes amusing, but always something consumable – there is nevertheless still a small group that insists that art is associated with insight alone. For this group, and for this type of art, there should also be appropriate museum buildings – museum buildings which are located well away from the large international networks, which are not involved in the global struggle for the culture and cultural tourism market, which are free of any commercial, gastronomic, advertising, and entertainment functions.

This ambition is by no means divorced from social and economic reality. As the new millennium began, the museum and entertainment empire established by the Guggenheim and its director Krens collapsed abruptly and far from quietly – with a dramatic deficit and the foundation's capital slashed to a third of its previous level. The new SoHo branch was converted into a glamorous Prada boutique by Rem Koolhaas. The ironical aspect of this operation overshadowed (little to the regret of the art corporation's management board) the discreet burial of Gehry's plans for another gigantic Guggenheim museum in Lower Manhattan. The branch in Las Vegas (also designed by Koolhaas) opened only after serious difficulties and then was abruptly closed. The far-reaching expansion plans for Rio de Janeiro and Taiwan were shelved, as was the ostentatiously launched Internet project for a "virtual Guggenheim."

However, the entire international museum scene did not collapse along with the downfall of the "go-go Guggenheim," and there are still quite a few new museum buildings all over the world that contrast with the decline of the Guggenheim's flamboyant and fashionable subsidiaries. Nevertheless, the economic crisis has also led to disillusionment in the art business as well. The economy has halted art's development to become the luxury branch of the entertainment industry and won scope for it to conduct less spectacular, but more profound, experiments.

The great challenge that the new millennium will pose for art museum architecture may be precisely this – to create architectures that are in keeping with a narrowly defined view of art. The most effective refutation of Marinetti's prophecy might be precisely to design and build museums that are neither dormitories nor entertainment centers, but instead sober and, at the same time, poetic laboratories for pure sensory perception and unrelentingly rational critical thinking.

260

Acknowledgments

This chapter is a revised version of a lecture given by me to the ICAM Conference held at the Center for Architecture in Vienna on September 24, 2002. A few passages were previously published under the title "Die Architektur der Kunst: Zu den Museen der neunziger Jahre" in the catalogue volume *Museen für ein neues Jahrtausend: Ideen, Projekte, Bauten*, edited by Vittorio Magnago Lampugnani and Angeli Sachs (Munich: Prestel, 1999). A preliminary version (in German) appeared under the title "Erkenntnis versus Unterhaltung: Unzeitgemässe Betrachtungen zur Architektur der Kunstmuseen des 20. Jahrhunderts" in *TransAktion* (Zurich) issue 10, 2003.

Bibliography

*Bennett, T. (1995) *The Birth of the Museum: History, Theory, Politics*. London: Routledge.

Deneke, B. and Kahsnitz, R. (eds) (1977) *Das kunst- und kulturgeschichtliche Museum im 19. Jahrhundert* [The Art and Culture-historical Museum in the Nineteenth Century]. Symposium Proceedings, Nuremberg, April 9–11, 1975. Munich: Prestel.

Harten, E. (1998) *Museen und Museumsprojekte der Französischen Revolution, ein Beitrag zur Entstehungsgeschichte einer Institution* [Museums and Museum Projects of the French Revolution: An Essay on the Genesis of an Institution]. Münster: Lit.

*Hautecoeur, L. (1993) *Architecture et aménagement des musées* [Architecture and Interior Decoration of Museums]. Paris: Réunion des Musées Nationaux.

Henderson, J. (1998) *Museum Architecture*. London: Beazley.

Joachimides, A., Kuhrau, S., Vahrson, V., and Bernau, N. (eds) (1995) *Museumsinszenierungen. Zur Geschichte der Institution des Kunstmuseums: Die Berliner Museumslandschaft 1830–1990* [Museum Production: On the History of the Institution of Art Museums]. Dresden: Verlag der Kunst.

Judd, D. (1987) *Complete Writings 1975–1986*. Eindhoven: Stedelijk Van Abbe Museum.

Klotz, H. and Krase, W. (1985) *Neue Museumsbauten in der Bundesrepublik Deutschland* [New Museum Buildings in the Federal Republic of Germany]. Stuttgart: Klett-Cotta.

Krämer, S. (1998) *Die postmoderne Architekturlandschaft: Museumsprojekte von James Stirling und Hans Hollein* [The Postmodern Landscape of Architecture: Museum Projects of James Stirling and Hans Hollein]. Hildesheim: Olms-Weidmann.

Le Moniteur Architecture AMC (1999) France: musées récents [France: recent museums]. *Le Moniteur Architecture AMC*, special issue. Paris: Moniteur.

Levin, M. D. (1983) *The Modern Museum: Temple or Showroom*. Jerusalem: Dvir.

*Magnago Lampugnani, V. and Sachs, A. (eds) (1999) *Museums for a New Millennium: Concepts, Projects, Buildings*. Munich: Prestel.

Maier-Solgh, F. (2002) *Die neuen Museen* [The New Museums]. Cologne: DuMont.

Marinetti, F. T. (1909) Le Futurisme. *Le Figaro*, Paris, February 20.

Meyer-Bohe, W. (1997) *Grundrisse öffentlicher Gebäude: synoptische Gebäudetypologie* [Plans of Public Buildings: Synoptic Building Typology]. Berlin: Ernst and Sohn.

von Moos, S. (2001) *Das Museum als Architekturproblem: aktuelle Perspektiven und historische Voraussetzungen* [The Museum as an Architectural Problem: Contemporary Perspectives and Historical Precedents]. Lucerne: Hans Erni-Stiftung.

von Naredi-Rainer, P. (2004) *Museum Buildings: A Design Manual*. Basle: Birkhäuser.

*Newhouse, V. (1998) *Towards a New Museum*. New York: Monacelli Press.

Plagemann, V. (1967) *Das deutsche Kunstmuseum 1790–1870: Lage, Baukörper, Raumorganisation, Bildprogramm* [The German Art Museum 1790–1870: Location, Building, Internal Structure, Decorative Scheme]. Munich: Prestel.

Rückert, C. and Kuhrau, S. (eds) (1998) *"Der Deutschen Kunst...": Nationalgalerie und nationale Identität 1876–1998* ["German Art...": National Gallery and National Identity 1876–1998]. Amsterdam: Verlag der Kunst.

Sarnitz, A. (1992) *Museums-Positionen: Bauten und Projekte in Österreich* [Museum-positions: Buildings and Projects in Austria]. Salzburg: Residenz Verlag.

Shapiro, M. S. (ed.) (1990) *The Museum: A Reference Guide*. Westport, CT: Greenwood Press.

de Solà-Morales, I. (1982) Toward a modern museum: from Riegl to Giedion. *Oppositions*, 25: 69–77.

Spickernagel, E. and Walbe B. (eds) (1979) *Das Museum: Lernort contra Musentempel* [The Museum: Place of Learning versus Temple of the Muses]. Giessen: Anabas.

*Steele, J. (ed.) (1994–2004) *Museum Builders*, 2 vols. Chichester: Wiley.

Techniques et Architecture (2003–4) Museums: collection/culture. *Techniques et Architecture*, special issue, 469 (December/January).

Vidler, A. (1989) Losing face: notes on the modern museum. *Assemblage*, 9: 41–57.

Zentralinstitut für Kunstgeschichte München (1994) *Berlins Museen: Geschichte und Zukunft* [Berlin's Museums: History and Future], ed. Peter Bloch. Munich: Deutscher Kunstverlag.

Civic Seeing: Museums and the Organization of Vision

Tony Bennett

From the early modern period, museums have been places in which citizens – however they might have been defined – have met, conversed, been instructed, or otherwise engaged in rituals through which their rights and duties as citizens have been enacted. They have also been, from roughly the same period, primarily institutions of the visible in which objects of various kinds have been exhibited to be looked at. The issues I want to explore in this chapter are located at the intersections of these two aspects of the museum's history. They concern the respects in which the functioning of museums as civic institutions has operated through specific regimes of vision which, informing both the manner in which things are arranged to be seen and the broader visual environment conditioning practices of looking, give rise to particular forms of "civic seeing" in which the civic lessons embodied in those arrangements are to be seen, understood, and performed by the museum's visitors. Or at least by those visitors who are included in the museum's civic address. The rider is an important one. For while, since the French revolution, public museums have been theoretically committed to the service of universal citizenries, the practice has usually proved to be somewhat different with, at various points in time, women, children, the working classes, the colonized, and, in many Western countries still (Dias 2003), immigrants simply not being addressed by museums in ways that have enabled them to occupy the optical and epistemological vantage points which particular programs of "civic seeing" both require and make possible. Indeed, as we shall see, it is often through the forms of "civic seeing" that they effect that different kinds of museums have organized the distinction between citizens and non-citizens as precisely one of differentiated visual capacities.

As it will prove difficult to address these issues comprehensively in a chapter of this scope, I shall, instead, opt for a number of symptomatic examples which, ranging across different types of museum, will offer an insight into the civic assumptions informing some of the more distinctive "visual grammars" that have been developed in association with museum displays from the early modern period to the present. I look first at the regimes of vision associated with public art museums, and especially at how these have operated as a means for enacting social distinctions in ways that have run counter to art museums' claims to speak to and for all citizens. I then look at some of the contrasting ways, from cabinets of curiosity through to evolutionary

museums, in which a civic importance has been attached to seeing nature and the relations between different cultures in a proper light. In doing so, I also consider how questions of "civic seeing" relate to those concerning other forms of sensory involvement in museum displays and, indeed, to the more general forms of civic comportment associated with the museum's conception as a key site for "civic rituals" (Duncan 1995).

This prepares the ground for an examination of the respects in which "civic seeing" in the museum is always posed relationally as a project requiring that seeing be regulated in ways that are designed to offset the influence of other practices of seeing, usually those associated with commercial forms of popular visual entertainment, which are said to lure the eye into civically unproductive forms of visual pleasure. I shall then come, finally, to consider some of the key ways in which questions of "civic seeing" are posed in relation to contemporary museum practices. These include debates about the extent to which the tension between museums and commercial forms of visual entertainment have now collapsed to such a degree that the ability of museums to shape distinctive forms of "civic seeing" is called into question. They also include attempts to move away from the directed forms of vision that have dominated Western museum practices since the Enlightenment in favor of more dialogic practices of seeing which, in enabling a greater degree of visual give-and-take between different perspectives, might prove more conducive to the requirements of "civic seeing" in culturally diverse societies.

Divided Seeing: Visual Competence and the Art Museum

In a series of pamphlets he published in the final years and immediate aftermath of World War I, John Cotton Dana, the founding director of the Newark Museum, outlined his vision for a new museum, one which, escaping the influence of the old museums of Europe – and those American museums modeled on European examples – would become useful civic instruments for a young, democratic, and industrious nation. An important part of the set of rhetorical contrasts between old and new museums that he organized for this purpose consisted in the different ways in which they addressed the eye. New museums, he argued:

> are not to be storage warehouses, or community attics, or temples of dead gods, or copies of palaces of an extinct nobility, or costly reproductions of ancient temples, or grand and elaborate structures which are of service only as evidences of conspicuous waste by the rich and as ocular demonstrations of the unwise expenditure of public funds. (Dana 1917b: 18)

Instead, he argued, they should aspire to be Institutes of Visual Instruction if they were to engage the eye in a lively and useful civic fashion that would dispel what he had earlier called "the gloom of the museum" (Dana 1917a). Returning to the same theme three years later, the ethos of visual instruction to which the new museum should aspire was highlighted by his condemnation of America's existing art museums as mere "gazing museums" (Dana 1920: 13).

264

In the event, Dana's voice was not to prove the most influential in determining the future path along which American art museums would develop. While the 1920s and 1930s, especially in the context of the New Deal, did witness a significant stress on the public educational and civic role that museums should play in relation to the general population (see Adams 1939), and while Dana remained an active and influential contributor to these debates until his death in 1929, the practices of art museums over these years were, in Andrew McClellan's assessment, more in tune with the curatorial philosophy of Benjamin Ives Gilman at Boston's Museum of Fine Arts (McClellan 2003). As heir to the civic value that Victorian theorists of art had invested in aesthetic education as a means of ordering persons and adjusting them to their place in an ordered society, Gilman continued to stress the special responsibility of the art museum to cultivate an appreciation of beauty by exhibiting the classical and modern canons of painting and sculpture. For Dana, by contrast, it was precisely this prejudice that had to be broken in favor of an active engagement with the standards of beauty enjoying widespread use and circulation in the objects of everyday life if the museum were to become a "living, active and effective institution" (Dana 1917b: 23).

As Theodore Low (1942) was to note with regret, however, the tide was running against Dana, and against Gilman too, in favor of a conception in which, far from being a place for generalized forms of "civic seeing," in which the lessons to be derived from art's improving qualities were to be made equally available to all visitors, the art museum was to function as a space governed by what Pierre Bourdieu (1996) called "the pure gaze" of the connoisseur. This had been evident earlier in the century in the so-called "battle of the casts." This pitched the inimitable quality of the original prized by the connoisseur against the educational value that had been placed on casts in earlier Victorian conceptions of the art museum's function. The battle was resolved largely in favor of the former tendency at both the Boston Museum of Fine Arts and New York's Metropolitan Museum of Art (Wallach 1998: 49–56). This tendency was, moreover, significantly strengthened and generalized through the US art museum sector as a result of the influence of the course in museum studies that Paul Sachs ran at Harvard from the 1920s through to the 1950s. Focused on cultivating "the most exacting standards of an elite," this course promoted the interests of a "narrow cult of collectors, critics and fellow museum professionals" (McClellan 2003: 22) at the expense of the public in ways which, as Dana had warned, resulted in a complete absence of any engaged civic purpose or usefulness.

The tension that is traced here between the art museum as "an elite temple of the arts" and as "a utilitarian instrument for democratic education" (Hooper-Greenhill 1989: 63) has, however, a longer history, one in which the forms of "seeing" that the museum is to organize, and for whom, have constantly been points at issue. While the French revolution had opened the Louvre to the public, and celebrated its capacity as a venue for new forms of "civic seeing" in which the virtues of a republican citizenry would be strengthened, the actual practices of the museum assumed a public that was much the same as that which had informed pre-revolutionary plans for both the Louvre and the Luxembourg Gallery. There was no attempt to instruct the museum's new public on how to read and interpret the art displayed any more

Figure 16.1 The work of art: rural literalism satirized as a new form of cultural illiteracy ("Effet de la sale des *Pietà* sur les spectateurs ruraux," *Journal Amusant*, July 23, 1859).

than the Louvre was opened to popular arts rooted in the everyday lives of the people. "Theoretically one," as McClellan puts it, "the museum public was divided by degrees of visual competence" (McClellan 1994: 9). The connections between these divisions of visual capacity and contemporary social divisions were evident in a continuing tradition of caricature which, satirizing those who visited art museums without the requisite forms of visual competence, confirmed a sense of superiority on the part of those whose eyes had been trained in the correct ways of seeing. Honoré Daumier's engraving, discussed by McClellan, of a rustic family unable to appreciate the non-realistic nature of Egyptian funerary decoration thus finds its echo, more than a half-century later, in a caricature of rural visitors who, as Dominique Poulot (1994) notes, proved unable to respond appropriately to the new forms of attention required when religious art was placed in the secular and civic context of the art museum (fig. 16.1).

If it organized a division in class terms, the civic address of the Louvre was also uneven in terms of gender. For, whilst open to women, the Louvre only included them within its civic address indirectly and in purely auxiliary roles to the extent that, in accordance with the exclusively male conception of revolutionary citizenship, its primary concern was to inculcate the virtues of a republican brotherhood

through its construction of a male pantheon of civic virtue. The same was true, nearly a century later, of Ruskin's program for the museum in which both women of all classes and working-class men were addressed through an assumed norm of the middle-class man's relation to art. The resulting relay system of looks was one in which bodily passions and manual capacities were to be directed by subordinating them to the controlling influence of male and class-centered ways of seeing (Helsinger 1994).

Seeing and Enacting Nature's Civic Lessons

Although most conspicuously foregrounded in the practices of art museums and the debates to which these have given rise, questions concerning how best to arrange the visual environment so as to promote specific civic values have also been centrally implicated in the development of other types of museum. And, as in the case of the art museum, such debates have concerned more than the regulation of sight. As key sites for the performance of civic rituals, the organization of seeing that museums aim to effect has to be seen in relation to the more general ordering of the forms of self-presentation, social interrelation, and civic comportment that they construct as normative ideals for their visitors. Indeed, it is only in the context of this broader set of concerns that the specific civic value that is placed on seeing as such can be properly appreciated. For the privileging of sight in relation to the other senses that this represents is a relatively recent phenomenon and, since there are ample signs that the attention that is accorded to speaking, hearing, and touching in contemporary museum practices are now challenging the primacy of the visual, one whose historical rim may well now be in view. It is, indeed, precisely because this is so that there has been a marked revival of interest in those pre- or early-modern practices of collection and exhibition in which civic issues were posed in relation to a broader mix of the senses, rather than solely to vision in isolation.

Paula Findlen's work has been important in this regard, tracing the respects in which the development of museums as civil and, later, civic spaces depended on a series of transformations in their socio-sensory environments. Modeled initially, in early humanist conceptions, on the monastic *studium*, the museum was seen as a solitary and contemplative space sequestered from the noise of the world. "*Museum* is a place where the Scholar sits alone," John Amos Comenius wrote in 1659, "apart from other men, addicted to his Studies, while reading books" (cited in Findlen 1994: 102). The movement of the museum from the inner recesses of the house into more permeable spaces that accompanied the development of the Renaissance cabinet was also a movement from silence into sound as the museum's function as a *solitarium* gave way to its new conception as what Findlen calls a "conversable space."

Providing a context in which displaying nature served as a prelude to ritualized conversational exchanges between (mainly) elite males, this space played a key role in shaping both the codes of civility and the classed and gendered boundaries of civil society through the inclusions and exclusions that it operated. The parallel transition, in royal collections, from the private and enclosed *studio* of the prince to the *galleria* also involved the construction of more permeable spaces in which the codes

of civility that were cultivated through knowledgeable conversation about the collections were invested with a more public and civic significance. The Düsseldorf Gallery, while adjacent to the Elector's palace and accessible through it, thus also had separate outside entrances to which local artists, civil servants, and nobility had unrestricted access and through which, as Goethe recorded in the account of his visit to the Gallery in 1768, members of a more general public were also able to enter (Sheehan 2000: 33).

As places for looking and seeing, certainly, but also as places for ritualized conversations, such early modern museums did not isolate and privilege seeing at the expense of other forms of sensory involvement. The practice of seeing itself, moreover, was modeled on the norms of conversational give-and-take rather than itself constituting a norm of attentiveness to which, as would later be the case, the other senses would be obliged to defer. The "polymathic cabinets of curiosity" of the seventeenth century, Barbara Stafford (1994) thus argues, served as prompts for conversation as a means of resolving the perplexities occasioned by the puzzling juxtaposition of apparently disconnected objects. Equally, far from distancing the eye before a scene of ordered vision, they enticed the spectator to enter into the system of sideways looks characterizing the cabinet's regime of visuality. "Crumbling shells, clumps of madrepores, coral branches, miniature busts, Chinese porcelain teapots, small medals, intaglio gems, pottery shards, drawn and engraved portraits, masks, carved ivory, pickled monsters, religious utensils, and multicultural remains," she writes, "cacophonously 'chatted' among themselves and with the spectator" (Stafford 1994: 238).

The reciprocity between seeing and conversation that is evident here was intelligible where museum collections provided the props and occasions for ritual exchanges between members of a restricted civil society whose members were presumed to meet as equals. Its intelligibility, furthermore, depended on the assumption that such conversations could be conducted on the basis of the observable properties of things that were equally open to the inspection of all. These assumptions no longer held when, under the influence of Enlightenment conceptions, the museum was developed as an instrument of public instruction. Developed most influentially at the Muséum d'Histoire Naturelle, the program for the Enlightenment museum installed a hierarchical relationship between curators and visitors in the form of a practice of directed vision through which the latter, by following the guidance of the former, were to be made to see the rational order underlying nature's apparent diversity.

This hierarchical relationship was both social and epistemological. The curator and visitor were placed on opposite sides of a line separating those who had been trained to see the invisible order subtending nature's rational classification and those untrained beholders who needed to be tutored into the right ways of seeing if they were to absorb the civic import of nature's lessons correctly. This involved, Lee Rust Emerson argues, "a special discipline of seeing" (Brown 1997: 143) in which the exhibition of different species and *genera* in accordance with the differences in their observable characteristics was a technical device intended to lead the eye to an apprehension of the invisible logic of classification which, laying at the back of such visible differences in appearances, bore witness to a rational order underlying both nature

and, as the manifestation of that order, the human mind that was also capable of understanding it. Georges Cuvier's armoires, as Brown puts it, "charted a natural world whose apparent surfaces were only an index to what could be 'seen'" (1997: 78). The economy of the relations between words and things was entirely altered in this context. Just as the eye of the visitor was distanced from the exhibited objects in order to look through them to perceive the order underlying them, so words here functioned purely descriptively as a scientific nomenclature that was superimposed on the order of things via labels which located the exhibits to which they were attached in their proper place within the rationally partitioned space of *genera* and species.

In thus making the underlying order of nature democratically visible – or, at least, making it so in principle, provided only that the citizen would subordinate his vision to the direction of the curator – the Muséum d'Histoire Naturelle affirmed the principles of revolutionary citizenship by serving as a place "where citizens could behold for themselves the mutual identity of nature and reason" (Brown 1997: 131). That, at any rate, was the theory. In practice, as well as in Cuvier's own later interpretation, the Muséum, by providing an insight into the invisible order underlying natural and, by implication, social life as well, served, in the aftermath of the political upheavals of the revolution, as an antidote to excessive political passion. "Civic seeing" here was an object lesson in order. The same was true of the civic lessons that the evolutionary museums, which flourished in the closing decades of the nineteenth century and in the early twentieth century, were meant to impart, but with the significant qualification that the order that had now to be seen and learnt was an evolutionary one governed by the principles of unidirectional and progressive time. This was, then, a developmental order which enjoined the "evolutionary showmen," who aimed to translate the principles of Darwinism into museum displays, to do so in ways that would make the lessons of evolution, and the political conclusions to be drawn from those lessons, readily perceptible.

This involved, as I have argued in more detail elsewhere (Bennett 2004), striking a delicate balance between two conflicting tendencies. On the one hand, the exhibition of progress needed to be arranged so as to locate viewers within developmental time in ways that would promote, as a civic task, an awareness of the need to contribute to the continuing progress of civilization, and thus ward off the threat of social stagnation or, worse, degeneration. The depiction of particular customs, technologies, and ways of doing things as outmoded in evolutionary terms thus served as a spur to the adoption of new forms of behavior that would further the evolutionary development of civilization, freeing it from the drag effect of unthinking habit.

On the other hand, however, in a political context in which socialist agitation was proving increasingly influential, and in which the naturally ordained orders of gender were being seriously questioned by the programs of first-wave feminism, such displays were also called on to stress the principles of evolutionary gradualism. By giving a new meaning to the old maxim that "nature makes no jumps," Darwin's account of evolution as the incremental outcome of countless unintended minor variations provided a template for late Victorian liberalism in its concern to manage progress by both encouraging and stimulating it, while simultaneously restraining it

within the pre-established limits of a capitalist and patriarchal – and, of course, colonial – social order.

This resulted in a number of significant departures from the forms of "eye management" associated with the Enlightenment museum. For, since the order of things constructed by evolutionary displays was a developmental one, that order could not be revealed, as in the Enlightenment museum, by organizing the visitor's gaze to look through the objects displayed in order to provide a glimpse of the broader order of classes and *genera* into which they fitted. Yet the order of things that evolutionary arrangements aimed to render perceptible was, like its Enlightenment predecessor, still an invisible one. As the outcome of countless unintended variations, evolution, whether of species, of design traits, or of culture and civilization, was not itself directly perceptible. It could only be made visible by displaying – side by side – forms of life, or artifacts, that both resembled each other and yet were also different, and to do so in a manner that suggested that those differences had resulted from the passage of time. Evolution, that is to say, could only be seen in the relations between things and not in things themselves. This entailed that, far from looking *into* things, the visitor's eye had to be directed to look *along* the relations between them. And, even then, a correct appreciation of the direction and tempo of evolution could not be guaranteed. How to ensure that visitors followed things in the right order? How many objects to include in a sequence, given that too few intervals between the start and the end of evolutionary series would dramatize evolution, whereas too many, while getting across the message of evolutionary gradualness, would tend to clutter displays and make them illegible? These were the kinds of debates that preoccupied the directors and curators of evolutionary museums in their endeavors to make the new order of nature that the evolutionary sciences had constructed civically readable.

While clearly different from both the "pure gaze" of connoisseurship and the practice of seeing associated with the Enlightenment museum, the practice of looking along developmental series promoted by evolutionary museums was equally a form of directed seeing. As such, it gave rise to its own distinctive way of distinguishing those who could, and those who could not, properly perceive and understand its message. The structure of the "pure gaze," as we have seen, separates those who have been tutored to see art aesthetically, in and for itself, from those who have not. The penetrative look into natural history displays in order to perceive the rational order that lies behind the visible differences that mark nature's surface appearances also inscribed a division in the visiting public between those trained in the techniques of penetrative seeing and those weekend and holiday visitors who, seeing little distinction between the Muséum and the menagerie, which was also located in the Jardin des Plantes, related to both as assemblages of the curious, the marvelous, and the exotic (Burkhardt 1997; Spray 1997).

The differentiation of visual capacities associated with evolutionary museums was different in kind to the degree that it arose immanently from the logic underlying evolutionary displays rather than from the uneven distribution of particular visual trainings. For the meaning of evolutionary displays could only be taken in by the eye which, in sweeping along the relations between objects in evolutionary series, could also fathom their direction. This was possible only from the vantage point of the

most highly developed stages of evolution. Just as, in the evolution of species, only the evolved human eye could see and understand the processes that had made its own development possible, so also only the eye that was socially and culturally evolved could properly "take in" the meaning of evolutionary displays of cultural artifacts, peoples, and ways of life. This vantage point was most evidently socially marked in its racialization: since their undeveloped state, both culturally and physiologically, was taken as axiomatic, non–white peoples and their cultures were gathered in museums only to be looked at, not to look. It was, however, also a classed vantage point, requiring that the visual practices of the working classes be subjected to a developmental program if they, too, were to see evolution correctly. In this case, as with the other examples we have considered, museum programs for "civic seeing" also involved a struggle to detach sight from the influence of popular forms of visual entertainment in view of their capacity to corrupt or misdirect the eye.

From Obstructed to Distracted Vision

The scene that Charles Willson Peale reveals and invites us to enter in his famous self-portrait before his Philadelphia museum in 1822 is, Susan Stewart (1995) argues, one of attentive viewing in which a Quaker woman holds up her hands in astonishment at the sight of a mastodon, while the attention of a father and his son are divided between the exhibits and the open book the boy is carrying as a guide, just as, behind them, another figure looks diligently at the exhibits (fig. 16.2). Seurat's *Cirque* (1891) provides a contrasting scene in which, as Jonathan Crary (2001) discusses it, the audience is distracted into a state of trance-like immobility and disengagement from the scene of simulated movement represented by the circus performance: note, for example, the two men talking to one another on the row near the back (fig. 16.3). The painting thus reworks contemporary concerns, which were as evident in responses to early cinema as they had been in debates about earlier visual technologies such as the magic lantern, of an audience stunned into a numb, and numbing, inattentiveness as the perceptual assault of the new visual media complemented the shock of the new that was the hallmark of modern city life.

By contrast, on the cover of the April 1891 edition of *Frank Leslie's Popular Monthly*, the magic lantern is shorn of its associations of visual trickery in a depiction of a lecture at the American Museum of Natural History in which the look of the audience is subjected to the authoritative guidance of the lecturer. The same was true, later, of the conditions on which film entered into the museum. Although the American Museum of Natural History was one of the first museums to experiment with film, its distrust of the medium was reflected in the delay of fifteen years between the invention of the kinetoscope in 1893 and its first film screening. Even then, film was admitted only in carefully regulated contexts: films were to be used only in lectures where their meaning could be mediated via the scientific authority vested in the lecturer, and where the risk of distracted forms of inattentiveness could be minimized (Griffiths 2002).

My purpose in juxtaposing these scenes of spectatorship is to highlight the respects in which museums have pitched themselves against what have been vari-

Figure 16.2 The museum as a scene of attentive viewing: Charles Willson Peale, *The Artist in his Museum*, 1822, oil on canvas, 103³/₄ x 79⁷/₈ in (263.5 x 202.9 cm). Reproduced courtesy of the Pennsylvania Academy of the Fine Arts, Philadelphia, gift of Mrs Sarah Harrison (The Joseph Harrison, Jr Collection).

Figure 16.3 Distracted vision: George Seurat, *Cirque,* 1891. Paris, Musée d'Orsay. Photograph RMN/© Hervé Lewandowski.

ously construed as the clouding, diverting, hynoptic, dazzling, numbing, or shock effects of more popular visual technologies in their concern to promote those forms of visual and, more broadly, perceptual attentiveness that are needed if visitors are to take part in the forms of civic self-shaping that the modern public museum has been concerned to promote. If the images I have selected here are all nineteenth-century ones, there are both earlier and more recent versions of similar tensions in the social organization of vision that have defined the countervailing forces with which museums have had to contend in their endeavors to lend a civic direction to the eye. The earliest version of these tensions is traceable to the growing epistemological and social gap that emerged, early in the eighteenth century, between the practices of wonder and those of curiosity. By the time of Diderot's *Encylopédie*, Lorrain Daston and Katharine Park argue, curiosity had cast off its reputation as a somewhat idle, undisciplined form of seeing to be ranked as a noble pursuit demanding sustained attention of a kind that only a few could achieve. Wonder, by contrast, had come to be regarded as a form of gawking, "a low, bumptious form of pleasure" that

Figure 16.4 Wonder as gawking: "Lost in Wonder," Norton, *Frank Leslie's Historical Register of the United States Centennial Exhibition*, 54.

"obstinately refused to remedy the ignorance that aroused it" (Daston and Park 1998: 328).

These terms in which curiosity and wonder were contrasted played a significant role in articulating the distinction between the elite and the vulgar as a distinction of visual practice and sensory comportment within the developing class dynamics of early capitalism. We can also see their lingering influence well into the nineteenth century. In fig. 16.4, the difference between, on the one hand, disciplined and knowledgeable looking and, on the other, ignorant gawking is depicted as a division within the group assembled before an exhibit at the 1876 Centennial Exhibition in Philadelphia. Joy Kasson, in discussing this image, draws attention to the difference between the knowledgeable and focused attention of the well-dressed couple at the left of the group and the other spectators who "stand amazed, mouths agape" in an "awkward posture (hands in pocket, necks craning upward)" which "marks them as visually unsophisticated, while their clothing suggests that they are probably poor and from the country" (Kasson 1990: 38).

A similar social division informed the terms in which, at the end of the nineteenth and start of the twentieth century, the distracted attention attributed to film audiences – who were strongly associated, prior to the introduction of narrative cinema and respectable exhibition venues, with the unruliness of the urban working masses

– served as a negative counterpoint to the ideal of the rational, attentive, well-ordered museum-going public. And it is true still of the terms in which the relations between museums and television audiences are posed when, as in a 1996 article in *The Daily Telegraph*, a visit to the museum is invoked as an antidote to the culture of the "couch potato," the late-twentieth-century embodiment of distracted vision, who, it is said, "sits back on the sofa, his face vacuous and dumb, and stares at the television screen, and shovels popcorn, crisps, chocolates into his agape mouth while programmes reel by" (cited in Michael 2000: 106). For Seurat's *Cirque*, we could now substitute a typical scene from the UK television series *The Royle Family* in which a roomful of couch potatoes eat, drink, gossip, fight, and make love before the box that is never able to claim more than half of their attention.

Yet, instructive though they are, these parallels across a two-century period can prove misleading if attention is not also paid to the role of different theories of vision and the accounts these offer for the failed or distorted vision of the popular classes. The ways in which distinctions of visual capacity mark, and are marked by, social distinctions, that is to say, have to be understood as being also conditioned by different accounts of the mechanisms of seeing. As Jonathan Crary's work has shown, the transition from the geometric optics which governed European accounts of vision in the seventeenth and eighteenth centuries to the physiological optics which governed nineteenth-century accounts of vision played a key role in redefining the terms in which class anxieties associated with the politics of vision were posed. Within geometric optics based on the Cartesian model of a detached and decorporealized observer, the challenge for museums and other rational forms of visual instruction was to counter the influence of popular visual entertainments whose effect was seen as one of clouding or obstructing vision by placing an irrational filter between the eye and the world. The challenge for the museum here was to provide a clear and transparent rational alternative to such obstructed vision.

Within physiological optics, by contrast, vision was viewed as rooted in the physiological structure of the body and, thereby, emerged as simultaneously subjective (different from one person to another) and social (to the degree that the body is affected by the social conditions in which it is formed). This meant that the reform of vision to attune it to the requirements of "civic seeing" was a developmental rather than a restorative project in the sense that it had to take account of the embodied nature of the visitor's visual capacities and the ways in which these might be affected by specific social conditions (Bennett 2004: ch. 7). For Henry Pitt Rivers, accordingly, it was not enough to simply arrange evolutionary displays to teach the working man the lessons of progress; account had also to be taken of the specific circumstances, rooted in working-class occupations, that limited or impaired working-class vision so as to put in place a developmental program of visual instruction that would counteract those influences.

Account has also to be taken, so far as contemporary debates are concerned, of the changed relations between museums and commercialized forms of popular visual entertainment. If the incorporation of television, video, touch-screen computer displays, and Imax theaters into museums has undermined the distinction between museums and other contemporary forms of audiovisual culture, the increased importance of blockbuster exhibitions has also undermined the distinction between

275

museums and the field of commercialized cultural production. There are, indeed, those who, like Paul Virilio (1994) and Jean Baudrillard (1982), have argued that these distinctions have now been eroded to such an extent that museums have themselves become "distraction machines." Such postmodernist perspectives typically overlook the variability of museum experience arising from the practices of different types of museum and variations in the social characteristics of their visitors. They also, Nick Prior suggests, miss the respects in which museums are now typically obliged to negotiate and balance the needs and interests of different audiences to meet government requirements that they both enlarge and diversify their visitor profiles. This means, he argues, that "the contradictory tensions that once might have threatened the idea of the museum are now permanent fixtures within it" (Prior 2003: 67; see also chapter 31 of this volume).

The tension between the museum as civic educator and the negative pull of distracted vision is thus often enacted *within* museums as forms of "civic seeing" compete with distracting visual technologies within the museum space. This tension is, indeed, sometimes playfully foregrounded in exhibits whose primary *raison d'être* is to engage with the organization of museum space as a form of meta-commentary on the conditions of museum practices. Duane Hanson's *Tourists* (1970) – two figures located in one of the galleries at the Scottish National Gallery of Modern Art – is a case in point (fig. 16.5). Gaudily dressed in casual holiday clothes, cameras at the ready, shopping in hand, these two life-like figures, installed unmarked in the middle of the gallery, catch the visitor unawares. Their verisimilitude is so strong that it takes a while to realize that they are not really other visitors, but an exhibit which, in occupying the position of spectator, foregrounds the question of the visitor's look. Are they knowledgeable visitors? Ignorant ones? Are they puzzled? Attentive? Or just bluffing? And what kind of visitor am I? How do the other visitors see me? As like these? Or as different? There is not really any way of answering these questions which, nonetheless, are insistently raised, injecting a restless tension into the museum space as the visitor is caught between self-recognition and identification as also a tourist and an uncertainty regarding just how best to play the role of spectator which, forced by the exhibit into self-consciousness, is thereby made problematic, no longer habitable on a purely spontaneous basis.

Yet these figures also point to something of broader significance by calling attention to the importance of point of view within the museum space. Throughout the greater part of the eighteenth and nineteenth centuries, seeing civically was a practice to be undertaken from the singular and fixed spectatorial position that museums sought to arrange as the ideal vantage point from which to see and understand the logic underlying the exhibition arrangements. The key developments in the twentieth century, particularly during its later decades, worked to pluralize the optical – and, thereby, also the epistemological and political – vantage points that visitors might take up within, or bring with them into, the museum space. This was, and continues to be, partly a matter of the development of interactive displays which, freeing visitors from the tutelary grip of earlier, more directive forms of curatorial authority, leaves them more scope for constructing their own forms of engagement with the museum environment. No longer addressing a detached observer placed before an exhibition arranged for his or her contemplative inspection, interactive

276

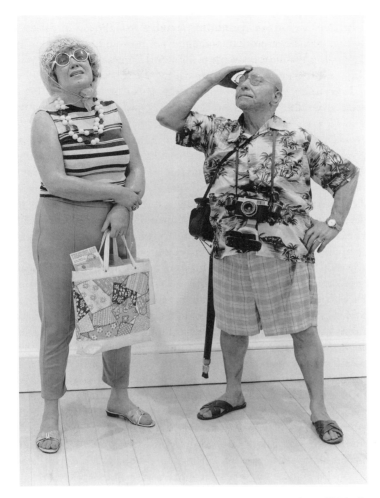

Figure 16.5 The spectator as exhibit: Duane Hanson, *Tourists*, 1970. Reproduced courtesy of the Scottish National Gallery of Modern Art, Edinburgh.

displays also often dislocate the eye from its controlling position in favor of more multi-sensory forms of engagement in which sight, hearing, and touch interact to produce a more embodied, active, and participatory relationship to the museum, and to other visitors.

These transformations, Andrew Barry argues, have, in turn, to be understood in relation to the shift from earlier, more corporate models of citizenship to those of neo-liberalism. If interactivity promotes the development of more active forms of self-direction, less reliant on the authoritative guidance of others, this reflects a change in the role of public authorities from one of directing the citizen to one of establishing the conditions in which citizens can become more active in, and more responsible for, their own government (Barry 2001: 135). It is, however, in response

to the politics of difference and the influence on museums of the emerging agendas of cultural citizenship in their commitment to the recognition of differentiated cultural rights and entitlements that demands for museums to develop more plural forms of "civic seeing" have been most insistently pressed.

Seeing Differences Differently

Museums have, of course, always, at least in their modern forms, been places for making differences – whether natural, social, or cultural – visible. They have done so, however, mainly to and for a controlling point of view which, while theoretically universal, has, in fact, in accordance with the restricted understandings of citizenship prevailing at different historical moments, been restricted to white, middle-class men only, to white men only, to white men and women only, or to men only. Their depictions of difference have also usually been hierarchically arranged, especially, in the context of museums' varied roles in relation to colonial histories, in racialized hierarchies – whether they be those of the developmental series of typological arrangements, cranial exhibitions, or exhibitions resting on Orientalist assumptions (Dias 1998). The first significant challenges to such hierarchical visualizations of cultural difference came, in the United States, from Franz Boas's development of the life group in its commitment to reconstruct the totality of a culture as something to be understood on its own terms and, in France, from the similar exhibition forms developed at the Musée de l'Homme by Paul Rivet and Georges-Henri Rivière and, subsequently, the *ensemble ecologique* developed by Rivière at the Musèe des Arts et Traditions Populaires (Dias 2003). While these new visual technologies proved important as a means for equalizing the relations between exhibited cultures in the museum space, they proved problematic in other regards, seeming to fix the cultures they depicted in a condition of static timelessness (Dias 1994). Their chief limitation from a contemporary perspective, however, is that they did little to challenge the assumption that there was one, and only one, point of view for the visitor to occupy.

By contrast, the terms in which questions of "civic seeing" are now posed typically stress the need for exhibitions to be arranged so as to allow multiple possibilities in terms of how they are both seen and interpreted. The demands of indigenous peoples, of diasporic communities and minority ethnic groups of longstanding, of women, and of minority sexualities for recognition within the museum space have thrown into high relief the socially marked nature of the supposedly universal, singular point of view museums had earlier constructed as the sole one from which their civic lessons might be correctly seen and interpreted. At the same time, new approaches to difference, whether of ethnicity, sexuality, or gender, which stress their unfixed, relational, constantly mobile nature, have called into question the taxonomic approaches to difference which characterized museum practices throughout the nineteenth century and well into the twentieth.

This stress on the relationality of difference – the view, as Kevin Hetherington (2002: 196) puts it, "that we all differ from one another because of gender, class, ethnicity, age, sexual orientation, etc. and not that just some differ from an unmarked

norm" – has led, in the steps that museums have taken to translate public-policy agendas of cultural diversity into practical and material forms, to access strategies that are posed in terms of "multiple optics rather than a singular trained one" (2002: 192). And this, in turn, has led to a significant renewal of interest in exhibition practices from the pre-Enlightenment period when the eye was not so singularly addressed or so authoritatively regulated. James Clifford's (1997) influential conception of museums as "contact zones" – as places where the perspectives of different cultures can mix and mingle, entering into dialogic exchanges that are not subordinated to a controlling point of view – has thus been connected to a notable increase in the attention paid to cabinets of curiosity both for the possibility they hold out of a more flexible, varied, and dialogic organization of the visitor's lines of sight and as a reminder of exhibition contexts in which seeing was accompanied by reciprocal relations of conversational give-and-take.

It is, however, in programs intended to make museums accessible to the visually impaired that the continuing optical bias of museums is most revealingly thrown into high relief. The visually impaired, Hetherington argues, constitute a special case for the museum as "they are not just another category of difference demanding that they be recognised and catered for, from the start they are Other to the principles of the museum as a space of vision and conservation" (Hetherington 2002: 195). Examining a number of initiatives, from the Tate's first touch tour for the blind in 1976 to the 1998 tactile display and book produced by the British Museum to make the Parthenon Frieze accessible to the visually impaired, Hetherington usefully draws attention to the respects in which they reflect a continuing optical bias. The tactile book prepared for the Parthenon Frieze, for example, aimed to make available to touch an impression of the frieze as it might be seen, thus functioning as a sight-centered organization of touch in a context where actually touching the frieze itself was not allowed. It was, as Hetherington puts it, "an optical prosthesis in which the hand (secondary) can become like the eye (primary)" (2002: 199). It is a useful example in underlining how far museum practices would need to change if the eye-centered programs of "civic seeing" that have dominated the museum's post-Enlightenment history were to be developed into places for more pluri-directional civic exchanges that engage a broader range of the visitors' senses.

Acknowledgment

The research for this chapter was completed as a part of the program of the ESRC Centre for Research on Socio-cultural Change. I am grateful to the ESRC for its generous support.

Bibliography

Adams, T. R. (1939) *The Museum and Popular Culture*. New York: American Association for Adult Education.

Barry, A. (2001) *Political Machines: Governing a Technological Society*. London: Athlone Press.

Baudrillard, J. (1982) The Beaubourg effect: implosion and deterrence. *October*, 20: 3–13.

*Bennett, T. (2004) *Pasts beyond Memory: Evolution, Museums, Colonialism*. London: Routledge.

Bourdieu, P. (1996) The historical genesis of the pure aesthetic. In P. Bourdieu, *The Rules of Art*, pp. 285–312. Cambridge: Polity Press.

*Brown, L. R. (1997) *The Emerson Museum: Practical Romanticism and the Pursuit of the Whole*. Cambridge, MA: Harvard University Press.

Burkhardt, R. W. (1997) La ménagerie et la vie du muséum. In C. Blanckaert, C. Cohen, P. Corsi, and J-L. Fischer (eds), *Le Muséum au premier siècle de son histoire*, pp. 481–508. Paris: Éditions de Muséum National d'Histoire Naturelle.

Clifford, J. (1997) *Routes: Travel and Translation in the Late Twentieth Century*. Cambridge, MA: Harvard University Press.

*Crary, J. (2001) *Suspensions of Perception: Attention, Spectacle, and Modern Culture*. Cambridge, MA: MIT Press.

Dana, J. C. (1917a) *The Gloom of the Museum*. Woodstock, VT: Elm Tree Press.

— (1917b) *The New Museum*. Woodstock, VT: Elm Tree Press.

— (1920) *A Plan for a New Museum: The Kind of Museum it will Profit a City to Maintain*. Woodstock, VT: Elm Tree Press.

*Daston, L. and K. Park (1998) *Wonders and the Order of Nature, 1150–1750*. New York: Zone Books.

Dias, N. (1994) Looking at objects: memory, knowledge in nineteenth-century ethnographic displays. In G. Robertson, M. Mash, L. Tickner, J. Bird, B. Curtis, and T. Putnam (eds), *Travellers' Tales: Narratives of Home and Displacement*, pp. 164–76. London: Routledge.

*— (1998) The visibility of difference: nineteenth-century French anthropological collections. In S. Macdonald (ed.), *The Politics of Display: Museums, Science, Culture*, pp. 36–52. London: Routledge.

— (2003) Cultural difference, diversity of cultures and cultural diversity: the case of the Musée du Quai Branly. Paper presented at the Museums and Difference Conference, Centre for Twenty-first Century Studies, University of Milwaukee.

Duncan, C. (1995) *Civilising Rituals: Inside Public Art Museums*. London: Routledge.

Findlen, P. (1994) *Possessing Nature: Museums, Collecting, and Scientific Culture in Early Modern Italy*. Berkeley, CA: University of California Press.

*Griffiths, A. (2002) *Wondrous Differences: Cinema, Anthropology, and Turn-of-the-century Visual Culture*. New York: Columbia University Press.

Helsinger, E. (1994) Ruskin and the politics of viewing: constructing national subjects. *Harvard University Art Museums Bulletin*, 3 (1).

Hetherington, K. (2002) The unsightly: touching the Parthenon Frieze. *Theory, Culture and Society*, 19 (5/6): 187–205.

Hooper-Greenhill, E. (1989) The museum in the disciplinary society. In S. M. Pearce (ed.), *Museum Studies in Material Culture*, pp. 61–72. Leicester: Leicester University Press.

Kasson, J. S. (1990) *Marble Queens and Captives: Women in Nineteenth-century American Sculpture*. New Haven, CT: Yale University Press.

Low, T. L. (1942) *The Museum as a Social Instrument*. New York: Metropolitan Museum of Art/American Association of Museums.

McClellan, A. (1994) *Inventing the Louvre: Art, Politics, and the Origins of the Modern Museum in Eighteenth-century Paris*. Cambridge: Cambridge University Press.

*— (2003) A brief history of the art museum public. In A. McClellan (ed.), *Art and its Publics: Museum Studies at the Millennium*, pp. 1–49. Oxford: Blackwell.

Michael, M. (2000) *Reconnecting Culture, Technology and Nature: From Society to Heterogeneity*. London: Routledge.

Poulot, D. (1994) Le musée et ses visiteurs. In C. George (ed.), *La Jeunesse des musées: Les musées de France au XIXe siècle*, pp. 332–50. Paris: Musée d'Orsay.

Prior, N. (2003) Having one's Tate and eating it: transformations of the museum in a hyper-modern era. In A. McClellan (ed.), *Art and its Publics: Museum Studies at the Millennium*, pp. 51–76. Oxford: Blackwell.

Sheehan, J. J. (2000) *Museums in the German Art World: From the End of the Old Regime to the Rise of Modernism*. Oxford: Oxford University Press.

Spray, E. (1997) Le spectacle de la nature: contrôle du public et vision républicaine dans le Muséum Jacobin. In C. Blanckaert, C. Cohen, P. Corsi, and J-L. Fischer (eds), *Le Muséum au premier siècle de son histoire*, pp. 457–80. Paris: Éditions de Muséum National d'Histoire Naturelle.

Stafford, B. (1994) *Artful Science: Enlightenment Entertainment and the Eclipse of Visual Education*. Cambridge, MA: MIT Press.

Stewart, S. (1995) Death and life, in that order, in the works of Charles Willson Peale. In L. Cooke and P. Wollen (eds), *Visual Display: Culture beyond Appearances*, pp. 30–53. Seattle: Bay Press.

Virilio, P. (1994) *The Vision Machine*. London: British Film Institute.

Wallach, A. (1998) *Exhibiting Contradiction: Essays on the Art Museum in the United States*. Amherst: University of Massachusetts Press.

Space Syntax: The Language of Museum Space

Bill Hillier and Kali Tzortzi

Space syntax is a theory of space and a set of analytical, quantitative, and descriptive tools for analyzing the layout of space in buildings and cities (Hillier and Hanson 1984; Hillier 1996). Originating in architecture, it aims to answer key architectural questions: does the layout of space make a difference? If so, what kind of difference? And how may these differences be realized through design? For museums and galleries, it asks: does spatial design influence how people move through the layout? Does it make a difference to how a gallery works as a social space? Can it be used to enhance curatorial intent? Does the way in which spaces are arranged into visitable sequences and objects are organized spatially play a role in shaping the experience of the museum visitor?

Curatorial intent has received much attention in recent years, and now forms a focal theme for museological studies. A substantial literature exists on how curators may realize their intentions, and how changing intentions may reflect deeper changes in the contextual society. *Architectural* intent has received much less attention, in spite of an increasing realization, particularly through innovative architectural projects, that spatial design can make a significant difference to the museum experience.

One reason for the lack of academic – as opposed to architectural – interest may be purely practical: the absence of a *language of space* in which to formulate clear distinctions between one kind of spatial layout and another. This chapter aims to fill this gap by introducing the space syntax theory and methodology for analyzing spatial layouts as *configurations* of related spaces, and showing how they can be used to investigate the social functioning and cultural meaning of spatial layouts. Syntactic studies of museums over the past two decades are reviewed to show both the wide range of layout issues that have been covered, and also how the accumulation of new ideas and techniques has brought the study of *architectural* and *curatorial* intent closer together. We end the chapter by suggesting that the museum/gallery constitutes a more or less well-defined spatial type, with varied potentials to act both as a pedagogical device for communicating knowledge and narrative, and for transmitting a non-narrative meaning in the form of an embodied spatial and social experience.

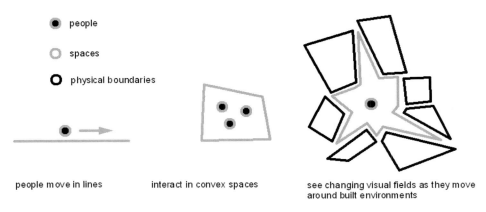

people

spaces

physical boundaries

people move in lines

interact in convex spaces

see changing visual fields as they move around built environments

Figure 17.1 Space is *intrinsic* to human activity: moving through space, interacting with other people in space, or even just seeing ambient space from a point in it, has a natural and necessary geometry.

The Basic Ideas of Space Syntax

Space syntax is based on two philosophical ideas. The first is that space is not just the *background* to human activity and experience, but an *intrinsic* aspect of it. For example, human movement is essentially *linear*, in that movement traces are line patterns; interaction between two or more people is essentially *convex*, in that it requires a space in which all points are visible from all others; and we experience ambient space in buildings and cities as a series of differently shaped *isovists*, or visual fields (fig. 17.1). Because human activity has its own *natural geometry*, we tend to shape space in ways that reflect this.

The second idea is that how space works for people is not simply about the properties of this or that space, but about the *relations* between all the spaces that make up a *layout*. For example, how people move will be affected by the *configuration* of spaces within a layout; that is, the way it offers sequences and choices in a more or less intelligible way. We need, then, to know how to *describe* layouts as spatial configurations with reasonable consistency if we are to examine the effects of different layouts on how people move. This is not straightforward since, although human languages have words that describe spatial relations between two or three elements ("between," "beyond," "inside," and so on), they do not have comparable terms for more complex sets of spatial relations. This may be because patterns of spatial relations are so basic to our existence that they form part of the apparatus we think *with*, rather than think *of* (Hillier 1996).

So we need to find a way to analyze spatial configurations of the kind we find in building and urban layouts. The key to how this can be done lies in a very simple observation: that spatial layouts are different when seen from different points within them. For example, if we take the simple layout in fig. 17.2a and locate ourselves in the gray space marked 0, we have a choice of four spaces one space away – and so 1-deep and marked 1 – then three spaces 2-deep, and so marked 2, and two spaces 3-deep, and so marked 3. If we add them up, the *total depth* of the gray space from

283

Bill Hillier and Kali Tzortzi

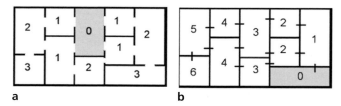

a b

Figure 17.2a–b Spatial layouts are different when seen from different points within them. If we locate ourselves in the gray space marked 0 (a), we have a choice of four spaces one space away – and so 1-deep and marked 1 – then three spaces 2-deep, and so marked 2, and two spaces 3-deep, and so marked 3. If we start in the corner gray space marked 0 (b), we have one space 1 deep, two 2-, 3-, and 4-deep, and one each at 5- and 6-deep. The *total depth* of the gray space from all other spaces is the measure of its degree of integration in the complex.

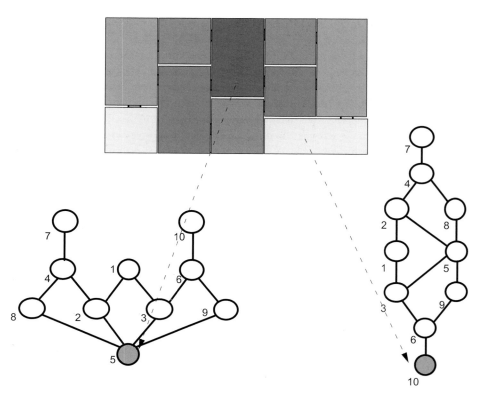

Figure 17.2c The relations between each space and all the others in the layout can be made visually clear in two ways: by shading spaces according to the *integration values* resulting from the analysis, from darkest for most integrated through to lightest for least; or, by making the chosen space the "root" of a *justified graph*, in which the levels of depths from each space are read as vertical levels. So an integrated space has a shallow graph, a segregated space a deep graph.

284

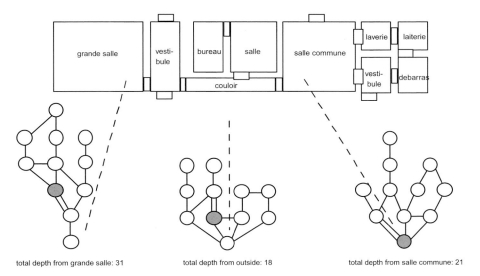

total depth from grande salle: 31 total depth from outside: 18 total depth from salle commune: 21

Figure 17.3 The justified graphs of the rural French house from the outside, the *salle commune*, and the *grande salle* show how culture manifests itself in the layout of space. For example, the *salle commune*, the space used for everyday living, is not just a space with certain furnishings and implements, but also with a certain configurational relation to the house as a whole: it is the most integrated function space and lies on all rings of circulation in the layout.

all other spaces is 16. If we start in the corner gray space marked 0 in fig. 17.2b, we have one space 1 deep, two 2-, 3-, and 4-deep, and one each at 5- and 6-deep, giving a total of 30. This is the basis of the measure of the degree of *integration* of each space in a complex. The lower the total, the more integrated the space; that is, the fewer you have to pass through to go to all other spaces in the layout. The less integrated, or more *segregated*, the space, the more spaces you have to pass through to go to all the others. We can clarify this by making each of the chosen spaces the "root" of a *justified graph*, as in fig. 17.2c, in which the levels of depths from each space are read as vertical layers above the root. So an integrated space has a shallow graph, a segregated space a deep graph. *Integration* values are then indices of the relations between each space and all the others in the layout.

Space syntax analysis combines these two basic ideas. Spatial layouts are first *represented* as a pattern of convex spaces, lines, or fields of view covering the layout (or, as we will see, some combination of them), and then calculations are made of the *configurational* relations between each spatial element and all, or some, others. We can use these techniques to show how culture manifests itself in the layout of space by forming a spatial pattern in which activities are integrated and segregated to different degrees. The spaces we identify with functional labels such as "living room," "kitchen," or a "reception" room are not just spaces with certain furnishings, decorative styles, and equipment, but also with a certain *configurational* relation to the house as a whole. For example, in the rural French house shown in fig. 17.3, together with its justified graph from the outside (treating this conventionally as a single

285

space), the *salle commune*, used for everyday living, is the most integrated function space, much more integrated, for example, than the *grande salle* for the formal reception of guests on special occasions, or the male householder's *bureau*. The pattern of integration values resulting from the analysis can be thought of as a *deep structure* in the layout, and it can be brought to the surface by simply shading spaces according to the values, from darkest for most integrated through to lightest for least (red to blue if colors are used).

Making mathematical patterns visually clear by using colors or shades to represent numbers is an essential feature of space syntax analysis, since it makes underlying patterns, which cannot easily be seen in the plan, immediately clear to intuition. Other kinds of unobvious pattern can be made clear by the justified graph. For example, we can see from the justified graph of the French house that the *salle commune* lies on all rings of circulation in the layout, and this is far from obvious in the plan. Bringing *structures* to the surface in this way accesses them to design thinking and allows them to be used as *ideas to think with* in creative design. But we can also use our ability to identify structures as a step in cultural and social analysis. For example, to the degree that the spatial expressions of functional patterns are found to be consistent across a sample of houses – taken, say, from a region or a social group – then we can say that we are finding evidence of cultural patterning in the layout of the house itself which can be numerically demonstrated. In this way, syntactic analysis can show that the layouts of houses and, indeed, of buildings in general, can be seen, *in themselves*, as spatial expressions of culture (Hanson 1998).

Showing How Layout Shapes Movement and Co-presence

But space not only reflects and expresses social patterns, it can also generate them by shaping a pattern of movement and co-presence in a layout. In general, and with important exceptions, syntactic analysis can show that the pattern of spatial *integration* in a spatial layout will correlate to some degree, and often to a high degree, with a pattern of movement. Fig. 17.4a, for example, shows the traces of the first ten minutes of movement for a hundred visitors entering the Tate Britain gallery, showing that some spaces are much more visited than others (see below). Fig. 17.4b then shows the patterns of *visual integration* in the gallery considered purely as a spatial pattern. This kind of syntactic analysis is created by first filling all the space of the layout with a uniform grid, as fine as we like, then drawing the visual field from the central point in each grid square, and subjecting the overlapping visual fields to integration analysis. So visual integration analysis shows not simply what can be seen from each space, but how many visual fields we have to move through to get to see the whole layout from each point in it.

The pattern of visual integration in fig. 17.4b clearly resembles the density of movement traces in fig.17.4a, and this can be checked statistically. By correlating the average density of movement traces in each space with their average visual integration, we find an r^2 value of 0.68, meaning that 68 percent of the differences in movement rates between spaces is related to the pattern of visual integration in the layout

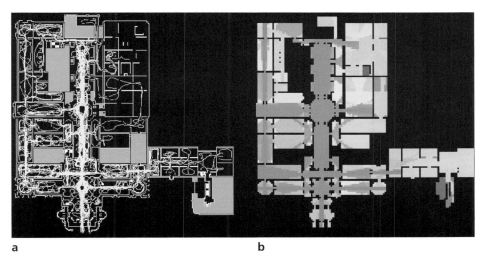

a b

Figure 17.4a–b The traces of a hundred people entering the Tate Britain gallery and moving for ten minutes (a) show that, upon entering, visitors quickly diffuse into many, but not all, parts of the gallery. The density of movement traces clearly resembles the pattern of visual *integration* in the spatial layout, shown in (b).

as a whole. By shaping movement in this way, the spatial layout of course also shapes a certain pattern of *co-presence* amongst visitors, and this is one of its most powerful effects.

Studying Museums and Galleries with Space Syntax

The basic strategy of syntactic analysis is then to measure the configurational properties of the spaces that make up the layout, and through this to identify the key *structural* features of the layout. These can then be correlated either with the ways in which spaces are categorized ("living room" or "early baroque" are equally categorizations of space) or with movement rates within and between them, or both. Since in museums spatial layout is commonly used both to express and to support a pedagogical intention of some kind, and to shape a pattern of visiting, space syntax analysis can show how it is done and assess how it is working. Syntactic analysis can in effect be used to show that spatial layout is both a *dependent* variable, in that it can reflect pre-given social, cultural, or pedagogical ideas, and an *independent* variable, in that spatial design can, and usually will, have the consequence of shaping a pattern of movement and co-presence amongst those using the layout.

In practice, syntax analysis is usually rather more complex, with many other measures of the configurational positions of spaces in a layout, and also measures of the layout as a whole (Hillier and Hanson 1984). For example, research has shown that an important guide to how a layout works can be its *intelligibility*, defining this as the degree to which what can be seen from individual spaces in the layout gives a good

guide to the position of that space in the layout as a whole. For example, from each space we can see how many connections to other spaces it has, but not how integrated it is, since that depends on a whole complex of relations most of which cannot be seen from individual spaces. The degree to which the pattern of *connectivity* of spaces correlates with the pattern of integration values is then a good guide to the *intelligibility* of the layout (Hillier et al. 1983).

Design Choices

How then has space syntax been used to develop our understanding of spatial layout in museums and galleries? The first published study using space syntax to study the museum/gallery was Hillier et al. (1982). This was about design choices, and took the form of an analysis of the schemes proposed for the extension to the National Gallery, London. The purpose of the study was to show that by studying critical spatial properties, such as axiality, segmentation, and movement choices, the effects of spatial design on the informational potential and social character of the designs could be more explicitly discussed, and so allow a more considered functional assessment to complement the aesthetic considerations.

Reviewing the designs, the study suggested that the functioning of a scheme characterized by major axes which cross its length and width, and combined with secondary axial lines directly intersecting the main ones, would generate quite different pedagogic potentials and social experience to a more elaborate layout. One would facilitate a *pedagogic* approach in which a simple structure, with variety and directness of spatial relations and sequencing, would suggest a chronological presentation of the collection, and permit a more simultaneous appreciation of paintings and awareness of others. The other would, by allowing a range of alternative routes, encourage a more exploratory visiting style, and at the same time reduce awareness of other visitors and lead to shorter and less regular encounters between them. In effect, the various schemes offered quite different outcomes in terms of the *spatial culture* that each might encourage; the one more overtly pedagogic and at the same time more public and ceremonial, the other more exploratory and private. As it turned out, political development ensured that neither of the schemes was built, but the spatial character of the Sainsbury Wing as it was finally built is critically reviewed below.

Space and Knowledge

Shortly after the study of design choices, Peponis and Hedin (1983) published a seminal paper that provided a more thoroughgoing critique of the pedagogic and social implications of layout. The paper was based on a comparison between two galleries of the Natural History Museum, London: the Birds Gallery, which had remained almost unchanged since it was originally designed in 1881, and the Human Biology Hall, which had recently been reorganized according to new exhibition design principles.

The authors argued that in the Birds Gallery, the experience of spaces, arranged on both sides of a central aisle, which emphasized synchrony and hierarchical order, reflected the hierarchy of the classificatory ideas of nature that dominated scientific thinking in the eighteenth century. In the Human Biology Hall, nature was presented though a sequence of spaces with varying depths, a spatial feature that, they argued, reflected the theory of evolution that prevailed from the middle of the nineteenth century. The changes in exhibition design were also held by the authors to reflect the changing relationship of visitors to knowledge, from direct and explicit to indirect and elaborated. While in the Birds Gallery, the scientific knowledge was abstract, in that it was displayed but not explained, in the Human Biology Hall, it took a more physical, and didactic form, reinforced through the popularist use of educational technology. The authors also saw current educational thinking reflected in the layout in that the subdivided and axially fragmented exhibition layout served to individualize learning, in contrast to the older morphology, characterized by the central aisle which acted as an integrating point and generated a collective interaction between people and objects. In all these senses, the authors contended, the changes in layout reflected changes in ideas of scientific knowledge and its forms of transmission.

Comparing Design Alternatives

A wider comparative study of layouts, focusing on both social and pedagogical implications, was made by Pradinuk (1986). He set out from the conceptual framework for the transmission of knowledge developed by the sociologist Basil Bernstein (1975) in his theories of curriculum and pedagogy. Pradinuk transposed Bernstein's concepts of "classification" and "frame," originally developed to describe differences in educational knowledge and its transmission, to a more overtly spatial interpretation. He used *classification* to mean the visual insulation of the gallery contents from each other, which would either encourage or handicap cross-comparisons, and *framing* to mean the degree to which the layout was sequenced to generate a more or less rigid circulation, and so govern the degree of differentiation in visitors' itineraries. Within this theoretical framework, he discussed how spatial classification and framing would affect the pedagogical relations between curators and visitors and the social relations among visitors, and suggested a typology of some of the best-known and most influential galleries in Europe.

Pradinuk's work inspired Choi's empirical studies of movement and space use in museum and gallery layouts in the early 1990s. For his PhD thesis of 1991, Choi investigated how far movement in the spaces of eight art museums in the US was shaped by spatial configuration, rather than, for example, by the objects on display (see Choi 1999). He recorded visitors' itineraries and spatial distribution within the layout in two ways: first as "state" counts by recording the numbers of people, both static and moving, in each space in a series of visits; second, as "dynamic" patterns, by unobtrusively tracking individual itineraries and recording the frequency with which each space was visited, and recording as *tracking score* the number of people who visited each space, and as *tracking frequency* the number of times each space was

visited. He then correlated the two sets of observations both with non-spatial factors, such as the number of objects in each space, and with various measures of spatial configuration, including convex and axial connectivity and integration and also a measure of visual range, meaning the number of other spaces visible from each space.

The results showed that for the "state" description there was no correlation between the number of standing or moving people and the number of objects, and only an inconsistent relation with configurational variables. For people that could be seen from each space, there was, however, a strong and more or less consistent relation with configurational variables. The results from the analysis of the "dynamic" tracking data told a very different story with a strong and consistent pattern of correlation between tracking score and configurational variables and an even stronger pattern of correlation with tracking frequency.

Choi also showed that the degree to which movement was predictable from configuration was dependent on the degree of syntactic intelligibility and integration of the layout, a phenomenon that had been previously noted for urban movement (Hillier et al. 1987). On the basis of these findings, Choi proposed to distinguish two models according to the role of space in structuring the pattern of movement: the *deterministic* model, according to which movement is forced as circulation choices are restricted; and the *probabilistic* model, according to which movement is allowed to be more random but modulated by configurational variables.

The design implications of Choi's results were explored by Peponis (1993), using the case of the museum to illustrate how understanding functional potentials at a more abstract level allowed much clearer formulation of a range of strategic design alternatives. Taking the Human Biology Hall in London's Natural History Museum (see above) as a polar case in which an intricate and localized layout leads the visitor to lose any sense of the building as a whole and the social nature of the museum experience, and the Guggenheim in New York as the opposite case of a layout in which public space dominates a highly deterministic viewing sequence, so that the "two scales of viewing come together into a single experience" (1993: 59), he argued that the High Museum of Art in Atlanta exploits both potentials and creates a much richer informational and social experience. It does this in two ways: first, through a structure of integration, or *integration core*, which continually guides locally varying movement patterns in the galleries back to balcony-like spaces overlooking the socially active main atrium; secondly, by creating a system of visibility in the galleries themselves that is much richer than the system of potential movement, so that works of art form the foreground and other visitors, appearing at varying depths in the visual field, sometimes in other galleries and sometimes in the main atrium, form a background. In this way, the spatial layout created a "built choreography of movement and encounter" (1993: 60), in which the museum was an experience of objects and of other people richly integrated with each other in continuously varying ways.

Space and Visiting Culture

Design issues were very much to the fore in the study of the Tate Britain gallery by the Space Syntax Laboratory of University College London in 1996 (Hillier et al.

1996). The study was commissioned by the Tate to ascertain the likely impact of major additions and changes that were then being proposed to the existing layout, and how they might affect the patterns of visiting and, more importantly, the *spatial culture* of the gallery. Visitor surveys had shown that visitors valued the informal and relaxed atmosphere of the Tate, and tended to visit quite impromptu and to repeat visit. These were clearly key factors in the success of the gallery in spite of its somewhat remote location. The puzzle was how the formalized, neo-classical layout of Tate Britain (fig. 17.4a) could have created what seemed to be a distinctly informal visiting culture.

The first task was to grasp how the gallery worked, and understand the pattern of movement, which previous studies had concluded were random. Recording the routes of one hundred people for the first ten minutes of their visit (fig. 17.4b) showed that, upon entering, visitors quickly diffused into many, but not all, parts of the gallery. Many moved along the central axis of the building from the main entrance and then turned into one of the shorter cross axes, but with a strong bias to the left-side galleries. Many others also turned immediately right to go to the Clore Gallery (a late twentieth-century extension), but although this led to high flows in the main access spaces in the Clore, there was a comparative paucity of visits to the immediately adjacent dead-end spaces. To a surprising degree, the main feature of the pattern established in the first ten minutes of visits turned out to be reflected in the all-day movement pattern.

This study entailed an unusually thorough study of movement and space use, and its approach has become the standard method for researching spatial layout in galleries and museums. Since, for the most part, the layout of Tate Britain takes the form of room-like spaces with entrance spaces often, though not always, aligned in sequences, counts of visitors crossing each threshold were made throughout the working day, so that dividing the result by two (because each visitor both enters and leaves the space) gives a mean occupation rate for each space. Separate counts and plots were also made of how many people were viewing exhibits in each space, again throughout the working day. Each space could thus be indexed with moving rate, a viewing rate, and a total occupancy rate.

The counts were then correlated with the integration values given by the *convaxial* representation and analysis of the layout, in which rooms were treated as linked to all spaces to which there was a direct visual connection. It was found that, as in the case of visual integration discussed earlier, there was a very strong and linear relation (an r^2 of 0.68, on a scale from 0 to 1, with 0 meaning no relations and 1 a completely deterministic relation), which showed that the gallery is being read by visitors in the way it is designed: as rooms linked visually through entrances in *enfilade*.

The key outcome of the Tate study was that it showed the power of a building to shape what went on in it through spatial layout. But what made the gallery work this way, and could this in some way explain how an informal visiting pattern arose from a formal layout? In fact, the spatial analysis had already made the reason clear by bringing to light an *integration core* (fig. 17.4b) which linked the main entrance through the main axis to the deeper parts of the building, and structured access both to the galleries from the entrance, and between galleries in different parts of the

building. The axis, and the ways in which the galleries were related to it, thus played a key role both in making the layout intelligible as a whole (this was numerically confirmed) and in organizing movement both in and out of the gallery and within the gallery. This is the layout structure which we call a *shallow core*, and which has been shown to create a sense of dynamic informal encounter in many types of building. This also has the additional, emergent effect which we have come to call *churning*: people moving within the gallery continually *re-encounter* not only those moving in and out of the gallery, but also those they have encountered previously, perhaps on entering the gallery. As people tend to unconsciously survey those with whom they are co-present, a re-encounter event can also be a conscious or unconscious recognition experience, a kind of minimalist version of meeting someone for a second time. These re-encounters feel like random events but are really a predictable effect of the layout. The *churning* effect of a layout constantly disengages people from each other and then, with a certain probability, brings them together again. Layouts with *churning* tend to be experienced as more socially exciting than those which preclude it by over-sequencing. This then is how an informal, and apparently highly random, pattern of visiting, with a sense of dense encounter, can arise from a formalized, neo-classical layout.

Spatial Genotypes

Starting out from the Tate Britain study, Huang (2001) sought to develop a more theoretical approach to issues of the spatialization of knowledge and social relationships in museum layouts. Taking into account the accumulated syntactic studies, and setting this against the wider *museological* literature, he argued that two key themes were embedded in the spatial layout of the modern museum: *organized walking* and the *congregation of visitors*. The former is realized by the organization of spaces into visitable sequences so as to map knowledge, and the latter is manifested by the creation of gathering spaces, the *integration core*, where the congregation takes place. Huang saw these two *genotypical themes*, of organizing sequences and gathering spaces, as providing the ground for a typology of museum buildings.

To illustrate this argument, Huang analyzed the syntactic structure of a set of museums taken from different time periods and countries, and classified them according to their strength of sequencing and the depth of their integration core. He observed that the integration core of the museum had tended to become deeper with time, and suggested that this shift in the pattern of space had an additional effect on the pattern of co-presence and co-awareness: the physical encounter of people through movement which took place in the shallow core was weakened and replaced by the virtual encounter of visitors through visibility, rather than physical co-presence, in the deep core of the museum. There was no comparable trend as far as the strength of sequencing was concerned, though he did observe a particularly strong sequencing tendency in British museums.

This uneven distribution of genotypes in terms of time and place suggested, Huang argued, that progress is not so much evolutionary, but a matter of finding different ways of resolving an underlying conflict between their social and informa-

tional function within a finite set of possible ways to design museum and gallery layouts.

Space and the Viewer

Issues of building forms were added to those of layout by Psarra and Grajewski with the aim of enabling not only a better understanding of museum space, but also a better understanding of architecture as a larger, three-dimensional, spatial, formal, social, and symbolic entity within which spatial characteristics of the kind space syntax measures occur.

Setting out from the fact that the condition of interaction between architecture and the viewer presupposes an understanding of the building, the authors studied, in the context of the Museum of Scotland in Edinburgh (Psarra and Grajewski 2000a), the geometric, volumetric, and surface articulation of the building and related it to its syntactic characteristics. The paper made also a proposition about the ways in which the viewer can grasp the three-dimensional sculpturing of the building and looked at how three-dimensional formal characteristics can affect space cognition and intelligibility.

The link between space syntax and the architectural and narrative potential of museums was further explored by the authors in the study of the Art Gallery and Museum, Kelvingrove (Psarra and Grajewski 2000b, 2002) and mainly by Psarra in the comparative analysis of the two museums discussed above, together with the Natural History Museum, London and the Burrell Museum, Glasgow (Psarra 2005). In this paper she looked at how architectural concepts such as axiality and "spatial layering" affect integration, and suggested that architecture uses syntactic properties to mediate the relationship between the building and the displays, create a varied and interesting experience, and stimulate further exploration. From the historic buildings to the contemporary ones, museum architecture moves from "showing" to "telling" and from classification to narrative.

Space and Cognitive Function

More recently, a shift of emphasis within the literature of space syntax was suggested by the contributions to the Fourth International Space Syntax Symposium, held in 2003: from the discourse of the social and informational implications of museum layout as a whole, to a discussion of the behavioral and cognitive functions of the exhibition space in particular.

This interest was clear in a paper by Peponis et al. (2003), which explored the relationship between layout and visitor behavior in open–plan exhibition settings (see also Peponis et al. 2004). It reported research into two traveling science exhibitions, which displayed mainly interactive individual exhibits, classified according to conceptual themes; these were made evident through various means, from thematic labeling to coloring and spatial zoning. The challenge of this project, both methodological and theoretical, was to explore how a permissive, open layout, allowing

almost any pattern of movement and unobstructed visibility, may influence the pattern of exploration.

By looking at the spatial arrangement of individual exhibits in relation to visitors' *contacts* (i.e. their awareness of exhibits) and *engagements* (i.e. physical interaction) with exhibits, the study revealed that spatial parameters had a powerful effect on the way in which people explored the exhibitions. Interestingly, the pattern of contacts was affected by variations in direct accessibility, while the pattern of engagements was influenced by the degree of individual exhibit cross-visibility.

The authors also looked at the spatial arrangement of exhibits on the same theme. It was found that while the sequencing of contacts was affected by the extent to which the plans were thematically grouped, engagements resulted from a conscious decision, the cognitive registration of thematic labels. This implies that the design of space can add relationships between objects which are otherwise equivalent in terms of accessibility or visibility, and affect the ways in which displays are perceived and cognitively mapped.

Space as a Symbolic System

Having discussed how the museum layout acts as a pedagogic device which communicates knowledge and narrative, we now come to see that it can also work as pedagogy aimed at transmitting a non-narrative meaning. Stavroulaki and Peponis (2003) have argued that C. Scarpa's design of the Castelvecchio Museum stages our perception of how exhibits are related and constructs spatial meaning.

To illustrate this argument, the authors discussed first the positioning of statues in the sculpture galleries of the museum. It was demonstrated that their seemingly free spatial arrangement revealed at closer inspection a deliberate configurational pattern: the location of each statue took into account that of others, so that their gazes were either directed to each other, or intersected at a common point in space – often the integration axis (fig. 17.5). But the perception of these changing relationships between the statues' gazes depended on the visitors who occupied the point of intersections and acknowledged the convergence of gazes; so the structure of the field of intersecting gazes could be revealed though movement. The statues became more than objects to be seen, and distant viewing was replaced by an embodied experience. In this way, space not only generated patterns of encounter between visitors, but also sustained a field of co-awareness, generated by the co-presence of both visitors and statues.

Interaction between Architectural and Curatorial Strategy

The study of the Sainsbury Wing by Tzortzi (2003) also witnesses this recent emphasis on the micro-level of spatial arrangement in museum settings and the pattern of interdependencies between architectural and curatorial intent. The author first analyzed the morphology of movement and argued that this was explained by the

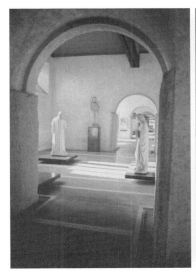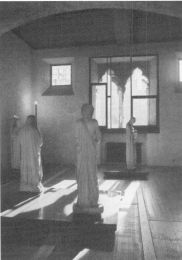

Figure 17.5 View of spatial relationships between statues at Castelvecchio Museum, Verona. Photograph by Kali Tzortzi.

configuration of the layout. The observation study – which involved recording the routes of one hundred people through the galleries – showed that the spaces that seemed to lie more often outside the search track of visitors were those of the central sequence of the tripartite layout, the intended circulation spine of the gallery. It was suggested that this feature is related to the "non-Hamiltonian" structure of the gallery's graph: if the visitor follows the route proposed by the gallery, he or she cannot pass through all the spaces and return to the original starting-point, without having to return to some of the same spaces or miss parts of the gallery.

But if, on one hand, the power of space overrides the intentions of the curators when it comes to the morphology of exploration, on the other hand, the author argued, the synergy between curatorial strategy and spatial design renders successful the gallery's operation. She demonstrated that the display layout used spatial potential to maximize the impact of objects: the maximization of axiality eliminated distancing effects, and in combination with the open spatial relationships, favored thematic or aesthetic relationships between works; intentional vistas and axes that reinforced each other served the placement of paintings in strategic locations at the end of long lines of sight or in the deepest spaces, a display device that aimed to create a visual effect and thus induced movement. As a by-product effect of both the spatial layout and the arrangement of the display, the spatial character of the itinerary became more coherent and the experience more deterministic.

Looking at Castelvecchio in comparison with the Sainsbury Wing (Tzortzi 2004), the author found a different kind of integration of the design of space with the layout of the display; rather than using space to enhance the exhibits, the architect used objects to articulate and elaborate space, and this seemed to have an effect by making

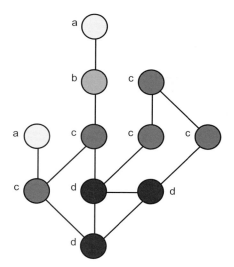

Figure 17.6a The *abcd* typology of spaces according to their embedding in the layout. An *a*-space is a dead end. A *b*-space is on the way to a dead end, so you must return the same way. A *c*-space has one alternative way back, and a *d*-space is more than 2-connected and lies on at least two rings.

the visitor culture more exploratory, and the museum visit, an architectural experience, a spatial event.

The Museum/Gallery as a Spatial Type

Syntactic studies, then, are increasingly looking at the interaction between the two aspects of spatial layout: the layout of objects within spaces and the layout of the relations between spaces, and showing them to be both highly interdependent and powerful in their ability to shape the experience of the visitor. But what can be said more generally? It is perhaps too early to draw general conclusions about the layout of exhibits within spaces, or the interaction between this and the configurational interrelations between spaces, but at the level of the configuration it does seem possible to make generic suggestions about the nature of the museum/gallery as a spatial type, and how architectural intent can serve curatorial intent at this level.

To do this we must introduce some simple theoretical ideas which are too recent in their genesis to have yet had great influence on empirical studies. These ideas concern certain *intermediate* properties of spaces between the local and the global through which we can assign each space in a layout a *typological* identity according to how each fits into a local complex and so acquires potentials for occupation and movement. We can show how this is done (fig. 17.6a) by using the justified graph from the exterior of the French house shown in fig. 17.3. Each space is categorized

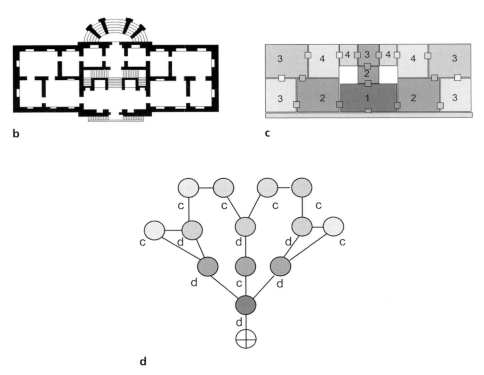

b

c

d

Figure 17.6b–d The plan for a museum designed by L. C. Sturm in 1704 (b). If we examine its spatial plan (c) and its justified graph (d), we find features that seem to characterize the museum/gallery as a spatial type: there is a *gathering* space at the entrance for setting out from and returning to, and a layout of exhibition spaces into a *visitable sequence*, so you can walk through the gallery without back-tracking or getting lost.

as one of four generic types. An *a-space* is 1-connected, and so is a dead end, has no through movement potential, and is likely to be a space for *occupation* only, like the *grande salle* or the *bureau*. A *b-space* has more than one connection but lies on the way to a dead end, or a number of dead ends (the *salle*, which leads to the *bureau*), so all movement through a *b*-space must eventually go back the same way. In a *tree*, that is a complex without circulation *rings*, and so without choice of routes between spaces, all spaces must be either *a*- or *b*-spaces. A *c-space* is 2-connected and lies on at least one circulation *ring*, and has one alternative way back, so movement can come back through one other space. The spaces of the French house associated with female working activity (*laverie*, *laiterie*, and *debarras*) form a sequencing of *c*-type spaces. A *d-space* is one which is more than 2-connected and lies on at least two rings, and so has more than one alternative way back. A *d*-space tends to be a local focus for movement, and in the French house we find that the only internal function space (as opposed to a transition space such as a corridor) which is a *d*-space is the *salle commune*, the principal everyday living area, which lies on all the rings of circulation (Hillier 1996: 275–334).

297

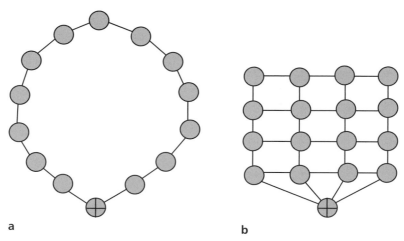

a b

Figure 17.7a–b The museum/gallery as a spatial type is characterized in general by deep interconnected rings of space. There are two extreme possibilities: at one extreme there is the single ring of space in which every visitor has to go through the same sequence of space in the same order (a); at the other extreme is the maximally connected grid, which tends to form a complex hard to understand and impossible to visit in an orderly sequence (b).

 The number and pattern of the different space types in a layout will affect its degree of integration, in that in general b- and c-spaces increase segregation since they increase *sequencing*, defined as the need to pass through spaces to get to other spaces, while a and d tend to increase integration by increasing the connectivity of circulation spaces, or adding spaces which are immediately adjacent to circulation space and so do not add to the need for movement through spaces to get to others.

 We use this idea of spatial types to address the most basic question of all: how far does the museum, and its sister, the gallery, constitute a distinct spatial type, with common features across time and space. We can usefully begin with the museum designed by L. C. Sturm in 1704 (fig. 17.6b), often said to be the first of its kind. If we examine its plan (fig. 17.6c) and its justified graph (fig. 17.6d), we find two features that seem to recur often enough to warrant inclusion in any definition of the museum/gallery as a spatial type. There is a *gathering* space near the entrance, which serves as a space for setting out from and returning to; and, linked to this, there is a set of spaces which are strongly sequenced so they can be walked through without back-tracking or getting lost. In the justified graph, this shows itself as deep rings which interconnect to each other but which eventually lead back to the gathering space. This type of pattern is very much a defining characteristic of the museum/gallery as a spatial type, though, of course, there are many exceptions, so we should see it as a generic, rather than universal, pattern.

 We can then clarify some of the most common variations in the type by examining the types of space. A pattern of space made up of deep interconnected rings eventually returning to the same space must be made up of c- and d-spaces, and how

298

many of each there are and how they are arranged will have a dramatic effect on the experience of the visitor. The more *c*-spaces, then the more constrained the visitor will be to particular sequences, while the more *d*-spaces, then the more there is choice and potential for exploration. The Sturm gallery, for example (fig. 17.6c), has six *d*-spaces, in which there is a choice which can lead you round more than one way, and eight *c*-spaces, in which you must either return the way you have come, or go on to the next space in the sequence. So, it offers slightly more sequencing than choices. This will not always be the case. For example, the galleries in Tate Modern in London, which were intended to be modeled on the layout of the Tate Britain gallery (see above) in fact reverse the proportions of *c*- and *d*-spaces: in Tate Britain around two-thirds are *d*-spaces, offering a certain exploration potential and choice of pathways for visitors, while in Tate Modern, less than one-third is *d*- and more than two-thirds are *c*-spaces, with much greater constraints on exploration and choice of routes. This is reflected in what many experience as the very different feel of the two galleries.

We can clarify this dichotomy by taking these different layout potentials to extremes. At one extreme, we have the case in which every space is a *c*-space. In this case, the layout can only take the form of a *single sequence* of spaces (fig. 17.7a), and so in effect a single large ring of spaces in which every visitor has to go through the same sequence of spaces in the same order. At the other extreme, in which every space is a *d*-space, with each connected to all of its neighbors, we have the *grid of spaces* (fig. 17.7b), which is virtually impossible to understand and visit in an orderly sequence, and offers so much choice that, without other constraints, every visit is a new but unmemorable experience.

The balance between *c*- and *d*-spaces will therefore be a crucial factor in visitor experience. The way in which spaces are connected to each other will inevitably influence the potential pattern of movement and, by implication, the way in which visitors explore exhibitions and are exposed to information and to each other. This has clear implications both for the pedagogical function of the museum and for its social function. On the pedagogical side, we can use the sequencing of spaces to support and express a didactic view of how exhibits should be experienced and in what order. This can be very powerful where there is a legitimate and illuminating narrative, as for example in showing the chronology of an artist's work (the 1996 Cezanne exhibition at London's Tate Britain would be a strong example), or a sequence of contrasts (as in the 2002 Matisse–Picasso exhibition at Tate Modern). In such cases, spatial sequencing gives tacit articulation to an intellectual experience, and so becomes positive for the visitor. But in the absence of a "necessary narrative," an overly sequenced layout may appear as unnecessarily constrained. The alternative is to design space in such a way that sequences are more localized, and interconnected so as to allow visitors to choose different paths and construct their own pattern of experience. This reduces the most overt kind of didactic potential through space, and in effect transfers some degree of intellectual control to the visitor.

The *social* effects of the balance between sequencing and choice are more subtle, but perhaps even more potent. Like any spatial layout, a museum or gallery will generate and sustain a certain pattern of co-presence and encounter amongst visitors through the way it shapes movement. If a layout takes the form of a single sequence,

then by and large and subject to variations in speed, visitors will enter, circulate, and leave the exhibition in the same order. The limiting case is the "Indian file" in which we are always behind some people and in front of others, and there need be no variation in this, and so little change in the pattern of co-presence. On the other hand, a layout with a certain degree of structured choice, realized through an intelligible *shallow core*, will mean that visitors who enter the layout together will often split onto different pathways, and then re-encounter each other some time later, perhaps moving in the opposite direction, creating the *churning* effect we referred to earlier, and thus enhancing the social experience of the visit.

Conclusion

This review has shown how syntactic theories have progressively evolved and how methods have been gradually extended, and that new themes and questions are now open to investigation. Having established a clear link between spatial layout and the functioning of layouts, the ground has been established for asking more far-reaching theoretical questions about issues of cognition and perception, about visual space, or space as symbolic system, ideas that are increasingly emerging in syntactic research. At many levels, then, in the study and design of museum and gallery layouts, space syntax has emerged as a powerful tool not only for asking questions, exploring design alternatives, and making strategic choices, but also for enhancing our intuitions about the effect of space on our cognitive and social experience.

Bibliography

Bernstein, B. (1975) *Class, Codes and Control*, vol. 3: *Towards a Theory of Educational Transmissions*. London: Routledge and Kegan Paul.

Choi, Y. K. (1999) The morphology of exploration and encounter in museum layouts. *Environment and Planning B: Planning and Design*, 26: 241–50.

Hanson, J. (1998) *Decoding Homes and Houses*. Cambridge: Cambridge University Press.

*Hillier, B. (1996) *Space is the Machine*. Cambridge: Cambridge University Press.

*— and Hanson, J. (1984) *The Social Logic of Space*. Cambridge: Cambridge University Press.

—, Burdett, R., Peponis, J., and Penn, A. (1987) Creating life: or does architecture determine anything? *Architecture and Behaviour*, 3 (3): 217–31.

—, Hanson, J., Peponis, J., Hudson, J., and Burdett, R. (1983) Space syntax: a different urban perspective. *Architect's Journal*, November 30: 47–63.

—, Major, M. D., Desyllas, M., Karimi, K., Campos, B., and Stonor, T. (1996) *Tate Gallery, Millbank: A Study of the Existing Layout and New Masterplan Proposal*. London: Bartlett School of Graduate Studies, University College London.

*—, Peponis, J., and Simpson, J. (1982) National Gallery schemes analyzed. *Architects' Journal*, October 27: 38–40.

Huang, H. (2001) The spatialization of knowledge and social relationships. In *Proceedings of the Third International Space Syntax Symposium*, pp. 43.1–43.14, Atlanta (undertow.arch.gatech.edu/homepages/3sss/Proceedings_frame.htm).

Peponis, J. (1993) Evaluation and formulation in design: the implications of morphological theories of function. *Nordisk Arkitekturforskning*, 2: 53–61.

*— and Hedin, J. (1983) The layout of theories in the Natural History Museum. *9H*, 3: 21–5.

—, Conroy Dalton, R., Wineman, J., and Sheep Dalton, N. (2003) Path, theme and narrative in open plan exhibition settings. In *Proceedings of the Fourth International Space Syntax Symposium*, pp. 29.1–29.20, London (www.spacesyntax.net/symposia/SSS4/fullpapers/29_Peponis.pdf)

—, —, —, and — (2004) Measuring the effects of layout upon visitors' spatial behaviors in open plan exhibition settings. *Environment and Planning B: Planning and Design*, 31 (3): 453–73.

Pradinuk, R. (1986) Gallery room sequences: pedagogic, social, categoric and mnemonic effects. Unpublished MSc thesis. London: Bartlett School of Architecture and Planning, University College London.

Psarra, S. (2005) Spatial culture, way-finding and the educational message: the impact of layout on the spatial, social and educational experiences of visitors to museums and galleries. In S. MacLeod (ed.), *Reshaping Museum Space: Architecture, Design, Exhibitions*, pp. 78–94. London: Routledge.

— and Grajewski, T. (2000a) Architecture, narrative and promenade in Benson and Forsyth's Museum of Scotland. *Architecture Research Quarterly*, 4 (2): 122–36.

— and — (2000b) Tracking visitors can help improve museum layouts. *Museum Practice*, 13 (5/1): 10.

— and — (2002) Track record. *Museum Practice*, 19 (7/1): 36–42.

Stavroulaki, G. and Peponis, J. (2003) The spatial construction of seeing at Castelvecchio. In *Proceedings of the Fourth International Space Syntax Symposium*, pp. 66.1–66.14, London (www.spacesyntax.net/symposia/SSS4/fullpapers/66Stavroulaki-Peponis.pdf).

Tzortzi, K. (2003) An approach to the microstructure of the gallery space: the case of the Sainsbury Wing. In *Proceedings of the Fourth International Space Syntax Symposium*, pp. 67.1–67.16, London (www.spacesyntax.net/symposia/SSS4/fullpapers/67Tzortzpaper.pdf).

— (2004) Building and exhibition layout: Sainsbury Wing compared with Castelvecchio. *Architecture Research Quarterly*, 8 (2): 128–40.

New Media

Michelle Henning

New media is everywhere in museums these days – in the form of hand-held information devices, information kiosks, installation art, display supports, and archiving systems, as a means to reorganize working practices, and to keep track of visitors.[1] It is used to make new kinds of museums, such as "virtual museums," and to represent the things in existing museums. Most simply described as computer-based or digital media, it is the product of the convergence of mass-media practices and technologies with data-processing technologies (Manovich 2001: 23). In the context of the museum, it introduces changes in display, working practices, and in the museum's relationship to its audience. New media involves the translation of older practices and representation into digital form. Media production, circulation, and consumption all become computer based. This means not just the emergence of new cultural technologies and practices, but the transformation of existing ones in a process that has been termed "remediation" (Bolter and Grusin 2000).

Each new technology is welcomed for its potential to change and improve the existing order of things, or, alternatively, distrusted as a threat to the status quo. This is very true of new media because of the way in which it remediates existing and well-established institutions such as museums. In the case of the museum, advocates of new media see it as a means to modernize, popularize, and increase the efficiency of a rather staid or old-fashioned institution. The film and media scholar Alison Griffiths describes the attraction of new media for museum directors and curators as its "promise to democratise knowledge, to offer contextual information on exhibits, and to boost museum attendance" as well as to "offer flexibility" and help represent "complex ideas and processes," enlivening exhibitions, providing multiple viewpoints and encouraging social interaction between visitors. Skeptics see new media as threatening the authenticity of the artifact, the authority of traditional sources of knowledge, and as vulgarizing museums, turning them into commercialized sites for "edutainment" (Griffiths 2003: 375–7).

Though both positions are often grounded in experience, neither allows us to distinguish between different types of new media and their different uses. Both contain unexamined assumptions about museums and new media. For instance, hostility to the use of new media in the museum is shaped by the perception that the two are antithetical in character. New media is associated with technologies that are hi-tech

and miniaturized, with representations that are transient and "virtual," and with popular entertainment. The museum is associated with the static, the monumental, with historical permanence and materiality, and with education. In my view, these differences are less significant than they may appear and other similarities and differences are more revealing. Meanwhile, the notion that new media will improve museums overvalues new technologies, while underestimating the extent to which new media brings with it its own structures of knowledge and practices.

In this chapter, I argue for a different understanding of new media. I suggest that new media is best thought of as a means to organize and structure knowledge and visitor attention in the museum, not as a means of communication or set of devices. I attribute a transformative power to new media, but one that does not exactly match that envisaged by the new media advocates or skeptics in the museum. In my view, new media is most interesting for what it does to the hierarchies of knowledge in the museum, particularly in relation to the division between "front and back regions" of the museum (the phrase is from the sociologist Erving Goffman; see Goffman 1990). At the end of the chapter, I suggest how a return to ways of organizing knowledge that predate the modern museum offers the most promising possibilities for reinventing museums and new media. To begin, though, I want to lay the foundation of my argument by considering how exhibitions and museums have historically participated in the development of new media and how museums themselves can be considered media.

Historicizing New Media

Historians of computing and of new media trace the origins of this technology in Babbage's analytical engine, the Jacquard loom, and Vannevar Bush's concept of a Memex machine. New media developed in World War II, in Alan Turing's code-cracking work, in the concept of military situation rooms, and the technology of the German Magnetophone (Kittler, 1999; Manovich 2001: 22). The new media theorist Lev Manovich sees new media as the merging of two histories: of computers and calculating machines and of analogue media (Manovich 2001: 21–6). We can draw another thread into this narrative if we trace the development of exhibition techniques in museums and international expositions. This history would include the introduction of *in situ* display techniques, such as tableaux and dioramas, to museums in the 1880s and 1890s. It would include the development of interactive display techniques in avant-garde exhibition design, beginning in 1928 with El Lissitzky's Soviet Pavilion at the Pressa Exhibition in Cologne. Long before computers made it possible to synthesize different media into multimedia or produce "virtual" environments, exhibition design was a means to combine different media, to physically immerse an audience in artificially constructed settings, and to engage them in active, physical manipulation of their surroundings.

The techniques of immersion and interactivity, which we now associate with new media, developed in circulation across a number of exhibitionary sites and institutions. This process of circulation was also a process of translation and reinvention (Barry 2001: 139). Tony Bennett describes how new disciplines, discourses, and tech-

Michelle Henning

nologies circulated and developed in the nineteenth century across the "linked sites" of the "exhibitionary complex" (Bennett 1995: 59). Bennett defines the exhibitionary complex as "a set of cultural technologies concerned to organize a voluntarily self-regulating citizenry," but it was also a circuit through which ideas and techniques of display and archiving were exchanged. For instance, in the United States, between the 1880s and the 1940s, theories and technologies of display circulated between department stores and museums, facilitated by the involvement of department store magnates in museum governance and the employment of the same architects and designers across both institutions (Leach 1989: 128). In the same period, theater design and window-dressing employed many of the same designers, and could also be considered as neglected but important practices in the development of new media. The view that new media might be brought into the museum as a modernizing influence is based on a too-rigid separation between the development of museum display techniques and the transformation of display practices across a wide range of cultural sites. Similarly, the view that new media vulgarizes the museum, bringing it closer to commercial entertainment sites, disregards the already intimate connections across the "exhibitionary complex." The concept of a circuit through which display and archiving techniques were exchanged and developed allows for a different understanding, in which museums were sites for the development of the techniques of display and of archiving now deployed in new media.

Museum displays parallel the organization and modes of address of modern analogue media ("old media") and new media. An excellent example can be found at the American Museum of Natural History (AMNH) in New York. In the famous halls of dioramas, dating from the 1920s to the 1940s, the darkened spaces recall cinema auditoriums. The backlit habitat dioramas are breathtakingly naturalistic. Taxidermy, painted backdrops, and wax modeling, though "multimedia," are combined to give the organic coherence of narrative cinema, inviting us to momentarily forget their status as representations and imagine they are more than skin deep. They position the visitor as a voyeur looking into a scene in which his or her presence is not acknowledged. This position and the careful arrangement of the scenes according to Romantic compositional techniques, allow visitors to imaginatively identify with the animals. The dioramas are discrete scenes, each of a different species, but unified in a larger common narrative about African or American mammals, for instance. The insertion of the dioramas into the walls organizes the visitor's movement through the space; though you may move around the space in any way you like, the display encourages visitors to walk in a loop around the room.

If you pass from the diorama halls into the Hall of Biodiversity, opened in 1998, it is as if you have wandered into a different media age. On the "Spectrum of Life" wall, among specimens in jars, taxidermy, pinned insects which flock across the wall and up to the ceiling, are interactive touch screens and screens showing video clips of animals in their habitats. Visitors are expected to navigate between very different kinds of information and modes of representation (the Hall was marketed as "interactive"). Poetic and visual connections and resemblances are just as possible as scientific comparisons. Many museums keep alcohol-preserved specimens out of public display, considering them unsightly and reserving them for scientific study. Here the hierarchy of representation is broken. The arrangement of the animals on the wall

304

resembles a network, or a branching tree structure used in the production of inter-active media. The diorama halls represent the thinking of late nineteenth- and early twentieth-century natural history and conservationism, with careful boundaries drawn between each species, and animals organized by geography, and humans placed outside the natural world. The Hall of Biodiversity represents more recent developments in biology and environmentalism, with an emphasis on diversity and interdependence. In the same hall, an immersive exhibit places visitors in a simula-tion of a tropical rainforest – complete with sounds and smells.

Museums as Media

Museums are sometimes described as media in that they communicate messages to an audience. For those who adhere to a "broadcast" theory of media, this is con-tentious, since they define media by a separation or distance between transmitter and receiver. Yet, as the media theorist Harold Innis wrote in the 1950s, media commu-nication may be thought of in terms of temporal as well as spatial distance. He dis-tinguished between media which communicate across time (for example, a statue) and those which are relatively ephemeral, but mobile, and communicate across space (such as a letter on paper; Angus 1998). We can go even further and think of museums as media in respects other than their communicative role. Media studies has long prioritized communication and representation, but this emphasis is changing. Recent media theory deals in form and materiality as much as messages. The notion of media influence, which had become disreputable because it assumed that audiences uncritically absorb media messages, has taken on new life in studies of how media shape perception and manage attention (Crary 1999). From this perspective, media work on our bodies: organizing our movement and our time, soliciting different modes of attention and different viewing positions. In histories of modern transformations of perception, exhibitions play a special part because they develop techniques of "organized walking" and the choreography of spectators. Writers interested in contemporary perception look to the panorama, the diorama, and the wax museum for its origins (for example, Schwartz 1998; Griffiths 2002).

The notion that media transform perception and attention is not new: Marshall McLuhan argued that media should be treated as staples like "cotton and oil" and that the main impact of media was in the "change of scale or pace or pattern that it introduces into human affairs" (McLuhan 1964: 8). McLuhan saw technologies as the basis of economies and social organization, affecting "the entire psychic life of the community" (1964: 22). He emphasized the materiality of media through the concept of "material bias" which he takes from Harold Innis. "Material bias" refers to the orientation of specific media toward the production of certain kinds of knowl-edge and perceptions, and their material resistance toward the production of other kinds. In this way, media are constitutive of society, limiting what can be experienced and how it is experienced (Angus 1998). Questions of scale and temporality are not just about cognition or "psychic life" but necessarily involve bodies. To understand new media in the museum *and* the museum as a media form, we need to examine the

material ways in which they organize and structure knowledge and perception through the production of bodily experiences.

Eilean Hooper-Greenhill has looked at how museums "shape knowledge," using Michel Foucault's distinctions between different "epistemes," and suggesting that recent changes in museum practices may be indicative of the fact that the modern episteme, which began in the nineteenth century, is ending (Hooper-Greenhill 1992: 215). Media historians make a more explicit connection between the development of new media and an epistemic break. The media theorist Friedrich Kittler (1999: xxx) maps the media age of electrical and electronic systems onto a new postmodern episteme

Kittler also historicizes the different media in terms of their functions of processing information, recording, storing, and networking. These concepts derive from the study of computer-based or digital media. This approach brings museums within the purview of media studies because museums are also technologies for archiving, preservation, storage, and the construction of cultural memory. Museums find their place in the history of media, and new similarities between museums and media become apparent. For instance, in the late nineteenth century, at the same time as early photography and phonography were being deployed as memory/storage devices, preserving for posterity the traces of the dead and dying, new museums were engaged in preserving natural and "folk" worlds which were thought to be rapidly becoming extinct (Haraway 1989; Kittler 1999; Sandberg 2003).

Comparing New Media and Museums

The characteristic that distinguishes the museum from other media is its inability to detach objects, scenes, people, from their fixed place in time and space, and to allow them – or their forensic traces – to circulate as multiples and reproductions. Historically, at least, the museum is attached to things. One misconception about new media is that it threatens this attachment because it deals in information and data, in the virtual rather than the material. However, we can see that the priority of the object in museums has been declining for some time, and that an increased emphasis on information and communication predates new media. As early as the 1930s, a new emphasis on invisible, intangible processes and concepts in science led to the development of new display techniques in science museums. In the late 1960s, the San Francisco Exploratorium broke with the traditional model of a museum, which safeguards and displays a collection. Its only objects were temporary display devices intended to communicate scientific principles through "hands-on" methods. By the 1930s, curators began to use projected film to supplement artifact-based exhibits. In Otto Neurath's Museum of Society and the Economy in Vienna (founded in 1924), conventional museum displays were replaced with pictorial charts, graphs, and posters. In the 1950s and 1960s, in world fairs and international exhibitions, immersive and multimedia displays, such as Charles and Ray Eames's designs for IBM, or Le Corbusier's *Poème électronique* for the Philips Corporation, prefigured computer-based multimedia exhibits (Mondloch 2004). In the same period, art museums and galleries saw the beginnings of installation, media, and performance art.

As well as questioning the view that new media threatens the artifact, we can dismiss some of the usual distinctions between new media and old media, such as the belief that new media is characteristically interactive, or that the defining characteristic of new media is that it is made of discrete units, digital samples, whereas old media was analogue and continuous (Manovich 2001: 49–61). Manovich has shown how old media is also "interactive" and also involves discrete units (such as the frames in a film). He sees the distinguishing characteristic of new media as its programmability, which derives from the translation of media into computer data ("numerical representation"). Flowing from this are principles of modularity, automation, variability and transcoding. Briefly, these describe how new media objects are assembled out of discrete units which can continue to exist outside the larger whole; how generic scripts or programs take over some of the operations involved in media production or use; how new media objects can "exist in different, potentially infinite versions" tailored to different users; and how the logic of computer data organization merges with cultural categories to produce a new "computer culture" (Manovich 2001: 27–48).

Manovich's principles of new media illuminate significant similarities and differences between new media and museums. Numerical representation makes it possible to store enormous amounts of data and digitized media, something that makes new media museum-like, on the one hand, and distinguishes it from museums, on the other, since objects themselves cannot be stored, only their encoded representations. The principles of modularity and variability allow for the production of different interfaces from the same data, and of personalized versions of the same media object. Similarly, museums can produce different exhibitions from the same collection, although not simultaneously. Transcoding describes how computer programming's own modes of organizing data become cultural forms in their own right. Many new media objects are fundamentally databases, accessed through an interface (Manovich 2001: 219). Their interfaces are modeled on existing genres and media, including the museum because of its archiving and classifying functions, hence the "virtual museums" which are not simply the websites of existing museums but websites which use museum metaphors, with "halls" instead of "pages." One example is the Kook's Museum curated by Donna Kossy with its Conspiracy Corridor, Hall of Hate, and Library of Questionable Scholarship.

In virtual museums, "visitors" may access texts, images, sounds, or movies that only exist as a collection in the database. The variability and modularity of new media even allow Internet virtual museums to create "museum collections" which do not exist together in one database, but as different pieces of data in numerous databases accessed through the Web. Since the museum only exists in new media form, and since digital media are so easily manipulated, the authenticity of the artifacts becomes questionable. Many virtual museums are humorous and playful, working as contemporary curiosity museums like the (real) Museum of Jurassic Technology in Los Angeles, and unsettling the visitor's ability to discriminate between the real and the fake.

Perhaps the most significant similarity between new media and museums is their twin functions of storage and display. Some museum writers and workers have described the museum in theatrical terms, with the display areas or exhibition halls

understood as a "stage" in which the objects become actors, and the backstage area as the place where objects are processed, turned through processes of classification and organization, from mere things, to museum artifacts (Bennett 2002: 39). This approach has the virtue of conceiving objects as active and culturally shaping, once placed in a network of relationships (Bennett 2002). The analogy to the data and interface relationship in new media is equally useful. In modern analogue media, in the phonograph, the film, the photograph, we have a master (such as a negative) which resembles the multiple copies taken from it. In new media, numerical representation means a separation of storage and display. Data are stored as numbers and algorithms, unreadable except through specific kinds of software. The interface is not just a display, but a means of accessing the data, organized in a database. New media objects turn discrete pieces of data into coherent "texts." Museums also organize objects into displays, and into a coherent picture of the world.

All media produce problems of storage: an ever-growing archive of photographs, recordings, films, and so on, has to be stored somewhere. This is not just a crisis in storage, it is a crisis in knowledge – in how to make sense of the unmanageable mass of stuff accumulating in museums and archives. This crisis was felt early in the history of modern media and of the modern museum. As Friedrich Nietzsche observed, too many "indigestible stones" of knowledge, presented to people without regard for their own life experience, had produced a tendency to embrace new information "lightly," superficially (Nietzsche 1874: 78–9). Museums handled this through the separation of research collections and the public display (though the problems of insufficient space for the ever-growing collections continued to haunt them). This was the first step in addressing the problem of incoherence, and confused, disoriented, and distracted spectators. Next, they reorganized displays into clean, uncluttered exhibitions, marshaling objects into more coherent narratives, and using new techniques to direct visitor attention and encourage certain trajectories through the museum space (Griffiths 2002: 10–17).

A "storage mania" marks the early years of new media, like the early years of the modern museum. Anything that can be collected, digitized, and stored is, regardless of the amount of time it would take anyone to view or read every item in the archive. Manovich writes of how the Internet "crystallized the basic condition of the new information society: overabundance of information of all kinds" (Manovich 2001: 224 and 35). Computers are efficient storage devices, compressing enormous amounts of data, but produce the same problem for the user as all storage systems: how to quickly access the one piece of information you want. The principle of automation enables software to classify and search data, from software that can search for strings of text to search engines that can compare visually similar images. The problem with automatic searching is that it remains limited while computers are unable to engage with media semantics; the similarities they find are similarities in digital encoding, in computer data, as opposed to the cultural similarities and connections we might make (Manovich 2001: 33). Even so, computerized automatic searching drastically increases the possibilities of sorting through an otherwise unmanageable accumulation of data.

Remediating the Museum

New media offers the museum a means to undo the separation of public display and research collection in the museum. Through new media objects, visitors are able to access far more of a collection, albeit translated into visual or textual data, than could possibly be placed on display. Thus, new media enables the exhibition to become like an interface, through which visitors may access different objects in the collection, according to preference, and make their own comparisons. This relates to the arguments about access and democratizing put forward by the advocates of new media in museums. New media, with its capacity for automated searching and its database structure, seems to promise that visitors' access to the collection will no longer be constrained by the mediation of curators, nor are objects limited to the part given them in the context of a particular narrativized display. Through kiosks and touch screens representing objects that are not on display and contextual information beyond that given in labels and exhibition text, it seems possible to produce a deeper and more diverse engagement between visitors and the museum.

One interesting and innovative example of the use of new media to access a collection was *Orbis Pictus Revised* made by Tjebbe van Tijen and Milos Vojtechovsky between 1991 and 1996. This art installation combined three-dimensional, "hands-on" experiences with computer touch screens, and was based on a seventeenth-century schoolbook, *The Orbis Sensualium Pictus* (The World Explained in Pictures; fig. 18.1). The original book contains a hundred and fifty pictures placing objects in naturalistic tableau-like scenes (such as still lives and landscapes) with accompanying text defining the objects in various languages. The pictures consist of discrete elements that are then associated with words in different languages.

Orbis Pictus Revised exploited this similarity between the emblematic pictures and modern computer interfaces. The exhibition was made up of three parts: first, a chain of fifty objects linked by visual association to fifty of the pictures in the *Orbis Sensualium Pictus*, encouraging other poetic associations to be made. Secondly, an interactive computer installation showing changes in the way in which the world is pictured and described, from the seventeenth century to the present day. This allowed comparison with earlier and more recent books through a search system using only images and spoken word. Through touch screens and switches, visitors could link parts of pictures to related images from the different books, navigating through time or through the book's structure. Finally, a second interactive computer installation allowed visitors to place plain gray objects on different sensors, which responded with spoken seventeenth-century and twentieth-century definitions. In *Orbis Pictus Revised*, the analysis and comparison of repeated objects and motifs gave a meaning and direction to users' interaction, while the use of objects and sound introduced new dimensions of sensation.

Another example of new media used to access a collection is the COMPASS (Collections Multimedia Public Access System) project at the British Museum which began in 1997. The stated aims of the project include improving visitors' experiences, making the collection more accessible, and enabling an enriched understand-

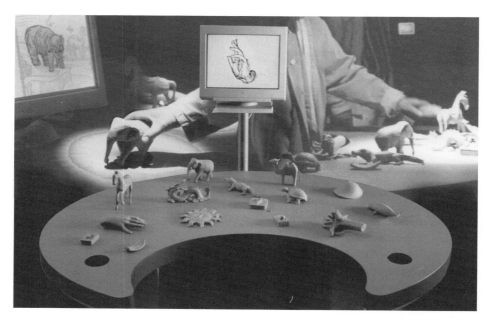

Fig. 18.1 *"Orbis Pictus Revised*: Touching and Feeling," an interactive computer installation with symbol objects that can be placed in three different language areas on a table and thus will give sound icons and will speak (in English, German, or Latin) definitions for children of beings, things, and phenomena from both the seventeenth and the twentieth centuries. Simultaneously, tableau pictures from the *Orbis Sensualium Pictus* of Comenius and from similar twentieth-century books are shown on the monitor. Originally produced for Zentrum für Kunst und Medientechnologie, Karlsruhe, 1994. Reproduced courtesy of Imaginary Museum Projects/Tjebbe van Tijen.

ing of the objects' original cultural contexts (Callender 2002a). As part of the project, kiosks were installed in the British Museum Reading Room in 2002. The terminals are designed to resemble open books, with a touch screen proportioned like a book, and a book-like interface. The system contains written text (contextual and descriptive), images, and other multimedia content. This content was partly drawn from the museum's existing collections management system, but the text from that "was not considered suitable for a public system," so new copy was created. This derived partly from existing publications oriented toward a visiting public, such as education packs, catalogues, and exhibition text, but was mostly produced anew by the museum curatorial staff in an easy-to-read format (Callender 2002a). This example shows how the new media interface does not straightforwardly give visitors access to the "back regions" of the museum, to its own archiving and data systems. New media only increases access by remediating the content of the museum. Interestingly, it is the concept of accessibility itself (based on the view that since visitors are non-specialists and often not fluent English speakers, they must have simplified text), which limits access to the workings of the museum.

Interactivity and Immediacy

Though the use of new media as a means to access the collection and archiving system opens up lots of interesting exhibitionary possibilities, it brings its own problems. Manovich questions the ethics of passing on the responsibility for selection and choice from the author to the media user, suggesting that it involves an abdication of responsibility on the part of authors/curators; he compares it to the way in which large corporations pass costs and labor from the company onto customers (Manovich 2001: 44). Other writers have questioned the social and philosophical implications of prioritizing individual visitor experience, and treating visitors as "clients" or "customers" invited to make personalized selections (Hooper-Greenhill 1992: 211–15; Hein 2000: 65–87).

The example of kiosks and installations providing access to a collection that is elsewhere also raises questions about interactivity. Interactive "hands-on" exhibition design originated in the attempt to disrupt traditional practices of aesthetic contemplation, in Marxist ideas of self-realization, and in radical and liberal theories of education (Buchloh 1987: 86; Hein 1990: xvii, 11–12). Interaction is not simply visible activity (button pressing and so on), but the invisible, cognitive links made between different pieces of information and different sensory stimuli. Manovich discusses interactive computer media as part of the modern tendency to "externalise the mind," in which we follow the media designers' own mental structure of links between information, rather than making our own associations. We are asked to treat pre-programmed links as if they were our own mental associations and to treat media as if they were simply, in Raymond Williams's phrase, "intermediate substances" for the communication of pre-existent ideas (Williams 1977: 159; Manovich 2001: 55–61).

This is part of what new media theorists David Jay Bolter and Richard Grusin describe as the "desire for immediacy" which shapes new media. They write: "Our culture wants both to multiply its media and to erase all traces of mediation: ideally it wants to erase its media in the very act of multiplying them" (Bolter and Grusin 2000: 5). The communications theorist John Durham Peters argues that all media are shaped by a cultural desire for unmediated communication. This is why Victorian Spiritualists quickly adopted and adapted modern media in the séance. The dead spoke by imitating the tapping of Morse code down the telegraph wire (Peters 1999: 94). Also, "early radio history is inseparable from daring imaginings about the flight of souls, voices without bodies, and instantaneous presence at a distance" (Peters 1999: 104). Modern culture is dominated by this model of pure, disembodied communication, yet, as Peters shows, even the most intangible media interrupt our communications and conversations with an insistent materiality which takes the form of interference or resistance.

The anxious desire for transparent communication has shaped the deployment of new media in museums, in particular, interactive new media. Manovich describes the tendency to treat standard computer interfaces (such as Windows) as a transparent window through to the data held by the computer. Interfaces, he points out, have their own language and conventions derived from elements of older media and come with their own ideology or "bias," shaping not just what it is possible to do with the

311

computer, but "how the computer user conceives of the computer itself" (Manovich 2001: 65, 71). This is evident in the British Museum kiosks and the *Orbis Pictus Revised* installation, which rework elements of older media forms (books). Commonly, interfaces are treated as gateways to access the collection, rather than as themselves cultural texts. There is also a supposition that visitor interaction is visible and readable, and it is reassuring to see visitors busily engaged with exhibits, as opposed to walking and looking, even if it is not evident that they are learning more from the process (Macdonald 2002: 240). While the pleasures and thoughts of visitors remain elusive, the economic need to keep visitors coming and the desire that the museum is successful lend a certain attractiveness to media which seem to make the visitor experience more measurable. In the British Museum, the COMPASS system allows the museum to monitor its visitors' use. David Jillings, the head of new media at the British Museum, summarized:

> We logged around 800 hours of unsupervised public use on five workstations during April this year [2002]. We recorded some 2,250 user sessions. The average user session was 21 minutes. The average number of museum artefacts looked at in each session was 18. Over 24,000 searches of the database were made, and some 66,000 records were displayed on screen in total. (quoted in Callender 2002a)

The attraction of being able to quantify visitor use in this way is evident. It is interesting to note, for instance, that visitors spend little more than one minute looking at artifacts on the workstations, which suggests that this new media object engages a channel-flipping form of attention. Faced with the mass of information available in the database, visitors, to use Nietzsche's term, "embrace it lightly." Yet, though the system can monitor time spent, it cannot make visitor pleasures more transparent. New media objects have become heavily invested with notions of transparency and immediacy – with making visitors readable, giving direct access to the collection, allowing visitors to follow their own mental associations – but this is misleading. Perhaps one of the reasons that new media seems to promise this to an even greater degree than old media is that the interface increasingly seems dislocated from any material presence in the world. There is a belief that new media objects are more "virtual" than other media, and digitization is associated with "dematerializing," electronics with increasing miniaturization. Yet not only does new media have its own material bias and resistances, the real back regions of new media are resource-hungry and heavily polluting processes involved in the production of hardware and the laying of cables, the construction of an immense material infrastructure to support our virtual worlds.

The ability of new media to increase visitor access, and reconnect back and front regions of the museum, also needs to be seen alongside the impenetrability of computer processes to the user. According to Hilde Hein, this was one reason why Frank Oppenheimer was opposed to the use of computers as a means to construct the Exploratorium's interactive displays. One founding principle of the Exploratorium was that the manufacture of exhibits should be a process open and visible to the public. The operation of computers is invisible, and watching someone use one makes for dull viewing (Hein 1990). Oppenheimer also saw that computers as display

devices could actually undermine the principle of hands-on science on which the Exploratorium was based, because the point was to make invisible scientific processes visible and to demystify them. In his view, hands-on science should be empowering, demonstrating to visitors that modern science and technology were not beyond our comprehension and that we should not give up the attempt to understand the world (Hein 1990: xvi–xvii). More recently, science centers (including the Exploratorium) have abandoned this approach. In Explore, the successor to the Bristol Exploratory (whose founder, Richard Gregory inspired Oppenheimer's Exploratorium), computer-based displays demonstrate bodily processes; for instance, how our bodies respond to certain kinds of images. What the display does not show is how the computer measures and represents back to us those physiological changes. What becomes invisible in the display is the computer itself. Computers, in this context, appear as almost magical technologies.

We could argue that there is nothing wrong with a touch of the magic show in the museum. The history of exhibitions and of media is also the history of magic: of spectacle, showmanship, of illusion and phantasms. Just because the invisible workings of miniaturized electronics do not easily give up their secrets, we do not abandon the attempt to understand them. However, what we learn from interacting with them might not necessarily coincide with the intended message of the display. The technology theorist and psychologist Sherry Turkle has studied what children learn from electronic and computational toys. If, as Jean Piaget showed in the 1960s, children use their toys to theorize their world, by taking them apart and seeing how they work, children in the age of electronic toys do the same. However, the invisibility of the workings of electrical components and computers means that the theories they develop through play differ from those developed by children with mechanical toys. They draw on a different body of circulated knowledge (such as knowledge of psychology and behavior) to understand their not-quite-alive animated toys (Turkle 1998). In the case of computer-driven exhibits, like the one at Explore just described, the explicit message of the display is presumably about the way in which physical changes in our bodies connect to psychological responses. But the display also teaches the power of computers to "read" us and respond to us. This is not just a question of explicit, articulated knowledge but also of bodily know-how, of habit and sensation.

In a discussion of IBM's Information Machine display at the 1964–5 New York World's Fair, Ben Highmore argues that "It is the form of the display that addresses an audience with a 'content' aimed not at the mind or the heart but at the body's own potential for change" (Highmore 2003: 128). He reads the Information Machine as offering a bodily experience of the computer age, processing visitors as if they were pieces of data, and giving a taste of the magical power of technology, even whilst its explicit pedagogic aim was to demystify computers. The pavilion was like a giant ride that literally moved an entire audience into the air and then bombarded them with images on multiple screens. By lifting spectators out of their everyday bodily experience, the pavilion hooked consumer desire for IBM products to a sense of bodily transcendence. The pavilion recoded the traumatic experience of technological modernity as a magical (if momentary) liberation from one's own body, and from current social conflict (Highmore 2003: 146–7).

313

Many contemporary exhibits also use the mobile and sensational techniques associated with theme-park rides: for example, in the Earth Galleries of London's Natural History Museum, visitors enter via an escalator that passes through a giant sculptural globe. However, the new media exhibits that interest me here are much less sensational in their form. Kiosks engage visitors in corporeal and cognitive activities that are familiar: using a mouse and keyboard, making selections from a number of on-screen options are activities engaged in both in work and in leisure for many people (Manovich 2001: 65–6). Unlike the Information Machine, kiosks involve visitors in tasks that are habitual and banal. But the hi-tech production process of the museum and the apparent power of invisible but animate technology cement the position of the visitors as consumers of a finished product, and translate them into data to be processed. This orientation is explicit in the case of the British Museum kiosks, where feedback systems translate the activities of visitors into numerical data, and where museum spectatorship and economic exchange are part of the same system: the kiosk technology allows the museum to charge the cost of reproductions and information to users' credit cards (Callender 2002a).

Power Plays, Commerce, and Media Magic

This changed relationship between the museum and its visitors is not simply the product of the introduction of new technologies into the museum. It is largely a result of political and economic changes that began in the 1970s. The larger museums introduced structural changes in response to changes in their funding, in their relationship to other tourist attractions, and to a sense that they were becoming outmoded. Until then, museums produced most exhibitions and displays in-house, with natural history museums, for instance, employing their own taxidermists. In the 1970s, museums began to employ professional communicators and designers to mediate their messages to the public. By the early 1990s, this situation had inverted so that museums increasingly contracted out aspects of exhibition design to specialist firms (see chapter 25). Older skills like taxidermy were not so frequently required, and this work, too, they contracted out. A whole satellite industry has developed, specializing in museum exhibit design and production. Museums have become clients for new media companies, purchasing custom-built systems (the COMPASS system involved an architectural design company, hardware company, and software company).

In this context, questions of access, participation and interaction, democratization, and so on, though they may be real concerns for curators and museum educators, are also marketing terminology, overlaid on another discourse of profitability, cost, customer satisfaction. New media attracts corporate sponsorship too. For instance, the Science Museum in London received money from Toshiba for its kiosk system. In return, Toshiba get a "sponsored by Toshiba" inscription on each terminal, a Toshiba button on the menu which links to a screen full of information about Toshiba's products, a screen detailing their other sponsorship deals with the museum, and regular statistical information on the use of the kiosks (Callender 2002b).

Advocates of new media celebrate its democratizing potential, its ability to make multiple viewpoints available, to turn visitors into authors, and to engage people in the production of their own stories. But it is clear that such expensive and technically impressive systems function as a kind of capital, a central means by which contemporary museums now compete with one another for prestige. They are deployed in what have been described as "power plays" at the museum (Luke 2002). One example, again at the British Museum, is the computer graphics simulation accompanying the display of the Elgin Marbles. This simulation shows the statues isolated and spun through three dimensions, completed, animated, and "repainted." In a conference paper, Gillen Wood interprets this simulation as an intervention in the debate about the repatriation of the marbles. He argues that, in place of actually returning the marbles, the museum has produced "a virtual restoration and a virtual repatriation," which implicitly denies the necessity for a real return of the Elgin Marbles to Greece, making the things themselves the justification for "a larger, virtual museum experience of cultures past" (Wood 2001). (Though one can also see how a virtual simulation might instead prepare a museum-going public for the absence of the real thing.)

Wood draws attention to the political function of new media objects in the museum context, as well as another instance of how new media technology offers magical transcendence. Resembling the commercial "virtual tours" of proposed buildings produced by architectural firms, the video offers a viewing position unrelated to any actual, possible, historical experience of the intact marbles and entirely the product of our own culture, shaped by the aesthetics of cinema and virtual reality. In the nineteenth and twentieth centuries, the actual Elgin Marbles elicited a Romantic appreciation of ruins, a meditation on the passing of time and the gulf between antiquity and the present, but also provoked anxieties regarding their deteriorated state, which play a part in the British Museum's argument against their repatriation. Wood reads the Elgin Marbles video simulation as a technological scrubbing-up of the marbles, obliterating the differences between past and present, replacing the Romantic experience with a technologically enchanted "eternal newness."

New Media and the Return to Curiosity

We could conclude that, far from democratizing, increasing access, and otherwise progressively changing the museum, new media is caught up in "power plays," furthering the museum's role in the production of an acquiescent citizenry who are now positioned as consumers of the museum experience. However, there is another side to the story, which suggests that new media objects can also work to undermine this, modeling ways of thinking and understanding which are non-hierarchical and decentralized, and privileging allegorical and arbitrary associations, correspondences, and resonances. This potential has been recognized and explored in a number of new media art projects, which explicitly link the structures and language of new media to Baroque allegory and to the seventeenth- and eighteenth-century cabinets of curiosity.

For instance, the Baroque schoolbook on which *Orbis Pictus Revised* is based is closely linked to the allegorical emblem books of the same period. The way the installation links a Baroque cognitive structure to the structure of interactive new media has a precedent in Walter Benjamin's writing, which associates film's montage structure with Baroque allegory. His study of Baroque emblems underpins an understanding of film montage as an assemblage of discontinuous parts, which makes visible the lack of a natural or inevitable link between form and meaning (Bürger 1984: 68). Similarly, by drawing a parallel between the Baroque tableau and the modular and variable principles of new media, *Orbis Pictus Revised* enables past cultural forms to denaturalize contemporary ones.

Like the emblem book, the curiosity museum provides an historical model for contemporary new media projects. Online virtual museums, such as the Kooks Museum mentioned earlier, invoke the curiosity museum while exploiting one of the most scandalous aspects of the Web: the difficulty in policing the line between "good" and "bad" information. The modern museum operates as a technology to sort good from bad, true from false, and this distances it from both the curiosity cabinets and the popular curiosity and dime museums of the nineteenth and early twentieth centuries. Recent media art projects compare the Web to curiosity museums and cabinets, exploring how we collate and make sense of dispersed data using Internet search engines and dynamic systems of links. Examples include *Wonderwalker*, a project by Marek Walczak and Martin Wattenberg for the Walker Art Center in Minneapolis in which users produce a shared map of web links; *Information Tsunami Wunderkammer* by the Shiralee Saul, a text-based Web project which compares Web searching to beachcombing and colonial collecting; and *Encyclopaedia Mundi*, an installation by Tony Kemplen, using security cameras, software designed for the blind, speech recognition software, and an Internet search engine to translate a collection of thrift store tourist souvenirs into images, sounds, text, and back to images. All these projects draw attention to the Internet's status as an arbitrary accumulation of data, but also to the potential it has for the construction of new experiences.

The examples I have given here come from academic and art contexts. These are not the only contexts in which we may glimpse the potential for new media and the museum to creatively reinvent one another. We can find it too in recent museum displays which rework the exhibition medium. For example, in the Darwin Centre at London's Natural History Museum, the traditional separation between research collection and display collection is beginning to be unraveled, and in the Grande Galerie de l'Évolution in Paris, linear and naturalistic modes of organizing museum objects are replaced by decorative, symbolic, and non-naturalistic display. In a discussion of the "return to curiosity" in contemporary art exhibitions, the art historian Stephen Bann suggests that the curiosity cabinet allows us to view objects as "a nexus of interrelated meanings – which may be quite discordant – rather than a staging post on a well trodden route through history" (Bann 2003: 120). A similar thing can be said of new media, with its modular, variable structure. New media's greatest promise is to be found not in appliances and devices, kiosks and touch screens, but in the part it plays in a return to curiosity.

Acknowledgments

The Arts and Humanities Research Council funded the research leave during which parts of this chapter were written, and a British Academy Small Research Grant funded visits to some of the museums discussed here.

Note

1 I am using the term "new media," as it is used by its principal theorists, as a singular term, although this is not strictly grammatically correct since the singular of "media" ought to be "medium." Used in the plural, however, it would refer to the full range of media that are new at a given moment, whereas in the singular it has come to refer specifically to computer-based, digital media.

Bibliography

Angus, I. (1998) The materiality of expression: Harold Innis' communication theory and the discursive turn in the human sciences. *Canadian Journal of Communications*, 23: 1.

*Bann, S. (2003) The return to curiosity: shifting paradigms in contemporary museum display. In A. McClellan (ed.), *Art and its Publics: Museum Studies at the Millennium*, pp. 116–30. Oxford: Blackwell.

Barry, A. (2001) *Political Machines: Governing a Technological Society*. New York: Athlone Press.

Bennett, T. (1995) *The Birth of the Museum: History, Theory, Politics*. London: Routledge.

— (2002) Archaeological autopsy: objectifying time and cultural governance. *Cultural Values*, 6 (1/2): 29–47.

*Bolter, J. D. and Grusin, R. (2000) *Remediation: Understanding New Media*. Cambridge, MA: MIT Press.

Buchloh, B. (1987) From faktura to factography. In A. Michelson, R. Krauss, D. Crimp, and J. Copjec (eds), *October: The First Decade 1976–1986*, pp. 76–113. Cambridge, MA: MIT Press.

Bürger, P. (1984) *Theory of the Avant-garde*. Manchester: Manchester University Press.

Callender, B. (2002a) The British Museum exhibits its kiosks, August 29, 2002 (www.kioskmarketplace.com; accessed August 2004).

— (2002b) England's kiosk-museum connection, May 29, 2002 (www.kioskmarketplace.com; accessed August 2004).

Crary, J. (1999) *Suspensions of Perception: Attention, Spectacle and Modern Culture*. Cambridge, MA: MIT Press.

Goffman, E. (1990) *The Presentation of Self in Everyday Life*. Harmondsworth: Penguin.

Griffiths, A. (2002) *Wondrous Difference: Cinema, Anthropology and Turn of the Century Visual Culture*. New York: Columbia University Press.

*— (2003) Media technology and museum display: a century of accommodation and conflict. In D. Thorburn and H. Jenkins (eds), *Rethinking Media Change: The Aesthetics of Transition*, pp. 375–89. Cambridge, MA: MIT Press.

Haraway, D. (1989) *Primate Visions: Gender, Race and Nature in the World of Modern Science*. London: Routledge.

Hein, H. (1990) *The Exploratorium: The Museum as Laboratory.* Washington, DC: Smith-sonian Institution Press.

*— (2000) *The Museum in Transition: A Philosophical Perspective.* Washington, DC: Smith-sonian Institution Press.

Highmore, B. (2003) Machinic magic: IBM at the 1964–1965 New York World's Fair. *New Formations*, 51 (1): 128–48.

Hooper-Greenhill, E. (1992) *Museums and the Shaping of Knowledge.* London: Routledge.

Kittler, F. (1999) *Gramophone, Film, Typewriter.* Stanford, CA: Stanford University Press.

Leach, W. R. (1989) Strategies of display and the production of desire. In S. J. Bronner (ed.), *Consuming Visions: Accumulation and Display of Goods in America 1880–1920*, pp. 99–132. New York: Norton.

Luke, T. W. (2002) *Museum Politics: Power Plays at the Exhibition.* Minneapolis, MN: University of Minnesota Press.

Macdonald, S. (2002) *Behind the Scenes at the Science Museum.* Oxford: Berg.

McLuhan, M. (1964) *Understanding Media.* London: Routledge and Kegan Paul (cited from the 2001 edn).

*Manovich, L. (2001) *The Language of New Media.* Cambridge, MA: MIT Press.

Mondloch, K. (2004) A symphony of sensations in the spectator: Le Corbusier's *Poème électronique* and the historicization of new media arts. *Leonardo*, 37 (1): 57–61.

Nietzsche, F. W. (1874) On the uses and disadvantages of history for life, trans. R. J. Hollingdale. In D. Breazale (ed.), *Untimely Meditations*, pp. 57–123. Cambridge: Cambridge University Press, 1997.

Peters, J. D. (1999) *Speaking into the Air: A History of the Idea of Communication.* Chicago: University of Chicago Press.

Sandberg, M. B. (2003) *Living Pictures, Missing Persons: Mannequins, Museums and Modernity.* Princeton, NJ: Princeton University Press.

Schwartz, V. R. (1998) *Spectacular Realities: Early Mass Culture in Fin-de-siècle Paris.* Berkeley, CA: University of California Press.

Turkle, S. (1998) Cyborg babies and cy-dough-plasm: ideas about self and life in the culture of simulation. In R. Davis-Floyd and J. Dumit (eds), *Cyborg Babies: From Techno-sex to Techno-tots*, pp. 317–29. New York: Routledge.

Williams, R. (1977) *Marxism and Literature.* Oxford: Oxford University Press.

Wood, G. (2001) The virtual Elgin Marbles. Paper presented at the American Comparative Literature Association Annual Conference, Boulder, Colorado, April 20–22.

Visitors, Learning, Interacting

Introduction

Visitors pervade this volume, as they do – with varying frequency – museums. Other parts of the *Companion* highlight a wide range of forms of interaction between museums and their visitors, publics, communities, or customers – the language chosen being indicative of the kind of relationship sought. These range from the relatively exclusive through the predominantly paternalistic to the more interactive and inclusive. The previous parts of the *Companion* have made clear that there have been widespread – though never all-encompassing – shifts in museum–visitor relationships over time. In particular, contributors have drawn attention to the fact that many museums have come to give greater priority to the envisaged needs or desires of potential audiences in planning their exhibitions, and that, increasingly, they conceptualize "their public" as plural. Part III provided further discussion of this transforming visitor emphasis and considered some of the ways in which museums attempt to "speak to" and even shape those who visit via a range of mainly nonverbal forms of address, such as visual technologies and spatial layout.

In Part IV, these matters are explored through a focus on visitor experience in museums and especially in relation to questions of learning and education, broadly understood. While the ways in which visitors interact with museums cannot be confined to learning and education, as other chapters in the *Companion* demonstrate, they are nevertheless extremely important, not least because this is a major way in which museums influence those who visit and, indirectly, society more generally. Efforts to evaluate museums – a preoccupation that has itself grown alongside the new emphasis on the visitor – also typically focus upon trying to assess what visitors may have learned, though chapters here highlight some of the shortcomings of many of the approaches employed so far.

In the first chapter of Part IV (chapter 19), John H. Falk, Lynn D. Dierking, and Marianna Adams of the Institute for Learning Innovation, an institution which has been a major player in museum educational research, argue that life-long and what they call "free-choice" learning is becoming increasingly important in "the knowledge economy." In a context in which knowledge and the ability to adapt are at a premium, museums take on a renewed importance as institutions capable of offering opportunities for individuals to engage in learning of their own choice. Like George E. Hein (another luminary of museum education) in chapter 20, they show

how the changing conception of the museum's role – from being mainly a source of authoritative knowledge to providing opportunities for individuals to learn in their own ways – meshes with shifts in educational theory. Behaviorist approaches, in which the visitor is understood as responding more or less effectively to the museum's stimulus, have been superseded (in most areas of theory if not in all areas of practice) by "constructivist" approaches. These latter are based on perspectives that emphasize the input of the learner in the meaning-making process and, as such, recognize the variable ways in which it may take place.

Trying to understand this variability and the factors that may influence it is a major task of current museum educational research. As Falk, Dierking, and Adams argue, differences of physical setting (for example, what kind of museum is involved), of socio–cultural context (whether visitors are part of a group), and of personal attributes and inclinations (for example, artistic taste) can all make a difference to how an exhibition is received. Moreover, they point out that the exhibition experience cannot be understood as confined only to the time when an exhibition has just been visited – the moment at which most visitor research attempts to assess it. Learning from a museum experience may, perhaps, only develop over time, growing in significance in retrospect as it interacts with other life experiences. Trying to incorporate even some of these factors into an analysis is clearly extremely difficult, though a wide range of approaches is discussed in Eilean Hooper-Greenhill's survey of visitor research (chapter 22) and the Institute for Learning Innovation has devised its own scheme – "personal meaning mapping" – outlined here. The even bigger challenge is to bring research that recognizes variations in reception together with the approaches to understanding the grammar of museums discussed in Part III.

The extent to which learning and education should be emphasized relative to other aspects of museums, such as the aesthetic and social responsibility, has long been a matter of debate and sometimes of dispute, as Hein (chapter 20) shows in his discussion of the history of museum education (mainly in the United States). However, as he argues, even those who are seen as proponents of positions alternative to the educational, still often concede that the museum has a broadly educational role; and setting these up as oppositions or alternatives is, perhaps, more a matter of polemic or a bid for resources than of useful distinctions to make either analytically or in practice. Hein himself provides further argument for the constructivist position or what he also here describes, influenced by the philosopher of education John Dewey, as progressive education; and he discusses some of the implications that this has for museum practice and the nature of exhibiting.

This is also taken up by Andrea Witcomb (chapter 21), who draws directly on Hein's classical model of types of learning in museums to explore the idea of interactivity. Although "interactivity" has become one of those fashionable terms (like "community" discussed by Crooke in chapter 11) associated with a progressive approach, it is used to denote a wide range of types of exhibit and of understandings about the nature of exhibit–visitor relationships. As Witcomb shows, in some cases – especially those exhibits dubbed "hands-on" – these are rather mechanistic and based on behaviorist models. More progressive, "constructivist" approaches to interactivity, by contrast, try to avoid the mechanistic "right-answer" model and aim instead to allow for visitors' own, variable, input. A problem with this, however, as

she discusses, is that the visiting experience may become atomized and even alien-ating. This "atomization" would seem to be another manifestation of the individu-alization discussed by Beier-de Haan in chapter 12, and, as such, can be understood in relation to broader socio-cultural shifts in ways of understanding and expressing identity. As both chapters show, however, there is a risk with such approaches that senses of the shared and collective – important aspects of identification and of museum visiting – may be lost. Interacting with other visitors, as well as the exhibits, is clearly part of the museum experience.

Understandings of how visitors experience museums are only now becoming more developed, as Hooper-Greenhill's discussion of a wide range of museum visitor research makes clear (chapter 22). Indeed, even getting at what would seem a fairly straightforward matter, namely counting how many people go to museums, is fraught with difficulties and different (though not always acknowledged) methods of mea-suring. As Hooper-Greenhill notes, even at this relatively "hard" end of research, very different results have been recorded. Nevertheless, there has been growing sophistication of approach, paralleling both the move to more constructivist theo-rizing and the allied shift in museums themselves toward regarding their audience as differentiated and "active interpreters." New methods, or the use of combinations of methods, have been devised to try to access such interpretations and the range of differentiations; and also to begin to tackle questions of those who do not visit as well as those who do (see also chapter 3). What we see here is the beginning of more interactive approaches to studying museum visiting.

Living in a Learning Society: Museums and Free-choice Learning

John H. Falk, Lynn D. Dierking, and Marianna Adams

Globally, Western societies are in the midst of changes as great as any in their history, changes that are affecting everyone. These changes, which directly influence museums of all types, are tied to the shifting of Western economies from ones that are industrially based to those that are information and knowledge-based (Dizard 1982). The transition from a goods-based to a knowledge-based economy was noted first in America by Princeton economist Fritz Machlup (1962), and substantiated over a decade later by the US Department of Commerce (1977). Knowledge and information (which Machlup felt were functionally the same) are rapidly becoming the major economic product of society. These changes are dramatically changing the way in which citizens in the developed world conduct their lives.

The engine that is driving this new transformation may be economics, but the fuel that it runs on is learning. Around the same time as futurists were beginning to herald the coming of the knowledge economy, a number of forward-thinking educators were talking about the transition of America and other developed countries into *learning societies* (for example, Sakata 1975; Christoffel 1978). These futurists argued that if Western countries were to fully transition into knowledge-based economies, economies where information and ideas were paramount, then learning across the lifespan would need to become central to the society as never before. Implicit in these notions was an appreciation of the limitations of the traditional formal education system and a growing awareness of the importance of other non-school sources of information and education (Hilton 1981). At least from the sixteenth century onward, there has been a pervasive assumption that one's parents' lives were different from one's own life and that one's children will have a still more uncertain and challenging time of it (Clifford 1981). These ideas seem to be fundamental to Western culture, and thus, too, the long-held belief in the importance of educating children. Education, it was believed, not only helped one to "make something of oneself," but taught flexibility, adaptability, and how to survive and even prosper in a chancy world (Clifford 1981).

It has long been understood that knowledge is available from many, many sources – what American educational historian Lawrence Cremin (1980) called the "config-

urations of education." Over the years, people have sought and received information from a wide range of both school and non-school sources. For example, in the early nineteenth century, Americans relied upon such diverse resources as farming almanacs for tips on agriculture and the evangelical movement for early versions of "self-help" courses (Cremin 1980). By the early twentieth century, Americans could turn to a wealth of resources in order to gain more and better knowledge: daily newspapers were in abundance, as were periodicals on everything from advertising to plumbing. Libraries, museums, and the increasingly popular encyclopedias were also available (Harris 1979). However, all of this notwithstanding, clearly something profound and different is occurring as the twenty-first century begins. The need to learn seems to be taking on a greater importance, a greater urgency, than ever before in our society. The informed citizen, not to be confused with the learned citizen, will be the archetype of the twenty-first century.

Today, Western societies, incrementally all societies, are evolving into learning societies because the knowledge economy is being built upon ideas, and developing – let alone keeping up with – new ideas requires learning. It takes information and experience to generate good ideas. The best route to new information, more refined knowledge, and the need for relevant experience is learning. Messing about with ideas, above all, requires openness to new information and a commitment to learning all the time. Cradle-to-grave learning has long been a goal of Western society, but it is increasingly becoming both a necessity and a way of life. As society becomes more and more inundated with information, each individual needs to learn qualitatively and quantitatively better strategies for dealing with information (Shenk 1997). In the twenty-first century, the learning strategy of choice for most people, most of the time, will be free-choice learning.

Free-choice learning – learning that is intrinsically motivated and reflects the learning individuals do because they want to, rather than because they have to – is not something new; it is something humans have always done. However, in the new learning society, free-choice learning will consume more of our time and be elevated to a higher status and importance. Free-choice learning includes watching the news on television, reading an arts magazine, surfing the Internet to find out about a health-related concern, touring an historic site while on vacation, and visiting a natural history museum to see a new exhibition on dinosaurs. All of these experiences are motivated by a desire to gain information, enhance understanding, and satisfy one's curiosity about the world. Whereas as recently as a generation ago, learning was perceived as a necessary but painful process that one "graduated" from sometime in adolescence, by the end of the next generation, learning will be accepted as something that everyone needs to do all the time (cf. Falk and Dierking 2002). But not only will learning be something that everyone *needs* to do all the time, it will be transformed into something that everyone will *consciously want* to do all the time. And given that citizens will spend the vast majority of their lives (97 percent) outside the formal education system, free-choice learning will continue to assume ever-greater value and importance. Museums have an important role to play in this arena. However, to do so successfully requires some rethinking – rethinking about what learning is and how museums can best facilitate *and* document such learning.

324

Changes in Perceptions of Learning

We all learn – continuously. Learning is as critical to our survival in a modern, tech-nologically sophisticated society as it was in ancient, more traditional societies. That humans learn has not changed, neither has the way in which people learn. What has changed dramatically is what people learn; also changed is our understanding of how and why people learn.

Much of what we understand about learning is based on a behaviorist conceptual framework. Underlying this framework are a number of assumptions, most signifi-cantly that learners come to the learning situation knowing nothing, or virtually nothing, and, after a suitable educational intervention, exit "knowing" something. That something is the "thing" that the instructor/designer chose for them to learn. Because, according to this framework, learners are assumed to be virtual blank slates, their prior experiences, interests, and motivations are assumed to be, if not irrele-vant, then not aggressively factored into the analysis of the learning process. This model of learning focuses primarily on the acquisition and retention of new infor-mation (Sylwester 1993). Behaviorist teaching strategies tend, therefore, to be more didactic and instructor-centered; the teacher provides the *what*, *when*, and *how fast* of the learning experience. Although providing some useful insights, the behaviorist–positivist learning model is now viewed as seriously flawed.

Through recent advances in neuroscience research we are able to literally see the brain learn. Rather than the straightforward process suggested by the behaviorist model, learning has been revealed to be a relative and constructive process (Sylwester 1993; Rosenfield 1994; Roschelle 1995; Falk and Dierking 2000). This framework, referred to as the constructivist model of learning, suggests that learning is a con-tinuous, highly personal process. Learners start from different cognitive frameworks and build on learning experiences to create unique, highly individualized schemas. Operating from a constructivist perspective requires accommodating to the diverse and individualized nature of learning (see chapter 20).

Although constructivist ideas of learning have been circulating in academic circles for quite some time, the behaviorist learning model continues to thrive in museums. Many museum practitioners, consciously or unconsciously, operate as if by properly adjusting the lighting, composing the right label, and positioning an object "just so," all visitors to the museum will emerge having had the same experience and having learned exactly the same thing. The constructivist model, however, sees learning as a highly contextual process. The learner's prior knowledge, experience, interests, and motivations all comprise a personal context, which is embedded within a complex socio-cultural and physical context. Learning can be described as the interaction and negotiation of these three shifting contexts in time and space (Falk and Dierking 1992, 2000). "In a world that allows for multiple perspectives, the conditions for meaning have become as important as the meanings themselves" (Roberts 1997: 132). From a constructivist perspective, learning in and from museums is not just about what the museum wishes to teach the visitor. It is as much about what meaning the visitor chooses to make of the museum experience.

John H. Falk, Lynn D. Dierking, and Marianna Adams

Toward a Usable Model for Understanding Learning from Museums

It makes sense to desire simple explanations for complex reality. For example, as presented in a book one of us (J.H.F.) recently read (Hagen 1997), a physician described how, during his days in medical school, he was constantly overwhelmed with the quantity of information. He said that some teachers could package the information very simply. "Here, this is what you need to know." Medical students loved those teachers, he said. But there were other teachers who always offered two or more (often contradictory) perspectives on things. This the students hated. "It involved more work on our part," said the doctor. "Who wants to be told that some people think this, and some people think that? It was so much easier just to be told what is what." But, he said, as the years went by and he became more and more experienced as a doctor, he realized that the concise, neatly packaged views were incorrect. The teachers had chopped off all the rough edges that did not fit into the system; unfortunately, what was chopped off invariably proved to be important information needed to make an effective diagnosis. In the end, the simplest solutions were not always the best.

For better or for worse, it is our opinion that learning is a phenomenon of such complexity that a truly simple model or definition will not result in a sufficiently realistic and generalizable model. You can only simplify the complexities of learning so much before they become less than useful. Consequently, what we have proposed is not really a definition of learning but a model for thinking about learning that allows for the systematic understanding and organization of complexity. The *contextual model of learning* is an effort to simultaneously provide a holistic picture of learning while accommodating the myriad specifics and details that give richness and authenticity to the learning process (Falk and Dierking 2000).

It turns out to be important that we designate the setting because the *where* and *why* of learning does make a difference. Although it is probably true that at some fundamental, neurological level, learning is learning, the best available evidence indicates that if you want to understand learning at the level of individuals within the real world, learning does functionally differ depending upon the conditions under which it occurs. Hence, learning in museums is different from learning in any other setting by virtue of the unique nature of the museum context; and at some important level, learning in a museum in Minneapolis is likely to be different from learning in a museum in Bristol. Although the overall framework we are about to suggest should work equally well across a wide range of learning situations – compulsory school-based learning as well as museum-based, free-choice learning – the specifics only apply to museums. In the final analysis, if you want to truly understand how, why, and what people learn in places like museums, specificity is essential. There is no simple, stripped-down, a-contextual framework for understanding learning. Learning is highly situated.

Thus, learning can be conceptualized as a contextually driven effort to make meaning in order to survive and prosper within the world. The *contextual model of learning* portrays this contextually driven dialogue as the process/product of the

interactions between an individual's *personal, socio-cultural*, and *physical* contexts over time. None of these three contexts is ever stable or constant; all are changing across the life-time of the individual. The *personal context* represents the sum total of personal and genetic history that an individual carries with him/her into a learning situation. Specifically, one should expect new learning to be scaled to the realities of an individual's motivations and expectations, which in the case of museums normally involve a brief, usually leisure and curiosity-oriented, culturally defined experience. One should expect learning to be highly personal and strongly influenced by an individual's past knowledge, interests, and beliefs, and one should expect learning to be influenced by an individual's desire to both select and control his/her own learning.

Humans are extremely social creatures; we are all products of our culture and social relationships. Hence, one should expect museum learning to be socio-culturally influenced. These socio-cultural influences occur at both the macro and micro levels. At the large-scale level, people are affected by their upbringing and culture and by the meaning and authority that an institution like a museum has within their community and culture. While on the micro level, the interactions and collaborations that occur within the visitor's own social group, as well as potentially the interactions the individual has with others outside the visitor's own social group – for example, with museum explainers, guides, demonstrators, or performers – strongly influence the visitor experience.

Learning always occurs within the physical environment; in fact, it is always a dialogue with that physical environment. Thus, one should expect visitors to react to exhibitions, programs, and websites in a voluntary, non-sequential manner, as informed by orientation and organizational cues provided by the setting. One should expect that a myriad of architectural and design factors, including lighting, crowding, presentation, context, and the quantity and quality of the information presented, will also affect the nature of the learning that happens there.

Finally, one should expect that learning from museums will not only rely on the confirmation and enrichment of previously known intellectual constructs but equally depend upon what happens subsequently in the learner's environment. All learning occurs over time in a cumulative process of acquisition and consolidation. Thus, experiences occurring after the visit frequently play an important role in determining, in the long term, what is actually "learned" in and from the museum. The nature of learning seems to be that "there are delays between an experience and genuine understanding and these delays are uncomfortable for educators" (Oakes and Lipton 1990: 39). Rather than understanding these delays as a natural part of the learning process, they are frequently regarded as unsuccessful learning. For example, if a museum visitor is not able to articulate information acquired or meanings made immediately upon exiting an exhibition, the assumption is often made that learning did not occur, when in reality, a conversation with that visitor a few days, months, or even years after the visit is likely to reveal that the museum experience was a very rich learning experience (Adams et al. 1997; Falk and Dierking 2000; Falk and Storksdieck 2005).

A key understanding that flows from this perspective is an appreciation that finding and documenting learning in museums requires setting aside the expectation that

learning will necessarily follow a totally prescribed and predictable course. In other words, well thought-out exhibitions and programs can facilitate visitor learning along predetermined pathways, but the learners themselves need to be given an opportunity to help reveal the nature and character of their own learning. Methodologically, this means that expectations that individuals will learn a specific concept or idea need to be tempered; individuals may learn specific concepts and ideas and they may not – but invariably they will learn something. More typically, visitor learning follows two parallel pathways: (a) the learning of global ideas; for example, that science or history is fun or that there are an amazing number of different kinds of plants and animals in the world; and (b) the learning of very specific, but usually idiosyncratic, facts and concepts; for example, that Pablo Picasso continued painting until the day he died or that Amazon dolphins use echolocation to find prey items in the muddy waters of the Amazon.

Determining the depth and breadth of visitor learning becomes the challenge for the investigator, as well as what specific variables most significantly contribute to the learning of different types of visitors. Everyone in the process needs to understand and respect that, in the end, what individuals learn depends not only upon the content of the exhibitions and programs, but equally upon visitors' prior knowledge, experience, and interest, what they actually see, do, talk, and think about during the experience. Also important is what happens subsequently in visitors' lives that relates to these initial experiences. Results from recent research (Falk and Storksdieck 2005) help to demonstrate just how complex are both the processes and products of learning from museums. More so than we have historically believed, all of these factors matter tremendously, and all are different for each person. The framework provided by the *contextual model of learning* proved useful for understanding visitor learning because it turned out that the only way to arrive at a reasonable explanation for why visitors did what they did and learned what they learned was to consider each of these multiple factors *simultaneously*, rather than individually. As this study confirmed, learning from museums is an exceedingly complex phenomenon requiring considerable effort and ingenuity to comprehend and assess.

Changes in Museum Learning Research

Along with a paradigm shift in our understanding of how visitors learn in museums, it follows that our approach to learning research must also shift. Most of the educational research techniques and strategies we are familiar with were developed in order to study learning in either a classroom or laboratory context and derive from a behaviorist perspective. Although these approaches are not without their benefits, there is clearly a need to refine these techniques and to create new ones that are more aligned with the assumptions underlying the constructivist learning model described above. Using behaviorist approaches, researchers have historically found it difficult, if not impossible, to clearly document evidence of learning in museums (Falk 1999; Falk and Dierking 2000). Is the implication to be drawn, therefore, that learning does not occur in these settings? Not at all!

This dilemma is best explained through the use of an analogy. Imagine that you hear a bird singing. You look up into the trees but you do not see a bird. Next you get the best optical tool of your day, a very powerful telescope and direct that scope toward the tree, but still you do not see the bird. Does that mean the bird does not exist? Of course not! Perhaps the bird is on the ground and you directed your focus up into the trees. Or more likely, perhaps a telescope was not the correct tool for seeing a bird in a tree. Given that you can hear a bird singing provides strong evidence that there really is a bird up in the tree, but in the absence of the right search image and appropriate tool (for example, a good pair of binoculars) finding the bird is challenging. In the same way, the search image and methods we have used in the past for measuring museum learning were insufficient to the task. The fact is, people do learn from museums (Falk 1999; Falk and Dierking 2000); however, as a field, we need to get better at finding that learning. A major impediment to the successful understanding of the role that museums play in facilitating public learning has been the paucity of valid and reliable instruments specifically suited to the unique contextual realities of free-choice learning. Free-choice learning, which is typical of learning from museums, is fundamentally different from the type of compulsory learning that occurs in schools.

The Institute for Learning Innovation has focused its investigations on free-choice learning. Our research is used to generate theory about learning and the museum experience and has two uses. First, it informs practice for museum practitioners and other free-choice educators, and establishes the cycle of theory informing practice that, in turn, informs theory again. Second, theories built on research findings are also used to inform and generate new research methods. In our search for more productive and sensitive methodologies, Institute researchers have developed a set of five characteristics that any responsive research methodology needs to incorporate in order to yield more meaningful and faithful evidence of the depth and complexity of free-choice learning experiences:

1 Allow for the individual's own unique learning agenda to emerge.
2 Address the effect of time on learning.
3 Respect that learning is always situated and contextualized.
4 Be open to a broad range of learning outcomes.
5 (in research-speak) Emphasize validity over reliability.

Let us briefly describe each of these issues.

Allow for the individual's learning agenda to emerge

A responsive research methodology should be designed to capture evidence of how the multiple perspectives that visitors bring to the museum, in combination with the experiences visitors have in the museum, result in the multiple meanings visitors construct from their museum experience. These meanings are emergent; they may or may not bear any resemblance to what the museum itself intended for the visitor to "learn/experience." Many research methodologies try to structure visitor

responses in rather narrow terms, dictated by the institution. Questions are developed and visitors are asked to respond to them in an order predetermined by the researcher. It is the museum's (and/or researcher's) agenda that gets addressed with this approach. The visitors' agendas, while they may occasionally sneak in around the edges of these methodologies, are rarely allowed to flourish and come to the fore in the data collection or analysis stages.

More responsive methodologies give the visitors' agendas room to emerge as fully as possible. Visitors' prior experiences, knowledge, and interests are essential variables in collecting and making sense of the data. Consequently, a variety of perspectives on exhibitions, programs, and the totality of the museum experience must be factored into the mix. When visitors are encouraged to raise what is at the forefront of *their* thinking, we come closer to understanding the various ways in which people approach and connect with the museum experience. Given the potential disparity between museum professionals' and visitors' views of what is happening in the museum, methods that capture these different perspectives have great value.

Address the effect of time on learning

Many research methodologies tend to limit investigation to the physical and temporal boundaries of the museum. Historically, and even still today, most data on museum learning are collected from visitors while inside the museum. Given that learning is a complex process that occurs over time, it should be expected that museum experiences require time to be accommodated and integrated into the fabric of visitors' lives. For example, if a museum experience is very intense or powerful, visitors often cannot synthesize, reflect upon, and then articulate their experience in just a matter of minutes. Certainly, collecting immediate exit responses is valuable but, when possible, attention needs to be given to how visitors integrate their museum experience with the rest of their life and that requires an interval of weeks, months, and sometimes years.

New understandings of the nature of learning are forcing new methods for documenting learning. As a result, there is growing appreciation within learning research communities of the need to extend the timeline for assessing learning (Falk and Dierking 1992, 2000; Falk 1998; Barab and Kirshner 2001). Much of what an individual learns in a museum, zoo, or science center only becomes apparent after the experience, and then only in relation to the individual's or family's construction of knowledge and experience. A recent investigation in Australia (Falk et al. 2004) demonstrated that visitors had distinctively different learning outcomes depending upon when you measured them: the visitors' long-term learning outcomes were not predictable from their short-term learning outcomes.

Respect that learning is situated and contextualized

Learning research models were first developed for use in laboratories where animals and humans were tested in clinically controlled conditions rather than in their natural environments. It was assumed that this was not problematic because this theoretical model posited that learning was a generalized, a-contextual phenomenon –

as long as the stimulus was the same, and laboratory conditions facilitated sameness, the response would be the same! Subsequent research suggests that these laboratory studies, however, only reliably measured how animals and people learned and behaved in laboratories, and could not be generalized to learning and behavior elsewhere in the real world (Schoenfeld 1999).

A more sensitive research approach requires that data be collected in as close to a natural, unobtrusive manner as possible, despite all its messiness (Brown 1992; Collins 1999; Cobb et al. 2003). Efforts should be made to embed data collection within the visitor experience, involving visitors in experiences that feel comfortable and appropriate, rather than feeling tested, probed, or prodded. Both the setting for data collection and the data must be authentic and closely tied to the experience being assessed. This is good advice for any learning research; it is essential for understanding free-choice learning since the most fundamental quality of such learning is that it is learning under the motivational control of the learner, not some experimenter or instructor.

Be open to a broad range of learning outcomes

Typically, the theoretical model of learning we have used in the past has divided learning artificially into cognitive, affective, and psychomotor domains with the greatest value placed on cognitive learning. Museum exhibition developers and programmers often limit their thinking about learning to knowledge-based outcomes such as "Visitors will learn three characteristics of Baroque art" or "Visitors will understand the importance of conserving water in arid environments." Recent research, both in the cognitive and neurosciences, shows that learning can not be so easily divided into cognitive, affective, and psychomotor domains, but rather emerges as a complex array of diverse, interconnected effects (Damasio 1994). More sensitive research methodologies need to be developed that can accommodate the subtlety and complexity of real learning. One way to do this is to actively recognize and seek evidence for a broad array of learning outcomes.

We have attempted to define and measure dozens of different learning outcomes from visitors (cf. Dierking et al. 2002), and have found eight outcomes that seem to emerge consistently from museum experiences. These are: knowledge, skills, interests, values, museum literacy, social learning, creativity, and awareness (Luke et al. 2001; Falk et al. 2004).

Emphasize validity over reliability

All research involves trade-offs. One important trade-off that all researchers must negotiate is the balance between validity and reliability. Validity is the degree to which measures actually measure something of meaning to measure. For example, measuring how much time visitors spend in front of an object may not actually meaningfully tell you whether learning was occurring. Reliability essentially means that if a sample of visitors is interviewed today and given the identical interview tomorrow, the results would be statistically the same. This means that the items in the interview consistently measure the same thing. The behaviorist tradition favored relia-

bility over validity, thus the common use of time as a measure in museums. An example of such behaviorist measures is the familiar "attracting" and "holding" time measures. However, research has shown that although it is possible to consistently measure how long people spend in an exhibition or the "dwell" time in front of an object, such measures do not necessarily tell you anything useful about whether or not someone has learned anything from that object (for example, Menninger 1990).

Both reliability and validity are important components. Ideally there is a balance, but there is always a tension between the two within a research design. Researchers must inevitably emphasize one side more than the other. A constructivist perspective would suggest that the emphasis should be more on establishing meaning and reality, and hence on validity.

Developing a Responsive Methodology

The need for the development of new, more responsive research methodologies emerged over several years during the Institute's investigations of numerous museum exhibitions and programs. For example, in a comprehensive evaluation of the Virginia Museum of Fine Arts' Lila Wallace Reader's Digest Collections Access project *Spirit of the Motherland*, evidence strongly suggested that most visitors were interested in creating their own narrative within the exhibition of African art and artifacts, and that they had learned *something* in the exhibition (Dierking et al. 1997). However, our research methodologies at the time limited our understanding of the complexity, depth, or degree of change in visitor learning as a result of their museum experience. It also appeared that other researchers were struggling with a similar inability to "find the singing bird." In a search for more responsive methodologies, we drew on developments in other related fields. For example, the work in authentic or performance-based assessment provided information about ways to develop reliable scoring rubrics and analysis approaches for a variety of qualitative responses (Persky et al. 1998).

These and other projects/readings were moving us to actively explore other ways of thinking about measuring changes in learning. One particularly interesting approach was concept mapping (for example, Novak et al. 1983; Novak and Musonada 1991; Ross and Mundy 1991; Barenholz and Tamir 1992; Gaffney 1992), an approach that seemed more respectful of the complexity of learning processes. However, concept mapping appeared to have two major deficiencies. First, most concept-mapping approaches required the learner to undergo considerable training so that they would know how to "correctly" construct a concept map. Not only did such training seem totally impractical in the free-choice setting where people have neither the time nor the inclination to invest in such a process, but it also seemed that the training would over-influence visitors' understanding of the topic.

Second, the "scoring" rubrics used by concept-map researchers were still very positivistic and reductionist. Although learners were permitted to "map" all of the idiosyncrasies of their personal cognitive reality, scoring was based upon the degree to which maps matched some predetermined cognitive reality. In other words, it was assumed that there was, basically, a single "right" answer. The real breakthrough

came in finding a way to use the strengths of concept mapping – the ability to more accurately understand the personal construction of ideas – while overcoming what we perceived to be its deficiencies – an unnecessarily lengthy training period and an overly positivistic scoring protocol. The result was the development of a methodology called *personal meaning mapping* (PMM). Developed by John H. Falk and researchers at the Institute for Learning Innovation (Falk et al. 1998; Luke et al. 1998; Falk 2003), PMM is an approach that we believe addresses all five of the criteria listed above. PMM is certainly not the only way to address these concerns, but we believe it is a productive step in this direction.

What is personal meaning mapping?

Personal meaning mapping (PMM) is designed to measure how a specified learning experience uniquely affects each individual's understanding or meaning-making process. It does not assume that all learners enter with comparable knowledge and experience, nor does it require that an individual produce a specific "right" answer in order to demonstrate learning.

The PMM assessment assumes that it is the norm, rather than the exception, that free-choice learning experiences have an effect on the underlying structure of an individual's understanding. However, exactly what an individual might learn as a consequence of a specific learning experience will vary considerably depending upon the individuals themselves and the social/cultural and physical context of the experience (Falk and Dierking 1992, 2000). The focus of PMM is not exclusively on the nature of change but equally on the degree of change in learning. The major insight of PMM is that quality learning experiences change people; the better the experience, the greater the change. Thus, what is most profitably quantified is not just what visitors learn but also how much and to what depth and breadth learning occurs. PMM is still interested in what a person learns, but the focus is on that person's unique "what," not some prescribed outcome. The method accepts and accommodates the multi-dimensionality of learning, uses this fact to generate different, equally valid measures of learning, and allows measurement of both individual and group learning.

PMM assesses how an educational experience uniquely affects the public's personal, conceptual, attitudinal, and emotional understanding across four, semi-independent learning dimensions. The first dimension measures the change in the quantity of appropriate vocabulary used by visitors, and is an indication of the *extent* of a visitor's knowledge and feelings. The second dimension measures the *breadth* of a visitor's understanding. *Breadth* is determined by measuring the change in the quantity of appropriate concepts used. The third dimension measures the *depth* of understanding, how deeply and richly a visitor understood the concepts they used. *Depth* is defined as the change in the richness of each of the concepts described by the visitor. Finally, the fourth dimension measures the *mastery* an individual possesses of the topic, whether a visitor's understanding is more like that of a novice or more like that of an expert. This is a holistic judgment, which, unlike scales one, two, and three, combines all available information into a single rating. In order to provide a richer sense of the methodology, two examples are provided below.

333

Understanding learning in an interactive art space

The PMM methodology was used to investigate the Art Sparks Interactive Gallery in the Laramie L. Leatherman Art Learning Center of the Speed Art Museum, Louisville, Kentucky (Adams 1999). An evaluation team, composed of education department staff members and Institute researchers, collected pre- and post-visit PMMs from thirty-nine adults who visited the gallery as part of a family group, as well as follow-up PMMs, conducted over the telephone, with roughly half of these same adults one month later. In addition, students visiting the gallery as part of a school field trip completed pre-visit maps and, several weeks after the museum visit, completed drawings and written explanations about their visit.

Through the PMM methodology, a framework evolved that described the ways in which visitors used the interactive gallery to construct their own personal meaning. For example, the data suggested that visitors made shifts in knowledge about art and about how to engage with it. In addition, the role of social learning was highlighted as visitors noted that the experience was "memory-making." Families responded to the physical and emotional safety that the gallery provided for them to explore. And, finally, the gallery stimulated families to make personal connections between the art and their own lives. This framework was extremely helpful for the museum staff to better understand exactly how visitors approached and made sense of the experience.

In the school study, the adapted PMM, which included drawing and writing, provided strong evidence that repeated experience in the Art Sparks Interactive Gallery resulted in students remembering more about the permanent collection. This issue was a particular concern for the museum since some staff feared that the appealing participatory nature of the interactive gallery would overshadow the permanent collection. The PMMs revealed that the playful, self-paced character of the Art Learning Center seemed to stimulate students to look more closely at the art in the main galleries and to think more conceptually about the work.

Museums in the Twenty-first Century

As we look ahead to the future of museums in the twenty-first century, we will not only have to accommodate to changing understandings of learning, but also to a rapidly changing world. Three interconnected, yet distinguishable social-economic trends are particularly worth noting here.

Change in the nature of goods and services

The first is that goods and services are becoming so abundant, that success in the marketplace is determined less by the ability to fulfill general needs and more by the ability to satisfy a consumer's personal desires and lifestyle. For the first time in human history, the majority of people in the West live in a world where the demand for goods and services, everything from food, shelter, and clothing to health spas and

entertainment, is no longer limited by supply; supply exceeds demand. The problem for most of the population is not whether or not there will be food on the table, but what type of cuisine to eat. The issue is not whether there is a roof over one's head, but what the roof should look like. This degree of affluence, for so many, both in the quantity and quality of goods and services available, is unprecedented in human history.

The result is a shift from consuming in order to merely satisfy the necessities of life to consuming in order to satisfy life's desires and values. In other words, consumption increasingly is less about needs than wants, less about things and more about ideas (Pine and Gilmore 1999; Zuboff and Maxmin 2002). A key aspect of this change is a shift away from goods and services aimed at the masses to goods and services customized to the wants and desires of the individual. Museums have historically operated on the mass-production model of "one size fits all" – this experience will meet the needs of all our visitors. This approach simply will not work any more. Museum offerings will need increasingly to be customized to the unique needs and interests of individuals.

The rise of free-choice learning

A second major trend relates to free-choice learning. Since success in a knowledge society is based upon having knowledge, the goods and services with the greatest value are those that support learning. Writing thirty years ago, anthropologist Nelson Graburn (1977) speculated that museum-going would be part of a larger societal trend, part of the changing landscape of leisure and work in a post-industrial society. In Graburn's view, "leisure is displacing work from the center of modern social arrangements" (1977: 6). Graburn was accurately anticipating the transformation of the developed world into the learning society described earlier. Today, "value-added" leisure experiences (which is another way to say leisure that has some kind of learning component) are the most sought after and rapidly expanding segment of the leisure market (Tribe 1995; Robinson and Godbey 1997). In other words, increasingly, the key to a successful leisure enterprise is to incorporate free-choice learning! Museums are quintessential free-choice learning institutions. In the twenty-first century, this reality will need to be "front and center" not "oh, and by the way."

The need for accountability

One of the stark realities of life today, and thus the third and final major social-economic trend, is the need for accountability. Everyone – trustees, funders, and the public – expects the institution not only to deliver on what it promises, but to provide evidence of that accomplishment. Once upon a time, success could be measured by numbers of visitors – so many thousands of people visited us last year. In the new learning society, what is important is not quantity but quality, not "numbers of hits" but "lives changed." Measuring success when quality is the coin of the realm

requires new approaches and new instruments. How do you measure quality? As we argued earlier, our accountability schemes need to be long term and embrace complexity.

All of these trends have importance for museums. In order to accommodate them, museums need, first and foremost, to adopt a new business model; they must begin by redefining what constitutes success. Individually and collectively, museums need to move away from the idea that the quantity of visitors cycling through an institution indicates success; quantity is an industrial age concept. Instead, museums need to invest in maximizing the quality of the learning experiences they provide. In tomorrow's society, everything will begin and end with quality. Curators of each and every museum should be asking themselves: what can I do today to improve the quality of the learning experience we provide each and every visitor? At the same time, they should also be asking: how will I measure and record that accomplishment so that I can demonstrate success to my funders, my trustees, and my public? The measure of success of a museum should be lives changed not bodies served. In the crowded leisure marketplace of the twenty-first century, hundreds if not thousands of organizations and businesses will be vying for the public's time, each trying to serve their leisure needs. But only a few have the capacity to transcend the ephemeral, the ability to truly transform individuals. The organizations and businesses that can provide quality, transformative experiences will thrive; the others will be left scrambling for the crumbs.

The key that unlocks all of this is free-choice learning. Museums need to embrace the fact that they are in the business of supporting individuals in their quest for knowledge and understanding – not the knowledge and understanding we might deem that an individual needs, but rather the knowledge and understanding that an individual decides that they need. In the learning society of the twenty-first century, the greatest and most transformative experience an individual can have is one that supports and facilitates his/her intellectual interests and curiosities; and not just for a moment, but across a life-time. That is a ride that no amusement park can ever duplicate.

Museums must move away from the idea that they are here to serve the learning needs of the "masses." If there is a single thread that runs through each of the trends described above, it is that a museum's focus needs to be directed to supporting the individual's ability to exercise choice and control over his/her life, particularly as it relates to learning. Fortunately, as industries go, the museum community is well situated to transition toward this new way of doing business. Museums are already strongly associated with free-choice learning; they already know how to provide unique experiences; they possess spaces that the public perceives as safe and important to the community; they have the capacity to accommodate individual needs and many, if not most, already appreciate that some kind of assessment is essential. However, being predisposed to accommodate these three major social and economic trends is not the same thing as actually fulfilling them. Determining how museums can best facilitate and support free-choice learning in the context of these trends will be the major challenge of the next ten to fifteen years. If they can accomplish this, then they will continue to be prominent and fundamental players in this new learning society.

Bibliography

Adams, M. M. (1999) Summative evaluation report: Art Learning Center Art Sparks Interactive Gallery for the Speed Art Museum, Louisville, KY. Technical report. Annapolis, MD: Institute for Learning Innovation.

—, Falk, J. H., Cobley, J., and Pruitt, R. (1997) Phase I evaluation report. Motivations and expectations of the general museum visitor for the National Museum of African Art. Technical report. Annapolis, MD: Institute for Learning Innovation.

*Barab, S. A. and Kirshner, D. (2001) Rethinking methodology in the learning sciences. *Journal of the Learning Sciences*, 10 (1/2): 5–15.

Barenholz, H. and Tamir, P. (1992) A comprehensive use of concept mapping in designing instruction and assessment. *Research in Science and Technological Education*, 10 (1): 37–52.

Brown, A. L. (1992) Design experiments: theoretical and methodological challenges in creating complex interventions in classroom settings. *Journal of the Learning Sciences*, 2: 141–78.

Christoffel, P. (1978) *Toward a Learning Society: Future Federal Funding of Learning*. Princeton, NJ: The College Board.

Clifford, G. (1981) The past is prologue. In K. Cirincione-Coles (ed.), *The Future of Education: Policy Issues and Challenges*, pp. 127–35. Beverly Hills, CA: Sage.

Cobb, P., Confrey, J., diSessa, A., Lehrer, R., and Schauble, L. (2003) Design experiments in educational research. *Educational Researcher*, 32 (1): 9–13.

Collins, A. (1999) The changing infrastructure of education research. In E. C. Lagemann and L. S. Shulman (eds), *Issues in Education Research: Problems and Possibilities*, pp. 289–98. San Francisco: Jossey-Bass.

Cremin, L. (1980) *American Education: The National Experience*. New York: Harper and Row.

Damasio, A. R. (1994) *Descartes' Error: Emotion, Reasons, and the Human Brain*. New York: Avon Books.

Dierking, L. D., Adams, M., and Spencer-Etienne, M. (1997) Final evaluation report for Spirit of the Motherland for the Virginia Museum of Fine Arts. Technical report. Annapolis, MD: Institute for Learning Innovation.

*—, Cohen Jones, M., Wadman, M., Falk, J. H., Storksdieck, M., and Ellenbogen, K. (2002) Broadening our notions of the impact of free-choice learning experiences. *Informal Learning Review*, 55 (July–August).

Dizard, W. P. (1982) *The Coming Information Age*. New York: Longman.

Falk, J. H. (1998) Pushing the boundaries: assessing the long-term impact of museum experiences. *Current Trends*, 11: 1–6.

— (1999) Museums as institutions for personal learning. *Daedalus*, 128 (3): 259–75.

*— (2003) Personal meaning mapping. In G. Caban, C. Scott, J. H. Falk, and L. D. Dierking (eds), *Museums and Creativity: A Study into the Role of Museums in Design Education*, pp. 10–18. Sydney, Australia: Powerhouse.

— and Dierking, L. D. (1992) *The Museum Experience*. Washington, DC: Whalesback.

*— and — (2000) *Learning from Museums: Visitor Experiences and the Making of Meaning*. Walnut Creek, CA: AltaMira Press.

— and — (2002) *Lessons without Limit: How Free-choice Learning is Transforming Education*. Walnut Creek, CA: AltaMira Press.

*— and Storksdieck, M. (2005) Using the *contextual model of learning* to understand visitor learning from a science center exhibition. *Science Education*, 89: 744–78.

—, Moussouri, T., and Coulson, D. (1998) The effect of visitors' agendas on museum learning. *Curator*, 41: 107–20.

*—, Scott, C., Dierking, L. D., Rennie, L. J., and Cohen Jones, M. (2004) Interactives and visitor learning. *Curator*, 47 (2): 171–98.

Gaffney, K. E. (1992) Multiple assessment for multiple learning styles. *Science Scope*, 15 (6): 54–5.

Graburn, N. H. (1977) The museum and the visitor experience. In *The Visitor and the Museum*, pp. 5–32. Prepared for the 72nd Annual Conference of the American Association of Museums, Seattle, WA. Washington, DC: American Association of Museums.

Hagen, S. (1997) *Buddhism Plain and Simple*. Boston: Charles E. Tuttle.

Harris, N. (1979) The lamp of learning: popular lights and shadows. In A. Oleson and J. Voss (eds), *The Organization of Knowledge in Modern America, 1860–1920*, pp. 83–101. Baltimore, MD: The Johns Hopkins University Press.

Hilton, W. J. (1981) Lifelong learning. In K. Cirincione-Coles (ed.), *The Future of Education: Policy Issues and Challenges*, pp. 147–57. Beverly Hills, CA: Sage.

Luke, J., Adams, M., Abrams, C., and Falk, J. H. (1998) Art around the corner: longitudinal evaluation report. Technical report. Annapolis, MD: Institute for Learning Innovation.

—, Dierking, L. D., and Falk, J. H. (2001) The Children's Museum of Indianapolis Family Learning Initiative: phase I baseline report. Technical report. Annapolis, MD: Institute for Learning Innovation.

Machlup, F. (1962) *The Production and Distribution of Knowledge in the US*. Princeton, NJ: Princeton University Press.

Menninger, M. (1990) The analysis of time data in visitor research and evaluation studies. In S. Bitgood, A. Benefield, and D. Patterson (eds), *Visitor Studies: Theory, Research, and Practice*, vol. 3, pp. 104–13. Jacksonville, AL: Center for Social Design.

Novak, J. D. and Musonada, D. (1991) A twelve-year longitudinal study of science concept learning. *American Educational Research Journal*, 28: 117–54.

—, Gowin, D. B., and Johansen, G. T. (1983) The use of concept mapping and knowledge vee mapping with junior high school science students. *Science Education*, 67: 625–45.

Oakes, J. and Lipton, P. (1990) *Making the Best of Schools: A Handbook for Parents, Teachers, and Policymakers*. New Haven, CT: Yale University Press.

Persky, R., Sandene, B. A., and Askew, J. M. (1998) *The NAEP 1997 Arts Report Card: Eighth-grade Findings from the National Assessment of Educational Progress*. Washington, DC: US Department of Education, Office of Educational Research and Improvement.

Pine II, B. J. and Gilmore, J. H. (1999) *The Experience Economy: Work is Theater and Every Business a Stage*. Boston, MA: Harvard Business School Press.

*Roberts, L. C. (1997) *From Knowledge to Narrative: Educators and the Changing Museums*. Washington, DC: Smithsonian Institution Press.

Robinson, J. and Godbey, G. (1997*) Time for Life: The Surprising Ways Americans Use their Time*. University Park, PA: Penn State University Press.

Roschelle, J. (1995) Learning in interactive environments: prior knowledge and new experience. In J. H. Falk and L. D. Dierking (eds), *Public Institutions for Personal Learning*, pp. 37–52. Washington, DC: American Association of Museums.

Rosenfield, I. (1994) *The Invention of Memory: A New View of the Brain*. New York: Basic Books.

Ross, B. and Mundy, H. (1991) Concept mapping and misconceptions: a study of high-school students' understandings of acids and bases. *International Journal of Science Education*, 13: 11–23.

Sakata, B. (1975) Toward lifelong learning. *Educational Perspectives*, December 14.

Schoenfeld, A. L. (1999) Looking toward the 21st century: challenges of educational theory and practice. *Educational Researcher*, 28 (7): 4–14.

Shenk, D. (1997) *Data Smog: Surviving the Information Glut*. New York: Harper Collins.

Sylwester, R. (1993) *A Celebration of Neurons: An Educator's Guide to the Human Brain*. Alexandria, VA: Association for Supervision and Curriculum Development.

Tribe, J. (1995) *The Economics of Leisure and Tourism*. Oxford: Butterworth–Heinemann.

US Department of Commerce (1977) *The Information Economy*. Washington, DC: US Government Printing Office.

Zuboff, S. and Maxmin, J. (2002) *The Support Economy*. New York: Viking.

Museum Education

George E. Hein

Defining Museum Education

The educational role of museums is as old as the modern museum, but only since
World War II has it matured into an acknowledged profession. Today, along with a
growing literature in the field, there are graduate degree programs in museum edu-
cation, professional positions for museum educators, large, standing committees for
educators within major professional museum organizations (international, national,
and regional), and journals dedicated to museum education. This represents a dra-
matic change in less than fifty years since museum education staff began organiz-
ing. Yet a question posed by Lawrence Vail Coleman sixty-five years ago, in his
monumental three-volume survey of US museums, can still be asked:

> It seems the time has come for museum trustees to face a familiar question. Are
> museums primarily educational, or are they for only such educational work as can be
> carried on without limiting the curatorial function? A few museums have decided for
> education first, but most – most of the great as well as most of the small – are still
> letting education get along as best it can in an awkward setting. (Coleman 1939: II, 392)

As had been recognized since at least the early nineteenth century, museums, by
their very nature, are educational institutions (Hooper-Greenhill 1991a). Only later
did museum education come to be one (usually major) specialized function within
the museum. The term "education," however, was not always used. By the time that
Coleman was writing, for example, it had acquired such negative connotations for
museum educators – implying obligatory, formal, fact-laden information transfer –
that many in the museum world preferred to use the term "interpretation." Tilden's
(1957) classic and still useful book does not mention education, and Alexander's
(1979) thorough primer on all aspects of museology has a chapter on interpretation
but none on education.

Nevertheless, whatever the term and however conceived, education has long been
an important and increasingly specialized role for museums. This chapter outlines
the history of museum education, especially in the United States, before consider-
ing shifts in museum theory and their implications for museological practice. The

final section, on the relationship between museum education, social change, and social responsibility, extends the theoretical discussion in the earlier sections by turning to the work of John Dewey and its implications for museum education today.

Early Museum Education

Collections of objects, even collections carefully classified, organized, and preserved, are not necessarily primarily educational – the world includes many fine private collections. As soon as these objects are in a public museum, however, they are incorporated within a broadly educational project, though not one that is necessarily effective. As Wittlin (1949: 133) points out: "The creation of the Public Museum was an expression of the eighteenth-century spirit of enlightenment which generated enthusiasm for equality of opportunity in learning . . . In practice, the traditions of the former private collections were carried on in the public museums, notwithstanding the contrariety of purpose and of circumstances."

Wittlin further summarizes the history of European (including British) museum education into two "reform" periods: the first from the mid-nineteenth century to World War I and the second in the inter-war period, 1919–39. The former was characterized by a strong emphasis on illustrating national and imperial strength, as well as serving as "an instrument of investigation into a variety of scientific problems and, to some extent, of education" (Wittlin 1949: 149). The second period witnessed an enormous growth of both museums and museum education, with dual emphasis on nationalistic political themes (for example, in support of socialist society in the USSR and fascist societies in Germany and Italy), as well as on exhibiting new conceptions of art and science.

The United States was long recognized as the leader in developing the educational role of museums. Orosz (1990) has argued that "American" (i.e. United States) museums were firmly educational from their outset (see also chapter 8), although he acknowledges that a steady stream of criticism questioned how well they lived up to their educational missions. Children's museums, universally recognized as primarily educational, began in the US with the establishment of the Brooklyn Children's Museum (originally the Brooklyn Institute of Arts and Sciences) in 1899, and many US museums developed strong education departments in the early years of the twentieth century, often in collaboration with local school districts.

Although, in general, nineteenth-century museums were acknowledged to be educational institutions, the actual educational work was carried out in a haphazard and often unsatisfactory manner when viewed from the perspective of subsequent educational theory. Museum education was subject to the same constraints that limited the formal education sector: there was little historical background and limited theory to guide any institution that attempted to educate a large segment of the population. Although Western educational theory goes back to Plato, the concept of educating *hoi polloi* only became popular in the nineteenth century.

Critics of museum education in the nineteenth century, who described museums as restrictive in admission, lacking in orderly arrangement of objects, and with poor guidance for visitors, were uttering views also frequently expressed about state

schools for the public in that period. Formal education was still limited to a minority of the population (despite school attendance laws, many children lived on farms far from schools or worked long hours in factories) and, beyond the primary grades in which reading, writing and simple mathematics were taught, restricted to the classical curriculum.

Efforts to exploit the educative function of museums were guided by curators and directors; there was no formal education staff. The recognition of education as a specialized function of museums is primarily a twentieth-century phenomenon, paralleling the emergence of modern human development theory, the establishment of the social sciences as legitimate academic subjects, and the establishment of the modern state school and its rejection of the classical curriculum.

Modern Museum Education

Current definitions of museums – whether describing an institution that contains precious objects, material of primarily historical or scientific value, natural settings designated as museums, or specially built exhibitions used to illustrate ideas – usually include some statement about public access and education. According to the International Council of Museums (ICOM n.d.): "A museum is a non-profit making, permanent institution in the service of society and of its development, and open to the public, which acquires, conserves, researches, communicates and exhibits, for purposes of study, education and enjoyment, material evidence of people and their environment." This statement, on the current ICOM website (2005), illustrates the growing recognition of the significance of education. In the 1946 definition, from which this one evolved, education is not mentioned.

A similar evolution is seen in the series of policy statements issued by the American Association of Museums over the past thirty-five years. The Belmont Report (American Association of Museums 1969) made a case for federal support of US museums and argued that the museum's function to provide "pleasure and delight" to visitors was not incompatible with an educational mission. It proposed that the educational work of museums be strengthened. A more recent policy statement, *Excellence and Equity*, described in its preface as "the first major report on the educational role of museums ever to be issued by the American Association of Museums," states boldly: "[This report] speaks to a new definition of museums as institutions of public service and education, a term that includes exploration, study, observation, critical thinking, contemplation and dialogue" (American Association of Museums 1992: 6). While such a definition was hardly new in 1992, the report reflects a growing priority being accorded – by some at least – to education among the museum's various functions (see also Anderson 1997).

Education versus aesthetics and social responsibility

According to Zeller (1989), in a lengthy and thorough essay on the history of art museum education, three possible museum "philosophies" or missions can be identified: the educational museum, the aesthetic museum, and the social museum. Each

can be illustrated by reference to a seminal museum figure from the late nineteenth and early twentieth century.

The museum as an educational institution was championed by George Brown Goode (1851–96), curator and administrator at the Smithsonian Institution (Kohlstedt 1991; see also chapter 9). Goode once stated that an "efficient museum" would consist of "a collection of instructive labels, each illustrated by a well-selected specimen" (quoted in Alexander 1983: 290), and he argued that the museum should be an institution of ideas for public education. By contrast, Benjamin Ives Gilman (1852–1933), also a museum administrator, argued for the primacy of the aesthetic role of a museum, that it be considered a temple for the contemplation of beauty. He felt that art galleries, especially in contrast to university museums, were not well suited for formal education. The third position, emphasizing the social responsibility of museums, is illustrated by the work of John Cotton Dana (1856–1929; see Peniston 1999). Dana, first a librarian and then director of the museum he founded in Newark, New Jersey, may have had a stronger influence on museum professionals, both curators and educators, than either Gilman or Goode; his students assumed leadership roles in many museums as they grappled with the rapidly changing world after World War I.

A closer examination of the work of these three powerful figures suggests, however, that this clear-cut categorization of their views is inadequate. To a significant degree, all three recognized the educational role of the museum, while also acknowledging other goals. Even Goode's position as a proponent of the "educational" museum was not unmitigated. For example, he did not think that museums were appropriate venues for educating children.

> I should not organize the museums primarily for the use of the people in their larval or school-going stage of existence. The public school teacher, with the illustrated textbooks, diagrams, and other appliances, has in these days a professional outfit which is usually quite sufficient to enable him to teach his pupils. School days last, at the most, only from four to fifteen years, and they end with the majority of mankind, before the minds have reached the stage of growth favorable for the reception and assimilation of the best and most useful thought. (Goode 1888: 307)

The champion of the aesthetic museum – Gilman – is remembered today primarily for his educational efforts. He introduced "docents" into the gallery, arguing that funds should be shifted from hiring more guards to adding staff who could talk intelligently to visitors about the paintings, and installed extensive, large-print labels in the galleries to accommodate the needs of the general public, stating: "I think it is nonsense to acquiesce in opening our doors on Sunday and at the same time to do nothing to help the Sunday visitor" (Gilman 1924). The "Sunday visitor" was a euphemism for working-class museum-goers who could only come on their one day free from work; Gilman here shows social responsibility as well as educational concern. Dana, too, defies easy categorization: his methods for achieving his social agenda were certainly educative, both in general – he believed the social role of the museum was to educate the community, and specifically – he hired a former school superintendent to develop and implement an educational plan for the museum.

Even if all of these important figures can be seen as valuing education, the idea that museums are primarily educational continued to be controversial, especially in the art museum community. Although there were various proponents of education in art museums, interviews with US art museum directors in the 1980s found museum education to be regarded with some disdain (Eisner and Dobbs 1986), a position that is still held in some quarters (for example, Cuno 2004).

Specialized educational work

The progressive social-political movements of the late nineteenth century and, specifically, the progressive education efforts in most Western societies, combined with child development research, led to the development of specialized educational activity and specialized personnel in museums in the twentieth century. The methods used were closely associated with those of the progressive education movement: learning from and with objects, an emphasis on inquiry, the use of local material and activities, and appeal to the visitors' interests and prior experiences. Story-telling, lectures illustrated with lantern slides, and kits for distribution to schools were all popular. The earliest mention of the title "museum educator" is in Coleman's 1927 publication, *Manual for Small Museums*.[1] Previously, work was carried out by "curators" and "gallery instructors."

Today, education is a major museum function, carried out by a dedicated staff and of concern to curators, exhibition designers, and other museum professionals. In large museums, the education staff, including part–time workers, docents, and occasional teachers, may represent up to 50 percent of all employees. Museum educators engage in an extremely broad range of activities (Hooper-Greenhill 1989, 1991b). A recent survey of the tasks of art museum educators (Wetterlund and Sayre n.d.) collected data on "seven areas of programming: tour programs; informal gallery learning programs; community, adult and family programs; classes and other public programs; partnerships with other organizations; school programs; and online educational programs." This showed that museum educators carried out more than forty-five different kinds of task on these programs, including not only the familiar classes and tours but activities such as organizing community festivals, developing partnerships with universities and city agencies, setting up video-conferencing, and assisting students to curate exhibitions on museum websites. The survey does not include all the additional responsibilities of museum educators, such as supervising staff and volunteers, serving on exhibition development teams, or participating in visitor and other research. Not only is museum education a broad and demanding field, however, it is also constantly changing and expanding. Museum educators are now viewed (Bailey and Hein 2002) as a "community of practice," a phrase applied to work groups, classrooms, and other informal associations whose members carry out similar, often collaborative, tasks and build a shared expertise (Wenger 1998).

The workforce dedicated to museum education is primarily female, even in science museums (ASTC 2002), reflecting traditional gender divisions in our society. In the US, in the 1970s and 1980s, museum educators, following major social trends, participated, with some success, in feminist political efforts to improve their standing within the larger museum workforce (Glaser and Zenetou 1994).

344

Educational Theory

A century of enormous expansion of education, both in the formal and informal sectors, as well as an explosion of social science research and intellectual ferment have provided the opportunity to consider contrasting theoretical and practical approaches to education. Broadly, educational theories can be classified according to two domains: the theories of learning and the theories of knowledge they profess (Hein 1998). All educational theories include views on both these topics and their combination suggests particular educational practices (pedagogy) and results in different kinds of educational programs.

Theories of learning can be roughly grouped along a continuum from "passive" to "active," that is, from theories, on one extreme, that consider the mind to be a passive recipient of new sensations that are absorbed, classified, and learned, to the opposite extreme that postulates that learning consists of active engagement of the mind with the external world, wherein the learner gains knowledge by thinking about and acting on the external world in response to stimuli. The combined research of the past century has resulted in almost universal agreement that learning is an active process that requires engagement, and that this process is significantly modulated by the learner's previous experience, culture, and the learning environment (Bransford et al. 1999; see also chapter 19).

Theories of knowledge are concerned with whether learning entails acquiring truths about nature or constructing knowledge, either personally or culturally, that is "true" only for those who accept it. These two domains, theory of learning and theory of knowledge, can be graphically represented as a two-dimensional plot that delineates a range of educational theories, and can be described by the extremes of each continuum in terms of the four quadrants in fig. 20.1.

Any educational program, whether for a school or a museum, either explicitly or implicitly involves notions of learning and education that can be plotted onto the diagram. Although the traditional notion of a passive mind receiving information and somehow absorbing it without active participation in the learning process has been generally discredited in the educational research community, it dominated classical behaviorist stimulus–response theory and received considerable attention in the museum profession in the inter-war period. The only major museum visitor studies research program in the world prior to the 1960s (Robinson 1928; Melton 1935; Melton et al. 1936), carried out in the United States under the auspices of the AAM and funded by the Carnegie Corporation, was strictly behaviorist; only observational "tracking" studies and paper-and-pencil tests for school children were employed (see also chapter 22).

Stimulus–response theory (behaviorism) persists dominantly in the formal sector; it provides the theoretical basis for the belief that progress in schools can be adequately assessed through short-answer, paper-and-pencil tests (or, more commonly today, fill-in-the-blank computer-scored tests); that memorization and drill can substitute for meaningful experiences; that both knowledge and learning settings can be isolated from real-world contexts without diminishing learning; as well as a number of other regimented practices common to state school systems. In the main, museum

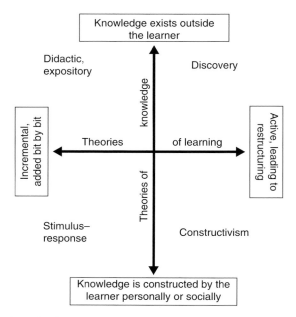

Fig. 20.1 Theories of education.

educators recognize that this theory is not appropriate for learning in the museum, although the pressure from the formal sector leads many to design programs that tend to that direction. Besides the recognition that the "passive mind" theory may be insufficient to describe museum learning, there is the added practical problem that most museum education activities are of short duration, sporadic, carried out in settings unfamiliar to many participants, and incidental to disciplined educational exposure; all conditions unfavorable to traditional pedagogy.

One consequence of the concept that the mind is active and that previous experience, culture, disposition, and development influence learning, is the increasing importance of learners' characteristics for educators. If the learner is seen as a passive vessel into whom education is poured (to use the crude but popular metaphor) then the focus of any pedagogy is on organizing the subject matter and presenting the content in the most appropriate way so that it can be absorbed by the student (or museum visitor). But the notion of an active mind mandates a concern for the particular "mind" of the learner. Thus, in the past century, and especially in the past fifty years, a variety of schemas have been proposed to analyze learner characteristics. One focus has been on dispositions, leading to classifications of types of learner. These schemes include binary (analytic/global; left brain/right brain) as well as multiple classifications of types of learning styles, minds, or intelligences (see Hein 1998).

Another approach is to isolate developmental stages and discuss appropriate education for the resulting categories of learner. In the museum literature, this is illustrated by discussions focused on learning by children (Maher 1997: ch. 5) or adults (Chadwick and Stannett 1995; Sachatello-Sawyer et al. 2002). A final approach exam-

ines the social context of learning, with an emphasis on either past experience (i.e. culture) or the current educational situation (i.e. the milieu in which learning takes place in the museum). While the particulars that are emphasized by the various theoretical analyses differ, the commonality among all is a recognition of the need to take into account all the possible factors – development, culture, previous knowledge, and current environment – that may influence learning. Current interest in accessibility – physical, intellectual, and cultural for *all* visitors – can be viewed as a result of the shift in perspective to focus on visitors, the increased interest in the social role of museums, and increased sensitivity to the multiple viewpoints that need to be accommodated in the museum (Falk and Dierking 2000; see also chapter 19).

Increasingly, this constructivist conception that learning in the museum represents meaning-making by museum visitors – that these meanings are mediated not only by museum objects and the way in which they are presented (exhibited) but also powerfully by the visitors' culture, previous personal experience, and conditions of their visit – is recognized as an essential consideration for museum education (see Silverman 1995; Hooper-Greenhill 1999; Rounds 1999).

The Constructivist Museum

Constructivism has a particular appeal to the educational work of cultural institutions because it matches the informal, voluntary nature of most learning associated with museums. However, its application to museum education presents a number of particular challenges.

Exhibitions

If the educational intention of museum exhibitions is to facilitate visitor meaning-making, then this has a profound impact on the nature of exhibitions and how they are conceptualized and constructed. Most obviously, if the goal is to facilitate visitors' opportunities to reach their own understandings, then the authoritative curatorial voice needs to be muted and modified. Museums have addressed this issue in a variety of ways, including by providing several different interpretations of an object or exhibit or by encouraging visitors to add their comments. Some exhibitions have incorporated visitor comments into the exhibition space and a few art museums have even encouraged visitors to add their own labels to displayed works (Nashashibi 2002). Other strategies have included posing provocative questions to visitors, rather than answers; or seeking to upset linear or chronological representation.

Creating exhibitions that do not assume curatorial authority has also involved a greater range of people in exhibition development (Roberts 1997). This includes not only museum educators but also the expansion of visitor research and "front-end" (i.e. prior to exhibition completion) evaluation, as well as efforts to involve the community (see chapter 11). There have also been some radical experiments, involving engagement between particular social groups and other visitors in the museum, such as Heinecke's *Dialogue in the Dark* (Heinecke and Hollerbach 2001)

in which visitors enter totally dark spaces to be guided by docents who have low vision.

Redefining "learning" and "education"

Another response to the shift toward constructivism is the redefinition of education as "meaningful experience" rather than "defined content outcome." One component of this shift is seen in discussions of the definitions of "learning" and "education." A recent exchange was sparked by the suggestion (Ansbacher 2002) that "learning" was too restrictive a term for describing museum experiences. In general, as was pointed out above, definitions of learning are now broad enough to include enjoyment, satisfaction, and other outcomes from experiences. Dewey's (1938) comment that experience is educative (unless it "distorts or arrests the growth of further experience") has received considerable attention.

Evaluation and research

Currently, the visitor studies research community has largely relegated behaviorist-oriented research to the background and seeks to employ methods that are more consistent with constructivist views of education, adapted from general social science research practices applied to educational research. Thus, conversational analysis (Leinhardt et al. 2002) and socio–cultural theory (Leinhardt et al. 2002; Paris 2002), as well as concept mapping (chapter 19) and other naturalistic methods, are considered more appropriate to investigating learning in museums than experimental design approaches (Hein 1997; see also chapter 22). However, it is important to acknowledge that only behavior, not mental processes, are directly observable by common social science methods, and all analytic tools require interpretation by humans who always bring cultural biases to their analysis.

Educational work with schools

The emphasis on experience and personal meaning-making in the museum community raises serious issues for specialized educational work with school children. On the whole, formal education in the UK and the United States most recently has moved in the direction of an emphasis on the development of educational "standards," increased use of testing for outcomes, and linking funding to various measures of "success" and "failure." The adoption of a national curriculum in the UK in 1989 quickly led to a series of publications proposing ways in which museums could support the curriculum.

More recently, in both countries, standards, while still significant, have been overshadowed by mandatory testing programs, not always carefully aligned with curriculum content. It is the tests that determine what is taught more than the standards. In the United States, where required tests seldom include arts and humanities, these subjects have become "endangered species" in the curriculum (von Zastrow 2004). The divergence of policy directions between most museum education programs and state schools complicates the tasks for museum educators.

Assessing outcomes of constructivist education

If a more constructivist educational theory is used, then the question of *what* outcomes to measure becomes significant. If visitors are intended to make personal meaning from their museum experience, then how can the outcome be measured? What criteria can be applied to distinguish a successful museum educational activity from one that is a failure? This issue is larger than the concern to match museum education activities to educational needs in the formal sector; it needs to be addressed in any effort to evaluate learning in the museum. Two strategies have been employed to begin to answer this question – the development of special procedures to assess learning, and redefinitions of outcomes for museum visits – but it remains a complex issue and is discussed further by Eilean Hooper-Greenhill in chapter 22.

Social Change and Social Responsibility

Museum education converges with social responsibility: the social service that museums, as public institutions, provide is education. A constructivist or progressive educational mission necessarily puts an emphasis on social change.

From its earliest formulations by John Dewey, progressive education has been a means for achieving a social goal, namely the improvement of society. In *Democracy and Education* (1916), Dewey states this clearly. While he sees education as a biological necessity for all organisms, and for humans as essential for the continuation of culture, he argues that achieving particular kinds of society is dependent on certain forms of education. In a society that is satisfied with the status quo (a "static" society), one that wishes to continue unchanged, traditional forms of education are sufficient. But, if there is a wish to better society – to create a "progressive" society – then another form of education is required.

> In static societies, which make the maintenance of established custom the measure of value, this conception (i.e. "the catching up of the child with the aptitudes and resources of an adult group") applies in the main. But not in progressive communities. They endeavor to shape the experiences of the young so that instead of reproducing current habits, better habits shall be formed, and thus the future adult society be an improvement on their own. (Dewey 1916: 79)

Underlying all of Dewey's work, and that of most progressive educators both in the formal sector and in museums, was a deep moral sense and two intense beliefs: faith in democracy and in the efficacy of education to produce a more democratic society (Westbrook 1991: xv). The following are some of the matters to which Dewey drew attention and that need to be addressed in any attempt to formulate and implement progressive museum education.

1 Constant questioning of all dualisms, such as those between fine and applied arts, theory and practice, or categories of visitors. As Dewey pointed out, such distinctions frequently result in making value judgments, in raising one above the other in a moral sense, and thus lead to inequalities in society.

2 Recognition that the goal of education is further education, that solving prob-
 lems means that new problems are unearthed, that the outcome of inquiry is
 further inquiry. On the one hand, such a stance, taken consciously, prevents
 museum educators from accepting simple solutions or assuming that reaching an
 "educational objective" is sufficient. On the other hand, it forces educators to ask
 themselves whether they have provided the requirements for repeated and con-
 tinuing inquiry, such as open-ended questions, lots of materials, or alternative
 possible approaches to inquiry.
3 Applying progressive education theory universally. Museum educators need to
 do more than challenge their visitors; they need to constantly challenge them-
 selves, examine their practice, and reflect on the extent to which it matches –
 both in process and in content – the theory they espouse.
4 Connect educational work back to life. One of the hallmarks of Dewey's educa-
 tional theory and practice was a constant concern that school be part of life, not
 divorced from it. In museum education work (including the development of exhi-
 bitions), we need to emphasize that exhibitions should come from life experi-
 ences and should connect to situations outside the museum.

Finally, and in summary, Dewey not only recognized the confusion and com-
plexity of life, he embraced it. His philosophy of pragmatism did not attempt to
describe an ideal world, distinct from the awkward and constantly changing realities
of actual existence. A recognition that permeated all his ideas was that life is never
simple or easy; it is always complex, uncertain, and messy. The price for giving up
any "quest for certainty" (Dewey 1929) is the necessity of accepting an uncertain,
changing world in which we struggle to make meaning. But the reward is to embrace
life with its opportunities for both meaning-making and feeling, and rejoice in the
complexities of the rich environment in which we struggle.

Note

1 I am indebted to Derek Monz for this reference.

Bibliography

Alexander, E. P. (1979) *Museums in Motion: An Introduction to the History and Function of
 Museums*. Nashville: American Association for State and Local History.
— (1983) *Museum Masters: Their Museums and their Influence*. Nashville: American Associa-
 tion for State and Local History.
American Association of Museums (1969) *America's Museums: The Belmont Report*.
 Washington, DC: American Association of Museums.
— (1992) *Excellence and Equity: Education and the Public Dimension of Museums*. Washington,
 DC: American Association of Museums.
*Anderson, D. (1997) *A Commonwealth: Museums and Learning in the United Kingdom*.
 London: Department of National Heritage.

Ansbacher, T. (2002) What are we learning? Outcomes of the museum experience. *The Informal Learning Review*, 53 (1): 4–9.

ASTC (2002) Science center workforce 2001: an ASTC report. Washington: Association of Science-Technology Centers.

Bailey, E. B. and Hein, G. E. (2002) Informal meets formal: museum educators and communities of practice. *ASTC Dimensions* (November/December): 9–11.

Bransford, J. D., Brown, A. L., and Cocking, R. R. (1999) *How People Learn*. Washington, DC: National Academy Press.

Chadwick, A. and Stannett, A. (eds) (1995) *Museums and the Education of Adults*. Leicester: National Institute for Adult Continuing Education.

Coleman, L. V. (1927) *Manual for Small Museums*. New York: G. P. Putnam's Son.

— (1939) *The Museum in America: A Critical Study*, 3 vols. Washington, DC: American Association of Museums.

Cuno, J. (ed.) (2004) *Whose Muse? Art Museums and the Public Trust*. Princeton, NJ: Princeton University Press.

Dewey, J. (1916) *Democracy and Education*. New York: Macmillan, 1944.

— (1929) *The Quest for Certainty*. New York: Minton, Balch and Co., 1988.

— (1938) *Experience and Education*. Terre Haute, IN: Kappa Delta PI; New York: Simon and Schuster, 1997.

Eisner, E. and Dobbs, S. (1986) *The Uncertain Profession: Observations on the State of Museum Education in Twenty American Art Museums*. Los Angeles: Getty Center for Education in the Arts.

Falk J. H. and Dierking, L. D. (2000) *Learning from the Museum*. Walnut Creek, CA: AltaMira Press.

Gilman, I. B. (1924) Information frames. Unpublished manuscript, January 20. Boston, MA: Museum of Fine Arts Archives.

Glaser, J. R. and Zenetou, A. A. (1994) *Gender Perspectives: Essays on Women in Museums*. Washington, DC: Smithsonian Institution Press.

Goode, G. B. (1888) Museum-history and museums of history. In S. Kohlstedt (ed.), *The Origins of Natural Science in America*, pp. 297–319. Washington, DC: Smithsonian Institution Press, 1991.

Hein, G. E. (1997) The maze and the web: implications of constructivist theory for visitor studies (www.lesley.edu/faculty/ghein/papers_online/mazeweb/mazeweb_1997.html; accessed September 22, 2005).

*— (1998) *Learning in the Museum*. London: Routledge.

Heinecke, A. and Hollerbach, U. (eds) (2001) *Dialog im Dunkeln: Eine Austellung zur entdeckung des Unsichtbaren* [Dialogue in the Dark: An Exhibition for the Discovery of the Unseeable]. Hamburg: Consens Ausstellungs.

Hooper-Greenhill, E. (ed.) (1989) *Initiatives in Museum Education*. Leicester: Department of Museum Studies.

— (1991a) *Museum and Gallery Education*. Leicester: Leicester University Press.

— (1991b) *Writing a Museum Education Policy*. Leicester: Department of Museum Studies.

*— (1999) *The Educational Role of the Museum*, 2nd edn. London: Routledge.

ICOM (International Commission of Museums) (n.d.) ICOM definition of a museum (http://icom.museum/definition.html; accessed September 22, 2005).

Kohlstedt, S. G. (1991) *The Origins of Natural Science in America*. Washington, DC: Smithsonian Institution Press.

Leinhardt, G., Crowley K., and Knutson, K. (eds) (2002) *Learning Conversations in Museums*. Mahwah, NJ: Erlbaum.

Maher, M. (ed.) (1997) *Collective Vision: Starting and Sustaining a Children's Museum.* Washington, DC: Association of Youth Museums.

Melton, A. W. (1935) *Problems of Installation in a Museum of Art.* Washington, DC: American Association of Museums (reprinted 1988).

—, Feldman, N. G., and Mason, C. W. (1936) *Experimental Studies of the Education of Children in a Museum of Science.* Washington, DC: American Association of Museums (reprinted 1988).

Nashashibi, S. (2002) Visitor-written labels in US art museums. Unpublished MA dissertation. Orinda: JFK University.

Orosz, J. J. (1990) *Curators and Culture: The Museum Movement in America, 1740–1870.* Tuscaloosa: University of Alabama Press.

Paris, S. G. (ed.) (2002) *Perspectives on Object-centered Learning in Museums.* Mahwah, NJ: Erlbaum.

Peniston, W. A. (ed.) (1999) *The New Museum: Selected Writings by John Cotton Dana.* Washington, DC: American Association of Museums.

*Roberts. L. (1997) *From Knowledge to Narrative: Educators and the Changing Museum.* Washington, DC: Smithsonian Institution Press.

Robinson, E. S. (1928) *The Behavior of the Museum Visitor*, n.s., no. 5. Washington, DC: American Association of Museums.

Rounds, J. (ed.) (1999) Special issue on meaning making. *Exhibitionist*, 18 (2): 5–44.

Sachatello-Sawyer, B., Fellenz, R. A., Burton, H., Gittins-Carlson, L., Lewis-Mahony, J., and Woolbaugh, W. (2002) *Adult Museum Programs: Designing Meaningful Experiences.* Walnut Creek, CA: AltaMira Press.

Silverman, L. H. (1995) Visitor meaning-making in museums for a new age. *Curator*, 38 (3): 161–70.

Tilden, F. (1957) *Interpreting our Heritage*, 3rd edn. Chapel Hill, NC: University of North Carolina Press.

Wenger, E. (1998) *Communities of Practice: Learning, Meaning, and Identity.* Cambridge: Cambridge University Press.

Westbrook, R. B. (1991) *John Dewey and American Democracy.* Ithaca, NY: Cornell University Press.

Wetterlund, K. and Sayre, S. (n.d.) Art museum education programs survey 2003 (www.museum-ed.org/research/surveys/2003mused/index.shtml; accessed September 22, 2005).

*Wittlin, A. S. (1949) *The Museum, its History and its Tasks in Education.* London: Routledge and Kegan Paul.

von Zastrow, C. (2004) *Academic Atrophy: The Condition of Liberal Arts in America's Public Schools.* Washington, DC: Council for Basic Education.

Zeller, T. (1989) The historical and philosophical foundations of art museum education in America. In N. Berry and S. Mayer (eds), *Museum Education: History, Theory, and Practice*, pp. 10–89. Reston: The National Art Education Association.

Interactivity: Thinking Beyond

Andrea Witcomb

"With over 200 interactive exhibits filling six galleries, visitors of all ages enjoy a full day of adventure and exploration at Questacon – The National Science and Technology Centre" claims a booklet advertising Australia's national capital attractions (National Capital Attractions Association 1997). Meanwhile, Te Papa in New Zealand points to its success with visitors as the result of "wowing" them with "fascinating displays, and high-tech fun" (Te Papa 1999). At La Habra in California, the Children's Museum "is an active learning center where young children can challenge themselves, discover how the world works, try on new roles and learn through play in our hands–on exhibits and programs" (Museums of Orange County 1997).

Museum advertisements like these can be found all over the world. They are part of a widespread focus on interactives and interactivity as marketing tools that became particularly prevalent in museums from the late 1980s but began in the nineteenth century. They suggest a distinction between interactives and interactivity, on the one hand, and ordinary displays of objects and images, on the other; and they promise "adventure," "fun," and "play" – experiences not usually associated with the traditional museum. In this chapter, I look at the reasons behind this "interactives fetish" (Hughes 2001) and at some of the assumptions made about the nature of the relationship between museums and their visitors, especially the conceptions of learning that are involved.

Interactivity as "Interactives"

The idea of interactive displays has a long history. Kathleen McLean (1993), for example, traces it back to as early as 1889, when the Urania in Berlin contained visitor-activated models and a scientific theater, as well as to the Deutsches Museum in Munich which was experimenting with film and a variety of working models in 1907. Barbara Reid and Vicky Cave (1995), from the Science Museum in London, locate the first examples of the use of interactives in 1937 at the Palais de la Découverte in Paris. Later examples include the New York Hall of Science which opened in 1964, the Lawrence Hall of Science in 1968, and the Exploratorium in 1969, all

of which illustrate the strong association between interactives and science museums and science centers.

The development of interactives in a context of ideas about scientific methodology, particularly the idea of the experiment, has shaped the wider museological community's understanding of the nature and purpose of interactives. This understanding almost invariably involves:

1 The presence of some technological medium.
2 A physical exhibit which is added to the main display.
3 A device which the visitor can operate, involving physical activity.

These characteristics are often, and accurately, described by the phrase "hands on." This is based on a mechanistic or "technical" understanding of interactives (Witcomb 2003), which come to be seen as devices that "the visitor touches . . . and something then happens: for every action, there is a reaction" (Lewis 1993: 33).

The consequence of this understanding is that interactivity seems to be generally understood as a process that can be added to an already existing display and that most often involves some form of computerized technology. This has the major, and unfortunate, consequence of limiting the notion of interactivity to the use of "interactives." This is why many museums typically regard only certain of their exhibition areas as "interactive"; and why they see interactives as fundamentally different from conventional forms of interpretation.

One aspect of this perceived "difference" is that interactives are typically understood as more "entertaining" than traditional exhibits. This idea is not totally naïve. There is a well-established body of research which shows that the addition of interactives to a display may increase the amount of time that visitors spend in an exhibition (Stevenson 1994). As early as 1936, for example, Melton "demonstrated that average time at an exhibition went from 13.8 to 23.8 seconds if visitors manually manipulated components" (in Hein 1998: 143–4). Figures from the Science Museum in London in the 1990s show such differentials continuing, with Launch Pad, the museum's first modern interactive gallery, attracting over 500,000 visitors per year, corresponding to "714 visitors per square metre per year in Launch Pad as opposed to 44 visitors per square metre per year in the rest of the museum" (Thomas 1994: 33). Such research has also found that interactive exhibits are especially attractive to children and families, who form the mainstay of museum audiences.

Interactives, Audience, and Entertainment

These "entertainment value" features of interactives have been important in a context in which museums are increasingly conceived as part of the entertainment and media industries, and in which they often have to meet some or all of their budget through entrance fees. However, there is more at work here than the attempt to boost audience numbers. As Sharon Macdonald (2002) shows in her ethnography of the Science Museum, interactives are typically understood by staff not only as providing "fun" (something that the visitor is understood to be seeking in modern museum

visits), but as allowing visitors to be "active" and to exercise choice. As such, in employing interactives, curators in Macdonald's study felt that they were empowering the visitor and thus being more democratic in their museological practice, while also meeting the managerial demand for a product that would increase the museum's share of the market. What was involved here was a broader process in which interactivity, choice, and democracy came to be thought of as going together – and as even being interchangeable (2002: 186).

Interactives are also seen by some in the museum world as part of a contemporary "language of the mass media" which museums must speak if they are to be able to communicate with young people. As Rabbie Hier, the founder of the Museum of Tolerance in Los Angeles (in defence of the museum's heavy use of multimedia) has put it: "Where are your kids now? . . . They're at the computer, and after that they're going to watch television. That's the kids of America. This Museum wants to speak to that generation. We have to use the medium of the age" (Tigend 1993: 3, quoted in Lisus and Ericson 1995: 5).

George MacDonald (former director of the Museum of Civilization in Ottawa and the Museum of Victoria in Melbourne) was one of the first to argue that museums must become part of the "information society," and to point out that this means not only adapting the walls and floors of museums to take the necessary hardware, but also engaging with – and becoming part of – the cultural language of the contemporary media sphere itself (MacDonald 1987, 1991, 1992).

Pedagogies

There is also a widespread belief that interactives, by virtue of being "hands on," offer a more effective pedagogical tool than traditional forms of exhibition-making (Screven 1992; Koester 1993; McLean 1993; Russell 1994; Stevenson 1994). For example, Stevenson talks of the capacity of interactives to "inspire and provoke exploration . . . and to tempt people to look more thoughtfully at traditional museum displays" (Stevenson 1994: 32).

There is, however, a growing body of dissent that suggests that interactives are, in fact, ineffective in producing the learning outcomes for which they were designed (Borun et al. 1993; McClafferty 1995). Known for their slogan of "minds on" as well as "hands on," critics such as Terry Russell (1994) and George Hein (1998) have highlighted a pedagogical difference between those who hold on to a behaviorist/didactic model of learning based on behaviorist psychology and those who advocate a constructivist approach based on cognitive developmental psychology. They argue that a "minds-on" approach, rooted in the latter, is both more effective and democratic than a mechanistic "hands-on" approach; and that a more effective pedagogy – breaking the association between interactives and interactivity – is possible.

George Hein (1998) further suggests a continuum of educational epistemologies lying between a "realist" position, in which knowledge is understood as gained directly through observation or experience of the world, and a "constructivist" position, which argues that knowledge is socially and culturally mediated. Associated

with these, respectively, are the didactic learning model, in which learning is seen as involving the direct transmission of knowledge from teacher to learner, and the constructivist model, in which learning is conceptualized as a process of experiencing the world and making sense of it in one's own mind within the context of one's cultural background. As Hein explains, pedagogies may to some extent mix epistemologies and learning theories; and, on the basis of this, he constructs a fourfold typology of pedagogies: didactic expository; stimulus–response; discovery; and constructivism (see chapter 20, and especially fig. 20.1). This can be usefully applied to different kinds of interactive museum experience in order to highlight the differences between them in terms of their underlying assumptions about visitors and the nature of learning within the museum. The first two are relatively familiar and I deal with them briefly below, before elaborating more fully on "discovery" and "constructivism."

Didactic expository model

A didactic expository model is one in which the museum continues to maintain a role for itself as an authoritative source of knowledge. The curator is a figure of authority and his/her definition of the world is the one that holds. Clearly at odds with the rhetoric surrounding the use of interactives in museums, it is nevertheless all too easy to find examples, particularly in science centers, that are conceived in this way. As Barbara Reid and Vicky Cave (1995: 27) comment, "To date, interactive displays have been broadly concerned with the transmission of ideas and concepts rather than the contemplation of objects or the history of scientific development." Such interactives do not invite an analytical or critical reading of the principles they are designed to communicate. They avoid the role of cultural and historical explanation and, in the case of science museums, this means that they fail to make links between the scientific principles they represent or debates in society about science (Barry 1998). They thus fail to communicate the value of science to society as well as its limitations.

Didactic approaches to interactives see learning as a simple communicative process – from the museum to the visitor – in which interactives virtually control what visitors do, learn, and even feel. This is illustrated by McLean's (1993: 95) claims that designing an interactive exhibit "requires an ability to integrate communication goals (what you want the visitor to *learn*) with behavioural goals (what you want the visitor to *do*), and even emotional goals (what you want the visitor to *feel*)" (italics in original text).

Stimulus–response

This "control" idea is taken to its extreme in the stimulus–response model in which the aim is to transmit knowledge by emphasizing repetition and rewarding correct answers. For example, interactives might congratulate the visitor when he or she pushes the right button, lifts the appropriate flap, arranges items in a correct sequence, or gives the right answer on a touch screen. When this approach is used to achieve a desired ideological outcome, such as, for example, at the Museum of

Tolerance in Los Angeles, the result can be close to indoctrination. In this museum, a variety of multimedia stations which invite interaction are designed to position the visitor as someone in need of learning to be tolerant. An electronic host, called Mr Big Mouth, shuts off any alternative meanings which visitors might develop by voicing constant examples of intolerance. Just as you think you might be understanding things a little and becoming more tolerant, he puts you back into your place as an intolerant person in need of reform. Tolerance, at this museum, is something that is up to each individual to demonstrate irrespective of class, race, or economic position. As the final neon message puts it: "Who's responsible? You are." The Museum of Tolerance ends up pushing for an American version of individualism as the way to avoid future holocausts (Witcomb 2003).

Discovery

The discovery model, based on a realist epistemology and a constructivist learning theory, is, perhaps, the most popular current framework for developing interactives and understanding interactivity in the context of the museum; and it is here that most of the more exciting developments are taking place. Interactives informed by a constructivist learning theory are based on a more nuanced understanding of the nature of communication in which the production of knowledge is embedded in the process of communication and there is an awareness that this is two-way. This has also meant that more research on the modes of learning and museum visiting has been necessary (see the other chapters in this Part).

Discovery approaches are beginning to be reflected in arguments for the development of interactive exhibits that aim to promote the making of meaning. For example, Gilbert and Stocklmayer (2001), from Questacon in Canberra, have taken on board many of the criticisms of the transmission model of interactives and are attempting to develop a model which takes account of what the learner or visitor brings to the experience. While they continue to maintain a realist position on knowledge, their arguments are clearly based on a constructivist learning theory, recognizing and using the learners' backgrounds or what they call the "personal awareness of science and technology" or PAST. They argue that a successful interactive in terms of its educational as well as entertainment values should:

> have a clear focus on the "target," the phenomenon or idea which is of interest to science . . . ; the Experience which is the activity provided by the interactive exhibit; the Personal Awareness of Science and Technology (PAST) which a visitor brings to bear on an exhibit and is influenced by it; and the Remindings, recalling memories of events or circumstances which are similar to those provided by the experience. (Gilbert and Stocklmayer 2001: 2)

Only those interactives which foster the last two criteria, they argue, will be pedagogically successful.

Kid's Island, a discovery center for two- to five-year-olds at the Australian Museum in Sydney, is a good example of what a discovery approach can mean in practice. Behind the various activities, which include pretend play, dress-ups, various

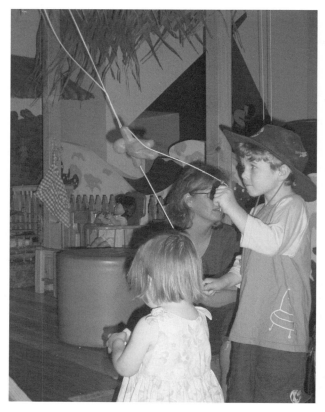

Fig. 21.1 Discovery learning: operating a pulley system at Kid's Island, Australian Museum, Sydney, December 2003. Photograph by Andrea Witcomb.

kinetic experiences, and mechanical interactives such as pulley systems (fig. 21.1), there is a constructivist learning theory. While all the activities are open ended in that the focus is on exploration rather than on getting the right answers, Kid's Island is firmly embedded within a realist epistemology. Not only is its focus on the material world, but its context is that of a natural science and anthropology museum and its aim is to introduce a real existing world. Thus all the dress-ups and toy animals relate to animals in the collection, and the cubby house reflects a real Pacific Island design motif. There are also plenty of real things to touch and feel, such as shells, natural fibers, stuffed animals, and bark.

Various art galleries have also begun to explore the possible uses of interactives for making art accessible to children, and have drawn on developmental theories of learning to do so (Simpson 2002). The focus is on incorporating multi-sensorial experiences in ways that explore "the social context, subject matter and emotional content . . . the materials and tools of the artist" and "basic tools of art production such as colour, texture, line etc." (Simpson 2002: 8). Interactives used to achieve this include "mechanical activities or games such as dressing up, jigsaw puzzles and

reproductions of art works in movable fabric, magnetic or three dimensional components" (2002: 8), as well as "computer technology involving animation or the manipulation of images" (2002: 9).

Constructivism and interactivity

The fourth pedagogical style, constructivism, has not been taken up as enthusiastically as the discovery model. This is not surprising given that museums deal with the material world and this is not easily reconcilable with an idealist epistemology. However, if one looks to the notion of interactivity rather than at interactives *per se*, it is possible to discern attempts at developing exhibitions that take constructivism and interactivity as their premise. Such exhibitions deploy what I have called "dialogic interactivity" (Witcomb 2003).

Dialogically interactive exhibitions tend to make an effort to connect with the visitor by representing aspects of visitors' own cultural backgrounds and using open-ended narratives. An example is the Eternity Gallery at the National Museum of Australia. This gallery combines traditional object displays, touch-screen computers, and video and oral histories (accessed through a phone) to provide an interactive space in which the viewer is invited to consider him or herself as part of Australian history through everyday activities. The everyday is, in a sense, lifted out and up, and made into the extraordinary.

Organized into biographies that represent emotions, attitudes, and experiences – separation, mystery, hope, joy, loneliness, thrill, devotion, fear, change, passion – the exhibition very simply presents aspects of people's lives through the use of photographs, a few objects, first-person narration, and the use of multimedia consoles to extend the narrative. There is also the opportunity for visitors to record their own personal story. Direct contact is established with each visitor through an appeal to their own human experiences. In this sense it is open ended, making no authoritative claims about defining what it is to be Australian. It allows visitors to make their own meanings and then encourages them to document those for others. The problem, however, is that the nation becomes nothing more than the sum of individual experiences. Taken too far, a constructivist approach to exhibition-making can result in an emptying out of meaning and a consequent loss of understanding of community based on commonality of experience.

There are, however, more complex examples of dialogic exhibitions that work with the idea of interactivity. Often, these spaces are also working with notions of "immersion" and "experience." They do so, not within a didactic framework, however, but through creating an aesthetic where there is a space for poetic, affective responses. Very often, this is achieved through a highly aesthetic form of exhibition-making. Examples are the Museum of the Holocaust in Washington (Appelbaum 1995; Freed 1995) and the new South African Museum of Apartheid (Till 2003; see also chapter 29). Both of these museums use the full range of the creative arts to construct a highly immersive, experiential environment. Unlike the Museum of Tolerance in Los Angeles, however, their aim is to produce a dialogue. Strikingly, the Museum of the Holocaust does this by explicitly resisting the temptation to use emotive language.

Andrea Witcomb

Conclusion

These examples are not without their problems. Art can be alienating, as can a focus on difference. A constructivist approach to exhibition-making could end up representing an atomistic interpretation of community. What can be taken from it, however, is the notion of dialogue. Taken seriously, dialogue could become the basis for a new understanding of interactivity in museums. Such an understanding would break the association between a mechanistic understanding of interactives and attempts to democratize the museum, as well as too uncritical a reliance on technology, as the basis for the way forward.

As this chapter has shown, interactivity is too often understood as simply an outcome of interactives. Yet there can be a vast gulf between interactive (as an adjective) and the possession of interactives (as a noun). In that gulf lie not only differing pedagogical approaches but completely different ideas on the social function of museums. For those who maintain that museums should aspire to become spaces for dialogue across differences of experience, it is much more important to develop a clear idea of the possibilities inherent in the notion of interactivity. Its application may or may not include interactives, but it will involve thinking of the museum audience first, a willingness to recognize differences in values and claims to knowledge, and a desire to develop partnerships between the museum as an institution and the audiences which use it. For this reason alone, interactivity is something that all museum professionals should be engaged in developing.

Bibliography

*Appelbaum, R. (1995) Designing an "architecture of information": The United States Holocaust Memorial Museum. *Curator*, 38 (2): 87–94.

Australian Museum (2003) *Places Young Kids Love to Visit* (pamphlet). Sydney: Australian Museum.

*Barry, A. (1998) On interactivity: consumers, citizens and culture. In S. Macdonald (ed.), *The Politics of Display: Museums, Science, Culture*, pp. 98–117. London: Routledge.

Borun, M., Massey C., and Lutter T. (1993) Naïve knowledge and the design of science museum exhibits. *Curator*, 36 (3): 201–19.

Freed, J. I. (1995) The United States Holocaust Memorial Museum: a dialogue with memory. *Curator*, 38 (2): 95–110.

*Gilbert, J. K. and Stocklmayer, S. (2001) The design of interactive exhibits to promote the making of meaning. *Museum Management and Curatorship*, 19 (1): 41–50.

Hein, G. E. (1998) *Learning in the Museum*. London: Routledge.

Hughes, P. (2001) Making science "family fun": the fetish of the interactive exhibit. *Museum Management and Curatorship*, 19 (2): 175–85.

Koester, S. E. (1993) Interactive multimedia in American museums. Archives and Museum Informatics Technical Report, 16.

Lewis, P. N. (1993) Touch and go. *Museums Journal* (February): 33–4.

*Lisus, N. A. and Ericson, R. V. (1995) Misplacing memory: the effects of television format on Holocaust remembrance. *British Journal of Sociology*, 46 (1): 1–19.

Luke, T. (1996) Memorialising mass murder: entertainmentality and the United States Holocaust Museum. *Arena Journal*, n.s. 6: 123–43.

McClafferty (1995) "Did you hear Grandad?" Children's and adults' use and understanding of a sound exhibit in an interactive science centre. *Journal of Education in Museums*, 16: 12–16.

MacDonald, G. F. (1987) The future of museums in the global village. *Museum*, 155: 212–13.

— (1991) The museum as information utility. *Museum Management and Curatorship*, 10: 305–11.

— (1992) Change and challenge: museums in the information society. In I. Karp, C. Mullen Kreamer, and S. D. Lavine (eds), *Museums and Communities: The Politics of Public Culture*, pp. 158–81. Washington, DC: Smithsonian Institution Press.

Macdonald, S. (2002) *Behind the Scenes at the Science Museum*. Oxford: Berg.

McLean, K. (1993) *Planning for People in Museum Exhibitions*. Washington, DC: Association of Science-Technology Centers.

Museums of Orange County, California (1997) pamphlet.

National Capital Attractions Association (1997) *National Capital Attractions: Cultural, Historic and Recreational Sites of the Canberra Region* (pamphlet). Canberra: NCAA.

Reid, B. and Cave, V. (1995) The All Hands interactive gallery at the National Maritime Museum. *Journal of Education in Museums*, 16: 27–8.

Russell, T. (1994) The enquiring visitor: usable learning theory for museum contexts. *Journal of Education in Museums*, 15: 19–21.

Screven, C. G. (1992) Computers in exhibit settings. *Spectra*, 19 (1): 7–11.

Simpson, M. (2002) Interactive art exhibitions: an overview of developments in the USA. *Journal of Museum Education*, 22: 7–10.

Stevenson, J. (1994) Getting to grips. *Museums Journal*, 94 (5): 30–32.

Te Papa (1999) @ *Te Papa: The Papa turns one* (pamphlet). Wellington: Te Papa Tongarewa National Museum of New Zealand.

Thomas, G. (1994) The age of interaction. *Museums Journal*, 94 (5): 33–4.

Till, C. (2003) Apartheid, gaming and gold: South Africa on safari, a guide to museums, money and the market. Unpublished keynote address given at the Museums Australia National Conference, *The Other Side*, May 25–30, Perth, Australia.

*Witcomb, A. (2003) *Reimagining the Museum: Beyond the Mausoleum*. London: Routledge.

Studying Visitors

Eilean Hooper-Greenhill

Museum visitor studies is a rapidly evolving, controversial, and dynamic field, which is attaining a new urgency as questions about the social uses of culture are raised in the context of issues of identity and the politics of diaspora and difference. These issues raise vital philosophical questions about the place and purpose of museums which can only be answered if and when museums broaden their perspectives to include the views of their audiences.

One of the greatest challenges for museums at the beginning of the twenty-first century is the turn to the visitor. A response to the call to become more visitor-focused will require considerable changes in the professional practices of museums. It will entail expanded visitor or audience research and this, in turn, will require the development of new professional skills, a re-prioritization of resources, and a re-conceptualization of museum policies and plans. Already, a considerable body of research into the experiences of museum visitors has emerged, and the evaluation of museum exhibitions and educational provision is now recognized as a distinct field of museum practice.

This chapter examines the scope and development of museum visitor studies, outlines approaches to the evaluation of exhibitions, describes patterns of museum use, and discusses current moves to develop a deeper understanding of perceptions of museums. The first section of this chapter gives a brief overview of the development of visitor studies and introduces some key issues. In the sections that follow, these issues are examined in more depth.

The emergence of museum visitor studies can be conceptualized as several, loosely interlocking intellectual journeys. In terms of how visitors are conceived, there is a shift from thinking about visitors as an undifferentiated mass public to beginning to accept visitors as active interpreters and performers of meaning-making practices within complex cultural sites. In relation to the purposes of studies, there is a development from internal museum studies with operational and professional remits to broader policy-related work and deep studies based on a drive to understand and explain rather than (or as well as) to manage. And in respect of the theoretical approaches, there is a move from a narrow, backward-looking paradigm based on behaviorist psychology and a transmission or expert-to-novice model of communication to a more open and forward-looking interpretative paradigm that employs a cultural view of communication involving the negotiation of meaning.

The Scope of Museum Visitor Studies

"Visitor studies" is an umbrella term for a range of different forms of research and evaluation involving museums and their actual, potential, and virtual visitors which collectively might be termed the "audience" for museums. These studies focus on the experiences, attitudes, and opinions of people in and about museums of all sorts (art, history, science; national, local, private, and so on). Different terms are used by different writers, including evaluation, visitor research, visitor behavior, audience development, audience studies. These diverse terms reveal the fragmented character of the field, its origins in several distinct intellectual, professional, policy-related, and academic areas of enquiry, and the range of purposes for which these various studies are produced. Looking at the development of visitor studies internationally, the degree of development is very uneven. In most museums in most parts of the world, including the UK, museum visitor studies remains a largely unexplored territory. Museum-based research is most firmly established in the United States, where it is carried out by museum staff or by consultants, and has been most prevalent in science and children's museums. Policy-related enquiries and in-depth sociological studies can be found in a wider geographical field.

It is only very recently that the different kinds of evaluation and research, carried out by different agents and agencies for different purposes, have been conceptualized in a collective way under the banner of "visitor studies." However, this is as convenient a way as any to group highly diverse work. It enables the placement of complex, theoretically informed studies, such as that of the French cultural sociologist Pierre Bourdieu, in relation to the more pragmatic studies carried out for practical and operational purposes within museums; and in bringing together very different kinds of studies, it allows an overview of a growing intellectual field.

The study of museum visitors has a long history, but one which is rather thin until the past two or three decades. There are a number of useful accounts of the development and scope of museum visitor studies, including Loomis (1987: 16–33), Falk and Dierking (1992), Bicknell and Farmelo (1993), Screven (1993), Hooper-Greenhill (1994), Hein (1998: 42–53), and Hooper-Greenhill and Moussouri (2002). Each of these, however, has been produced within a specific context, and therefore only gives a partial picture.

Hein points out that there was very little systematic work on visitor experiences during the first half of the twentieth century (Hein 1998: 43), and Loomis (1987) confirms that there were limited studies in what he calls "visitor evaluation." Loomis identifies a small number of studies carried out for a range of different purposes; these include a major European study of the role of museums in cultural life which was carried out in 1908, the use of museums by school children, and reviews of materials for teachers (Loomis 1987: 25–6). The best known of these early studies focus on the observation of behavior in museum galleries, on the assumption (prevalent at the time) that observations are more objective and reliable than what people might say in interview, and that the behavior of visitors can indicate the educational effectiveness of exhibitions and displays. Interestingly, given today's politicization of the uses of culture, the early studies in both America and England are rooted in a view

of entitlement, premised on the conviction that museums are educational organizations, that visitors deserve the best educational opportunities possible, and that evaluation and research can help with the development of optimal provision.

Benjamin Ives Gilman, a museum practitioner, observed those features of exhibition design, such as poor placement of labels, that caused fatigue; he then made practical recommendations for improved gallery design (Loomis 1987: 16–18; Hein 1998: 44). Two Yale psychologists, Arthur Melton and Edward Robinson, offer examples of the more sustained studies that are sometimes possible for academic researchers. A suite of observational studies of how visitors used museum galleries was carried out between 1928 and 1936 (Loomis, 1987: 21–2; Hein 1998: 47–51). Hein (1998: 51) usefully compares the work of Melton and Robinson with a little-known study carried out in the late 1940s by Alma Wittlin in England. While Melton and Robinson observed the behavior of museum visitors, taking time spent as an indicator of "interest," Wittlin asked visitors open-ended questions about exhibitions, and encouraged some visitors to produce sketches of their reminiscences. The two studies introduce one of the most interesting debates in museum visitor studies – that of appropriate research paradigms. The two studies represent different ways of theorizing museum experiences and different approaches to what counts as evidence. The observational studies are based on behavioral psychology, attempt to treat museum galleries as though they were neutral research laboratories, and limit research data to observations carried out by the assumedly neutral researchers. Wittlin, on the other hand, views the museum as a natural setting in which learning may perhaps happen, welcomes individual subjective views, and accepts both the speech and the drawings of the visitors as evidence.

While exhibition evaluation was one of the first forms of visitor study, by the end of the 1960s museum visitor surveys had become familiar in the USA, the UK and, to a limited degree, elsewhere. Initial work on sampling methods and techniques at the Royal Ontario Museum in Canada and at the Milwaukee Public Museum in America proved influential for museum-based researchers (Loomis 1987: 25–6). Meanwhile, Bourdieu and Darbel's book *L'amour de l'art* (originally published in 1969), based on surveys of museum visitors in France, Greece, Holland, Poland, and Spain, has proved to be a seminal work for sociologists and cultural theorists, but has been barely noticed by museum professionals, perhaps because it was not translated into English until 1991.

Participation in the arts in general and in museums in particular formed the basis for a number of large-scale, policy-related studies carried out on an international basis during the 1980s and 1990s. There were many in the UK, usefully summarized by Davies (1994); Schuster (1995) summarizes a number of international studies of visitors to art museums, although the implications of his conclusions have been challenged (Hooper-Greenhill 1995). These quantitative studies have provided an essential overview of the social use of museums; they present basic demographic details such as the age, gender, ethnicity, educational attainment, and social class of people using museums, but they have been limited in their analysis of the socio–cultural significance of these data.

Museum visitor surveys and participation studies sought demographic information, and accumulated data about those who used museums. In general, museum

users were shown to be wealthier, better educated, of a higher social class than the population as a whole, with this being more marked in art galleries than in more general museums. But demographic overviews could reveal nothing about why people did not use museums, and for this, different methods began to be employed. In the UK, the appointment of marketing officers in the mid-1980s introduced not only more efficient visitor surveys in individual museums, but also new research methods linked to market research. While few individual museums carried out what were known as "non-visitor surveys," a small number of very influential pieces of work, loosely characterized as "market research," demonstrated how interviews and focus groups could be useful in exploring perceptions and feelings about museums (for example, Trevelyan 1991). It began to be clear to museum professionals that if attitudes and values were to be explored, then the subjectivity of the visitor, and even more of the "non-visitor," was in fact essential evidence.

Since the development of museum studies as an academic field, increasing numbers of social scientists have sought to use the museum as a field for research. Many of these cultural studies are studies of visitors. These studies, generally based in universities and frequently carried out as extended pieces of work (often originating from doctoral study), tend to consist of theoretically informed, in-depth studies which are more concerned to understand events through the development of a critical explanatory framework than to produce management or policy-related information or to improve practice (Katriel 1997; Macdonald 2002).

From this brief overview, it can be seen that museum visitor studies encompass a range of types of study carried out by different bodies, for different purposes, and using different research paradigms. These studies have been developing in a relatively piecemeal manner over the past hundred years, are now well established in America, and recognized as important in Britain (Bicknell and Farmelo 1993), Canada (Dufrésne-Tassé 2002), France (Eidelman and Van Praet 2000), Germany (Graf 1994), Australia (Scott 1995), and elsewhere. Much of this kind of work is stimulated by the educational philosophies of museum staff, and much is shared on an international basis through the aegis of ICOM/CECA (the International Council of Museums' Committee on Education and Cultural Action). Dufrésne-Tassé (2002) has provided useful compilations of recent research and evaluation projects. The literature is now enormous. Where Hein identified very few papers prior to the 1960s, in 1998 he reported that hundreds of studies were carried out each year in America alone (Hein 1998: 56). While museum-based studies are less numerous in other countries, collectively the volume is considerable; if the scope of visitor studies is broadened to include cultural studies, the literature grows again.

Getting the Message: Evaluating Exhibitions or Evaluating Visitors?

Exhibition evaluation is one of the earliest forms of visitor research. The first studies were based on unobtrusive observation, tracking the movement and behavior of visitors in the space of the exhibition, producing maps of the tracks made that showed which were the "hot" (frequently visited) and which the "cold" spots in the exhibi-

365

tion. In 1928, Robinson developed the concepts of "attracting power," the power of an exhibit to attract viewers, measured by what proportion of visitors stopped to look, and "holding power," the length of time spent looking. As museum visitor studies searched for appropriate methods during the later years of the century, these methods were recycled. "Attracting power" and "holding power" were still being used in the UK during the 1980s and maps of visitor movements were produced in the 1990s.

In the US, the evaluation of exhibitions and educational programs was fueled by accountability and the need to "measure" outputs for funders and sponsors. Many studies attempted to "measure" the attainment by visitors of previously specified educational objectives using pre- and post-testing and visitor tracking. Many studies were carried out that focused on visitor behavior within the confines of the gallery, with very limited attention paid to the social or cultural contexts of visitors. Alternative approaches using naturalistic, ethnographic methods were more limited in number, although Wolf and Tymitz (working with the approaches championed by Robert Stake) produced accounts acknowledging the complexity of real-world educational settings during the 1970s (Hein 1998).

Based on American behaviorist approaches, a large and unique research program was set up at the Natural History Museum in London. A twenty-year exhibition development plan included the identification of new staff roles, which defined curators as subject specialists distinct from exhibition developers who researched museum visitors and tested the success of exhibitions. Studies focused on whether the exhibition visitor had understood the message that the exhibition intended to transmit. The objective was the development of an exhibition technology, a set of critical standards, which, if deployed correctly (it was thought), would produce exhibitions that would always be effective (Miles et al. 1988). The model used was that of educational technology, which was then being used in the design of materials for programmed learning. These principles were adapted for exhibitions, and the reactions of visitors were then tested.

In the American studies, useful lessons were learnt about exhibitions as communicative media, which, while they seem obvious today, are still not always acted upon. For example, it was learnt that information about the visitor's level of understanding of the subject matter of the exhibition would be useful in designing the exhibition and in writing the labels, and that providing conceptual and spatial maps at the beginning of the exhibition ("advance organizers") could help visitors understand the purpose and layout of the exhibition. Screven (1986) summarizes many of these findings, and he encourages curators to develop goals for exhibitions in such a way that their attainment can be measured.

Similarly, many of the ideas developed at the Natural History Museum have become basic tenets for good museum communication design. While couched in language that today seems overly mechanistic, many of the "precepts for the design of effective exhibits," which were originally proposed in 1979, can still be seen as offering good advice: "the organisational structure of the exhibition should be clear to the visitors," "provision should be made for various levels of ability, knowledge and interest," "provision should be made for visitors to engage in active response." However, others of these principles reveal the underlying didacticism of the

approach: "careful thought should be given to the order in which information is to be learnt and this order should be carried through to the design of the exhibits" and "exhibits should have explicitly stated objectives which specify exactly what visitor effects are intended" (Miles and Tout 1994a). While these principles might have been effective with motivated learners sitting down and working through a tape-recording of programmed instruction in order to learn a language, they were to prove more problematic in the busy, distracting spaces of an exhibition.

It is clear from these latter "precepts" that the Natural History Museum team (and many of the American evaluators) were working from a transmission (or "bull's-eye") model of communication and an expert-to-novice model of teaching (Hooper-Greenhill 2000). These models place the communicator/teacher (in this case the exhibition developers) in charge of defining the information that is to be transmitted. The receivers or learners (the visitors), seen as a mass, or a "population" as Miles and Tout call them (1994a: 92), are expected to absorb and retain the message. It was taken for granted that if the medium (the exhibition) was sufficiently well designed this would happen automatically.

This approach comes very close to "evaluating visitors" (Loomis 1987). Evaluation can be defined as making a judgment of quality; if the extent to which visitors have absorbed the intended messages of the exhibition is being judged, this raises ethical questions and questions about the motivations of visitors. During this period of visitor studies, most research failed to make a distinction between the competent production of effective communicative media and the use made of this media. As it began to be realized that visitors were not always as inclined to strive toward the attainment of educational goals as evaluators might have wished, so the concept of "goal-free" evaluation emerged. It was at much the same time that what came to be known as "effects studies" in communication and cultural studies came to the conclusion that audiences were less malleable and less predictable than was at first thought. The audience began to be conceived as "active" or, as Miles and Tout (1994b) put it, to have an agenda of their own.

By 1994, Miles and Tout admitted that although they had developed much useful knowledge about exhibition design, this in itself did not mean that visitors would learn what they were expected to learn. The meaning of the museum visit to the visitor also had to be taken into account (Miles and Tout 1994b). Once this was realized, the attempt to find a foolproof way of designing effective educational exhibitions seemed doomed to failure, along with attempts to measure what visitors had learnt. If visitors were not always motivated to learn, then however well designed the exhibition might be, learning – as anticipated and planned for by the exhibition developers – might not take place and any measurement of cognitive gain could only show failure. A more open-ended approach to exploring the experience of visitors was needed, as was the recognition that learning goes beyond learning facts, and is not always limited to what exhibition developers predict.

If exhibition evaluation raised questions about how the learning of visitors as active interpreters in their own right could be understood, it offered useful ideas from a narrower perspective about how exhibition production could be improved through piloting and testing initial ideas, concepts, and exhibition prototypes with visitors. Three main stages for carrying out evaluation were identified: front-end

evaluation (also called preliminary research), formative evaluation, and summative evaluation were proposed for the beginning, the middle, and the end of the exhibition project. Within this more limited scope, where the characteristics, interests, and learning styles of diverse audience groups are researched and accommodated, and specific ideas and communicative elements are reviewed and tested by actual or potential visitors, evaluation remains a useful professional tool, although one that is not always easy to implement.

While visitor studies during the 1970s and 1980s were limited in England to a few of the larger national museums, in America, greater development occurred and a range of different kinds of studies was carried out. A shift from thinking about producing effective educational media to considering methods to enable learning changed the focus of studies, and although some work remained locked into a behaviorist paradigm that entailed extreme distrust of research methods deemed "subjective" or "anecdotal," a new approach based on constructivist learning theory was emerging during the 1980s (see chapters 19 and 20). American studies are usefully summarized in Falk and Dierking (1992, 2000).

Much of the work on exhibition evaluation has taken place in science museums or science centers where there has always been a specific desire to transmit conceptually based information as part of an ambition to improve the public understanding of science. Considerable work has also been done in children's museums, again because of overt educational aims for exhibitions. Other types of museum, such as art museums or museums with mixed collections, have not been equally interested in the response of their visitors and very few studies can be identified (Hooper-Greenhill and Moussouri 2002).

Counting and Mapping

There has been a considerable amount of work that has attempted to quantify specific characteristics of visitors and to map forms of museum use on the basis of these characteristics. These attempts to survey visitors have occurred at the level of individual museums, but have also been carried out on a larger scale which has involved either surveying a number of museums as a group, or the questioning of samples of the whole population in their homes. These surveys are based on demographic variables such as social class, education, income, occupation, age, ethnicity, and religion; in these studies, these variables are viewed as strong influences on attitudes and behaviors.

Individual museum visitor surveys have now become routine in many of the larger museums across the world. Basic knowledge of visiting patterns and the breakdown of types of user of the museum is regarded as essential management information; these surveys are rarely published. In museums with limited resources, or in parts of the world where museums are less well developed, visitor surveys are not carried out. In the UK, this kind of visitor study began in the 1960s, and many of the early published surveys are listed in Merriman (1991).

Museums find their visitor surveys useful in a number of ways, as the following example demonstrates. Harvey carried out a questionnaire survey at the National

Portrait Gallery, London, in 1985, and having mapped the demographic character-istics of visitors, she went on to ask respondents whether they would visit if an entrance fee of £1 was charged. She discovered that men were less willing than women to pay this charge, and thus the imposition of a charge would have the effect of increasing the proportion of female visitors (which was already larger than that of male visitors). The numbers of drop-in visitors would also decrease. As a result of this, the entrance charge was not levied as the museum did not want to change the shape of its visitor profile. She also found that visitors would like a café, and this led to a long-term development, involving roofing external spaces, which resulted in a café being opened about ten years later.

In an effort to gain an overview of museum use, some summaries and aggrega-tions of the findings of a number of museum visitor surveys have been made. Museum visitor surveys in England are summarized in Davies (1994). Marilyn Hood summarized what had emerged from a large number of surveys carried out during the previous ninety years in the United States by stating that the typical, frequent museum visitor was in the upper education, occupation, and income groups. Moving beyond demographic variables as indicators of attitude and action, she went on to propose what have become known as "psychographic factors." She proposed that the frequent museum visitor looked for opportunities to learn, the challenge of new experiences, and to do something he/she considered to be worthwhile. Occasional visitors, on the other hand, preferred leisure activities where they felt at ease and comfortable and which enabled sociality and active participation (Hein 1998: 115–16).

There are only a few examples of museum visitor surveys carried out in a linked way across a number of museums. In Canada, for example, a number of museums and the zoo in Toronto combined to audit their visiting patterns as part of a market research initiative (Linton and Young 1992). Bourdieu's study of visitors to museums in four European countries in the 1960s is rare. It is unusual to work across coun-tries in this way, but the research is equally unusual in being based on an overt intel-lectual framework grounded in critical theory, the sophistication of the research methods, the depth of the analysis, and the use of this analysis in theory-building. Museum visitors were (again) found to be more highly educated and of a higher social class than the public as a whole. However, Bourdieu used his findings to take forward his work on cultural and symbolic capital and to confirm his view that museums operate to distribute cultural capital and through this to distinguish between social groups. Taste, he proposes, which is reproduced through schooling and through family activities and milieu (what Bourdieu calls "habitus"), and which enables those in higher social classes to take advantage of cultural opportunities apparently open to all, is perceived (by society) as a natural attribute which justifies the increased advantages it enables (Bourdieu and Darbel 1991).

This early work (1969) acted as one of the foundation stones for some of the most powerful and influential social theories of the twentieth century. Because of this, Bourdieu's conclusions about the excluding character of museums have been fre-quently recycled. However, it must be remembered that the research was carried out during the 1960s in parts of Europe where, even now, museums are not at the fore-front of change. Unquestioning repetition of the findings of Bourdieu as though

369

they apply to museums in other parts of the world forty years later must be challenged. The findings, however, must be accepted as valid in their context and they raise essential questions about museums and their overt and implicit social purposes.

Large-scale demographic studies have occasionally been conducted that involve samples of national or regional populations. In 1971, for example, the establishment of a national museum policy in Canada led to a very comprehensive national survey involving interviews with 7,230 people (Dixon et al. 1974). The findings underpinned considerable investment in museum development.

In England, a considerable number of participation studies have been carried out since the 1980s by a range of governmental agencies, tourist boards, market research companies, and museum consultants (Hooper-Greenhill 1994: 58–60). One of the main questions asked by these national studies is: what is the size of the audience for museums? And this apparently simple question can serve as an example of the difficulties of this form of museum research. A rapid review of some of the claims made by different researchers will reveal some of the difficulties in establishing a reliable overall figure of the number of visits made to museums or of the percentage of the population which uses museums on a regular basis. The picture that emerges from these studies is neither clearly delineated nor consistent.

In 1990, Middleton suggested that 29 percent of British adults (those aged 15+) visited a museum at least once in 1989, and that on this basis the adult market (as he put it) was just under 13 million people (Middleton 1990: 23). In 1998, Middleton reported that the numbers of UK adults visiting museums had fallen to 11.9 million (26 percent of the adult population) and that visits were unlikely to increase in the foreseeable future (Middleton 1998: 18). A little later, however, Selwood (2001: 354–5) suggested that there were between 80 million and 114 million visits to museums in the UK. A report on regional museums in 2001 was more cautious: it suggested that over 77 million visits were made each year (Resource 2001: 6), and further indicated that this number might be falling. But the *Manifesto for Museums*, which was published by a consortium of museum bodies in early 2004, was more upbeat. It stated that the 2,500 museums in the UK received more than 100 million visits each year, more than all the country's live sporting events combined, and that where additional investment has been made in regional museums, visits had increased in the few months following the investment by 7 percent. The *Manifesto* also suggested that 37 percent of UK adults, over 17 million people, and 50 percent of school-age children visited once per year (NMDC 2004).

Figures such as these must be considered carefully. Data are derived in a number of different ways, and include both the number of visits reported by individual museums, and data from questionnaires of samples of the general public. These data sources are frequently merged to provide a holistic figure of museum use, and much of the data is neither reliable nor comparable (Selwood 2002). In a review of a range of reports into museum use, Davies described how some of the figures quoted by museums are derived from ticket sales, while others are estimations; estimations may also be used by researchers where museums have not returned data (Davies 1994: 35).

In addition, the size of the audience for museums will vary according to how "museums" are defined. The NMDC figures above relate to 2,500 museums in the

UK; at least one report quoted by Davies discusses visits to 1,759 museums, which may be the number who returned details to the tourist boards. Sometimes the category "museums" includes art galleries, and sometimes it does not. Numbers of "visits" and numbers of "visitors" are not the same; multipliers are used to convert the percentage of the population agreeing that they visit museums to a figure for the total number of visits to museums per year, and this multiplier varies. It is based on how often the researcher thinks that museum visitors might actually visit per year. For example, in one study discussed by Davies, it was estimated that 16 percent of the population of the UK might have visited at least twice per quarter, and the overall number of museum visits per year was placed by this particular study at 120 million.

There are further problems. Where questionnaires are used with population samples to gain an overview of museum use, varying parameters in relation to time are used. Some questionnaires, for example, ask if visits have been carried out in the past year, some in the past two years, and one survey used the time-frame "nowadays." The size of the audience for museums in the UK is therefore difficult to determine, as is the percentage of the population who use museums. It is perhaps fair to say that about one-third of the population uses museums, but it is generally acknowledged that much better systems are required to gather reliable evidence.

It is clearly not as easy as might be assumed to quantify visitors and to map patterns of use. The information available must be treated critically. It is easy to fall into the trap of thinking that museums have always and will always be visited only by those of higher social class and higher levels of education. Overviews of the use of museums by the population as a whole will disguise a more complicated pattern of use. An emphasis on the largest statistics may mask substantial variations in what purports to be the national picture. Myerscough (1988), for example, found that 30 percent of visitors to Liverpool Museums were from lower social classes. At the present time in the UK, as in other parts of the world, the question of who uses museums, why, and what prevents a broader social use, have become highly politicized questions.

New Paradigms: The Turn to Understanding

Measuring, counting, and mapping have formed the basis of the vast majority of museum visitor studies. But demographic studies only provide certain sorts of information. A map of the pattern of use of museums, whether on a small or a large scale, does not provide an understanding of the value of that experience to visitors, and structured questionnaires are of limited use in developing an in-depth knowledge of attitudes, values, and feelings. As long as successful communication was conceptualized as the effective transmission of a clearly defined message through an appropriate medium to a large mass of receivers, the focus on measuring the take-up of the message seemed to have the potential to lead to improved educational provision. However, new ways of understanding the complexity, contingency, and provisional character of communication as mediated cultural transactions between individuals or groups, with their own social experience, prior knowledge, and biographical/his-

torical position, have exposed the limits of research grounded in positivist and behaviorist paradigms (Carey 1989; Hall 1997; Hooper-Greenhill 2000). Attempts to understand learning in museums, acknowledging the active character of the individual and the social construction of learning, have led to new research questions and the use of more interpretative research methods (Leinhardt et al. 2002; Paris 2002).

During the 1990s, sustained challenges to earlier approaches to visitor studies emerged. In 1993, the Science Museum in London published a collection of papers that presented an overview of museum visitor studies. In a paper introduced by the editors as "heretical" (Bicknell and Farmelo 1993: 9), Lawrence (1993) called into question the prevailing theoretical paradigm that underpinned most evaluation work up to that time. Discussing this in the context of the history and development of sociology, she points out how the methods used in museum visitor studies (predominately observations of behavior, structured questionnaires, and interviews), which were presented as independent of theory, were in fact rooted in an already outdated approach to social studies based on empiricism and educational (behaviorist) psychology. She describes how in other fields of study, interpretative social theories (including symbolic interactionism, phenomenology, and ethnomethodology) had become established. The central problematic for social scientists had become the construction of meaning; methods used included detailed qualitative description and analysis of events and situations gained through immersion in the research site, and careful listening to and analysis of speech.

A further challenge emerged later from a different perspective. Most museum visitor studies has taken place in science museums and science centers, and, in 1997, two scientists, Roger Miles and George Hein, became involved in what has become known as the Hein–Miles debate (Bitgood 1997; Hein 1997b). Here the argument is located within a different territory, that of competing philosophical explanations of science, and a different language is used. Alternative views of knowledge, learning, teaching, and research are set out, positioned as realist and anti-realist. The realist (or logical empirical) approach (Miles 1997) understands knowledge as external to the knower, generalizable, value-free, discoverable through empirical reasoning, and able to be transmitted to students. The anti-realist (constructivist) perspective (Hein 1997b) views knowledge as that which is constructed by the knower, relative rather than absolute, intertwined with values, and provisional.

These are large-scale and continuing debates in the social sciences, well summarized by many (Fay 1996; Hacking 1999). In some ways, the arguments can be side-stepped by saying that there may be bits of knowledge that are generally accepted and used, such as the principles of gravity, but that the way in which people come to understand these principles is variable and depends on a range of factors. If (some) knowledge is constant, coming to know (a process of learning) is not. Much of the debate in the museum field failed to distinguish between, on the one hand, what could be accepted by scientists as valid explanations of the world, and, on the other hand, what is known about how learning occurs. If learning requires the individual and collective production of meaning, and if the necessary interpretative processes vary according to the social, cultural, educational, and gendered positions of learners (as they do), then whatever experts may agree amongst themselves, the processes

of understanding remain complex and contingent. For museum visitor studies, it is this recognition that is vital, both for the production of communicative events such as exhibitions or educational programs that are meaningful to visitors, and in the research on the interpretation of these events that are made by those visitors who use them.

If meaning-making processes are contingent, variable, and fluid, then how can they be researched? In order to understand the sense that visitors make in museums, it is not enough to observe what people do, and it is not enough to ask demographic questions. While some information will be gained from these approaches, a more in-depth approach is necessary to probe interpretative strategies and repertoires. This demands a turn to interpretative philosophies and qualitative research methods. Within the social sciences, interpretative and constructivist philosophies have a long and creditable history. Constructivist educational theories are also of long standing. Together, they provide a strong foundation for the development of a more nuanced and sophisticated approach to museum visitor studies.

There are still only a few studies in what will become a new and strong tradition within museum visitor studies. Two brief examples indicate the character and strengths of this approach. Macdonald's ethnographic analysis of the development of the exhibition *Food for Thought* at the Science Museum in London included research designed to understand how visitors to the exhibition framed their experience culturally, going beyond whether or to what extent they "got the message," to explore how they decoded and recoded their experience (Macdonald 2002: 219). Visitors were observed, tracked, and interviewed after their visit. While the methods used are familiar, the sophistication and focus of the research questions and the depth of analysis, which uses the explanatory power of cultural theory, are of note. The analysis of the visitors goes beyond theorizing them as active or passive to show how the level of physical interaction demanded of the visitor, and their own positioning of themselves as streetwise consumers, meant that their responses to the exhibition were mostly not very critical or reflective. The ethnographic approach enables the analysis of visitors to be placed within the contestations and ambitions that characterized the development of the exhibition itself.

In a very different study, Katriel carried out four years of "ethnographic visits" to two of Israel's pioneer museums. Through observing tour guides in their interaction with visitors, she analyses their narratives and performances, and the ways in which these are modified to accommodate the specificities of diverse audience groups. The "tour performances" invoke a master narrative about Israeli settlement, immigration, and the relationships between Jewish and Arab inhabitants. She shows how the guided tours are one manifestation of a continuing struggle for identity, power, and self-determination. The analysis is organized as an ethnography of communication performance constructed on the basis of visual forms and verbal behavior; the connections between the material objects displayed in the museum and the interpretative stories told by the tour guides come together in an exploration of the tour as a performance event. The analysis is extended into a discussion of how pasts are constructed and communicated and how identity is debated, mediated, and modified (Katriel 1997). In this ethnographic visitor study, audio-tape and video-tape are used to capture words and events, but, again, it is not the research methods them-

selves that construct this study as of value; rather it is the depth and scope of the analysis.

These sociological studies are large and in depth, extended over many years. Their research questions are theory-based and they seek to explore social phenomena in an open-ended way; the researchers themselves are very obvious throughout the discussion, positioned as reflective and responsive researchers; and the analysis of the museum event is placed within contexts that extend the analysis beyond the museum. The primary aim of these and related studies (for example, Handler and Gable 1997) is deep understanding rather than the improvement of practice.

Work of this kind, which focuses on perceptions and cultural understandings, has been slow to develop in the professional context. There are a number of reasons for this. This kind of study is time-consuming, expensive, and presents some difficulties in terms of method, especially in relation to generalization, and does not feed directly into museum practice. In America, the strong functionalist and managerial approach of visitor studies has led to a tremendous suspicion of work based on evidence that seems "anecdotal" or "subjective." This is also true to some extent in the UK, especially where policy-makers are concerned. However, increasingly it is being realized that if people use museums because of how they perceive them, then any understanding of the visitor must include investigation of what their perceptions are.

In the UK, the politicization of museum use, as a result of strong government emphasis on increasing social inclusion, has made this understanding very urgent. With the emphasis on learning, and, now, the outcomes of learning, naturalistic research based on qualitative methodologies is increasingly becoming accepted. In common with much policy-related sociological research, attempts have also been made to link qualitative and quantitative research methods; to show how, for example, individual learning outcomes can be characterized in a generic way (Hooper-Greenhill 2004; Hooper-Greenhill et al. 2004). The need for accountability and the emphasis on evidence-based social policy have stimulated new approaches to the measurement of learning that encompass the cultural character of museum use and use a socio-cultural explanation of learning, which insists that learning in museums goes beyond cognitive gain, is not only stimulated through museum collections, and is not always intentional or purposeful.

An overview of museum visitor studies reveals the main topographical features of a new field of study. These include a very diverse body of work, including large-scale studies of social participation, museum visitor surveys, and studies of visitor responses to museum exhibitions and other events. An enduring concern with the character of museum education and learning can be identified, but definitions of what counts as learning remain fluid. The studies have been carried out for academic, professional, or policy-related purposes, each purpose with its own standards and criteria of success. The underpinning conceptual frameworks, and the theoretical paradigms on which the work is based, have shifted in parallel with broader shifts in social theory, but remain contentious. Unlike many intellectual fields, museum visitor studies encompasses desires, perspectives, and experience from both academic and professional environments, and while this is peculiarly fascinating, it also establishes particular challenges for those who work and study in this area.

Bibliography

*Bicknell, S. and Farmelo, G. (eds) (1993) *Museum Visitor Studies in the 90s*. London: Science Museum.

Bitgood, S. (1997) The Hein–Miles debate: an introduction, explanation and commentary. *Visitor Behaviour*, 12 (3): 3–7.

Bourdieu, P. and Darbel, A. (1991) *The Love of Art: European Art Museums and their Public*, with Dominque Schnapper, trans. Caroline Beattie and Nick Merriman. Cambridge: Polity Press.

Carey, J. (1989) *Communication as Culture: Essays on Media and Society*. Boston, MA: Unwin Hyman.

Davies, S. (1994) *By Popular Demand: A Strategic Analysis of the Market Potential for Museums and Art Galleries in the UK*. London: Museums and Galleries Commission.

Dixon, B., Courtney, A., and Bailey, R. (1974) *The Museum and the Canadian Public*. Toronto: Culturcan.

Dufrésne-Tassé (ed.) (2002) *Evaluation: Multi-purpose Applied Research*. Paris: ICOM/CECA.

Eidelman, J. and Van Praet, M. (eds) (2000) *La Museologie des sciences et ses publics*. Paris: Presses Universitaires de France.

*Falk, J. and Dierking, L. (1992) *The Museum Experience*. Washington, DC: Whalesback Books.

— and — (2000) *Learning from Museums: Visitor Experiences and the Making of Meaning*. Walnut Creek, CA: AltaMira Press.

Fay, B. (1996) *Contemporary Philosophy of Social Science*. Oxford: Blackwell.

Graf, B. (1994) Visitor studies in Germany: methods and examples. In R. Miles and L. Zavalo (eds), *Towards the Museum of the Future: New European Perspectives*, pp. 75–80. London: Routledge.

Hacking, I. (1999) *The Social Construction of What?* Cambridge, MA: Harvard University Press.

Hall, S. (ed.) (1997) *Representation: Cultural Representations and Signifying Practices*. London: Sage.

Handler, R. and Gable, E. (1997) *The New History in an Old Museum: Creating the Past at Colonial Williamsburg*. Chapel Hill, NC: Duke University Press.

Harvey, B. (1985) *Visiting the National Portrait Gallery*. London: HMSO.

Hein, G. (1997a) The maze and the web: implications of constructivist theory for visitor studies (www.lesley.edu/faculty/ghein/papers_online/mazeweb/mazeweb_1997.html; accessed July 9, 2004).

— (1997b) A reply to Miles' commentary on constructivism. *Visitor Behaviour*, 12 (3): 14–15.

*— (1998) *Learning in the Museum*. London: Routledge.

*Hooper-Greenhill, E. (1994) *Museums and their Visitors*. London: Routledge.

— (1995) Audiences: a curatorial dilemma. In S. Pearce (ed.), *Art in Museums*, pp. 143–63. London: Athlone.

— (2000) *Museums and Interpretation of Visual Culture*. London: Routledge.

— (2004) Measuring learning outcomes in museums, archives and libraries: the Learning Impact Research Project (LIRP). *International Journal of Heritage Studies*, 10 (2): 151–74.

*— and Moussouri, T. (2002) *Researching Learning in Museums and Galleries 1990–1999: A Bibliographic Review*. Leicester: RCMG.

—, Dodd, J., Phillips, M., O'Riain, H., Jones, C., and Woodward, J. (2004) What did you learn at the museum today? The evaluation of the impact of the Renaissance in the Regions

Education Programme in the three Phase 1 Hubs (August, September, and October 2003). London: Museum, Library, Archive Council and RCMG (www.mla.gov.uk/information/publications/00pubs.asp).

Katriel, T. (1997) *Performing the Past: A Study of Israeli Settlement Museums*. New Jersey: Lawrence Erlbaum.

Lawrence, G. (1993) Remembering rats, considering culture: perspectives on museum evaluation. In S. Bicknell and G. Farmelo (eds), *Museum Visitor Studies in the 90s*, pp. 117–24. London: Science Museum.

Leinhardt, G., Crowley, K., and Knutson, K. (2002) (eds) *Learning Conversations in Museums*. New Jersey: Lawrence Erlbaum.

Linton, J. and Young, G. (1992) A survey of visitors at an art gallery, cultural history museum, science centre and zoo. *ILVS Review*, 2 (2): 239–59.

Loomis, R. J. (1987) *Museums Visitor Evaluation: New Tool for Management*. Nashville, TN: American Association for State and Local History.

Macdonald, S. (2002) *Behind the Scenes at the Science Museum*. Oxford: Berg.

Merriman, N. (1991) *Beyond the Glass Case*. Leicester: Leicester University Press.

Middleton, V. (1990) *New Visions for Independent Museums in the UK*. London: Association of Independent Museums.

— (1998) *New Visions for Museums in the 21st Century*. London: Association of Independent Museums.

Miles, R. (1997) No royal road to learning: a commentary on constructivism. *Visitor Behaviour*, 12 (3): 7–13.

— and Tout, A. (1994a) Outline of a technology for effective science exhibits. In E. Hooper-Greenhill (ed.), *The Educational Role of the Museum*, pp. 87–100. London: Routledge.

— and — (1994b) Impact of research on the approach to the visiting public at the Natural History Museum, London. In E. Hooper-Greenhill (ed.), *The Educational Role of the Museum*, pp. 101–6. London: Routledge.

—, Alt, M. B., Gosling, D. C., Lewis, B. N., and Tout, A. F. (1988) *The Design of Educational Exhibits*, 2nd edn. London: Unwin Hyman.

Myerscough, J. (1988) *The Economic Importance of the Arts in Britain*. London: Policy Studies Institute.

NMDC (National Museum Directors' Conference) (2004) *A Manifesto for Museums: Building Outstanding Museums for the 21st Century*. London: National Museum Directors' Conference.

Resource (2001) *Renaissance in the Regions: A New Vision for England's Museums*. London: Resource, the Council for Museums, Archives and Libraries.

Schuster, J. M. (1995) The public interest in the art museum's public. In S. Pearce (ed.), *Art in Museums*, pp. 109–42. London: Athlone.

Scott, C. (ed.) (1995) *Evaluation and Visitor Research in Museums: Towards 2000*. Sydney: Powerhouse Museum.

Scott, G. P. (ed.) (2002) *Perspectives on Object-centred Learning in Museums*. New Jersey: Lawrence Erlbaum.

Screven, C. G. (1986) Exhibitions and information centres: some principles and approaches. *Curator*, 29 (2): 109–37.

— (1993) United States: a science in the making. *Museum International*, 45 (2): 6–12.

Selwood, S. (ed.) (2001) *The UK Cultural Sector: Profile and Policy Issues*. Westminster: Policy Studies Institute and Cultural Trends.

— (2002) Measuring culture. *Spiked Culture* (www.spiked-online.com).

Trevelyan, V. (1991*) "Dingy Places with Different Kinds of Bits": An Attitude Survey of London Museums among Non-visitors*. London: London Museums Service.

Globalization, Profession, Practice

Introduction

Many of the changes and developments in the museum world of the late twentieth century – including those discussed in other parts of this *Companion* – can be seen, to varying extents, as instances of, or responses to, "globalization." While there are different interpretations of what might be meant by "globalization" – and while its lack of precision as a term means that it is often deployed as an excuse for matters too readily deemed beyond the control of governments or organizations – it is most often used, as by Mark Rectanus, in the opening chapter of Part V (chapter 23), to refer to an intensification of relations and movements at inter- and transnational levels, and to a greater consciousness of what happens in other parts of the world and of their ramifications, both global and local. Globalization, as such, has considerable implications for the workings and even the future of museums, for the nature of exhibitions, the museum profession, and museological practice.

Museums can be said to have long demonstrated a kind of global awareness, via their collecting from many parts of the world, and the museum form has itself undergone remarkable global spread, though, as Christina Kreps importantly points out in chapter 28, in other parts of the world there have long existed similar, but not identical, museological forms that do not have their origins in diffusion from the West. Nevertheless, since the 1950s and 1960s there has been a strengthening and increasing complexity of connections between often distant places. This has also resulted in some non-Western museological practices and ideas beginning to be drawn upon to reshape those dominant in the West, as Kreps suggests, and as is illustrated in relation to thorny questions of repatriation in the chapters by Tristram Besterman (chapter 26) and Patty Gerstenblith (chapter 27).

As Rectanus shows (chapter 23), this period of intensified globalization is characterized too by an increasing corporatization of many areas of culture, including museums; and it is bound up with an aestheticization of communication, increased global traffic in images and symbols, and the spread of "event culture" and "promotional culture." In numerous aspects of their operation, museums find themselves caught between two different pulls: on the one hand, toward global homogenization – borrowing models, ideas, technologies, and even exhibits from museums elsewhere – and, on the other, toward the kind of differentiation on which establishing their niche in an increasingly competitive, and increasingly internationalized, market may

depend. Rectanus takes us through some of the areas in which these globalizing trends are most apparent in museums: administration, curation, and exhibition; architecture and design; and consumption. What he shows is that museums are not simply caught up in globalization, but that they are important players in global image wars, in the commodification and promotion of aesthetics and design, and in the production of new, and especially technologically innovative, modes of representation.

Market rationales are now largely accepted by museums, as Rectanus notes. They seem, indeed, to be unavoidable because although most museums are rich in terms of their collections, they are usually rather short of cash for operational activities, as Bruno Frey and Stephan Meier point out in chapter 24. Even publicly funded museums typically rely to some extent on sponsorship, charging, donations, and commercial activities. A key task for those running museums is to decide how to act in the face of the options available – options that are increasingly considered with reference not only to national or local financial, cultural, or legal contexts (including matters such as tax arrangements and the laws regarding de-accession, as Patty Gerstenblith also discusses) but also in light of what museums in other parts of the world are doing.

Frey and Meier, in chapter 24, draw on the field of cultural economics to highlight the factors involved in trying to work through the complex of possibilities. As they show, the competition has in many respects become tougher, as museum visitors today are more likely to travel and to make their museum comparisons and choices across a much wider geographical area. The rise of what Frey has called "superstar museums" – museums that become household names for people in many parts of the world and that often have a major impact on tourism in the locations in which they are based – is one response to this and to the developments discussed by Rectanus. However, although establishing a "superstar museum" can potentially transform a location – Bilbao is the iconic example – Frey and Meier note that, if only economic regeneration is sought, museums are rarely the most effective answer. What needs to be remembered, as argued in other contexts in this *Companion* (for example, chapter 19), is the distinctiveness of museums, in this case their *cultural value*. The cultural economic approach seeks to find ways to take this into account too.

The diversification of museums, their taking on of new roles, and the increasingly complex contexts, financial and otherwise, in which they operate, also have major implications for museum work and museum staff. Patrick Boylan, in chapter 25, discusses the expansion in numbers of museum staff, in the kinds of role that they undertake, and in guidelines and training to help them perform them. As with the financial and legal environments in which museums operate, there are significant differences between national contexts and between different kinds of museums. Equally, there are, perhaps increasingly, many commonalities, including, in many parts of the world, shifts toward greater employee "flexibility," which generally means, in effect, that individuals are required to perform a greater range of tasks, and that more positions are temporary and short-term – all features that are seen in other parts of the more globalized economy. The establishing of international museum organizations to try to ensure good practice and to make sure that museum staff are trained in matters such as ethics (see chapter 27) is a more positive development, in this case

an instance of an active globalized response to – and intervention in – the changes underway.

That ethics and legal considerations have been a major concern of international and national museum organizations in recent years is mainly, though not exclusively, a response to some of the challenges produced by changing relations between different parts of the world. Calls for the repatriation of artifacts to their original "owners" are primary among these. As Besterman discusses in chapter 26, such calls are often problematic for museums, which may see them as running counter to their vision of providing knowledge for humanity as a whole; as Gerstenblith shows (chapter 27), the legal arrangements may vary from one country to another, and depend on whether or not human remains are involved. What is evident in relation to ethics and law is that both are increasingly being faced with challenges not only within familiar existing understandings but also those rooted in alternative conceptions of, for example, matters such as ownership, property, or the nature of a museum itself.

Such alternative conceptions are further explored in chapter 28 by Christina Kreps. This final chapter in Part V looks at a range of non-Western models of museums and museum-like practices to highlight other ways of caring for and displaying objects, and of engaging visitors. Opening up, as it does, other ways of thinking about the museum and museology, this chapter also leads directly into the final part of the *Companion*, in which controversies, changes, and futures are brought, directly, to the fore.

Globalization: Incorporating the Museum

Mark W. Rectanus

Globalization, like the museum itself, represents a contested terrain. This is reflected in competing discourses which attempt to map the most visible forces of globalization in politics, the media, and culture – as well as those that investigate how globalization plays out in our everyday lives. Curator and critic Hou Hanru asserts that "The question of the global versus the local is now the central issue in artistic and cultural debates. However, the global and the local are not separate entities positioned to fight against each other. Instead, they are two sides of the same coin" (2003: 36). The Guggenheim, with its ever-expanding universe of branches (in Berlin, Bilbao, Las Vegas, Venice), seems to epitomize *the* "global museum," both in terms of its successes as a vehicle for cultural tourism but also its controversial relations to local cultural politics (Hoffmann 1999; Rectanus 2002; Wu 2002). Despite its high profile within the international museum scene, it is questionable whether the Guggenheim has become a model for global expansion that other museums or cultural institutions will choose to emulate. While this chapter will not focus on the Guggenheim *per se*, the Guggenheim "franchise" is also indicative of a less visible globalization of contemporary museums. In fact, the debates surrounding the Guggenheims, and the continuing redefinition of the museum in globalized societies, reveal that most museums today are also "global" in some similar, but less apparent, respects and have been becoming so for some time.

The internationalization of exhibition programming, exchanges of collections, and the movement of curators and directors were already well-established features of many national museums even before the advent of "blockbuster" exhibitions in the 1970s, a concept and strategy that was largely created by Thomas Hoving, director of the Metropolitan Museum of Art. Hoving launched *The Treasures of Tutankhamun* (1972) exhibition, which started at the British Museum, London and subsequently toured the US, ending at the Met (Barker 1999: 128). The blockbuster marked a pivotal moment in the globalization of the contemporary museum by: (a) establishing routinized systems of international mass marketing and product merchandising; (b) globalizing tropes of national culture (e.g., "national treasures"), canon (e.g., "Impressionism"), and identity; (c) validating the museum's mandate from governments (in Europe and North America) to democratize and reach new audiences; (d) aspiring to both entertainment and enlightenment (Huyssen 1995: 24);

and (e) providing a vehicle for corporate image promotion through corporate sponsorships. Yet, the commercial tenor of the blockbuster is only one dimension of globalization, albeit one that has remained critical for many larger national museums like the Metropolitan or the Tate, London.

Increasingly, museums operate both "inside" their own global networks of material exchange and collaboration, and "outside" the historically circumscribed boundaries of social and cultural production (for example, with other cultural institutions, foundations, the media, and corporations). In doing so, they challenge and re-map the relations between culture, identity, and nation. As Sharon Macdonald observes, "Precisely because they have become global symbols through which status and community are expressed, they are subject to appropriation and the struggle for ownership" (1996: 2). Thus, the museum also becomes the site of culture wars and cultural crises which register shifts in global economics, politics, and the media. This chapter will examine the intersections of the museum and globalization from multiple perspectives which reflect the contested nature of the museum as an institution and the discourses surrounding it. These will include theories of globalization related to museum studies; administration, curatorial strategies, and technology; architecture and design; consumption; hybrid models, and alternative practices.

Globalization Theory and Museums

Malcolm Waters has concluded that globalization is based on relationships between social organization and territoriality, which are distinguished by three central functions of exchange: material exchanges localize, political exchanges internationalize, and symbolic exchanges globalize (1996: 8–9). Globalization theories underscore the tensions and paradoxes between simultaneous homogenizing and differentiating tendencies which characterize these exchanges. Such tensions are manifest in the museum. The material exchange of artifacts or collections, for example, is key to maintaining exhibition programs. Although it is conducted globally, it unfolds and is recontextualized locally. This provides new opportunities for site-specific interventions by curators, artists, and audiences to engage communities in *the creation of locality* – a critical dimension of globalization theory developed by Arjun Appadurai (1996: 198).

As Martin Prösler observes, the museum's links to politics, the economy, and the nation-state have, historically, been expressed through the *materiality* of its collections. In this regard, the museum's historical and territorial expansion: "occurred in close connection with those political factors in globalization which have provided the contemporary *world order* with its basic structure. Moreover, the museum was, and remains, epistemologically a space in which the *world is ordered*, in which, with the assistance of material objects, the 'world' is realized, understood and mediated" (1996: 22). Certainly the museum's functions as a site of representation and touristic consumption are part of *historical processes* of globalization related to nation-building (Robertson 1992) and the structuring of experience.

Although nineteenth- and early twentieth-century museums reflected networks of global exchange, they were more closely linked to notions of *cultural* differentiation,

rather than homogenization, of material culture – which became associated with contemporary globalization (i.e., the production, distribution, and consumption of branded products and images). Beginning in the 1950s and 1960s, the impact of media culture (e.g., television), the fusion of popular culture, political protest, and event culture (e.g., rock music), and the corporatization of all forms of global exchange (material, political, symbolic) signaled a new, *accelerated* phase of globalization. The museum assumed an increasingly visible role in these processes of contestation and exchange which reflected a blurring of cultural and social hierarchies identified with postmodernity (Lash 1991; Schulze 1992) and with its reconceptualization as a "mass medium" (Huyssen 1995).

Exhibitions reveal an interplay and recontextualization of the global within the local. The contents of the exhibition and the aesthetics of their presentation relate to the *symbolic exchanges* of culture which globalize. When the Guggenheim sends its *Art of the Motorcycle* (1998) exhibition from New York to Bilbao, we see the globalization of the motorcycle as a contemporary cultural icon within the (privileged) space of the museum, i.e., its display as a work of art. At the same time, we might ask how this exhibition is received by audiences within distinct local contexts. In the case of the Guggenheim Museum Bilbao, and many other museums, a significant percentage of the audience is visiting the museum as part of cultural tourism. This complicates the definition of the local, and notions of global and local consumption. We know that cultural artifacts and works of art are multiply-coded and open to diverse and contested interpretations. However, the works and their reception are also structured and channeled through the context(s) of display or mediation, for example, in a gallery, as an advertisement for an exhibition, or in corporate offices. How curators and museums "translate" culture into the local context is a pivotal dimension and *process* in mediating exhibitions. These tensions, in turn, relate to the broader *disjunctures* of global flow among ethnoscapes, technoscapes, financescapes, mediascapes, and ideoscapes which characterize globalization (Appadurai 1996) and are simultaneously played out through the museum's own implication in each of these "scapes."

The museum plays a vital role as an instrument and icon of local cultural politics and urban culture. This aspect is directly related to the notion that *political exchanges internationalize*. The Deutsche Guggenheim Berlin is multiply signified as a Guggenheim museum, a part of the Deutsche Bank (located in its Berlin offices), and originally as an instrument of US–German cultural exchange (Rectanus 2002: 185–6). In order to anchor the museum's global image to a specific local context, cultural politics draws on the materiality and iconography of architecture. Beginning with the Centre Pompidou's function as one of the first mixed-use cultural centers containing a major museum, Ian Ritchie identifies a shift in the relationship among three factors: image (the museum's location and function within urban space as a privileged site), container (the "internal spatial experience" visitors share with one another), and contents (the interaction between visitors and the objects of the museum's collection (Ritchie 1994: 12). The museum's role as a mixed-use facility within larger urban office and entertainment complexes reflects its multiple functions as a site of urban marketing and tourism, global branding, and of visual consumption (Urry 1995: 150, 169). The Deutsche Guggenheim Berlin, for example,

383

physically and symbolically represents the interests of corporate capital (and property development) in the center of the "new Berlin" (as political center), while muting the dissonances between East and West and Germany and the US which were historically embedded within cultural politics. By linking the words "Deutsch(e)," "Guggenheim," and "Berlin," the museum becomes a signifier for cultural, national, and corporate identity (Rectanus 2002: 186–7).

The gradual redefinition of museums as cultural centers which merge community outreach and education with consumption and entertainment alerts us to its integral role as part of *event culture*. Cultural events are deeply embedded within global networks of media communication which the museum must access in order to reach audiences, advertise, and fundraise. They also form the core of most corporate sponsorships (for example, VIP privileges, opening receptions in museum spaces, celebrity appearances). Events within and outside museum spaces are now an integral part of engaging audiences in the production of culture and social change. Hou Hanru observes that:

> In reality, art equates art *event*. Or to be more precise, if the artwork is to be effectively presented, it needs to be part of an art event. We are now living in the society of communication. Spectacle is the form. The spectacle, or the event, is the very horizon and the bottom line of "reality." To hold an event, the institution is an indispensable physical condition. It is also more importantly, the ideological foundation. What kind of institution should be created is now the crucial question. This is because the institution is the central element in the power system, or mechanism, that defines the notion and boundary of art itself. (2003: 36)

These boundaries have become increasingly fluid during the past three decades. Artists continue to challenge the perceived authority of museum space through public installations and intervention, such as Christo and Jeanne Claude's *Wrapped Reichstag* project, or collaborative projects that involve museums, artist collectives, and audiences. The 2002 Gwangju Biennale, curated by Hou Hanru, included alternative spaces for artist collaboratives from Asia, and contributed to this process of reshaping the regional terrain within which museums, curators, and artists collaborate. Biennials and triennials, such as the well-established Venice Bienniale, have become influential in the global communication of art exhibitions. Yet, critic Michael Kimmelman points out that they also have developed their own networks of exchange "so that the shows have a kind of life of their own, almost apart from all the other art that people see and buy. It's like an alternate universe of art making" (2003: 38).

What impact do projects from this universe "outside" the museum ultimately have on the institutional structure of the museum? Emma Barker believes that public perceptions of museums may actually be much slower to change than curators, critics, or artists concede, concluding that:

> the notion of the museum as a sacred space dedicated to the timeless and universal values of art has persisted in the face of the many mutations that art institutions have undergone in recent years. As such, they have remained largely resistant to the critical concerns that have emerged within academic art history over the past few decades. (1999: 253)

384

While museums seem to retain a privileged status in the transmission and representation of culture, I would argue that they also respond to increasingly diverse publics and communities who seem to redefine the museum's "use-value" in terms of a differentiated spectrum of functions and museum experiences, which may simultaneously involve aesthetic engagement, entertainment, criticism, and material consumption (for example, shopping).

The redefinition of the museum within the diverse contexts of globalization relates to shifts in the production of culture and social meaning. Curator Philippe Vergne seems to be addressing the challenges to the museum "as a sacred space" when he speaks of:

> a crisis in art and the underlying practices of cultural institutions: a crisis that echoes the historical ruptures, the political traumas, and the epistemological breaks that have occurred over the last thirty years and have challenged the centrality of the Western world. The fact is that since the 1960s and the independence and liberation movements of decolonization, new kinds of discourses have emerged, irrevocably altering Eurocentric discourses and their fragile claims of universal validity. (2003: 18)

However, we simultaneously see the spread of museum models which tend to promote the interests of corporate capital, and the incremental privatization of museums as part of commercial and urban event culture. The latter is most apparent in many EU nations (more recently in Germany, The Netherlands, Italy, and Denmark) where state funding for culture has been dramatically reduced and where regional cultural politics increasingly turns to public–private models similar to Britain, Canada, and the USA (including sponsorships). In his articulation of a new sense of what globalization means for the museum, Vergne is, of course, aware of the corporation's hegemonic interests in globalization. However, he also underscores the diverse forms of globalization that are created locally, for example, what Japanization means for the Koreans, Indianization for the Sri Lankans, or Vietnamization for the Cambodians (Appadurai 1996: 32). Thus, the simultaneous emergence of conflicting discourses regarding what the museum represents in postcolonial societies and the forces which alter the institutional structure of the museum reveals the disjunctures of globalization (Appadurai 1996). What has emerged are very different definitions of the museum itself and how and where it is situated within the complex map of globalization.

Administration, Curating, and Technology

There are two separate but related forces at work in the redefinition of museums as *global institutions*. First, museums have incorporated many of the functions of other cultural institutions, including their uses as sites for events, education, shopping, and visual consumption. Second, they are simultaneously attempting to distinguish themselves from these other cultural entities, especially other museums and cultural centers, through thematic specialization. Both of these processes – i.e., functional de-differentiation and thematic specialization – reflect forms of institutional

hybridization (Lash 1991: 11–15; Rectanus 2002: 175–6). This is particularly strik-
ing in the growth of new science and technology museums (Macdonald 1998),
museum complexes ("meta-museums") combining several museums under one con-
ceptual roof, or multiple museum projects as instruments of economic development.
For example, Wolfsburg, Germany (corporate headquarters for Volkswagen AG)
created a "master-plan" for the city and region, including: a major new museum of
contemporary art, the Kunstmuseum Wolfsburg, which competes with international
exhibitions; the Wolfsburg Science Center, which reinforces obvious links to Volks-
wagen technology; and Volkswagen's *Autostadt*, which radically reconfigures the
notion of a corporate museum into a theme park, hotel, and event venue for corpo-
rate representation (Rectanus 2002: 190–95; Siemes 2003: 37).

These institutional strategies for positioning the museum within regional and
global markets for culture are also linked to systems of museum management and
administration. Walter Grasskamp argues that the internationalization of museum
management has, over the course of several decades, reached most smaller regional
museums. As a result, historical differences among museums, which were largely
based on national or regional identities and collection profiles, have become less
important (Grasskamp 1992: 90–91). This not only problematizes the museum's role
as a cultural arbiter but also relativizes the identity of museums that cannot develop
their own distinctive mission and profile.

Moreover, museum administrators have gradually accepted market rationales as
a primary indicator of success, replacing predominantly normative-based objectives,
for example, artistic, national, or aesthetic, which were problematic in their own right
(Schulze 1992: 522–8). Although rationales of administrative efficiency are man-
dated as part of institutional accountability for state-funded institutions, there are
also larger forces at work which involve the corporatization of private and publicly
funded cultural institutions on a global basis. Here again, democratization efforts of
cultural policy in the EU and North America became synonymous with promotion.
This reflects a more generalized acceptance of promotional objectives and discourses
throughout cultural institutions and in societies in general – the emergence of what
Andrew Wernick (1991) terms *promotional culture*.

Within museum administration there are also global flows (Appadurai 1996) of
technology transfer at work. Information technologies and management software for
cultural institutions are now commonplace and indispensable. Exhibition technolo-
gies and services are "outsourced" by museums and corporations. Consultants such
as Bellprat Associates create exhibitions for science centers (for example, Wolfsburg
Science Center), technology museums (Anniversary Exhibition of the Fraunhofer-
Gesellschaft at the Deutsches Museum), themed environments showcasing technol-
ogy (for example, *Rock 'n' Rail*, Verkehrshaus, Lucerne), or corporate trade shows
(for example, the recreation of New York's 5th Avenue at the International Auto-
mobile Exhibition (IAA) in Frankfurt for Chevrolet and Cadillac). Bellprat's website
explains that: "These can include purely artificial worlds or environments as well as
those which offer a combination between a real place and a synthetic adventure
world. In either case, it is a question of turning dreams into smoothly functioning
reality" (Bellprat 2003).

What is at stake here is not only the contents of technology exhibitions, but the manner in which such exhibitions are conceptualized, designed, and implemented on a global basis. By creating and merging cultural (ambience of New York's 5th Avenue and Rockefeller Center), technological (automobiles), and lifestyle environments, such practices reveal the global flow and disjunctures (Appadurai 1996) of image culture, technology, and entertainment which destabilize historical notions of culture's institutional boundaries. However, such reconfigurations also provide an opportunity for the museum to interrogate its own involvement in technology and software transfer, i.e., as more than a site for "smoothly functioning reality." Schulze argues that cultural institutions which operate primarily within economic and administrative parameters are actually missing an opportunity to provide alternative forms of cultural programming (beyond niche marketing) which would differentiate themselves from other competing offerings for experience, event, and lifestyle (1992: 528–9).

A crucial question is to what extent globalized administrative networks and technology transfer alter museum programming, curatorial practices, and exhibition strategies. As a museum director, Kathy Halbreich (Walker Art Center) emphasizes the importance of retaining functional distinctions between corporate and cultural institutions: "If you start to think – and I think about the language I use to sell my institution all the time – it's very easy to accept the corporate model as the appropriate model for a cultural institution. We should be well run, all those things, but I don't think we're corporations" (Marincola 2001: 96). Nicholas Serota, director of the Tate, London, remarked that reduced public funding for museums created more pressure to shift exhibition programming to blockbuster shows which attract larger audiences and corporate donors. Serota chose to balance such exigencies with a policy that limited the museum to one blockbuster each year at the Tate (Marincola 2001: 98–9). At the same time, however, the Tate, like many other museums during the 1980s and 1990s, became more proactive in garnering corporate support (Wu 2002: 137) and expanding the museum franchise regionally (not unlike the Guggenheim) as an instrument of regional economic development (Barker 1999: 178–99).

Developing exhibitions to introduce audiences to new artists and cultural programs, while maintaining a sound fiscal base, undoubtedly remains one of the main challenges for museum directors and curators. With respect to globalization, exhibitions dealing with multiculturalism and identity seemed to offer an alternative to the blockbusters of the 1970s and 1980s. However, Mari Carmen Ramírez has pointed out that, by focusing on the national canon of modernist artists, some exhibitions in the North and West were actually blockbusters in disguise which facilitated the transfer of global capital: "one of the unacknowledged forms in which this exchange has taken place has been through art exhibitions, which under the semblance of collective representation have functioned to mask the complex process of validation of Latin American countries in global financial centers represented by New York" (1996: 25).

Ramírez has argued that there is a direct link between the artists acquired by patrons of Christie's or Sotheby's and the degree to which Latin American nations were successful in promoting their financial interests through cultural identity (espe-

387

cially Mexican, Colombian, Venezuelan, and Cuban-American economic elites; 1996: 30). Wu shows how corporate interests, such as Philip Morris, have been leveraged in exhibitions, galleries, and art markets in Asia in order to provide cultural legitimacy (2002: 177–83). In a similar vein, the inter-relationships between Charles Saatchi's collecting practices, private galleries, and the Brooklyn Museum of Art were exposed during the controversy and ensuing litigation on the *Sensation* exhibition featuring "Young British Artists" (YBAs) in 2002. Simon Ford has concluded that "Much of the hype surrounding the YBAs was linked to the promotion of London as a global player in the financial services industry" (quoted in Marshall 2002: 5). Institutional boundaries and interests (corporate, museum, foundation, state) have become fluid – a part of the global flow – and difficult to identify. The "often hidden alliances that characterize the new corporate landscape . . . raise serious questions of transparency, representation and accountability" (Davies and Ford 2000). Not only are museums inevitably and necessarily involved in global (art) markets of exchange, through processes of acquisition and de-accessioning, but they also support global capital flow by functioning as sites of corporate representation in the promotion of (trans-)national economic interests.

Exhibitions thematize and reflect upon the very nature of globalization. Increasingly cognizant of the homogenizing forces of global media and cultural capital, directors and curators have explored alternatives for reconceptualizing exhibitions by working against the grain of existing categories and canons of representation. The following observations by curators illustrate attempts to integrate discourses surrounding globalization into exhibition strategies and programming.

In approaching the notion of the global, many curators develop exhibitions with a thematic focus that will allow the artists' works to speak and interact with other works in that context, rather than grouping artists according to national or territorial affiliations. Paul Schimmel refers to creating "a level playing field" that does not privilege a particular artist or region. Ramírez believes that Schimmel's exhibitions, such as *Out of Actions: Between Performance and the Object, 1949–1979* (1998) or *Global Conceptualism: Points of Origin* (1999) "show how these people were on par with other artists working in other places. That is what is really interesting. The agenda for this field is to show those connections, to show and to translate" (quoted in Marincola 2001: 40). Yet, some critics have claimed that "global conceptualism" was also implicated in the networks of global discourses (and global corporate sponsorship for the exhibition), which it was attempting to deconstruct (Meyer 1999).

The notion of "translatability" frequently appears within curatorial discourses on globalization and culture. Ramírez believes that "translating what the values of one context are to the values of another context" forms an integral part of the curatorial role: "I've been called by museum directors who want . . . to discuss whether they should have a separate gallery for Latin American art. I say, no, that's ridiculous, put them where they belong, next to whomever they belong – whether it's Warhol or whomever" (quoted in Marincola 2001: 41). For Cuauhtémoc Medina, translation into a different context is less important than attempting to preserve the locality of art, which is difficult to achieve as works circulate globally and become de-territorialized (Kortun and Medina 2003: 31). Once the work leaves the local context, within which it can potentially maintain some links to locality, Medina

believes it soon becomes a signifier of cultural politics. He argues that this has been the case with the work of Mexican artist Gabriel Orozco (now a leading "brand" of Mexican art), or the exhibition *Mexico: Splendors of Thirty Centuries*, a blockbuster exhibition at the Metropolitan Museum of Art, New York (1990) which was designed to "sell" Mexico (Kortun and Medina 2003: 32). However, Vasif Kortun, director of Proje4L Istanbul Museum of Contemporary Art, suggests that the days of the high-profile national exhibitions are gone. Referring to his experience in Istanbul, Kortun asserts that museums must continue to negotiate legitimacy within the contexts of the local, particularly the cultural authorities – who still reflect the "vestige of local archaic power" – rather than forces within "the center," i.e., the forces of globalization from Europe and North America (Kortun 2003: 32).

From an institutional perspective, Kathy Halbreich has attempted to integrate the tensions of globalization into the programs of the Walker Art Center, in part by creating a "Global Advisory Committee." The word "international" in the Center's mission statement has now been replaced by "global" (Halbreich and Desai 2003: 69). Part of the rather difficult process of actually reflecting globalization in museum operations has been to involve more departments within the Center in all aspects of the exhibitions and programming, to create multidisciplinary communities within the Center and ties to local communities. This goes beyond the conceptualization of community outreach as a niche market for fundraising and development, by creating opportunities for a dialogue on community and its relationship to museum programs. Simultaneously, it recognizes the importance of museums as social as well as cultural institutions. At the Proje4L Istanbul, the museum provides a space for neighborhood youth to meet and interact (Kortun 2003). This may open interesting opportunities for reformulating the functions of smaller museums as more open models of social communication which respond to very specific local needs, rather than creating generic, structured environments of museum pedagogy or outreach.

Architecture and Design

Museum architecture has become a critical factor in creating links to communities in several ways: physically, symbolically, functionally, and experientially. First, the physical presence of the museum within urban, suburban, or rural spaces not only creates a unique socio-cultural environment through its interaction with other structures and spaces, it also contributes to a distinctive sense of the local by drawing upon artifacts, artists, and audiences from diverse global contexts who participate in the life of the museum. Second the museum structure has become a signifier for communicating and marketing the museum's image regionally and globally. High-profile designs, such as Frank Gehry's Guggenheim Museum Bilbao (fig. 15.5), have become a corporate brand for the Guggenheim Foundation and for Gehry's firm, which creates similar designs for other projects (for example, the Walt Disney Concert Hall in Los Angeles). Third, new building and annexation projects provide additional space for exhibitions, collections, or support services, while also increasing space for cafés, museum shops, visitor centers or auditoriums, and interactive media for reference and education. Such projects play a significant role in main-

taining and expanding the visitor base and financial support for all cultural institu-
tions. Museum directors consider expansion projects to be one of the most impor-
tant factors in maintaining support for their institutions (Association of Art Museum
Directors 2002). Fourth, the creation of new museum structures or expansions signal
the public demand for high-quality, experiential environments designed to heighten
interaction with culture. While electronic interactivity is a major factor contributing
to themed environments in many science, technology, and history museums, art
museums are also increasingly characterized and defined by the integration of archi-
tecture into the museum experience.

 One of the most frequent criticisms of contemporary museum architecture is that
it overwhelms the museum's contents, and that image and experience have relativized
the significance of collections and exhibitions (see chapters 14 and 15). Thomas
Krens, director of the Guggenheim Museums, has been widely criticized for using
Bilbao primarily as a satellite space for the Foundation's collection rather than cre-
ating a model that would also encourage a greater dialogue with indigenous Basque
culture (Szeemann 1999: 9; Baretzko 2000: 134). Before it opened, the success of
Daniel Libeskind's Jewish Museum Berlin shifted attention to audience interaction
with the structure, as a quasi-touristic experience, rather than engaging the contents.
On a very different, but related, plane of representation, Libeskind's design for the
Imperial War Museum North in Manchester reveals the tensions between themed
environments or spaces created by structural characteristics and the mediation of
concepts and narratives in the exhibitions. While the Imperial War Museum attracts
and engages visitors by recreating the sensory aspects of war through visualization
technologies similar to rock festivals (use of sound, light, visual distortion), it
attempts to establish a basis for the sensory experience through the exhibition's mul-
tiple narratives in texts and artifacts (Rectanus 2002: 144). At what point does the
aesthetic mediation, be it in the structuring of the museum space or the exhibitions,
rob the contents of their communicative power and potential? The functions of
image, architecture as "packaging," and technologies of audience interaction – the
"Disneyfication" of museum spaces – are related but not identical phenomena which
influence the cultural contexts within which museums operate.

 If Gehry and Libeskind represent one end of the spectrum indicating a global
branding of the museum image, there are also projects which propose different
responses. Renzo Piano, for example, discusses a new path for recent projects such
as the Museum for the Fondation Beyeler, marking a visible evolution from his earlier
work, such as the controversial Centre Pompidou (fig. 15.3). Referring to the
Fondation Beyeler and museum design in general, he concludes that:

> This museum should completely serve the viewing of art. This is not as simple to
> manage as it sounds. You simply cannot just build neutral white spaces, as the thesis
> of the "white cube" would have it. They kill works of art just as the hyperactive spaces
> do, that museum buildings make into an end in and of themselves. (quoted in Mack
> 1999: 88)

Architects themselves have become the object of museum exhibitions. The
Louisiana Museum of Modern Art in Denmark (fig. 15.1) recreated large atelier

spaces as part of a series devoted to leading architects, including *Renzo Piano: The Architect's Studio* (2003). Architecture and design have emerged as new, important elements of museum programming, indeed contemporary cultural production. Yet, their status within the museum is problematic for many curators like Paul Schimmel, who voiced serious concerns when his own institution (the Los Angeles Museum of Contemporary Art) made design a priority:

> Quite frankly, I'm very concerned for the MOCA. We have made a decision to go into the area of design. We've obviously had a very active program in architecture, and, I assure you there wasn't an architect in Los Angeles, or beyond that, who didn't see the opportunity to show at MOCA as some kind of enhancement to their ability to get jobs and to have a broader international profile. As complicated as it is in the area of architecture, it's even more so in the area of "design." (quoted in Marincola 2001: 48)

This concern is certainly not an indictment of design *per se*, but rather a caution regarding how the museum should define design and how it can be presented. Design collections and exhibitions about design have become a staple of the contemporary museum scene. They range from museum architecture as an exhibition in its own right (Jewish Museum Berlin), to corporate museums (the Vitra Design Museum in Germany), to museums founded by designers (Sir Terence Conran's Design Museum of London), to stylish museum spaces as urban sites for evening events (Palais de Tokyo, Paris), or to new museums which accord design equal status alongside modernist art collections (Pinakothek der Moderne, Munich). Moreover, design is inextricably linked to the functions of globalized technology. This was illustrated by an exhibition mounted by the LA MOCA in 2003. *Retrofuturism: The Car Design of J. Mays* was a tribute to the work of Ford Motor Corporation's vice-president for global design, who is most widely known for his influence on the "New Beetle" (Hodge 2002). As a nostalgic look at the impact of Ford's "classic" designs on contemporary concept cars, it is indicative of a succession of problematic exhibitions (for example, Guggenheim's *Art of the Motorcycle*) which blur the boundary between exhibitions and corporate promotion.

Consumption

Design features prominently in the products and promotions of museum shops – a logical fit with new design collections. Design and technology create fluid links to other sites of cultural consumption and experience in the media. *Newsweek* magazine devoted a special issue to design, validating its legitimacy within contemporary culture by referencing the museum experience: "Design has never been more accessible (Crate & Barrels sprouting like Starbucks; restaurants and hotels could be design museums) . . ." (Gordon 2003: 61).

> Walking into Murray Moss's downtown Manhattan housewares store, Moss, is like walking into a museum. There are pristine white walls and objects – from Delft pottery to designer toilet-paper holders – in locked glass cases. Name cards identify an item's maker and date of origin. Handrails keep visitors at a distance. (Kalins 2003: 59)

The larger point is not that design, fashion, and many forms of popular culture should be banned from museums. Rather, we should consider these exhibitions in terms of their potential to illuminate how objects of cultural and commercial production are embedded in everyday lives by *critically* examining the intersections between these objects (such as the automobile or motorcycle) and their *multiple* functions in altering society and culture. How and why, for example, have the automobile and fashion become objects of entertainment and desire, sources of creativity, and simultaneously an integral part of the social fabric; for example, in the automobile's relation to urbanization, the environment and lifestyle, or fashion's relationship to social status, the body, and identity?

The museum has become a site for the *representation of design* and the *design of representation*, by creating new forms of exhibition, presentation, and display. The significance of design and the museum extends far beyond the proliferation of design shops as museums or the expanded functions of museum shops for design products and image merchandising, whereby each museum establishes its own market niche and visual image, i.e., brand logo. The museum provides a site for the legitimation of design as a commodity and as a form of aesthetic structuring of communication ranging from brand-name products to design for political campaigns and fundraising for social causes, or a wider "political economy of design" (Foster 2002: 22). This process facilitates the incorporation of commercial discourses (for example, automobile and fashion design) into contexts that have been less *overtly* structured by commercial interests such as museums (Wernick 1991).

Simultaneously, the growth of museum branches in corporate headquarters signals the appropriation of culture for corporate space and the transfer of cultural capital from the museum to the corporation. More pragmatically, museum branches in corporate lobbies are often used to ease zoning restrictions on height or street space when corporate centers include "public spaces" (Wu 2002: 189–200). Branches also provide a satellite facility for museum shops and high-profile art work (for example, Warhols) which attract business workers in downtown locations. Few museums are willing to address the potential conflicts of interest between corporations and museums with regard to branches as promotional spaces, or larger issues regarding corporate boards and museum trustees. Projects that reference the latter – for example, the work of artist Hans Haacke – either occur outside museum spaces (Haacke was banned from the Guggenheim) or are rarely introduced into exhibitions.

Yet, as an integral force of globalization, consumption also provides an aperture for investigating the relations between the museum and other sites of consumption. Certainly, consumption can neither be reduced to the extremes of manipulation, on the one hand, nor forms of subversion and empowerment, on the other. Acts of consumption, as well as its uses, and the desire to consume or collect, are dependent upon diverse forms of mediation and complex contexts of consuming. Sponsorships (cultural, social, environmental, or educational) are actually a response to threats to corporate legitimacy and reflect the continuing crises related to corporate practices and products (for example, tobacco, alcohol, food safety, corporate corruption) as well as anti-globalization movements.

Warhol's prediction that department stores will become museums and museums will become department stores seemed to provide a point of departure for *Shopping: A Century of Art and Consumer Culture* at the Schirn Kunsthalle, Frankfurt and the Tate, Liverpool (2002–3). On the one hand, *Shopping* attempts to map the representation of product design and merchandising as processes of exhibition and display, and, on the other, it interrogates, by implication, the audience's understanding of museum spaces as sites for visual consumption and entertainment (Grunenberg 2002: 31–2). Although the exhibition itself does not assume an overtly critical posture regarding the museum's legitimizing role in expanding sites of consumption, it raises questions about the limits of consumption and the manner in which postmodern societies understand it. Boris Groys's commentary on *Shopping* proposes that consumption and the museum are ultimately linked by their relations to notions of death and the archival:

> The most consistent form of consumption is . . . general annihilation – the definitive use of all things. Death is an ideal consumer because it consumes everything . . . Every consumer, if he takes to this field, will in the long run become similar to death, or consumed by death himself. Now the history of art, as is well-known, begins as the archiving of death – through the erection of burial places, pyramids and museums. Art consumes death – it consumes consumption – and at the same time archives this consumption . . . But while art is consuming consumption and archiving scenes of this consumption, it succeeds in escaping simple subjugation under the constant changes in fashion, and simultaneously creates new, critical variants of consumption. (Groys 2002: 59–60)

In a similar vein, Andreas Huyssen draws our attention to the museum's potential as a space for "creative forgetting," i.e., as "both a burial chamber of the past . . . and as [a] site of possible resurrections, however mediated and contaminated, in the eyes of the beholder" (1995: 15). This certainly speaks to cultural recycling (retro-designs à la *Retrofuturism*) as well as to the re-contextualization and re-presentation of culture which occurs within and around the museum. What are the implications of this process when history and memory, both individual and collective, are digitally enhanced, edited, reproduced, archived, disseminated, and consumed globally? How does the mediatization of museum collections create new modes of consumption, but also destabilize our understanding of what it means to "consume" the "original?" Thus, the consumption of the image as a "real" artifact within the museum, or disseminated in cyberspace, not only alters the manner in which we receive exhibitions, it is changing the manner in which museums function as institutions.

Hybrids and Alternatives

Digital technologies have wide-ranging implications for the museum and its role as a force which operates within global networks of cultural exchange and communi-

cation. More specifically, there is a fundamental reconfiguration of museums with respect to: (a) how their contents are mediated to publics via electronic storage and dissemination; (b) the legitimacy of media art and online art in exhibitions; (c) curatorial practices which reflect the aesthetics of media art; and (d) how the museum positions itself as a "content provider" within a global media marketplace (Rectanus 2002: 214, 223). The museum not only competes locally with other institutions for leisure, entertainment, and education in order to attract new audiences, it also is on the brink of becoming a "global player" in the media industry by providing research and development for "cultural software." This is evident in a number of hybrid museums which fuse technology, art, and cultural production, most notably the Ars Electronica Center (Linz, Austria), the Zentrum für Kunst und Medientechnologie (ZKM) in Karlsruhe, Germany, and the InterCommunication Center in Tokyo, Japan.

These centers are hybrid not only with respect to their funding (government, corporate, and/or foundations); they fuse the functions of multiple museum models (art, science, technology) as well as laboratory spaces within one complex. I also consider them to be "meta-museums," which are defined by two key processes: (a) their attempt to represent and mediate the discourses of their constituent museums or institutes through networked communication, and through projects designed to create new modes of artistic communication linked to virtual communities; and (b) their adaptation of the technical characteristics of the technologies they exhibit. Meta-museums conceptualize their activities as multi-dimensional, nonlinear, interactive, and networked (Rectanus 2002: 221). Much like the Internet and the development of cyberspace, meta-museums can become simply one more space for the dissemination of products. However, projects like the ZKM also are playing a crucial role in deconstructing the aesthetics of technology – for example, video game culture – through their exhibition practices and collaborations with artists (Rectanus 2002: 220–22).

Other new museum models have emerged during the past three decades which might be considered hybrid. Although corporate museums have a long history as sites of technological display and commercial representation, they have assumed new functions which exceed historical notions of patronage or philanthropy. The convergence of interests among government, cultural institutions, foundations, and corporations has blurred the boundaries between public policy, corporate interests, and the mission of museums. As corporations move from product-based economies to information-based systems involving the global circulation of capital resources, culture's communicative value becomes a resource for launching new museum projects. Thus, we can identify a variety of museums that have their genesis in corporate foundations (particularly in banking and insurance), including the Fondation Cartier, Paris, the Hypo-Bank Kulturstiftung, Munich, and the Generali Foundation, Vienna. Each of these museums has evolved into more than a corporate art collection and has developed its own programming and exhibition strategies. They reflect a relatively high degree of diversity in their exhibition programming in comparison with corporate museums or corporate collections. Such diversity is most pronounced in the exhibitions of the Generali Foundation which addresses more political and social issues than most other contemporary museums – corporate or

public. In doing so, the Generali's director, Sabine Breitwieser, has gained the respect of leading artists and curators. To what extent will some hybrid models evolve into relatively independent institutions that will risk conflicts with their corporate founders and trustees?

Finally, we should also be conscious of forms of exhibition culture outside of museums or in cooperation with museums that redefine the museum. Virtual communities and artist collaboratives which appropriate advertising and media or use performance art to stage events outside the museum (for example, Guerilla Girls, Com & Com, Icelandic Love Corporation) are increasingly visible and influential (Bianchi 2000). While the expansion and influence of regional biennials and triennials reflect competing discourses on globalization or provide forums for the reconceptualization of globalization, they also risk becoming routinized networks which only marginally impact the institutional structure of museums (Kimmelman 2003: 38). Because many museums in the North and West (particularly in Canada, the EU, and USA) have mixed funding schemes – dependent upon the state, foundation, endowment, corporate sources – they must be attentive to the multiple demands of these interests. For museums in the southern and eastern hemispheres, where state funding is limited or non-existent, some directors turn to the local community as well as to patrons.

Creating stronger ties to communities out of economic *and* programmatic motivations seems to be a common goal for most contemporary museums. Corporations are also very much interested in merging cultural and social sponsorships (for example, Philip Morris's "Arts Against Hunger Campaign") in order to maintain and insert their interests into local politics and communities. By involving communities more intimately in the process of exhibition planning and programming, museums may be able to seize upon opportunities for creating new forms of locality which communicate *and* display the dissonances between the global and the local. Due to the breadth and diversity of their offerings, their status as centers of cultural events and entertainment, but also as sites of criticism and conflict, museums are uniquely positioned to engage the *social imagination* in order to participate in and initiate the process of redefining globalization (Appadurai 2000: 6; Becker 2002: 134).

Bibliography

Appadurai, A. (1996) *Modernity at Large: Cultural Dimensions of Globalization*. Minneapolis, MN: University of Minnesota Press.

— (2000) Grassroots globalization and the research imagination. *Public Culture*, 12 (1): 1–19.

Association of Art Museum Directors (2002) *The State of the Nation's Art Museums*. New York: Association of Art Museum Directors.

Baretzko, D. (2000) Die reinste Verschwendung: Magie zwischen Minimalismus und Exzentrik – Tendenzen im Museumsbau der neunziger Jahre [Sheer extravagance: magic between minimalism and eccentricity – tendencies in museum construction of the 1990s]. In U. M. Schneede (ed.), *Museum 2000: Erlebnispark oder Bildungsstätte* [Museum 2000: Theme Park or Educational Institution], pp. 129–41. Cologne: Dumont.

Barker, E. (ed.) (1999) *Contemporary Cultures of Display*. New Haven, CT: Yale University Press.

Becker, C. (2002) *Surpassing the Spectacle: Global Transformations and the Changing Politics of Art*. Lanham: Rowman and Littlefield.

Bellprat Associates AG (n.d.) Bellprat Associates showroom (www.bellprat.ch/start.html; accessed April 19, 2003).

Bianchi, P. (2000) Kunst ohne Werk: Ästhetik ohne Absicht [Art without artwork: aesthetics without intention]. *Kunstforum*, 152 (thematic issue on performance).

Davies, A. and Ford, S. (2000) Culture club. *Metamute* (M18) (www.metamute.com; accessed December 12, 2003).

Foster, H. (2002) *Design and Crime – and Other Diatribes*. London: Verso.

Gordon, D. (2003) Meet the titans of taste: the philosopher king. *Newsweek*, October 27: 61.

Grasskamp, W. (1992) *Die unästhetische Demokratie* [The Unaesthetic Democracy]. Munich: Beck.

Groys, B. (2002) The artist as consumer. In M. Hollein and C. Grunenberg (eds), *Shopping: A Century of Art and Consumer Culture*, pp. 50–60. Ostfildern-Ruiz: Hatje Cantz.

Grunenberg, C. (2002) Wonderland: spectacles of display from the Bon Marché to Prada. In M. Hollein and C. Grunenberg (eds), *Shopping: A Century of Art and Consumer Culture*, pp. 17–37. Ostfildern-Ruiz: Hatje Cantz.

Halbreich, K. and Desai, V. N. (2003) Musings on globalism and institutional change. In P. Vergne (ed.), *How Latitudes Become Forms: Art in a Global Age*, pp. 66–75. Minneapolis, MN: Walker Art Center.

Hanru, H. (2003) Initiatives, alternatives: notes in a temporary and raw state. In P. Vergne (ed.), *How Latitudes Become Forms: Art in a Global Age*, pp. 36–9. Minneapolis, MN: Walker Art Center.

Hodge, B. (ed.) (2002) *Retrofuturism: The Car Design of J. Mays*. New York: Universe/Rizzoli.

Hoffmann, H. (1984) *Kultur für alle: Perspektiven und Modelle* [Culture for Everyone: Perspectives and Models]. Frankfurt am Main: S. Fischer.

— (ed.) (1999) *Das Guggenheim Prinzip* [The Guggenheim Principle]. Cologne: Dumont.

Hollein, M. and Grunenberg, C. (eds) (2002) *Shopping: A Century of Art and Consumer Culture*. Ostfildern-Ruiz: Hatje Cantz.

Huyssen, A. (1995) *Twilight Memories: Marking Time in a Culture of Amnesia*. New York: Routledge.

ICOM (2002) Museums and globalization: bibliography (1964–2001) (http://icom.museum/bibliography2002.html; accessed November 10, 2003).

Kalins, D. (2003) It's cool to be warm. *Newsweek*, October 27: 59–60.

Kimmelman, M. (2003) Rushed memorials and show bloat. *The New York Times*, December 28: 38.

Kortun, V. (2003) The necessity of public funding? Conference on Populist Politics and its Consequences for Cultural Production and Display. Danish Contemporary Art Foundation, March 7–8, Copenhagen, Denmark.

— and Medina, C. (2003) The local tango and the global dance. In P. Vergne (ed.), *How Latitudes Become Forms: Art in a Global Age*, pp. 28–35. Minneapolis, MN: Walker Art Center.

Lash, S. (1991) *Sociology of Postmodernism*. London: Routledge.

Macdonald, S. J. (1996) Introduction. In S. J. Macdonald and G. Fyfe (eds), *Theorizing Museums: Representing Identity and Diversity in a Changing World*, pp. 1–18. Oxford: Blackwell.

— (ed.) (1998) *The Politics of Display: Museums, Science, Culture*. London: Routledge.

— (2003) Museums, national, postnational and transcultural identities. *Museum and Society*, 1: 1–15.

Mack, G. (ed.) (1999) *Kunstmuseen: auf dem Weg ins 21. Jahrhundert* [Art Museums into the 21st Century]. Basel: Birkäuser. (English edition, trans. M. Robinson, Gardner's UK).

*Marincola, P. (2001) *Curating Now: Imaginative Practice/Public Responsibility*. Philadelphia: Philadelphia Exhibitions Initiative.

Marshall, R. (2002) An interview with Simon Ford. *3 a.m. magazine* (www.3ammagazine.com/litarchives/2002_may/interview_simon_ford.html; accessed December 10, 2003).

Meyer, J. (1999) Global conceptualism: points of origin, 1950s–1980s. *ArtForum* (September) (www.findarticles.com; accessed January 11, 2004).

Prösler, M. (1996) Museums and globalization. In S. J. Macdonald and G. Fyfe (eds), *Theorizing Museums: Representing Identity and Diversity in a Changing World*, pp. 21–44. Oxford: Blackwell.

Ramírez, M. C. (1996) Brokering identities: art curators and the politics of cultural representation. In R. Greenberg, B. W. Ferguson, and S. Nairne (eds), *Thinking About Exhibitions*, pp. 21–38. London: Routledge.

*Rectanus, M. (2002) *Culture Incorporated: Museums, Artists, and Corporate Sponsorships*. Minneapolis, MN: University of Minnesota Press.

Ritchie, I. (1994) An architect's view of recent developments in European museums. In R. Miles and L. Zavala (eds), *Towards the Museum of the Future: New European Perspectives*, pp. 7–30.

Robertson, R. (1992) *Globalization: Social Theory and Global Culture*. London: Sage.

Schulze, G. (1992) *Die Erlebnisgesellschaft: Kultursoziologie der Gegenwart* [The Experiential Society: A Cultural Sociology of the Present]. Frankfurt am Main: Campus.

Siemes, C. (2003) Das Leben made by VW [Life made by VW]. *Die Zeit*, April 24: 37.

Szeemann, H. (1999) Ecce Museum: Viel Spreu, weinig Weizen [Ecce museum: much chaff, little wheat]. In G. Mack, (ed.), *Kunstmuseen: auf dem Weg ins 21. Jahrhundert* [Art Museums into the 21st Century], pp. 7–10. Basel: Birkäuser. (English edition, trans. M. Robinson, Gardners UK).

Urry, J. (1995) *Consuming Places*. London: Routlege.

*Vergne, P. (ed.) (2003) *How Latitudes Become Forms: Art in a Global Age*. Minneapolis, MN: Walker Art Center.

Waters, M. (1996) *Globalization*. London: Routledge.

Wernick, A. (1991) *Promotional Culture: Advertising, Ideology, and Symbolic Expression*. London: Sage.

*Wu, C. (2002) *Privatising Culture: Corporate Art Intervention since the 1980s*. London: Verso.

Cultural Economics

Bruno S. Frey and Stephan Meier

The museum world has changed substantially in the past decade and gained more relevance in economic terms. The number of visitors has increased in the United States and in Europe, as museum visits have become one of the most important leisure activities and tourist attractions. Many special exhibitions designed as "blockbusters" attract large crowds comparable to other major events in the leisure industry. Even Las Vegas, the former "sin city," realized that "more Americans visit art exhibitions than sports events" (*The Economist* 2001). In response, the casinos started their own art galleries to attract more visitors. In aggregate, increasing numbers of visitors around the world spend considerably more money on the arts than they ever did before.

Most museums, however, are struggling for survival and chronically lack financial resources. The decrease of public funding in the past decade, and the increasing competition between art organizations for visitors, public grants, and donations, may explain some of the trends in the museum world and the behavior of museum directorates. The recent efforts of museums to increase their revenue may be seen, for example, as reactions to the "harsher" competition for funding. But museums seem to be extremely rich taking into account their major assets: the exhibits (for art museums the art works). The incentives for the museum directorate, however, to sell some exhibits, or even to include them in financial accounts, are low. This chapter focuses on the behavioral patterns of museum directorates and the particular economic features of museums, with particular reference to the importance of the institutional setting.

Cultural economics applies economic thinking to the arts. It is not restricted to financial aspects, such as subsidies and costs, but uses an economic model of human behavior to understand social aspects of the arts. The Economics of the Arts has established itself as a major discipline within the economic approach to the social sciences. This approach is based on a systematic study of the interaction between the behavior of individuals and institutions (Becker 1976; Frey 1999). The latter may consist of particular decision-making systems (for example, the market, democracy, hierarchy, or bargaining), norms, traditions, and rules, as well as organizations (such as the state, parties, or interest groups). A specific model of the behavior of human beings – the "rational choice model" – is assumed: preferences (i.e. what people

desire) and constraints (imposed by social institutions and by income, prices, and time available) are carefully separated. Changes in behavior are attributed to changes in constraints because such changes can be empirically identified. At least in the basic model, preferences are taken as given. It is difficult, if not impossible, to empirically identify changes independent of the behavior to be explained. Therefore, in order to avoid empty statements of the kind "people undertake a particular action because they like to do it," behavior to be explained is attributed to constraints, in particular to the working of institutions. The economics of museums thus understood clearly distinguishes itself from other approaches to studying museums, in particular the sociology of museums or art history (for example, DiMaggio 1986; Foster and Blau 1989).

The economics of museums has been the topic of several publications (for example, Feldstein 1991; Schuster 1998; Meier and Frey 2003). It has been treated in general surveys (Throsby 1994; Blaug 2001) and monographs and textbooks (see Frey and Pommerehne 1989; Towse 1997; Benhamou 2000; Throsby 2001; Frey 2003). Below, we first briefly discuss aspects of supply and demand; and then analyze how different institutional settings can affect the incentives and behavior of museum management. We include here discussion of some important developments, such as charging and sponsorship, blockbuster traveling exhibitions, and superstar museums, often seen as the way forward in the museum world.

Supply

Cost structure

Museums face a cost structure that differs from other firms in the service industry and can explain some of their particularities. Museums have (a) high fixed costs and low variable costs; (b) the marginal cost of an additional visitor is close to zero; (c) the costs of museums have a dynamic component which is disadvantageous for the enterprise; and (d) opportunity costs constitute a substantial part of the costs of a museum.

(a) *High fixed costs* Museums in general operate with considerable high fixed costs: buildings, collection, staff, insurance, technical outfit, and so on, cannot be varied in the short run. Independently of output (for example, numbers of visitors or numbers of exhibitions), the costs to run museums remain the same. Fixed costs include the costs of acquisition, which for paintings especially increased dramatically when the art market exploded in the 1980s and insurance fees went up accordingly.

(b) *Marginal costs are close to zero* To determine how much should be produced, marginal costs of a museum constitute crucial economic information. They indicate how costs vary with output. The cost of an additional visitor is most of the time close to zero. If a museum sets up an exhibition, the basic operating costs are for opening the museum on that particular day. When more people enter the museum, average costs decrease. However, there are some situations

where marginal costs are not zero. At so-called "blockbuster" exhibitions, for example, an additional visitor imposes "congestion costs" on other visitors (see Maddison and Foster 2003 for evidence for the British Museum).

(c) *Dynamic cost* Like most cultural organizations, museums experience a productivity lag producing constant financial problems. They thus suffer from a "cost disease" as wages increase with general increases of productivity in the economy. In the cultural sector, wages develop as in the normal economy but productivity increases lag behind those of the other sectors. The classic example is the Mozart symphony which always needs the same number of staff. There is little scope for increasing productivity, and costs therefore increase constantly. Although there are no empirical studies of "cost disease" for museums, there are areas where it could possibly be redressed, such as: items being shown on the Internet, surveillance undertaken by cameras; the use of more volunteers, activities being outsourced; or the introduction of "leaner" forms of management.

(d) *High opportunity costs* Museums typically own a huge endowment of high value. Art works and historic artifacts bring not only storage and conservation costs but also opportunity costs. The real costs of this capital stock would become apparent if museums borrowed money to buy pieces. The annual interest, which the museum would have to pay, would constitute the real capital costs. The opportunity cost of a painting or artifact is its monetary value in an alternative investment. The annual rate of return can be seen as the cost of the item. Other opportunity costs might include alternative uses of the museum building. For most museums, the value of their holdings is by far their greatest asset. At least some museums have realized that a closed museum costs more than just the operating expenses of the building. There are alternative uses for the rooms of the museum, such as renting for business lunches or other social events. Most museums do not put a value for their collection in their accounts. Neglecting opportunity costs can partly be explained by a rational reaction of the museum's directorate to action of the political sector (this will be discussed in more detail in the section on public subsidies below).

Organizational form of museums

Museums can be private for-profit organizations, private non-profit organizations, or public organizations run in a non-profitable way (or some combination of these). In Europe and the United States, the non-profit organizational form is predominant. Different hypotheses can be put forward to explain the dominance of non-profit firms in the museums world and the arts in general (see, for example, Hansmann 1981; DiMaggio 1986). According to Weisbrod (1977), non-profit organizations were founded due to an unsatisfied demand for public goods.

If making variable admission charges is not possible, individuals can be asked to pay more voluntarily, for example, by becoming donors. The non-profit form dominates the for-profit enterprise in getting donations because consumers lack exact information about the quality of the good and service provided. There is therefore no ordinary possibility to make a complete contract to protect donors against exploitation. Donors then prefer non-profit firms where the possibility that the

managers of the firm exploit donors and consumer is limited. However, as we discuss in the next section, the non-profit organization has problems of its own concerning the supervision of the managers of such firms. Although there is no possibility to distribute the profits due to the non-profit form, there is still much leeway for managers either to receive huge fringe benefits or to behave not in the interest of the museum.

Demand

The demand for museums can be divided into two parts: (a) *private demand* exerted by the visitors; and (b) *social demand* from persons and organizations benefiting from a museum but not paying for it directly.

Private demand

The number of visits can be analyzed by a traditional *demand function* capturing the major factors determining the number of visits. Its features can be empirically measured by using data on museum visits and on the factors included in the demand function, normally by a multiple regression analysis. The goal is to answer the question of how demand varies when, for example, prices change – all other determinants of demand kept equal.

There are three major determinants relating to *prices* or *costs*:

1 *Entrance price* Together with the number of visits, this determines the respective revenue gained. "Price elasticity" is the term used to indicate by how much visitor attendance decreases when the entry price is raised. Econometric estimates for a large number of different museums in different countries suggest that the demand for museum services is price inelastic (Luksetich and Partridge 1997), i.e. an increase of the entrance price by one percentage would decrease the attendance by less than one percentage. Overall, the low price elasticities suggest that museums can generate significant increases in revenues through admission fee increases.

2 *Opportunity cost of time* This indicates what alternatives the visitors have to forgo when they visit a museum. For people with high, full-income potential and variable time use, mostly the self-employed, the opportunity cost of time is higher than for people of low income and fixed work time. The latter are therefore expected to visit museums more often, all other things being equal. The opportunity cost of a museum visit not only depends on the time actually spent in the museum, but also on how much time is required to get to the museum, i.e. the location, the parking facilities, and so on. For tourists, the opportunity cost of time tends to be lower than for local inhabitants because they often visit a city with the purpose of visiting the respective museums. To measure the effect of opportunity costs properly, one has to separate the effect of opportunity costs from the income effect. The demand for museums increases with income. But with higher income normally also opportunity costs increase. If the effects are

separated, one finds a positive income and a negative opportunity costs effect on demand.

3 *Price of alternative activities* These are, most importantly, substitutive leisure activities, such as other cultural events (theater, film), sports, restaurant visits, time spent with friends at home, and so on. Museums may also constitute a substitute for other museums. The higher the price of such alternatives, the higher is museum attendance, all other things being equal. But complementary costs, such as travel, accommodation, and meals, also systematically influence the number of museum visits. The higher their price, the lower is the rate of museum visits.

Income is another determinant of the demand for museum visits. Econometric estimates reveal an income elastic demand, i.e. rising real disposable income favors museums. As already mentioned, the income effect has to be separated from the effect of higher opportunity costs due to higher potential income. An important factor is also the high correlation of income and *education*. Better-educated people have the human capital necessary to more fully enjoy museums than people with lower education. This factor plays a larger role for museums of (modern) art and history, but plays a lesser role for museums of science and technology, especially for museums of transport (railways, cars, or space travel).

There are many *other determinants* that must be included in a well-specified museum demand function. One is, of course, the quality of the collection or special exhibition mounted. Luksetich and Partridge (1997) estimate that the value of the collection increases attendance figures. Other factors which influence demand are the attractiveness of the building, the level of amenities provided, such as the general atmosphere, the extent of congestion in front of the exhibits, the cafés and restaurants, and the museum shop. Important also are marketing efforts, especially regular and vivid advertising.

A final determinant of the rate of museum visits is individual preferences. These are difficult to measure independently. Econometric studies of museum demand often indirectly capture them by introducing past visits as a determinant. In all empirical estimates this factor proves to be highly significant: people who used to visit a museum in the past are likely to do so also in the present and future. Their demand even increases with past consumption, making museum visits an "addictive" good.

Social Demand

Museums produce effects for people not actually visiting the museum. These benefits cannot be captured by the museums in terms of revenue.

External effects

Museums create *social values* for which they are not compensated in monetary terms and, therefore, may have little incentive to develop. Five types of such external effects may be conveniently distinguished:

1 *Option value* People value the possibility of enjoying the objects exhibited in a museum sometime in the future.
2 *Existence value* People benefit from knowing that a museum exists but do not actually visit it now or in the future.
3 *Bequest value* People derive satisfaction from the fact that their descendants and other members of the community will in the future be able to enjoy a museum if they choose to.
4 *Prestige value* People derive utility from knowing that a museum is cherished by persons living outside their community. They themselves need not actually like and visit the museum.
5 *Education value* People are aware that a museum contributes to their own or to other people's sense of culture and therefore value it.

This list of "*non-user benefits*" indicates that museums may indeed provide many social values for which they are not compensated by revenue. Museums may also produce negative external effects whose costs are carried by other persons. An example would be the congestion and noise carried by museum visitors to a community.

The non-user benefits and costs have been empirically measured using three different techniques:

1 *Representative surveys* Best suited are *contingent valuation studies* which were first developed to capture environmental values but have served well to capture cultural values (for an application to museums, see Martin 1994).
2 *Analysis of revealed behavior by individuals* One well-developed procedure is to estimate by how much the property values in a city are raised by the existence of a museum as people are willing to pay more for a house that is located in an area with a rich cultural life (Clark and Kahn 1988).
3 *Analysis of the outcome of popular referendums* on museum expenditure. In Switzerland, with its many referendums, this approach has been successfully used to identify option, existence, and bequest values of buying two paintings by Picasso for a museum (Frey and Pommerehne 1989: ch. 10).

Museums produce *monetary values* for other economic actors. They create additional jobs and commercial revenue, particularly in the tourist and restaurant businesses. These expenditures create further expenditures (for example, the restaurant owners spend more on food) and a multiplier effect results. *Impact studies* (see, for example, Towse 1997), measuring the additional market effects created, are popular among politicians and administrators because they provide them with reasons to spend money on museums. However, these studies have to be interpreted with much care. Impact studies tend to focus on the wrong issue. The *raison d'être* of museums is to produce the unique service of providing a certain type of cultural experience to its visitors, as well as to provide the non-user benefits discussed above. The museum's task is *not* to stimulate the economy; there are generally much better means, such as opening a theme park, to do so. If one follows the line of argument of impact studies, one would have to give preference to whatever expenditure leads to more economic stimulation.

Bruno S. Frey and Stephan Meier

A reasonable policy for a museum is to emphasize its *cultural value*, and to determine the non-user values created by serious empirical studies sketched above. A museum must make an effort to produce those values no other institution can; namely, to provide the present and future generations with specific cultural experiences. Museums should not try to imitate other institutions such as theme parks. Museum people should not forget where their *comparative advantage* lies and should refrain from competing on other grounds.

The Institutional Approach to Museum Behavior

The services produced in a museum are not purely externally given but have to be decided by its decision-makers. The main actors in a museum, determining the museum services, are the directorate and their professional staff. For the sake of simplicity, this discussion is restricted to the directorate. The analysis concentrates on the incentive these actors have to behave in a certain manner. The directorate is assumed to be concerned primarily with its own well-being. The directors' utility depends on their own income and the prestige they get within their reference group, which consists mainly of arts lovers and the international museum community. A second source of amenity is derived from the agreeable working conditions and job security. But the museum directorate is not free to do whatever it wants to do because it faces certain constraints on its actions. Differences in these institutionally determined restrictions explain the museum management's behavior.

Three institutional arrangements may affect managers' behavior: (a) the ownership structure (financing), which sets the incentive for museums managers to help ensure that they accomplish their goals efficiently; (b) competition (often lacking in the museum world) that would enforce efficiency; and (c) performance measurement and transparency, which make it easier to evaluate the museum directorate. In the following sections, we will discuss in particular the first two institutional arrangements. Questions of performance measurements and transparency will, however, evolve in the discussion of the restrictions imposed by the institutional setting.

The finances available are the most important constraint on the museum's directorate. Other constraints, such as limited space or legal and administrative burdens imposed by the bureaucracy or labor unions, can also weigh heavily. The sources of income differ considerably from one museum to another. From a politico-economic point of view, the institutional set-up and the nature of funding of the museum are expected to have a strong influence on the behavior of the directorate. The incentives for the museum's directorate to behave in a certain way vary significantly depending on this institutional framework (see Frey and Pommerehne 1989). Most of the literature focuses on the "ideal types" (in Max Weber's sense) of a "purely public" and "purely private" museum (an exception is Schuster 1998).

In the following sections, we discuss museum behavior from an institutional point of view focusing on public versus private museums before analyzing how these institutional differences influence the management of the collection, pricing decisions, and the provision of visitor amenities. We then consider how competition can change

404

the behavior of public museums dramatically. Competition between museums can force efficiency and improve the services provided by the museum.

Public vs Private Museums

Directors of purely *public museums* rely exclusively on public grants. The government allocates them funds to cover the expenses considered necessary for fulfilling their tasks. While they are expected to keep within the budget, if a deficit occurs, it will be covered by the public purse. This institutional setting provides little incentive to generate additional income and to keep costs at a minimum. The directorate will not allocate energy and resources generating additional income because any additional money goes back into the national treasury. If they were to make a surplus, the public grants would be decreased, which acts as an implicit tax of 100 percent on profits. The museum's management tends to move away from a commercial to a non-commercial framework in order to reduce the pressure of having to find their own income sources to cover additional costs. When the directorate is no longer forced to cover costs by its own efforts, it can legitimize its activities by referring to intrinsic "artistic," "scientific," or "historical" values. This application of non-commercial standards helps the museum directors to achieve their goal of prestige, top performance, and pleasant working conditions.

Directors of a purely *private museum*, on the other hand, have a strong incentive to increase the museum's income because their survival depends on sources of money such as entrance fees, revenue from the restaurant and the shop, and additional money from sponsors and donors. If private not-for-profit museums generate a surplus, they are able to use it for future undertakings.

Most museums, however, are somewhere between the polar cases of purely public and purely private museums. In the past few years, public museums have increasingly moved in the direction of private museums as state support has decreased, especially in Europe (NEA 2000). Directors have been given more discretion and pressure to generate income.

How Institutions Affect Behavior in Four Important Areas

The management of the collection

In most museums of the world, a considerable part of the holdings is not exhibited and not accessible to the general public. What constitutes the major part of the wealth of such an institution thus does not appear on the balance sheet.

The failure to consider the opportunity costs of holding a collection throws up the question why such behavior takes place. Museum managers are well aware that their holdings have a great value, and they cannot be assumed to be irrational. But why do rational, well-informed people systematically not account for these large sums of money? Three reasons can be proposed which may explain the behavior of the museum management:

1 The government imposes a *legal constraint* on selling. Many or even most public museums in continental Europe are prohibited from de-accession, though it is often allowed in the United States and to a lesser extent also in Britain. Nevertheless, as O'Hagan (1998: 171) argues, "The real opposition arises from the museum personnel and not from the law." Even in the United States, where it is legal to sell part of the collection, curators argue that it is not ethically right to do so, unless this contributes to improving the collection.

2 There may exist a voluntary contract between the museum directorate and donors who generally want to keep intact the collection that they have given. The directorate is faced with a trade-off between receiving additional paintings and having to accept additional restrictions (Weil 1987).

3 Public museums lack an *incentive* to sell their holdings because, first, when a painting or artifact is sold, the revenue gained is not added to the museum's disposable income, but, according to the rules of the public administration in most countries, goes into the general public treasury or the budget allocated to the museum is most likely to be correspondingly reduced. Secondly, selling collected items means that the existing stock is at least partly monetized, which eases outside interference by politicians and parliamentarians in the museum's business (O'Hare and Feld 1975). The museum directorate's "performance" becomes easier to evaluate and the buying and selling prices of particular items can be compared. As long as the criteria for evaluation are exclusively of an art historic or subject-specialist kind, the museum community is to a substantial extent able to define its performance itself. This is a useful and successful survival strategy that museum administrations do not voluntarily give up.

By contrast, private museums may be active in buying and selling, as is the case with private American art museums (Feldstein 1991: 21).

Setting entry fees

There are large differences between museums in the way in which they set the entrance fees. There is an extensive discussion about whether to charge or not to charge (see O'Hagan 1995). This discussion probably goes back to Hans Sloane, whose donation led to the founding of the British Museum conditional upon an entrance fee not being charged. Most national museums in Britain today do not impose an entry fee. In the United States, there are also some museums, at least the national ones, which do not levy an explicit entrance price.

Two main arguments are put forward in favor of free admission, but the arguments have shortcomings. First, because there are some positive side-effects connected with a museum, as discussed above, the museum should be paid for by taxation. But the benefits are not distributed equally, and an accurate taxation according to these benefits is almost impossible. Those who visit a museum probably benefit the most from the museum. Therefore, an entrance price should be levied on top of the contribution from general taxation. There does not seem to be any evidence that this measure hits low-income groups disproportionately (O'Hagan 1998: 178). In the system without charges, it is not only the majority who pays but also the poor income

group who benefits the least. Secondly, the low or zero marginal cost of a visitor leads to the view that to charge a zero price is efficient, i.e. if the museum is open, it costs nothing to allow a visitor to enter who gets a low but positive utility from the visit. As mentioned above, the assumption of zero marginal costs can be criticized on various grounds. Some of the problems can be avoided by adopting a pricing option which deviates from the two extremes.

There is a variety of pricing options besides free entrance: donation boxes with and without price suggestions, seasonal tickets with zero marginal pricing, a museum pass, a free day policy, or a more sophisticated price discrimination. The price discrimination, which is supported by economists, can be undertaken in time of high demand and/or in respect of the type of visitor. A lot of museums, even those who do not charge for their permanent collection, have higher entrance fees for special exhibitions. Additionally, the museum could charge more at weekends. Tourists could be charged more than residents, which makes sense from an economic and political point of view. Prices could also be differentiated between visitors who want to spend little time on the visit to a museum and those who want to spend more time. In periods of high demand, when the art museum's capacity is fully used, two entry prices could be set, a high and a low one. The high-priced entry will generate a shorter waiting queue and will be used by the first category of visitors. The low-priced entry option will be used by the second category of visitors, among them students and other young people who do not want to spend much money but have plenty of time available. Price differentiation is advantageous for both categories of visitors (one gets in more quickly, the other pays less) as well as for the museum administration which can therewith raise its revenue.

The question of how pricing influences the finances of the museum not only depends on the price elasticity of demand. Charging can also influence the flow of public subsidies and donations. Moreover, pricing decisions influence the income generated by ancillary income, such as the revenue gained from the shop and restaurant which depends on the number of visitors. The complementarities between admission fees and sales in museum stores and restaurants affect optimal pricing strategy. The empirical result in Steiner (1997) suggests that an additional free day does not maximize revenue because the decreased admission revenue due to the free day is not compensated for by more sales in the shop and restaurant.

Special exhibitions

Special exhibitions are increasingly important for museums, and almost all museums engage in it to some extent. Special exhibitions, especially of art, are often composed of exhibits from all over the world and are often designed to be traveling exhibitions.

The boom in special exhibitions contrasts with the financial problems most museums are facing (Frey 2003). Even in some of the world's leading museums, some wings are temporarily closed, and opening hours are reduced in order to save money. Curators are concerned that they have less and less money available for the restoration and conservation of their collection. Why should special exhibitions be different?

On the *demand side*, special exhibitions have some special features worth noting:

1　*High income effect*　Consumers tend to spend an increasing share of their rising income on visiting specially arranged art exhibitions.
2　*Attracting new visitor groups*　Special cultural events, such as special exhibitions, are widely advertised and are therefore able to attract new groups not normally visiting museums. In order to overcome people's resistance to enter museums, they are "dressing-up."
3　*Newsworthiness*　Special exhibitions are *news*, and attract the attention of television, radio, and the print media, which is otherwise impossible to get to the same degree, and especially free of charge. It is easy to get media people to report on a special exhibition, while the permanent collection is hardly newsworthy.
4　*Low cost to visitors*　Special exhibitions are closely linked with tourism. A considerable number of visitors come from out of town, from other regions, and often from foreign countries. The combination of a cultural event with tourism lowers the individual's cost of attending in various ways. In the case of increasingly popular package tours, consumers only have to take the initial decision and all the rest is taken care of by the travel agent. In the case of culture, where it is often burdensome to acquire the tickets from outside, the reduction of decision and transaction costs are substantial. The strong attraction of special exhibitions to tourists also affects the price elasticity of demand. Tourists relate the entry fee to their expenditures for the overall trip. A given price increase is then in comparison perceived to be relatively small and does not have much impact on demand (see Blattberg and Broderick 1991).
5　*High demand by business*　Special exhibitions offer many opportunities to make money (see, for example, Feldstein 1991). They not only extend to the tourist industry but also to catering firms and publishers.

There are also various special determinants on the *supply side* of special exhibitions:

1　*Low production cost*　The absolute cost of many special exhibitions is certainly high, but it is low *compared* to the sum that would be required if all the resource inputs used were attributed to them. Important resources are taken from the permanent venues and only additional costs are covered by the special artistic events. Museum employees may be used to organize and run special exhibitions, but the corresponding cost is not attributed to the special events. Some cost factors, though substantial, normally only appear in disguised form. The museum rooms, where the special exhibitions take place, do not enter the costs accounted for as the opportunities forgone are not part of the book-keeping.
2　*Evading government and trade union regulations*　Special events allow cultural institutions more freedom to act outside restrictions imposed by the government and trade unions. Special exhibitions provide a good opportunity for directors to appropriate at least part of the extra revenue generated and therefore keep some discretion over these funds. Moreover, special exhibitions make it possible to

evade at least some employment restrictions, especially as most of those employed on them are only part-time and temporary, are not union members, and are therefore not legally bound by trade union regulations.

3 *More sponsorship* Politicians and public officials have an interest in special exhibitions. They are not only seen to be responding to the respective demands of the arts world and the local business community, but they also have an excellent opportunity to appear in the media as "patrons of the arts" (at taxpayers' expense). Business is also more prepared to sponsor special exhibitions than regular activities, where legal provisions often hinder sponsorship. The most important reason is certainly the higher media attention for these events and their particular contribution, but also that an individual firm has more control over the funds contributed.

As special exhibitions become the rule rather than the exception, there is pressure to have them carry the whole cost, and to subject them to the same government and trade union regulations as other museum activities. Even if the rapid rise in special exhibitions cannot be expected to persist, they have had a strong and lasting impact on the museum world. Although special exhibitions are financially attractive in the sense that they generate considerable additional revenue via entrance fees, there is still no study calculating the rate of return of special exhibitions. It is known in general that special exhibitions not only require much in the way of additional human and material resources, but are also costly in terms of transport and insurance. Special exhibitions may not be the financial salvage of museums, if costs are attributed correctly, but museum directors may like such an event due to the attention received from the art world and the media recognition gained (Meier and Frey 2003: 9–10).

Commercial activities

Beside the core activities of the museum which are directly related to the works exhibited or stored, and for which some of them charge an entrance fee, most museums also engage in ancillary activities. The revenue from these activities can make a large contribution to operational expenses (see, for instance, Anheier and Toepler 1998; Heilbrun and Gray 2001: 211). Museums operate museum shops, restaurants and cafés, sell catalogues, make money with parking lots, organize cultural journeys, and so on. The first museum shop was established by the Metropolitan Museum of Art in New York in 1908 (Weisbrod 1988: 109), and remained for a long time an exception rather than the rule. Today, a lot of American museums not only operate their own shops, but even run off-site stores in the city in which the museum is located or even in a totally different city, as does the Metropolitan Museum of Art.

Is the museum world increasingly commercialized? The empirical evidence is ambiguous: Heilbrun and Gray state, for the United States, that "Earned income accounted for only 16.1 percent of the total in 1993 but rose to 25.9 percent in 1997" (2001: 210). In contrast, Anheier and Toepler (1998: 240) conclude from their more

in-depth study of the USA that "art museums have not become significantly more commercial in recent years." Much more research is needed to gain firmer knowledge.

Competition between Museums

Beside the ownership structure (public vs private), competition is the most crucial setting for increasing the efficiency of museums. Does competition really lead to a better service for the consumers and more efficient supply or will the competitive situation just lead to more benefits for the politicians in charge? In the following, we focus on three dimensions in which competition can take place: (a) competition for visitors; (b) competition for public subsidies; and (c) competition for donations.

Competition for visitors and prestige

In recent years, the number of museums has increased worldwide. For example, in the case of art museums in Switzerland, more than 45 percent were founded in the past fifteen years. In the United States, the number of museums increased by more than 13 percent in only five years (1987–92; NEA 1998: 3). Not only did the number of museums increase but more museums became accessible to people due to reduced travel costs, so shifting the frame of reference for visitors as well as for museum administrators.

While museum directorates have always been aware of tacit competition with other institutions, there is now more open competition over a much broader area for visitors, commercial activities, and sponsors. In the extreme case, this may lead to a "superstar" effect on museums (see Frey 2003). Some art museums, in particular, have reached the status of *superstars* and have become household names for hundreds of millions of people. Such museums are mostly associated with major tourist cities which, in turn, owe part of their prominence to the superstar museums (see also chapters 23 and 31).

Superstar museums are able to exploit the economies of scale in reaching out to a large number of people. They are not only featured in newspapers, on radio and TV, but can raise enough money to produce their own videos and virtual museums. These costs are essentially independent of the number of consumers and therefore favor the major museums because the set-up costs are normally too large for smaller institutions. While the latter will certainly catch up (a homepage will soon be a matter of course for all museums), major museums will have the funds to improve their scope and quality so as to keep their lead. Superstar museums have also started to establish museum networks by trading on their brand name.

Superstar museums find themselves in a new competitive situation. Their reference point shifts from other museums in the city or region to *other* superstar museums. This competition between the superstars extends over a broad area, including commercial activities and sponsors. They must also make great efforts to maintain their status. Frantic activities are therefore often undertaken: special exhibitions are organized in the hope that they turn out to be blockbusters, visitors' amenities are improved (for example, a larger variety and fancier restaurants), and

410

new buildings with stunning architectural designs are added (as in the case of New York's Museum of Modern Art). The superstar status tends to transform museums into providers of *total experience*, a new role that stands in stark contrast to the traditional notion of museums as preservers of the past.

However, this competition is only effective if the directorate has the incentive to change its behavior in response to the tougher competition. In recent years, such institutional factors have changed, which may explain the changing behavior of public museums. In particular, the degree of state support and the extent of bureaucratic control have decreased for museums. This, of course, changes the incentives for the museum's directorate dramatically: suddenly, the administrators are interested in earning more money by attracting more visitors and raising additional money through sponsorship or shops.

Competition for public subsidies

Museums and all other cultural organizations compete for public subsidies. Such competition can lead to biased incentives to supply museum services. The incentive to provide services for few cultural "freaks" increases as the cultural bureaucracy is presumably most staffed with lovers of the arts. The incentive to increase the revenues by providing amenities to visitors is low. This application of non-commercial standards helps the museum directors to achieve their goal of receiving enough public grants. Maddison (2002: 1) shows that "[s]tatistically analyzing data drawn from a panel of UK museums, evidence is found that increases in non-grant incomes do indeed result in a statistically significant reduction in future government subsidies."

In the competition for public money, political connections are crucially important. Public grants will therefore be distributed to traditional organizations which already have a close relationship to the cultural bureaucracy. Innovative and new organizations have fewer opportunities to receive public grants.

There are, however, other possibilities to distribute public grants to the arts and museums in particular. One alternative is a *cultural voucher system* in which every citizen receives cultural vouchers which they can use in cultural organizations of choice. Competition for these cultural vouchers, for which the cultural organization receives public money, will lead to a change in the supply of museum services. The museum directorate has to supply services satisfying the wishes of those who demand and finance it.

Direct democracy constitutes a second alternative to distribute public money. In such a system, people may directly decide on the amount given to the arts and on who will receive the money. As discussed in Frey (2003: ch. 8), direct democratic rules (in Switzerland) do not lead to decreased public assistance for the arts but, in the case of Switzerland, to the contrary. The opportunity for citizens to directly decide on arts subsidies provides an incentive for museums managers to supply those cultural services, which will be supported by the citizens. Moreover, pre-referenda discussion induced, increases public interest in the arts. A third alternative to distribute public grants to museums is to *subsidize donations* to museums, as via tax reductions which are typical in the United States.

411

Bruno S. Frey and Stephan Meier

Competition for donations

Tax rebates to private individuals and firms in return for contributions and gifts to non-profit institutions actively expand the range of possibilities open to suppliers of art and culture (Schuster 1999). In the United States, individuals may deduct up to 50 percent of gross income, firms up to 10 percent of taxable earnings. When the marginal tax rate falls, the financial advantage of donating decreases. The resulting support for the arts is hard to measure, but is known to be significant. Museums therefore often spend considerable sums on fund-raising. Steinberg (1986) estimated that for the arts a marginal dollar spent on fund-raising would bring in an additional $2.07.

The competition for donations and the resulting dependence on this financial source influences the behavior of the museum directorate in two further important dimensions. First, with this type of support through "uncollected" taxes, also called "tax expenditure," the recipient has little incentive to raise profits and therefore to pursue a differentiated price policy. To receive donations, museums have to be seen as needy. But that does not necessarily mean that "potential" surpluses are made to disappear in the form of costs being pushed up, for the recipient has to show (potential) givers that the gift will be used "efficiently," that is, that "outstanding" museum purchases will be made and "exceptional" exhibitions put on. Obviously, this type of art support may be associated with conditions that lead to restrictions on the decision-making power of the directors of cultural institutions.

Secondly, donors can exercise some measure of control over the activities of museums, as discussed in Glaeser (2003). They can either interfere in the programming or they can contract legally binding limitations on the collections they donate. The limitations on the collections may greatly affect museum management. Most donors want to highlight their own visions. While curators normally win the battle over display, donors strongly restrict – and mostly prevent – the selling of donated items. Museums dependent on donations are therefore rarely able to manage their collections on the market, which imposes considerable opportunity costs on museums. As the donations are partly financed by the public via their tax expenditures, the restrictions imposed by the donors on the museums are a relevant concern for the public.

Conclusions

This chapter has analyzed the behavior of museums from an economic point of view in which the primary decision-makers in a museum are assumed to behave at least partially in a self-interested way. The institutional setting (for example, whether a museum is privately or publicly funded) constitutes the most important framework that shapes behavioral incentives for the museum directors. Four important activities have been analyzed from this institutional perspective: the management of the collection, pricing, special exhibitions, and ancillary activities. Directors of private museums have more of an incentive to attract large crowds and to generate additional income from ancillary services compared to the directorate of public museums.

412

In public museums, the directorate is often not able to use additional revenue generated and may even fear that subsidies will be reduced accordingly.

However, in recent years, differences between "purely private" and "purely public" museums have been disappearing as public museums gain more autonomy, public subsidies decrease, and private museums are faced with many public restrictions. More research is needed to understand how these new developments in the museum world influence the behavior of the museum directorate.

Bibliography

Anheier, H. K. and Toepler, S. (1998) Commerce and the muse: are art museums becoming commercial? In B. A. Weisbrod (ed.), *To Profit or Not to Profit: The Commercial Transformation of the Nonprofit Sector*, pp. 233–48. Cambridge: Cambridge University Press.

Becker, G. S. (1976) *The Economic Approach to Human Behavior*. Chicago: Chicago University Press.

Benhamou, F. (2000) *L'économie de la culture*. Paris: La Découverte and Syros.

Blattberg, R. C. and Broderick, C. J. (1991) Marketing of art museums. In M. Feldstein (ed.), *The Economics of Art Museums*, pp. 327–46. Chicago: University of Chicago Press.

Blaug, M. (2001) Where are we now on cultural economics? *Journal of Economic Surveys*, 15 (2): 123–43.

Clark, D. E. and Kahn, J. R. (1988) The social benefits of urban cultural amenities. *Journal of Regional Science*, 28: 363–77.

DiMaggio, P. (ed.) (1986) *Nonprofit Enterprise in the Arts*. Oxford: Oxford University Press.

The Economist (2001) Hangings in the Wild West. *The Economist*, August 4.

*Feldstein, M. (ed.) (1991) *The Economics of Art Museums*. Chicago: University of Chicago Press.

Foster, A. W. and Blau, J. R. (eds) (1989) *Art and Society: Readings in the Sociology of the Arts*. Albany, NY: State University of New York Press.

Frey, B. S. (1999) *Economics as a Science of Human Behaviour*. Dordrecht: Kluwer.

*— (2003) *Arts and Economics: Analysis and Cultural Policy*. Berlin: Springer.

— and Pommerehne, W. W. (1989) *Muses and Markets: Explorations in the Economics of the Arts*. Oxford: Blackwell.

Glaeser, E. L. (2003) *The Governance of Not-for-profit Organizations*. Chicago: University of Chicago Press.

Hansmann, H. B. (1981) Nonprofit enterprise in the performing arts. *Bell Journal of Economics*, 12 (2): 341–61.

Heilbrun, J. and Gray, C. M. (2001) *The Economics of Art and Culture*. Cambridge: Cambridge University Press.

Luksetich, W. A. and Partridge, M. D. (1997) Demand functions for museum services. *Applied Economics*, 29: 1553–9.

Maddison, D. (2002) Causality and museum subsidies. *Working Paper Series*, University of Southern Denmark.

— and Foster, T. (2003) Valuing congestion costs in the British Museum. *Oxford Economic Papers*, 55: 173–90.

Martin, F. (1994) Determining the size of museum subsidies. *Journal of Cultural Economics*, 18: 255–70.

*Meier, S. and Frey, B. S. (2003) Private faces in public places: the case of a private art museum in Europe. *Cultural Economics*, 3(3): 1–16.

NEA (National Endowment for the Arts) (1998) Museums, arboreta, botanical gardens and zoos report 18% growth, 1987–1992. Washington, DC: NEA.

— (2000) International data on government spending on the arts. NEA Research Division Note, no. 64. Washington, DC: NEA.

O'Hagan, J. W. (1995) National museums: to charge or not to charge? *Journal of Cultural Economics*, 19: 33–47.

— (1998) *The State and the Arts: An Analysis of Key Economic Policy Issues in Europe and the United States*. Cheltenham: Edward Elgar.

O'Hare, M. and Feld, A. L. (1975) Is museum speculation in art immoral, illegal and insufficiently fattening? *Museums News*, 53: 25–31.

Schuster, J. M. (1998) Neither public nor private: the hybridization of museums. *Journal of Cultural Economics*, 22: 127–50.

— (1999) The other side of the subsidized muse: indirect aid revisited. *Journal of Cultural Economics*, 23: 51–70.

Steinberg, R. (1986) The revealed objective functions of nonprofit firms. *The RAND Journal of Economics*, 17(4): 508–26.

Steiner, F. (1997) Optimal pricing of museum admission. *Journal of Cultural Economics*, 21: 307–33.

Throsby, D. C. (1994) The production and consumption of the arts: a view of cultural economics. *Journal of Economic Literature*, 33: 1–29.

*— (2001) *Economics and Culture*. Cambridge: Cambridge University Press.

*Towse, R. (1997) *Cultural Economics: The Arts, the Heritage and the Media Industries*. Cheltenham: Edward Elgar.

Weil, S. E. (1987) Deaccession practices in American museums. *Museum News*, 65: 44–50.

Weisbrod, B. A. (1977) *The Voluntary Nonprofit Sector: An Economic Analysis*. Lexington, MA: D. C. Heath.

— (1988) *The Nonprofit Economy*. Cambridge, MA: Harvard University Press.

The Museum Profession

Patrick J. Boylan

Although a small number of the world's museums have existed for many hundreds of years, the great majority are very recent creations in historical terms. In most developing countries of Africa, Asia, the Caribbean, and the Pacific regions of the world there were few if any museums during their colonial periods. Even in more developed countries in numerical terms most museums have been created since the end of World War II and therefore are younger than the two world bodies with particular responsibility for them: the United Nations Educational, Scientific and Cultural Organisation (UNESCO) at the intergovernmental level and the International Council of Museums (ICOM) at the non-governmental and professional level.

This chapter looks at the growth and diversification of museum employment; and at some of the most significant issues facing museum workers today. It also addresses the increasing professionalization of museum employment, including the establishment of professional codes and organizations, and the expansion and nature of professional training.

Expansion of Museum Employment

The considerable increase in museum numbers over the past fifty years has been accompanied by a massive expansion in numbers of museum employees. For example, through much of the 1980s, an average of three new museums were opening every week in the United Kingdom, while at the same time the average number of professional staff employed by a typical well-established museum probably doubled. In an unscripted aside during the Museums Association's centenary year look into the future at its "Museums 2000" seminar in 1989, the then Director of the Science Museum, Neil Cossons, showed – at least half seriously – that if the then current rate of growth in UK museum numbers and staffing continued, by about 2050 over half of all British workers would by then be employed in museums, though each would have to rush around during their lunchtimes and rest days to visit about seven rival museums a day to achieve the mid-twenty-first century museum visitor numbers that were being forecast on the same basis!

There are no reliable worldwide estimates of the number of museum professionals, let alone the total number of employees, professional and non-professional, of the world's museums, and there can be massive variations between the staff numbers of apparently very similar museums in different countries, and indeed within the same country. For example, until the rapid succession of reforms in the laws governing French museums in the early 1990s even the forty or so most important provincial museums – those designated as *Musées Classés: 1ᵉ Classe* – were allowed only two professional staff, a *conservateur* and a *conservateur-ajoint* (curator and deputy), both employed and allocated by the national Ministry of Culture, while the remaining *Musées Classés* were entitled to just one state curator. Consequently, the capacity of the staff of such museums was very limited. There is a similar tradition amongst the provincial museums of Italy where even the very limited number of professional staff may not work completely full time, but may hold a university teaching post in their academic specialization or a position in the antiquities inspectorate as well.

In contrast with the museums of what might well be their twin cities in perhaps France or Italy, a major UK city museum of directly comparable size, collections, and importance would typically have at least fifteen professional staff and more than fifty in total, reflecting the much wider role of the museum's approved mission within its community and region. In practice, the French seem to have succeeded in at least partly overcoming these traditional restrictions on staffing by the creative, though simple, device of designating and administering each important collection as a separate museum with its own independent professional staff, even where these different "museums" may well amount to no more than one or two galleries sharing a single museum building.

Also, it should be said that, after many years of expressions of concern, not least from the mayors and other authorities of the cities who actually own these major regional museums, the French restriction on professional staff numbers has now been lifted, and appropriate training and qualification structures are being established to provide the professional staff needed as the cities begin to employ additional professional staff over and above that national quota established almost a century and a half ago.

Estimating the number of museum workers is difficult since few countries have reliable national statistics specifically covering museum employment. An indication of the major global expansion in museum staff numbers, however, can seen in the explosive percentage growth in membership of the International Council of Museums (ICOM) over the past three decades: less than 1,000 full members in about 50 national committees in 1974 has now grown to around 18,000 in 140 countries.

The United States Department of Labor does have a national category covering "archivists, curators and museum technicians" with a national total of 21,030 employed (and a mean annual salary of $39,950) in 2003. In comparison, the same annual statistics record 162,800 librarians and library assistants. On the other hand, a mid-1990s' survey by the American Association of Museums (AAM) found that museums in the US were by then employing 92,000 full-time staff and a further 56,000 part-time staff, including those in non-professional and administrative positions. (However, these were substantially outnumbered by the more than a quarter

of a million regular volunteers.) Two other highly significant findings of the study were that over the previous quarter of a century the membership of the AAM had increased by over 400 percent, but that less than 40 of the 10,000 AAM members of the time (0.4 percent) had more than twenty-five years' membership in the Association.

The most recent attempt to estimate museum employment numbers in the UK is the 1999 analysis of data from the country's approximately 1,300 "registered" museums as part of the government-funded DOMUS (Digest of Museum Statistics) initiative (Carter et al. 1999). This identified 15,365 FTE (full-time equivalent) paid staff across the UK's registered museums: 12,590 in "permanent" positions, 2,275 on temporary contracts, and 744 being self-employed freelance specialists. However, the paid staff were substantially outnumbered by an estimated 25,205 FTE unpaid volunteers. In terms of museum ownership and governance, most of the paid staff were employed by three categories of museum: national museums and galleries (6,065), local authority (4,799) and independent trust museums (3,307).

The very high level of volunteer staffing of UK museums (an average of 17 volunteers per registered museum, compared with just 11 full-time and 4 part-time paid staff) is markedly different from the situation in the majority of major countries of the world other than the US and Canada. In line with their respective labor markets more generally in recent years, museums in these three countries have moved toward far higher levels of consultant and temporary or short-term contract staffing than was the case just a few years ago. This is also in marked contrast with museums and related bodies in continental Europe and in most other regions of the world, which still tend to have a largely paid workforce, typically part of the regular and permanent staffing of central, regional, or local government.

Changes in Roles

The growth in museum employment is not only due to the creation of new museums, but also includes the increasing complexity and specialization of museum work internally in relation to the traditional curatorial and collections management duties of collection, conservation, exhibition, and research. There has been a rapid expansion of the museum's role into new important areas of responsibility, particularly the increasing recognition that museums must accept a far wider educational and social role within their society and community. The International Council of Museums (ICOM) definition of a museum, incorporated in the 1974 *Statutes of ICOM*, stressed that far from being just a building containing a collection and receiving visitors, a museum must be seen as "a permanent non-profit institution, in the service of society *and its development*" (emphasis added).

This much wider role is seen in the rapid expansion in many parts of the world, from major Western cities to the museums of the major conurbations of the developing world, such as Mumbai (formerly Bombay), Mexico City, or Rio de Janeiro, of educational programs, activities aimed at reaching out to, and involving, traditionally separated or disadvantaged groups, including racial minorities, immigrant or displaced rural populations, people with disabilities, and those living in the many

"inner-city" areas that suffer great social and economic problems. The "ecomuseum" movement, launched in France in 1971, similarly aimed to take on an explicit community development and empowerment role within smaller, generally more rural, communities.

At the same time, in a growing number of countries, governments are currently seeking to de-couple cultural sector (and, indeed, many other traditional public sector) institutions and services from direct government management and civil service conditions of employment, including pay and benefits. For example, following its constitutional change of March 2003, declaring the country to be a "democratic *decentralised* Republic" (emphasis added), France is aiming to transfer an estimated two million government service employees, including, for example, a large part of the state historic buildings and archaeology service in one of the earliest phases, to regional or local bodies and conditions of employment or to fully privatized organizations.

Diversification of Museum Work

Traditionally, museum employees could be separated into two very distinct groups. On the one hand, there were what I have termed "scholar-curators" (see, for example, Boylan 2002), who emerged in the eighteenth and nineteenth centuries when the wealthy collector or learned society for gentlemen began to hire paid labor to assist with the care and maintenance of their museums and collections and their wider scientific work. These employee curators modeled their work very much on the activities (and probably the narrow, object-centered, attitudes as well) of the traditional connoisseur private collector or a specialist academic researcher in their chosen academic discipline, whether this be art history, archaeology, ethnography, geology, or whatever. In the past (and in some traditions even today) these scholar-curators (or museologists in the traditional sense) typically made up the whole of the museum's professional staffing. In such cases, the director also viewed himself or herself primarily as still a scholar-curator, probably viewing his/her role as that of chief curator rather than the chief executive or manager. Any time spent on essential supervision of the administrative policies and operations of the institution, and for liaison with the museum's political masters or other key funders, was seen as at best an irritation, at worst as an unwelcome sacrifice of valuable academic time.

In such systems, scholar-curators undertook almost all of the museum's specialized work: acquiring collections, specimens, and works of art, researching, cataloguing, and documenting their collections, and interpreting and communicating their significance through the museum's permanent display galleries, temporary exhibitions, publications, and educational programs such as lectures and guided visits. The "generalist" scholar-curators (usually very small in number) were in turn supported by a single category of non-professional support staff, lowly regarded manual workers mainly undertaking security, cleaning, and building maintenance duties, plus a small number of office staff to provide secretarial assistance.

There are still museums dominated by the "scholar-curator" model, where the museum directorship is a short-term (perhaps three to five years maximum),

appointed or even elected, temporary promotion, with the main duties being primarily administrative – someone to sign the accounts, documents, and liaise with the governing and funding bodies – rather than those of longer-term leadership and strategic management of the museum. Typically, under such policies the directorship is modeled on that of the elected head or chairperson of a university department. At the end of the prescribed period, the director returns – no doubt with great relief – to his or her first love: academic or curatorial research among the collections. Equally, senior or even middle-level staff out of sympathy with the ideas and plans of the director, could simply sit back, procrastinate, and wait for the end of the current troublesome director's term of office.

In 1992, I carried out an extensive survey of the staff structures and job titles in a hundred museums of many kinds and sizes across the five continents, as recorded in the staff lists included in recent annual reports of the museums concerned deposited in the UNESCO/ICOM Information Centre in Paris (Boylan 1993). This showed that in many parts of the world, museums and their professional staffs continue to be locked into what many now regard as an outdated nineteenth-century vision of museums with a relatively narrow range of staff, mainly consisting of such "scholar–curators" at the professional level. In contrast with this, however, apparently very similar museums in different countries and traditions had not only a far larger staff in terms of numbers, but also a much more diversified staff in terms of professional and technical specializations, reflecting their contemporary vision of museums as active, often very complex, organizations "in the service of society and its development," as the ICOM definition of a museum describes it.

The history of ICOM itself documents at least in part the increasing diversification and division of labor within the museum world. The first full ICOM general conference, held in Paris in 1948, called for the proper recognition and training of the museum's technical staff, using the then current title of "museographers" to cover a wide range of support staff, including collection care and exhibition technicians. The following general conference, in London in 1950, recognized "restorers" as a distinct museological profession, and initiated a survey of these, including the availability or otherwise of professional training, qualifications, salaries, time allowed for scientific work, and other conditions of work, including pension arrangements. The next general conference, in Milan in 1953, recognized the need for museums to employ education specialists with recognized teaching qualifications, and set up an International Committee for Museum Education.

The New York general conference of 1965 was perhaps the most important and influential in the early years of ICOM, recognizing as valid and important parts of the museum profession a diverse range of at least eleven categories of professional museum work: "museum curators, scientific laboratory personnel, restorers of works of art, conservation technicians, qualified persons . . . recruited from the teaching profession" in charge of educational and cultural activities, a wide range of technical personnel including specialists in "audio-visual techniques, [exhibit] installation and presentation, lighting, climate conditioning, security, library techniques and documentation etc." The New York conference also recognized the need for a parallel system of special training for the personnel of small museums where necessarily one or two people have to undertake a very wide range of specialist tasks.

Possibly the first comprehensive attempt to define the range of specialized museum jobs was the study prepared in 1978 for the Canadian Museums Association, which identified and defined twenty-four distinct professional and non-professional museum employment positions in Canadian museums, with indications of the qualifications, training and other requirements, and the main responsibilities and job activities of each (Teather 1978). This trend toward increased diversity and specialization continues. A museum careers guidebook produced in 1996 in the Smithsonian Institution's Office of Museum Programs detailed no less than sixty distinctive museum jobs identified and analyzed in a study of museums in the United States (Glaser and Zenetou 1996).

Another important trend in a growing number of countries is the increasing importance of management within the museum sector. Where there is significant decentralization of responsibility for a museum's personnel, buildings, and finance from a government ministry or other public body to the institution itself, this has to be accompanied by the employment of a wide range of professional specialists, such as human resources or personnel managers, architects, building surveyors and engineers, security managers, and accountancy, audit and other financial specialists. Also, with the increasing demand for museums and similar bodies to generate an ever-increasing proportion of their budgets through fund-raising and commercial activities, there is a corresponding need for specialists in marketing, public relations, membership, and retailing. At the same time, the job content and skill requirements of many of the staff in what have traditionally been regarded as largely or wholly museological positions (such as curators, conservators, registrars, and education and exhibits staff) now need to be greatly expanded to cover a wide range of what used to be regarded as purely administrative or management skills. In the growing number of countries and systems where this new, more managerial, museum culture has emerged, most if not all graduate-level staff, together with at least the more senior levels of museum technician, will find themselves managing projects, budgets, other staff, information, and, not least, managing themselves under delegated responsibility for different parts of their work.

Challenges of Change

Paradoxically, it was a large body of traditionally trained professionals of my generation – those joining the profession in the 1950s and 1960s – who were the main driving force behind the new, far wider, vision of museums and their potential. However, this rapid diversification of the nature of museum employment, particularly at the professional level, has often been very challenging and unsettling to many of the same generation (indeed, arguably to whole countries in some cases) who came into museums through that long-established tradition of the museum professional as essentially consisting of those generalist "scholar-curators" or "museologists." The best current estimate is that while professional jobs within UK museums have more than doubled in the past quarter of a century, the total number of curators has hardly increased at all (and appear to have fallen greatly in some traditional areas, such as natural history curatorship). In other words, virtually all this doubling of the

professional jobs within UK museums has been in areas other than curatorship, particularly in conservation, education, design and exhibition work, and in the rapidly growing areas of managerial, financial, and administrative support, such as marketing and fund-raising. Numbers of curators, in the traditional sense, have therefore fallen over the past twenty-five to thirty years from around 30 percent of the UK national museum workforce to under 12 percent as a consequence of the growth of these newer sectors of the museum profession within the nation's museums.

Traditional curators are inevitably feeling very much under threat in the face of such drastic changes. Similar patterns and reactions can be seen in many other countries and museum traditions. Moreover, museum professional training is also failing to keep up with these major changes, since the great majority of advanced museum training courses are still focused almost exclusively on education in the two areas of curatorship and conservation in the traditional sense (and then very largely on initial postgraduate but pre-employment formation and qualification). It is important to stress that the ICOM definition of "professional museum worker" is a very wide one, and covers all professional, technical, and managerial employees of both traditional and non-traditional museums and heritage services, as well as the staff of a wide range of related bodies, including not-for-profit contemporary art galleries and science centers without permanent collections, conservation and professional training institutions, museum-related government and professional agencies and associations, natural and cultural sites, monuments and parks and cultural centers recording and promoting the intangible cultural heritage.

A Changing Profession

Until very recently, the great majority of museum jobs in the world were permanent positions within some form of government or local government service and conditions of employment. Indeed, this pattern was so widespread that in the early days of the "independent" museum sector, which has emerged in recent years in some countries, particularly the UK, the terms and conditions of employment, and often even the salary scales and pension arrangements, adopted by this newly emerging sector were taken directly from the established public-sector collective agreements. However, the rapid moves toward privatization and decentralization now occurring in many countries are breaking down these traditional structures. For example, in the UK, national museum staff were all moved from central government civil service employment conditions to direct contracts with their individual museums from the mid-1980s onward, while similar moves are being made in many of the newly emerging democracies of Central and Eastern Europe as well as in other Western countries.

The most common popular image of a museum is still the large-scale, public institution, probably housed in a monumental-scale building in a major city – the traditional, national and civic museums of the European model. However, the massive expansion in the number and range of museums that has taken place in recent decades has been very different from this pattern. Often the new museums have developed new types of governance and – not least – new kinds of staff structures,

very different from those of more traditional museums. Many are the responsibility of non-profit foundations and similar organizations, and operate without the permanent support and guarantees of governments or other public authorities.

Consequently, for both financial and legal reasons, this new generation of museums may not be able to offer the kind of lifelong, guaranteed, professional employment traditionally expected by the professional staff of public museums. Also, as many of these new types of museum are relatively small and have few staff, they are frequently unable to meet all their specialized professional and technical needs through their permanent staff. They consequently depend to a greater or lesser extent on temporary, part-time, and private-sector specialists to fill gaps in their staffing, especially in most areas of conservation, exhibition design and production, and increasingly in curatorship, documentation, and research as well.

Within the United States, in particular, for many years there has been a great deal of flexibility in the staffing of museums, with many specialists being engaged by the museum on a short-term contract basis or as self-employed professional museum workers or "consultants" to undertake a specific museological or research job. Major changes are also taking place in some countries in relation to employment in even the largest traditional public museums, with legal and administrative moves toward both full privatization and the halfway position of the widespread contracting out of professional and technical services, including staffing, already in progress in some European countries. For example, in The Netherlands some major national museums have already been transferred to management by private foundations, albeit with a strong government involvement. In the UK, for ten years each national museum and gallery had to report annually to the government on the steps they had taken toward the contracting out to private-sector services of an official list of over twenty different museum activities, which include all four key museum professional functions of curatorship and documentation, conservation, research, and exhibition work. Although this requirement and the compulsory competitive tendering across local government services were dropped following the change of government in 1997, public-sector museums remain under considerable pressure to demonstrate that they are achieving "best value" in comparison with private provision or contracting out across all their activities.

The indications are that over the past fifteen years or so more than two-thirds of the total British central government expenditure and a similar proportion of the civil service have been moved out of the traditional public service. Though museums have not yet been affected as much as many other government services, if present policies continue, museums also will very soon see a major shift from permanent staffing to temporary staffing and to the transfer of key services to the private sector and consultants.

Similarly, there was a rapid trend through the 1990s toward what is termed a "contracting culture" amongst many British local authorities. Typically in such cases, perhaps as few as 5 percent of the present employees of each traditional service are being retained as core staff of the authority as "purchasing officers," buying services either from semi-independent internal profit-seeking "businesses" or from the private sector. In such cases, the remaining 95 percent or so of the employees of the service are all transferred to the new service-providing "businesses" or even com-

pletely to the private sector, even though they may then continue to undertake exactly the same kind of curatorial, conservation, exhibition, education, or other professional or technical work within the same museum or other public service of the authority as they did when they were museum employees.

Further, it is clear that very much the same principles of actual privatization or quasi-privatization and major transfers of public employees to the private sector are being proposed elsewhere in the world. For example, these principles are being actively promoted by a considerable number of international advisory and aid agencies (including Western governments and the World Bank) currently working in countries undergoing major political change (for example, the former Socialist states of Central and Eastern Europe and the former Soviet Asia, and, indeed, in countries in many other parts of the world). These trends are likely to spread rapidly to many other areas of the world as at least strong recommendations, and perhaps even conditions, for international development and economic reconstruction aid.

With more than a third of the countries of the world now receiving such international advice and aid, the trend toward the privatization of museum employment at least, and perhaps of the museums themselves, seems certain to accelerate. Indeed, on the basis of current trends, it is reasonable to predict that within the foreseeable future directly employed professional workers may become a minority within bodies such as ICOM, as they are already in some sister UNESCO non-governmental organizations, such as the International Council on Monuments and Sites (ICOMOS) and in parts of the conservator/restorer profession.

Consequently, over recent years, the ICOM definition of "professional museum worker" has broadened markedly, particularly with the recognition in 1995 that in many countries traditional direct employment, typically by a public service employer for life, is being replaced by much more flexible and less secure systems, including the extensive use of short-term and freelance contracts, and even fully privatized services, especially in specialist support services such as conservation and restoration, exhibit design and production, photography, and buildings, including security work. ICOM therefore now defines the term "professional museum worker" to include:

> all the personnel of museums or institutions qualifying as museums in accordance with the definition in Article 2, para. 1, having received specialized training, or possessing equivalent practical experience, in any field relevant to the management and operations of a museum, and independent persons respecting the *ICOM Code of Professional Ethics* and working for museums as defined above, either in a professional or advisory capacity, but not promoting or dealing with any commercial products and equipment required for museums and services. (ICOM Statutes, Article 2.2)

ICOM's official guidance on interpreting the phrase "having received specialized training, or possessing equivalent practical experience" is that national committees should recognize all persons who have successfully completed a first degree or diploma relevant to some aspect of museum employment in a university or other post-secondary education technical institute or college. However, particularly in the case of older museum workers, who may have entered the profession before such

specialized education or training was available, ICOM continues to admit those exercising professional responsibilities in a museum who have gained through practical experience a level of knowledge and professional competence at least equivalent to that of a university or college graduate.

Professional Education and Training

Over many decades, centuries even, there have been intense arguments and debates about what exactly it is that turns a group of employees or practitioners within a certain area of work into a "profession," and there are a bewildering number of definitions of the word. However, as with the definition above, most of these make it clear that in order to earn the right of professional status the work must involve a specialized range of skills requiring both advanced training and working experience, coupled with a general acceptance of high ethical standards in relation to the area of work (see chapter 26).

In the museum field, the need for some form of specialized training in curatorship and other key museum activities has been recognized for very many years. The École du Louvre in Paris has offered museum-related academic and professional training since the 1870s, while degree courses in museology have been offered in Buenos Aires, Argentina, since the late 1920s and at the University of Rio de Janeiro, since 1933. In the UK, the Royal Commission which studied the problems of the national museums and galleries between 1927 and 1930 recognized the need for formal training for new curators. The Museums Association very quickly took up the challenge in 1930 with the establishment of its Museums Diploma training, organized and taught and examined on a voluntary basis in leading national and local museums by more experienced members of the Association, and the first one-week training course was held in London in 1930 and continued with some modifications and developments in structure and syllabus until 1980, when the Association contracted out the formal teaching of the Diploma to Leicester University's Department of Museum Studies. The Association nowadays recognizes a greater number and wider range of courses, but retains control over admission to the Associateship of the Association which grew out of the original Museums Diploma.

Between 1984 and 1986, I chaired the small international working group charged by the Executive Council of the International Council of Museums (ICOM) to prepare an International Code of Professional Ethics for museum workers. Our study, which led to the final text adopted in 1986, was basically a rather conservative exercise: we sought the common ground and shared factors in almost a hundred existing approved codes and statements of museum ethics of national and international organizations and of individual museums. To achieve this, at an early stage I prepared for our working group a structured concordance between approximately forty examples of current ethical policies and statements from very different sources around the world, ranging from those of individual museums to national guidelines and codes. Out of these models and comparisons, at the beginning of 1985, we prepared the first draft of an ICOM Code, which we then took forward into a world-

wide consultation exercise, which attracted a welcome and unprecedented response from the profession around the world.

It was most interesting that only two completely new themes, not found in any of the existing ethical codes analyzed, had to be added to the text as finally approved at ICOM's 1986 Buenos Aires general conference as a result of this feedback. The first of these was on the community role of the museum, and we therefore added a subclause to the Institutional Ethics part of the Code insisting that the museum has an ethical obligation to attract new and wider audiences and should offer opportunities for community and individual involvement in the museum. The other new factor added to both the Institutional Ethics and Professional Ethics parts of the Code was their respective ethical obligations toward training. In its latest (2001) update, the Professional Conduct part of the Code details the obligation in respect of professional cooperation and training as follows:

> Members of the museum profession have an obligation to share their knowledge and experience with their colleagues and with scholars and students in relevant fields. They should respect and acknowledge those from whom they have learned and should pass on such advancements in techniques and experience that may be of benefit to others without thought of personal gain.
>
> The training of personnel in the specialised activities involved in museum work is of great importance in the development of the profession and all should accept responsibility, where appropriate, in the training of colleagues. Members of the profession who have responsibility for junior staff, trainees, students and assistants undertaking formal or informal professional training, should give these persons the benefit of their experience and knowledge, and should also treat them with the consideration and respect customary among members of the profession. (ICOM Code of Ethics for Museums, para. 8.2)

However, the development and promotion of training for museum work had been recognized as a key obligation of the profession and its supporting organizations long before this. Immediately after the end of World War II training was seen to have a central role in the improvement of museums and museum standards, and was adopted as one of the key priorities of both the then newly established UNESCO and ICOM when each was formally inaugurated in Paris in successive months in October and November 1946. Indeed, the young Brazilian delegate to the inaugural intergovernmental meeting of UNESCO, Mario Barrato, was a graduate of the University of Rio de Janeiro museology course (and later returned to serve as a very distinguished head of the course). At the formal inauguration of UNESCO, with its First General Conference at the University of Paris, Sorbonne on November 20, 1946, he argued strongly for UNESCO to take the initiative in promoting the development of museums and of professional standards and training for museum work. Less than two months later, in January 1947, museum training formed one of the central planks of UNESCO's founding contract with ICOM. Thus, the issue of the training of museum personnel at all levels (including what were at that time, worldwide, the rare specialties of museum education and public relations services) was enshrined in the basic charter setting out ICOM's role, with particular reference to the objectives of UNESCO.

425

Patrick J. Boylan

In 1955, the Seventh General Conference of ICOM held in New York devoted a considerable amount of time to a wide range of issues relating to museum training, and at the end of the conference the General Assembly adopted four key resolutions relating to training which, again, are just as relevant today as they were half a century ago:

> It is vital that museum personnel of all categories should have a status corresponding to that of the academic profession, since the required qualifications and responsibilities are similar. With equal qualifications and years of service, a member of the staff of a museum should have the same status and salary as professionals in the teaching world or other learned institutions.
>
> A candidate for the post of museum curator should possess a university degree. Exceptions may be made for candidates of unusual merit.
>
> Curators for all types of museums should receive a postgraduate training in a university or technical school covering museology in general. This training should include both the theory and practice. Training may be undertaken by museums in the form of internships. This may include such subjects as field research, scientific examination of works of art, and technical studies pertaining to candidate's own speciality. These postgraduate studies should receive the sanction of a diploma.
>
> Curators and other trained museum personnel should be provided with the necessary facilities and time to carry on research and scientific work independent of their regular museum duties. They should also have opportunities to increase their knowledge through study in other museums in their country and abroad, and to participate in seminars and conferences at home and abroad.

Looking back over the history of ICOM, it is clear that the 1965 General Conference marked a turning point in ICOM's involvement with museum training, and the following triennial period saw a great increase in both direct and indirect activity. Jean Chatelain, Director of the Museums of France and the then Chairman of the Committee for Administration and Personnel, announced in 1966 plans for the holding of three experimental training courses under the direct auspices of ICOM, as part of the study of training methods. Preparations were also made by ICOM for the bringing together of all the European experts working directly in the museum training field. This meeting was held in Brno, Czechoslovakia, in 1967, the thirteen participants being drawn from eight European countries. The objective of the meeting was to try to coordinate the work, under the leadership of ICOM, of the then very small number of permanent museum training centers in different parts of Europe, in the hope of coordinating their teaching programs, diplomas, and teaching methods, and, not least, to promote exchanges between the various European training centers of museum studies teachers, students, and training philosophy.

The most far-reaching decision of the meeting was to pool information through the ICOM Secretariat on their respective training programs and curricula with a view to the Secretariat preparing the first draft of what was variously described as a "common elementary programme" or "basic syllabus" which, after further discussion and development, might be adopted as a common basis for both the existing training courses and for any new museum staff training programs that might be proposed in the future. However, in addition, the meeting resolved:

426

(a) that museology should be recognised as a true discipline in its own right, and that

(b) it was necessary to place as much importance on the teaching of museology as on museography, and distinguish between the training for future heads of museums, who, it was felt, must receive a complete training, museological as well as museographical, in contrast with future museum technicians whose training could be strictly museographical in content.

It is fair to say that, whilst entirely well intentioned, the attempt in (b) above to distinguish at the point of entry to museum work between future "museologists," who it was assumed would progress to the most senior levels of the profession, and "museographers," who would remain at a strictly technical level (undertaking, for example, exhibition work or basic physical care of the collections), has been a source of considerable difficulty and at times tension in subsequent years. Despite the ever-increasing complexity of museum work, and the consequent blurring of what were, I believe, already artificial boundaries in 1967, the perceived dichotomy between the curator or museologist and all other categories of museum employee remains a source of difficulty today in many parts of the world.

The Eighth General Conference of ICOM in 1968, held in Cologne and Munich, West Germany, approved the creation of a new International Committee for the Training of Personnel (ICTOP), as a direct consequence of recommendations of the previous year's Brno meeting of European museum training centers. The 1968 General Assembly also adopted as part of ICOM's triennial program for 1969–71 ambitious plans, supported by UNESCO, for a series of regional museum training survey and teaching visits "entrusted to highly experienced persons in the museum field and in the teaching of museology." During the triennial period, four substantial missions were arranged: a Pacific–European survey by Frank H. Talbot, one to Latin America by Raymond Singleton, and two by members of ICOM staff: Georges-Henri Rivière to North Africa, and Yvonne Oddon to West Africa. Thanks in part to the support of the British Council, which also became actively concerned with museum training at that time, the Chairman, Raymond Singleton, also traveled extensively in other countries, including Australia, on behalf of ICOM. Work also began on a substantial hardback book, *Training of Museum Personnel/ La Formation du personnel des musées*, with twelve authors contributing to create a substantial review of the present state of museum training, and this was eventually published by ICOM with financial assistance from the Smithsonian Institution in 1970.

By this time, ICTOP had held its first major symposium on museology and museum training, hosted by its Chairman at Leicester University, England, in July 1969. During the symposium, there was much discussion of a wide range of issues, including the need for museology to be recognized by university and other authorities as a valid academic discipline, and for the establishment of an internationally recognized basic syllabus and standards for professional training qualifications. One important conclusion of the survey of existing university and professional training centers was that there was already a great deal of common ground on the question of the essential elements of the syllabus. The meeting adopted a total of ten resolutions which together have continued to be at the heart of the Training Committee's objectives and work program down to the present time. These included the view:

> That it is considered imperative that, in every country possessing a museology centre, the diplomas granted by these centres be officially recognised as, or equivalent to, university diplomas and that they give access to the profession at a certain level, providing that they guarantee studies of sufficient length and quality in all fields of museology.

By June 1971 the proposed draft basic syllabus was sufficiently developed for it to be discussed at a special meeting of the Training Committee in Marseilles, and after much discussion and some amendments mostly of a technical and detailed nature, the ICOM Common Basic Syllabus for Professional Museum Training was formally adopted during the 1971 Ninth General Conference of ICOM held in Paris and Grenoble during August and September 1971. The syllabus set out in some detail the minimum elements that needed to be included in any basic professional museum training course or program, whether a full-time university course or a less formal training program arranged by, for example, a local museum association or even an individual museum, the nine principal elements being:

1 Introduction to Museology: History and Purpose of Museums
2 Organisation, Operation and Management of Museums
3 Museum Architecture, Layout and Equipment
4 Collections: Origin, Related Records Set-up and Movement
5 Scientific Activities and Research
6 Preservation and Care of Collections
7 Presentation: Exhibitions
8 The Public (including public facilities)
9 Cultural and Educational Activities of Museums

The original Basic Syllabus greatly influenced the development of curatorial and museum management training and is used to a greater or lesser extent in a high proportion of the several hundred university and equivalent museum education and training centers and courses around the world. The text has been regularly reviewed and updated as necessary, the most recent version being that of 2000, now titled *ICOM Curricula Guidelines for Museum Professional Development* (ICOM 2000). The focus of this has moved from the original detailed list of what should be taught – the inputs – to a structure that identifies the desired outputs – the competences that professionals need to demonstrate, covering:

1 General Competences
2 Museology Competences
3 Management Competences
4 Public Programming Competences
5 Information & Collections Management and Care Competences (ICOM 2000)

In 1983, the Training Committee's annual meeting in Bergen broadened the debate, calling for each museum to analyze the responsibilities and training needs of all kinds of museum personnel, not just the traditional specialist professions such as curators, and to establish appropriate learning goals and training arrangements for each post. This was accompanied by a recommended outline induction training

scheme for all new entrants to museum work, regardless of their background or status in the museum's hierarchy. This focused on five questions which, it was argued, should be asked in the context of relevant elements of any basic museum training program:

1 *Museums* – why do we have them and what is their function in society? (Purpose, history, ethics and responsibilities, the national and international museum movement.)

2 *Collections* – how do we get them, how do we study them and care for them, and what do we do with them? (Acquisition and disposal, documentation, research, storage, conservation/restoration.)

3 *Museum organisation* – who does what in the museum and how do they do it? (Goals and objectives, long-term planning, legislation, management including governing authority and governance, funding and finance, staff, public relations.)

4 *The museum and its public services* – why do we provide them, how do we organise them, and how are they used? (Exhibition and display including planning, design, preventive conservation, interpretation, education and extension programmes, community relationships, visitor services – shops, catering etc., information services and publications, client groups – individual visitors, groups, school parties, special needs.)

5 *Physical facilities* – how do we provide maximum access to museum facilities while safeguarding the collections? (Maintenance, security, public access, preventive conservation.)

The Bergen symposium further stressed that the amount of training required in different elements of what might be termed a basic understanding of the museum and the individual's job within it would vary greatly from one category of employee to another. A financial expert, whose responsibilities included the audit of museum collections, would need a detailed training in both practical and ethical matters relating to the care and documentation of collections, with just a basic training in fire safety and physical security duties, while the balance of the training program for a museum security assistant or guide would be almost exactly the opposite in terms of the amount of training time allocated to these two key museum activities within a basic training program for non-curatorial personnel. The symposium concluded with specific recommendations on the training of museum security personnel.

Conclusion

The Bergen principles have gradually been gaining acceptance within the worldwide museum community. For example, the Office of Museum Programs of the Smithsonian Institution has organized successful induction workshops for new employees from a wide range of museums across the US based on the ICTOP proposals, and the major UK study on museum training and career structure (the 1988 Hale Report of the Museums and Galleries Commission) recommended that similar induction training programs should be compulsory for every new recruit to museums regard-

less of the level of their job.

Nevertheless, almost sixty years on from the initial international work of UNESCO and ICOM, recognition of the professional status of museum workers varies widely from country to country, and from museum to museum within many countries, and there is still much to be done to convince employers – and, sadly, some fellow professionals – that professional training and qualifications are essential in the face of the increasing complexity of museum work.

Bibliography

*Baghli, S. A., Boylan, P. J., and Herreman, Y. (1998) *The International Council of Museums (ICOM) 1946–1996: Fifty Years in the Service of Museums and their Development*. Paris: International Council of Museums.

Boylan, P. J. (ed.) (1992) *Museums 2000: Politics, People, Professionals and Profit*. London: Routledge.

— (1993) Museum careers: ever changing and ever growing. *Museum International*, 45 (4): 4–7.

*— (2002) A revolution in museum management requires a revolution in museum professional training. In K-N. Huang (ed.), *Museum Professionalism: Forum of Museum Directors, 2001*, pp. 157–98. Taipei: National Museum of History.

— (ed.) (2005) *Running a Museum: A Practical Handbook*. Paris: UNESCO/ICOM.

Carter, S., Hurst, B., Kerr, R. H., Taylor, E., and Winsor, P. (1999) *Museum Focus: Facts and Figures on Museums in the UK, issue 2*. London: Museums and Galleries Commission.

Glaser, J. R. and Zenetou, A.A. (1996) Museums: A Place to Work – Planning Museum Careers. London: Routledge.

*ICOM (International Council of Museums) (2000) *ICOM Curricula Guidelines for Museum Professional Development* (museumstudies.si.edu/ICOM-ICTOP/index.htm).

ICOM/ICTOP (International Committee for the Training of Personnel) (2002) *Museum Training*. ICOM Study Series. Paris: International Council of Museums.

Kavanagh, G. (ed.) (1994) *Museum Provision and Professionalism*. London: Routledge.

Teather, L. (1978) *Professional Directions for Museum Work in Canada: An Analysis of Museum Jobs and Museum Studies Training Curricula*. Ottawa: Canadian Museums Association.

Van Mensch, P. (ed.) (1989) *Professionalising the Muses: The Museum Profession in Motion*. Amsterdam: AHA Books.

Museum Ethics

Tristram Besterman

Museum ethics seeks to provide a purposeful, philosophical framework for all that the museum does. Developed from within the museum profession, museum ethics is an expression of the continuing debate about the responsibilities that museums owe to society. As such, ethics reminds the museum of the need to identify those to whom it is morally accountable for what it does and how it behaves. With a pedigree that goes back to the early twentieth century, it is really in the past twenty-five years that museum ethics has become a distinct field, reflecting a growing professionalization of museum practice.

Museum ethics reflects social context and articulates a contract of trust between the public museum and society; and it expresses both fundamental principles that stand the test of time and more subtle shifts of emphasis, reflecting social change and the evolving role of museums in society.

> Social change has had an impact on moral attitudes and caused a change in ethical behaviour. Multi-cultural acceptance has manifested itself as a part of the new ethical dimension of museums. Concern for right action, right representation and equal and fair treatment for all has altered the thinking, planning, programming, and orientation of many museums. (Edson 1997: 48)

Ethics is an expression of social responsibility, which necessarily concerns relationships between people. The museum practitioner certainly has a duty of care to an object, but that responsibility has meaning only within an ethical context of human interaction. The plundering of archaeological sites across the globe destroys evidence of the past: a museum which buys a plundered artifact connives in damaging people; the cultural identity of a village or a nation is violated and the ability of humankind to understand its origins is curtailed. Ethics defines the relationship of the museum with people, not with things.

Ethics is useful because it maps a principled pathway to help the museum to navigate through contested moral territory. For instance, most museums are committed to the principle of making their collections as widely accessible to their audiences as possible. However, some artifacts have a sacred significance to living communities, for whom public display of such material would be deeply offensive. Such

conflicting claims on the actions of the museum exemplify three important aspects of museum ethics. The first is that ethics must respond to an increasingly complex context for the museum, in which choices are rarely between "right" and "wrong," but often involve informed judgment about "competing goods" (Lovin 1994).

The second aspect is that the ethical context for museums is never fixed, but is continually evolving, both as a result of the intense analysis to which museum practitioners subject their own values, and in response to the shifting values of the society which they serve and to which they are accountable. Twenty-five years ago *churinga*, made and worn by Australian Aboriginal men at initiation ceremonies, were openly displayed in museums, whose "right" to display them went unchallenged. Today, *churinga* are hidden from public gaze, as culturally sensitive objects, and museums that wish to reflect (museums are unlikely adequately to "represent") aspects of indigenous Australian culture work in partnership with Aboriginal communities.

The third aspect derives from the way in which museums and their collections embody human relationships across the four dimensions of space and time. Museums uniquely occupy a contemporary, historic, and future place: the portrait connects the viewer to an artist and his sitter three hundred years before; the pin transfixing an insect and its data connects the entomologist with a collector's way of studying the natural world a century ago; the form of the *churinga* connects the Western visitor with an indigenous source nation living 12,000 miles away today; the consolidation of a fragile artifact and its protection connects the expert conservator with a user in a future generation; the order placed with a fair-trade supplier connects the customer in the museum shop with the livelihood of a source community in Africa today. There is no part of the museum that is free from ethical implications.

The Philosophical Origins of Ethics

The human impulse that has nourished the development of moral philosophy over more than two thousand years has drawn sustenance from the same intellectual sources that seek expression through the museum. Whilst museum ethics has a relatively recent history as a subject *per se*, the roots of museums and philosophical thought are closely entwined and burrow deeply into the history of humankind's need to make sense of the world and our place within it. Aristotle (384–322 BCE) assembled a museum of natural history in Athens in the fourth century BCE, many of the specimens for which (and much of the funding) were provided by Aristotle's tutee, Alexander the Great (see chapter 8). Aristotle's *Nicomachean Ethics*, in which ethics is conceived as "the rational exercise of virtues within socio-political life" (Cooper 1998: 29), is considered by many to be the most influential of all writings in Western moral philosophy.

It is, however, a more universalist conception of ethics, characteristic of eighteenth-century European Enlightenment rationality, that is often drawn upon by some Western museums. This is witnessed, for example, in the "Declaration on the Importance and Value of Universal Museums," drafted in 2002 and signed by nineteen major museums from Europe and North America (British Museum 2003). This

has been deployed by the British Museum as an argument for retaining contested artifacts, such as the marble sculptures removed from the Parthenon Frieze by Lord Elgin in the eighteenth century.

The British Museum's (unilateral) claim to universalism is, however, contested. For example, a leading African museum practitioner has drawn attention to the morally dubious provenance of material held in the collections of these self-proclaimed universal museums and has questioned their use of the term "universal" (Abungu 2004). The Pitt Rivers Museum, at the University of Oxford, has developed a different ethical paradigm around the notion of the relational museum, based on the recognition that:

> A museum's collections are created through a mass of relationships between the people who originally made and exchanged objects, the collectors of the objects and the museums in which they are currently held. In order to understand both the past and the present of a museum it is necessary to understand these relationships. (Pitt Rivers Museum 2002)

These different philosophical approaches to, and understandings of, the nature of the museum have varied implications for how museums should act in particular contexts. The lack of a consensus on such issues means that ethical values must be mediated within the institutional context; the process of debating and articulating such values should be managed by the museum in an open and inclusive way, and be subject to continuing reflection and review.

Codifying Museum Ethics

The twentieth century saw the first moves to codify the norms of accepted practice particular to museums in published form. The USA led the way in articulating the ethical principles that underpinned the idea of "public benefit" when the American Association of Museums published, in 1925, its *Code of Ethics for Museum Workers*, based on the following conception of museums: "Museums, in the broadest sense, are institutions which hold their possessions in trust for mankind and for the future welfare of the [human] race. Their value is in direct proportion to the service they render the emotional and intellectual life of the people" (AAM 2000).

In the late 1970s, during a renaissance in museums and the maturing of scholarly museology, ethics became the subject of increasing debate in museums both in the UK and the US. From 1977, ethical guidelines were published that set out principles on the care of collections, governance, and service to the public. The American Association of Museums' 1978 *Museum Ethics* explored issues such as scholarship, conflicts of interest, relationships between staff, and the responsibilities of governing bodies as well as staff.

The 1980s and 1990s witnessed radical political and economic reform in the West. Privatization was redefining the boundaries between public and private sectors, especially in the UK; and the museum sector was changing rapidly as heritage became big business, and a new breed of independent trust museums brought a

culture of enterprise and "customer focus" into the museum sector. This raised questions about the ethics of the free-market enterprise approach. Prime Minister Margaret Thatcher's claim that "there is no such thing as society" seemed to some to undermine the framework in which socially reflexive moral principles should operate. Other factors also put ethics onto the museum agenda, as the American Association of Museums' 2000 *Code of Ethics* explained:

> During the 1980s, Americans grew increasingly sensitive to the nation's cultural pluralism, concerned about the global environment, and vigilant regarding the public institutions. Rapid technological change, new public policies relating to non-profit corporations, a troubled educational system, shifting patterns of private and public wealth, and increased financial pressures all called for a sharper delineation of museums' ethical responsibilities. (AAM 2000: afterword)

Redefining the museum became an ethical issue in the UK in the mid-1990s. The then current definition of a museum, formulated twenty years earlier, stated that a museum was "an institution that collects, documents, preserves, exhibits and interprets material evidence and associated information for the public benefit" (Museums Association 1995: 2). Although the list of core activities was accurate enough, the definition failed to mention the social purpose of the museum and the implicit social contract between museum and user. After two years of deliberation and consultation, in 1998 the UK Museums Association adopted the new definition formulated by its Ethics Committee: "Museums enable people to explore collections for inspiration, learning and enjoyment. They are institutions that collect, safeguard and make accessible artefacts and specimens, which they hold in trust for society" (Museums Association 2002: 7).

Redefining the museum in these terms was important for two reasons. First, it helped to reposition the museum sector within a national political agenda that placed culture at the center of social, educational, and economic policy. The new definition provided a means by which museums could communicate to their key stakeholders a message of social and political relevance. It defines *who* (as well as what) the museum is for, and understands this as a fundamentally ethical issue.

The second reason why the new definition was important was the foundation that it provided for developing a new code of ethics for museums. The 1998 definition is quoted at the beginning of the *Code of Ethics for Museums* (Museums Association 2002: front cover). By placing the interests of the museum user at the forefront, the definition provided a template for the new Code, which begins each of its ten constituent sections with the words "Society can expect museums to . . ." This was timely, since the post-Thatcherite political agenda reflected a reiterated government view that there *is* such a thing as society, not just as a rebuff to Thatcherism, but as a tenet of belief in the role of the state both to shape society and to serve its citizens in an enlightened democracy.

The American Association of Museums also places the social purpose of museums unequivocally at the center of its Code, and reminds us of their changing role in society:

Ethical codes evolve in response to changing conditions, values, and ideas. A professional code of ethics must, therefore, be periodically updated. It must also rest upon widely shared values. Although the operating environment of museums grows more complex each year, the root value for museums, the tie that connects all of us together despite our diversity, is the commitment to serving people, both present and future generations. (AAM 2000)

At the supranational level, the UNESCO-affiliated International Council of Museums (ICOM) set an important standard in 1986 when it adopted its *Code of Professional Ethics*. After minor revision, it was re-adopted in 2001 as the *Code of Ethics for Museums*. Perhaps reflecting the difficulty of amending a code that requires international consensus, the 2001 ICOM Code expresses a more traditional museum ethics, in which responsibilities for collections take a more prominent place than obligations to society. However, ICOM defines a museum as: "A non-profit making, permanent institution in the service of society and of its development, and open to the public, which acquires, conserves, researches, communicates and exhibits, for purposes of study, education and enjoyment, material evidence of people and their environment" (ICOM 2002: 26).

Ethical museum practice has been shaped and expressed through many other published codes in many nations. At institutional level, leading museums, such as those in Toronto, Washington, Canberra, and Sydney, have developed codes of ethics either on all aspects of the museum's activities or on specialist aspects, such as research, conservation, and display. The Royal Ontario Museum's Statement of Principles and Policies on Ethics and Conduct, approved by the museum's trustees in 1982, was particularly comprehensive. At national and international levels, specialists have developed ethical codes on subjects as diverse as conservation, archaeology, sites and monuments, natural history, art history, and museum retailing. These have been propelled largely by professional concerns within the subject discipline to address issues not adequately covered elsewhere.

Accountability: To Whom?

Museums operate in the public realm, which is itself subject to change. This means, on the one hand, that they must be sensitive to the changing context. On the other hand, however, the museum owes allegiance to more than today's users and funding partners. Museums are the custodians of an intergenerational equity which may extend well beyond local or even national boundaries. The museum's stakeholders range from long dead benefactors and makers to future generations of users, from local audiences to overseas source communities, and from public funding bodies to private sponsors. Being accountable to such a diverse range of stakeholders inevitably involves reconciling competing claims on the museum.

The ethics of accountability does not mean, however, that the museum should be confined to a role that is merely responsive to stakeholder needs and aspirations. Museums are also places of creative interaction, in which traditional values and

orthodoxies can and should be challenged. An ethical museum should be free to surprise and to do the unexpected. However, this can lead to public controversy (see chapters 29 and 30).

Notions of "objectivity" and the advancement of human knowledge, as well as freedom to challenge convention, are also important in many museum contexts. They are, for example, central to the role of science museums in acting as trustworthy mediators between science and society. In some cases, however, scientific interests and aims to advance knowledge – which may be seen as seeking to be accountable to "the public" and future generations – may conflict with other interests. For example, scientifically fascinating materials, such as dinosaur fossils, may be from illicit sources (which generally means that international crime will have been involved), and a museum should refuse to acquire, research, or display them, whatever the potential scientific gains (see also below).

In recent years, in particular, scientific ideas have also sometimes conflicted with other worldviews (see also chapter 30). This has been especially so in relation to indigenous human remains (Simpson 1996; see also chapter 27). To which claimant group should the museum owe primary allegiance? The scientific community, claiming to represent humankind globally, wishes the museum to retain an irreplaceable scientific resource, providing evidence of human evolution and diversity; whereas the source community demands the unconditional return of their ancestors for reburial.

How this is dealt with is currently the subject of a good deal of debate and change (see, for example, Appleton 2003; Jenkins 2004; and also below). There is, however, an interesting contrast between how it is approached by a European museum holding indigenous human remains from overseas, and an equivalent museum in the country (for example, Canada, New Zealand) from which the remains originate. Both reflect aspects of colonial history, but whereas the museums in the latter group mostly operate within a legal framework which protects and champions the rights of indigenous people, European museums have no such legal framework for relating to the peoples whose material culture they possess. For Europe and its ex-colonies, the separation of geography has been allowed to override the connections of history in defining the legal and moral parameters of the museum. Nonetheless, a small number of museums in the UK have recently begun to return human remains to indigenous claimant groups. Primary ethical determinants were the illegitimacy of the act of removal at a time of great inequality of power, about a century ago, and the cultural significance of the remains as ancestors, held to be part of the living indigenous community. Museums that act in this way do so in keeping with their professional code and with international convention (UNESCO 1970; UNIDROIT 1995); and, increasingly, scientists are either working with, or seeking the consent of, indigenous groups in their research.

Collections: Ethical Management of a Core Resource

The possession of collections, and the manner in which they are managed and made accessible to the user, is what makes museums distinctive. A fundamental ethic is

that the public museum holds artifacts and specimens in trust for society. Collections are part of the public realm. If it is accepted that collections are, in effect, public property, then it follows that the curator, acting as "gatekeeper," must start with a presumption that the public has a right of access, and that any restriction of that access must be justified. That ethical obligation extends to all the museum's collections, whether they are displayed in public galleries or in store. Finding ways – physically, intellectually, or virtually – to optimize access to all the collections is an ethical obligation.

A cornerstone of the possession of collections by the museum is the notion of "permanence." Certainly, a benefactor who leaves a Turner landscape to an art museum in his will does so in the expectation that the museum will hold it "in perpetuity." If the museum does not collect nineteenth-century British watercolours, it would be unethical to accept the bequest. Refusal is entirely ethical if the terms of the bequest are unreasonable: say, for example, they stipulate that the landscape must be permanently displayed. If, however, the museum accepts the watercolour on the terms set out in the bequest, disposal would undoubtedly constitute an ethical breach of trust. It could also be challenged under trust law (see chapter 27).

In the US, however, many museums have considered the objects that they have purchased to be assets that can be "traded up" – sold to enable a better or more relevant example to be acquired by the museum. This is generally regarded in the UK as an ethically unacceptable practice. Collections, it is argued, should not be regarded as assets for sale, since that is not the purpose for which they are held by the museum. The argument advanced by the proponents of "trading up" is that it enables the museum to improve the quality of the collection, which must surely be in the public interest. Setting aside the notoriously changeable nature of "taste" and "value" in the art market over time, the practice raises particular questions when the sale proceeds are used for such purposes as refurbishing the picture store or developing conservation facilities. This is largely sanctioned in the US but not in most European countries (see chapter 27).

Disposal may, nevertheless, be the most ethical course of action in some circumstances. For example, the museum may lack the resources to care for an object or to make it accessible. Retaining objects in the public realm where they can be best used and looked after, is increasingly regarded as a greater public good than defending possession by a particular museum. For example, a museum in the UK had a number of old tractors deteriorating, unvisited, in its rural life collection store and lacked the resources to do anything with them. It chose to give them to a group of volunteer enthusiasts, who carefully restored them and now tour the tractors to rallies and public events all over the UK. In the UK, there is increasing acknowledgment that there is an ethical responsibility for a museum to remove permanently from the public realm an object which no longer serves any useful purpose to any museum. Taking such tough decisions will enable the museum to redirect scarce resources to developing collections which better meet the needs of the audiences served by the museum.

The ethics of disposal are inextricably linked to those of acquisition, which should entail a rigorous assessment of fitness for purpose in the first instance. The museum must ensure that the object is covered by the museum's acquisition policy, which

serves the purposes of the museum and takes into account the resources available in the long term. Resources include the funding to support people with relevant expertise, as well as the necessary facilities to house, conserve, document, and interpret the object. Museums are encouraged to ask whether an item might be better acquired by another museum; and whether untainted provenance can be established.

Museums are increasingly acting in partnership with each other, with other cultural organizations, and with their audiences. Acquisition and disposal policies are coming to be informed by a more consultative and collaborative ethic, in which regional and national networks and strategies are factored in. In the UK, for example, years of reducing budgets and giving priority to service delivery to ensure continued political support have made active collecting a luxury that has been, for many museums, regarded as unaffordable. But this is an ethically unsustainable strategy: the collections are the intellectual and spiritual capital of the museum, and if they are neglected or left to atrophy, the museum will eventually follow suit.

Applying Ethics in the Museum

As with other service industries with a social role, the museum sector is self-regulating: that is, it devises and monitors the application of its own ethical standards. There are no real enforcement mechanisms. Standing committees of the museum sector's professional bodies at national level investigate allegations of ethical malpractice, and, in the majority of cases, advice and guidance are sufficient to remedy the matter. In instances where seriously unethical conduct is not amenable to such counseling, a more formal process can be invoked that could lead to expulsion from membership of the professional association.

Since ethics is concerned with human behavior, its application starts and ends with the individual. Whilst institutions must have ethical policies in place, it is the individual's commitment to those institutional values – from members of the board to every member of staff – on which the museum's ethical credentials rely. That in turn depends on a well-resourced policy of professional development throughout the organization. In the UK, the award of both Associateship and Fellowship of the Museums Association requires the individual to demonstrate to the assessors a thorough grasp of museum ethics as a central plank of qualification. Postgraduate courses in museology today invariably include ethics as a core component of the course of study (see chapter 25). In theory, grossly unethical conduct could result in an individual being stripped of membership of his/her professional body. In practice, such cases (which are rare) are normally dealt with by the employer using the disciplinary procedures available under the individual's contract of employment.

Putting the public interest of the museum before personal interest should be the prime ethic for everyone involved with the museum because the potential for conflicts of interest is always present. For a trustee museum, members of the governing body may be chosen for their connoisseurship, knowledge of the market, links with industry, or other forms of influential connection. Any personal interests that might compete with those of the museum should be disclosed and recorded. Such transparency also applies to museum staff. The knowledge and passion of a museum

curator may be linked with private collecting, or may be harnessed by the market in the form of consultancy. Avoiding the taint undermining public trust in the museum is important: it is not enough to ensure that the individual does not compete with the museum, the ethical standards of the museum and its staff must be *seen* to be above suspicion.

At institutional level, there are two prerequisites for the ethical museum. First, the organizational *values* must be explicit and ethical. Everyone in the museum should be aware of these values and be signed up to them (and ideally be involved in formulating them). Establishing such values as openness, accountability, transparency, probity, ethical stewardship, and social responsibility depends on good leadership and governance. Second, the *policies* of the museum should spring from such values and either incorporate or be consistent with the codes of ethics of the museum sector. For a public museum, policies on functions such as acquisition and disposal, and learning and access, should be in the public domain – ideally published on the museum's website.

In the UK, the national, standards-based registration scheme (rebranded the accreditation standard from 2005) has ethical standards built into it. Being an accredited museum is a prerequisite for grant aid from a range of government-derived and charitable trust sources, and for advice from museum-sector bodies. An effective sanction against a governing body that is found to have acted unethically is the loss of accredited status for its museum. This would result in the museum being deprived of the oxygen of financial and professional support. That is a fate that the governing bodies of all UK accredited museums wish to avoid.

Ethics and the Law

To some extent, laws provide the codified expression and means of enforcement for principles designed to protect the interests of society and the citizen. However, there can be many matters of ethics that are not covered by the law, and very occasionally legal requirements and moral responsibilities may conflict. For example, a curator has contractual obligations to his or her employer. If the museum's governing body acts in a way that requires the curator to act unethically (but not illegally), the curator can notify the professional body, which may investigate and hold the employer to account, but will be powerless to protect the curator, who may be in breach of contract as a result of acting from conscience, from disciplinary action by the employer.

Ethical standards in museums can anticipate and prompt changes in the law. For over thirty years, the ethical standards of museums in the UK referenced the international "Convention on the Means of Prohibiting and Preventing the Illicit Import, Export and Transfer of Ownership of Cultural Property" adopted by UNESCO in 1970, despite the fact that the convention had no legal force under statute law anywhere in the UK. The ICOM Code and the Museums Association Code require museums to exercise due diligence in considering any object for acquisition, loan, bequest, or exchange to establish that the source of the object has valid title. For a museum, "valid title" means a complete provenance that demonstrates that the

object has not been "illegally acquired in, or exported from, its country of origin or any intermediate country in which it may have been owned . . ." (ICOM 2002: 10).

A landmark in a long-term campaign within the UK museum sector to outlaw the illicit trade was the publication of *Stealing History: The Illicit Trade in Cultural Material* (Brodie et al. 2000), commissioned by ICOM UK and the Museums Association. This report exposed the scale and human impact of the destruction of the international archaeological patrimony, and the manner in which UK legislation sanctioned the trade in illicit material in the auction rooms of Britain. As a result, the government convened an advisory panel, whose recommendations led directly, in 2002, to the UK becoming party to the UNESCO 1970 Convention, and to the passing of the Dealing in Cultural Objects (Offences) Act 2003. That which had previously been unethical, but not unlawful in the UK – namely, for a museum to acquire certain categories of cultural object illicitly removed from its context, irrespective of whether that had occurred in the UK or elsewhere – became both unethical *and* unlawful.

The legal status of human remains in museums is complex (see also chapter 27). The UK government's *Report of the Working Group on Human Remains* (in museums) discusses this in detail (DCMS 2003). Whilst a museum may possess parts of a human being, they may not be regarded as "property" under English law. The report recommends that the statute legislation that prevents national museums in the UK from dispossessing themselves of items from their collections be amended "to empower national museums to relinquish human remains" (DCMS 2003: 161). Whilst the status of the indigenous claimant is the subject of hotly contested ethical debate, the issue may be resolved under human rights legislation. The Human Rights Act 1998 could be interpreted to include as "victims" indigenous communities outside the UK which suffer a continuing wrong as a result of the retention of their ancestral remains by a museum.

Conclusion

The center of gravity is shifting in the ethical paradigm of the Western museum. A museum tradition that originated in the universalism of the European Enlightenment increasingly challenges the restrictive boundaries of that cultural inheritance. The possession, presentation, and interpretation of material culture raise highly sensitive issues of "representation" and "ownership," in which cultural values beyond the material come into play and demand attention. In this evolving ethical framework, museums have an opportunity to reflect, respect, and nourish the human spirit as well as intellect, and to celebrate different ways of seeing, studying, and comprehending the world.

Museums that respond to social change embrace a consultative, open, and non-presumptive methodology. The ethical museum is trusted in a society of diverse cultures and values, and becomes a safe place for peoples of different beliefs and backgrounds to meet and find common ground. Trusted as a place where narrative truth and factual accuracy are both fostered and openly examined, the ethical museum prompts questions about the balance, perspective, and assumptions upon

which such cultural ideas are constructed. The ethical museum is not an indiscriminately tolerant institution: prejudice, cant, deceit, and ignorance have a place in the museum, but only within a rigorously interpreted context that enables the user to discover the damage to society that they can cause. The thoughtful and inclusive museum, which avoids misrepresentation, and in which a diversity of cultures can find enlightenment based on mutual understanding and trust, expresses an ethic that can only be of benefit to society.

Bibliography

*AAM (American Association of Museums) (2000) *Code of Ethics for Museums* (www.aam-us.org/aamcoe.cfm; accessed July 12, 2004).

Abungu, G. (2004) The declaration: a contested issue. *ICOM News*, no. 1 (icom.museum/pdf/E_news2004/p4_2004-1.pdf; accessed July 14, 2004).

Appleton, J. (2003) UK to restitute human remains? *Anthropology Today*, 19 (3) (June).

British Museum (2003) Declaration on the importance and value of universal museums: the statement and signatories. British Museum press release "Newsroom" (www.thebritish-museum.ac.uk/newsroom/current2003/universalmuseums.html; accessed July 14, 2004).

*Brodie, N., Doole, J., and Watson, P. (2000) *Stealing History: The Illicit Trade in Cultural Material*. Cambridge: The McDonald Institute for Archaeological Research.

Cooper, D. E. (ed.) (1998) *Ethics: The Classic Readings*. Oxford: Blackwell.

DCMS (Department of Culture, Media and Sport) (2003) *The Report of the Working Group on Human Remains*. London: HM Government, Department of Culture, Media and Sport, Cultural Property Unit.

*Edson, G. (ed.) (1997) *Museum Ethics*. London: Routledge.

Fforde, C., Hubert, J., and Turnbull, P. (2002) *The Dead and their Possessions: Repatriation in Principle, Policy and Practice*. London: Routledge.

ICOM (2002) *Code of Ethics for Museums*. Paris: International Council of Museums.

Jenkins, T. (2004) Human remains: objects to study or ancestors to bury? Occasional Paper no.1, May. London: Institute of Ideas.

Lovin, R. W. (1994) What is ethics? American Association of Museums Forum: Occasional Papers and Readings on Museum Issues and Standards, pp. 15–20. Washington, DC: AAM.

Museum and Galleries Commission (2000) *Restitution and Repatriation: Guidelines for Good Practice*. London: Museums and Galleries Commission.

Museums Association (1995) *Codes of Ethics*. London: Museums Association.

*— (2002) *Code of Ethics for Museums*. London: Museums Association.

Pitt Rivers Museum (2002) The relational museum: a major ESRC funded project October 2002–September 2005 (www.prm.ox.ac.uk/RelationalMuseum.html; accessed July 25, 2004).

Simpson, M. G. (1996) *Making Representations: Museums in the Post-colonial Era*. London: Routledge.

UNESCO (1970) Convention on the means of prohibiting and preventing the illicit import, export and transfer of ownership of cultural property (www.unesco.org/culture/laws/1970/html; accessed July 12, 2004).

UNIDROIT (1995) Convention on stolen or illegally exported cultural objects (www.unidroit.org/english/conventions/1995culturalproperty/1995culturalproperty-e.htm (accessed September 13, 2005).

Museum Practice: Legal Issues

Patty Gerstenblith

Museums are repositories of the tangible remains of the past and present and are centers for education and scientific advancement. Nonetheless, in recent years, museums have become increasingly embroiled in legal issues which focus on questions of collections management, particularly acquisitions and de-accessions. While providing an introduction to the legal issues surrounding the management of the modern museum, this chapter will present some aspects of recent controversies and debates.

Legal Structure

In the legal sense, museums are usually incorporated entities and may be either public or private institutions that are dedicated to purposes of promoting education and science. By being incorporated, museums can more easily own property (real property, the collections, and other assets) and are given perpetual existence. Furthermore, the managers are protected from suit in their individual capacities through limited liability. In much of the world, museums are public institutions, primarily funded by local or national governments. In the United States, however, most museums are private institutions, under the governance of a board of trustees or directors composed of private individuals. While these museums rely primarily on private funding, they receive several significant forms of subsidy from both national and local governments as well.

Museums typically function as charitable, non-profit organizations, which means that while they may earn a profit from their various activities, they must return any profit earned to their original, non-profit purpose. Museums do not have owners or shareholders, and any profit earned may not be distributed in the form of dividends or income. The lack of members with a financial interest, such as shareholders, or of defined beneficiaries, as in a private trust, leads to difficulty in oversight and enforcement of appropriate standards of conduct for the managers of charitable organizations. The party with standing to enforce these obligations is generally restricted to the state attorney general, who acts on behalf of the public. Supervision is also provided indirectly through the Internal Revenue Service, which can

impose excise taxes or even loss of tax-exempt status if the managers of a museum violate the tax code provisions. Donors and their heirs have standing to enforce a reversion of a gift if the museum violates a restriction that was imposed by the original donor. None of these mechanisms, however, is designed to assure effective and appropriate oversight of the functioning of a museum.

As charitable organizations, museums benefit from both direct and indirect subsidies. In addition to exemption from corporate income tax, donations given to museums qualify as deductions either from income for individuals and corporations, or from the valuation of an estate for estate tax purposes. Under state law, charitable organizations may be exempt from property tax, sales tax, and other state and local taxes.

Museums often receive direct grants of public funds. For example, the major New York museums, such as the Metropolitan Museum of Art and the Brooklyn Museum, lease the land on which they are located from the city at a nominal rent and receive funds that directly subsidize their general operating budgets. Museums are also routinely the recipients of public grants for specific purposes, such as for particular exhibitions or research projects through the National Foundation of the Arts and Humanities. Stephen Weil points out that while most museums in the United States are considered private institutions, the extent of direct and indirect government support they receive requires both a level of public service equivalent to that of public institutions and a similar standard of accountability and transparency (Weil 1999: 230).

In exchange for these financial benefits and occasional exemptions from other legal rules, various requirements are imposed. These requirements have two sources: first, the tax code, and, second, state common law. The tax code requires that charitable organizations serve a public purpose. In the case of museums, this is an educational and scientific purpose. In addition, the tax code restricts political lobbying and absolutely prohibits the endorsement of political candidates. Finally, the trustees are prohibited from earning private gain in their capacity as trustees. State common law also imposes fiduciary obligations on trustees of charitable organizations.

The way in which the American museum's educational and scientific purposes are understood has changed significantly over time. Museums in the post-World War II era were described as being in the "salvage and warehouse business" (Weil 1999: 229). Their goal was to gather, acquire, preserve, and study the record of human and natural history. In that sense, museums were certainly fulfilling an educational and scientific purpose in adding to the store of human knowledge about a wide range of subjects. However, understanding of this educational purpose has shifted significantly so that now most museums view their educational mission to be one of interpretation and presentation, not just to a narrow scholarly community or to those already accustomed to visiting museums, but to the neighborhood community and the public at large. As such, the museum has been forced to reach out into the community through exhibits that emphasize cultural and social contexts rather than presentation of objects (Boyd 1999: 199–203; Weil 1999: 233–8). This evolving understanding of the mission of museums raises new questions as to how museums fulfill their educational purpose.

443

The trustees and directors of charitable organizations are subject to the two basic fiduciary obligations of the duty of loyalty and the duty of care. The duty of loyalty requires that trustees remain true to the purpose of the charitable organization – in the case of museums, their public educational purpose. In particular, trustees must not engage in conflicts between their self-interest and the interests of the museum's beneficiary, that is, the public. The duty of care requires that trustees be attentive to the management and preservation of both the physical assets of the museum (the building and, in the case of a museum, its collections) and the monetary assets (endowments and other financial investments).

The standard used to evaluate the conduct of charitable trustees in fulfilling the duty of loyalty is generally recognized to be a standard of utmost loyalty to the trust, with any form of self-dealing strictly prohibited. The conduct of the trustees in fulfilling the duty of care is generally judged by the "prudent investor rule" which expects a trustee to act as would a prudent person handling his or her own funds (White 1996: 1052–4). This rule was devised, as its name indicates, primarily in the context of financial investments and does not apply easily to the conduct of trustees or directors in caring for other types of assets, particularly the unique objects that form the collections of museums.

Problems in the acquisition and de-accessioning of objects in a museum's collection may implicate both the fiduciary's duty of loyalty and duty of care. De-accessioning or de-acquisition is the process by which objects are removed from a museum's collection. This can occur through sale, exchange, or occasionally even the discarding of an object (Gabor 1989: 1005). While public attention has focused over the past two decades on museums' de-accessioning policies in light of the trustees' obligations, somewhat less attention has focused on museums' acquisitions policies in this context. This chapter will turn next to explore some of the legal issues and controversies that have arisen in recent years concerning museums' de-accessioning policies.

De-accessioning Policies and Paradigms

Museums in the United States are freer to remove objects from their collections than are museums in European countries. For example, in deciding that museum trustees could sell objects from the museum's collection, one court stated that "[a]n art museum, if it is to serve the cultural and educational needs of the community, cannot remain static. It must keep abreast of the advances of the times, like every other institution whose purpose is to educate and enlighten the community" (*Wilstach Estate*, 1 Pa. D. and C. 2d 197, 207 [1954]). In England, the British Museum Act of 1963 puts limits on the conditions under which a museum may remove an object from its collection. These circumstances seem limited to when "the object is unfit to be retained in the collections of the Museum and can be disposed of without detriment to the interests of students" or if the object has become "useless for the purposes of the Museum by reason of damage [or] physical deterioration . . ." (Palmer 2000: 24). For most purposes, once a European museum acquires an object, it must retain the object (Meyer 1979: 216).

The ability of a museum in the United States to de-accession an object depends, to a considerable extent, on the circumstances under which the object was originally acquired. Was the object itself a gift, was it purchased with donated funds, or was it purchased from unrestricted general funds of the museum (White 1996: 1063–5)? The answer to this question determines whether the gift is restricted in such a way that would prevent its removal from the museum's collection.

If the museum violates a donor restriction that prohibits alienation, the museum will forfeit the object, which would then revert either to the donor or the donor's estate or to another charitable institution, depending on the terms of the original gift. The prospect of forfeiture serves as a sufficient disincentive so that the museum does not attempt to alienate the work of art. It may not be in the interest of a museum to accept a gift with such forfeiture provisions. Because courts are often reluctant to order the forfeiture of a gift to a charitable institution, such as a museum, the restriction must be stated explicitly and not merely as the donor's wish. A well-known example of an unenforceable wish of a donor involved the 1967 bequest of Adelaide Milton de Groot to the Metropolitan Museum of Art of her collection of paintings. Soon after receiving these paintings, the Metropolitan sold off thirty-two of the Impressionist works in order to raise funds to cover its earlier purchase of a Velázquez painting, *Juan de Pareja*. The donor had expressed the wish in her will that whatever paintings the Metropolitan did not want should be given to other specified museums. The donor did not, however, express her wish in a way that would be legally enforceable and so the Metropolitan was free to dispose of the paintings as it did, although this led to public criticism and increased scrutiny from government regulators (Meyer 1979: 118; Hoving 1994: 291–306).

The case of the Barnes Foundation illustrates many of the problems inherent in donor-restricted gifts to museums. The Barnes Foundation, located in a suburb of Philadelphia, contains one of the world's most extensive collections of Impressionist paintings, as well as a variety of ethnographic objects and other types of art works. Dr Barnes imposed a large number of restrictions on the Foundation's future operation. Not only did he prohibit the sale of any of the paintings and objects, he prohibited the removal of any works even for temporary loan or any changes in the arrangement of the collection's display. He also imposed restrictions on the public's ability to visit the museum and the ways in which the Foundation could raise funds. As a result, the Foundation's trustees have been in court numerous times over the years. In an early suit, the museum was forced to open its doors to the public on a more regular basis in order to maintain its tax-exempt status. In more recent years, the Foundation has suffered financial hardships and its trustees have sought release from some of Dr Barnes's strict controls. As a result, courts have permitted funds to be raised from the charging of admission fees, traveling exhibits, and the sale of typical museum paraphernalia based on works in the collection (*In re The Barnes Foundation*, 684 A.2d 123, 130–1 [Pa. Sup. Ct 1996]). Under the doctrine of deviation, the court has recently reorganized the Foundation's board and will permit the gallery to move into downtown Philadelphia if sufficient funds are raised (*In re The Barnes Foundation*, 69 Pa. D. & C. 4th 129 [2004]). The fate of the Barnes Foundation illustrates the extreme complications that can arise over the years when numerous and burdensome restrictions are placed on the operation of a museum.

If a museum wishes to be free of a particular restriction, it may seek a court order of *cy près*. *Cy près* is an equitable doctrine that applies if the terms of a charitable gift are found to have become impractical, illegal, or impossible to carry out and if the court determines that the donor had a general charitable intent. The doctrine allows the court to change the terms of the gift while remaining as close as possible to the donor's original charitable purpose (Lee 2000: 181–5). Courts generally seem to grant requests to sell objects relatively freely, whether pursuant to a specific *cy près* analysis or not (*In re Gary's Estate*, 288 NYS 382, 383–4 [NY Sup. Ct 1936]). On the other hand, courts have sometimes refused to grant *cy près* when they conclude that it is not impossible to carry out the donor's original purpose (*Museum of Fine Arts* v. *Beland*, 735 NE 2d 1248, 1252 [Mass. 2000]). Another legal doctrine that allows departure from the precise terms of a charitable gift is that of administrative deviation (*Cleveland Museum of Art* v. *O'Neill*, 129 NE 2d 669, 671–2 [1955]; Lee 2000: 185–6).

There are several reasons why a museum may seek to de-accession an object in its collection. Among these reasons are: a desire to improve the quality of a collection by acquiring a better example of a particular artist or time period; elimination of a piece that does not fit into the current collection; elimination of pieces that are thought to be redundant with others in the collection; changing notions of taste, and the desire to obtain funds to meet general operating expenses or for particular capital improvements to the museum's physical facility. One of the strengths of American museums is, in fact, their ability to remove particular objects from their collections. When done to improve the quality of the collection, such de-accessioning generally raises few questions from either a legal or ethical viewpoint.

However, if the purpose of de-accessioning is to raise funds to meet other financial obligations, most typically a deficit in the museum's operating budget or to make capital improvements, more questions will be raised (*Cleveland Museum of Art* v. *O'Neill*, 129 NE 2d 669, 670 [1955]). Some legal commentators have argued that this adds much-needed flexibility to museum finances and that it should be legally permissible (White 1996: 1065–6; Goldstein 1997: 224–7, 246). For example, the New York Historical Society, which was nearly forced to close in 1993, put up $3 million worth of art as collateral for a $1.5 million loan from Sotheby's. In 1995, it sold $16 million worth of Old Master paintings but was thereby able to remain in existence.

On the other hand, de-accessioning to raise funds has led to legal difficulties for some museums. In response to several controversial de-accessions from the Metropolitan Museum's collection in the 1970s, the museum and the state attorney general entered into a voluntary agreement which called for consultation with the attorney general and the donor's heirs before objects are de-accessioned and for their public sale at auction (Goldstein 1997: 222). The Illinois state attorney general brought suit against the trustees of the George F. Harding Museum, alleging not only the improper sale of art works from the collection to raise operating funds but also the payment of excessive salaries to themselves and various other conflicts of interest (*People ex rel. Scott* v. *Silverstein*, 408 NE 2d 243, 245 [Ill. App. Ct 1980]).

The sale of objects from a collection may also involve a breach of trust, most likely because the sale has been to a museum trustee and is therefore considered self-dealing

446

in violation of the fiduciary's duty of loyalty. The Museum of the American Indian had allegedly sold off objects from the collection in indiscriminate fashion, including sales to trustees (Meyer 1979: 213–15). Another example of a sale in breach of trust is one in which the sale price is clearly below market value or when the trustee had the duty to retain the work.

In addition to direct legal constraints, professional codes of ethics can also play a role in evaluating the conduct of museum fiduciaries and professional staff in de-accessioning decisions. Both the American Association of Museums (AAM) and the Association of Art Museum Directors (AAMD), two of the largest museum associations in the United States, have codes that establish policies for the de-accessioning of objects in their collections. These policies take a restrictive view, limiting legitimate reasons for de-accessioning to the purpose of acquiring other works, while the AAM code adds direct care of collections (AAMD n.d.; AAM n.d.).

Restitution from Museum Collections

In recent years, probably the most controversial and legally fraught aspect of museum collections management is that of the restitution of objects from museum collections. This question has arisen in three particular contexts: art works looted during the Holocaust, antiquities and archaeological objects, and human remains and objects of indigenous cultural patrimony. In examining the question of restitution, one should also recall the question of museum acquisitions policies – in particular, how better acquisitions policies can prevent the need, in the future, for restitutions from a collection, thereby protecting the collection and the museum's other assets in order to better serve the museum's public purpose.

Restitution of art works stolen during the Holocaust

The return of art works stolen during the Holocaust to the original owner or, more likely, to the original owner's heirs, from a strictly legal point of view, is not any different from the question of the return of art works stolen under other circumstances. However, the particularly egregious and tragic circumstances under which these works of art were stolen have brought considerable attention to this problem (Nicholas 1994; Palmer 2000). This ought to prompt a more careful examination of all museum collections in an effort to ensure that museum collections do not contain stolen property. Museums are also now often victims of theft, as illustrated by what was perhaps the most spectacular theft of art works – the theft of numerous masterpieces from the Isabella Stewart Gardner Museum in Boston in 1990.

In a country that follows the common law (the United Kingdom, United States, and Canada, as examples), a thief can never convey good title to stolen property (*nemo dat quod non habet*), even if the property passes into the hands of a good faith purchaser or possessor. This contrasts with the continental European rule which, under certain circumstances, permits title to stolen property to transfer to a good faith purchaser. This difference in legal rules concerning transfer of title may permit title to stolen property to be "laundered" in countries that follow the good faith pur-

chaser doctrine. Courts in the US and UK have had to confront the question of whether they should apply the legal rule of the jurisdiction where the property is located at the time of trial or whether they should apply the rule of the jurisdiction where the transfer of property occurred. While the latter rule was applied in an older English case (*Winkworth* v. *Christie, Manson and Woods Ltd* [1980] 1 Ch 496, [1980] All ER 1121), courts in the United States have almost uniformly applied the rule of the forum jurisdiction (*Autocephalous Greek-Orthodox Church of Cyprus* v. *Goldberg and Feldman Fine Arts*, 917 F.2d 278 [7th Cir. 1990]). In a more recent decision, the English court held that it would not apply the German rule to cut off a claim to a stolen art work on the grounds that this would be against English public policy (*City of Gotha* v. *Sotheby's* [1998] 1 WLR 114; QB [1998]).

Most legal systems contain a mechanism for the cutting off of legal claims after the passage of a certain amount of time. In common law countries, statutes of limitation provide that a law suit must be brought within a certain length of time from when the cause of action accrued. In the United States, where this is regulated under the law of individual states, the time period is typically quite short, ranging from two to ten years. In continental European and other nations, such statutes operate under a principle of prescription and often provide two different time periods, depending on whether the current possessor has acted in good faith. The purpose of such statutes is to prevent the bringing of a claim after the evidence has grown stale, witnesses are no longer available, or their memories have become unreliable and, from the museum's perspective the most important consideration, to provide security of title and facilitate commercial exchanges.

Despite the policies in favor of these statutes, judges have been reluctant to cut off the claims of original owners because art works are easily transported to different jurisdictions and are easily hidden for many years (as happened with the Holocaust-looted art works). This makes it difficult for owners to bring their claims within a short time of the theft. Because the statutes do not define when the cause of action accrues, judges have the opportunity to assure to the original owner a reasonable opportunity to locate the stolen art work and learn the identity of the current possessor.

Many jurisdictions have therefore fashioned a mechanism that delays the accrual of the cause of action, sometimes for an extended period of time. New York has adopted the "demand and refusal" rule. The original owner's cause of action does not accrue until the owner has made a demand for return from the current possessor and the possessor refuses (*Menzel* v. *List*, 267 NYS 2d 804 [NY Sup. Ct 1966]; *Kunstsammlungen zu Weimar* v. *Elicofon*, 678 F.2d 1150 [2d Cir. 1982]). More recently, the New York courts have grafted onto the "demand and refusal" rule the equitable doctrine of *laches*, an additional means by which the current possessor may bar the original owner's claim, if the original owner delayed unreasonably in bringing suit and the current possessor was prejudiced by this unreasonable delay (*Solomon R. Guggenheim Foundation* v. *Lubell*, 569 NE 2d 426 ([NY 1991]).

Other jurisdictions in the United States have adopted a "discovery rule." Under this approach, the accrual of the cause of action is delayed so long as the original owner uses due diligence in attempting to discover the whereabouts of the stolen art work (*O'Keeffe* v. *Snyder*, 416 A 2d 862 [NJ 1980]; *Autocephalous Greek-Orthodox*

Church of Cyprus v. *Goldberg and Feldman Fine Arts*, 917 F 2d 278 [7th Cir. 1990]). California is the only state in the United States with a statute of limitations that specifically delays accrual of the action for the recovery of "any article of historical, interpretive, scientific or artistic significance" until the original owner has discovered the location of the stolen property. (Cal. Code Civ. Proc. §338 [c]). In January 2003, a new statute went into effect in California which suspends the statute of limitations for the recovery of art works stolen during the Holocaust until December 31, 2010 (Cal. Code Civ. Proc. §354.3).

As attention to the problem of art works looted during the Holocaust grew, museums in the United States responded to the possibility of increased government regulation by taking several steps to ensure more adequate self-regulation. This resulted in the issuance of new guidelines from the AAM and AAMD to encourage museums to be more careful in making new acquisitions and in accepting works as gifts and on both short- and long-term loan. The guidelines also called for significant new provenance research of art works currently in museum collections in an attempt to identify any works that may have been looted during the Holocaust. Many of the major museums in the United States have undertaken this work and have now posted the results on their websites so that potential claimants can learn if a particular museum has in its collection any works of art with gaps in their ownership history between 1933 and 1945. However, this research, as time-consuming and labor intensive as it is, has focused almost exclusively on paintings and has not encompassed other types of objects that were looted, including furniture, objets d'art, and objects of Judaica.

As of spring 2002, approximately one thousand objects in American museums were identified as having questionable gaps in their provenance (Cuno 2002). Only twelve claims had been brought against museums in the United States (Spiegler 2001: 300–303; Gerstenblith 2003: 438–9). Most of these cases were settled by private agreement. Four of the paintings were returned to private hands; eight remained in public collections, often with compensation paid to the claimants (Gerstenblith 2003: 440–41). One case raised the interesting question of the liability of the dealer to the museum (which was not the party to whom the dealer had sold the painting) and of the value of the loss to the museum, which had received the painting as a gift. These questions were not answered as the case was settled privately with the gallery compensating the museum for an undisclosed sum (*Rosenberg* v. *Seattle Art Museum*, 124 F. Supp. 2d 1207 [WD Wash. 2000]).

Two additional cases have been brought against European museums (the Belvedere and Leopold in Vienna) in United States courts for recovery of art works stolen during the Holocaust (*US* v. *Portrait of Wally*, 2002 US Dist. LEXIS 6445 [SDNY 2002]; *Altmann* v. *Austria*, 541 US 677 [2004]). In *Altmann* v. *Austria*, the heirs of Adele Bloch-Bauer sued Austria to recover the value of four Klimt paintings which are still located in Austria. The United States Supreme Court held that Austria is not immune from suit in California under the Foreign Sovereign Immunities Act, thereby allowing the claim to proceed to trial. This opens the possibility of many more claims being brought in US courts against foreign museums for the recovery of the value of stolen art works in their collections, even when the works are not physically present in the United States.

449

Claims have been brought against European museums, particularly in France, Austria, Germany, and to some extent England (Palmer 2000: 129–57). At the end of the war, approximately two thousand works of art were placed in various French museums. In the late 1990s, the Artworks Sub-committee of the Study Mission on the Spoliation of Jews in France undertook to study the background of these works. As a result, thirty-two works of art were returned to their proper owners, but little was learned definitively about the other works and these remain in French museums (Palmer 2000: 150–57).

In the wake of the publicity surrounding the Egon Schiele case in New York, in 1998 Austria passed the Act of the Federal State on the Return of Cultural Objects from the Austrian Federal Museums and Collections (BGBI No. 181/1998, Articles 1 and 2 [1] [i]), which led to examination of the collections of Austrian museums to determine their background and authorized the return of objects to the owners or their heirs at the museum's discretion. The categories of objects affected by this law include those that the owners agreed to transfer to Austria after the war in exchange for permission to export other possessions. The results have been inconsistent. In 1998, a collection was returned to the Rothschild family, but Austria has refused to relinquish the Klimt paintings to the heirs of Adele Bloch-Bauer. Finally, German museums succeeded in recovering two Dürer paintings taken from the Kunstsammlungen zu Weimar and the medieval treasures taken from the Quedlinberg Monastery during the war by American servicemen. It seems likely that claims against museums by descendants of Holocaust victims will continue at least so long as the evidence of proper ownership is still available. Museums need to consider not just the legal technicalities but also the moral and ethical concerns that these claims engender.

Archaeological heritage

Museums that maintain collections of archaeological objects have also confronted increasing claims for restitution. Some of these claims focus on antiquities that have been housed in a particular museum collection for centuries, such as the Parthenon Sculptures and Rosetta Stone in the British Museum. Thus far, museums have generally resisted these calls for restitution, in part because these objects may be among the most valued and visited objects in a particular collection, in part because of fear that restitution of a few objects will make the rest of their collections vulnerable to subsequent claims. In December 2002, eighteen of the world's leading museums issued the Declaration on the Importance and Value of Universal Museums, in which they argued that objects that have been in a museum collection for a period of time become part of the cultural heritage of the new nation and therefore claims for restitution should be resisted. The declaration furthermore posits that the actions of the past should not be judged by the mores or laws of today and that the role of the museum that collects objects from throughout the world should be valued and maintained. Despite the attention given to claims for restitution, no museum has been forced to return any object that was acquired during the nineteenth or even early half of the twentieth century. The concerns in this regard seem to focus more on ethical and historical questions than on legal issues.

Of greater relevance to museums are archaeological objects that have been acquired in more recent times. In addition to the usual concerns about the possible acquisition of objects that are stolen in the traditional sense, when acquiring antiquities museums need to be aware of particular legal rules, international conventions, and domestic legislation that may restrict the ability to acquire antiquities. Archaeologists who have studied the market in antiquities estimate that approximately 85–90 percent of antiquities on the market do not have documented provenance (that is, a history that can be traced to the archaeological find-spot) and they suggest the likelihood that most of these antiquities are the product of recent site looting (Chippindale and Gill 1993; Elia 2001). Museums need to be particularly cautious in acquiring undocumented antiquities or they run the risk of losing these objects and their value. In addition, when museums act as the final consumers of undocumented antiquities, they contribute to the problem of site looting. Looting of archaeological sites destroys the context in which the remains of the past are found and irreparably injures the ability to retrieve and reconstruct the past. When they contribute to this problem, museums are failing to fulfill their educational and scientific purposes.

Many archaeologically rich nations have enacted laws that vest ownership of newly discovered antiquities in the nation. Any objects excavated and removed without permission of the government are therefore stolen property. These laws reduce the incentive to loot sites by preventing the looter from gaining title to the looted antiquities. The legal status of such objects as stolen property was first tested in the United States in the criminal prosecution of dealers conspiring to deal in Pre-Columbian artifacts from Mexico in 1977. A series of cases applying this doctrine to civil replevin suits in which the artifacts were returned to their country of origin on the grounds that they were stolen property culminated in June 2003 in the affirmance of the conviction of a prominent New York dealer for conspiring to deal in antiquities stolen from Egypt (*US* v. *Schultz*, 333 F.3d 393 [2d Cir. 2003]).

The Metropolitan Museum of Art's acquisition of the Lydian Hoard illustrates the application of this legal doctrine to a museum. The Lydian Hoard was a collection of over 360 objects, including fragments of wall paintings, marble sphinxes, gold, silver, and bronze vessels, and jewelry, dating to the sixth century BC (Kaye and Main 1995). The Met secretly acquired the hoard, which had been looted from a series of tombs located in west-central Turkey, between 1966 and 1970 for over a million dollars and kept the objects in storage for fear of discovery of their true origin. However, when the Met placed a few of the objects on display in the mid-1980s, Turkey decided to sue for recovery of the hoard. Turkey's vesting law dates to the early 1900s and the hoard was therefore stolen property. Although the Met initially resisted Turkey's claim based on the statute of limitations, once the court held that Turkey's claim was not time-barred, the Met agreed to settle and returned the entire hoard (*Republic of Turkey* v. *Metropolitan Museum of Art*, 762 F. Supp. 44 [SDNY 1990]). These examples reinforce the point that museums, as well as private collectors, must be cautious in acquiring archaeological objects that originate in a nation with a national ownership law because, unless the object was obtained before

the effective date of the legislation, the likelihood is that the museum will be acquiring stolen property.

The United Kingdom in October 2003 enacted a new Dealing in Cultural Objects (Offences) Act 2003 which creates a new offense of dealing in "tainted cultural objects." One commits this offense if he or she "dishonestly deals in a cultural object that is tainted, knowing or believing that the object is tainted" (section 1, subsection 1). The statute defines a "tainted object" under the following circumstances: "(2) A cultural object is tainted if, after the commencement of this Act – (a) a person removes the object in a case falling within subsection (4) or he excavates the object, and (b) the removal or excavation constitutes an offence" (section 2, subsection 2). Subsection 4 refers to objects removed from "a building or structure of historical, architectural or archaeological interest" or from an excavation. For the purposes of the statute, it does not matter whether the excavation or removal takes place in the United Kingdom or in another country or whether the law violated is a domestic or foreign law (section 2, subsection 3).

Antiquities and other art works may be subject to seizure and forfeiture if the object is not declared or not properly declared upon import because of a mis-statement as to value or country of origin. Mis-statements of both value and country of origin led to the forfeiture of a fourth-century BC gold phiale from Sicily which had been purchased by New York collector Michael Steinhardt. Although the dealer knew that the phiale originated in Sicily, the country of origin of the phiale was stated to be Switzerland and its value was placed at $250,000 rather than the actual $1.2 million. This constituted a material misrepresentation and violation of the US Customs statute. The phiale was therefore held to be contraband and it was forfeited and eventually returned to Italy (*US* v. *An Antique Platter*, 184 F.3d 131 [2d Cir. 1999]).

Finally, import of cultural objects, particularly antiquities and ethnographic objects, may be prohibited under Article 9 of the 1970 UNESCO Convention on the Means of Prohibiting and Preventing the Illicit Import, Export and Transfer of Ownership of Cultural Property. In the United States, import restrictions on designated categories of archaeological and ethnological materials may be in place pursuant to either an emergency action or a bilateral agreement between the United States and another party to the Convention. In addition, the import of any stolen cultural property that has been documented in the inventory of a museum or other public collection is also prohibited (19 USC §§2601–13).

This summary of the various legal doctrines and rules that may apply to a museum's acquisition or loss of archaeological objects should demonstrate the legal regime now in place in many nations with respect to antiquities. Museums need to be versed in the intricacies of these legal rules and they must be prepared to abide by them so as to avoid risk of loss from their collections as well as of financial assets. Acquisitions made in ignorance or in violation of these legal rules will also cause negative publicity and will be likely to result in tensions between the museum and the country from which these objects originate which, in turn, will make cooperative efforts in the future more difficult. Finally, museums should recall their role as educational institutions and avoid contributing to the loss of knowledge that results from the looting of archaeological sites.

Human remains and indigenous cultural objects

In 1990, Congress enacted the Native American Graves Protection and Repatriation Act (NAGPRA; 25 USC §§3001–3013). Among its provisions, NAGPRA requires museums that receive federal funds to prepare inventories of Native American human remains and associated grave artifacts in their collections. These inventories identify the cultural and geographical affiliations of these remains to the extent possible. The museum must notify those Native Americans reasonably believed to be culturally affiliated with the inventoried items. Museums must also prepare and publish less detailed summaries of unassociated funerary objects, sacred objects, and cultural items.

Native American tribes can obtain restitution based on the cultural affiliations established in the inventories and summaries. Human remains and associated grave goods must be returned expeditiously upon request by a lineal descendant, Indian tribe, or Native Hawaiian organization. If the inventory does not establish a cultural affiliation, a Native American tribe or Hawaiian organization may still obtain restitution by proving by a preponderance of the evidence that it has a cultural affiliation with the items. If the requested items are unassociated funerary objects, sacred objects, or cultural objects, and if cultural affiliation can be established, then the requesting group must present a prima facie case that the agency or museum does not have the right of possession to the item. Upon presentation of a prima facie case, the burden of proof shifts to the museum to establish that it does have the right of possession.

As with the examples of restitution claims for art works stolen during the Holocaust and for archaeological artifacts, when NAGPRA was first enacted, many in the museum community protested that NAGPRA would result in the emptying of museum collections. It is difficult to determine how many human remains and objects have been returned under NAGPRA because, while information concerning the inventories and summaries must be published, there has been no systematic publication of the materials returned (Roberts 2000: 89). While it may be assumed that a fair number of human remains have been returned, so far as the information that is available indicates, very few objects that had been on display in museums have been returned, with many of the objects that have been returned apparently coming from storage. One significant exception was the restitution in the summer of 2001 of totem poles, carved house posts, and a façade from a Tlingit clan house that were returned from five different museums to the Tlingit tribe of Alaska (Mullen 2001: 9).

The NAGPRA process has resulted in a significant increase in the knowledge and understanding of indigenous cultural objects housed in American museums. Many of these objects had not been fully catalogued or studied before NAGPRA required the museums to produce the inventories and summaries. Additional knowledge concerning not only these artifacts but also Native American history and culture has been gained through the collaboration with tribes that is mandated by the NAGPRA repatriation process (Nafziger and Dobkins 1999: 83–91). At the same time, new museums have been established within the Native American community; in some situations, the repatriation process is not so much a removal of indigenous cultural objects from museums as a shift in the type of museum that cares for and displays the objects.

Those objects that have remained in their original museum locations can now be presented to the public with increased sensitivity, knowledge, and understanding.

Restitutions of indigenous objects from museums in other countries have also occurred, but these have generally been the result of private negotiation rather than the result of a single national statute that has imposed a process similar to that of NAGPRA. In Canada, a report produced by the Task Force on Museums and First Peoples focused more on the ways in which museums display and interpret First Nations' cultural remains than on restitution (Bell and Paterson 1999: 196–9). The Simon Fraser University Museum of Archaeology and Ethnology and the Saanich Native Heritage Society reached an agreement which prevented the export of a privately owned human-figure bowl, allowed the museum to retain custody of the bowl, and allowed the society to use the bowl for purposes of display and traditional use. The National Museum of Man in Quebec repatriated a collection of potlatch objects to the U'mista Cultural Centre in Alert Bay, British Columbia, in 1975 (Bell and Paterson 1999: 199–202). Returns of Maori indigenous objects have also been few, but in 1996 the Otaga Museum returned the Mataatua meeting house to the Ngati Awa with the New Zealand government paying compensation to the museum with which it planned to build a different meeting house (Paterson 1999: 123–5).

The same is true of human remains, although here greater sensitivity is shown to the concerns for reburial, and human remains have often been voluntarily withdrawn from display (Paterson 1999: 125). In England, the report of the Ministerial Working Group on Human Remains published its report in November 2003 on the disposition of human remains in English museums (Weeks and Bott 2003). While the scope of its work is limited to human remains and so is not comparable to NAGPRA, the desire to confront issues of human remains reflects an increasing sensitivity to indigenous cultural issues within England and other nations that is likely to have an impact on museum collections.

Conclusion

While museums throughout the world are viewed as repositories of the tangible remains of human society, museums must increasingly concern themselves with legal issues. While these issues often focus on relatively mundane questions, such as property law and tax exemptions, museums now also must concern themselves with stolen art works, illegally excavated and removed archaeological objects and dismembered cultural monuments, and, finally, indigenous cultural objects and human remains. All of this reflects an increasing sensitivity to these issues throughout the world, as well as an understanding that concern for these issues is necessary if museums are to fulfill their essential educational and scientific purposes.

Bibliography

AAM (American Association of Museums) (n.d.) *Code of Ethics* (www.aamus. org/aamcoe.htm).

AAMD (Association of Art Museum Directors) (n.d.) www.aamd.org/deaccess.shtml.

Bell, C. E. and Paterson, R. K. (1999) Aboriginal rights to cultural property in Canada. *International Journal of Cultural Property*, 8: 167–211.

*Boyd, W. L. (1999) Museums as centers of controversy. *America's Museums, Daedalus*, 128 (3): 185–228.

Chippindale, C. and Gill, D. W. J. (1993) Material and intellectual consequences of esteem for Cycladic figures. *American Journal of Archaeology*, 97: 601–59.

Cuno, J. (2002) The international trade and the ethics of collecting. Harvard Arts Panel, February 21, 2002 (videotape of panel discussion available at www.law.Harvard.edu/faculty/martin/artspanel_symposium.htm).

*Elia, R. J. (2001) Analysis of the looting, selling, and collecting of Apulian red-figure vases: a quantitative approach. In N. Brodie, J. Doole, and C. Renfrew (eds), *Trade in Illicit Antiquities: The Destruction of the World's Archaeological Heritage*, pp. 145–53. Cambridge: McDonald Institute for Archaeological Research.

Gabor, D. R. (1989) Deaccessioning fine art works: a proposal for heightened scrutiny. *UCLA Law Review*, 36: 1005–49.

Gerstenblith, P. (2003) Acquisition and deacquisition of museum collections and the fiduciary obligations of museums to the public. *Cardozo Journal of International and Comparative Law*, 11: 409–65.

Goldstein, J. R. (1997) Deaccession: not such a dirty word. *Cardozo Arts and Entertainment Law Journal*, 15: 213–47.

Hoving, T. (1994) *Making the Mummies Dance*. New York: Simon and Schuster.

Kaye, L. M. and Main, C. T. (1995) The saga of the Lydian hoard antiquities: from Uşak to New York and back and some related observations on the law of cultural repatriation. In K. W. Tubb (ed.), *Antiquities Trade or Betrayed: Legal, Ethical and Conservation Issues*, pp. 150–61. London: Archetype.

Lee, W. A. (2000) Charitable foundations and the argument for efficiency: balancing donor intent with practicable solutions through expanded use of *cy près. Suffolk University Law Review*, 34: 173–202.

Meyer, K. E. (1979) *The Art Museum: Power, Money, Ethics*. New York: William Morrow.

Mullen, W. (2001) Return of relics helping Tlingit close the circle. *Chicago Tribune*, July 25: 9.

Nafziger, J. A. R. and Dobkins, R. J. (1999) The Native American Graves Protection and Repatriation Act in its first decade. *International Journal of Cultural Property*, 8: 77–107.

*Nicholas, L. (1994) *The Rape of Europa: The Fate of Europe's Treasures in the Third Reich and the Second World War*. New York: Alfred A. Knopf.

*Palmer, N. (2000) *Museums and the Holocaust: Law, Principles and Practice*. Leicester: Institute of Art and Law.

Paterson, R. K. (1999) Protecting *Taonga*: the cultural heritage of the New Zealand Maori. *International Journal of Cultural Property*, 8: 108–32.

Roberts, J. C. (2000) A Native American Graves Protection and Repatriation Act census: examining the status and trends of culturally affiliating Native American human remains and associated funerary objects between 1990 and 1999. In D. F. Craig (ed.), *Topics in Cultural Resource Law*, pp. 79–90. Washington, DC: Society for American Archaeology.

Spiegler, H. N. (2001) Recovering Nazi-looted art: report from the front lines. *Connecticut Journal of International Law*, 16: 297–312.

Weeks, J. and Bott, V. (2003) Scoping survey of historic human remains in English museums (www.culture.gov.uk/global/publications/archive_2003/wgur_report2003.htm; accessed March 28, 2004).

*Weil, S. E. (1999) From being about something to being for somebody: the ongoing transformation of the American museum. *America's Museums, Daedalus*, 128 (3): 229–58.

White, J. L. (1996) When it's OK to sell the Monet: a trustee–fiduciary–duty framework for analyzing the deaccessioning of art to meet museum operating expenses. *Michigan Law Review*, 94: 1041–66.

Non-Western Models of Museums and Curation in Cross-cultural Perspective

Christina Kreps

Collections and structures with museum-like functions have existed throughout the world since ancient times. In Asia, precious items were often deposited in temples and shrines for safekeeping (Bazin 1967: 29; Ambrose and Paine 1993: 6). Chinese emperors were making collections of paintings and calligraphies as early as the third century BC (Bazin 1967: 26). In India, *chitrashalas*, or painting galleries, "were a means of education as well as a source of enjoyment, the paintings and sculpture providing lessons in history, religion, and art" (Ambrose and Paine 1993: 6). Indeed, as Clifford has noted, "accumulating and displaying valued things is, arguably, a widespread human activity not limited to any class or cultural group" (1997: 217). The role of curator is also an ancient occupation. "In many societies objects important to the group were appointed custodians. For example, in the Cross River region of West Africa certain masks were appointed an elder or respected person to take responsibility for them" (Ambrose and Paine 1993: 6).

These early examples of museum-like structures, collections, and curators are generally distinguished from what has come to be seen as the concept of the modern museum which developed in Europe in the seventeenth century (Ambrose and Paine 1993: 6). The notion that the museum is a uniquely modern, Western cultural invention has become deeply rooted in Western museology to the point of neglecting other cultures' models of museums and curatorial practices. Recent studies, as outlined in this chapter, are making up for this lack of attention.

Non-Western models of museums and curatorial practices have value in their own right as unique cultural expressions, and as examples of human cultural diversity. But they also have much to contribute to our understanding of museological behavior cross-culturally, or rather, how people in varying cultural contexts perceive, value, care for, and preserve cultural materials. The study of these phenomena also tells us something about what items from the material world people choose to collect, assign special value to, and preserve for the future. It may also open up the investigation of non-Western concepts of time and its reckoning, since objects often are used to mark specific historical moments and the flow of time, and can act as both

markers and makers of history in a people's sense of historical consciousness (Hoskins 1993).

The recognition of non-Western models of museums and curatorial practices has relevance to the political and cultural concerns of non-Western or indigenous peoples whose material culture has been collected and housed in museums. The widespread assumption that non-Western peoples are not concerned with the care and long-term preservation of their cultural materials has long been used to justify its collection and retention in Western museums. While many valuable objects in museums may not have been preserved otherwise, many cultures have long had their own methods of cultural heritage preservation. It is now well known that the removal of certain objects from their source communities has led to the demise of related cultural traditions, particularly those concerning spiritual beliefs and religious practices (see Peers and Brown 2003). Some native peoples, such as the Zuni, believe that the alienation of particular objects from their original context has even created an imbalance in the universe that can only be restored with the return of these objects (see, for example, Childs 1980).

Over the past couple of decades, representatives of source communities, along with other critics, have called for the examination of the historical development of museums and ethnographic collections within the context of Western colonialism, and how "collections brought together under conditions of colonialism are embedded in power relationships" (Nicks 2003: 20). In response, museum professionals have subjected their field to a much-needed self-scrutiny. As a result, more equitable relations between museums and source communities are being forged and leading to the development of more inclusive, collaborative, and culturally relative museological approaches.

This chapter provides examples of non-Western models of museums and museological behavior from a wide range of cultural settings, and examines them from the perspective of comparative museology.

Critical and Comparative Museology

Comparative museology is the systematic study of the similarities and differences among museological forms and behavior cross-culturally (Kreps 2003b: 4). There is, of course, a great deal of variety among Western museums, though also a set of broadly shared practices and assumptions. By placing these in critical and dialectical relation to non-Western museological practices, understandings of Western museological practices can be extended. Museological practices are those that are concerned with the preservation of valued cultural materials. They include the creation of structures or spaces for the collection, storage, display, and preservation of objects, as well as practices related to their use, interpretation, care, and conservation. Cultural heritage preservation is defined as the transmission of culture through time.

Comparative museology can be seen as one of the many outcomes of the postcolonial critique of museums and museum practices that began to emerge in the 1980s and 1990s from both the scholarly community and those whose cultures have

been historically represented in Western museums housing ethnographic collections (see chapter 10). No longer can we take the Western museum concept and curatorial practices as naturalized givens, but must now see them as cultural artifacts in themselves, or products of particular historical and cultural contexts created to serve specific interests and purposes. This more critically informed and reflexive approach has illuminated how curatorial positions of authority and power can shape museological practice.

The postcolonial critique of museums and what can be seen as one of its offspring – a new critical theory of museums – also have been concerned with the discourse of Western museology. Discourse analysis has been a powerful tool for unveiling how Western museological discourse has produced certain ways of thinking and talking about museums and curatorial practices, while disqualifying and even making others impossible to see. Western museology, as a discursive field or constructed domain of thought and action, has been an apparatus for producing knowledge about and exercising power over the curation and preservation of cultural materials.

Professional Western museology has rested almost exclusively on one knowledge system, namely the modern Western one. This knowledge system has dictated why and how non-Western cultural materials have been collected as well as the ways in which they have been perceived, curated, and represented. Within this particular knowledge system, non-Western objects have been systematically organized and reconfigured to fit into Western constructs of culture, art, history, and heritage. Due to the hegemony of Western museology, most people have difficulty thinking and talking about museums, curation, and heritage preservation in terms other than those provided by Western museological discourse. One of the goals of critical and comparative museology is to "liberate" culture – its collection, interpretation, representation, and preservation – from the management regimes of Eurocentric museology. The liberation of culture is not only about restoring people's rights to and control over the management of their cultural heritage, it is also about liberating our thinking so that we can recognize museological behavior in other forms (Kreps 2003b). The liberation of culture allows for the emergence of a new museological discourse that includes multiple voices, representing a broad range of perspectives and bodies of knowledge that have been historically overlooked.

The final section of this chapter discusses current trends in Western museums that reflect more inclusive, cross-culturally oriented approaches to curation and cultural heritage management. These trends exemplify how critical and comparative museology is being applied in practice. They also reflect a shift in a primary focus on objects in museums to a focus on the social relationships represented by collections and the museum as a social arena (Handler 1993).

Indigenous Models of Museums and Curation

Shrines and temples

Shrines and temples are often seen as similar to museums because they are places that store, display, and preserve highly valued objects. The care of shrines and

temples, as well as their contents, is frequently entrusted to certain members of society – especially healers and priests – who may be seen as their "curators." In many respects, these structures have functioned to preserve and pass on cultural traditions, beliefs, and values, and their expression in material forms. As Okita (1982) emphasizes, the significance of shrines extends far beyond religious beliefs and practices, and is ultimately connected to nearly all aspects of life:

> The importance of shrines as a vehicle, transmitting a people's cultural heritage, does not emanate from the fact that shrines are the embodiment of socio-religious ideas that give meaning and sustain life in a traditional society. The objects kept in the shrines, the worship or festival that takes place there are all symbolic acts that sometimes deal with the traditions of origin of a people, the rather inexplicable natural forces or phenomena that must be personified or certain norms or laws considered necessary for the sustenance of society all of which are invariably connected with the life cycle . . . The ideas behind or the significance of festivals, shrines and the objects connected with them, are what every traditional society wants to pass on from one generation to another. (Okita 1982: 9–10)

Okita adds that the village as a whole or a clan elder may be responsible for taking care of the shrine and protecting its contents.

Sacred storage houses

In tribal villages throughout the Malay Archipelago special houses were created to store sacred paraphernalia such as hunted heads, ancestor relics, lineage symbols, and other valuables. These sacred storage houses also sometimes served as temples (Bellwood 1985: 151). The Pardembanan Batak of Sumatra formerly erected temples (*parsoeroan*) to house the spirits of ancestors as well as sacred objects used in their veneration, such as gongs, drums, and precious ceramics. The *datoe*, or priest, was responsible for looking after the *parsoeroan*, placing offerings to the spirits and summoning them by beating the sacred drums. The *parsoeroan* was part of a larger sacred enclosure where villagers assembled for ceremonies (Bartlett 1934: 2–3).

Bartlett wrote that in 1918 there were very few *parsoeroan* left in north Sumatra due to the people's conversion to Islam or Christianity (1934: 5). However, in the course of conducting research in Indonesia over the past decade or more, I have observed that the practice of collecting and storing sacred and other objects, such as heirlooms, has not died out in the islands. Collections of objects can still be found in the rafters and attics of traditional houses or in other structures, such as granaries or rice barns. Traditionally, the granary has carried a sacred aspect and thus has been treated with reverence. Rice barns can be attached to a house or consist of a separate building. They are often elaborately carved and decorated, and the number and size of a family's rice barn, as well as the quality of its workmanship, are signs of the owner's wealth and prestige (Waterson 1990: 59).

While conducting research in East Kalimantan (Indonesian Borneo) in 1996, I observed how the *lumbung*, or rice barn, was still being used to store family heirlooms (in addition to rice supplies), such as gongs, drums, brassware, and highly

valued Chinese jars known in the Indonesian language as *tempayan* or *guci*. In conversations with community members in one village, I learned that although today each family possesses its own individual rice barn, in former times, the village maintained a *lumbung desa*, or communal rice barn. It was used to house communal property such as ritual regalia and goods received in payment of fines when customary laws were broken. One villager explicitly likened the rice barn to a "traditional museum," or a place where special items are stored, protected, and preserved to be passed on to future generations.

Indigenous conservation and preservation

I also discovered that the rice barn was similar to a museum in how it exhibited a preservation ethos as well as actual conservation techniques. In this region of East Kalimantan, rice barns are generally located outside villages and on high ground where they can be protected from fires and floods. The overall design of the rice barn and certain architectural features act as forms of "preventive conservation." For example, movable awnings and vents work to regulate the temperature inside the barn and facilitate ventilation, operating as a "climate control" system. Thatched roofing also aids ventilation and is considered to be a particularly appropriate technology adapted to hot and humid tropical climates (Waterson 1990: 87). Charcoal is also sometimes placed inside the rice barn as a dehumidifier. Indigenous techniques of "pest management" are also evident in the *lumbung*. Curved wooden planks or disks are placed at the top of piles that support the structure to prevent rodents from entering the rice barn. Inside the rice barn, other measures are taken to protect its contents from pests. In one village, I was told that the skin of a weasel–like animal is hung inside the rice barn because its pungent odor is said to repel mice and rats. Natural fumigating agents, such as the smoke of burning peppers, are also used to eradicate insects and to slow the growth of mold and fungus. In sum, the *lumbung* is an indigenous model of a museum both in terms of a place to house precious goods and in the conservation techniques employed to protect them.

The Maori *pataka* is similar to the Indonesian *lumbung* and other sacred structures as a space designed to store food reserves and precious items, as well as being a symbolic and physical manifestation of the ancestors, wealth, and status. Traditionally, the *pataka* was used by a chief and contained valuable objects, such as ornaments, weapons, ritual regalia, and preserved foods. It was ornately carved and had its own name and history related to the ancestor from which a tribe's descendants traced their heritage. The owner's personal *mana*, or power, was invested in the *pataka* and ensured its protection (American Museum of Natural History object label 2002; see also Evans 1999).

"Indigenous museums" in Oceania

Mead (1983), in "Indigenous Models of Museums in Oceania," likens museum–like structures created by cultures throughout the Pacific region to Western museums. To Mead, the Maori meeting-house is an example of an indigenous model of a

museum because it is used to store and display carvings, photographs, traditional weapons, valued art objects, and heirlooms, as well as being a communal gathering place (1983: 98). He also describes the "custom houses" found in the Eastern Solomon Islands, and asserts that some "look very much like museums." They are similar to museums in their function as a place to store and display valued objects, and as an educational resource where local art traditions can be studied and preserved (1983: 99). Mead also provides examples of indigenous customs and beliefs that help protect objects kept in custom houses. He explains that, in keeping with the traditions of most Polynesian and Melanesian societies, the items stored in the houses are considered taboo. The taboo status of these objects works as a traditional security system since it functions to restrict access and use (1983: 101).

The traditional men's houses, *haus tambaran*, of the Sepik River region of Papua New Guinea are also often cited as indigenous models of museums (for example, Lewis 1990; Simpson 1996; Stanley 1998). These richly decorated structures vary in style and use from one ethnic group to another. But, in general, they have been used as a meeting place and for ceremonies and rituals related to male initiation rites. Lewis describes *haus tambaran* as "sacred repositories where objects were ritually preserved" (1990: 159). *Haus tambaran* may also serve as a workshop for the production of ritual objects and other arts in addition to a place for displaying and preserving them. As structures designed for preserving valuable objects and for teaching younger generations about tribal history, beliefs, and cultural practices, *haus tambaran* have been important centers for the transmission of local cultural knowledge (Simpson 1996: 112). Traditionally, women and uninitiated males were not allowed access to the *haus tambaran* (Kaeppler 1994: 21), but, today, traditional customs such as this are being modified to accommodate changing attitudes and socio-economic conditions. In some cases, outsiders, including tourists, as well as women are allowed access due to the increasing use of *haus tambaran* as community cultural centers and museums.

The example of the *haus tambaran* shows that the museum concept is not an entirely new cultural form in Papua New Guinea. As Mosuwadoga, a former director of the Papua New Guinea National Museum in Port Moresby, asserts:

> The necessity for building a communal type of house to secure and to house these objects is not a new or uncommon practice. Papua New Guinea was doing this long before the museum reached our country. The name and function of a museum can be looked upon in our society today as fitting into our basic ideals, which were with us long before any influence actually reached us. (quoted in Edwards and Stewart 1980: 157)

Indeed, in Papua New Guinea and elsewhere, present-day indigenous museums are, as Simpson points out, contemporary versions of old traditions: "They show evidence of concepts of collection, storage and preservation being applied within a particular cultural framework as extensions of earlier traditions, but with the adoption, in some instances, of modern museological environmental, security, and recording methods" (1996: 107).

462

Collections and audiences

Indigenous museums are often distinguished from their Western counterparts by the nature of their collections, how these collections are used, and their audiences. Simpson notes that indigenous museums are generally devoted to the collection, display, and preservation of objects originating from within their own communities, and that "most of the objects continue to fulfill their original function, and indeed are frequently still in regular usage" (1996: 13). This stands in contrast to the situation of ethnographic collections in Western museums, which have been removed from their source communities and no longer fulfill their original functions (see Peers and Brown 2003).

While it is true that objects are given new values and meanings and serve different purposes once they are recontextualized into the frameworks of Western museum culture, we should not assume that they remain stable in their source communities and always continue to be used for their original purposes. The meanings, values, and functions of objects in indigenous contexts can also be contingent. To many Indonesian societies, for instance, objects, especially sacred objects and heirlooms, possess an agency that allows them to move around, often on their own accord, and take on new identities. While some objects must stay in place and are intentionally removed from circulation, others are supposed to circulate, and in the course of their social lives, are given new values, meanings, and functions. Furthermore, the purposes objects can serve and the values they can hold in a Western museum setting are not entirely different from those in their original contexts. In both indigenous and Western museums objects function as a medium to communicate and transmit knowledge, and are valued for the stories they can tell. They can also be used as "evidence" in both contexts; for example, of a historical past or in claims to authority (Clifford 1988; Hoskins 1993).

Because objects in indigenous museums tend primarily to represent aspects of the source community's own culture, it is often assumed that the "storage and contemplation of culturally removed objects is a peculiarly Western practice" (Margaret West quoted in Simpson 1996: 113). Simpson states that apart from war trophies or other objects with prestige value "in indigenous [museum] models, few objects from other cultural groups were displayed" (1996: 113). Such assertions imply that non-Western peoples have not been interested in exotica or foreign objects as "curiosities." My own research on museums and curatorial practices in Indonesia, however, shows otherwise. Elsewhere (see Kreps 1998, 2003b) I have described the elaborate collecting and curatorial practices of the Dayaks of Borneo who are well known for their extensive collections of Chinese jars. These objects are highly prized partly because they originated outside Dayak culture. Neller and other authors have commented on a similar inclination among Hawaiians: "The Hawaiian appropriation of European objects stood on equal footing with the European appropriation of Hawaiian objects" (Neller 2002: 127). As further evidence of how a fascination with objects of "others" may be a widespread human tendency, during the course of my research on the Provincial Museum of Central Kalimantan in Indonesian Borneo, in 1991 and 1992, I heard from community members that one of the reasons they did not visit the museum was because it housed collections that were *biasa* or common; that is,

463

Christina Kreps

things from their own culture. They told me that they would visit the museum if objects from other cultures and countries were shown because these would be more intriguing.

It is often argued that a particular "discipline of looking" has been developed in the Western museological context and that this is characterized by "the disconnection of objects from the contexts in which they were made and used" (Bolton 2003: 43). Certainly, the "discipline of looking," as it has been developed in Western museum culture, is particular to that context (see chapter 16). However, we should not dismiss the possibility that other cultures have developed their own disciplines of looking as well.

It is also often asserted that non-Western peoples do not value objects in and of themselves or for their intrinsic qualities as much as they value their symbolic meanings and functions (see Cannon-Brookes 1984; Bolton 2003). Furthermore, it has long been contended that there is no appreciation of "art for art's sake" in traditional societies. But the case of Dayak jar collectors, mentioned above, contradicts both these claims. Dayaks historically have been intensely interested in the artistic merits of individual jars and their formal properties. In fact, Dayaks have been referred to as "native connoisseurs" due to their expertise in discerning matters of authenticity, provenance, dating, qualities of glazes, form, decoration, and other formal criteria used to evaluate a jar's worth (O'Connor 1983: 402–5; Harrisson 1990).

Comparing Western and Indigenous Models: Access and Objects

While some of the generalized assertions about indigenous societies may be accurate in some cases, they certainly are not true for all. At the same time, while there are many points at which certain Western and indigenous models of museums converge, especially in their purposes and functions, there may be distinct differences.

One of the most overt differences between indigenous and Western models of museums rests on issues of access and what falls within the public domain. The modern, Western museum is generally considered a public entity, and, in fact, this is what has distinguished it from its predecessors, that is, royal cabinets and private collections (see chapter 8). Museum collections are held in the public trust, and by definition are to be accessible to the public. Information about collections is, in principle, available for public consumption. However, in many traditional societies, access to indigenous models of museums, such as temples, rice barns, and meeting houses, is restricted to certain members of the community; for example, males, initiated individuals, priests, ritual specialists, and village leaders of customary law. Restricted access runs counter to the democratic ideals of contemporary Western museums since public access and the dissemination of knowledge have become their primary aims (Ames 1992; Pearce 1992; Simpson 1996).

The collections in Western museums are also generally considered public property or the property of a museum. But objects or collections housed in indigenous museums may not be. In many cases, they remain the property of certain families,

individuals, clans, or ritual organizations, which exercise proprietary rights over particular objects or collections. For example, in the Kwagiulth Museum and Culture Centre in British Columbia, Canada, objects are not considered the property of the museum, but rather the property of certain individuals or families. Objects such as masks and ritual regalia are displayed with labels that identify the object's owner, generally a chief and his family. "The objects belong to specific families since, traditionally, there is no such thing as tribal property" (Clifford 1991: 227). Displays in the museum thus reflect traditional rights to the ownership of property as well as systems of social organization and kinship. In such cases, indigenous customs and values have been adapted to the modern museum setting.

Access to knowledge about certain objects and rights to their interpretation may also be restricted in some societies due to the sacred nature of the objects. For instance, while conducting research on the Provincial Museum of Central Kalimantan, I observed how the museum staff often called on *basir*, or ritual specialists, to help them interpret particular objects in museum displays, such as those related to religious rituals and ceremonies. Although the museum was modeled on a Western-style ethnographic museum and staff members were instructed in "professional museum methods," they consulted with the *basir* out of respect for their specialized knowledge regarding these objects and their rights to it. Particular objects are thought to be unique creations endowed with their own meanings and powers known only to the *basir* who made them. This knowledge is considered sacred, non-public, and can only be acquired through a long apprenticeship. It must also be paid for, and is thus "owned" by an individual *basir*. Because objects were made for specific purposes and endowed with their own meanings, museum workers were reluctant to usurp the *basir*'s authority and write generalized statements on exhibit labels (Kreps 2003b: 31–4).

This approach, until recently, has differed significantly from that taken in Western museums where curatorial authority has rested in the hands of professional museum staff. It also reflects a different perspective on what objects represent and how they may be used. In the scientific tradition of Western ethnographic museums, objects in displays are often "stand ins" for a particular class of objects or particular aspect of culture. In such contexts, they have been denied their singularity as "exhibition classifications . . . shift the grounds of singularity from the object to a category within a particular taxonomy" (Kirshenblatt-Gimblett 1991: 392).

Some Native Americans, like various other indigenous peoples, are concerned about the public nature of museum collections, and rights governing their access and use. According to tribal traditions, objects might have restricted access; for example, only to women or to men, or to appropriate spiritual authorities (see, for example, Parker 1990). As Peter Jemison, from the Seneca tribe puts it:

> The concept in the white world is that "everyone's culture is everyone else's." That's not really our concept. Our concept is there were certain things given to us that we have to take care of and that you are either part of it or you are not part of it. If you are not a part of it, then you don't have to worry about it. But if you are a part of it, then you have got to be actively taking care of it on a yearly basis, or on whatever basis it is taken care of. (quoted in Parker 1990: 37)

465

For many indigenous peoples, objects are animated with a life force or energy and have spiritual power. They can possess or embody spirits, for example, those of ancestors, which must be carefully looked after. In some cases, objects do not just represent the spirit of an ancestor but are that ancestor. Mead emphasizes this point in his description of Maori *taonga*, or cultural treasures, and their *mauri* (living force): "For the living relatives the *taonga* is more than a representation of their ancestors; the figure is their ancestor and woe betide anyone who acts indifferently to their *tipuna* (ancestor)" (1990: 166).

Because of their supernatural powers, objects are also sometimes viewed as dangerous or having a volatile nature that has to be mitigated. This is not necessarily diminished when they enter a museum. As Emmanuel Kasaherou, director of the Musée Territorial de Noumea explains: "Even today there are many Kanak people who are uneasy when viewing traditional objects with supposed magical powers, which could be dangerous to the viewer. With these ways of looking at traditional objects, the purpose of the museum is hard to understand" (quoted in Bolton 2003: 50). While collaborating with Torres Strait islanders on the production of an exhibit mounted at the University of Cambridge, Herle encountered a similar attitude toward certain objects: "Some material, such as objects associated with sorcery or death, was rejected for display, because these items may retain an inherent dangerous potency" (Herle 2002: 238).

These views of objects differ from the ways in which objects are viewed in Western museums where they are generally seen as inert objects valued primarily on the basis of their material rather than spiritual or supernatural properties. What becomes clear in looking at how objects are perceived and treated in indigenous contexts is that they are embedded in a larger socio-cultural context, in direct relationship to people's lives, and are part of continuing cultural traditions. The curation of these objects may also be based in the social organization and structure of a society, and reflect specific kinds of relationships among people, objects, and society.

Indigenous Models of Curation

Philip Cash Cash, a Native American scholar, suggests that people's relationships to objects are ultimately social ones and therefore curatorial work is a form of social practice. Cash Cash defines curation as "a social practice predicated on the principle of a fixed relation between material objects and the human environment" (2001: 140). The "principle of a fixed relation" means "those conditions that are socially constructed and reproduced as strategic cultural orientations vis-à-vis material objects" (2001: 141). Cash Cash's definition of curation implies that people's strategic orientations in relation to objects are not only social constructs, but can also become cultural traditions over time. Thus, each society can have its own curatorial traditions or patterned ways of seeing, valuing, assigning meaning to and treating objects, which, like all other aspects of culture, change over time.

The curation of heirloom property, or *pusaka*, in many Indonesian societies, conforms to Cash Cash's definition of curation as social practice. *Pusaka* can take the form of either tangible or intangible cultural property, such as ritual regalia, textiles,

466

beads, masks, tools, weapons, ornaments, ceramics, musical instruments, manuscripts, dances, stories, oral literature, or found natural objects like stones. Land and houses may also be *pusaka*, in addition to objects of foreign origin acquired through trade, gift exchange, or warfare. These may include European canons and other weapons, Indian textiles, and Chinese ceramics (Damais 1992; Hoskins 1993). Virtually anything can be designated *pusaka*. But not everything that is inherited is *pusaka*, nor can objects be created to play this role. An object or entity becomes *pusaka* in the course of its social life. As Kartiwa, an Indonesian anthropologist and museum professional, puts it:

> Whether they are owned by individuals, a family, extended family or clan, collectively by a tribe or ethnic group, or whether they are treasures of a sultan's palace or princely realm, pusaka are a creation by a society . . . It is the meaning a society gives these objects, not anything innate in the objects themselves, which makes them pusaka. (1992: 159)

Pusaka have been critical to maintaining kinship ties and keeping track of lineages because they can be among the most important links to the authority of ancestors. An heirloom object, such as a carving, often recalls a founding ancestor in imagery or stories, and thus becomes a "visible symbol of the transmission of traditions" (Taylor and Aragon 1991: 43).

In many cases, *pusaka* are under the care and protection of specific members of society, such as ritual specialists, leaders of customary law, or royal functionaries, who act as *pusaka* curators. In the courts of Java, for example, the curators of royal heirlooms are known as Abdi Dalem. The Abdi Dalem, who are "people of the inner circle," are responsible for safeguarding the physical and spiritual properties of the heirlooms and passing on this knowledge and responsibility to younger generations (Kartiwa 1992: 159–60).

One of the most highly revered *pusaka* items is the *keris* or sacred dagger. *Keris* are not merely inanimate objects, but can take on supernatural or magical powers known as *kasiat*. The *keris*'s *kasiat* can be engaged to protect people from danger or bring good fortune. While some *keris* possess *kasiat*, others carry another magical force called *ampuh*. *Keris* with *ampuh* are more difficult to control and must be approached with care (van Duuren 1996: 60–61). To ensure that the powers in a *keris* behave in a benevolent manner, the *keris*'s curator must perform certain services on its behalf. This includes periodical offerings and ritual bathings in incense, perfumed water, coffee, and tobacco smoke (Kartiwa 1992: 164). In Javanese royal courts, the *nyirami*, or ritual cleansing of a *keris*, is a grand and solemn ceremony (van Duuren 1996: 62). Curators, in addition to being responsible for maintaining a *keris*'s spiritual integrity, are also charged with preserving its physical integrity. They may use citrus juice and oils to polish and treat the blades of *keris* before wrapping it in a special cloth and storing it in a safe place (Richter 1994).

The social practice of curating *pusaka* in Indonesia is one example of how curatorial work is grounded in particular social and cultural contexts, reflecting a people's particular "strategic orientations" to objects. Moreover, as a means of preserving valuable cultural property and transmitting cultural knowledge and traditions over

time, the Indonesian concept of *pusaka* as a whole can be seen as a non-Western approach to cultural heritage preservation. "A pusaka object possesses an intimate spiritual connection with its owner or custodian. In daily life the latter may not often make use of, see or even think about his pusaka, but if it were in danger of theft, damage or destruction he would do everything in his power to save it" (Soekmono 1992: 52).

Traditional practices associated with the curation of *pusaka* continue to undergo change in response to other social and cultural changes, especially those related to religious practices and beliefs, as well as systems of social organization. But the overall idea of *pusaka* is an enduring concept in Indonesia that has proved to be adaptable to changing conditions. Today, rights to the ownership and care of *pusaka* may be transferred to public museums. Nevertheless, in such settings, *pusaka* continues to symbolize people's cultural identity and heritage. In the words of Adji Damais, an Indonesian scholar and museum professional:

> Whether we are talking about sacred and powerful protective objects worn by ancestral heroes or the symbols of modern nationalism . . . it is clear that the concept of pusaka is a pervasive one, close to the heart of Indonesian ideas about objects, and therefore the world . . . We need to understand the idea of pusaka in order that we may relate to . . . and constitute . . . our heritage. (Damais 1992: 208)

We can see, through this example, how both objects and people have been intertwined in the curatorial process and how the process has not been divorced from social relationships. This approach differs from that most often taken in Western museums where, until recently, the object was the center of attention. However, as museum curators and other staff have begun to work more closely with members of source communities, their attention has shifted from a focus on objects to a focus on the social relationships represented by collections, and acknowledgment of the importance of objects to the contemporary needs and concerns of source communities (Kreps 2003a). This trend marks the move from a colonial to a cooperative and collaborative museology (Clifford 1997).

Cross-cultural Approaches to Curation and Heritage Management

Throughout the world, indigenous people are entering mainstream museums in unprecedented numbers and exercising greater control over how their cultural materials are being curated and represented (see Peers and Brown 2003). In the process, conventional curatorial practices are being transformed to accommodate diverse perspectives and interests, and more inclusive, cross-culturally oriented approaches to curation and cultural heritage management are being developed. "The museum itself has become a field-site – a place for cross-cultural encounter and creative dialogue" (Herle 2002: 246).

In the United States, for instance, Native American scholars, curators, spiritual leaders, and advisers are contributing to the redefinition and reformulation of cura-

torial practices as Native American methods of "traditional care" are being integrated into museums and taking their place alongside those of Western museology. The ways in which non-indigenous museums store, conserve, display, and interpret objects are being called into question, showing that what is seen as appropriate in one cultural context may not be in another. In addition to being asked to repatriate or remove "culturally sensitive" objects from displays, museums are also being instructed in how to store and care for them in keeping with traditional protocol. For example, since some objects are considered to be living entities, they need to be able to breathe. Therefore, museum curators are being asked not to store such objects in plastic or other sealed containers. Requests may also be made to separate certain objects from others, based on their native classification, such as male or female, sacred or non-sacred, and those associated with life and those associated with death, in museum storage rooms (see Rossoff 1998; Flynn and Hull-Walski 2001; Kreps 2003b). Philip Cash Cash sums up some of the results of greater collaboration as follows:

> Traditional religious practitioners are now beginning to experience greater freedom to introduce and apply indigenous forms of curation within the museum. As indigenous curators, they bring to the museum a newly added dimension of human potential that is testimony to the immediacy, vitality and power of objects to mediate the lived, everyday world we have now come to share. (2001: 144)

A cross-cultural approach to curation and cultural heritage management invariably entails viewing curatorial work as a continuing social process, and the acknowledgment of the social and cultural dimensions of people's relationships to objects. Curation is no longer just about taking care of objects. It is also about cultivating harmonious relationships directed toward redressing historical wrongs, and showing respect for diverse worldviews and belief systems as they pertain to people's perceptions of, and relations to, objects. By looking at curation as social practice and part of continuing social processes, we can better appreciate how objects, despite their enclosure and isolation in museums, are still "things in motion" with "social lives" (Appadurai 1986). This perspective illuminates the way in which objects are linked to whole systems of cultural expression and are not always what outsiders perceive them to be. Cross-culturally oriented approaches to curation are inherently about sharing curatorial authority and power, and making room for the inclusion of multiple forms of knowledge and expertise.

> In the face of demands to include more voices in decisions about exhibits and research, museums have the opportunity to gain strength by giving up power. They give up power in the sense of granting authority to Native people in making decisions about the use and accessibility of relevant collections, and they become stronger through the support and insights of the people represented in their collections and exhibits. (Haas 1996: 7)

What we are seeing is the emergence of more culturally relative approaches to curation and museum work. But in calling for a more inclusive and relative museology, we must be cautious about imposing what Richard West has referred to as "a

Christina Kreps

new, reverse exclusivity to replace the old exclusivity" (1993: 7) or succumbing to extreme cultural relativism. We must remain skeptical of any cultural practice that works against the principle of human equality and dignity. The challenge is to rec-oncile our respect and need for cultural diversity with the need to acknowledge and respect the principles of human rights and cultural democracy.

 The study of non-Western models of museums and curatorial practices offers alternative perspectives on museological behavior, or, how people in various cultural settings perceive, value, care for, and preserve their cultural heritage in tangible and intangible forms. Such studies broaden our scope of inquiry, revealing new sites for exploration and explication. They show us that there is not one universal museol-ogy, but a world full of museologies and spaces for the convergence of diverse muse-ological forms and practices.

Bibliography

Ambrose, T. and Paine, C. (1993) *Museum Basics*. London: Routledge.
*Ames, M. (1992) *Cannibal Tours and Glass Boxes: The Anthropology of Museums*. Vancouver: University of British Columbia Press.
Appadurai, A. (1986) Introduction: commodities and the politics of value. In A. Appadurai (ed.), *The Social Life of Things: Commodities in Social Perspective*, pp. 3–63. Cambridge: Cambridge University Press.
Bartlett, H. (1934) *The Sacred Edifices of the Batak of Sumatra*. Ann Arbor: University of Michigan Press.
Bazin, G. (1967) *The Museum Age*, trans. Jane van Nuis Cahill. New York: Universe Books.
Bellwood, P. (1985) *Prehistory of the Indo-Malaysian Archipelago*. North Ryde, NSW: Academic Press Australia.
Bolton, L. (2003) The object in view: Aborigines, Melanesians, and museums. In L. Peers and A. Brown (eds), *Museums and Source Communities*, pp. 42–54. London: Routledge.
Cannon-Brookes, P. (1984) The nature of museum collections. In J. Thompson (ed.), *Manual of Curatorship: A Guide to Museum Practices*, pp. 115–26. London: Butterworth.
Cash Cash, P. (2001) Medicine bundles: an indigenous approach. In T. Bray (ed.), *The Future of the Past: Archeologists, Native Americans and Repatriation*, pp. 139–45. New York: Garland.
Childs, E. (1980) Museums and the American Indian: legal aspects of repatriation. *Council for Museum Anthropology Newsletter*, 4 (4): 4–29.
*Clavir, M. (2002) *Preserving What is Valued: Museums, Conservation, and First Nations*. Vancouver: University of British Columbia Press.
Clifford, J. (1988) *The Predicament of Culture: Twentieth Century Literature, Ethnography, and Art*. Cambridge, MA: Harvard University Press.
— (1991) Four Northwest Coast museums: travel reflections. In I. Karp and S. Lavine (eds), *Exhibiting Cultures: The Poetics and Politics of Museum Display*, pp. 212–54. Washington, DC: Smithsonian Institution Press.
— (1997) *Routes: Travel and Translation in the Late Twentieth Century*. Cambridge, MA: Harvard University Press.
Damais A. (1992) Pusaka in times of change. In H. Soebadio (ed.), *Pusaka: Art of Indonesia*, pp. 205–8. Singapore: Archipelago Press.
van Duuren, D. (1996) *The Kris: An Earthly Approach to a Cosmic Symbol*. Amsterdam: Royal Tropical Institute.

Edwards, R. and Stewart, J. (eds) (1980) *Preserving Indigenous Cultures: A New Role for Museums*. Canberra: Australian Government Publishing Service.

Evans, R. (1999) Tribal involvement in exhibition planning and conservation treatment: a new institutional approach. *ICOM Ethnographic Conservation Newsletter*, 19: 13–16.

Flynn, G. and Hull-Walski, D. (2001) Merging traditional indigenous curation methods with modern museum standards of care. *Museum Anthropology*, 25 (1): 31–40.

Haas, J. (1996) Power, objects, and a voice for anthropology. *Current Anthropology*, 37: suppl. S1–S22.

Handler, R. (1993) An anthropological definition of the museum. *Museum Anthropology*, 17 (1): 33–6.

Harrisson, B. (1990) *Pusaka: Heirloom Jars of Borneo*. Singapore: Oxford University Press.

Herle, A. (2002) Objects, agency, and museums: continuing dialogues between the Torres Strait and Cambridge. In A. Herle, N. Stanley, K. Stevenson, and R. Welsch (eds), *Pacific Art: Persistence, Change and Meaning*, pp. 231–50. Honolulu: University of Hawaii Press.

Hoskins, J. (1993) *The Play of Time: Kodi Perspectives on Calendars, History, and Exchange*. Berkeley, CA: University of California Press.

Kaeppler, A. (1994) Paradise regained: the role of Pacific museums in forging national identity. In F. Kaplan (ed.), *Museums and the Making of Ourselves: The Role of Objects in National Identity*, pp. 19–44. London: Leicester University Press.

Kartiwa, S. (1992) Pusaka and the palaces of Java. In. H. Soebadio (ed.), *Pusaka: Art of Indonesia*, pp. 159–64. Singapore: Archipelago Press.

Kirshenblatt-Gimblett, B. (1991) Objects of ethnography. In I. Karp and S. Lavine (eds), *Exhibiting Cultures: The Poetics and Politics of Museum Display*, pp. 386–443. Washington, D.C.: Smithsonian Institution Press.

*Kreps, C. (1988) Decolonizing anthropology museums: The Tropenmuseum, Amsterdam. *Museum Studies Journal*, 3 (2): 56–63.

— (1998) Museum-making and indigenous curation in Central Kalimantan, Indonesia. *Museum Anthropology*, 22 (1): 5–17.

— (2003a) Curatorship as social practice. *Curator*, 46 (3): 311–23.

— (2003b) *Liberating Culture: Cross-cultural Perspectives on Museums, Curation, and Heritage Preservation*. London: Routledge.

Lewis, P. (1990) Tourist art, traditional art and the museum in Papua New Guinea. In A. Hanson and L. Hanson (eds), *Art and Identity in Oceania*, pp. 149–63. Honolulu: University of Hawaii Press.

Mead, S. (1983) Indigenous models of museums in Oceania. *Museum*, 35 (139): 98–101.

— (1990) The nature of Maori Taonga. In *Taonga Maori Conference Papers*. Wellington, New Zealand: Cultural Conservation Advisory Council, Department of Internal Affairs.

Neller, A. (2002) From utilitarian to sacred: the transformation of a traditional Hawaiian object. In A. Herle, N. Stanley, K. Stevenson, and R. Welsch (eds), *Pacific Art: Persistence, Change and Meaning*, pp. 126–38. Honolulu: University of Hawaii Press.

Nicks, T. (2003) Introduction to Part I: Museums and Contact Work. In L. Peers and A. Brown (eds), *Museums and Source Communities*, pp. 19–27. London: Routledge.

O'Connor, S. (1983) Art critics, connoisseurs, and collectors in the Southeast Asian rain forest: a study in cross-cultural art theory. *Journal of Southeast Asian Studies*, 15 (2): 400–408.

Okita, S. (1982) Museums as agents for cultural transmission. *Nigeria Magazine*, 143: 2–20.

Parker, P. (1990) *Keepers of the Treasures: Protecting Historic Properties and Cultural Traditions on Indian Lands*. Washington, DC: National Parks Service, United States Department of the Interior.

471

Pearce, S. (1992) *Museums, Objects and Collections: A Cultural Study*. Washington, DC: Smithsonian Institution Press.

*Peers, L. and Brown, A. (eds) (2003) *Museums and Source Communities*. London: Routledge.

Richter, A. (1994) *Arts and Crafts of Indonesia*. San Francisco: Chronicle Books.

Rossoff, N. (1998) Integrating native views into museum procedures: hope and practice at the National Museum of the American Indian. *Museum Anthropology*, 22 (1–2): 33–42.

*Simpson, M. (1996) *Making Representations: Museums in the Post-colonial Era*. London: Routledge.

Soekmono, R. (1992) The Candi as a cultural Pusaka. In H. Soebadio (ed.), *Pusaka: Art of Indonesia*, pp. 51–66. Singapore: Archipelago Press.

Stanley, N. (1998) *Being Ourselves for You: The Global Display of Cultures*. London: Middlesex University Press.

Taylor, P. and Aragon, L. (1991) *Beyond the Java Sea*. Washington, DC and New York: National Museum of Natural History, Smithsonian Institution and Harry N. Abrams.

Waterson, R. (1990) *The Living House: An Anthropology of Architecture of Southeast Asia*. London: Thames and Hudson.

West, M. (1981) Keeping place vs museum: the North Australian example. *Bulletin of the Conference of Museum Anthropologists (COMA)*, 7: 9–14.

West, R. (1993) Research and scholarship at the National Museum of the American Indian: the "new inclusiveness." *Museum Anthropology*, 17 (1): 5–8.

Culture Wars, Transformations, Futures

Introduction

Chapters throughout this *Companion* have discussed numerous controversies and changes underway in museums, and have speculated upon directions in which museums seem to be going or that they should, perhaps, take. In Part VI – the final Part of the *Companion* – this discussion is continued in a set of chapters that directly address questions of conflict, transformation, and museum futures.

The first two chapters deal with the so-called "culture wars," those conflicts over moral values and authority, patriotism and pluralism, objectivity and relativism, in which museums were – and remain – key sites and central players. In chapter 29, Steven C. Dubin provides a background to the rise of the notion of the "culture war" in the United States (from where the term emanated). Focusing primarily upon exhibitions of art and social history, he analyzes some of the most famous examples of public controversy centered on museums in the US, before turning to look at the case of South Africa, the focus of his current research. As a consequence of its own extraordinary and continuing political transformations, South Africa shows a wide and vivid spectrum of political use of museums and of conflicts over, or innovations in, representation. As Dubin explains, using museums as a means of trying to create new futures is a complex matter. Even in museums based on the most admirable of political motives, the fact that such museums may also be seeking to address a tourist market and to make a profit can generate contradictions; and in the most revolutionary of exhibitions there can still be conflict over the narratives constructed and the silences that these may entail.

"Culture wars" have also been fought in museums of science, which include museums of natural history, technology and industry, archaeology, and anthropology. Historically, and in many cases still today, such museums have been bound up with constructing public narratives of movement from past to future, of progress and scientific triumph, and of presenting the public with "facts" and "answers," effectively closing down rather than opening up debate. While there have been some high-profile controversies over the representation of science – notably from Creationists over evolution, from patriots over the proposed display of the bombing of Hiroshima, and from native groups over the ownership and use of human remains – Steven Conn (chapter 30) points out that in many ways there is *less* controversy over the depiction of science than there might be. Reasons for this include a con-

tinuing widespread popular understanding of science museums and of science itself as authoritative and objective, as well as the tendency of many science museums to conceptualize their audience as children and thus to focus on outlining basic ideas rather than tackling more challenging projects. Another reason is the corporatization of the museum, especially sponsorship and chasing audience volume, as also discussed by Mark Rectanus (chapter 23). Conn himself argues for an alternative future for science museums, as yet only glimpsed occasionally in recent and current museological practice, that would see them becoming places to put science into question, and to represent and even generate controversy.

This vision of the museum as a space of debate, and for the contemplation of serious questions, runs counter to the restructurings that Nick Prior (chapter 31) sees as coming to dominate – though not entirely fill – the museum landscape. Drawing on theorists of postmodernity, Prior argues that museums are increasingly becoming places of entertainment, spectacle, and distraction. His discussion highlights a wide range of trends in museums, including the role of museums in image-marketing and urban regeneration, the commercialization of display, and what Steven Conn (in chapter 30) calls "blockbusteritis," a move from authenticity to "staged authenticity," and chronological displays being replaced by "total experiences" and non-linear representations. All of these trends are bound up with museums becoming spaces of distracted – rather than orderly, measured, and discriminating – experience. Unlike the theorists of postmodernity who have mostly seen these changes as absolute, however, Prior points out that they may be coupled with others that point in other directions; and that these differences and contradictions – a pluralizing of the museum – are also characteristic of the present, and, probably, future.

Mieke Bal's call in chapter 32 is for an alternative to both the conventional museum – which she sees as producing a soporific discourse that conceptualizes the public only as a receiver – and to the superficial instant gratification of the "distraction machine" described by Nick Prior. One of the most noted cultural theorists of museums, Bal discusses what she calls the "language of museums" – spoken through such matters as the juxtaposition of paintings and of architecture (see also chapter 17) – in order to highlight the different kinds of relationship that can be established between museums and their audience. Trying to move beyond addressing "the public" as an undifferentiated mass and to recognizing its plurality, and, more radically still, seeking to transform the relationship between the museum and this plural public, is, she argues (as have various others in the *Companion*), a critically important task. Bal provides a critique of some of the claimed moves in this direction, such as *auteurist* exhibitions, in which an exhibition is openly authored and (in most, though not all, cases) acknowledged as a positioned – rather than "third-person" – perspective. She attempts to go beyond these, however, not only by setting out the theoretical ideas which should guide a more thoroughgoing transformation of the relationship between the museum and its audience, but by putting them into practice. Interestingly, both her own museum exhibition and her innovative video project, as described here, involved some approaches that could be seen as part of a culture of distraction – for example, eschewing linear order and mixing media – but her aim in employing these was to make museum viewing more, rather than less,

challenging; and to attempt to evoke more critical engagement, rather than less, from the diversified audience.

In the final chapter in this *Companion to Museum Studies*, Charles Saumarez Smith, Director of the National Gallery in London, also offers alternatives to a future of more and more distraction. He addresses certain ideas about the direction of cultural transformations and the way forward to the future that have become taken for granted by many of those responsible for museum policy. In particular, he considers the assumptions that objects will decrease in their significance relative to technology, which will inevitably come to occupy an increasingly major place in museums, positively transforming the museum experience; and that commerce and culture will become increasingly intertwined, the museum becoming less and less distinguishable from other spaces of contemporary culture, such as the shopping mall, as described by Prior. However, rather than accepting these as inexorable results of the course of globalization and postmodernity, and of what the public really wants, Saumarez Smith argues for recognizing the continuing importance of "the real," the distinctiveness of the museum, and of calm rather than distracted looking. Museums, in his future vision, should build upon these aspects; and should operate on principles other than just that of securing the largest possible visitor volume.

Saumarez Smith's call is not, however, for a single way forward, for a shared or unified vision of the future for museums. Rather, it is for an acceptance of multiple ways of doing things – of diverse museum futures. Equally, it is not an argument for "anything goes." Too often, he observes, discussion of the future is undertaken without sufficient grounding – like navigating without a map and compass.

My hope, as editor of this *Companion to Museum Studies*, is that this volume can act as such a map and compass in reviewing the current state of, and possible future directions for, museums. By charting the territory of contemporary museum studies, this *Companion* seeks to be a real companion in providing potential directions for contemporary and future museum studies and museum practice.

Incivilities in Civil(-ized) Places: "Culture Wars" in Comparative Perspective

Steven C. Dubin

Shortly before the decades-old Cold War underwent a complete meltdown, a new term burst into the consciousness of Americans: "culture wars." The phrase surfaced in the media in the late 1980s. Its subsequent entry into academic debate is generally attributed to sociologist James Hunter (1991), and it was propelled into national political discourse when Patrick Buchanan rallied the 1992 Republican National Convention to an urgent "war for the nation's soul." Thereafter, "culture wars" broadly penetrated popular dialogue.

"Culture wars" refer to the impassioned confrontations between groups within the same society, polarized over so-called hot button issues falling broadly within the realms of race and ethnicity; the body, sexuality, and sexual orientation; identity politics; religion; and patriotism and national identity. James Hunter defines "culture wars" as public conflict based upon incompatible worldviews regarding moral authority, or what he differentiates as "*the impulse toward orthodoxy*" from "*the impulse toward progressivism*" (Hunter 1991: 42–3, emphasis in original). The first position derives meaning from "*an external, definable, and transcendent authority*," whereas the contrary stance relies upon "*the tendency to resymbolize historic faiths according to the prevailing assumptions of contemporary life*" (1991: 44–5, emphasis in original). For the orthodox, God is the arbiter of right and wrong; for the progressive, it is the individual.

Superseding traditional cleavages based upon religious differences between Protestantism, Catholicism, and Judaism, and challenging materialist theories of conflict, "culture wars" reflect a more secularized and pluralistic American society. The tension between the ideal types of orthodoxy and progressivism cuts across spiritual and class lines, so that orthodox and progressive Jews, for example, could have less in common on certain issues than orthodox Jews and evangelical Protestants.

The resulting controversies have been particularly noticeable within specific venues and regarding certain social goods. Chief among them are museums, monuments, and heritage spots. These locales become *sites of persuasion*: memory and meaning are created at these nodes, and this is where social representations are constructed and public knowledge is produced. Conflict and negotiation habitually occur at sites of persuasion such as museums, manifest in revival, or reawakening dormant beliefs and values; in reaffirmation, asserting the importance of particular principles and standards; in recommitment, directing energies toward communal goals; in reclamation, asserting ownership over objects or knowledge that has been forbidden or denied; in repatriation, procuring what was seized by outsiders in the past; in recuperation, reinscribing personal narratives that have been suppressed or erased; in resanctification, restoring what has been profaned; and in reconciliation, developing new relationships between the past, the present, and alternative visions of the future.

The titles and subtitles of some of the most widely discussed books published on this subject during the 1990s increased the public's sense of impending crisis and ratcheted up the intensity of their emotions. Such charged rhetoric included "struggle" (Hunter 1991), "illiberal" (D'Souza 1992), "disuniting" (Schlesinger 1992), "ailing" (Hughes 1994), "wracked" (Gitlin 1995), "dispatches from the front" (Green et al. 1996), "betrayal" (Kors and Silvergate 1998), the cleverly dubbed "loose canons" (Gates 1992), and – the most self-dramatizing – "before the shooting begins" (Hunter 1994). Leaving aside the issue of how correctly these writers reflected what was actually going on, their discursive style undoubtedly heightened the general feeling of alarm.

Why Do Culture Wars Occur?

Culture wars are an epiphenomenon of social change, as well as political shifts and realignments, both nationally and globally. However, once they commence, culture wars develop in directions that their instigators, actors, and audiences cannot necessarily anticipate. In the case of the United States, a number of factors triggered the culture wars that originated in the late 1980s. Internationally, the fall of communism deprived Americans of a familiar, external enemy. The eclipse of the "evil empire" – a concept that had parsed the world into black and white – forced Americans to redraw their symbolic boundaries for the first time in nearly four decades.

In addition, activists galvanized various civil rights movements from the 1950s onward and produced an altered social landscape in the United States. African Americans, women, gays and lesbians, Hispanics, and others demanded community empowerment, and to become fully enfranchised citizens. The increased strength and visibility of those who were "previously disadvantaged" initiated intense struggles between those losing power or reaching for it, those exercising or resisting it. In other words, while some people aim to dismantle certain cultural barricades, others fervently defend them.

A reallocation of power has occurred to some degree, eroding the monopoly once held by established groups. It is not accidental that virtually every skirmish of the

culture wars within the art world was set off by work created by these former outsiders, marking these as contests over status and class (see Gans 1974). Moreover, many museums now boast curators who represent previously marginalized groups; such membership typically brings new perspectives and sympathies into play. And the intellectual orientation of this new generation of curators has generally been shaped by fresh academic theories such as feminism, postmodernism, the new social history, queer theory, and critical race theory. That leads to broaching subjects that were previously unexplored, as well as re-examining taken-for-granted assumptions and established museological conventions and methodologies.

As a general principle, culture wars are more likely to break out at times when there is a high degree of communal fragmentation and polarization, and widespread civic malaise and low communal morale (Dubin 1992: 38). The moral crusaders who have spearheaded these battles may represent either the political left or right. For regardless of their political orientation, they are ideologues who support a single interpretation of a work of art, an exhibition, or any other cultural expression, extract a few elements out of context to press their case, are often self-righteous and paternalistic, and overestimate the power that any cultural element can exert over people's behavior (Dubin 1994).

Why Do Museums Become Battlegrounds?

Museums are a primary way that a society represents itself: to its own members, and to the larger world. Exhibitions *solidify* culture, science, history, identity, and worldviews. There is a great deal at stake here. Museums commonly present the *real thing*: art, objects, and artifacts that bear the aura of the authentic. They endow the ideas within any exhibition with tangibility and weight.

Museums have become more democratic. As a result, more publics vie for their space, subject them to more careful oversight, and may even contest museum authority. It is increasingly clear that museums are politicized spaces, where all sorts of dramas can be played out. In Duncan Cameron's familiar formulation (1972), museums are increasingly forums, not temples (see also Karp and Lavine 1991). Museums must answer to a variety of stakeholders, and have become enmeshed in a web of funding sources, any of which can threaten to tighten the purse strings if they take offence at what is shown. Museums are thus potentially subject to a wide variety of conflicts of interest and constraints.

Exhibitions have shifted from being object-driven to being idea-driven. Today, the stories that are told in museums do not simply derive from the material that is displayed; it is more likely that a narrative is composed *incorporating* objects to illustrate particular ideas. And once you enter the realm of narrative and interpretation, there is more for audiences to challenge. People today increasingly wish to tell their own stories, rather than have others interpret their experiences for them. Debates over who is authorized to speak for whom, and about what, have created a sometimes disquieting and sometimes exhilarating dialogue over the politics of representation. One person's lexicon of translation and analysis may be another person's lexicon of anguish.

479

In the case of art museums, many contemporary artists relish smudging the line between what Mary Douglas (1970) calls "natural categories," how every society arranges basic experiences and understandings into binary oppositions. Artists have compressed categories; borderlines have become more permeable and crossings more frequent (Garber 1992); conflation and "transgression" have become increasingly valorized (Dubin 2001). Masculine and feminine, sacred and profane, public and private are now realms to interrogate, not automatically to assent to. But while soiling tidy notions may delight the artist, it can engender a great deal of dis-ease amongst the general public.

Artists were a primary target when the culture wars first erupted. They were vulnerable because many of them held personally marginal statuses, and many worked within relatively new disciplines (such as performance art) that could not offer institutional shelter. But that focus shifted as the 1990s proceeded, pushing museums of all types – art, history, natural history, cultural history, and so on – into the spotlight.

Does the Model Pass Muster?

As the millennium approached, it became as much a commonplace to acknowledge the culture wars as it was to deny their existence. Even as the concept has become popularly entrenched, critics have attacked it on both theoretical and methodological grounds. Some academics have argued that the term, as James Hunter defined it, was overly broad, that it provoked overheated rhetoric, and that Americans do not feel split by most social issues. Williams (1997), for example, dismisses the concept as a "popular myth." The various studies he collected (a) fail to substantiate Hunter's thesis of a bipolar political division in the US, and (b) determine that many issues that Hunter frames as either/or propositions are in fact both/and choices in the public's mind. And Brint takes Hunter's own point that 60 percent of Americans hold moderate positions to ask: "Can one have a proper war when two-thirds of the army are noncombatants?" (1992: 439). In an important study, DiMaggio et al. (1996) analyzed two decades of American public opinion survey data and also failed to uncover evidence of a mounting polarization of attitudes. And Alan Wolfe (1998) likewise dismisses the notion of an increased polarization of attitudes, based upon interviews conducted with American suburbanites which unearthed a shared sense of morality that bridges almost all racial, cultural, and gender differences.

James Hunter dismisses these objections by arguing (a) that it is reductionistic to "equate . . . culture with the aggregated attitudes of autonomous individuals," and (b) "public discourse is more polarized than Americans themselves" (Hunter 1996b: 246–7). The second point is important because it recognizes that the culture wars are a vital energy source for particular interests: they generate good news copy and exciting sound bites, plump up individual reputations, inflate organizational membership rosters, and confer the illusion of substantial support and moral authority onto particular spokespeople and their groups.

Contemporary cultural conflicts do not require rock-hard divisions between worldviews to exist. After all, individuals are notoriously difficult to pigeonhole

480

because they often bear contradictory impulses; political progressives can be cultural conservatives, as Karl Marx's own predilections demonstrate. Actual clashes depend upon both the exploitation of people's fears by politicians, ideologues, or the media, and the successful mobilization of public support for or against some specific contentious issue. Once marshaled, and their energy expended, individuals may return to a variety of social positions and belief systems, only to be potentially reassembled in different alliances, over diverse matters, at some future moment.

Many writers argue that museums and the material that they display transmit as well as validate ideologies (see Berger 1977; Bennett 1995), and that those who control them determine both the way in which a society perceives itself and is perceived by others (Duncan 1991). While this has been particularly true in the past, this chapter examines how different groups have challenged dominant discourses for a variety of reasons, with museums providing the battleground.

Below, I first discuss some major American controversies, and then analyze examples from post-apartheid South Africa. This comparative material expands the power and range of the culture wars concept. South Africa is a country in the making. As such, examining the development and implementation of alternative models of cultural action, presentation, and reconstruction in museums offers an important line of vision into the processes of social change since the first democratic elections were held there in 1994.

The Battle Within

Harlem on My Mind: The Cultural Capital of Black America, 1900 to 1968 (Metropolitan Museum of Art, New York, 1969) is perhaps the most explosive exhibition in American history. Although predating the emergence of the culture wars, it provided a template for the spate of comparable controversies that erupted in quick succession some two decades later (see Dubin 2000a). *Harlem on My Mind* brought the life of a teeming ghetto to the venerable halls of one of the nation's oldest and wealthiest museums. Appearing during a time of intense inter-ethnic conflict in New York City, and when basic social institutions were being questioned, this exhibition challenged both racial and aesthetic hierarchies.

As one of the first multimedia shows ever mounted – featuring greatly enlarged photographs and sound, but not fine art – *Harlem on My Mind* incurred the wrath of formalist art critics and traditional patrons. Moreover, some blacks were angered because they felt that the exhibition was paternalistic; black artists, in particular, felt snubbed because painting was excluded. Segments of the Jewish community were enraged that the catalogue contained what they felt to be anti-Semitic sentiments, and some Irish and Puerto Ricans also took offence at how the text represented them. Even the right-wing John Birch Society was infuriated because W. E. B. Du Bois, whom it reviled as a communist, was included in the show.

Tensions ran high, and the exhibition garnered headlines for months. Black artists repeatedly picketed the museum; unknown vandals damaged ten paintings in the museum's collection; and, on one particularly notable day, nearly a thousand boisterous protesters marched and shouted in front of the building, the various

481

delegations separated by an edgy police contingent. It was an unprecedented event.

It was also prophetic: its counterpart in the "modern era" of cultural wars in American museums was launched by a similar reaction to *The West as America: Reinterpreting Images of the Frontier, 1820–1920* (National Museum of American Art, Washington, DC, 1991). The motivation for this exhibition was to reconsider a large body of art that had long been considered heroic, authentic, documentary representations of America's shared tradition. The curators aimed to strip away the layers of myth that had shrouded this work. Drawing upon the scholarship of the so-called "new historians of the American West," who examine previously ignored issues of gender, race, and power in this region, and armed with academic theories such as deconstructionism, Marxism, feminism, and psychoanalysis, they explored the artists' motivations for creating such works, and the complex relationships they maintained with their patrons and audiences. The curators wished to highlight what had been glossed over in depicting the European settlement of the West: the displacement of native peoples, the suppression of their cultures, and the exploitation of natural resources.

But some politicians and members of the public were not willing to let go of cherished ideas and images. This called for a showdown. These sentiments were bolstered by the surge of patriotism generated by the outbreak of the first Gulf War, shortly before the opening of the exhibition. A few outraged members of Congress threatened to withdraw funds from the museum, a branch of the Smithsonian. Bowing to criticism from media pundits and visitors who had registered their dissatisfaction in comment books, the curators modified about ten of fifty-five wall labels that raised hackles.

This conflict represented a confrontation between a reinvigorated "victory culture" and a "culture of dissent" that had developed in the 1960s (Engelhardt 1994), and demonstrated that patriotism was not dead in a postmodernist world. "Generational" conflict of this sort, whether based strictly on age, or ideological allegiance, surfaced again in the prolonged debate over *The Last Act: The Atom Bomb and the End of World War II* (National Air and Space Museum, 1994–5), which intended to analyze the decision to use the atom bomb (dropped by the fighter plane the *Enola* Gay) and its repercussions (see also chapters 7 and 30).

The concerns raised over "balance" in the case of the *Enola Gay*, arose too during the controversy over *Gaelic Gotham: A History of the Irish in New York* (Museum of the City of New York, 1996). The history of New York City is, in many respects, the history of the Irish: this ethnic group has played a long and pivotal role in the city's development. But, to reiterate, power ebbs and flows: one hundred years ago, one in four New Yorkers was of Irish ancestry; this has dipped to merely 7 percent today. And reputations slide too: the annual bid of the Irish Lesbian and Gay Organization to be included in the St Patrick's Day Parade has been rebuffed repeatedly, blotching the public profile of the Irish community in many people's eyes.

Many of those who criticized the planning and execution of *Gaelic Gotham* believed it was important to celebrate the past, in order to reinvigorate the diminished Irish influence in New York. If there is a central lesson to be learned from the battle to control the show, it is that communities are multi-faceted and speak in many

voices, and that "leaders" may be self-appointed or represent only a small segment of the community. It is difficult for a museum to decide who deserves a hearing, and how much weight their opinion bears. Was the Museum of the City of New York (MCNY)'s role to be a passive one, simply providing a place for one part of a community to display its distinctive vision of history? Or was the role of these grassroots members merely advisory, as MCNY's staff moved to the business of translating concepts into effective displays?

Advocates of a dismissed Irish-American guest curator made headlines with accusations of financial malfeasance on MCNY's part, politicians threatened punitive action against the museum and the National Endowment for the Humanities (the major funder), and some lenders withdrew their property from display. What started as a contractual dispute mushroomed into a debate over intellectual property, the relation between a museum and its audiences, who is entitled to tell the story of a particular group and what is included or excluded from the narrative, and where to draw the line between community consultation and actual participation in the business of the museum. By the time an abridged *Gaelic Gotham* opened, it drew more yawns than praise or anger. The vigor of the pre-exhibition debate had dissipated into bruised egos and lessons learned – on the part of all the parties involved.

And, finally, the controversy sparked by *Sensation: Young British Artists from the Saatchi Collection* (Brooklyn Museum of Art [BMA], 1999) had the ring of familiarity to it, echoing the drama of its predecessors. The foil was the painting *The Holy Virgin Mary*, by Chris Ofili, an English-born artist with a Nigerian heritage. On one side, the main combatants included New York City's Mayor Rudolph Giuliani and other local politicians, the Catholic League for Religious and Civil Rights, and working- and middle-class Catholics; on the other, artists, the American Civil Liberties Union, and generally hip, politically concerned people. At issue was the depiction of Mary as a black woman, and with a clump of elephant dung representing one of her breasts. One faction viewed the painting as "blasphemous" and "perverted"; the other saw it as a reflection of the artist's ethnic and religious traditions and a question of freedom of expression (Ofili, like the mayor, is a Catholic).

Large street demonstrations occurred, reflecting both positions. An over-zealous, elderly protester threw white paint onto the canvas. And the media had a field day: a mayor, who was expected to throw his hat into a difficult political race, garnered daily headlines, as he sought to rein the museum in, constrict its financial lifeline, or even close it down should the BMA's directors refuse to remove the offending painting. In a basic respect, this was a classic "pseudo event," conjured up and diligently fostered by the media (see Dubin 2000a).

Ancillary issues were raised: BMA's complicity in "Sensation"-alizing the show, for example, and questionable ethical and financial relationships between the museum, the owner of the collection, and private dealers and galleries. Months later, and after each side had expended millions of dollars on legal fees, they reached an impasse: the courts did not allow the city to pursue any claims against the BMA, and the museum opted to absorb the financial losses it was forced to incur in its own defense and not to pursue its fight against the mayor. And what was the fate of the painting? It remained part of the exhibition throughout its scheduled run.

483

Steven C. Dubin

The Battle Abroad

Africa has been ignored as a site of culture wars, except as a reference point: on occasion the brutal ethnic and religious conflicts in numerous countries on that continent are held up as models of a *genuine* clash of traditions (see Hunter 1996a: 246). To address this deficiency, I cite a number of controversies regarding South African museums as evidence that the culture wars concept has relevance beyond the American experience (see also chapters 11 and 12).

Precisely because the present South African government has promoted a doctrine of reconciliation regarding the past, and a policy of non-racialism regarding the present and future, museums have become a prime location to translate new principles into reality. The version of the culture wars concept most relevant to the South African experience is one set down by James Hunter himself: conflict between "a world view that seeks to maintain . . . normative ideals and social institutions" and "a world view that seeks its transformation" (1996a: 244).

"A benchmark exhibition"

Just as *Harlem on My Mind* provided a template for controversies that have enveloped contemporary exhibitions in American museums, one particularly divisive exhibition offers significant insight into concerns that preoccupy South Africans: *Miscast: Negotiating Khoisan History and Material Culture*, curated by University of Cape Town art professor Pippa Skotnes (South African National Gallery, Cape Town, 1996). *Miscast* brought to the fore issues of cultural ownership: who has the right to speak for whom? Can a person from one group legitimately represent the experiences of another? *Miscast* also highlighted the shortcomings of time-honored cultural institutions by addressing questions that these places had largely ignored, and by examining lives that they had long overlooked or narrowly pigeon-holed. *Miscast* also forced many people to expand their thinking about what museums are, and what they might become. And it had tangible consequences for the people whose heritage it presented: the exhibition became the focal point for Khoisan[1] individuals holding divergent points of view to solidify and affirm a precolonial identity, and contemplate future political action such as pressing land claims.

The most well-known (and infamous) permanent museum display in South Africa has been the so-called Bushman (or San) diorama at the South African Museum in Cape Town, portraying the original inhabitants of Southern Africa (to be discussed more fully below). *Miscast* contested it in fundamental ways. Whereas the diorama was a static depiction, *Miscast* was dynamic: it incorporated multiple perspectives, involved a variety of media and sensory experiences, and required the audience to interact with its various components. Whilst the diorama disregarded the reprehensible treatment accorded the Bushmen by European settlers and their descendants – it was legal to hunt and kill them well into the twentieth century (see Gordon 1992) – *Miscast* interrogated that history. And, significantly, *Miscast* was presented in the National (Art) Gallery, not at the nearby South African Museum, thus troubling entrenched notions of where nature and culture "belong."

On approaching one of the three interconnected rooms of *Miscast*, visitors were confronted with a floor entirely "carpeted" with enlarged, laminated reproductions of newspaper articles, official documents, and photographs of Bushmen. Like it or not, anyone entering this space was forced to trample upon these native faces. All thus became complicit with oppressing the Bushmen, and many people were deeply dismayed by this. Resin casts of body parts, as well as fiberglass models of "trophy heads," dominated other areas. And cabinets of scientific paraphernalia from the nineteenth and early twentieth centuries – locating the Khoisan as specimens – shared space with contemporary photos of the Khoisan, examples of their material culture, and copies of rock art. Skotnes thereby presented these people as both object and subject. But as pertinent as *Miscast* was to a period of investigation and reflection (the Truth and Reconciliation Commission was commencing its hearings), it was rocked by controversy.

Certain critics challenged the legitimacy of Skotnes, a woman of European origins, exploring this social terrain. In their opinion, she did not have the requisite innate empathic powers to do so (see Skotnes 2001). Others objected to the fact that the display of the body casts in this public manner violated the Khoisan taboo against men and women jointly viewing human nudity. These responses simultaneously highlight the politics of representation and the politics of reception; in other words, the point where curatorial vision collides head on with audience understandings and reactions. *Miscast* and the responses it garnered raised increasingly familiar questions of cultural ownership and cultural spokesmanship.

Return of the "natives"

The moving and protracted saga of the Khoikhoi woman Saartje (or "Sarah") Bartmann provides a meaningful bridge between museum practices in the past and actions in the present. Sarah Bartmann was born in 1789, and in 1810 she was living in Cape Town, apparently working as either a slave or a servant. Here Bartmann agreed to a British ship doctor's proposition to accompany him to London. His intention? She would be exhibited as a physical anomaly, the "Hottentot Venus," in Britain, and later on in Ireland and France.

A common attribute of Khoikhoi women is steatopygia, or hefty, protruding buttocks, which stirred an enormous degree of curiosity in Europeans. Bartmann was displayed from Piccadilly to high-society gatherings, generating amazement as well as contempt, attraction as well as revulsion. Some voyeurs considered her to be the "missing link"; to others she represented a thrilling zone of forbidden sexuality. Bartmann was only in her mid-twenties when she died in France in 1815. Thereupon the legendary anatomist Georges Cuvier dissected her body and made a plaster cast of it. He also preserved her brain and genitalia in glass containers. Astonishingly, these remained on public display at the Musée de l'Homme in Paris until the 1970s or 1980s.

Bartmann's remains were finally repatriated to South Africa in 2002 after Khoisan groups intensely lobbied government officials in both South Africa and France. Sarah Bartmann now embodies the enduring abuse and oppression of women, and the racist, colonial mindset that nearly annihilated the indigenous peoples of Southern

Africa. For Jean Burgess, a member of Khoisan royalty who opened the bottles that had held Bartmann's remains and wrapped them for appropriate burial, their return was a compelling event: "[T]here was this pain carried over from generation to generation . . . it is a spiritual pain that I personally could never comprehend until I touched Sarah Bartmann's remains. This woman's spirit could not rest . . . her return to most Khoisan women had such a big spiritual effect, it was the beginning of a process of decolonizing of spirituality" (author interview with Jean Burgess in Grahamstown, July 2, 2003).

Khoisan leaders nixed a proposal to bury her in Cape Town's Company Gardens, a lush trace of the Dutch East India Company's early dominion over this region. She was buried instead atop a hillside just outside the little town of Hankey, nearby her presumed birthplace. Local Khoisan hope to construct their own museum in Hankey, reflecting *their* perspective on Bartmann and themselves. From Africa to Australia to North America, aboriginal groups demand that the other (largely unnamed) Sarah Bartmanns be de-accessioned from museums and universities (see, for example, Thomas 2000). Once-routine museum practices now cause offense and extreme distress. At the moment, native knowledge and desires are challenging the expertise and authority of scientists and museum curators.

The post-apartheid museum

Since 1994, South African museum curators, artists, politicians, educators, and others have endorsed different means of "nation-building" – the catchphrase used to denote the construction of a "Rainbow Nation." Each approach advocates a distinctive stance toward the past and to what degree it should be eradicated or amalgamated. Their respective proponents have produced a wide range of responses to refashion this society, from obliteration through transformation to new construction.

One complex and significant example concerns the changing fortunes of the aforementioned Bushman exhibition in Cape Town's South African Museum (SAM, the country's oldest). Its fate reflects the fluctuations of public sentiment toward images and representation. Generations of school children (and particularly whites) have adored this diorama, which features life casts made during the first quarter of the twentieth century. Scientists at the time were anxious to document the "Bushman" (San) and "Hottentot" (Khoikhoi) before they completely disappeared.

Until the 1960s, SAM was a broad-spectrum museum. In order to alleviate expanding storage and exhibition pressures, the South African Cultural History Museum was established in the nearby Slave Lodge (first built in 1679, name restored after 1998). In the course of this restructuring, the Bushmen stayed put: the diorama remained with "natural" history, whereas material reflecting the classical, European, and Asian experience was separated out and transferred.

Some people believe that this demeans Bushmen by "equating" them with animals, and locks them into an ahistorical and apolitical unreality that ignores their actual harsh fate. According to SAM curator Patricia Davison, "[T]hat the ideological implications of the move could go relatively unnoticed at the time, and later become relatively transparent, is an example both of the naturalizing capacity of ideology and of its inherent tendency to become acutely obvious" (Davison 1990: 161).

Others, however, think that it substantiates the San claim as first peoples of Southern Africa.

Negative voices have intensified in recent years. SAM personnel responded by incorporating this dissent into the display itself: the museum posted text that summarized contemporary debates so that viewers could understand the variety of reactions that the diorama evoked. SAM supplemented this by displaying copies of news articles, information concerning the making of the casts, as well as providing a social history of the people who were depicted. Until 2001, this approach created the sense of a continuing discussion (although the degree to which the public actually engaged with this material is questionable). But then SAM shut down the diorama in April of that year. In official parlance, it was "archived and sealed from public view."

The closure decision followed the radical restructuring in 2000 of fifteen local museums and sites into Iziko Museums of Cape Town. The first chief executive officer of Iziko decided to consign this exhibition to the dustbin of history, erase all the controversy, and eradicate the Khoisan yet again. He characterized this as a dramatic gesture to demonstrate that the museums were changing; it was met with cheers as well as denunciation.

In language strikingly similar to that adopted by some critics of *Miscast*, certain Khoisan applauded the decision, arguing that the diorama was "vulgar": "The Khoisan are shown as animals to Europeans and their children, who laugh at the depiction," one leader remarked (*Saturday Cape Argus*, March 31–April 1, 2001). At the same time, representatives of other indigenous peoples asked if the diorama could be transferred to them. A representative of the Xu! and Khwe San groups declared: "A museum must be created in our own ownership so that things that happened in the past can be preserved, even the wrong things. We want the public to see how it was" (*Cape Times*, March 30, 2001).

A new chief executive officer was appointed in 2003, one who is proud of his Khoisan descent. His approach is more open-ended: he is polling various indigenous groups with the possibility that a revamped exhibition incorporating the original casts can be developed. A recent SAM poster trumpets that this is the place where "Nature Meets Culture." Such language dissolves the partition between natural history and cultural history, and neutralizes the drawn-out debate over this division.

A second major strategy that South African museums and other sites of persuasion have adopted to respond to changing social conditions has been to convert places of pain or deceit into settings for candid learning, reflection, leisure, or profit-making. But one potential pitfall is to debase or undermine the original significance of an experience by packaging it with a tourist bent. For example, the Slave Lodge, until recently the cultural history branch of Cape Town's South African Museum, is being transformed. The impetus is a significant archaeological rediscovery made in 1998: investigators located the steps leading to the slave cellar, and unearthed hundreds of eighteenth- and nineteenth-century artifacts.

Prior to 1998, no reference was made to the system of slavery that literally propped up both the local economy and this specific edifice. Only now is that history being dealt with: the site will become a museum devoted to slavery. According to Iziko chief executive officer, Jatti Bredekamp (interviewed by the author in Cape Town on June 11, 2003), the objects on display will resonate with the voices of the

slaves as well as the slaveholders. But the gravity of the subject could be subverted should the proposal by a Cape Town-based historian win favor: "Many of the features of the Lodge could be celebrated in a courtyard restaurant, the stones of which were laid by slaves," he suggests. "Authentic food and wine from that period could be served by waitrons in period dress . . . This restaurant could be a great money spinner for the museum" (Shell 1999: 52). When profit is the driving force, history rapidly becomes farce. The boundaries between genuine homage and camp would become quite blurred in this instance.

But when the motivation to re-examine the past stems from other intentions, the results can be gripping. An example of refashioning a place of notoriety into its antithesis is what has happened on Robben Island. Situated in Cape Town's Table Bay, Robben Island has been a place of banishment for lepers, the mentally ill, and prisoners of war. But by far, those who have been exiled to Robben Island have been men deemed to be criminal for resisting various regimes: the rule of the Dutch, the British, or the apartheid government. Over the years, Robben Island has held disobedient slaves, Xhosa chiefs and rebels, dissident Muslims, and innumerable members of the African National Congress, among others. Robben Island was also "home" to Nelson Mandela for eighteen of the twenty-seven years he was incarcerated as a political prisoner. The last such inmates were released from the island in 1991. The keys were handed over to ex-prisoners in 1997, literally putting the inmates in charge of the institution. The buildings and grounds of Robben Island have been converted into an open-air museum, with an emphasis upon the experiential.

It becomes clear to anyone who disembarks from the half-hour ferry ride onto Robben Island that this is not a museum in the traditional sense. Instead of unnamed curatorial authority shaping the visitor's experience, everyone who comes here is steered through the buildings and grounds by ex-prisoners, each of whom may tell a somewhat different story. These former inmates explain the daily routine, the degradations and the oppression, but also point out how prisoners united to educate one another and to sketch out plans for a non-racial South Africa. The prominence accorded to the experiential, however, can sometimes border on the bizarre. At one point administrators proposed renting out cells overnight for the "prison experience" (Rassool 2000: 113).

Robben Island has not completely shaken its controversial reputation. Ex-prisoners have repeatedly clashed with administrators, accusing them of financial mismanagement, corruption, and even fraud. At one point they locked themselves in their old cells and conducted a hunger strike, a powerful evocation of the past. And various parties have leveled charges of racism regarding personnel matters, highlighting feelings of preferential treatment and inequality at the museum. Transforming a place so imbued with pain and bigotry into an exemplar of reconciliation is obviously a process fraught with mis-steps and setbacks.

Apartheid was the proverbial elephant in the South African lounge that was repeatedly disregarded or talked around. But the emancipatory events culminating in 1994's open election created a broad-based desire in South Africans to excavate what George Orwell dubbed "memory holes," dredge up the buried contents, and

then insure that the public could witness what was once hidden away. Innovative new museums are a prime spot to do just that.

That is the *raison d'être* of the Apartheid Museum (located between Johannesburg and the sprawling black township of Soweto), which opened its doors in 2001. The museum is adjacent to Gold Reef City, built upon the grounds of a defunct gold mine; it is an amusement park cum casino cum theme park. The Apartheid Museum directly owes its existence to this carnivalesque space: the developers were required to "give something back to the community" in order to receive their gaming license. And those men, Solly and Abe Krok, have a checkered local reputation. An enraged letter-to-the-editor writer angrily noted: "A great deal of New SA amnesia is at work in the euphoric reception accorded the newly opened Apartheid Museum . . . Has it been forgotten that under apartheid, the museum's 'angels,' the Krok brothers, peddled pernicious skin-lightening products?" The writer wonders: "Is the Apartheid Museum an atonement for the defunct Twins Pharmaceutical's past collusion in propping up apartheid's hierarchy of colour?" (*Business Day [SA]* December 10, 2001).

In spite of this questionable genesis from gaming profits, the museum is notable in many respects. Visitors are shunted straight away through either of two passageways, recreating the capriciousness of apartheid's racial classification system. Once inside, dozens of video screens bring apartheid to life, as do maps, news clippings, wall-sized photographs, and the seemingly endless lists of apartheid legislation. And there is an unnerving space where over one hundred closely clustered nooses are suspended from the ceiling; each represents one of the political prisoners hanged by the apartheid regime (fig. 29.1).

One of the two partners of the firm that designed the museum describes it as "emotional architecture," representing the "horrible sublime" – it is beautiful *and* dangerous, it both attracts and repels. He states, moreover, that because it is dense with material, and takes a long time to negotiate, "The museum people I think probably say they're no spaces to deal with museum fatigue, but the point is to actually make a strong mark. It's not about comfort, it's about discomfort" (author interview with Jeremy Rose in Johannesburg, December 9, 2003).

There have been criticisms of what the museum presents. A public debate has raged over the relative absence of attention to the anti-apartheid activities of white liberals such as Helen Suzman. Moreover, because of the inclusion of the history of white settlement in Johannesburg, as well as Southern Africa's precolonial history, the actual focus of the museum is somewhat indistinct. And indigenous groups such as the Khoisan feel that they have been slighted in this sweeping survey; some Afrikaners have disliked the portrayal of their group; and a disgruntled visitor once stormed out, declaring the place to be full of "communist propaganda."

Finally, the District Six Museum in Cape Town also addresses a significant historical void. Located just north-east of Cape Town's city center, District Six once boasted a cosmopolitan mix of Coloureds (mixed race), blacks, Indians, Malays, Jews, and a sprinkling of people of varied European descent. Many locals believe that the soul of the area prefigured today's much-touted concept of a "Rainbow Nation," a non-racialist South Africa. The District was methodically flattened, starting in 1966,

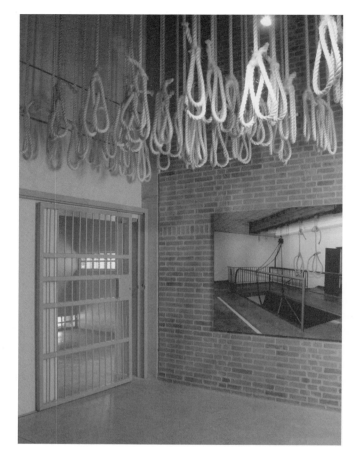

Figure 29.1 The Apartheid Museum, South Africa. Reproduced courtesy of the Apartheid Museum, South Africa.

by order of the Group Areas Act (GAA), one of the most despised components of the apartheid system. The GAA granted the government the right to declare neighborhoods to be the exclusive domain of particular racial groups. By the early 1980s, estimates place the number of residents removed at between 55,000 and 65,000.

District Six is dreamily recalled through a veil that accentuates the live-and-let-live attitude of the place, its sense of harmony, tolerance, equality, personal security, and *helpmekaar* or sharing. As Linda Fortune, a former resident and a District Six Museum staff member puts it: "What have we got left? . . . [P]eople tend to romanticize about District Six, we don't want to think about the pain. We don't want to think about the suffering, only the juicy bits, the sweet memories" (author interview with Linda Fortune in Cape Town, June 10, 2003). What is much less often addressed is the gangsterism and dire poverty that also affected many of the inhabitants there. Another staff member revealed that she once compiled a pamphlet describing the vibrant combination of people in the area, and mentioned prostitutes

as one of many local types. But a fellow employee "got furious." She explains: "He said, 'No, no, no. We didn't have those sorts of people working in District Six'" (author interview with Haajirah Esau in Cape Town, June 12, 2003). This pervasive romanticizing provides a challenge for any museum engaging with the subject.

Museums in South Africa have awakened from the nightmare of apartheid at long last. Many (if not all) of them have committed considerable time, effort, and expense to rid their exhibitions of the ideological baggage of colonialist and apartheid-era dogma, and realign them in accord with the more humanitarian principles that now underpin this society. This transformation has unfolded with varying degrees of success over the past decade. As Kevin Cole of the East London Museum notes: "[T]he trouble is, we never thought about the gaps [before]; where are the gaps? So we need to elicit inputs from people who could raise the questions or point out the gaps . . . It is a whole different thought process now" (author interview in East London, SA, July 7, 2003).

Conclusion

One final anecdote captures the tentative stage of reconciliation that characterizes South Africa today. At the site of the so-called Battle of Blood River of 1838, where Voortrekkers (Boer pioneers) defeated their Zulu foes, a private museum commemorates the engagement with a decided bent toward the point of view of those soon-to-be settlers. More recently, the national Department of Arts and Culture has constructed a museum highlighting the Zulu perspective, just across the Ncome River from it, and debate has raged over the markedly discordant estimated body counts that each museum presents. Tourists wishing to visit both places must currently drive a roundabout road connecting the two. A proposed bridge would allow people to walk conveniently from one bank to the other. Although funding exists to complete this simple project, the opposing sides have remained just that, facing off one another like their ancestors did over 150 years ago. These advocates, equipped with their dual perspectives, have not yet figured out how to meet one another half way, to their mutual benefit.

Daily life in contemporary South Africa vacillates between exhilaration and frustration, hope and cynicism, confidence and anxiety. This society has been reborn, but it has not yet matured. South African museums, and the controversies that have emerged in them, have become a microcosm of this labile state of affairs. As we have seen, strikingly similar events also have occurred in American museums. In both fledgling and established democracies, the concept of culture wars offers a persuasive instrument with which to analyze such public conflicts. What seems certain is that museums will continue to be sites of such conflicts.

Note

1 "Khoisan" is a widely used yet disputed term. It reflects a linguistic amalgamation of "Khoi" or "Khoikhoi" (Hottentot) pastoralists/herders with "San" (Bushman) hunters.

Steven C. Dubin

Bibliography

Bennett, T. (1995) *The Birth of the Museum: History, Theory, Politics*. London: Routledge.

Berger, J. (1977) *Ways of Seeing*. London: Penguin.

Brint, S. (1992) "What if they gave a war . . .?" *Contemporary Sociology*, 21 (4): 438–40.

Cameron, D. (1972) The museum: a temple or the forum? *Journal of World History*, 14: 189–202.

Davis, N. J. and Robinson, R. V. (1996) Religious orthodoxy in American society: the myth of a monolithic camp. *Journal for the Scientific Study of Religion*, 35: 229–46.

Davison, P. (1990) Rethinking the practice of ethnography and cultural history in South African museums. *African Studies*, 49: 149–67.

*DiMaggio, P., Evans, J., and Bryson, B. (1996) Have Americans' social attitudes become more polarized? *American Journal of Sociology*, 102: 690–755.

Douglas, M. (1970) *Natural Symbols: Explorations in Cosmology*. New York: Pantheon.

D'Souza, D. (1992) *Illiberal Education: The Politics of Race and Sex on Campus*. New York: Vintage.

*Dubin, S. C. (1992) *Arresting Images: Impolitic Art and Uncivil Actions*. New York: Routledge.

— (1994) Censors to the right of me, censors to the left of me. *New Art Examiner*, 21: 26–31, 53.

*— (2000a) *Displays of Power: Controversy in the American Museum from Enola Gay to Sensation*. New York: New York University Press.

— (2000b) How Sensation became a scandal. *Art in America*, 88: 53–9.

— (2001) Censorship and transgressive art. In N. J. Smelser and P. B. Baltes (eds), *International Encyclopedia of the Social and Behavioral Sciences*, vol. 3, pp. 1588–92. Amsterdam: Elsevier.

Duncan, C. (1991) Art museums and the ritual of citizenship. In I. Karp and S. D. Lavine (eds), *Exhibiting Cultures: The Poetics and Politics of Museum Display*, pp. 88–103. Washington, DC: Smithsonian Institution Press.

Engelhardt, T. (1994) *End of Victory Culture: Cold War America and the Disillusioning of a Generation*. New York: Basic.

Foucault, M. (1980) *The History of Sexuality*, vol. 1: *An Introduction*. New York: Vintage Books.

Gans, H. J. (1974) *Popular Culture and High Culture*. New York: Basic Books.

Garber, M. (1992) *Vested Interests: Cross-dressing and Cultural Anxiety*. New York: Routledge.

Gates, H. L. (1992) *Loose Canons: Notes on the Culture Wars*. New York: Oxford University Press.

Gitlin, T. (1995) *The Twilight of Common Dreams: Why America is Wracked by Culture Wars*. New York: Metropolitan Books.

Gordon, R. J. (1992) *The Bushman Myth and the Making of a Namibian Underclass*. Boulder, CO: Westview Press.

Green, J. C., Goth, J. L., Smidt, C. E., and Kellstedt, L. A. (eds) (1996) *Religion and the Culture Wars: Dispatches from the Front*. Lanham, MD: Rowman and Littlefield.

Hughes, R. (1994) *Culture of Complaint: A Passionate Look into the Ailing Heart of America*. New York: Warner Books.

*Hunter, J. D. (1991) *Culture Wars: The Struggle to Define America*. New York: Basic Books.

*— (1994) *Before the Shooting Begins: Searching for Democracy in America's Culture War*. New York: Free Press.

— (1996a) Reflections on the culture wars hypothesis. In J. L. Nolan, Jr (ed.), *The American Culture Wars: Current Contests and Future Prospects*, pp. 243–56. Charlottesville: University Press of Virginia.

— (1996b) Response to Davis and Robinson: remembering Durkheim. *Journal for the Scientific Study of Religion*, 35: 246–8.

Karp, I., and Lavine, S. D. (eds) (1991) *Exhibiting Cultures: The Poetics and Politics of Museum Display*. Washington, DC: Smithsonian Institution Press.

Kors, A. C. and Silvergate, H. A. (1998) *The Shadow University: The Betrayal of Liberty on America's Campuses*. New York: Free Press.

*Legassick, M., and Rassool, C. (2000) *Skeletons in the Cupboard: South African Museums and the Trade in Human Remains*. Cape Town: South African Museum.

Rankin, E. and Hamilton, C. (1999) Revision; reaction; re-vision: the role of museums in (a) transforming South Africa. *Museum Anthropology*, 22: 3–13.

Rassool, C. (2000) The rise of heritage and the reconstitution of history in South Africa. In R. Field and D. Bunn (eds), *Trauma and Topography: Proceedings of the Second Colloquium of the Landscape and Memory Project*, pp. 97–127. Johannesburg: University of Witwatersrand.

Schlesinger, A. M. (1992) *The Disuniting of America: Reflections on a Multicultural Society*. New York: W. W. Norton.

Shell, R. C. H. (1999) From diaspora to diorama: the UNESCO feasibility study for the cultural amplification of the memory of slavery and the slave trade in Southern Africa, part one: the Lodge. *Quarterly Bulletin of the National Library of South Africa*, 54: 44–56.

Skotnes, P. (2001) "Civilised off the face of the earth": museum display and the silencing of the /Xam. *Poetics Today*, 22: 299–321.

Thomas, D. H. (2000) *Skull Wars: Kennewick Man, Archaeology, and the Battle for Native American identity*. New York: Basic Books.

*Williams, R. H. (ed.) (1997) *Cultural Wars in American Politics: Critical Reviews of a Popular Myth*. New York: Aldine de Gruyter.

Wolfe, A. (1998) *One Nation, After All: What Middle-class Americans Really Think About: God, Country, Racism, Welfare, Immigration, Homosexuality, Work, the Right, the Left and Each Other*. New York: Viking.

Science Museums and the Culture Wars

Steven Conn

The Certainty of Science in an Uncertain World

In 1887, the Academy of Natural Sciences in Philadelphia faced an internal contro-
versy. The Academy was the oldest, most venerable natural history institution in the
country, the first, among other things, to display a fossil dinosaur. In 1876, the
Academy began to offer "popular courses," sets of lectures open to the general public
and given by the Academy's "professors." In a report on the success of the lectures,
Henry McCook had announced to the rest of the Academy in 1882 that "The Pro-
fessors have kept in view in all their instructions, the aim of the Academy, which is
not to give a general and rudimentary knowledge of all sciences but to give thorough
furnishing to special students in particular branches of science."

By 1887, however, there seemed to be a problem. The Committee on Instruction,
which oversaw the program of the public courses, began to question the content of
some of the lectures. The committee became concerned with "the possible danger
which might arise to the Academy from the Popular course if at any of the lectures
theories should be urged which might cause offence to a portion of the public, in
which case it feared the blame would be visited upon the Academy." The commit-
tee insisted that such scientific disagreements should be discussed at the Academy,
but it felt that such disputes "are hardly proper subjects for a lecture to an unscien-
tific public . . ." The committee went on to suggest that the lecturers confine them-
selves to "undisputed facts . . . without enunciating theories on which scientific men
themselves are not agreed."

Moreover, the committee worried that by lecturing on controversial theories, the
Academy would be seen as giving affront to the very public upon which it relied.
"Mere theories," the committee offered, "should yield place to facts in science where
the theories are known to be regarded with strong disfavor by a portion of the com-
munity to which the Academy must look for moral as well as financial support." The
committee passed a resolution asking its professors to refrain from controversial or
offensive discussion.

The source of these controversial theories surely had a single name: Darwin. In
suggesting that lecturers stick only to the "facts," the powers at the Academy tried
to cling to a notion of science where the facts of the natural world were, for the most

part, indisputable, and, like the frameworks of natural history themselves, did not change. These facts did not change, of course, because they reflected God's plan for nature. That older conception of science, by the late nineteenth century, was fading.

The newer science was driven less by observable facts than by abstract theory. Theories needed facts to prove or disprove them, but those facts were ultimately less interesting than the theories themselves. Unlike the "facts" of the old natural history, these new theories were precisely disputable, and in the most troubling ways. Indeed, the whole endeavor of the new science was predicated on conflict and debate.

The professors at the Academy rejected the committee's proposal "contemptuously." They did not acknowledge that the committee had any right to dictate lecture content. The committee, however, seems to have prevailed. During the academic year 1899–1900, for example, Benjamin Sharp offered five lectures on the topic "Comparative Anatomy and Physiology," Philip Calvert gave five lectures on "The Means of Defense of Animals," and Witmer Stone taught a five-lecture course on the "Structure and Morphology of Birds." Interesting and informative lectures no doubt, but hardly the cutting edge of science. Like the museum displays themselves, lectures came to be viewed as a way to entertain and inform the general public, but not to make them aware of the most important developments and changes in natural science.

As this small contretemps at the Academy of Natural Sciences suggests, museums of natural history could not avoid confronting the controversies that surrounded their work in the wake of Darwin. Museums, whose purpose was to collect, classify, and display the natural world for visitors, now found that the implications of that enterprise spoke directly to the debate between science and religion. This particular problem did not go away. In the 1920s, the American Museum of Natural History, under the leadership of Henry Fairfield Osborn, opened "The Hall of the Age of Man," an exhibit tracing what was then understood about the evolution of the human species. In 1926 Reverend John Rouch Straton, pastor of New York's Calvary Baptist Church, denounced the exhibit in an angry article in the *Forum*. "Unproved theories," he railed, "are being used to-day to lead our children away from the Bible revelation." Near hysteria, he went on:

> I have seen literally thousands of school children pass through the Hall of the Age of Man . . . in watching them, I was overwhelmed with the conviction that it was nothing short of a crime against the human race to fill the immature minds of these little children with the debasing idea of the brute origin of man on such flimsy and tricky "evidences."

The episode has a depressing familiarity, at least for those of us in the United States. Darwinian ideas still provoke almost Galilean spasms of anger on the part of America's religious fanatics. Familiar too is Reverend Straton's "solution" to the problem. He demanded of the museum that it "roll all of the show-cases containing these gruesome old bones to one side of the Hall and put on the other side another row of show-cases setting forth the Bible teaching concerning the creation of the world and man and the Bible philosophy of life." The good reverend did not get his wish at the museum, but somewhere he smiles. As I write this, school boards around

the United States, controlled increasingly by Christian fundamentalists, have fought successfully to remove Darwin from school science curriculums, or to have Creationism – tarted up these days as "intelligent design" – taught alongside it in the science classroom. Thanks to this hostile takeover of American education, Reverend Straton need not fear that America's "immature minds" are being corrupted today. Indeed, a majority of Americans according to some surveys do not "believe" in Darwinism, and President George W. Bush is among them.

But the fight between Darwinian science and Christian sensibility that got fought in the halls of Philadelphia's Academy of Natural Sciences and New York's American Museum of Natural History helps bring into focus the larger questions that lie at the intersection of science, politics, public sentiment, and public display.

By the second half of the nineteenth century, "science" grew to have an unrivaled authority in the Western world. Its definition also expanded so that it might include not simply the study of the natural world, but the study of history (Herbert Baxter Adams was pre-eminent among the "scientific" historians), the organization of department stores, and the way in which factory labor would be run (called by the early twentieth century "scientific management").

"Science" dazzled people because it seemed to provide unarguable results, especially when those results were applied to industry and technology. The dizzying way in which the world transformed in the late nineteenth and early twentieth centuries – the progress of the age, which virtually everyone took as an article of faith – both reflected and was driven by the triumph of "science." At the same time, science promised to solve problems and answer questions definitively. Science, after all, differed from philosophy and religion precisely because it ended debates rather than stimulating them.

These were the expectations, I suspect, that visitors brought with them when they entered the doors of a science museum. The exhibits would display questions settled and debates resolved. Science museums would present the world understood, organized, and managed, and in so doing reinforce the very idea of the power of science. Further, those expectations were underscored, I believe, because museums conveyed these messages by means of objects. Elsewhere I have described the "object-based epistemology" that framed the way in which late Victorians understood the world – an assumption that objects could convey knowledge, and that they could do so transparently (Conn 1998). Documents, and the people who wrote them, after all, might lie, but museum specimens did not. These beliefs, modified across the twentieth century to be sure, probably still shape the expectations of many who visit science museums. They still expect the museum to present exhibits that demonstrate science's conclusiveness, rather than its doubt, and that portray science as a central part of our progressive world. That science museums could display controversial ideas is not merely offensive to some, it fundamentally contradicts the very understanding many have about what "science" is in the first place.

This chapter, then, will examine some of the more recent controversies surrounding science museums, particularly in the United States. Those controversies help us track the ways in which ideas about the nature of science have changed, about the role of museums as the place where the public encounters science, and about whether we need to be protected, as the Academy of Natural Science's Committee

on Instruction believed, from the more unsettling ideas circulating in the world of science.

The Classification of the Science Museum

Let us begin with a quick genealogy. In the United States, the first serious museum endeavor was Peale's Museum, founded in the late eighteenth century in Philadelphia by Charles Willson Peale. Peale's was famous for a stunning collection of natural history specimens – including a fossil mastodon – and for its collection of portraits of eminent Americans painted by Peale and by some of his many children. From Peale's thus descends the art gallery and eventually the art museum in the United States, though after Peale's closed in the early nineteenth century there would not be a permanent collection of art available for public viewing until after the Civil War. Peale arranged his natural history collection using Linnaean classification, making it among the very first museums to use this new, scientific system to bring order to its specimens, and by extension to the natural world. In this sense, all museums of natural history in the United States also trace their origins back to Peale's.

Throughout most of the nineteenth century, natural history museums were synonymous with science museums. By the end of that century, however, other, more specialized collections began to grow out of the roots laid down by natural history museums. A few medical schools, for example, assembled medical collections to aid in teaching medicine. More significantly, many museums of natural history added an additional department to accommodate the natural history of humankind. Indeed, it does not stretch things too much to say that the new discipline of anthropology grew up in the natural history museum. A few institutions were founded specifically to be museums of the new science, and its cousin archaeology, most notably at Harvard, the University of Pennsylvania, and Berkeley. But, as these examples suggest, separate museums of anthropology were almost always attached to larger colleges or universities. In any event, regardless of where anthropological material might be displayed, the intellectual frameworks of natural history largely governed the way in which that material was collected, classified, and exhibited through much of the twentieth century.

By the late nineteenth century, natural history museums had spawned yet one more kind of offspring: the museum of technology. Among the earliest of this kind stand Philadelphia's Franklin Institute and Chicago's Museum of Science and Industry. The former evolved into a technology museum from an earlier life as a nineteenth-century mechanic's institute; the latter was, like the Field Museum of Natural History, a product of the 1893 World's Columbian Exposition. Initially, these too displayed their collections in much the same way that natural history museums displayed theirs. In both settings, exhibits told a story of progress, either in the natural world or in the industrial one.

These, then, constitute the constellation of "science" museums in the United States at the beginning of the twenty-first century: natural history, anthropology, technology and industry, and variations on these themes. In the remainder of this

497

chapter, we will visit each type to look at the kinds of political controversy they have engendered in the post-World War II era.

Category Jumpers: Museums and Anthropological Objects

Sometime in the 1920s, a shadowy conspiracy known only as the "Mu'tafikah" came together in order to "liberate" non-Western pieces of art from American museums, places the Mu'tafikah referred to as "centers of art detention," and return them to their "rightful" owners. In the words of one member of the organization: "we decided that we would be their desecrators, that we would send their loot back to where it was stolen and await the rise of Shango, Shiva and Quetzalcoatl."

Of course, the Mu'tafikah and their conspiracy of art liberation existed only in the pages of Ishmael Reed's rollicking 1972 novel *Mumbo Jumbo*. Writing in the midst of various political convulsions around the world in the 1960s and early 1970s, Reed captured a sense that postcolonial struggles had a cultural front in addition to political, military, and economic ones. For many in newly emerging nations, Western museum collections, filled with material bought, excavated, or otherwise taken from the Third World, amounted to nothing less than the wholesale abduction of their cultural patrimony, theft of the very material those nations might use to fashion a collective identity and an historical legitimacy.

Fights over who owns what, and under what circumstances, are at least as old as the expropriation of the Parthenon sculptures by Lord Elgin early in the nineteenth century. And as Reed, through the creation of his Mu'tafikah, suggests, many of the highest profile fights have been over art objects; most recently, many art museums have been combing through their acquisition records to see what, if any, of their collection came via a Nazi route. In several instances, works of art have been returned to the families from whom the Nazis stole them during the Third Reich (see chapter 27).

But, in fact, Ishmael Reed and his Mu'tafikah misread the cultural winds blowing in 1972 on two levels. First, the debates over how to deal with "anthropological" or "ethnographic" objects have been taking place at least as vigorously in natural history museums as in art museums. Second, that debate has not been so much over whether to "liberate" these objects from the context of Western museums altogether, but rather how to change the categorical frameworks in which the objects are presented. This categorical shift during the past generation in the way in which non-Western objects are treated within the museum itself has been an attempt to change how these objects – and thus the people who made them – are defined. Material once seen as "anthropological" or "ethnographic" – and thus scientific – is now seen increasingly as "art" (see also chapter 5).

This trend probably began with the opening of the Michael Rockefeller Wing at the Metropolitan Museum of Art in New York in 1982. There, a collection of objects from the Pacific Islands, Africa, and pre-Columbian America was installed in a way that treated the objects like pieces of fine art. What might have been exhibited in order to illustrate anthropological ideas was now displayed in order to highlight aes-

thetic and artistic values. Often under lucite cases and spotlit sensually, these objects are now commonly labeled according to the conventions of Western art historical practice even if, as often as not, the name of the "artist" is "unknown." This categorical shift informs the display of non-Western objects at museums ranging from the National Museum of African Art on the mall in Washington to the Seattle Museum of Art, which has been designed to show off the museum's stunning collection of Northwest Coast material.

Political pressures certainly have played a large role in expanding the definition of "art" to include objects that used to reside in the category of ethnography (though it also bears remembering that only in the past generation have many European art historians and critics acknowledged American painting as part of the category of "art" as well – some still don't). In the wake of decolonization, and with an increasing awareness of the connection between anthropology and imperialism, treating other people as objects of scientific study rather than as actors in their own history and culture has become increasingly problematic for natural history and anthropology museums. Likewise, newly independent peoples no longer wanted to see themselves represented anthropologically in museum galleries, especially when so many of those exhibits stressed the static and "primitive" nature of their cultures.

The reciprocal implication of this move out of the natural history diorama and into the art museum gallery is that only as art will those people and cultures truly be appreciated on par with the West. Displayed near the Rembrandts and Van Goghs, Benin bronzes or Moche pots will acquire a new aura, and we will value the makers of those objects similarly. Rather than awaiting their liberation, as Ishmael Reed imagined, objects from non-Western cultures have been banging on the doors of art museums demanding, with increasing frequency, to be let in. As a result, though the discipline of anthropology itself coalesced inside the museum, it has become increasingly untenable to exhibit anthropological objects in the old way.

One solution to the dilemma of how to exhibit anthropological material may be to give members of exhibited groups a much larger role in creating exhibits. To that end, in 1989, the United States Congress created the National Museum of the American Indian (NMAI), to be located on the National Mall, right in the middle of the national museum complex. The NMAI has recently opened, and while the early reviews have not been enthusiastic – including my own – it may yet evolve into a more interesting place. But its creation does underscore the fact that, far from eschewing the museum, many Native Americans and their advocates are enthusiastic to present their cultures in a museum context, even one sponsored by the Federal government.

NAGPRA and the Return to the Natives

If Ishmael Reed imagined in 1972 the return of non-Western cultural patrimony in a spectacular and revolutionary act of violent liberation, the reality, at least in the United States, has proved legalistic and bureaucratic. In 1990, the year after the NMAI was chartered, the United States Congress passed the Native American Graves Protection and Repatriation Act (NAGPRA).

NAGPRA was the culmination of a generation of activity on the part of Native Americans and their advocates. By the 1980s, the Smithsonian Institution had begun to return items to Native groups. In 1989 the Field Museum in Chicago adopted a repatriation policy and began returning objects from its collections. But those constituted individual and voluntary actions. Under the terms of NAGPRA, every institution in the nation which has ever received Federal money is required to create an inventory of Native American objects in its collection and to publish that inventory publicly. Those inventories have become the basis upon which tribal groups can make requests for items to be returned.

The emphasis of NAGPRA, as its name suggests, is on human remains, objects associated with burials, and objects more broadly associated with religious practice. It has created an unprecedented access to museum collections, and as a result, natural history museums, anthropology museums, and colleges and universities with Native American collections now have staff members who work full time on NAGPRA requests and compliance.

The real issues raised by NAGPRA, however, are not procedural or logistical. Rather, they are interpretative. The law stipulates that cultural affiliation must be established between the group requesting repatriation and the material in question. That affiliation can be determined based on geography, oral historical tradition, or ethnographic data. But those criteria only raise more questions: How are oral traditions to be evaluated? How reliable are ethnographic reports? Have the boundaries of cultural geography not changed over time? Further, NAGPRA raises other basic questions. By what criteria are objects evaluated as funerary or religious? Can or should certain objects be destroyed, or reburied, because one side in the dispute believes that they should be, or do the imperatives of preservation and study restrict the treatment of those objects? Are there fundamentally different ways of knowing and understanding that separate white America from Native America that make any use of Native material by non-Natives simply unacceptable? Tricky, difficult questions to be sure, all the more so because they come heavy with political baggage. Can these questions even be answered in dispassionate ways, given the centuries of dispossession, decimation, and brutality that Native Americans have endured?

At its crudest, NAGPRA pits scientific research, seen as disinterested, enlightened, value-free, and best carried out by whites in their museums or universities, against flaky, New Agey, anti-intellectual spiritualism which uses NAGPRA as a way of achieving cheap victories in the identity politics wars. In fact, most NAGPRA requests have proceeded quietly and uneventfully, though some Native American groups have complained about the burdensome process and about institutional foot-dragging on the part of some museums.

But these issues have flashed publicly most spectacularly in the case of Kennewick Man. The man in question was unearthed in July 1996 by the United States Army Corps of Engineers on the Columbia River near Kennewick, Washington. Preliminary dating of the skeleton put it at roughly 9500 BCE, a remarkably early find, made more important by the fact that there is very little archaeological material from that particular era in the New World. Very quickly this find was contested by five tribes in the Pacific Northwest – the Confederated Tribes of the Umatilla, the Confederated Tribes and Bands of the Yakima Indian Nation, the Nez Perce Tribe of Idaho,

the Confederated Tribes of the Colville Reservation, and the Wanapum Band – under NAGPRA. All five tribes claimed ancestral connection with the skeleton and, using NAGPRA, demanded that the skeleton be impounded and removed from forensic examination. In 2000, the United States Department of the Interior issued a decision on the matter agreeing with the five tribes and concluding that there was a "continuity" and a "reasonable relationship" between the ancient skeleton and the contemporary groups.

Whether Native Americans in the late twentieth century could really demonstrate a "cultural affiliation" with a skeleton as old as Kennewick is problematic enough, especially since we know very little about him and nothing about the "culture" of which he was once a part. Complicating matters further, examinations done on the skeleton before he was locked away in a vault seem to hint that Kennewick Man, whoever he might have been, was not Indian – at least not in the anatomical ways we understand that group. The skeleton suggests a person with "caucasianoid" features. The implications of that, should they prove to be true, are fascinatingly far reaching. Should Kennewick Man turn out to be of European extraction, at least as determined by current forensic anthropology and genetic analysis, not only would the five tribes involved in the dispute not have any claim over the bones, but Americans of some other ethnicity – Irish? Swedish? Danish? – might well be entitled to file a NAGPRA claim for them.

Taken to one logical, if ugly conclusion, the identity of the skeleton might be taken as proof that those we now call Native Americans were not, in fact, the first arrivals in the hemisphere, that, indeed, they may have usurped or displaced some European groups already here, and thus Native Americans have no special claims to territory or sovereignty rights on the continent. Some have accused the five tribes of filing the NAGPRA claim precisely because they realize all this, that they have no connection at all – cultural, genetic, or otherwise – to this skeleton, and that they want the bones reburied as a way of keeping the lid on this political Pandora's box permanently sealed. At the very least, Kennewick Man might well alter and complicate our understanding of how the continent was peopled in the first place. As anthropologist Robson Bonnichsen has put it: "We have always used the term paleo-Indian to describe the remains of this era. But this may be the wrong term. Maybe some of these guys were really just paleo-American" (quoted in Egan 1996).

Thus, the work of repatriation mandated by NAGPRA and taking place in natural history museums and anthropological collections around the United States really centers on the questions of who will control our understanding of the past, and who owns some of the material with which we might achieve that understanding. NAGPRA was created in response to several decades of political pressure and to redress what have come to be seen as historical wrongs. However, NAGPRA has also created other political problems and revealed fundamental epistemological divisions.

Of course, NAGPRA only governs American material residing in American collections. It is a unique piece of law, shaped by the particular history of relations between Euro-America and Native America, and by the politics that have grown up around that history in the past generation. During the same political moment, however, increasing numbers of museums, governments, and international organizations have tried to deal with some of the same questions across international

borders. In the 1970s, under the auspices of UNESCO, many of the world's major museums signed on to protocols governing how material could be legitimately acquired from other countries. For the most part, those agreements do not speak to the issue of repatriation.

The Egyptian government has welcomed back, with great ceremony, King Rameses I – or at least a mummy that many believe to be the king. It was returned by the Michael Carlos Museum at Emory University in Atlanta, which had, in turn, bought the mummy from the Niagara Falls Museum in Canada. Whether or not the mummy is actually that of Rameses I may be beside the point: the Egyptian government has been applying increasing pressure to have many of its most famous antiquities returned to it, including the Rosetta Stone, now in London's British Museum, and a bust of Nefertiti on display in Berlin. The Egyptian government hopes that the triumphal return of Rameses will be only the first of many, and it remains to be seen whether other governments will follow the Egyptian lead in demanding the return of cultural material. The vexing question of how to balance competing claims of who owns what and under what circumstances took a particularly tragic turn as we all watched the archaeological museum in Baghdad looted in 2003 while American soldiers did nothing to stop it (see chapter 13).

Science and Technology in the Nuclear Age

Nowhere has the connection between science and progress been illustrated more emphatically than in displays of technology. These displays formed a central part of world fairs and other temporary exhibitions that defined the late Victorian period on both sides of the Atlantic. Those displays, while often organized around "national" accomplishments, were usually sponsored by private companies. When these temporary spectacles of technological triumph were given permanent homes in museums, exhibits of technology continued to enjoy close relationships with the companies and corporations that create new technologies in the first place. There is nothing remarkable in that observation. Indeed, since the early twentieth century, many technology companies have sponsored exhibits designed to highlight their new products, a phenomenon that continues to the present day.

What does seem remarkable is the extent to which the narratives that frame the display of technology have remained stubbornly impervious to any rewriting. In science museums, technology is always good and functions as the central actor in human progress. These museums studiously avoid presenting any darker narratives about progress, even though many of us acknowledge at least a little ambivalence about technology and its effects on society. A case in point, as stunning to me as it seems typical: "Petroleum Planet," the display about petroleum at the Museum of Science and Industry in Chicago. The exhibit serves as a thinly veiled celebration of the black gold and of its centrality to the modern world: "Getting chilly outside? Don your favorite Gore-Tex jacket and apply some lip balm. Breath a little ripe? Brush your teeth and top it off with a nice minty stick of chewing gum. And remember to thank the petroleum industry while you're at it!" Nowhere in the exhibit do we learn about oil spills, about the air pollution that results from burning fossil fuels,

or about climate change. Oil fuels our world. Its discovery, recovery, and refining are necessary for life as we know it. Put simply: "Petroleum isn't just a material – it's a way of life." The exhibit has been sponsored by BP-Amoco. Exhibits like these have popped up in Europe as well, including a BP-sponsored "Ecology" display at London's Natural History Museum, and in each case the museum gallery has simply been turned into an extension of the corporation's public relations apparatus.

It is probably fair to say, however, that no technological development has caused so many to question the very relationship between technology and progress, or caused more debate and anxiety over the role of what President Dwight Eisenhower called "the military–industrial complex," than nuclear weapons and nuclear power. And yet though those debates have raged since August 1945, one seeks in vain to find any of them represented in museum displays of the development of the nuclear age.

As the United States approached the fiftieth anniversary of the events of World War II, the nation engaged in a veritable orgy of remembrance: memorials, speeches, parades, statues, documentaries, books. Men (and to at least some extent women too) now in their seventies and eighties, frail many of them, found themselves dubbed publicly "The Greatest Generation" by television news drone Tom Brokaw. And the rest of the nation seemed largely to agree.

As one small part of these commemorations, the Smithsonian Institution's National Air and Space Museum (NASM) – a highly specialized and, I might add, spectacular off-shoot of the science and technology museum – proposed an exhibit built around the *Enola Gay*. The *Enola Gay* itself was the airplane which dropped the first atomic weapon on Hiroshima in August 1945, but the exhibit designers at the NASM had something a bit more ambitious in mind. The committee planning the exhibit, which it originally titled *The Crossroads: The End of World War II, the Atomic Bomb, and the Origins of the Cold War*, hoped to mount something that would examine the dawn of the nuclear age from several points of view.

Juxtaposed in this exhibit were rationales for dropping the two nuclear bombs and photos of the Japanese cities – and people – upon whom those bombs were detonated. Most poignantly, the exhibit included the small metal lunchbox of a Japanese child incinerated by the blast. As described by historian and NASM curator Michael Neufeld:

> Through the use of proper lighting, sound insulation, black-and-white photographs, artifacts from the mission and Hiroshima, and a restrained text, a quiet contemplative mood will be established in the exhibit. The morality of the bombing will be addressed in particular in the section on the decision to drop the bomb. The exhibit will not attempt to impose any particular point of view, but will give visitors enough information to form their own views of a decision that to this day remains controversial. (quoted in Linenthal and Engelhardt 1996: 18)

An interesting, even complex exhibit – and it never saw the light of day. Once word got out about the Air and Space Museum's plan for the *Enola Gay*, it created – pardon – an explosion of controversy. Veterans' groups, in particular, and more so the politicians beholden to them, objected strenuously to the very suggestion that

there might be anything at all militarily or morally ambiguous about having dropped the atomic bombs on Japan, though such questions were certainly raised at the time. Such suggestions, they railed, were fundamentally unpatriotic, they amounted to a betrayal of the Greatest Generation, and, worst of all, they smelled of historical revisionism. In a speech attacking NASM's *Enola Gay* exhibit among other things, Republican presidential candidate and World War II veteran Bob Dole called his effort to stem the growing tide of "political correctness" his "final mission." (It was not. After losing the 1996 election to Bill Clinton, septuagenarian Dole's final campaign turned out to be as the spokesperson for the impotency drug Viagra.)

In the end, the Smithsonian folded under the pressure. Members of Congress threatened to withhold the Smithsonian's funding and demanded the resignations of NASM officials (which they got). In the end, the NASM put up a smaller exhibit featuring a piece of the *Enola Gay*'s fuselage, a few other artifacts, and not much else, "a beer can with a label," as Air Force historian Richard Hallion described it (see fig. 7.1). No matter. The now-dead exhibit continued to serve as a whipping boy for conservative politicians and radio talk-show hosts like Rush Limbaugh.

The furor over the *Enola Gay*, of course, was not really over science as such, but over history (see chapter 7). But lost amidst the hue and cry was the fact that the nuclear age was already on display in a number of venues throughout the country and had been for some time. This nuclear exhibitionary complex consists of a constellation of formal museums, corporate offices, historic sites, and military installations. Taken together, tens of millions of Americans have visited exhibits devoted to nuclear weapons and nuclear power. None of these exhibits has attracted the same public glare that came to wither the *Enola Gay* exhibit. That probably has something to do with the centrality of the Smithsonian on the nation's cultural and political landscape. The *Enola Gay* was not the only exhibit on the nation's mall to attract fierce attention in the 1990s. The nuclear exhibitionary complex, however, has operated without public outcry because these displays present, by and large, a remarkably upbeat, uncomplicated, almost Whiggish view of the nuclear age. In this sense, the critics of the *Enola Gay* were quite right: in the context of other exhibits of nuclear weaponry, the idea that nuclear weapons might be dangerous, destructive, and something other than benign peacekeepers was revisionist indeed.

During the Cold War, at places like the Air Force Museum at the Wright-Patterson Air Force Base in Dayton, Ohio, the Bradbury Science Museum at Los Alamos, New Mexico, and the National Atomic Museum in Albuquerque, America's nuclear capabilities have been presented to the public as the guardian of national security in a hostile world. A 1958 vintage exhibit at Chicago's Museum of Science and Industry on "Seapower" can be seen in some ways as typical. Illustrated with a map of the globe encircled with red lines, the portion of the exhibit devoted to nuclear weapons demonstrated that no point on the planet was out of reach of American nuclear missiles.

Public opposition to the testing, deployment, and proliferation of nuclear weapons began almost immediately after the first nuclear explosions. None of these exhibits acknowledged that controversy, nor did they acknowledge the growing body of medical data demonstrating just how dangerous radiation could be to the human body. That should come as no surprise. These exhibits, after all, were products of a

Cold War environment and were sponsored largely by entities with a vested interest in fighting it. The public might well be terrified by the dangers of nuclear weapons presented in magazines, books, and movies, but at these displays they would learn to love the bomb.

More surprising, however, is that the sunny view of nuclear technology in exhibit halls seems to have survived Three Mile Island, Chernobyl, and the end of the Cold War largely intact. While for most people the issue of nuclear weapons has lost the urgency and immediacy it had in the 1980s, the National Atomic Museum in Albuquerque, chartered by Congress in 1969, is about to move into a new, expanded facility in 2006 and change its name to the National Museum of Nuclear Science and History. In the new building visitors will see exhibits on the wonders of nuclear medicine, they will be able to "weigh the risks and benefits of food irradiation," and to view a working atomic clock. Still, the museum's mission remains to tell "the story of the Atomic Age, from early research of nuclear development through today's peaceful uses of nuclear technology." In the new building visitors will also get to see an exhibit on the history of the Cold War entitled: "Waging Peace."

A Nineteenth-century Museum in a Twenty-first Century World

In the mid-1990s, the Field Museum of Natural History in Chicago, one of the largest, most dynamic museums of its kind in the world, changed its name. It is now simply the Field Museum. What's in a name change? Perhaps one future for American science museums. To be sure, the Field Museum remains one of the world's most vital institutions for research and education about natural history. But the elimination of "natural history" from its name may be a way of giving the museum flexibility to stretch the definition of what natural history means, and thus what might be displayed inside the building. The Field Museum, looking perhaps to shed a perception of itself as a dusty, slightly stolid museum, is now a place where visitors can see traveling shows devoted to *Chocolate* and to the treasures of Cleopatra – both fun shows, but not what one usually thinks of in a natural history museum, and that is probably just the point.

While science museums remain remarkably popular with visitors in the United States, I suspect that they have glanced enviously at art museums and their ability to generate big publicity and huge crowds with "blockbusters." Art museums – especially American ones – have mounted show after show of Impressionist paintings, and crowds continue to throng to see them (and to buy the associated merchandise). What Impressionism is to the art museum, dinosaurs could be to the natural history museum, and here the Field Museum is again instructive. The Field purchased the biggest blockbuster dinosaur of them all. Her name is Sue and she is the largest, most complete skeleton of a Tyrannosaurus ever unearthed. Bought at auction for roughly ten million dollars, Sue almost instantly became the most famous resident of the Field. When some exhibit designer can figure out how to mount a *Dinosaurs and Impressionism* show, museum marketing will have reached a divine apotheosis. (In a parallel development, The Met discovered some years ago that franchising its own

museum store to up-scale malls around the country could be quite profitable. During my last sprint through Chicago's O'Hare Airport I noticed that the Field Museum had opened a museum shop as part of the airport's retail operations. It is easy enough to find amidst the chaos of O'Hare – just look for the life-sized replica of a Brachiosaurus.)

Many in the art world now recognize that the blockbuster shows carry their own costs to museums, and the same will prove to be true, I suspect, for science museums that catch "blockbusteritis." First, blockbusters can have the effect of distorting what the public sees in the museum and driving out other kinds of exhibits that do not have the same appeal or effect on the bottom line. Dinosaurs, after all, are really only a small part of the research and collections at the Field. Second, blockbusters – increasingly expensive to mount – force an even greater reliance on corporate money, and that dependence might also have the effect of bending institutional priorities. The Field Museum, after all, did not actually have the money to purchase Sue on its own; much of the cash came from McDonald's and Disney. Can an animated film featuring Sue, complete with a "Sue-per sized" happy meal, be far off?

Given the public and political outcry that has greeted American museums of natural science and of technology, since Reverend Straton denounced the American Museum of Natural History, when they have attempted to mount exhibits with even modestly challenging content, one could hardly blame them if they chose to avoid controversial topics altogether. Why not display instead a notion of science as disinterested and "objective," despite the intellectual dishonesty that would surely entail? As these institutions, created in the nineteenth and early twentieth centuries, try to reinvent themselves for a new millennium, however, I believe they may discover that the way they can make themselves newly relevant is by embracing political controversies rather than hiding from them.

Nineteenth-century natural history collections – endless arrays of stuffed birds, insects under glass, trays of mollusk shells – stand as perhaps the best symbol of the dusty, antiquated, boring museum. While some want the natural history museum to break from that past to become a more entertaining, interactive place, others have argued that the old-fashioned work of collecting, identifying, and classifying ought to be the center of museum work in the future. Leonard Krishtalka and Philip Humphrey, both of the Natural History Museum at the University of Kansas, believe that natural history museums should play a central role in addressing the "biodiversity crisis." As they see it, "museums must immediately harness their vast, authoritative, collection-based information" in order to better understand "the evolutionary and ecological pulse of the earth's . . . 15 million or more species." Few – at least outside the Bush Administration – would argue with the idea that a better understanding of how life on earth works is essential for earth's future stability and sustainability, and so Krishtalka and Humphrey conclude that "natural history museums should be poised to inform the environmental management of the planet" (2000: 611–17).

Looked at this way, natural history museums have never seemed more important or exciting, their collections of embalmed animals never more relevant. But putting natural history museums at the center of work dealing with biodiversity, however

506

urgent that work is, necessarily puts them at the center of a host of political debates, some international in scope. Further, given the drift of science museums, one wonders if it is a realistic goal for these museums. Put another way, will corporations be willing to sponsor a museum-based system of "biodiversity informatics?"

And yet, skepticism to one side, Krishtalka and Humphrey are on to something quite important about the future of science museums. While most primary scientific research is now done in colleges and universities, and in specialized institutes, museums remain the places where large numbers of people encounter science one way or the other. Most museums certainly recognize the responsibility they have to educate the public, and yet most are still as reluctant to address the most pressing, and, yes, controversial topics as they were in 1887 when the Academy of Natural Sciences' Committee of Instruction wanted to stop discussing Darwin publicly.

Increasingly, citizens of democratic societies are faced with political choices around matters of science. Examples abound: climate change, human cloning, genetically modified food, the allocation and use of water. These issues, and a dozen others, are as difficult as they are urgent. And yet most people are forced to make these political choices almost blind. In the political matters involving science, most of us remain woefully ignorant citizens.

Science museums in the United States, then, might reconceive of themselves as town halls for science. They might function, as some do already in the UK and in Scandinavia, as places where the interested public could come to see exhibits, hear lectures, and watch debates about the issues where science and politics intersect. The new Marian Koshland Science Museum, which opened in Washington, DC in April 2004 and which is the museum arm of the National Academy of Sciences, tries to engage its visitors precisely on the terrain where science meets policy. Despite the beatings some museums have taken publicly during the battles of the recent culture wars, museums still speak to most people with voices of authority and legitimacy. Trading on that legitimacy to make us all more literate scientific citizens might well be the greatest function science museums could serve.

It also might help with another of the science museum's major challenges in the twenty-first century: the composition of its audience. Science museums continue to attract great numbers, but the vast majority of those visitors are under the age of sixteen. Since the mid-twentieth century, science museums have largely abandoned the adult audience, and as a result much of the science presented in these places is aimed at a ten-year-old. Educating children about science, convincing them, as these exhibits often try to do, that science is fun, is certainly a worthy enterprise. But by failing to reach adults, science museums have, however inadvertently, only widened the gap between our scientific literacy and the political choices we are asked to make. Only when the science museum engages a broad adult audience will it help move science into the public realm, and only then can we all approach political decisions as better-informed participants. If science museums take up this challenge, then they will become fully and truly civic institutions. Perhaps by embracing the uncertainty of science and showing it to us, science museums can help us all navigate through an uncertain world.

Steven Conn

Bibliography

*Asma, S. (2001) *Stuffed Animals and Pickled Heads: The Culture and Evolution of Natural History Museums*. Oxford: Oxford University Press.

Butler, S. (1992) *Science and Technology Museums*. Leicester: Leicester University Press.

*Conn, S. (1998) *Museums and American Intellectual Life, 1876–1926*. Chicago: Chicago University Press.

Daedalus (1999) Special issue on museums, vol. 128 (Summer).

Egan, T. (1996) Tribe stops study of bones that challenge history. *The New York Times*, September 30.

Fine-Dare, K. (2002) *Grave Injustice: The American Indian Repatriation Movement and NAGPRA*. Lincoln, NE: University of Nebraska Press.

Kirstein, P. (1989) The atomic museum. *Art in America*, 77: 44–5.

Krishtalka, L. and. Humphrey, P. S. (2000) Can natural history museums capture the future? *BioScience*, 50 (July): 611–17.

Lindqvist, S., Hedin, M., and Larsson, U. (eds) (2000) *Museums of Modern Science*. Canton, MA: Science History Publications.

Linenthal, E. and Engelhardt, T. (eds) (1996) *History Wars: The Enola Gay and Other Battles for the American Past*. New York: Henry Holt.

Macdonald, S. (ed.) (1998) *The Politics of Display: Museums, Science, Culture*. London: Routledge.

*White, R. (1997) Representing Indians. *The New Republic*, 216 (April 21): 28–34.

*Yanni, C. (1999) *Nature's Museums: Victorian Science and the Architecture of Display*. Baltimore, MD: The Johns Hopkins University Press.

Postmodern Restructurings

Nick Prior

It is a bracing morning, December 2002, and a group of expectant teenagers wait for the doors to open. They have come to play the arcade games. Fingers twitching, the young digital junkies enter at 10 a.m. and head straight for their favorite machines. *The Sims*, *PacMan*, *Donkey Kong*, *Tomb Raider* – they are all here. Many gamers will stay all day, leaving with sore fingers at closing time, only to return tomorrow. Others will meet at specially arranged times for one-to-one challenges or to try to beat a legendary high score.

But this is not some seedy high-street amusement arcade or urban funfair. It is the Royal Museum in Edinburgh and the exhibition is *Game On: The History, Culture and Future of Videogames*. For a £5 entrance fee visitors are offered a cultural history of the games industry, which includes a nostalgic trip through the classics, installations detailing the art of game design, and a jukebox area where one can listen to some of the best arcade game music ever composed, including specially commissioned pieces by groups like *The Prodigy*. But it is Zone 2, with its collection of 120 playable games, that draws the punters. Colonized by curious parents, skilled teenagers, and dewy-eyed nostalgics alike, the exhibition space elicits the kind of "hands-on" enthrallment that many museums have been after for years. It is a far cry from the pious space imagined by traditionalists. Far enough, perhaps, to question whether the museum has a distinct identity from the amusement arcade at all.

For, undoubtedly, the notion of the museum has been pushed beyond its origins in Enlightenment and elite connoisseurship and beyond the rather drab, dusty enclave imagined by critics of the museum-as-mausoleum. Today's museums, it is claimed, are unabashed crowd-pullers that appeal to entertainment as much as education and owe as much to the theme park as the modernist canon. This chapter addresses itself to the issue of the museum under postmodernity. My intention is not to provide a critical overview of the fundamental socio–economic displacement known as postmodernity itself. Rather, I want to review some of the claims made about the effects that this displacement has had on the museum as a cultural institution. In other words, I want to identify recent characterizations of the museum as having slid toward the postmodern cultural scene, its *modus operandi* based upon the "soft" values of consumption, distraction, and spectacle.

To this end, I have designated three museological restructurings that encapsulate essential, but not exclusive, dimensions of recent changes in the museum. The themes are: (a) urban regeneration and the soft city; (b) spectacles of exhibition and display; and (c) changing conventions of aesthetic perception. I have chosen to begin with the museum's location in the city for two reasons. First, the museum is an urban phenomenon and feeds into and off arrangements in the city at large. Conceptions of recent urban change, therefore, have similar (if skewed) implications for the museum itself. Secondly, there has been a tendency in much of the literature on museums to ignore its dynamic relationship to the city in favor of the nation. This is an unfortunate oversight given the richness of the relationship between the urban and the museological, as well as the potential connections to be made between a developed literature on the city and an emerging critical approach to the museum. As an archetypal modern institution, then, the museum can be approached as a useful barometer of changes afoot in the urban order as a whole and can reveal a fuller picture of how cities and museums mediate each other, even if loose characterizations of both as *post*modern need to be treated with caution.

Urban Regeneration and the Soft City

Jonathan Raban's (1974) classic statement on the "soft city" – a yielding, amorphous labyrinth, that wraps itself around the urban dweller – has itself now been enveloped by the rather gluttonous discourses of postmodernism. Raban's thesis, that modern urban life inhabits the form of a dazzling display through which one's identity is constantly shifting, marks the beginnings of an avowedly "cultural" way of looking at the city. According to Raban, cities, by their very nature, are plastic. They comprise a libidinous *mélange* of visual fragments from which people select their provisional attires, progressively dislodging the fateful certainties of city life represented in dry statistical reports and architectural plans. Resembling an "emporium of styles," the soft city is the theatrical city of fashions, appearances, and commodities that awaits the indentations of "do–it–yourself" identities. This gives urbanism the kind of dreamlike quality imagined in Benjamin's (1999) Second Empire Paris, where the city's myriad displays of commodified enchantments appear as a "phantasmagoria."

In 1970s' London, the city reached such a level of stylistic plasticity, for Raban, that it essentially eroded "the conventional distinctions between dream life and real life," such that "the city inside the head can be transformed, with the aid of the technology of style, into the city on the streets" (Raban 1974: 65). Whilst this pliant urbanism is often punctuated by the hard realities of violence and social suffering, such urban pathologies are more than counterbalanced by the utopic potential of the soft city, where life is experienced as a "maelstrom of possibilities" (Raban 1974: 75). The city might be frighteningly impersonal, then. It might reek of moral decay and economic exploitation. But it is also full of magical qualities and the constant irruption of pleasure, anarchy, and diversion (Wilson 1991).

By the late 1980s, the soft-city approach had become the standard by which postmodern urbanism was judged. Most famously, David Harvey's *The Condition of Post-*

modernity (1989) opens with a description of Raban's book as presaging the shift away from the hierarchic concerns of urban planning and Fordist systems of accumulation to the city staged as a series of rapidly accelerating cultural styles and signals. The postmodern condition, for Harvey, consists of a wholesale compression in the experience of space and time, where "flexible accumulation" in the system of material production has its existential counterpart in the constantly fluctuating environment of the city. Our postmodern urban landscape, suggests Harvey, consists of unprecedented spaces in which "very different worlds seem to collapse upon each other, much as the world's commodities are assembled in the supermarket and all manner of sub-cultures get juxtaposed in the contemporary city" (Harvey 1989: 301–2). This is the city of arts festivals, heritage centers, cinemas, and shopping malls, the city in which one's self is constructed through expressive codes of fashion, and leisure time is to be filled with a series of "experiences." This is the city, in short, where Marx's characterization of capitalist modernity, in which "all that is solid melts into air" (1967: 83), finds its ultimate expression in the volatile fashions, markets, and commodities of the postmodern condition.

The ramifications of this acceleration are, unsurprisingly, felt across a range of cultural forms and discourses. In architecture, postmodern flux is said to be exemplified by buildings that incorporate a range of historical designs and fragments from popular culture, and a deracination of the austere style of high modernists like Le Corbusier. Postmodern architects Robert Venturi and Charles Jenks are singled out by Fredric Jameson, for instance, as architectural proponents of the vernacular and commercial, "the motel and fast-food landscape of the postsuperhighway American city" (Jameson 1998: 30). In art, postmodernism is the indiscriminate collision of different cultural worlds – the reproductive silkscreens of Robert Rauschenberg, the fragmented bodies of David Salle, the self-referential portraits of photographer Cindy Sherman – or even the end of painting itself (Crimp 1993). In philosophy, postmodernism is Lyotard's (1984) "incredulity to metanarratives," the death of universalisms, and the endless play of language. In urban planning, it is the demise of large-scale functionalist schemes and the pursuit, instead, of pluralistic strategies of local redevelopment aimed at bringing about a "re-enchantment of the built environment" (Ley 1989: 53).

All of which is expressed in an increasingly fluid relationship to urban space. For more than anything, the soft city works as a massive complex of global economic and cultural *flows* (Castells 1989; Featherstone 1991; Patton 1995; Soja 1995; Dear 2000) in which people are bombarded by pluralized commodities circulating at unprecedented speeds. Here, the debt is to Simmel's (1903) classic statement on psychic over-stimulation in the metropolis and the resulting "blasé" attitude of the urbanite. The new urbanism cranks visual intensity up to a new level because it rests more firmly than ever on what Lash and Urry (1994) call "economies of signs and space." Driven by an ever-quickening cycle of commodity production, objects have become more mobile than ever. And what is increasingly produced, it is argued, are not the "hard" material products of organized capitalism, but the "soft" post-material goods of a radically decentered post-industrialism – images, information, and design-intensive objects that function in the new symbolic economy (Baudrillard 1981, 1993).

511

In the era of cultural tourism, for instance, the image of the city provides a framework of meaning through which it produces itself symbolically (Trasforini 2002). There is, in effect, a semiotic production of the city that works to reduce the complex aggregation of urban elements to an easily digested sign – the Eiffel Tower and *haute couture* in the case of Paris, for instance. The tourist industry thrives on such collective and imaginary geographies by turning cities, towns, and villages into sites of pleasure. Modern cities have always, of course, advertised themselves to the outside world through the use of images. But now, according to writers like Robins (1993), the very identity of the city is constituted in global media. Images become the essential means by which perceptions of the city are constructed and aligned to the needs of the postmodern marketers. Cities like Venice, Florence, and Paris, in particular, are constructed as exceptional dreamscapes, perhaps museums in themselves, to which fantasies of romance and artistic reverie are attached – perfect for a "tourist gaze" that yearns for the "liminal" experience (Urry 1990).

Indeed, as competition for the treats of global tourism intensifies, it becomes increasingly important for particular cities to emphasize what marks them out from other cities, to carve out a market niche for themselves. Certainly, the collapse of spatial barriers noted by Harvey (1989) does not imply a concomitant dissolution of space *per se*. If anything, in fact, we have become more sensitized to the difference that location makes (Crane 2002). The cultural economies of key cities like Tokyo, London, Paris, and Los Angeles are based precisely on degrees of specialization and distinctive cultural conventions that give these cities an edge in the global market (Scott 2000).

Undoubtedly, then, cities have become highly aestheticized places, and a number of studies have drawn attention to the central role that culture and the arts now play in the success of cities that were once dependent on large-scale industry. Zukin notes, for instance, that in America, local business elites, backed by government authorities, have financed a transformation in downtown areas away from the "old, dirty uses of space in a manufacturing economy" (Zukin 1996: 44) toward the new symbolic economy of the arts. Since the 1980s, in particular, economic redevelopment has focused on installing artist's quarters, galleries, and museums in the derelict warehouses and disused waterfronts of cities like New York. The regeneration of SoHo into an artist's settlement, for Zukin, was part of a bigger story involving long-term de-industrialization, art's increasing investment value, and New York's postwar rise to prominence at the center of the modern art world. Cultural capital, in this process, had become a means to transform the property market at the behest of local governments and corporations who recognized artistic ambience as a useful selling point. More specifically, artists' lofts acquired the veneer of bohemian chic, suited to the lifestyle patterns and consumption habits of professional, high-income wage earners ("yuppies"). The resultant gentrification, for Zukin, registers the final victory of consumption over production in the fabric of American civic life and the displacement of poorer residents priced out of the local housing market. Today, SoHo even boasts a branch of the Guggenheim Museum on the corner of Prince Street and Broadway.

In the UK, investment in the cultural infrastructure of major cities has accompanied a re-branding of older manufacturing areas, particularly in the north, as cul-

tural centers. Recent developments in Glasgow, Manchester, Liverpool, and Newcastle, in particular, have rested on a faith in arts and leisure regeneration programs to bring financial and administrative services to the city, as well as cultural tourism (Wynne and O'Connor 1998). Liverpool, which boasts the most substantial network of museums in England outside London, has a high-profile outlet of the Tate Gallery at Albert Dock, for instance; and Gateshead's Baltic Centre for Contemporary Art opened in July 2002 in a former flour mill to join a collection of glassy new cultural buildings and loft apartments along the River Tyne. Both cities were subsequent competitors for the title of "European Capital of Culture 2008," partly on the strength of the re-imaging of these cities as places of artistic vibrancy. To the victor (in this case Liverpool), the post-industrial spoils. Success in these competitions, preceded by years of civic promotion and expansionism, can see a city's fortunes boosted by large-scale investment in local tourism, business, and property. Glasgow's recent "renaissance" as a thriving urban center, for instance, has been attributed to its success in the 1990 competition.

Museums are crucial to the unfolding of the new urbanism, then, because they are symbols of cultural revitalization in what might be called the "soft economy," an institutional marker for any city or region that is serious about improving its image or attracting tourists. Almost all cities have museums of one sort or another and their numbers are steadily increasing (Ballé 2002). In North America, cities such as Philadelphia, Kansas City, San Francisco, and Baltimore have wedded their master plans for new cultural districts to the erection of new museums. Elsewhere, such as Bilbao, museums have become *the* most significant attraction point for the city. The Guggenheim Museum's "must see" architecture, in this case, has put the Basque city on the map as far as cultural tourism is concerned (see fig. 15.5); whilst, in London, the opening of Tate Modern (fig. 14.8), on the south bank of the Thames, has had similar, though less dramatic, consequences for the profile of the Southwark area. Indeed, part of a wider strategy to transform Bankside, the gallery sees its role not just as displaying international, modern, and contemporary art, but as a "major vehicle in the regeneration process" itself (Cochrane 2000: 8).

Whether this amounts to anything more than a change in real-estate values, and yet more cappuccino culture for a middle-class public, is yet to be seen. In fact, the overall purpose and effectiveness of these public policies is still to be properly assessed. In Bilbao, for instance, despite an initial honeymoon period between the Guggenheim and the local population, there is evidence that local businesses have not thrived as expected (Lorente 2002). The clash between trenchant poverty and glittering architecture is evident within a few blocks in the city, and many local artists have viewed the museum as an instrument of cultural colonialism. New urbanism is, perhaps, not so new after all, if continuing evidence pointing toward "dual cities" and social exclusion is anything to go by (Castells 1989; Davis 1992). But irrespective of how limited the social gains of art are, or how few local artists are involved, the accumulated cultural glamour and visibility of the city's symbolic economy, with museums at the center, play an important role in the construction of place and the "cut-up space of distinctive signs" known as the postmodern city (Baudrillard 1993: 77).

Spectacles of Exhibition and Display

Notwithstanding examples of large-scale urban expansionism, the collection and the exhibition remain the most powerful media of the contemporary museum, and the conditions under which art is displayed are crucial both to the status of displayed objects and the position of the spectator. Our second restructuring, then, relates to one of the most visible changes apparent in recent museum practice – the commercialization of display, the rise of the blockbuster exhibition, and the provision of spectacular or simulational "experiences."

Guy Debord's 1967 book, *Society of the Spectacle*, has become a cultic reference point for social theorists and others assessing the foundations of postmodern consumer society. Its thesis, that life has become "an immense accumulation of spectacles" (see Debord 1977: para. 1), lifted the Marxist tradition of ideology critique into a 1960s that were witnessing the progressive colonization of everyday life by commodity culture. The encounter between market society and image production had, for Debord, ended in a generalized separation between life as "directly lived" and its representation in image. Not merely a "collection of images," therefore, but a "social relationship between people . . . mediated by images" (Debord 1977: para. 4), spectacle was a way of characterizing the fundamental separation between seeing, with its implied sense of passive spectatorship, and doing.

Under the guidance of postmodern theory, spectacle has become shorthand for the performance of the visual apparatus of the commodity form. This includes display in all its guises, from TV, cinema and advertising to shopping malls, heritage centers, and museums (Cooke and Wollen, 1995). With its confusion of representation and reality, spectacle is a realm of fantastical contrivance, a kind of democratization of the image in the age of consumerism, the power of which continues to reside in the devotion accorded to the visual as a world of pleasure.

Needless to say, the marriage of display and commodity form has longer historical roots than many writers appear to recognize, and even Debord traced the society of the spectacle back to the 1920s. The nineteenth century, in particular, witnessed a massive explosion in technologies of the visual and an attendant development in a culture of looking (Crary 1990; Jay 1993). As Benjamin (1999) noted, modern cities like Paris were marked by new spaces of visual seduction that encouraged the pleasures of consumption and a heightened awareness of exhibition and fashion. At the Dufayel store in Paris, for instance, the thematic ordering of the shop's material goods actually borrowed from the visual technology of the diorama and the order of things at the museum, uniting both as "'machines' of capitalism" (Georgel 1994: 119). Meanwhile, the rise of the great international exhibitions of the nineteenth century stitched culture and commodity even more tightly in ways that glorified the nation and entertained an enlarged public (Altick 1978; see also chapter 9). London's Great Exhibition of 1851 and Paris's Exposition Universelle of 1855, in particular, were enormously successful displays of capitalist progress. Comprising industrial, commercial, and artistic exhibitions, these were spectacles of unprecedented visual power, designed specifically to take the breath away (Greenhalgh 1989: 76). In fact,

in conception and design, they were the precursors to many of today's grand popular entertainments.

A century and a half after the first great international exhibition, the fate of the spectacle in the museum world is apparent both in the unmitigated commercialization of museum display and the rise of the mass-appeal show. Exhibition policy at many museums tapers increasingly with the logic of show business – putting on an event to attract maximum publicity and attendance, whilst performing a separation between audience and object. Standard output for large museums includes massively organized, high-profile exhibitions, many of them packaged as units of artistic commerce to guarantee high levels of sponsorship. Some exhibitions are sent abroad on "world tours" to become part of the global circulation of cultural goods. Otherwise, host institutions stage dazzling sets for canonical objects, giving unprecedented levels of exposure to "auratized" works such as the *Mona Lisa*, which resides in its own viewing space at the Louvre.

But it is the "blockbuster" exhibition that has become the most defining feature of contemporary museum display, its visibility now ruling the public's perception of art. This mirrors the shift away from the museum's preoccupation with the permanent collection toward the three-month exhibition as the most effective crowd-puller (Barker 1999). Beginning with the Pompidou's series of multimedia shows in the late 1970s and 1980s, museums throughout the world have followed the blockbuster format, with giveaway titles such as *Origins of Impressionism*, *Illuminating the Renaissance*, *The Genius of Venice*, and the ubiquitous *Treasures of . . .* exhibition. Among the highest attendances at single venues have been to shows devoted to single artists from the modernist period such as Cézanne, Picasso and Van Gogh. Both *Henri Matisse* (Museum of Modern Art, New York, 1992–3) and *Claude Monet, 1840–1926* (Art Institute of Chicago, 1995) attracted nearly a million visitors, for instance (Barker 1999), whilst the opening hours of Britain's summer blockbuster of 2002, *Matisse Picasso*, at Tate Modern, were extended into the night to accommodate fervent demand.

Not merely exhibitions, however, but also opportunities to sell large quantities of merchandise, the commercial spin-offs from these shows range across all commodity forms. Once upon a time, the stands at museum shops sold postcards and posters, a few books, and some table mats. Now, however, merchandise covers everything from film, opera and poetry, to fashionable clothes, catalogues, and kitchenware, albeit at upper-class prices. Revenue provided by the shop and the café is, clearly, crucial to the survival of the contemporary museum. So much so, in fact, that museum merchandise is now found beyond the museum's walls at a range of high-street outlets. The Science Museum, for instance, has opened a retail outlet in Selfridges, Oxford Street, redoubling the relationship, already mentioned, between department store and museum.

Moreover, the cultural cachet of the museum gives the kind of add-on value and instant brand recognition cherished by opportunist market men and big corporations alike. Beyond the shop and its fetishization of the art commodity, a network of agencies, including arts councils and public–private business partnerships, has grown to exploit the opportunities that the arts afford to corporate life. For the profile of the

museum and its mega-shows make it extremely attractive to companies looking to improve their image. Corporate sponsorship yields cheap publicity and gives companies an air of responsibility and civility. Big banks are keener than ever, for instance, to wine and dine their guests in style, often choosing the gallery or the museum as their hospitality venue, whilst private viewings give ample opportunities for corporate networking and after-dinner speeches (Wu 2002).

Multinationals and banking giants, it appears, now occupy the place once occupied by wealthy aristocrats and aspirational industrialists. From the 1980s, corporate power has gained an increasing grip on contemporary culture, framing and shaping it while appropriating art museums and galleries as their own public-relations media. As Wu points out, in Britain, sponsorship was a cornerstone of Thatcherite policy during the 1980s, and its manifestation in the arts ranged from government-backed business–arts initiatives to corporations possessing their own curators and art departments. In the art museum itself, the transformation from elite enclave to "fun palace" is the flipside to cultural commodification, manifested in the appointment of business-oriented museum directors as well as the commercial practices of traditional institutions like the Royal Academy, which has been known to turn its courtyard into a car showroom (Wu 2002). Even the *outré* art of young contemporary artists has use-value for companies willing to associate themselves with "radical" or "cutting-edge" culture because it garnishes the corporate image with an air of innovation and risk-taking. In fact, one of the most controversial shows of recent years, *Sensation*, an exhibition of "Young British Artists" at the Royal Academy, comprised works from the collection of Charles Saatchi, an investment and advertising mogul renowned for leading Margaret Thatcher's advertising campaigns during the 1980s. The emphasis on provocation has also been a useful selling point for museums trading on shock value, from the Tate Gallery's Turner Prize to Gunther von Hagens's notorious *Body Worlds* exhibition at the Atlantis Gallery in East London.

In many cases, the shift toward a more spectacular museum has accompanied a change in modes of display as well as the role of curatorship itself. One of the most noticeable changes has been an expansion in the repertoires informing the layout and order of the collection. No longer are chronology and abundance, of the kind found at MoMA under Alfred Barr, the automatic ordering principles for today's museums. The idea of the universal survey, ideationally bound to Enlightenment narratives of progress, has appeared increasingly unrealistic and outdated, as has the old top-down model of museums, whereby curators and scholars present the fruits of their connoisseurship to a passive audience. Instead, museums are embracing mixed arrangements aimed at opening up audience interpretation beyond the linear narratives of traditional art history.

At Tate Modern, for instance, works are scrambled into thematic blocks – "History/Memory/Society," "Nude/Action/Body," "Landscape/Matter/Environment," "Still Life/Object/Real Life" – that create novel and accidental juxtapositions between artists ordinarily separated by the big historical story. In New York, one of MoMA's big millennium exhibitions, *Making Choices*, abandoned chronology in favor of a dozen or so separate exhibitions grouped by subject. And at the Musée d'Orsay, modernist works are placed less in relation to their canonical value than to heterogeneous categories such as "naturalism" and "symbolism," or

fitted to complement the architectural design of the building (Sherman 1990). This not only points to a more open-ended or "democratic" approach to the collection, but also to a kind of "splice and dice" pattern that echoes the development of sampling culture at large, in contemporary music especially, where objects from disparate locations are lifted, borrowed, or brought together to form new or temporary constellations.

For a while now, many museums have also experimented with moving images, electronic points of information, room settings, and reconstructions. Some non-art museums have even begun to include live actors and actresses, simulated smells, and interactive exhibits. And whilst there continues to be fundamental differences between art museums and heritage centers, affinities between the two at least suggest themselves in relation to the construction of more popular and interactive displays, where wrap-around drama is increasingly the ambience to go for.

Indeed, heritage centers are archetypal postmodern sites, here, not only because history is flattened to the "shallow screen" of entertainment, as Hewison (1987: 135) puts it, but because, at another level, it no longer matters whether this history is real or not. For heritage, it is argued, is an elaborate fake, a postmodern pastiche of an imagined past that becomes more real than the past itself. It is the spectacle of heritage and authenticity that is consumed rather than any messy, muddy, diseased reality itself. The past becomes staged as real but eats reality whole in the quest for entertainment. Heritage is what MacCannell (1974) terms "staged authenticity," where the fabricated image has precedence over the real if it holds more aura, magic, or authenticity.

Assisted by high-tech virtual displays, audio animatronics, 3-D imaging and the like, it is now possible to "be" at some of the major places and events of Western civilization – World War II, Agincourt, Culloden – in a manner that concentrates the experience way beyond anything reality offers. This is what Umberto Eco in *Travels in Hyperreality* (1987) means by "hyperreality," a larger-than-life version of history that replaces history itself. "Real" history no longer matters because it has been replaced by slick displays, signs, and simulations. Heritage is a postmodern form, in other words, because it fits the third order of simulacra set out in Baudrillard's *Symbolic Exchange and Death* (1993), a world beyond mere "mechanical reproduction" as Benjamin (1970) had imagined it. In the era of digital code and cybernetics, we encounter perfect copies of originals that never existed. "No more true and false," writes Baudrillard, since *today reality itself is hyperrealist*" (1993: 64, 74, emphasis in original). The advent of highly simulated environments, such as theme parks and heritage centers has taken us beyond Debord's spectacle, where (critical) distance is still possible, toward total immersion in environments that "collapse reality into hyperrealism, the meticulous reduplication of the real" (1993: 71). It is not just that "heritage-ized" locales become *associated* with TV costume dramas and brown heritage signs, but that these signs themselves ("Catherine Cookson country," "Jane Austen country," "Robin Hood country," "The Land o' Burns") outpace and thereby supersede the original. In the world of heritage, an "original" place or collection of objects is no longer necessary, for we have passed into an era of the "fusional, tactile and aesthesic (and no longer the aesthetic)" (Baudrillard 1993: 71). All of which hints at a significant shift in the perceptual

517

Nick Prior

conventions that operate at museums: from an aesthetics of distinction to a culture of distraction.

Postmodern Perception: From Distinction to Distraction?

Bourdieu and Darbel's classic study of European art museum audiences, *The Love of Art* (1991), remains one of the most influential academic studies of the social indices of art perception. Its findings were central to Bourdieu's continuing study of culture-mediated power relations, as found in the book *Distinction* (1984), for instance, as well as social surveys of the behavior of museum audiences across the world. Its core assumption, that visiting a museum is a function of one's social location, identified the mechanism by which art appreciation differentiated those from higher social backgrounds (possessing what Bourdieu would later term "cultural capital") from other social groups. In doing so, it dealt a blow to older approaches to aesthetics, often Kantian in origin, that assumed that taste was a natural sense faculty of aesthetic judgment, somehow unswayed by social conditions.

For Bourdieu and Darbel, the notion of the "pure response" or unmediated aesthetic encounter serves to mask the fact that cultural predispositions toward art are really manifestations of primary and secondary socialization processes. What visitors bring to the museum in terms of cultural capital, in other words, matters more than the perceived quality of the object or the policies of the institution itself. Different perceptual frameworks operate in the museum according to the logic of class differentiation, where middle-class visitors are more likely to decipher the art object "aesthetically," using schemas that locate the work in a system of artistic meaning. "Pictorial competence" is thereby defined as socially accumulated knowledges of art historical terms as well as a perception of differences between schools, movements, styles, and so on. The uninitiated and dispossessed, on the other hand, struggle to apprehend art works beyond their physical properties. The working classes, in particular, for Bourdieu, tend to reduce art to a series of "primary significations" – age, color, price, and so on – that fit with the schemes of interpretation available to them. When placed before an aesthetic artifact or in a building that is "too rich" or "overwhelming," such visitors feel completely "out of their depth." To this extent, the museum continues to "strengthen the feeling of belonging in some and the feeling of exclusion in others" (Bourdieu 1993: 219, 225, 236).

Influential and necessary as this sociological analysis has been, much in Bourdieu's account has begun to appear dated and in need of supplementation. This is, of course, not surprising given that the data informing both *The Love of Art* and *Distinction* were collected during the 1950s and 1960s. First, the concentration on social class over other dimensions of audience stratification reduces analysis of social inequalities to a "modernist" taxonomy of social formations that is unable to capture complex and cross-cutting mechanisms of inequality based on class, gender, age, and ethnicity (Bennett et al. 1999). Whilst recent surveys of museum audiences have often confirmed Bourdieu and Darbel's conclusions, they have also pointed to a broadening and diversification of the audience base and variations in visitor profile

518

from one museum to another (Merriman 1989; Hooper-Greenhill 1997; Selwood 1998).

Secondly, museums, themselves, have changed radically since the 1960s and cannot be characterized as inert upholders of dominant ideology or agents of social control that unreflexively sustain the privileges of a cultural elite (Macdonald and Fyfe 1996). Indeed, many have actively engaged with work like Bourdieu's to over-come historical limitations in audience perception, raise awareness of social exclusion, or give voice to marginalized communities (Hooper-Greenhill 1997). Thirdly, the tight fit posited by Bourdieu between cultural habits and social class may fail to account for broader patterns of culture and economy that open up the visual arts beyond a limited elite. Huge coverage of the arts in global mass media, whilst not toppling high and low cultural hierarchies, *tout court*, have certainly weakened modernist systems of cultural classification and the notion of artistic autonomy (Lash 1990). The expansion of the visual arts complex, as well as the rise of mass higher education, have, at the very least, opened up possibilities for the dissemination of art knowledge beyond the cultivated bourgeois. The erosion of boundaries between the aesthetic and the economic, between art and popular culture, are the result of processes of cultural commodification outlined in this chapter, which have themselves placed museums alongside shopping malls and cinemas within the realms of consumption and entertainment. New audiences have emerged from this mix with less dichotomized – that is, *either* cultivated or popular – ways of seeing culture that suggest a revision of Bourdieu's overly integrated account of class and cognition (Lash 1990; Urry 1990; Featherstone, 1991).

In fact, it is these broader social, cultural, and economic trends and their impact upon modes of perception that postmodern commentators such as Jameson, Baudrillard, and Virilio have attended to. For these writers, the acceleration of visual culture under postmodernity has widespread implications for how image forms are perceived, irrespective of class. For Virilio (1994), for instance, the advent of instantaneous visual and audiovisual technologies has generated a rapid decline in retention rates and mnemonic recall. As visual impressions increase in intensity and quantity, the eye ceases to discriminate between images. Inherent in the technologization of vision is, therefore, the demise of contemplation itself, for the "automation of perception" (Virilio 1994: 59) replaces an aesthetics of meditation with a culture of distraction: "As the rational universe goes, so goes the effect of the real. Looking sideways, always sideways, rejecting fixity of attention, drifting from the object to the context, escaping from the source of habit, from the customary seems to have become impossible" (Virilio 1991: 47).

For Jameson, similarly, information overload is a predominant condition of our consumer landscape. Under postmodernity, the image form has proliferated to such a degree that consumers are bewildered, unable to make sense of the flood of visual fragments that rushes toward them. The dominant perceptual system of "late capitalism" is a permanently saturated one, where older modernist ways of seeing have been replaced with a more extreme form of Simmel's blasé attitude – the inner life abandoned to a series of momentary sensations. As individual art works lose their discrete qualities and aesthetic boundaries, for Jameson, they become cast adrift in a vastly accelerated visual soup. The art image is thereby stripped of all autonomy

and aesthetic progress, absorbed into the visual commodity market to compete with other leisure forms such as shopping, television, and sports events. The very fundaments of aesthetic judgment are rendered impossible under such conditions because one has no time to make value decisions about images.

The museum is a particular casualty of postmodernity, then, because the notion of contemplation upon which it has traditionally distinguished itself (from carnivals and pubs, for instance), has crumbled, to be replaced by a "phenomenology of mingled reactions" (Jameson 1998: 118). Like the cinema visit, in other words, a trip to the museum is a trip through a series of successive sequences and stimuli to which reaction times are reduced, and where the only response is an instantaneous "yes or no" (Baudrillard 1993). This is particularly so in large museums with expansive collections or exhibitions, where one grasps to make sense of room upon room of yet more images. At the Pompidou, for instance, according to Schubert, "the noise level and overcrowding [make] it impossible to concentrate on individual works of art in any meaningful way" (Schubert 2000: 60). And if the bustling crowds at the latest blockbuster exhibition do not weaken contact between art and audience, then cultural exhaustion eventually does!

Of course, many of these claims about a postmodernized perceptual system fall into the trap of homogenizing the audience, treating perception as a function of media manipulation to which passive recipients succumb like mindless automata. New audience research, conversely, tends to point to a much more skillful and animated audience able to negotiate or even overturn the meanings offered in media such as the museum (see chapter 22). Perception, in this sense, is a lot more multifaceted than can be contained in the assessment offered by Jameson, Virilio et al. Moreover, whilst a lot more "diffuse," audiences are still stratified and segmented on the basis of various types of social, economic, and cultural capital (Abercrombie and Longhurst 1998). So whilst the museum may well have become something of a "distraction machine," it nevertheless continues to function as a source of social identification and differentiation, even if the relationship between perception and stratification is somewhat looser than connoted in Bourdieu's work. To entirely overlook the connection between social background and cultural habits, as some postmodernist writers have done, is to risk throwing the baby out with the bath water. What is needed, to anticipate the conclusion, is an approach that treats "strong" forms of postmodern theorizing with caution, but remains equally skeptical of static conceptions of the museum as unchanged since the nineteenth century.

Conclusion: Going, Going, Gone?

After the heady days of postmodernism's rise, when "pomospeak" has tripped off the tongues of academics, journalists, and architects alike, it has become necessary to reflect on its legacy for the museum and the city. One appealingly simple claim is that both have become so soft as to have, in effect, disappeared – modernism's two great pantheons reduced to post-material pulp. For the museum, this extends Malraux's (1954) claim that reproductive technologies such as photography have given rise to the "museum without walls." With the advent of virtual tours, digital

collections, and electronic exhibitions, as well as the wholesale expansion of visual consumer culture, the museum is no longer a *museum*, in this view, but a network of post-industrial flows, a nondescript dispenser of consumer pleasures or a broker of information (Keene 1998). If the French revolution was the midwife of the first great public museum, it is consumption and the information revolution that have killed it. Baudrillard's (1982) fatal image of the "Beaubourg Carcass" as cultural supermarket, therefore, becomes the final snapshot of a culture flattened by its own weight, giving a postmodern twist to Adorno's characterization of the museum as mausoleum.

As for the city, extreme theorists of culture and technology have encouraged us to think about its disappearance as a physical and bounded conglomeration and its softening into instantaneous or cyberspatial forms (Mitchell 1999). For Virilio, for instance, technologies of speed – modern transport systems, especially – have abolished all distances, rendering the city as a geographical entity irrelevant. The city as a distinctly modern space is displaced into the saturated immediacy of time, where "the new capital is no longer a spatial capital like New York, Paris or Moscow, a city located in a specific place, at the intersection of roads, but a city at the intersection of practicabilities of time" (Virilio and Lotringer 1997: 67).

Of course, both of these accounts have contributed to our understanding of contemporary socio-cultural change, but, in the end, the analyses are oversimplified and exaggerated. Fatal characterizations in the postmodern literature are too partial and limited to confront some of the more complex and refractory issues affecting urban and museological life. The museum is still thriving as a bastion of civic virtue, its place assured by the stubborn materiality of urban space, and a (largely middle-class) audience hankering after an aesthetic experience. In any case, history does not unfold in such discrete and decisive stages that the modern and the postmodern are opposed as binaries. The very fact, for instance, that museums and cities continue to elicit features and contain behaviors central to the modernist writings of Benjamin and Simmel, shows how complex the coexistence of historical trends and cultural processes is.

Whilst many of today's museums have been ravaged, twisted, and transformed into cultural multiplexes, it is too glib to call them *nothing more* than "Disney theme parks" or "funhouses," dumbed-down to appeal to some lowest common denominator. Museums are complex institutions with long and specific histories that engender in them often contradictory forces – scientism and religiosity, distinction and populism, public duties and private influences, speeding up and slowing down. In this sense, the museum has always had a dual role – both "church" and "whorehouse," to quote Renzo Piano (Centre Georges Pompidou 2000: 14) – its schizophrenic history played out through the value dilemmas that have dogged it since its inception. Hence, move away from the teeming concourses of museums, where Baudrillard's postmodern ideas might hold, and one will encounter signs of a more modern aesthetic explainable by a more Bourdieusian logic.

The whole rationale of suggesting the term "restructurings," then, is to convey the complex rhythms and periodicities of historical change, and not to overstate the contrast between what are misguidedly seen as distinct historical stages. The term *post*modern might be a useful shorthand for contemporary cultural change, but it can just as easily lead to confusion over the extent and abruptness of this change,

521

obscuring the precise mix of elements that exist in the contemporary museum (Prior 2003). The very ideas of both the museum and the city are being rethought and reconfigured, for sure – perhaps even softened. But strong versions of post-modernism need to be supplemented with a more textured understanding of the contradictory logics that have structured the museum from the outset, as well as the mediating role of social actors such as curators, directors, and audiences. Contemporary museums are marked by their variety as well as their increasing reflexivity, their residual appeal to connoisseurship as well as their homage to consumer culture, their role in reproducing social inequalities as well as their increasing democratization. This is the contradictory terrain on which museums have adapted for two and half centuries and which continues to make them such interesting objects of study.

Bibliography

Abercrombie, N. and Longhurst, B. (1998) *Audiences*. London: Sage.

Altick, R. (1978) *The Shows of London*. Cambridge, MA: Harvard University Press.

Ballé, C. (2002) Democratization and institutional change. In D. Crane, N. Kawashima, and K. Kawasaki (eds), *Global Culture: Media, Arts, Policy, and Globalization*, pp. 132–46. London: Routledge.

*Barker, E. (ed.) (1999) *Contemporary Cultures of Display*. New Haven, CT: Yale University Press.

Baudrillard, J. (1981) *For a Critique of the Political Economy of the Sign*. St Louis: Telos.

*— (1982) The Beaubourg effect: implosion and deterrence. *October*, 20: 3–13.

— (1993) *Symbolic Exchange and Death*. London: Sage.

— (1998) *The Consumer Society: Myths and Structures*. London: Sage.

Benjamin, W. (1970) The work of art in the age of mechanical reproduction. In W. Benjamin, *Illuminations*. London: Jonathan Cape.

— (1999) *The Arcades Project*. Cambridge, MA: Belknap Press of Harvard University Press.

Bennett, T., Emmison, M., and Frow, J. (1999) *Accounting for Tastes*. Cambridge: Cambridge University Press.

Bourdieu, P. (1984) *Distinction: A Social Critique of the Judgement of Taste*. London: Routledge and Kegan Paul.

— (1993) *The Field of Cultural Production*. Cambridge: Polity Press.

— and Darbel, A. (1991) *The Love of Art*. Cambridge: Polity Press.

Castells, M. (1989) *The Informational City*. Oxford: Blackwell.

Centre Georges Pompidou (2000) *Connaissance des Arts*, special issue. Paris: Société Française de Promotion Artistique.

Cochrane, G. (2000) Creating Tate Modern: 1996–2000. In I. Cole and N. Stanley (eds), *Beyond the Museum: Art, Institutions, People*, pp. 8–11. Oxford: Museum of Modern Art.

Cooke, L. and Wollen, P. (eds) (1995) *Visual Display: Culture Beyond Appearances*. Seattle: Bay Press.

Crane, D. (2002) Culture and globalization: theoretical models and emerging trends. In D. Crane, N. Kawashima, and K. Kawasaki (eds), *Global Culture: Media, Arts, Policy, and Globalization*, pp. 1–27. London: Routledge.

Crary, J. (1990) *Techniques of the Observer: On Vision and Modernity in the Nineteenth Century*. London: MIT Press.

Crimp, D. (1993) *On the Museum's Ruins*. Cambridge, MA: MIT Press.

Davis, M. (1992) *City of Quartz*. London: Vintage.

Dear, M. (2000) *The Postmodern Urban Condition*. Oxford: Blackwell.

Debord, G. (1977) *The Society of the Spectacle*. Detroit: Black and Red.

Eco, U. (1987) *Travels in Hyperreality*. London: Picador.

Featherstone, M. (1991) *Consumer Culture and Postmodernism*. London: Sage.

Georgel, C. (1994) The museum as metaphor in nineteenth-century France. In D. Sherman and I. Rogoff (eds), *Museum Culture: Histories, Discourses, Spectacles*, pp. 113–22. Minneapolis, MN: University of Minnesota Press.

Greenhalgh, P. (1989) Education, entertainment and politics: lessons from the great international exhibitions. In P. Vergo (ed.), *The New Museology*, pp. 74–98. London: Reaktion Books.

Hall, S. (1980) Encoding/decoding. In S. Hall, D. Hobson, A. Lowe, and P. Willis (eds), *Culture, Media, Language: Working Papers in Cultural Studies, 1972–79*, pp. 128–38. London: Hutchinson.

Harvey, D. (1989) *The Condition of Postmodernity*. Oxford: Blackwell.

Hewison, R. (1987) *The Heritage Industry: Britain in a Climate of Decline*. London: Methuen.

Hooper-Greenhill, E. (ed.) (1997) *Cultural Diversity: Developing Museum Audiences in Britain*. London: Leicester University Press.

*Jameson, F. (1998) *The Cultural Turn: Selected Writings on the Postmodern, 1983–1998*. London: Verso.

Jay, M. (1993) *Downcast Eyes: The Denigration of Vision in Twentieth-century French Thought*. Berkeley, CA: California University Press.

Keene, S. (1998) *Digital Collections: Museums and the Information Age*. Oxford: Butterworth–Heinemann.

Lash, S. (1990) *The Sociology of Postmodernism*. London: Routledge.

— and Urry, J. (1994) *Economies of Signs and Space*. London: Sage.

Ley, D. (1989) Modernism, post-modernism and the struggle for place. In J. Agnew and J. Duncan (eds), *The Power of Place*, pp. 44–65. Boston: Unwin Hyman.

Lorente, J. P. (2002) Urban cultural policy and urban regeneration. In D. Crane, N. Kawashima, and K. Kawasaki (eds), *Global Culture: Media, Arts, Policy, and Globalization*, pp. 93–104. London: Routledge.

Lyotard, J-F. (1984) *The Postmodern Condition*. Manchester: Manchester University Press.

MacCannell, D. (1974) Staged authenticity: arrangements of social space in tourist settings. *American Journal of Sociology*, 79 (3): 589–603.

Macdonald, S. and Fyfe, G. (eds) (1996) *Theorizing Museums*. Oxford: Blackwell.

Malraux, A. (1954) *The Voices of Silence*. London: Secker and Warburg.

Marx, K. (1967) *The Communist Manifesto*. London: Penguin.

Merriman, N. (1989) Museum visiting as a cultural phenomenon. In P. Vergo (ed.), *The New Museology*, pp. 149–71. London: Reaktion.

Mitchell, W. J. (1999) *City of Bits: Space, Place and the Infobahn*. Cambridge, MA: MIT Press.

Patton, P. (1995) Imaginary cities: images of postmodernity. In S. Watson and K. Gibson (eds), *Postmodern Cities and Spaces*, pp. 112–21. Oxford: Blackwell.

*Prior, N. (2003) Having one's Tate and eating it: transformations of the museum in a hypermodern era. In A. McClellan (ed.), *Art and its Publics: Museum Studies at the Millennium*, pp. 51–76. Oxford: Blackwell.

Raban, J. (1974) *Soft City*. London: Hamish Hamilton.

Robins, K. (1993) Prisoners of the city: whatever could a postmodern city be? In E. Carter, J. Donald, and J. Squires (eds), *Space and Place: Theories of Identity and Location*, pp. 303–30. London: Lawrence and Wishart.

Nick Prior

Schubert, K. (2000) *The Curator's Egg: The Evolution of the Museum Concept from the French Revolution to the Present Day*. London: One-Off Press.

Scott, A. J. (2000) *The Cultural Economy of Cities*. London: Sage.

Selwood, S. (1998) Poverty and access to the arts: inequalities in arts attendance. *Cultural Trends*, 31. London: Policy Studies Institute.

Sherman, D. J. (1990) Art history and art politics: the museum according to Orsay. *Oxford Art Journal*, 13 (2): 55–67.

Simmel, G. (1903) Metropolis and mental life. In *On Individuality and Social Forms*. Chicago: University of Chicago Press, 1971.

Soja, E. (1995) Postmodern urbanization: the six restructurings of Los Angeles. In S. Watson and K. Gibson (eds), *Postmodern Cities and Spaces*, pp. 126–37. Oxford: Blackwell.

Trasforini, M. (2002) The immaterial city. In D. Crane, N. Kawashima, and K. Kawasaki (eds), *Global Culture: Media, Arts, Policy, and Globalization*, pp. 169–90. London: Routledge.

Urry, J. (1990) *The Tourist Gaze: Leisure and Travel in Contemporary Societies*. London: Sage.

Virilio, P. (1991) *The Aesthetics of Disappearance*. Paris: Semiotext(e).

— (1994) *The Vision Machine*. Bloomington, IN: Indiana University Press.

— and Lotringer, S. (1997) *Pure War*. Paris: Semiotext(e).

Wilson, E. (1991) *The Sphinx in the City*. London: Virago.

*Wu, C-T. (2002) *Privatising Culture: Corporate Art Intervention since the 1980s*. London: Verso.

Wynne, D. and O'Connor, J. (1998) Consumption and the postmodern city. *Urban Studies*, 35 (5–6): 841–64.

Zukin, S. (1996) Space and symbols in an age of decline. In A. D. King (ed.), *Re-presenting the City*, pp. 43–59. London: Macmillan.

Exposing the Public

Mieke Bal

Interferences

That the museum – as institution, material object, and endeavor – interferes with, makes "noise," in other words causes interferences that trouble the "pure" aesthetic experience of visitors is so obvious, so inevitable, that there is no reason to deplore it. Such a lament would testify to a purist illusion pertaining to the desire, generally attributed to a vulgarized modernism, to cut the very bonds that link art to the social domain outside of which art could not be produced, live, or even be named. We are better off wondering what strategies might be effective in turning this situation into an advantage. For, given the social nature of art, the inevitable interferences are part and parcel of the experience of art.

The first consequence of this obviously "impure" state of exhibited art affects not so much the art of the art objects, as the public. It is the public to whom I dedicate some of the thoughts in this chapter. The plurality of the visitors – each with their own intellectual and aesthetic baggage, moods, knowledge, and expectations – makes any reference to *the* public impossible. This does not mean that the individual and its "-ism" reign supreme – that, instead of *the public*, we ought to speak of the innumerable individuals of whom it consists – because that would be the surest way of reinstating the generic singular that flattens any reflection on art–public relations (see Bourdieu and Darbel 1966, 1969). Instead, thinking of the public in the plural helps to avoid generalizing assumptions, and encourages the development of strategies that facilitate a diverse interaction between viewers and the objects on display.

Within the framework of the social constraints that induce some people and not others to visit art exhibitions, we can only assume that people go to see things that are there. Some people are interested to learn something about those things – although it is impossible to know what – while others prefer to be left alone, to have an "aesthetic experience," or to see things "as they are." But since things *are* not, in any simple sense, since they only exist within the frame of a circumscribed materiality and institutionality, it seems pointless to subject museum work to this illusion.

This is where the problems arise. While we know that it is impossible to provide pure aesthetic events, we do not know very well what to do instead. Whereas the

Mieke Bal

work of curating, hence, of interfering with art, remains indispensable, we can try
to limit and structure the interferences, the "noise," so as to mitigate their effects,
even their visibility, or we can blow them up, make them visible, and pluralize them.
In the latter case, the encounter with art becomes something like a literal encounter.
And it is this that I propose.

Against the illusion of transparency as well as against the narcissism of (guest)
curators that we have witnessed of late, where the presentation tends to become more
important than the objects, I have been thinking for some years about the possibili-
ties of working *with* the interferences – as a medium (for an overview of *auteurist*
exhibitions, see Huyssen 1995: 20). I have been dreaming about a practice of exhibit-
ing – by means of thematizing the "noise" – that aims to integrate a critique of trans-
parency with a dialogue that activates the publics, in the plural. Such a practice would
foreground rather than obscure the mechanisms and decisions that underlie the
presentation of objects by means of an artificial coherence that is both provisional
and indispensable.

In this chapter, I would like to say three things about the interaction between
displayed objects and their publics. The first concerns why addressing viewers by
definition turns into a dialogue with them – the perlocutionary aspect of showing,
its "second-personhood." The second concerns the potential productivity of the
"problem" of the institution and its interferences – the frame – for the viewers'
engagement. The third concerns the status of the visual beyond visualism – the
media – in its interaction with the public. Here the concept of translation becomes
relevant.

Second-personhood

In an earlier work, published under the title *Double Exposures* (1996), I undertook to
analyze the "language" of the museum wall: the signifying effects of the juxtaposi-
tion of objects, of explanatory labels; the disposition of the gallery space in relation
to the architecture and light; the recommended or even imposed itinerary; and, on
the highest level of generality, the effects of the division into art museums and ethno-
graphic, historical, or scientific museums.

To that end, I studied the contradictions or tensions within a museum of natural
history between a display of objects of African art destined to show the public a rich
plurality of cultures, and the labels specifying the political consequences of that same
plurality, there presented as dangerous instability. I framed that analysis in a reflec-
tion on the urban architecture around Central Park in New York, where a clear class
division separates African art, as "natural," ahistorical, and juxtaposed to phenom-
ena from the animal world, from European art, which is housed on the other, more
affluent side of the park (the Metropolitan Museum of Art also houses objects of
African art, but the latter's status in that museum is far from equivalent to that of
European art).

In another analysis in the same book, I studied the consequences of the architec-
ture of the rooms devoted to French Impressionism in the Metropolitan Museum
of Art in New York. There, the placement on the wall of what represents the grand

526

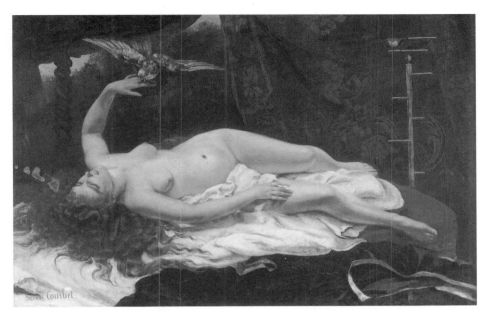

Figure 32.1 Gustave Courbet, *Woman with a Parrot*, 1866, oil on canvas. All rights reserved, Metropolitan Museum of Art, New York.

finale of the itinerary programmed by the architecture – Courbet's *Woman with a Parrot* (fig. 32.1) rather than the painting with the same title by Manet (fig. 32.2) – seemed highly significant. The choice of the Courbet as the climax of the show inscribed in the exhibition a hierarchy of the "homosocial" kind, whereby the older painter automatically gained the status of the master over the younger one, the obedient student. In this case, where the two works bear the same title and are from the same year, such a filiation was not at all obvious. Moreover, the systematic opposition of the Manet and the Courbet, in both the composition and the iconography of the woman, suggested more a polemical relationship than an admiring endorsement of the model (if we can speak of a model at all).

The effect of the neo–classical architecture lends itself to this reiteration of the cliché of a sociality specific to the Impressionists. Several rooms later, the exhibition ended in a quasi–religious wall, where the Courbet occupied the place of the altar, of the absolute masterpiece. But it was not only the contingency of the architecture that generated this effect. The accompanying label clearly showed that the curators responsible for the show – its "expository agents," as I call them – firmly believed in this homosocial arrangement as the historical truth about artistic relationships. A different "truth" does not seem to enter into the picture at all. This makes the stated truth invisible, naturalizes it. Within the usual limit of a hundred words, a wall label told a futile anecdote, adding nothing at all to the Manet painting it was meant to clarify. All it did was to send the viewers to the next painting, the climax of the show, pushing them away from the Manet and hastening them toward the Courbet.

527

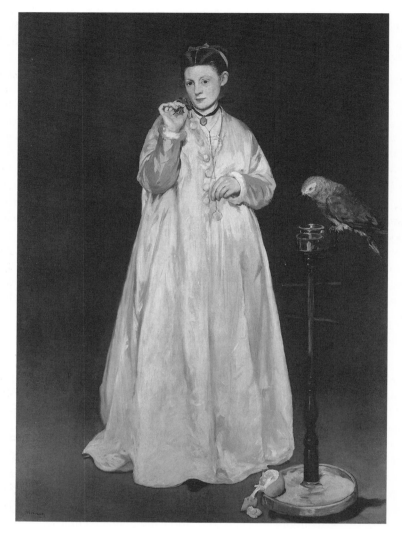

Figure 32.2 Edouard Manet, *Woman with a Parrot*, 1866, oil on canvas.

Whoever knows both paintings would have some sense of the consequences of such a problematic hanging.

But the analyses in *Double Exposures* – by definition critical, since that is the mission of analysis – were not always negative. In some cases, the contingencies of collective work and museal architecture produce felicitous "speech acts," unexpected and perhaps undesired effects. This was the case, for example, in the rooms of the Gemäldegallerie in Berlin-Dahlem as they were in 1994, where two paintings by Caravaggio were hung together with a minor work by Baglione, a hanging that produced a hallucinating sensual effect.

At stake, then, as these analyses demonstrate, are *effects* rather than programs and intentions. The principle on which *Double Exposures* was based was derived from a combination of analytical philosophy and the word-concept "exposition," in Greek the verb *apo-deik-numai*. This verb, in the characteristically Greek middle voice so cherished by Roland Barthes, can indicate the action of making public, of publicly demonstrating, publicly voicing, opinions and judgments. Or it can refer to the performance of actions that deserve to be rendered public (Nagy 1979: 217–20). For my purposes, I drew from it the notion that an exhibit is an event where someone renders something public, including the opinions and judgments of the exposing subject. Thus, an exposition is, by definition, also an argumentation whose enunciative situation, in which two voices alternate, is worth restoring. Moreover, exposition is also self-exposure. The expository gesture is doubly deictic. By showing the object, one shows oneself, for the finger that points is attached to a body, a person. The modernist "white cube" gallery was precisely mobilized, but in vain, to obscure that body.

The performance through which the exhibiting subject turns himself into an "expository agent" is perlocutionary: it is addressed to a receiver, the "second person" in grammar. This comparison with grammar is not gratuitous. According to Benveniste, language demonstrates that the person is not autonomous. The first person – the one who speaks first – must be confirmed in her authority to speak by the second person, the "you" who speaks in turn so that dialogue can happen. But if exhibiting is about communicating, the object is not autonomous. It is put on display by a "first person," the expository agent. The expository gesture of the latter indicates its object. That gesture is specifically realized in the time-space, the chronotopical situation that we can call "enunciative," even if the relative duration of an exhibition allows the agent to hide, thus leaving the object in charge of speaking on his behalf (Bakhtin 1970; Hirschkop and Shepherd 1989; Peeren 2005).

The expository act is, thus, a speech act – effective or, in the jargon of analytical philosophy, performative (Butler 1993, 1997). When the performative aspect of the gesture executes especially its perlocutionary aspect (its effect on the second person), it may become annoying because the agent is not available – not directly, not all the time – to take up his position as second person. This lack of availability, which comes from his invisibility, cuts the dialogue short and precludes the performance of a range of speech acts, such as affirmative ones, but also, among many others, interrogative, mandatory, and prohibitive ones. Hence the expository discourse is disguised as affirmative-only, as constative and informative, thus obscuring the way in which it solicits for the agent an authority that does *not* go without saying. This discourse makes public not so much the objects as a certain discourse on and about the objects – a discourse ruled by conventions, mostly flatly historical, vulgarly aesthetic, monographic, and monomaniac, and often, nationalist. But among the elements of this discourse that the material arrangement of the show most tenaciously defends is the question of the illusory transparency of the discourse of realism.

Against the authoritarian exhibition "in the third person," there is the so-called postmodern exhibition, sometimes called post-museal to use a term coined by museologist Eilean Hooper-Greenhill (2000; see also Bal 2003). But this type of exhibi-

tion does not *by definition* deconstruct the dictatorial monological structure. For, by lack of an adequate theoretical basis and a creative agent, the experimental show is in danger of remaining thematic. And if the theme chosen has no theoretical reason, it remains flat. This is not inevitable, however. One notable exception was the series of exhibitions called *Parti Pris*, organized in the Louvre in Paris by Régis Michel during the 1990s, in which the theme was given a relevant theoretical articulation. Another was the traveling show *Inside the Visible*, organized by Catherine de Zegher in 1996, whose general theme – art by women – was articulated through a theoretical problematic of contemporary aesthetics. Here a theme that could have remained flat was turned into an emancipatory theme of great relevance, and the women artists, till then more or less ignored, were instated as masters of the avant-garde (de Zegher 1994).

Two examples of shows from the year 2001 will help to further illuminate the difference between a flat and a theoretical thematic. The first was *Rembrandt's Women*, held at the Royal Academy in London (see Bal 2002a) and the second, *Art as Crime*, staged at the Louvre (Bal 2002b: ch. 4). The former exhibition was entirely framed by art expertise, as a mirror of men's expertise in "judging" the beauty of women, or rather, Woman. The expository agent, whether man or woman, retained the authority of the realist discourse that is historically connoted masculine, even though, as it turned out, the curator was a woman (Julia Lloyd Williams; see Williams 2001). The show thus created a category – Rembrandt's women, or Woman in Rembrandt – that neither art history nor the artist would recognize, and, hence, was unavowedly anachronistic. It presented itself "in the third person," a grammatical figure that obscures its anchoring in first-personhood. As usual, one was happy to have the opportunity to see so many works together that are usually separated, but the result was a culturally damaging perlocutive effect.

In contrast, *Art as Crime*, curated by Régis Michel (2001), simultaneously performed a critique of art and of its institutions. In other words, in a theoretical reflection in an exhibition of a group of works that were mutually illuminating, it demonstrated the suspect and ideologically fraught aspects of what is generally taken to be "natural" in art. This combining of works of undeniable artistic quality with labels that foregrounded the troubling aspects of those "great works," paradoxically imposed on the viewers the freedom to reflect and decide what to think. *Rembrandt's Women* was willfully condescending to the public taken as a whole; *Art as Crime* was demanding, analytical, and innovative.

Although the London exhibition specified the public according to a gender division that turns everyone – man or woman – into a clone of the master who is supposed to have constituted an oeuvre as a typology of Woman, it treated the public as unified. The Paris exhibition, by contrast, pluralized it. The instrument of that pluralization was the emphatic presence of the first person, the expository agent, who proposed, visibly, without imposing, so that each visitor could decide for herself. According to this model, one could say that the expository act is a proposition that requires a disposing act (on the play with punctuation, see Lacan 2002a, b).

The demarcation between the thematic and the more emphatically *auteurist* show is not always clear. *Auteurist* shows are clearly and openly "in the first person,"

proposing a story on the art told by a master of taste, with mastery as its sole justi-
fication. Indeed, in the guise of *auteurism*, this type of show tends to become an auto-
biographical discourse in the first person, with varying degrees of narcissism. To be
sure, curators like Harald Szeemann have things to say, and those things concern art
as they see it. And if the curator is sufficiently exceptional, those things are also
worth saying. But having worthwhile things to say is not the same as fundamentally
transforming the relationship between art and its publics, a relationship that is to
this day under-analyzed. For the shift of focus to the expository agent leaves in place
a monologism that the third-person and first-person discourses share. In his
2000–2001 exhibition *Voici: 100 Years of Contemporary Art*, held in Brussels, Thierry
de Duve, for example, had a lot of things to say, in particular about specific concep-
tual art. But he also had things to say about figurative art, and that is where he
changed gear (Duve 2000).

Attributing the agency of address to the object, de Duve's conception appears
related to mine – which is why it is necessary to say a few things about it. In fact,
our conceptions differ fundamentally. De Duve speaks of address, attributes a unique
voice to the object, and thus strikes the unified public dumb – yet again. Moreover,
the address attributed to the object is derived from the curator's voice. The symptom
of that derivation is the temptation of flat thematics: the object becomes the still life
with its represented objects (*la chose*), and the second-person discourse becomes the
mirror, a choice a bit too literal to work. But the monologism of de Duve's exhibi-
tion becomes even more manifest when the discourse of the objects is articulated in
terms derived from Christian doctrine: apparition, incarnation, resurrection. These
terms reduce not only the exhibited art objects to an exalted Christianity, but also to
a generalized aesthetic. In today's world, this reduction strikes me as a desperate
denial of the alterity of art.

But I am not looking to interpret the "first person" of de Duve's show, turning
him into a figure of the missionary. What worries me is not the specific contents, but
the monologism itself, the simple fact that de Duve calls his three biblical concepts
"truths." The denomination "truths" is noticeable as a product of the first-person
discourse. In other words, only when the expository agent, who borrows a discourse
in the first person, attributes to himself the authority that presents the objects as
true objects – presented in the third person – can this monologism sell, as universal
truth, a conception – here, a religious one – that is utterly specific, monocultural,
and personal.

By contrast, the true "second person" of the exhibition, the so-called "public,"
has no stake in hiding. If we conceive exhibitions as events of which the chrono-
topical position is not permanent since the situation of utterance cannot be perma-
nent, we must deduce that the event is reiterated in each visit, in each act of
confrontation between viewer and show. Repetition is understood here in the
Deleuzian sense, as forbidding identity between occurrences. Hence, the impossi-
bility to speak of *the* public, unified – to which the exhibition supposedly offers itself
as a mute, natural, and immutable thing. I will later make a case for the non-unified
nature of the public, but I first wish to say a few things about the second aspect of
this plurality, an aspect that emerges from framing.

Framing

Coming from an intellectual position of critical engagement, I have always found it difficult to deal with challenges from museum professionals who have alleged that it was rather facile to conduct a purely intellectual critique without taking material and financial limitations into account. Since then, I have had the opportunity to curate a small, experimental exhibition myself. It was an immensely fruitful experience, during which I learned about performing a maximally effective expository politics with extremely limited means – and to assess its effects.

I used this opportunity to stage an exhibition, to create an intellectual, physical, material, and aesthetic space where the plurality of the public could be made concrete, and the hand of the expository agent would be visible in its deictic function without constituting itself into an object of contemplation or an authority that held the truth. Instead, the agent was to be the first person who initiated the exchange and exchanged positions with the individuals occupying the place of the initial second person. The theoretical concept through which I had "thought" the concrete situation of "noise" was what is usually referred to as "framing."

The critique of the unified public was to be related to institutional critique through this concept. At stake were the conditions under which signs are communicated, that is, the conditions that determine and limit the signifying possibilities of signs. These conditions participate in the construction of space-time, of the chronotope within which each visitor finds herself confronted with the works on display. They are a mixture of negative and positive constructive meanings, and of material, institutional, and ideological frames. I wanted to turn this mixture into part of the visible gesture of showing. In this way, I aimed to overcome the separation between empirical, historical, and analytical studies.

Wishing to exceed the fixed frames, I first asked myself which rules underlie the practice of exhibiting. I am not speaking of material, financial, and institutional parameters – I do not know these well enough and cannot influence them – but rather of the rules or laws that underlie what a viewer, who comes to a museum voluntarily, perceives as *given*. Given, in the double sense of the word, since the presentation in general makes itself invisible, hence, is given, so that I do not see it and so that I cannot imagine it could be different from the way it is. Given, thus, are the following rules:

- *historicity*: information – dates, events – seems inevitably to frame the *visual* presentation. The objects are thus subjected to an unavowed determinism.
- *biography, monography*: the person of the artist constitutes the unifying principle even when the exhibition shows only a small selection from her oeuvre, and even when other objects are combined with those.
- *aesthetics*: the hanging interferes with the aesthetics of the objects. In the department of old master paintings of the museum where I curated my small show, for example, there is a tendency to alternate horizontal and vertical paintings as well as to respect a predetermined spacing. This produces a "natural" aesthetic that makes visitors feel at ease, at home, in the way you feel at ease in a room with

pleasant wallpaper and neutral furniture. The result is that one does not look too much at the paintings because one is already at ease. The paradox is that the pleasant ambience of the gallery ruins the art exhibited.

- *thematics*: to the extent that the thematic show has been the sole alternative, I wanted to avoid the reification of themes and the reiteration of the same content that a thematic organization would entail.

All these rules conspire to neutralize, indeed naturalize, exhibitions. And comfort counters the act of looking.

In order to liberate viewers from this constraint, I wanted to "re-educate" or – to allude to the Nietzschean term of "dressage" – to de-educate the publics, enticing them instead to endorse the activity of looking without the museum prejudging the manner in which this activity was performed. In short, I wished to alienate the publics from those naturalized rules. As a result, two necessities arose:

- to break with the *centralization of knowledge*, with the cloning, the molding of the visitor in the image and likeness of the curator – the site of knowledge – or of the guest curator – the site of a specific aesthetic. This is no plea for ignorance or for contempt for the knowledge of curators. I recognize the importance of knowledge, even if the kind of knowledge cultivated within museums is subject to debate. But there is no reason why the knowledge that sustains conservation and the categorization of works to be stored should also structure the presentation of those works to the public. Viewers are not clones of the curator.
- to do away with *unity*, that is, with the preconceived notion that an exhibition must be organized around, or on the basis of, a unifying concept; that is, that it must itself be unified.

If the predominant aesthetic is based on the unification of exhibition space, I was committed to de-stabilizing that unity.

Is that possible? The experimental example was *Judith Shows the Head of Holophernes* (fig. 32.3). It was a new acquisition of the Museum Boijmans Van Beuningen in Rotterdam, and as such needed to be presented to the publics. To unlearn the habit of grand "blockbuster" shows in order to re-learn looking, I first favored the model of the mini-exhibition. One gallery, one painting, in itself a minor work. This particular painting dates from the beginning of the seventeenth century, and was made by a little-known artist who left just six paintings, only two of which are perceived as being beyond the routine of craft. In such a case, a monographic show is thus rigorously impossible. But was that a reason to neglect this work, to deprive it of viewers? There was no need to tell "the truth" about it. More important was to wake it from its sleep. "An ambitious painter without obvious genius" was the general opinion of the museum. An intriguing representation of Judith after-the-act, remarkably static, and with qualities that are less than obvious (see Bal 2002b: ch. 4).

My primary goal was to make people spend time with the painting in whatever way they chose to – that was up to them. One way to achieve this was by de-naturalizing, hence, by de-aestheticizing it. For this purpose, the gallery space itself

533

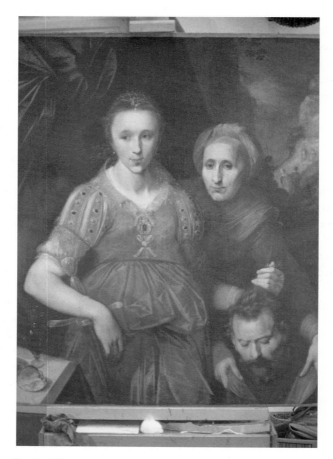

Figure 32.3 Gerrit Pietersz Sweelinck, *Judith Shows the Head of Holophernes*, 1605, oil on canvas. Reproduced courtesy of Museum Boijmans Van Beuningen, Rotterdam.

was left a bit disorderly: Sweelinck's painting was hung on a crimson screen, since it was about decapitation, but the color red was not quite the same as the red in Judith's dress. No unifying organizational principle was applied to the works displayed around it, apart from laying bare a number of possible *frames*, in the Derridean sense of the term. I wanted the painting to spill out of its frame, and the viewers to have a choice of frames. For example, pieces of household goods were displayed in a cabinet in front of the painting, each carrying a depiction of the story of Judith, Esther, or Delilah. The choice of mixed media also included drawings and prints; there was a mixture of categories, that is, of cultural "levels" or statuses.

To the left, other recently acquired works were hung. This was a way of showing the hand of the museum's curator, his specialization. To the right, half behind the central screen, was a series of portraits of women. This frame drew attention to the fact that the two women in the key painting looked very much alike, and that they

had remarkable facial features. On the right-hand wall was a small selection of thematically related works; that is, of works on relations between the sexes, but not all on killing, allegedly castrating, women: a Lucretia, the mythical victim, next to an attempted rape by a faun, next to Joseph and Potiphar's wife, and so on. Thematic, yes, but dynamic nonetheless; a dialogue between different aspects and versions of the theme rather than a repetition of that theme.

Behind the central screen was a small cabinet of graphic works in which the hanging was deliberately "ugly" and intimate. There was also a wall with biblical scenes, organized around the theme of the representation of the body in interaction. This time the theme was not of a semantic but of a visual semiotic nature. On the left were dismemberments, in particular, beheadings. The idea was to evoke questions like "a body without a head, is that still a person?" Alternatively, in keeping with Julia Kristeva's *Visions capitales* (1998), I wanted to suggest a profound relationship between beheading as a theme and the genre of the portrait, as a semiotic questioning of visual representation. I had a "local" reason for doing this – inspired by the painting itself.

I wanted to display the painting on the central screen, hence, to centralize it, but, at the same time, to explode it into fragments, blowing the fragments up, so to speak (fig. 32.4). On the left, at the bottom, was a work that foregrounded still life, and, at the top, the promise of the intimacy of domestic scenes; on the right, at the top, a landscape, at the bottom, the only other painting by the same artist of any interest – a portrait of his brother. Imagine this brother, the composer Sweelinck, very popular at the time and more famous than our ambitious painter; the same incipient baldness on his forehead, the same broken nose. Next to him, Holophernes, painted with love, but very dead.

The theme of the "portrait," foregrounded on the right-hand wall of the print cabinet, was resumed again on the back of the screen, where I hung, like a last-minute footnote, a sketch of a self-portrait of the artist. After the association between the brother and the victim, this one, between the faces of the two women and the artist, offers a possible explanation for the remarkable similarity between the facial features of the women; the same long cheeks, arched eyebrows, hollow eyes.

No wall labels imposed these associations, which stretched from the thematic to the genre-oriented, from the aesthetic *dispositifs* to the psychoanalytic. By contrast, the different frames were indicated sometimes with extensive labels, sometimes without any at all. The household goods, for example, were explained at length. But there was no information at all for the walls crammed with prints and drawings. In this way I sought to denaturalize the institution of label itself so that those that *were* there would be read.

My main goal, as I mentioned earlier, was to incite people to spend time in the gallery; to give them the freedom to choose relevant frames; to confuse them enough, disorient them, without making them reject the exhibition. In other words, I wanted to take the visitors' habits into account rather than to ignore the training, indeed, the indoctrination that museums have given for so long through their practices, which are so firmly anchored in our culture. But taking into account is not the same as perpetuating, for it is possible to respect, acknowledge, and critique all at the same time. Yes, there were historical considerations and data; yes, there were questions

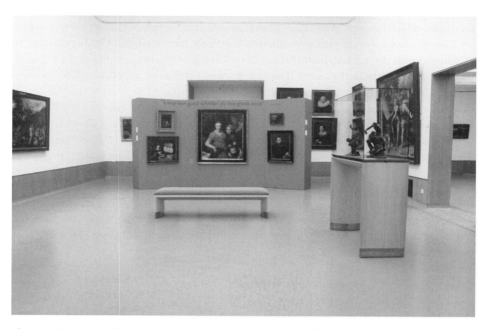

Figure 32.4 Installation shot of Gerrit Pietersz Sweelinck, *Judith Shows the Head of Holophernes*, 1605, oil on canvas, in the *Moordwijven / Lady Killers!* exhibition at Museum Boijmans Van Beuningen, Rotterdam. Reproduced courtesy of Museum Boijmans Van Beuningen, Rotterdam.

about the artist; and yes, the theme, the craft, and the aesthetic were all there. But they were offered as a possible guide only; nothing came "naturally," in acknowledgment of which there was, in fact, no itinerary. While the gallery was rectangular, and there was a transitional space to the next room, everything was done to make people turn around in circles

Translation

In addition to second-personhood and framing, the third and last concept whose relevance I want to discuss here is translation, specifically the idea that exhibitions are a form of translation. Translation: to conduct through, beyond, to the other side of a division or difference. If this notion of translation seems acceptable, I would like to propose some of its consequences (see Bal 2002b: ch. 2).

The first is one of "dissipation." The moment one endeavors to trans-late, there is no question but that some of the object remains in the "duct," the conduit, sticking to the walls left and right, engaging relations not only with its destination but inevitably with what comes along the way. This aspect is linked to the problematic of framing. Meanwhile, the object translated also leaves elements behind; hence the sense that a translation is always inadequate, impoverished. I would like

to see if something positive, something enriching can be derived from this idea of dissipation.

The second consequence is related to the fact that translation bridges a gap, an irreducible difference between the source-object and the target-object. The preposition "trans-," which the word "translation" comprises, is as deceptive as the noun "duct." For even if translation effectuates the passage, it can never quite build the bridge. The gap remains, and in the best of cases, the translation – the result of the act of translating – shows the scars.

Translation has a para-synonym, or a translation of this Latinate word, namely "metaphor," from the Greek. Nuances differ: literally, "metaphor" amounts to carrying beyond, to transference rather than translation. But the two words are close enough to allow decomposition. The noun "metaphor" suggests that the position of the second person is foregrounded in the extreme, as is framing as interference. Such provisional extremism allows me to underscore the fact that there are no limits in the integrated domain of cognition and affect to what an exhibition can suggest to its publics.

The word "metaphor," which can be read as a verb in the third-person plural, means "translating." I use it here to mark the plurality, in principle, of all translation, a plurality that the term "metaphor," in its dualistic conception, begins to suggest. The neologism of the verb serves to keep in mind the farther-reaching plurality of this rhetorical concept. In Greece, the word "metaphor" appears on removal vans. I suppose many artists would like this literal occurrence, especially those artists whose work abandons its normal coherence when they are "translated" through a multitude of styles, media, subjects, dimensions, and materials, in a play of metaphors, in a disunified exhibition.

"Translation" in the sense of transference, exchange, passage between present and past, language and image, form and meaning; passage and exchange between styles, sexes, media – in this sense, all artistic expressions, all works of art, are acts of multiple translation. Such acts can only be performed in a public performance when the publics recuperate their part of speech; when the viewer is enabled, encouraged, solicited to propose a particular version of the performance, including the theatricality that inheres in such acts of engagement with the exhibited objects.

The Other Side of the Publics

It is precisely here that a new challenge presents itself: how to change the habits of a public who, after a solid cultural training in seeing monologic exhibitions, no longer believes in the value, her abilities, or even the propriety of her own initiatives? The anaesthetized publics, addicted to wall labels and fearful of artworks – how to reschool them? I have recently devoted myself to another experiment. To explore the possibilities of trying to refocus attention, I have been experimenting with video, with a view to the most "democratic" medium of all, television.

I have made a series of nine video clips, each six and a half minutes long and each devoted to a single artwork (with two exceptions, where two related works are compared). My goal is to show people – who, for reasons of their own, wanted to engage

a work of art – how to speak about it, communicate with it, and convey their ideas and emotions about it. I chose six contemporary works and three old ones; six figurative works and three non-figurative ones; seven paintings and two sculptures. The three old works are all from one museum, the contemporary works from five galleries and one museum. The selection remained rather arbitrary, being dictated as much by practical considerations as by intellectual ones.

With conversations as the point of departure, each clip was given a title, to account for the particular mode of viewing that the work in question appeared to solicit. A theoretical theme, indicating a manner of looking, emerged from the statements of the people speaking. For two portraits of Rembrandt, for example, the theme became "Landscapes of the Face," for an abstract painting by David Reed, "Looking with the Body." For a baroque painting in which an extremely nasty Christ threatens an old woman, five people spoke from their different backgrounds in five religious traditions; the title here is "Make your Own Story." A gigantic sculpture that refused to be monumental was given the title "Moving Still."

In clip nine from this series, "Black-out, Blind Eye," about a painting by Marlene Dumas, it is not an exhibition you see. Rather, the object on display is the viewer. What is highlighted is the intimate engagement with the work, the plurality of voices and of what they say, the different frames that each person brings in. But most striking is the paradox of a kind of historicity that has nothing to do with the making of the object. The camera, too, takes part in the analytical discourse – as an expository agent.

To foreground the plurality of the publics, I chose my viewers from a variety of age groups and professions. In other videos in the series, you will see, among others, a retired medical doctor, a high-school student, a sick man, an administrator, a library intern, a librarian, a restorer of buildings, and a taxi driver. In the clip I wish to discuss here, the people are all professionals, but only one is a professional in art: they include a secretary, an architect, an administrator, and an art historian.

This video clip presents a contemporary painting in a private home. The painting, called *The Woman of Algiers*, by Dutch/South African artist Marlene Dumas, is hung at an awkward angle on a staircase (fig. 32.5). Of course, this is a very simple situation: a single artwork, easily categorized as a masterpiece if one likes such evaluations, in the most traditional medium of Western art – painting. My aim was to avoid questions – both rather tired yet still urgent – that a less "classical" object would have evoked.

I invited a small group of people to come to the house of the owner at a specific time. I did not tell them which artwork was involved, only that I wanted them to speak about and to a work of art. At the time of recording, I did not ask any questions, except to one woman, whom I asked if she liked the painting. None of the women had seen the painting before and only one was acquainted with the artist's work.

As already mentioned, the concept of the video series was the following: I wanted to exhibit the public, in order to broach the discussion of art at the moment when the roles between the first and second person are reversed. To the artworks I wanted to offer committed viewers who would take the time and trouble to articulate what moved them. But, as expository agent, my own public was elsewhere. I imagined this

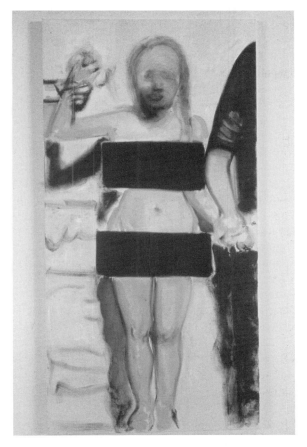

Figure 32.5 Marlene Dumas, *The Woman of Algiers*, 2000, oil on canvas, Los Angeles, private collection. Reproduced courtesy of Marlene Dumas.

series as a pilot for a television program, and I tried to offer my viewers a program that I had conceived as an opportunity for identifying rather than as a source of knowledge. I wanted to show – in the triple sense of the verb – the work framed not by the institution of the museum and its overwhelming rules, nor by inevitable chronology, but by its *situation of enunciation*.

Clearly, this painting did solicit the invited women viewers. I exposed them to the work without any preparation, two at a time, in the hope of encouraging the verbal articulations of conversation. The first pair responded more explicitly to the painful situation depicted: a naked young woman torn between two hands of military men. On the breasts and the genital area, two large black bars censored visibility. One of the women begins by saying: "That's exactly how I feel in San Francisco! And not at all here [in Los Angeles]." She explains: "There are cities where I feel sexually implicated, and in others not at all." This woman, an architect, responded to the depicted situation with a spatial sensibility to the relation between her body (as a woman) and public space.

Her interlocutor comments on the difficulty of seeing owing to the way in which the painting is hung, which forces her to look up. As a consequence, she finds the painting rather intimidating. Could it be in terms of this sensibility to hierarchy as invoked by spatial height that she invokes, a bit later, the allegory of justice and its scales? A third woman says that the young girl in the painting looks resigned to her arrest and undressing. A fourth woman says the opposite: for her, the closed fist, enclosed in the hand that holds her, suggests the defiance of impotent revolt. The contradiction between these two views, each put forward with passion and conviction, was for me the key moment in the making of this clip.

If I may translate my three theoretical concepts, I would point to a few moments of the video as examples. The first term concerns the speech act, the dialogue, in other words, the "second-personhood" between the work and the persons engaged in the act of looking at it. ("Second-personhood" refers to the fundamental dependence of each subject on his or her "other," be it the caregiver, the interlocutor, or the social environment. It is precisely this that de Duve ignores in his conception of "address.") The triumph of the plurality of the public occurs at the moment I just mentioned, when one woman says that the figure is resigned and another that she is revolting. The *dialogism* between the expository agent and the viewers becomes manifest through identification, at moments when one of the women says she has difficulty looking at the painting from below. The effect of the material situation is relevant; it foregrounds the extent to which the material conditions are part and parcel of the work on display. The framing is not reduced to these material conditions, but they do spill over onto it. The woman who enters the artistic space with a total and sudden identification, speaking of her self-consciousness as a sexual woman in some cities, of her inhibitions in others, demonstrates the importance of the viewer's subjectivity for all acts of looking.

Toward the end of the clip, one of the women suddenly says she is fed up with interpretation. She affirms that the painting is, before all else, just that: paint on canvas. She speaks of a total confusion between painting, skin, and canvas. This remark captures better than any other the kind of work that this artist makes. It could have been the ideal wall label. But it gains its specific importance through the conversation that trickles on later, within which the remark takes on a meaning that reinforces rather than contradicts it, the political tenor of the work. And, on a label, *that* meaning would have been lost.

For this woman, who says she resists, in the end, the act of translation that is interpretation translates what Jean-François Lyotard (1985) would have called the *figural*. She positions herself in the regime where the distinction between vision and language self-deconstructs. On the one hand, she continues to speak; in other words, to articulate her response to a painting and, hence, to take upon herself the position of the first person to which she, like all viewers, is entitled, and that she also owes to the work. Hence, inevitably, she translates. On the other hand, when she begins to speak, a bit like Proust, of small bits of paint, she stops the privileging of reference in favor of the visual. This, too, is a form of translation.

If we now consider together – in a conversation, precisely – the utterances of the four people, it is not so easy anymore to tell what is translation and what is not, nor to decide what to do about the contradiction. But nor can we get rid of it; that would

be such a waste! One utterance is situated in the spatial and sexual position, about which the other speaker says that it rests on a confusion of planes. One woman/speaker is enthusiastic about the strength of the girl, the other deplores her impotence. But both enter the stage and participate in the drama that happens before their very eyes. It is in this nascent debate, in these possible contradictions as well as in the "second-personhood" of the artwork, that the force of the plurality of the publics is located.

What can be the efficacy of such videos, of such an exposure, of such an exposition of art through its publics? Of course, I conceived this series with a long-term goal. I wanted to propose a series, specifically a program, that exposes the publics of television, publics that are infinitely larger than those of museums, to an encounter with art, one art work at a time. Believing that museums have done all they can to discourage people from looking with their own eyes, I advocate the single artwork. I engage it with a camera in a maximally validating manner. In this case, the small bits of paint are engaged one by one. The eye covered by an opaque film, the mouth radically ambiguous, the black spots of shadow behind the arm and leg that indicate – for one, the police photograph, for another, a second prisoner, the first of a long line of prisoners: all this generates the visual analysis of which the camera is the agent. Participating in the conversation, the camera shows what the people see.

This is important, for it is not in order to isolate the individual work in a splendid aesthetic purity that I wanted to make these videos that validated it. The work is neither the third person about which the discourse speaks, nor the first person in the sense of which the old new criticism assumed that the object "spoke itself" in a splendid autonomy. The camera that caresses, examines, engages the work, is also a spectator. And, in that function, the camera collaborates with the others. Alternating between the work and the spectators, the camera both exposes them and exposes itself, argues and responds. It is the hand of the expository agent that must not hide. Like the hand of the young woman represented in the painting, it is both resigned and defiant. The public, naked, is exposed, but unlike the girl, it is not alone.

Acknowledgment

This chapter forms part of a series of earlier projects, both academic and practical, that I have undertaken focusing on the question posed by the colloquium "L'art contemporain et son exposition," held at the Centre Georges Pompidou, October 5, 2002.

Bibliography

Bakhtin, M. (1970) *La poétique de Dostoievski*, trans. from Russian by Isabelle Kolitcheff, presented by Julia Kristeva. Paris: Editions du Seuil.
*Bal, M. (1996) *Double Exposures: The Subject of Cultural Analysis*. New York: Routledge.

— (2002a) Der Rembrandt der Frauen. In M. Bickenbach and A. Fliethmann (eds), *Korrespondenzen: Visuelle Kulturen zwischen Früher Neuzeit und Gegenwart*, pp. 27–54. Cologne: DuMont.

*— (2002b) *Travelling Concepts in the Humanities: A Rough Guide*. Toronto: University of Toronto Press.

— (2003) Visual essentialism and the object of visual culture. *Journal of Visual Culture* 2, (4): 5–32.

— (forthcoming) Sadism, masochism, and other stories: second-person art. *Visio*, 10 (1–2).

Bourdieu, P. and Darbel, A. (1966) *L'amour de l'art: les musées et leur public*. Paris: Editions de Minuit.

— and — (1969) *L'amour de l'art: les musées européens et leur public*, 2nd edn. Paris: Editions de Minuit.

Butler, J. (1993) *Bodies that Matter: On the Discursive Limits of "Sex."* New York: Routledge.

*— (1997) *Excitable Speech: A Politics of the Performative*. New York: Routledge.

Deleuze, G. (1968) *Différence et répétition*. Paris: PUF.

Derrida, J. (1978) *La Vérité en peinture*. Paris: Editions du Seuil.

Didi-Hubermann, G. (1992) *Ce que nous voyons, ce qui nous regarde*. Paris: Editions de Minuit.

de Duve, T. (1996) *Kant after Duchamp*. Cambridge, MA: The MIT Press.

— (2000) *Voici: 100 Years of Contemporary Art*. Brussels: Palais des Beaux Arts.

Hirschkop, K. and Shepherd, D. (eds) (1989) *Bakhtin and Cultural Theory*. Manchester: Manchester University Press.

*Hooper-Greenhill, E. (2000) *Museums and the Interpretation of Visual Culture*. London: Routledge.

*Huyssen, A. (1995) *Twilight Memories: Marking Time in a Culture of Amnesia*. New York: Routledge

Kristeva, J. (1998) *Visions capitales*. Paris: Musée du Louvre, Réunion des Musées Nationaux.

Lacan, J. (2002a) The insistence of the letter in the unconscious. In *Ecrits: A Selection*, trans. B. Fink, pp. 138–68. New York: W. W. Norton.

— (2002b) Function and field of speech and language in psychoanalysis. In *Ecrits: A Selection*, trans. B. Fink, pp. 31–106. New York: W. W. Norton.

Lyotard, J-F. (1985) *Discours, figure*. Paris: Editions Klincksieck.

Michel, R. (2001) *L'art comme crime*. Paris: Musée du Louvre.

Nagy, G. (1979) *The Best of the Achaeans: Concepts of the Hero in Archaic Greek Poetry*. Baltimore, MD: The Johns Hopkins University Press.

Peeren, E. (2005) *Bakhtin and Beyond: Conceptualizing Identity through Popular Culture*. Amsterdam: ASCA.

Williams J. L. (ed.) (2001) *Rembrandt's Women*. Edinburgh: The National Gallery of Scotland.

de Zegher, M. C. (1994) *Inside the Visible: An Elliptic Traverse of 20th-century Art in, of, and from the Feminine*. Cambridge, MA: The MIT Press.

The Future of the Museum

Charles Saumarez Smith

Some time in 1998, as Director of the National Portrait Gallery in London, I received an invitation out of the blue to attend a small and fairly select conference organized by the J. Paul Getty Trust and the Smithsonian Institution in a villa by the sea to the north of Rome. Its subject was described as "The Conditions for Culture and Cultural Institutions at the End of the Twentieth Century." The idea had been proposed by Charles Landry, a freelance consultant and author of *The Creative City* (2000), and Marc Pachter, who at that time was a senior policy adviser to the Secretary of the Smithsonian and was subsequently appointed Director of the National Portrait Gallery in Washington. Between them, they had come up with the suggestion that sixteen people should be locked in an expensive hotel for a long weekend in order to think about what might be the conditions for culture and cultural institutions at the end of the twentieth century with a view that this might help policy-makers to determine the future (see Pachter and Landry 2001 for an account of the deliberations).

What the experience of the Rome conference made me realize is that nearly everyone in the cultural arena works with a set of half-formed ideas and expectations as to what the future holds, a set of presumptions and beliefs, which inevitably helps to inform their decision-making and certainly in Britain can lead to the expenditure of very large sums of public money through the relevant government agencies of the Department for Culture, Media and Sport, the Arts Lottery Board, and the Heritage Lottery Fund. But these ideas are very seldom subject to any systematic analysis. There is, so far as I know, no existing study that has looked at the different versions of the future shape of culture over the next thirty years. The Department for Culture, Media and Sport does maintain a strategy division to consider such questions, but its conclusions are not published, nor are they subject to public debate. The Secretary of State may seek advice from think tanks, but the nature of the relationship between public policy and long-term strategic thinking is often unclear.

In other words, people involved in policy formation, as well as people like myself involved in the management of major cultural institutions, are in danger of being viewed as travelers without a compass, walking into the future without a clear sense of direction, making decisions which may or may not be governed by good instincts,

by the political mood of the moment, but which are not necessarily plotted systematically or subjected to critical cross-questioning.

The Technophiliac's Dream

The most obvious version of the future which has been established as an orthodoxy in current government thinking and in the wider cultural arena is the set of changes associated with new developments in information technology and the introduction of the worldwide web. The most extreme manifestation of technological determinism is the idea, which has been promulgated not least by the Department for Culture, that museums may simply be swept aside by the tide of new technology: that there is no point in looking at a pile of old bones if you can study them just as well, if not better, on the worldwide web, so that museums may be at the point of disappearing along with the high street bank. This is the doomsday scenario for museums, whereby their original functions and purposes as repositories of pictures and artifacts are rendered redundant by the capabilities of electronic storage and information retrieval. Or, looked at from another point of view, it can be described as the technophiliac's dream, whereby all forms of information and knowledge are available without moving from your computer terminal.

This may seem a somewhat extreme statement of the view. But there is no doubt that versions of it currently inform thinking about museums. An impressive manifestation of the re-invention of the museum in the light of new technology, for example, appears in the Dana Centre at the Science Museum, London (see Science Museum 2003). In Reading, UK, there is a newly refurbished city museum which has been handsomely funded by the Heritage Lottery Fund in the old and fine Victorian town hall (see www.readingmuseum.org.uk). Every gallery of the museum, whether it is devoted to the archaeological remains of Silchester or to nineteenth-century civic portraits or to the history of Huntley and Palmer's biscuit tins, provides visible and convenient access to a computer terminal which leads into a program about the collection and what is held in store. The computer terminal beckons like a siren voice in the corner of every room, brighter and infinitely more full of promise than any of the exhibits.

This characteristic of the design of the Reading Museum is combined with another tendency, which has become common, whereby the traditional method of narrative and chronological ordering has been downgraded in favor of displaying objects and works of art unsystematically. Suddenly, the artifacts, works of art, and biscuit tins look curiously arbitrary and meaningless, thus implying that it is the computer that will provide the order and system that is the key to understanding them and to their interpretation. The Reading Museum, in other words, is a visible manifestation of the philosophy – in many ways, a very successful one – that museums are tools for the communication of information and that, if computers can do this better than surviving artifacts, then so be it. The museum is transmogrified into what might more appropriately be considered a learning resource center, an attractive proposition for a local authority with a strong commitment to education (Macdonald 2000: 32).

This was the philosophy that informed some aspects of the planning of the proposed and now abandoned Libeskind wing at the Victoria and Albert Museum: the existing buildings of the museum were perceived to be an encumbrance on its future development and it was therefore believed to be essential to provide a building that could act as an effective emblem of a new form of museum – one which was not inhibited by the inheritance of the past, but could provide an image of a bright, new, technological future.

The Convergence of Commerce and Culture

If the first idea that informs much current cultural planning is a version of technological determinism, then the second is the belief in the increasing convergence of commerce and culture (Bayley 1989; Pine II and Gilmore 1999; Din 2000; chapters 23 and 31 of this volume). In this version of futurology, shops are becoming more like museums – places for visual and aesthetic display – while museums are becoming more like shops. If one looks at the pattern of current retailing, it is obvious that shops are increasingly trying to disguise their commercial function by dressing up their activity as if it is in some way socially or intellectually improving; so that, for example, the branch of Waterstones in Piccadilly is designed in such a way that the fact that it is a place in which to buy books is disguised by the appearance that it is a public library, encouraging the shopper to sit down and browse. There are shops like Egg in Knightsbridge or Rococo in the Kings Road which manage to aestheticize the display of their products in such a way that they are treated as cultural discoveries. The mail-order shop Old Town produces mail-order catalogues that are deliberately designed in such a way that one thinks that one is buying clothes designed and made in the early part of the twentieth century, while the Munich-based mail-order company Manufactum provides detailed historical information about the provenance of each of the objects and artifacts it sells (www.manufactum. com). This tendency is evident in Rem Koolhaas's Prada store in New York, which occupies the site of the former Guggenheim in Soho; and, equally, in the books published by Ellipsis, which treat the experience of shops as identical to that of art galleries, in terms of their design, environment, and aesthetic intent. So, as shops become more creative, more historical, and more aesthetically suggestive, museums are driven by their financial circumstances to become more aggressively commercial.

In terms of the interconnections between commerce and culture, the most interesting example is the new National Museum of New Zealand, called Te Papa, the Maori phrase for "Our Place," which opened in 1998 to great acclaim and is seen, with some justification, as a model of current museological thinking and its possible future development (fig. 33.1; Williams 2003; see chapter 12 of this volume). One aspect of Te Papa which very much informed its thinking was to try to break away from the traditional élite characteristics of museums, the idea that they are in some way a special and distinctive place for quiet study and contemplation, by modeling the displays wherever possible on new techniques in retailing and the entertainment industry. The graphics are deliberately loud. The mood is, quite deliberately, that of

Fig. 33.1 Te Papa Tongarewa National Museum of New Zealand. Reproduced courtesy of Te Papa Tongarewa National Museum of New Zealand.

a shopping mall. Instead of selecting Frank Gehry as the architect for the project in conjunction with Ian Athfield, one of the most intelligent and creative Wellington-based architects, the New Zealand government chose a large, Auckland-based, commercial practice. Commercial thinking has been expected to inform all aspects of the project. So, as fast as shops plunder the display techniques of museums and employ the best and most high-minded of architectural practices (Eva Jiricna, John Pawson, or David Chipperfield), so museums plunder the world of the fast-food chain in a movement toward radical democratization.

The Shrinking World of the Object

If two of the key trends in analyzing the future development of the museum are, first, the impact of new technology and, second, the increasing hybridization of

commerce and culture, then a third is the shrinking world of the object, the tendency for museums to reduce the amount of space given over to displays of three-dimensional objects and artifacts and to expand proportionately the space devoted to temporary exhibitions, shops, and cafés.

I remember first being aware of this tendency in the new Museum of Modern Art in San Francisco, designed by Mario Botta and opened in 1995, where the scale of the atrium and the sense of a huge and monumental entrance hall completely dwarf the experience of the collection inside, so that one can spend an afternoon in the shop, the lifts, the café, and the exhibition space without necessarily being aware that somewhere tucked away on the second floor in rather insignificant rooms is the residue of what used to be the central purpose of a museum – that is, its permanent collection. This is a trend that is also evident in the Tate at St Ives, a building with a magnificent exterior, a grand ceremonial entrance, a fine shop, and an excellent café on the roof, while the experience of the collection – what there is of a permanent collection – is curiously subsidiary, a couple of galleries which a visitor might almost overlook (Axten 1995).

The tendency to shrink the collection and expand its envelope is evident, too, in the new Getty Center in Brentwood overlooking the cityscape of Los Angeles, where the experience of the paintings is secondary to the experience of visiting the place as a whole – the site, the buildings, the gardens, and the view. Each part of the collection is carefully subdivided into its own subbuilding which is itself cocooned by so much public and circulation space that the circulation between the buildings is as much a part of the experience as the experience of the art itself. In other words, increasingly, in the design of museums, the building is at least as important as the collection it holds (see also chapters 14 and 15).

Challenging Orthodox Futurology

So far, my analysis of the future repeats the standard shibboleths by which public policy is formed. These are the types of idea that help to determine the direction of policy. They are held up like lamps before the eyes of museum administrators. And we all speak of them as if the future is easily predictable and will follow on from the present as inevitably as night follows day.

But it is important that we subject these ideas, the suppositions about the inexorability of change, to careful and close scrutiny, if only to save ourselves from the type of experience represented by the building of the Dome in London, in which enormous sums of government money were spent pursuing a set of well-established orthodoxies about the way visitor attractions work in such a way that, as has become obvious since its failure, nobody involved in its planning was really prepared to listen to anyone who might have been legitimately skeptical of the thinking involved (see Nicolson 1999).

So, let me begin with the issue of the onward march of new technology. There is no doubt that the world has been transformed by the availability of new technology and the increasing familiarity with the worldwide web. I am an advocate of museums ensuring that people can find out as much as possible about a museum away from it

Charles Saumarez Smith

Fig. 33.2 IT Gallery interior, National Portrait Gallery, London. Reproduced courtesy of the National Portrait Gallery, London. Photograph by Andrew Putler.

and should be able to get convenient access to information about a museum's holdings. At the National Portrait Gallery, I was involved in the installation of an IT Gallery as prominently as possible, so that people could sit and study information about the collection at the beginning or end of their visit or, for that matter, halfway through (fig. 33.2; Powell 2000; Saumarez Smith 2001). At the National Gallery, I am committed to the idea of using new technology to ensure that visitors have access to the best-quality information about the collection.

But being able to get access to new technology is far from assuming that new technology is going to sweep the need for museums aside. This is because the experience of physical, three-dimensional objects is different from the experience of images on a screen (Davey 2000; see also chapter 18 of this volume). Works of art have been freely available in good-quality reproduction for at least a century. But the availability of works of art in reproduction has not obviated the human need and desire to experience them at first hand.

My own experience of museum-visiting with my children is that they are perfectly capable of discriminating between the experience of reading about the Napoleonic Wars in a book or of consulting their computer for information and their desire to find out more about what soldiers wore at the Battle of Waterloo. The experience of seeing the surviving object, visiting the battlefield, and communing with their history is a different kind and category of experience from finding out about

them second-hand. So, one of their favorite museums is the Musée de l'Armée in Brussels, a museum which resolutely transgresses all the orthodoxies of museum display by being a kind of mad, but beautiful and suggestive treasure house. Another is the Museo del Ejército in Madrid, full of the paraphernalia of nineteenth-century war and soon to disappear as part of the ambitious expansion plans of the Prado.

Of course, it might be argued that my children have been warped in their sensibilities by their father's prejudices. But I noticed following the opening of the new Ondaatje Wing at the National Portrait Gallery in May 2000 that a relatively small number of people chose to sit in the IT Gallery, whereas a huge number of people came again and again to experience the extraordinary frisson of the new Tudor Gallery, where the Tudor paintings are displayed in such a way as to give an extreme feeling of what it is like to be present at the Tudor court, a form of intelligent communication which is very different in kind and character from sitting in front of a computer screen. So, it is important for museums and galleries to play to their strengths, to identify what is distinctive and special about the experience of going to a museum, rather than simply jumping on to the fast-moving bandwagon of new technology.

Let me now take my second example of standard futurology, which is the increasing hybridization between culture and commerce. In part, my skepticism about the desirability of blurring the boundaries between commerce and culture to too great an extent has been influenced by taking part in an international peer review team of Te Papa, the project in New Zealand, which I used as my example of the most extreme manifestation of this trend. The reality is that if one treats the experience of a museum as too obviously interchangeable with other experiences in life, no different in character to a visit to a motorway service station or a shopping mall, then the museum loses its sense of separateness and specialness, its cultivation of a dimension of experience which is apart from everyday life. I have been struck when visiting museums in Japan, which, after all, is one of the most highly commercial countries in the world, how they completely understand this sense of the museum as a sanctuary, somewhere for solitary, and slightly spiritual, aesthetic contemplation. We will lose a sense of the importance of calm looking and study at our peril. And as fast as we try to drive it out of our museums I suspect there is every likelihood that there will be a future movement to try to recover what we have lost.

My third issue in the standard package of futurology is the shrinking of the real. This was the point at which I got worried by the way public discussion took place about the response to the Dome. During the millennium year, there was a huge amount of debate about what went wrong with the Dome. Much of this concerned the role of particular individuals involved in the project and whether or not it was Michael Heseltine or Jennie Page or Simon Jenkins or Peter Mandelson or Lord Falconer who was most at fault. But what lay at the heart of the Dome as a public spectacle was the belief that it was about the future and not about the past, and that the public have a low threshold of interest in sustained narrative, so need to be stimulated by a series of short-run, interactive zones in which they are overloaded with visual and graphic information in such a way that the experience is curiously superficial and unsatisfactory.

It was not that the planning of the Dome lacked time because it was at least five years in discussion. Nor did it lack the highest level of expertise and advice, since it was able to call upon the services of large numbers of key people in the cultural arena. Nor did it lack a philosophy and a set of clear ideals. It was just that the philosophy was curiously flat and unadventurous, bereft of a genuine desire to communicate as effectively as possible the excitement and the complexities and the possibilities afforded by a glimpse into the future. Nor has the failure of the Dome in any way eradicated the philosophy that animated the Dome from the thinking of the government in its views as to what is appropriate in its cultural policy, as is evident in the planning of cultural events for the Olympics.

A Path toward the Future

So far, much of the discussion in this chapter has been negative, consisting of stating the standard current ideas about what the future might hold and then subjecting them to a dose of mild skepticism. So the third part of what I have to say spells out what should be the guiding principles in charting our path toward the future.

The first principle is that museums need to represent the cult of the real. There is no point pretending that museums can operate except as what they were founded to be – places that can act as repositories of objects from the past, things that people have wanted to preserve from the past into the future. There has been a strong movement in museums internationally to stress that museums are not about things, but about people, about people's understanding and experience of the past (Weil 2002). But this is a category error because the original impulse of a museum is contained in the idea that it represents the cargo of the past on consignment into the future and that we in the present are expected to be witnesses to these things which are in some way precious or special or beautiful or illuminating.

I can illustrate this feeling most effectively by comparing and contrasting two experiences I had some time ago in Newfoundland. The first was a visit to a major retrospective exhibition about the Vikings held in Cornerbrook (*Full Circle: First Contact, Viking and Skraelings in Newfoundland and Labrador*, August 25 to October 9, 2000), which used all the most sophisticated instruments of display technology to bring the Vikings alive, but since many of the artifacts were reproductions and since the technology of display was so elaborate as to dwarf the experience of the ostensibly insignificant and small-scale objects, the experience left one cold, like a film which used all the latest computer animation, but had somehow forgotten that it is expected to have a central narrative. Yet two days later, we visited the visitor center at L'Anse aux Meadows, the site of a small-scale Viking settlement dating from the late tenth century, which was discovered by two Norwegian archaeologists, Helge and Anna Stine Ingstad, in 1960. There they had reconstructed a film of the archaeological discoveries based on the archaeologists' own slightly primitive home movies. And there in the display cases were the tiny number of authentic objects discovered on the site, very beautifully displayed. I have seldom felt so strongly the authentic frisson of the communication of the experience of the past from a small number of

surviving artifacts. This was not the hyper-sophisticated experience of a museum professional responding to a particular type of museum display, but a much more primitive experience of the aura provided by the fragility and arbitrariness of survival and by the ability of objects to provide a set of subliminal suggestions as to what life was like in the past, the fact that these small objects had been handled by Vikings eking out a living in Vinland, the land of the sagas, over a thousand years ago.

The second principle is that museums should not necessarily be guided by the same principles as those of commerce. Even to say this nowadays is close to being heretical and I can feel, as I state it, the metaphorical dagger of official disapproval being planted squarely between my ribs. We are all expected to be market-oriented, rather than content-driven. There is a public mood in the media that we should not be animated by a sense of higher ideals, by a belief in the power of the human imagination, by the democratic right of the citizen to have a knowledge and understanding of the past (see Cuno 2004). And there is often a view that academic specialization is in some sense anti-democratic because it necessarily confines some areas of knowledge to those who have the time and the energy and the good fortune as well as the ability and the determination to be able to devote their lives to it.

I used to have the argument between market forces and academic content every time we were organizing a schedule of future exhibitions at the National Portrait Gallery, and the tensions in the organization of the public program are just as evident next door. I still believe the first question which should be asked is: is this going to be a worthwhile and interesting exhibition? Not, is this going to pull in the largest number of people? Institutions have a responsibility to treat the content of what they do as central to their activity, not just to act as vapid crowd-pullers. Paradoxically, institutions that are content-driven or, as the jargon goes, mission-driven are more likely to be successful, are more likely to attract public support, than those institutions that are purely market-driven and aim to provide merely pap out of the commercial marketplace (Saumarez Smith 2002).

The third principle is the importance of diversity. I always get suspicious if I feel that there is too obvious a view of necessary homogenization, the idea that the world is driving fast toward uniformity of practice and that there is only one best way to do things. It is obvious that, as fast as there is a move toward globalization, so there is an equal and opposite counter-tendency toward what has been described, rather disgustingly, as glocalization, the cult of the individual, the one-off, the special, the search for the characteristics that can differentiate regions and neighborhoods (see chapter 23).

If museums are confronted by a choice between the global and the local, then I hope that they will have the sense to choose the local, the opportunity to help to define what is different and special about a particular community and its history. Indeed, if I think what museum experiences have been special to me in recent years, then I recollect not the big museums, but the small-scale and the individual, the Museum of Cromarty based in an old courthouse in the north-west of Scotland which helps to define the history of that part of Scotland or the Inverness Miners' Museum in Inverness, Nova Scotia with its evocative account of the hardships of early settlement. These are museums that are not in the forefront of new develop-

ments, are not necessarily well funded or especially innovative in their practices, but they have preserved a sense of integrity in what they do and communicate effectively the meaning and experience of life in the past just as powerfully as they do information about it. Nor is this experience confined to the world of local history museums, but can be found just as much in small-scale art museums, like the Heide Museum of Modern Art established by John and Sunday Reed in the outskirts of Melbourne, where there is exactly the same sense of integrity in seeking to enhance the experience of the individual in looking at art.

In thinking about and facing the future, one is normally confronted by two possible positions. The first is that of the cultural pessimist who tends to deplore what is happening in the cultural field and to be nostalgic for a semi-fictive past, assuming the shortening of attention spans and the inevitability of the victory of mass culture. It is hard to occupy this position since it is so evident that there has been a great efflorescence of cultural activity over the past thirty years, and that whenever, during my lifetime, it has seemed as if a particular cultural form was moribund or ripe for extinction, then very commonly it has been subject to reappraisal and reinvention. Thus, to take only a very small number of examples, during the 1970s there was a mood of pessimism about the future of the English novel, as if novel-writing had reached the end of a blind alley in the narrowness of its subject matter and its tendency toward artificiality and parochialism. Likewise, people are constantly predicting the end of painting as an art form, as if paint is a material which has somehow exhausted its aesthetic potential, but there are still painters, still people fascinated by what can be achieved through traditional image-making.

Indeed, I feel as if I have lived through a whole series of erroneous, dystopian preconceptions about what was going to happen in the future. In the 1950s, it was normal to believe in the inevitability of the advance of communism and of nuclear war. In the 1960s, there was a mass belief that the world was changing forever. In the 1970s, it was impossible not to believe in inexorable British decline, the sense of ghastly, post-imperial anguish and decay. In the 1980s, a whole new set of orthodoxies took over: the ineluctable advance of capitalism, the belief in the supremacy of market forces. Once again, I recollect people saying that the world had changed forever and that there was no possibility of going back. But suddenly, in the 1990s, all over the world there were governments trying to achieve some sort of balance between issues of social responsibility and market forces.

If it is hard to occupy the position of the cultural pessimist, then I find it equally hard to sympathize with the kind of innocence of the cultural optimists who believe that all change is necessarily for the better and that we should embrace cultural change as inevitably for the good, whatever the losses on the way and without a clear sense of conscience and recollection as to what we might be sacrificing.

So, rather than looking into the future and trying uncritically to follow in whatever direction the world appears to be going, it is more important to consult one's conscience as to what are the essentials of museums, what lies at the heart of the experience of going to museums, and what is the irreducible core of looking at works of art or archaeology or social history. Of course, there will be different architectural and organizational solutions to the problems. Of course, there will be new forms of

cultural experience. Of course, there is going to be cultural change, which will be exciting as it is unpredictable. But real innovation is not necessarily achieved simply by trying to follow the perceived direction of current policy, but by care and thought and imagination in trying to achieve the best possible solution to the task which lies at the heart of the museum. And that task remains now as it has always been in the past: namely, how we are to enhance the visual and aesthetic and intellectual experience of the individual as he or she stands in front of – and communes with – objects and works of art which survive from the past, which provide clues to past lives, and which help to enrich our understanding of imaginative possibilities in the present.

Acknowledgments

The origins of this chapter lie in the third Andrew Martindale Lecture given at the University of East Anglia on December 6, 2000. I am very grateful to Professor Ludmilla Jordanova and Nichola Johnson for their invitation to give this lecture. A version of it was published as "What the Future Holds for the Past," *The Daily Telegraph*, December 16, 2000, p. A9. In reworking the text for publication, I am very grateful for help and comments from Mark Stocker.

Bibliography

Axten, J. (1995) *Gasworks to Gallery: Story of Tate, St Ives*. St Ives: Tate Gallery.

Bayley, S. (1989) *Commerce and Culture: From Pre-industrial Art to Post-industrial Value*. London: Design Museum.

*Cuno, J. (ed.) (2004) *Whose Muse? Art Museums and the Public Trust*. Princeton, NJ: Princeton University Press.

Davey, P. (2000) Museums in an *n*–dimensional world. *Architectural Review*, 208 (1242): 36–7.

Din, R. (2000) *New Retail*. London: Conran Octopus.

Landry, C. (2000) *The Creative City: A Conceptual Toolkit*. Stroud: Comedia.

Macdonald, S. (2000) Designs from the inside. *Museums Journal* (May).

Nicolson, A. (1999) *Lid off the Dome: The Inside Story of Britain at the Millennium*. London: HarperCollins.

*Pachter, M. and Landry, C. (2001) *Culture at the Crossroads: Culture and Cultural Institutions at the Beginning of the Twenty First Century*. Bournes Green: Comedia.

Pine II, B. J. and Gilmore, J. H. (1999) *The Experience Economy: Work is Theater and Every Business a Stage*. Boston, MA: Harvard Business School Press.

Powell, K. (2000) The masterplan development. In G. Hume, B. Buchanan, and K. Powell, *The National Portrait Gallery: An Architectural History*, pp. 205–35. London: National Portrait Gallery.

Saumarez Smith, C. (2001) Redesigning the National Portrait Gallery. *Access by Design* (Spring): 9–10.

*— (2002) Off the wall: how should institutions of traditional high culture respond to the "entertainment society?" *Blueprint* (September): 64–6.

Science Museum (2003) *In the 21st Century What Role Should a Museum Play?* London: Science Museum.

Charles Saumarez Smith

Weil, S. E. (2002) From being *about* something to being *for* somebody: the ongoing transformation of the American art museum. In S. E. Weil, *Making Museums Matter*, pp. 28–54. Washington, DC: Smithsonian Institution Press.

Williams, P. (2003) Te Papa: New Zealand's identity complex. *The Journal of New Zealand Art History*, 24: 11–24.

Index

Index

Index

Index

Index

Index

Index